UNIVERSITY OF ALBERTA
LIBRARIES

THIS collection includes 150 letters Emily Carr wrote to her friends Nan Cheney and Humphrey Toms and 100 other letters relating mainly to Emily Carr. The letters date from 1930 to 1945, the most prolific period in Carr's career as both painter and writer. In them she writes in colourful detail about her everyday activities, and discusses her painting—"the biggest thing in my life." There are outbursts of exasperation and anger as well as many indications of her caring, her warmth, her wisdom and her wit, and of her impatience with critics and poseurs; and they give insights into her various relationships with, among others, Lawren Harris, Ira Dilworth, Jack Shadbolt, Garnett Sedgewick, Dorothy Livesay, A.Y. Jackson, and Arthur Lismer.

Nan Cheney and Humphrey Toms shared Emily Carr's interest in art. Carr's relationship with Cheney dated back to 1930 but did not flourish until 1937 when Cheney moved from Ottawa to Vancouver, where she later became the first full-time medical artist at UBC. Humphrey Toms was only twenty years old when he first met Emily Carr, having asked to visit her after seeing some of her paintings, following which a warm friendship developed.

The correspondence between Cheney and Toms reveals how Carr was regarded at the time and attests to their mutual interest in the Vancouver art scene. As an active member Cheney relates gossip about the local art community, providing a very personal and often exceedingly critical view of the Vancouver art milieu of the time.

Walker has chosen not to change the original text of the letters and includes Carr's misspellings and grammatical irregularities, which give a feeling of immediacy to the writing. There are numerous examples of her talent for graphic description, how she felt "rag rug level" when depressed and how she "sat down with a spank" when ill. Perhaps most significant are the many revelations of her deep commitment to her work and of her industry and perseverance despite her failing health. "Queer how we go on," she wrote to Nan Cheney, "luck there is so much rubber in human composition."

DOREEN WALKER *is a senior instructor emerita of the Department of Fine Arts at the University of British Columbia.*

DEAR NAN

LETTERS OF

EMILY CARR

NAN CHENEY

AND

HUMPHREY TOMS

EDITED BY

DOREEN WALKER

University of British Columbia Press
Vancouver 1990

© THE UNIVERSITY OF BRITISH COLUMBIA PRESS 1990

All rights reserved

Reprinted 1991

Printed in Canada on acid-free paper ∞

Designed by Robin Ward, typeset in Perpetua by Pickwick

ISBN 0-7748-0348-7 (cloth)

ISBN 0-7748-0390-8 (paper)

Canadian Cataloguing in Publication Data

Carr, Emily, 1871–1945

"Dear Nan"

Includes bibliographical references.

ISBN 0-7748-0348-7 (cloth); ISBN 0-7748-0390-8 (paper)

1. Carr, Emily, 1871–1945–Correspondence.

2. Cheney, Nan, 1887–1985–Correspondence.

3. Toms, Humphrey N.W.–Correspondence. 4.

Painters–Canada–Correspondence. I. Cheney

Nan, 1887–1985. II Toms, Humphrey N.W.

III. Walker, Doreen, 1920– IV. Title.

ND249.C37A3 1990 759.11 C90-091463-7

This book has been published with the assistance of grants from
The Leon and Thea Koerner Foundation, the Nan Cheney Memorial Trust Fund,
and the Canada Council.

UBC PRESS 6344 Memorial Road

Vancouver BC V6T 1W5

CONTENTS

FOREWORD vii

INTRODUCTION ix

NOTE ON THE TEXT xxxi

ACKNOWLEDGMENTS xxxvii

ABBREVIATIONS xl

COLOUR PLATES *FACING* xl

CHRONOLOGY xli

ILLUSTRATIONS *FACING* xlvi

THE LETTERS 3

POSTSCRIPT 415

TRANSCRIPTION OF THE CARR LETTERS 418

EMILY CARR'S ''VARIATIONS'' 420

INDEX 427

FOREWORD

WHEN Nan Lawson Cheney died in her eighty-ninth year on 3 November 1985, she left instructions that there was to be no burial or memorial service. It was typical of her to thus shun ceremony or tributes, but she in fact deserved more recognition than she received during her lifetime. At a reception held to honour her memory, some of her many friends decided that something should be done to provide long overdue recognition of the significant role that Cheney had played both as a friend and a confidante of some of Canada's most prominent artists, particularly Emily Carr, and of Cheney herself as an artist.

Consequently, a small committee was formed to establish a memorial trust fund in Nan Cheney's name. Its members included Jessie Binning, Kay Cashmore, Denise Fiala, Peggy Sloan, Marion Smith, Doreen Walker, William Webber, and myself, as well as the late Geoffrey Andrew, who was a most enthusiastic early committee member. This group agreed that the trust fund should be used for two major purposes: to assist in publication of the letters between Emily Carr and Nan Cheney and to purchase paintings by Cheney for permanent display in a major public institution.

This book, *Dear Nan* (a title suggested by Kay Cashmore), is the fulfilment of the committee's first purpose. Nan Cheney's letters from Emily Carr were given to the Special Collections Division of the University of British Columbia Library in 1969. Until now little has been recorded about these two friends, nor about their mutual friendship with the younger Humphrey Toms. In this collection of letters among the three of them, which includes Carr's letters to Toms from the British Columbia Archives and Records Service, Doreen Walker has done a meticulous job of research and editing. The letters form an important contribution to the corpus of work on Emily Carr and to the cultural history of Canada in the 1930s and 1940s.

A start now also has been made in fulfilling the second purpose of the committee through the Vancouver Art Gallery's purchase of a painting of Nan Cheney's donated to the trust fund committee by Marion and Gordon Smith.

Victor Doray, Vancouver

INTRODUCTION

I am looking forward to seeing you tremendously to have someone after my own heart to talk to about work.
(Emily Carr to Nan Cheney, 9 May 1938)

EMILY CARR (1871–1945), NAN LAWSON CHENEY (1897–1985), and HUMPHREY TOMS (1913–83) were close friends who corresponded both regularly and sporadically between 1930 and 1945. Fortunately, more than 200 of their exchanges have been preserved: it is these, along with a closely related selection of letters by others, that form the contents of this volume.

Emily Carr's letters, dating from 1930 to 1944, provide the major portion of the compilation and embrace her most productive and creative years in both painting and writing. Well known as an inveterate letter-writer, her habit at times a compulsive one, she frequently referred to the many letters that "one way and another" she had to write. On one occasion she remarked that letter-writing had taken up all her time (#172). Her output indeed was prodigious, and among those who carefully preserved their share of the enormous total were Nan Lawson Cheney and Humphrey Toms.[1]

The letters that exist in such numbers surely manifest Carr's deep-seated need for friendship, as well as an equally enduring need, so evident in her stories and journals, to commit her feelings and experiences to paper. In sum, they form a significant part of the voluminous autobiographical record she amassed.[2]

Writing in a wide variety of forms was always an important means of expression for Emily Carr, and she often noted its value to her. "It seems to me it helps to write things and thoughts down," she observed in the journal she began in 1930.[3] "It sorts out jumbled up thoughts and helps to clarify them, and I want my thoughts clear and straight for my work." She reasoned that "trying to find equivalents for things in words" helped her find "equivalents in painting" and cited this as the reason for her journal.[4]

Emily Carr saw special values in letter-writing. "There is a side of friendship," she wrote, "that develops better and stronger by

correspondence than contact, especially with some people who can get their thoughts clearer when they see them written." "Another thing," she continued, "—that beastliness, self-consciousness, is left out, shyness, shamedness in exposing one's inner self there face to face before another, getting rattled and mislaying words." And, she concluded, "The absence of the flesh in writing perhaps brings souls nearer."[5]

Undoubtedly Carr's writing provided her with an emotional outlet as well. "Feel like firing off to someone," she wrote to Nan Cheney, "so will spill over onto you" (#39), and in her journal she reflected after an outburst, "Now, perhaps, having written it all down, the hatefulness will melt off to where the mist goes when the sun gets up."[6] Carr believed that in times of stress her writing could act as a "sedative," that she could lose herself in her story. "I have been writing stories," she recorded in 1936, "and that, I expect, eased me, pouring out that way. It seems as if one must express some way."[7] To Nan Cheney she disclosed, "too wrought up [for painting]. but queer to say I *did* write. I find when I need *calming* I get it that way best" (#183).

Story-writing had been a particular interest of Emily Carr since the 1920s,[8] and in 1926 she enrolled in a correspondence course to gain instruction.[9] Her letters and journals confirm that by the early 1930s story-writing was indeed an active pursuit. She was seeking criticism from friends (Lawren Harris among them),[10] enrolling in further courses, and submitting manuscripts for publication, albeit unsuccessfully at this time.[11]

It was from 1937 onwards, however, as Carr's health declined and her painting time became more limited, that her story-writing became increasingly important to her. Drawing on a wealth of personal experiences, she developed in these years the majority of sketches that would appear in her well-known books: *Klee Wyck*, *The Book of Small*, *The House of All Sorts*, *Growing Pains*, *Pause: A Sketchbook*, and *The Heart of a Peacock*.[12] Thinking particularly about her *Klee Wyck* stories (but surely applicable to many of the others as well), Carr wrote of the

"genuine pleasure" she derived from her writing and how it "helped hundreds of hours away" while she was unable to paint.[13]

Letter-writing became increasingly important to her as well; certainly the number of letters she wrote substantially increased. As visits and travel became more difficult, she seemed more anxious than ever to maintain, and ensure, contact with friends and to share her day-to-day thoughts and concerns with them. "A human conversing with another human," is how she described it.[14]

Emily Carr seemed to thrive both on the writing and the *receiving* of letters. "I need a letter," she wrote to Nan Cheney, "or whats the good of correspondence" (#9). And she was insistent that the letter-writing always be an *evenly* shared activity. "I will not write one-sided why should one?" she stated firmly, "its like talking to yourself in a cupboard."[15] Many of the letters she must have received have disappeared. A number were evidently destroyed in the 1936 "cleaning out" of her Simcoe Street house, and others in the move from Beckley Avenue in 1940.[16] But from her time at St. Andrew's Street a vast number of letters from many different persons were saved. Many were notes of congratulations and praise, often from strangers; and there were cards, letters, and telegrams from long-time friends. A few had been saved from earlier years ("I like a few old letters, a few old notes of the past," she had written).[17] Among the total were three from Nan Cheney and two from Humphrey Toms.[18] There can be no doubt that Cheney, as well as Toms, wrote many more letters to Carr. Apart from the obvious internal evidence, there is Carr's stern warning (with one of her frequent misspellings): "remember no letters no answears" (#174).

Nan Cheney was also a prolific letter-writer (a habit she continued until very late in her life). Those in this volume are mainly to Humphrey Toms, but they include as well a related group to Eric Brown and H.O. McCurry of the National Gallery of Canada, as well as the three to Emily Carr noted above.

Cheney's letters to Toms have survived intact. They extended from 1938 through to 1945, when Toms was serving in the Canadian

Army in Europe, and they were with him when he returned from overseas and moved to Vancouver in 1946. Toms was a highly respected amateur historian whose archival interests might have led him in any event to preserve his many letters. But he was surely encouraged to save them by Cheney's enquiries about their fate. "What do you do with them?" she asked more than once (#228). Clearly she hoped that they would be saved, just as she was saving Emily Carr's (#117). Eventually Toms returned the letters to her,[19] and she kept them until her death in 1985.

Toms' letters to Cheney exist only as typewritten excerpts. He has explained: "Nan, who always hoarded letters, kept all mine. About 1954 when I casually remarked that I might try to write some sort of a war diary of my own experiences, she handed the whole lot over to me. In due course I lost interest in the project but in January 1956 I made extracts from them for all mentions of Emily and then, with Nan's consent, destroyed them all."[20] (Toms completed a revised typescript of these extracts, along with selections from Cheney's letters to him, in 1979.) Thus, though the two corresponded well into 1945, the parts saved end in November 1941.[21] The last brief reference comes from a Quebec letter and tells of Toms ordering a copy of Carr's newly released *Klee Wyck* (#211).

How did these three people, so separated by age, come together, and what was the basis of their friendship? Their associations evolved over a ten-year period, and certainly their common interest was art. The beginning was in late November 1927 when Emily Carr and Nan Cheney met in Ottawa. Carr was in eastern Canada for the opening at the National Gallery of "Canadian West Coast Art: Native and Modern," an exhibition to which she was a key contributor.[22] For the first time it brought Carr to the attention of a number of eastern artists, including, and of particular significance for her, Lawren Harris and other members of the Group of Seven. In turn, she saw a number of paintings, by members of the Group and others, that were to have a crucial impact on her and her own work.[23]

Nan Cheney was part of the Ottawa art community that so

warmly welcomed the visiting west coast painter. In her journal, Carr wrote of being entertained by the Cheneys, whom she described as "charming young people with a lovely home on the canal," and noted: "She paints."[24] Years later, in recalling Carr's eastern visit, Cheney remarked: "There were quite a few painters living in Ottawa then and we were delighted to meet and entertain some one so original and different."[25]

Though they exchanged a few greetings in the intervening years, the two artists did not meet again until 1930, likely briefly in the spring when Carr was in Ottawa, but certainly in the summer when Cheney was a guest of her aunt in Victoria.[26] While there she visited often at Carr's Simcoe Street house, and on one occasion she was Carr's guest of honour at a garden tea.[27] (Photographs of Carr taken by Cheney that summer are in the Cheney Photograph Collection with the Special Collections Division of the University of British Columbia Library.) After Cheney returned to Ottawa in the fall, she wrote to Carr and thus initiated the correspondence that would follow. "I was tickled to bits to get your letter," Carr answered (#1).

It is clear from Carr's reply that a warm friendship had developed between them over the summer. But, although the letters continued for a time, they abruptly ceased in January 1933, prompting Carr to write in late 1935, "I thought I was dead to you shure" (#12). And it appears that in more than four years (until early 1937), Carr heard from Cheney only once.

Perhaps a partial explanation for this hiatus is found in Cheney's letters to Kathleen Daly Pepper. Daly (as she is known professionally), an Ottawa painter friend of Cheney, moved to Toronto in 1932 when her husband, George Pepper, joined the staff of the Ontario College of Art. From Cheney's fairly regular letters to her, it is apparent that for financial reasons Cheney had been forced to give up her settled Ottawa life and seek freelance work in Montreal in her former profession as a medical illustrator.[28]

There are no known letters from 1936, but Carr's journal testifies to another Carr-Cheney meeting: "Nan Cheney came Saturday. We

had a long talk," she recorded briefly on 4 July.[29] (An August teaching stint for Cheney at Banff had made a western visit possible.) Yet it was only following the Cheneys' move to Vancouver in March 1937, when Dr. Cheney was appointed to the staff of the Vancouver General Hospital,[30] that the letters began again and the friendship flourished. Carr wrote enthusiastically of the renewed contact: "Yesterday & today I had Nan Cheney, Eastern artist now living in Vancouver. She had lunch with me yesterday, had a tray too in my room. We have lots of mutuals and great pow-wows."[31] And a few months later she recorded: "I have had such a treat this week. Nan Cheney has been here every day. She is over from Vancouver to paint a portrait of me so we have chatted for long hours while she worked."[32]

Cheney became closely involved with Carr and her affairs primarily through her promotion of Carr's first Vancouver Art Gallery exhibition in 1938. ("But for your instigation it would never have been," Carr gratefully acknowledged [#67].) It was during this period and the few years following that the letters truly mount in number: in the year of the Vancouver show alone there were thirty-five. And there were frequent first-hand encounters: Cheney, Carr wrote, was someone after her own heart to talk to about work (#40).

But the friendship that the two so obviously enjoyed in both letters and visits suffered badly in Carr's very last years.[33] "I never hear from Nan nor write," Carr told Toms the year before her death (#244). In fact, Cheney had visited Carr in late 1943 (#240) and did so again in late 1944, but from the letter accounts of these meetings their friendship was by then strained indeed.[34] Clearly the two women had turned against each other.

Carr's refusal to have Cheney's portrait of her hung in a large Toronto exhibition in February 1943 (#231) was undoubtedly a bitter disappointment to Cheney and likely a major cause of their drifting apart. After 1942 Carr wrote only three brief, albeit friendly, letters to her: a Christmas greeting and two "thank yous" for flowers. Clearly Cheney was no longer either a principal correspondent or a confidante.[35] (By the 1940s Ira Dilworth, Carr's editor, had assumed

that role.) "Friendships are very delicate," Carr once wrote, "apt to snap when strained—shouldn't, but do."[36]

The Emily Carr-Humphrey Toms association dates from 1933 when the twenty-year-old Toms was still living with his parents in Victoria. Years later Toms recorded the circumstances of their first meeting, recalling that in the early 1930s he had been taken by a friend to the annual shows of the Island Arts and Crafts Society, where he had been "much impressed by the paintings of a woman named Emily Carr"—a name, he acknowledged, which he had "never heard of before." Sometime during July 1933, Toms wrote to Carr asking if he might visit her studio. From his account a pleasant evening ensued:

> *It was a quiet evening. There was one other person invited, Mrs. Gwen Cash . . . Emily was at first intensely shy but warmed up and showed us a number of her paintings. The evening ended with piping hot cocoa, buttered toast and jam and a friendly good-night.* [37]

By the mid-1930s, a warm association was clearly established. (Carr wrote to a friend, "Humphrey Toms . . . came over, and did the top apples for me. . . . He's such a nice boy and very willing to lend a hand.")[38]

Carr's letters to Toms throughout the 1930s were mostly brief notes, since they were seeing each other quite regularly. But from September 1940, when Toms began to teach at Enderby, BC, and especially during his service in the army in Canada and overseas, both the number and length of the letters increased, and Toms became one of Carr's numerous correspondents. Her last letter to him, sent from hospital to his station in England, attests to their mutual affection. "I thank you," she wrote, "for wanting me here when you come home," and she closed, "as always your old friend Emily" (#244). (Years later Humphrey Toms was described as "perhaps the one young man Emily never criticized.")[39]

Not surprisingly, it was through Emily Carr that Humphrey Toms and Nan Cheney met. Toms recorded that his first meeting with "Nan" took place at Carr's Beckley Avenue house in May 1938 and that their correspondence began shortly after. Probably their friendship became firmly established the following September when Toms was a guest of the Cheneys in Vancouver.[40] From then until the war's end, it was maintained almost solely through their letters. When Toms returned from overseas early in 1946 ("to find Emily's name was famous"),[41] he moved to Vancouver to attend the University of British Columbia and was able to continue his friendship with Nan Cheney first-hand. Over subsequent years he proved himself to be, time and time again, a most faithful and valuable friend.[42]

And what of the letters' content? The focus is essentially, although not exclusively, on "Emily"—the Emily Carr of her late, yet highly productive, years. And whether *by* her or *about* her, they provide a substantial body of documentary material, including views as to how Carr was seen *at the time*, not just as she later appeared to friends upon reflection.

Emily Carr was just days short of fifty-nine when the letters to Nan Cheney began. By then she was a mature and experienced artist, and she had produced a highly impressive body of painting.[43] Yet in 1930 she described herself (in her familiar, self-effacing way), as "old, old, old, in most ways and in others just a baby with so much to learn." She resolved that for the coming year she "must work harder, must go deeper."[44] Certainly the decade that followed was one of enormous productivity.

Biographical studies of Carr have made many aspects of her life and character familiar,[45] and the letters themselves have been a useful source for researchers. Their value and interest for the reader will surely lie in the directness of the contact they provide with the artist, as well as in the insights they give into her day-to-day living and her relationships with others throughout this significant fifteen-year span.

"Life wags on," Carr mused early in her correspondence with Cheney (#3); and much of the content of her letters is simply casual

"chatter" about the everyday activities and concerns relating to her home, camp, health, family, friends (and non-friends!), maids, shows, books, sewing, garden, pets—*as well as* her painting and writing. "I spose I'm just naturally a domestic woman," she wrote to Cheney. "I love houses & gardens & home things" (#180). Indeed, at times the multitude of concerns and distractions that invaded her daily life make one marvel at the extent of her creative achievements. ("I had everything ready for the cold snap," she wrote to Cheney, "birds extra sheltered, wood all in, garden put to bed" [#171], and so on.) She admitted that her only "grudge" against too much domestic work, was "not having enough time *beyond* the physical for the spiritual."[46]

In Carr's random recounting of her days, there are many displays of her well-known traits that reveal the diverse aspects of her personality. There are occasional outbursts of impatience, exasperation, and anger, notably in her later years ("I'm so intollerant," she acknowledged to Cheney [#183].) And there is as well evidence of racial bias in her use of terms that clearly were not so unacceptable at the time.

In contrast to these are the many demonstrations of her genuine caring and warmth, her appealing affection (often towards her various "beasts"), and her capacity as well as her need for friendship. The later letters reveal, as well, Carr's sobering thoughts regarding the war ("scars that will never heal" [#244]), and her philosophical acceptance of her deteriorating physical condition. "I made up my mind," she told Cheney, "just to gather up what was left of me & make the best of it" (#170). Liberally scattered throughout this collection are the countless examples of Carr's wonderful wit, and her ever-present talent for graphic description. She was "rag rug level" when depressed, and was "sat down with such a spank" when ill (#42 and 134). She wrote aptly, too, of "big pot" guests, of "sticky-seated" visitors, and of "hardy anual friends" (#190, 195, and 27).

During the time-span of these letters, Carr was in contact with numerous persons and her comments are revealing as to the nature of her relationships with them.[47] Of Lawren Harris she wrote, "we are

thoroughly interested in each others work, and lives, and our freind-ship is a deep one" (#170). And of Ira Dilworth, after a manuscript session, "It is lovely going over them with him" (#193). She later affirmed, "I love these two—from the bottom of my heart, & have cause to" (#207). With A.Y. Jackson it was different: "I never feel, in sympathy with him, & I think he feels same with me," she disclosed. "I have always felt he resented me as a woman artist" (#138). The situation with sister Alice was often difficult. Emily was at times so sympathetic (she read to her nightly); and at times so irritated. "Never were two sisters more different," she confided to Cheney (#180).

There are numerous references to Carr's artistic activities, and interesting accounts of camp life, but her letters offer few particulars as to exactly *what* she was painting: "Have 3 canvases on the go," she wrote in 1937, "always work two or three at a time as I dry out between each painting" (#24). And another time from camp: "I've done quite a lot of work slashing away" (#49). Often her remarks pertain to the tiring chores connected with her painting. "It is not so much *working* but *preparing* to work which seems so much effort," she related in 1940 (#174). And more positively, "I have stretched and primed 11 canvases, and feel very *nice*" (#174). There was also the mounting, framing, crating, and shipping (with "prohibitive" express rates) preliminary to the showing of her work. "I told Lawren once," she wrote to Nan Cheney, " 'any fool can *paint* a picture but not every genius can "crate" ' " (#178).

Perhaps surprisingly, there is little in the Carr letters of her deep attachment to Native life and art, the theme to which she had returned with such enthusiasm following the 1927 trip to eastern Canada. But by late 1930, she was no longer travelling to remote northern villages. Her final trip, to the villages of Alert Bay and Quatsino Sound in the northern Vancouver Island area, was completed in September 1930.[48] Nor was she at this time wholly absorbed in the painting of Indian subjects (indeed, she had executed both forest as well as Native-inspired sketches in her trips of 1929 and 1930).[49]

Barely into 1931 she recorded in her journal: "My aims are changing and I feel lost and perplexed. I've been to the woods today. It's there but I can't catch hold."[50]

Although this critical time for Carr is documented in numerous journal entries, it is barely indicated in the surviving letters.[51] In 1932 she allowed briefly to Cheney: "I've done a few canvases, & a lot of thinking." She continued, "Yes we do change our veiwpoint as we go on. . . . it is inevitable if we are to make any progress" (#8). Years later, in reflecting on this period of transition, Carr conceded that "It was not handling of paint but handling of thoughts which had overwhelmed me."[52] While she grappled with transcendental concerns she came to believe that "The only thing worth striving for is to express God. Every living thing is God made manifest."[53] She thus sought to express in her painting something of her own beliefs and spiritual convictions (albeit changing ones)[54] while focusing on the landscape as her theme: to show her love of God *and* nature as God *in* nature.

For a while Carr continued to work with Indian subjects (*Totem and Forest* [1931] and *Blunden Harbour* [1931–2] are perhaps the best known),[55] and she returned with enthusiasm to them later.[56] But primarily it was nature itself to which she was drawn. "I am wrestling again with my forests," she wrote to Cheney in 1932 (#6). Later Carr commented to Eric Brown on her change in direction: "I expect you select the Indian material for variety among the landscape work but I confess forests & woods, spaces & sky. are more engrosing to me these past few years. I feel they are more completely my own expression and interpretation."[57] The letters contain many expressions of her devotion to nature ("I love the earth and earthy things," she wrote to Toms [#244]); and of her yearnings for the woods when she was unable to be there. "Am dredful hankery for the Woods," she wrote longingly one spring, "A year since I came a cropper" (#198).

Carr's camping expeditions—some of which are described here—were to areas closer to home where she sketched the wooded landscapes, open spaces, enormous skies, and stretches of beaches.

The references both to her sketching trips and painting should be mainly considered in relation to these themes, for throughout the 1930s, and as late as 1942, she was interpreting her vision of these places. "Putting into visibility what gripped me in nature," she wrote in 1940.[58] *Wood Interior*, *Edge of the Forest*, *Young Pines and Sky*, *Above the Gravel Pit*, *Sunshine and Tumult*, and *Above the Trees* were part of her enormous output.[59]

Emily Carr often seems doubt-ridden in her letters about how her painting had been or would be received. And she seems equally curious about the public's response to the work of some others. ("Do you know what impression Jack Shadbolt made [in Toronto]?" she asked Nan Cheney twice in a row [#184 and 188]). Yet from 1930, the year the letters commence, Carr was receiving increasing recognition and support.[60] And by early 1933 it was claimed that she was "now beginning justly to be heralded as one of the foremost of Canadian painters."[61] Still, she obviously felt a continuing need for encouragement, approval, and (although likely she would have denied it) praise.

Carr's manuscript efforts are frequently mentioned: "I write much," she told Cheney, "and mostly in bed" (#83). But similarly to her painting she harboured many doubts concerning its worth, and once wrote of having "spasms of 'flop' terrors" (#198). The progress with her stories can be partially charted through the numerous references to them. "Finished the house of all-sorts & disgusted with it," she complained at Christmas time in 1937. But, she added, "have put it away for further maturing" (#25). Early in 1940, at a time when she said that writing was about all she could do, Carr reported to Cheney, "I have got through Woo's life . . . finished up to its last typing" (#137). Throughout the letters Carr tells of reading her stories to friends, sending them off for criticism, waiting (impatiently) for replies, and, in 1941, of hearing of their acceptance. "I am being published," she wrote to Humphrey Toms (#190).

Perhaps the most significant aspects of the Carr documents are the many revelations of her deep commitment to her work, both her painting and writing, and of her industry and perseverance despite

failing health. "My work was the biggest thing in my life,"[62] she wrote not long before her death in 1945, and the letters in this compilation provide abundant testimony to her earnestness. "Queer how we *go on*," she once wrote to Nan Cheney, "luck there is so much rubber in human composition" (#63).

In the Cheney letters to Toms, as in his excerpts to her, there is much about "Emily"; clearly Carr's welfare and her work were of particular interest to them both. Throughout their correspondence one gains insights into the particular nature of their relationships with the older woman. But the Cheney letters also attest to the many interests she and Toms shared. Cheney assured Toms that while he was teaching in Enderby she would keep him in touch with "news of the Art world" (#164) and her letters include numerous comments on artists and shows. Moreover, Cheney was personally involved in the local art scene—a scene of great interest to both Carr and Toms, and she tells of her role as an active member. Like Emily Carr, Nan Cheney had strongly held views which she obviously felt free to express to her younger friend. Her words on occasion are exceedingly critical, with a number more than matching Carr's for intolerance. Particularly offensive are her racist slurs and her inferences regarding homosexuality, which sadly, reflect attitudes all too prevalent at the time. Years later, Toms reasoned, perhaps in an attempt to justify some of the jarring remarks, "The style of personal letters is usually casual and some of their content the sort of gossip written between friends concerning persons they both knew or knew of."[63] The Cheney letters do, in sum, provide a view, albeit a highly personal one, of the Vancouver art milieu, its politics and its participants.

There can be little doubt that Nan Cheney wanted these letters to become public. After they were returned to her she saved them, edited them to a degree, and referred to them often in conversation. She seemed to recognize that they had a certain value as "history."

Her letters to the National Gallery show considerably more discretion, although they are apt to appear as self-serving. Shortly after

her move to the west coast she wrote to Eric Brown: "I can already share the feeling of being cut off from the East" (#16),[64] and her letters served in part as a means of maintaining contact. She forwarded news of the local scene, most particularly word of Emily Carr; but she wrote also in relation to her own career, often requesting information and exhibition facts, while at the same time revealing the informality possible in conducting gallery "business" at the time. Cheney, understandably, was clearly anxious to re-establish herself in the east as an exhibiting painter—a role, in a minor way, she had earlier enjoyed.[65] And she was particularly keen that her "Emily" portrait be shown and, she hoped, purchased (#53). It seems ironic that while Cheney was endeavouring to advance her career with the acceptance and sale of this work, Carr's changing view about its worth would be a factor straining their friendship in Carr's final years (#231).

For a few years after Emily Carr's death in 1945, Nan Cheney continued to pursue her modest painting career. But in 1951, circumstances for a second time dictated that she seek full employment. It was then that she again took up the profession in which she was originally trained and hence became British Columbia's first medical artist.[66]

Humphrey Toms pursued virtually two careers, that of plant pathologist, the profession in which he was formally employed (Agriculture Canada Vancouver Research Station), and genealogist, his self-directed freelance vocation, sparked originally by his research into his family ancestry in Cornwall during periods of leave in wartime England.[67] Toms was widely admired for his professionalism in his research into English local histories and also for his unstinting generosity in assisting others engaged in genealogical pursuits.[68] His inherent regard for the value of documents and documentation—so evident in his care and his annotations of the Emily Carr and Nan Cheney material—proved of inestimable value in the preliminary research for this compilation.

NOTES

1 The Emily Carr letters are now mainly in public collections. Those in this compilation are from the Special Collections Division of the University of British Columbia Library (UBCL), Nan Lawson Cheney Papers, box 1, files 1–33, and the British Columbia Archives and Records Service (BCARS; formerly the Public Archives of British Columbia). The 131 letters and cards from Carr to Cheney, as well as a letter from Carr to Jessie Faunt, are from the Nan Lawson Cheney Papers of UBCL that were acquired in 1969. Nineteen items from Carr to Humphrey Toms are from the BCARS, Humphrey Toms Papers, and were presented to the Archives in 1988 by Mrs. Jane Toms, sister-in-law of Humphrey Toms. (The twentieth Carr to Toms item, #83, is a card known only through Toms' transcription: "Letters from Emily Carr to Humphrey Toms," typescript, 1979, p. 3, property of Jane Toms.) The Emily Carr letters are published through the kind permission of John Inglis, son of the late Phylis Dilworth Inglis. Among the Carr letters that are still in private hands are those of the late Ada McGeer, with the Patrick McGeer family, Vancouver; those of the late Katherine Cullen Daly, with her son, Thomas C. Daly, Montreal; those of the late J.W.G. "Jock" Macdonald, with Dr. Joyce Zemans, Ottawa; and those of Myfanwy Pavelic, Sidney, Vancouver Island, which she retains. Mrs. Pavelic has stated in conversation that in the early 1940s she must have received hundreds of letters during her periods of study away from Victoria, but that, unfortunately, only a handful have been saved. For the numerous Carr letters that are cited in the annotations, sources are provided.

2 The Inglis and Parnall collections in the BCARS are the two major sources of Carr archival material. The Phylis Inglis Collection was purchased by the National Museums of Canada in 1976 and presented to the BCARS in 1985. It includes Carr correspondence, journals, manuscripts (books, short stories, addresses, notebooks, notes), photographs, clippings, pictorial material (drawing books, sketchbooks, and other sketches), and miscellaneous material. The Edna Parnall Collection was acquired by the BCARS in 1989 and includes diaries, notebooks, correspondence, a scrapbook, and a collection of books. The material in both these collections became the property of Ira Dilworth following Carr's death and was passed on to his nieces, Mrs. Phylis Inglis and Mrs. Edna Parnall, at his death in 1962. It has been well established by researchers that Carr's autobiographical writings, although revealing as to her personality, attitudes, and feelings, cannot be wholly relied upon for factual data.

3 Carr continued with her journal writing until 1944, recording intermittently. In the BCARS, Inglis Collection, are journals 2–18, extending from 1930 to 1944. In addition, the collection contains journal 1A, 1910; journal 1, 1927; and journal 19, n.d. [1929]. *Hundred and Thousands: The Journals of Emily Carr* [*H&T*] was published by Clarke, Irwin & Co. Ltd. in 1966. It was based on material taken from the 1927 and 1930–41 journal entries.

4 *H&T*, 23 and 26 Nov. 1930.

5 *H&T*, 26 Nov. 1935.

6 *H&T*, 5 Mar. 1940. Lawren Harris once wrote to her, "when you have need of ripping things up a bit, write me." BCARS, Inglis Collection, n.d. [1933].

7 *H&T* Ibid., 7 Feb. 1940, 1 Nov. 1936.

8 Flora Burns, a close friend of Carr from 1924, was aware of her early writing and was, at Carr's request, a critic of her work. See Burns, "Emily Carr," in *The Clear Spirit: Twenty Canadian Women and Their Time*, edited by Mary Quayle Innis (Toronto: University of Toronto Press 1966), 235. Mary Elizabeth Colman has

related that "it was in the early 1920s that Emily Carr first showed me her writing and that we discussed the possibility of her doing a book about her experiences." See Colman, "My Friend Emily Carr," *Vancouver Sun*, 12 Apr. 1952, p. 14.

9 The correspondence course was with the Palmer Institute of Authorship, Hollywood, California. Two of Carr's textbooks (now in the BCARS, Parnall Collection) are from a series published by the Palmer Institute entitled *Modern Authorship* and subtitled respectively *Technique of the Short Story* and *A Manual of the Art of Fiction*. (Carr has inscribed in the former, "November 1926" and in the latter, "June 29, 1927." Passages of particular interest are underlined.

10 In 1931 Lawren Harris, at Carr's request, read one of her Indian stories ("In the Shadow of the Eagle," later published in *The Heart of a Peacock*). He then urged her to do "an entire book of them." He stated that "there would be nothing like it and it would be a real contribution." Harris wrote further: "Writing and painting help one the other and the individual who does both has a wider base to stand upon and to work from. . . . it will give you another realm to live in." BCARS, Inglis Collection, Harris to Carr n.d. [1931].

11 Carr enrolled in courses in the summer of 1934 at the Provincial Normal School and in the following autumn in an adult education course at Victoria High School. For her accounts of these classes, see *H&T*, 9, 11, and 26 July 1934, 3, 8, and 10 Aug. 1934, 1 Oct., 3 Dec. 1934 and 1 Jan. 1935. See also 1 Oct. and 10 Dec. 1934 concerning rejections.

12 *Klee Wyck* (1941) was finished essentially in 1937–8, while *The Book of Small* (1942), although started in 1934, was developed primarily in the 1937–41 period. *The House of All Sorts* (1944) was begun in 1937 and worked on in the 1940s. "Bobtails," published in the same volume, was written mainly in 1941. *Growing Pains* (1946), Carr's "autobiography," was begun in 1940 and completed in 1943. An earlier version, written in 1938–9, remains unpublished. *Pause: A Sketchbook* (1953) is referred to in the letter as "Chins Up," and was written mainly in 1938 but was worked on again in 1943. *The Heart of a Peacock* (1953) contains stories from both before and after 1937, which were selected and edited by Ira Dilworth after Carr's death. "Woo's Life," which was revised in 1940, forms the second part.

13 NGC, Archives 7.1 Carr, E., Carr to Eric Brown, 30 June 1938. Near the end of her life Carr wrote to a friend, "I have been lucky indeed & have words come to me when I had to give up the woods & sketching & prepare for long inactivity." Carr to Katherine Cullen Daly, 17 January 1945, possession of Thomas C. Daly. See also Carr, *Growing Pains: The Autobiography of Emily Carr* (Toronto: Oxford University Press 1946), 359–60.

14 BCARS, Inglis Collection, Carr to Dilworth, n.d. [1942]. The previous year Dilworth had written to Carr: "These letters are just a way of having a chat with you." BCARS, Parnall Collection, 26 Oct. [1941].

15 Carr was referring to a lull in the letters she was receiving from her young friend Myfanwy Campbell (now Pavelic). See BCARS, Inglis Collection, Carr to Dilworth n.d. [24 Oct. 1944].

16 *H&T*, 28 Jan.-23 Feb. 1936, 2 Feb. 1940. Carr also wrote of destroying "stories, paper, letters" in her entry of 9 Jan. 1938.

17 *H&T*, 9 Jan. 1938.

18 Among the surviving letters *to* Emily Carr are 127 in the BCARS, Inglis Collection. This number includes 60 from Ira Dilworth and 49 from Lawren Harris. In the BCARS also are some 440 items (letters, notes, wires, and cards) in the Parnall

Collection. Included among these are 161 from Dilworth and 8 from Harris. (Carr admitted destroying some "personal" ones from Harris, "in fairness to him." BCARS, Inglis Collection, Carr to Dilworth, 14 Feb. [1942].) The two Toms letters dated 1941 and 1942 are from the BCARS, Parnall Collection. The three Cheney to Carr letters are from 1938 and were presented to UBCL, Special Collections Division, in 1986, through the courtesy of Mr. and Mrs. J.E.A. Parnall, Victoria, BC.

19 Toms, "Nan Lawson Cheney to Humphrey Toms," typescript (1979), property of Mrs. Jane Toms, Victoria, BC, sister-in-law of Humphrey Toms. The typescript contains extracts only.

20 Notes in Toms, "Letters to Nan Lawson Cheney from Humphrey Toms," Aug. 1979, 1. A copy of the 1956 typescript is in the UBCL, Cheney Papers, box 1, file 35.

21 Two postcards from Toms to Cheney sent while on leave in eastern Canada are in the UBCL, Cheney Papers, box 4, file 15. They are dated 21 June 1942 and 15 July 1942 and were somehow not with the other Toms to Cheney correspondence. There are no references to Carr in the brief message, and thus they have not been transcribed for this compilation.

22 Carr's works were included through the instigation of Marius Barbeau of the National Museum, although the final selection of the 26 paintings was made by Eric Brown of the National Gallery during his visit to Carr's studio in September 1927. Examples of Carr's pottery and her hooked rugs were also included in the show. Barbeau and Brown of the Ottawa institutions were co-organizers, and arranged the exhibition (which would travel to Toronto and Montreal), with the co-operation of the Royal Ontario Museum, Toronto; McGill University, Montreal; and the Art Association of Montreal. In the catalogue Brown wrote of "the work of Miss Emily Carr, of Victoria, BC, whose study of the country covers a long period of years, and whose pictures of it and designs translated into pottery, rugs, and other objects, form one of the most interesting features of the exhibition."

23 For Carr's journal accounts of her visits to artists' studios and exhibitions, see H&T, 14 Nov.-11 Dec. 1927. She recorded seeing the works of F.H. Varley, A.Y. Jackson, Arthur Lismer, Lawren Harris, J.E.H. MacDonald, Franklin Carmichael, and A.J. Casson, all of the Group of Seven, as well as paintings of Tom Thomson and Edwin Holgate (a Group member in 1930). Carr noted also seeing some "Indian things" when referring to paintings of Langdon Kihn, Holgate, Jackson, and Peggy Nicol. Both in her journal at the time of the trip and in reflection years later, it was Harris' paintings that she acknowledged particularly. As late as 1945 she recalled, albeit romantically: "His pictures . . . impressed me more than any in my life London Paris anywhere because they were what was in my heart I knew I was striving alone in the west for what the group men were striving for in the East" (Carr to Katherine Cullen Daly, 11 Feb. 1945). Shortly after Carr's return home Harris wrote to her: "The exhibition of West Coast art is on at the Gallery here [Toronto]. . . . Your work is impressive. . . . I feel that you have found a way of your own wonderfully suited to the expression of the Indian spirit and his feeling for life and nature." BCARS, Inglis Collection, 8 Jan. 1928. Concerning post-1927 developments in Carr's painting, see Doris Shadbolt, "The Mature Years Commence" and "The Formal Period," in The Art of Emily Carr (Toronto/Vancouver: Clarke, Irwin/Douglas & McIntyre 1979), 56–67, 70–8, and Doris Shadbolt, "The Formation of a Mature Style," Emily Carr (Vancouver/Toronto: Douglas & McIntyre 1990), 45–84.

24 *H&T*, 27 Nov. 1927.

25 In UBCL, Cheney Papers, box 7, file 10, are Cheney's notes: "Talk re Emily 1938 given to group of UBC students at the home of Mrs. [T.W.] Bingay, MacDonald St. Van 1938."

26 Cheney, in an interview with Andrew Scott ("Emily Carr," *Arts West* 4 Nov.-Dec. 1979:27), mentioned only the summer of 1930. However, as Carr stayed with the Barbeaus, Cheney's very good friends, it is most likely the two saw each other, however briefly, in Ottawa that spring. Conversations with Cheney also suggest this.

27 See Cheney cited in Scott, "Emily Carr," 27, for a vivid description of the occasion.

28 Kathleen Daly Pepper is referred to as Pepper, not Daly, throughout the notes to avoid confusion with references to Katherine Cullen Daly, her sister-in-law. Cheney's letters to Pepper told of the difficulties she was having finding steady employment. "My job is a temporary one only & I need the money so badly," she wrote to Pepper, 5 July 1934. Letter with Kathleen Daly Pepper, Toronto, who has stressed that the mid-1930s period was "a most trying time" for the Cheneys. Pepper to Walker, 26 Dec. 1988.

29 *H&T*, 4 July 1936.

30 Dr. Hill Cheney wrote to Kathleen and George Pepper of his disappointment at having to leave Ontario and "go to the wild and wooly [sic] West." Letter of 11 Jan. 1937 with Kathleen Daly Pepper.

31 [Ruth Humphrey], "Letters from Emily Carr," *University of Toronto Quarterly* 41 (Winter 1972):11, 22 Aug. 1937.

32 *H&T*, 17 Nov. 1937.

33 By early 1943 Cheney was asking Ira Dilworth for news of Carr. See BCARS, Inglis Collection, Dilworth to Carr, 2 Feb. 1943. Dilworth wrote, "Nan phoned to ask how you were. She said she was writing to Humphrey Thom [sic] . . . and wanted to give news of you."

34 BCARS, Inglis Collection, Carr to Dilworth, n.d. [Nov. 1944]. In her lengthy description of Cheney's visit, Carr was extremely critical of her guest. It was not unusual for Carr to turn on friends, but this outburst to Dilworth is particularly vitriolic.

35 It appears that Carr was all but totally absorbed in her friendship with Ira Dilworth. In the BCARS, Inglis Collection, are 250 Carr to Dilworth letters dating from winter/spring 1941.

36 *H&T*, 26 Nov. 1935.

37 Toms noted seeing Carr paintings at both the 1932 and 1933 IAACS exhibitions, but as Carr did not show in the latter it must have been the October 1932 show that he recalled visiting. He would have seen her paintings as well at a meeting held 14 Dec. 1932 at Carr's Simcoe Street house regarding her proposed "People's Gallery." See notes in Toms, "Letters from Emily Carr to Humphrey Toms," typescript, 1979, 1, property of Jane Toms. Gwen Cash also became a Carr enthusiast. See #63, note 2.

38 BCARS, Hembroff-Schleicher Papers, Carr to Edythe Brand, n.d. [16 Oct.] 1935. See also *H&T*, 22 June 1936.

39 Edythe Hembroff-Schleicher, *Emily Carr: The Untold Story* (Saanichton, BC: Hancock House 1978), 27.

40 A note in Toms, "Letters to Nan," 1, states: "In September Nan and Hill invited me to Vancouver to be their house guest and to attend the (then) very

formal opening of the 7th Annual B.C. Arts Exhibition." A photo of Humphrey Toms, Nan Cheney, and J.W.G. ("Jock") Macdonald, taken on Granville Street, Vancouver, by "Kandid Camera Snaps," is dated in Toms' handwriting as "Saturday, 17 Sept.-1938." The photo is the property of Jane Toms.

41 Notes in Toms, "Letters from Emily," 18.

42 Toms was particularly helpful in assisting Cheney with her affairs. In connection with her career as an artist he prepared lists of biographical information that included exhibitions in which she had participated and newspaper references relating to them. Through his efforts these documents reached the appropriate libraries and galleries. Only in Toms' very late years did his visits to Cheney cease. Evidently Cheney told Hembroff-Schleicher that she could no longer invite Humphrey to her home because of his smoking. See UBCL, Cheney Papers, Hembroff-Schleicher to Cheney, 12 Mar. 1978.

43 The principal work on Carr's painting has been done by Doris Shadbolt. See Shadbolt, *The Art of Emily Carr* (Toronto and Vancouver: Clarke, Irwin/Douglas & McIntyre 1979), and her most recent study, *Emily Carr* (1990). The main biographers (see note 45) have devoted considerable attention to her painting, as does Ruth Applehof in *The Expressionist Landscape: North American Modernist Painting, 1920–1947* (Birmingham, AL: Birmingham Museum of Art 1988).

44 *H&T*, 23 Nov. and 31 Dec. 1931.

45 The two principal biographies of Carr are by Maria Tippett, *Emily Carr: A Biography* (Toronto/Oxford/New York: Oxford University Press 1979), and Paula Blanchard, *The Life of Emily Carr* (Vancouver/Toronto: Douglas & McIntyre 1987). Edythe Hembroff-Schleicher in *Emily Carr: The Untold Story* (Saanichton, BC: Hancock House 1978) provides a series of essays on various aspects of Carr's life and career, including a valuable account of her exhibiting record. Her book contains an abundance of biographical material, some of which is based on the author's first-hand knowledge of the artist.

46 Smithsonian Institution, Archives of American Art (AAA), Hatch Papers, Carr to J.D., Jr. [John Davis Hatch], 2 Feb. 1941. Hatch, an art historian and consultant, had been Director of the Seattle Art Institute from 1928 to 1931. In 1941 he was Director of the Albany Institute of History and Art in New York. Carr had been explaining to Hatch that "to cook and to be domestic . . . seems to bolster up art and the pretty side of life and make it all fit together make life so much fuller."

47 In the year prior to her death, however, Carr expressed feelings of extreme loneliness. She wrote to Dilworth from hospital: "to all intents and purposes I *am* dead *now*. people have accepted the books & pictures of me *as* me. They forget the old derelict shoved away." BCARS, Inglis Collection n.d. [7 Jan. 1944].

48 Carr had recommenced her northern journeys in the summer of 1928 after a hiatus since 1912. The 1928 trip, which was her most arduous, included visits to native settlements in the Queen Charlotte Islands and the Skeena and Nass River areas. The two trips of 1929 were to the Vancouver Island villages of Nootka, Friendly Cove, and Port Renfrew. Works relating to Carr's 1930 trip, including *Zunoqua of the Cat Village* and *Strangled by Growth*, are found in Shadbolt, *The Art of Emily Carr*, 87–9, with catalogue entries 56–9. Edythe Hembroff-Schleicher, who knew Carr at this time, has commented on this venture: "I recall her departure up-island in August and a quick return because of bad weather. She was tired, disappointed, unenthusiastic about the material she brought back and determined not to go so far afield again." Hembroff-Schleicher, *Emily Carr*, 124. In 1942 Carr

related to Barbeau: "It is long since I went up north I doubt if the villages are at all the same—all white influence now—well the old people & places were lovely but changes are inevitable and I suppose it would not do to stick in one grouve forever." Marius Barbeau Collection, Canadian Centre for Folk Cultural Studies, Canadian Museum of Civilization, Hull, Canada, Carr to Barbeau, 28 Apr. [1942].

49 See Shadbolt, *The Art of Emily Carr*, 97–9, and catalogue entries 70–5, for landscapes executed in the 1929–30 period. See also Shadbolt, *Emily Carr* (1990), 53, 43, 140, and 166 for examples, and Tippett, *Emily Carr*, 167–72.

50 *H&T*, 12 Jan. 1931. In a talk in March 1930, Carr had spoken of the "emotional struggle of the artist to express intensely what he [sic] feels": *Fresh Seeing: Two Addresses by Emily Carr* (Toronto/Vancouver: Clarke, Irwin 1972), 12. It would seem that she was currently engaged in such a struggle, which would bring changes in both her theme and in her means of expression. Her beliefs in the importance of personal expression in art would have been reinforced and strengthened that same spring with her further exposure to the art and literature of modernism during an eastern visit, which included a notable stay in New York. See Applehof, "New York City: 1930," in *The Expressionist Landscape*, 63–70. Through her contact with Lawren Harris and his circle (renewed in Toronto on the same eastern trip) and her subsequent readings Carr had become interested in a possible relationship between art and the "spiritual"; she was endeavouring to absorb and adapt to her own needs the theosophical ideas to which she had been exposed (and which she later rejected [#177]). See Linda Street, "Emily Carr: Lawren Harris and Theosophy, 1927–1933," MA thesis, Institute of Canadian Studies, Carleton University, Ottawa, 1979. See also Blanchard, *The Life of Emily Carr*, 227–33, for a discussion of "My Aims are Changing!" For Shadbolt's recent discussion of this subject, see "An Interior Evolution: Belief and Attitudes," in *Emily Carr* (1990), 64–81.

51 Unfortunately most of the Carr to Harris letters have been destroyed. The three that are known are from the 1940s. (There is one each in the UBCL, Cheney Papers; BCARS, Inglis Collection; and BCARS, Parnall Collection.) From the Harris to Carr letters of the early 1930s, it is evident that she had discussed freely with him her struggles and the direction her work was taking. Years later she referred to this correspondence as "almost all work, one artist to another," and disclosed further, "I hardly realized what they meant to my work in the transition stage *how* he helped me." BCARS, Inglis Collection, Carr to Dilworth, 14 Feb. [1942], and n.d. [15 Feb. 1942].

52 Carr, *Growing Pains*, 358.

53 *H&T*, 3 Nov. 1932.

54 See #177, in which Carr discussed her initial enthusiasm and subsequent disenchantment with the tenets of theosophy. See also *H&T*, 12 Dec. 1933, 29 Jan., 7 Feb., and 22 May 1934; and Street, "Emily Carr," 1979.

55 Shadbolt, *The Art of Emily Carr*, 10, 92, and catalogue entries 2 and 63; and *Emily Carr* (1990), 82, 138. The two works are dated, respectively, 1931 and 1931–2.

56 In 1937 and 1941 Carr returned to Indian themes, likely under the influence of her writing and the anticipated publishing of her *Klee Wyck* stories. A journal entry of 1937 records: "I have been painting all day, with four canvases on the go—Nass pole in undergrowth. Koskimo, Massett bear, and an exaltant wood. My interest is keen and the work of fair quality." *H&T*, 20 April 1937. Four years later, with reference to her *Klee Wyck* stories, she wrote to Cheney (#198): "Going over the

Indian sketches has stirred up a homesickness for Indian." Carr possibly was influenced also by her publisher, who had hopes (which didn't materialize) of holding an exhibition in connection with the publication of *Klee Wyck*. See NGC, Archives 7.1, Carr, E., E.H. Clarke to Eric Brown, 16 June 1941. (Brown had died in 1939.)

57 NGC, Archives 7.1, Carr, E., Carr to Brown, 30 June 1938. In an article in 1929 Carr had posed the question, "What are we Canadian artists of the west to do with our art?" and had offered, as though in answer, "Shall we search as the Indian did mid our own surroundings and material, for something of our own through which to express ourselves?" Carr, "Modern and Indian Art of the West Coast," *Supplement to the McGill News* 10 (June 1929):20. In the period that followed, Carr, herself, would find in the western woods something that was peculiarly her own. Her shift in part was likely a result of advice from Harris who, in a well-known letter to Carr (BCARS, Inglis Collection, n.d. [1929]), proposed that she "create new things for a time at least." And further: "How about leaving the Totems alone for a year or more? I mean the Totem pole is a work of art in its own right and it is very difficult to use it in another form of art. But, how about seeking an equivalent for it in the exotic landscape of the island and coast, making your own forms within the greater forms." Evidently others, including Mark Tobey, also suggested this change, but Carr credits Harris as the first to recommend it. See Carr, *Growing Pains*, 343. With such paintings as *Strangled by Growth*, *Big Raven*, and *Totem and Forest*, all done in 1931, Carr perhaps felt that she had reached her "goal" with Native subjects. Writing in 1937 of her continuing enthusiasm for themes of woods and sky, she recorded: "just started a new woods & a new sky day before. . . . Maybe silly to go on & on at same themes but I am so far from my goal some new thing is always cropping up in them (those subjects) and both are eternally changing & so bubbling with life." BCARS, Hembroff-Schleicher Papers, Carr to Edythe Brand, n.d. [early Sept. 1937]. The question of why Carr turned from her earlier Native subjects after February 1931 is addressed in Shadbolt, *Emily Carr* (1990), 135–9.

58 *H&T*, 13 Dec. 1940.

59 See "A New Liberation" and "A New Integration" in Shadbolt, *The Art of Emily Carr*, 122–36, 138–78. See also catalogue entries 127, 118, 140, 111, 1, and 105.

60 In 1930 Carr's work was shown at the NGC (23 Jan.-28 Feb.) in the "Fifth Annual Exhibition of Canadian Art" and was very favourably reviewed by Jehanne Bietry Salinger in "Comment on Art," *Canadian Forum* 10 (Mar. 1930):208–10. A solo exhibition of Carr's painting (4–6 Mar.) sponsored by the Victoria Women's Canadian Club was held at the Crystal Garden Gallery. Carr was included in a travelling exhibition titled "Contemporary Canadian Artists," sponsored by the American Federation of Artists, which opened at the Corcoran Galleries, Washington, DC, on 9 Mar. 1930. The next month she showed with the Group of Seven at the Art Gallery of Toronto in their seventh exhibition. She was invited to show as well in the "Sixteenth Annual Exhibition of Northwest Artists" held at the Art Institute of Seattle from 1 Oct. to 18 Nov. The same institution held a solo exhibition of Carr's work from 25 Nov. 1930 to 4 Jan. 1931.

61 See H. Mortimer Lamb, "A British Columbia Painter," *Saturday Night* 48 (21 Jan. 1933):3.

62 BCARS, Inglis Collection, "Emily Carr to Ira Dilworth—Testament," n.d.

63 Notes in Toms, "Letters to Nan," 1.

64 Cheney also expressed these feelings to Kathleen Daly Pepper when she wrote, "We are certainly isolated out here as far as shows are concerned & Victoria is even worse." Cheney to Pepper, 20 June 1937.

65 Cheney was included in five exhibitions of the Royal Canadian Academy between 1929 and 1934: 1929–30, 1932, 1933, and 1934, and the travelling exhibition, also of 1934. Prior to Cheney's move to Montreal in the winter of 1933–4, a solo exhibition of her paintings was held at the James Wilson and Company Gallery, Ottawa (Cheney had studied under Peleg Franklin Brownell, a teacher associated with the Company). See "R.W.H.," "Nan Lawson Cheney Oil Paintings," *Evening Citizen* (Ottawa), 15 Mar. 1933, p. 4.

66 Dr. Cheney died in 1949 and in 1951 Cheney began working as a medical artist with the Department of Anatomy, Faculty of Medicine, UBC. She retired in 1962.

67 According to the information provided by G. Chan and V. Neil for the Inventory of Humphrey Toms' Personal Research Papers, 1983, with the Special Collections Division, UBCL, Toms' research in the beginning centred on the towns of Stratton and Bude in Cornwall, and then extended to north Cornwall and Devon. His personal visits during vacations included record offices and libraries in London, Devon, Cornwall, California, and Salt Lake City. His records consist of extensive correspondence, extracts from vital statistics records, parish registrars, maps, family trees, copies of wills and his personal notes of families in Devon and Cornwall. Many of the extracts date back to the sixteenth century.

68 See "Death of an Historian" [*Wadebridge Post and Weekly News*], 27 Aug. 1983, one of several obituary clippings forwarded to the Toms family in Victoria.

NOTE ON THE TEXT

PREPARATION of the Emily Carr correspondence presented major editorial problems, primarily concerning spelling and punctuation. Carr was well aware of her weaknesses in the mechanics of writing, and wished that she could have known "the rules of the game better."[1] "Often I wonder," she wrote, "at the desire in me being so strong and drivelling out in such feeble words and badly constructed sentences."[2] She disclosed as well that spelling and punctuation were "such a horrible trial."[3] And once, with a characteristic measure of dramatization and self-belittlement, she wrote to a friend: "I can never overcome spelling, that's a brain disease—simply can't tell sound or learn, too old."[4]

Certainly the misspelling in Emily Carr's letters provided significant difficulties. Whether her errors were from ignorance (as she often professed), carelessness, indifference, or by design, their number is enormous. Edythe Hembroff-Schleicher argues that Carr's misspelling was learned from her father and points to the same errors in Richard Carr's diary in the BCARS.[5] Whatever the cause, correct spelling clearly was of little importance to Carr, for surely sheer lack of concern accounts for the words that are both correctly and incorrectly spelled, sometimes on the same page.

In many instances Carr's spelling problems were compounded by difficulties with her handwriting, which even she allowed gave her "aweful puzzling." "I simply *have to reread* my letters over," she wrote to Ira Dilworth, "I write quickly & leave out words & they don't make sense."[6] This haste was surely a major contributing factor to errors and irregularities that abound, including those in grammar. The specifics of the idiosyncrasies in Carr's writing are outlined in "Transcription of the Letters," and in the list of Carr's "variations" of accepted spelling (pp. 418–19, 420–6).

Carr made no secret of the fact that she required editorial help in the preparation of her manuscripts, and generally, but not always, she was amenable to it. "Will get Miss Burns to correct spelling & punctuation," she wrote in 1938,[7] and later, when Ira Dilworth offered to act as her honorary editor: "his kindness lifted a tremen-

dous load from me, just as if he had knocked all the commas, full stops, quotes and capitals right to another planet."[8]

Carr frequently praised Dilworth for his editorial help. "He goes over punctuation & points out sometimes if he thinks I have not made a meaning clear," she told Myfanwy Pavelic, but then she insisted: "he never rewrites or re-words me." (She also remarked that when he saw the corrections of Ruth Humphrey and Flora Burns, he made her take them all out and go back to her own way.)[9]

For easier readability I at first considered correcting Carr's misspelling (retaining what she called her "mongrel" words)[10] and supplying or deleting punctuation as necessary. This approach had been followed in two earlier publications of Carr letters[11] and also in the editing of *Hundreds and Thousands: The Journals of Emily Carr*.[12]

However, for this compilation of personal letters, I ultimately decided that, notwithstanding the many difficulties, the original texts should be followed as closely as possible to preserve their value as primary source material. I also recognized that editorial interference in many instances would require, unnecessarily, arbitrary decisions about Carr's intentions and meanings. A number of the "errors" were likely intentional, and so deciding what to "correct" and what not to "correct" would be highly subjective. Thus, where words or letters are inserted for clarification (Carr's thoughts moved faster than her hand), they are separated from the original by square brackets, with the understanding that they may not necessarily be what Carr intended.

Emily Carr made it clear that her hastily written letters were intended solely for the recipient; she surely never imagined that they were material for publication.[13] Indeed, early in her friendship with Lawren Harris, for example, she urged him not to show her letters "to others," for she knew that she could not write her "innermost thoughts if anybody was to read them." She wanted to be able to "gabble freely."[14] And certainly she did. Myfanwy Pavelic, a recipient of many Carr letters, in commenting on the "spontaneous" quality of

her letter-writing, has affirmed that the letters read as if she were there. "If you knew her, it was as if she was talking to you," she related, "because she talked in stops and starts with her very original turn of phrase. There was nothing held back. That was one of the things I liked about her." Mrs. Pavelic has also confirmed that because Carr's pencil did not go as quickly as her head, what appear often in her letters as grammatical mistakes ("she give," "he like," etc.) are simply words that are left unfinished—a result of moving on. Others could certainly be intentional, in accordance with Carr's occasional way of speaking.[15]

I hope that by retaining Carr's informality and unorthodox manner of expression much of the flavour of the original letters and the sense of immediacy they conveyed will be preserved (acknowledging the loss in the transfer from the written word and "slovenly scrap" [#31] to the printed page). The reader should thus experience a more authentic contact with the artist and her thoughts than would be the case in an "edited" edition.

Consistency dictated that these decisions regarding Carr's letters be applied to all. (Nan Cheney, too, had certain spelling problems!) But since the misspellings in the other letters in the compilation are relatively few, "sic," enclosed in square brackets, is placed after them (except for Cheney's contractions). Throughout the text there are no deliberate silent corrections. The documents are thus presented "warts and all"—in Emily Carr's words, "unvarnished me."[16]

All interpolated material included in the text is enclosed in square brackets. In this manner addresses, when known, are given in full in the first instance. Dates, if provided, are printed as shown. In cases were no date is given and the envelope has been preserved, the postmarked date is given in square brackets. Estimated dates and those confirmed by internal evidence are similarly handled. Proper names appear as in the original with the corrected form (again in square brackets) juxtaposed.

Words that have been repeated inadvertently (all all, one one, for

example) have been retained, as have abbreviations, and underlined words are italicized. In the case of multiple underlinings, the number is indicated in square brackets.

The annotations are numbered separately in each letter. They identify, where possible, people and events to help clarify the various references in the texts. Artists' dates and those of persons frequently referred to in the text are included if known. Carr's own words from other sources are frequently employed, and in citing Carr, published references are used where available.

It is common practice in publications of this nature to delete certain phrases or passages as a courtesy to persons or family members who might be hurt or embarrassed by them; and it is well known that Emily Carr was capable, on occasion, of scathing remarks, often concerning those who were, or had been, good friends. But those attacked in these letters, either by Emily Carr or Nan Cheney, require no such protection; indeed, the critical outbursts reflect more unfavourably on the writers than on those who were the target of the comments.

The 250 items are presented chronologically, beginning with Carr's letter to Cheney of 11 November 1930, which marks the start of their correspondence, and ending with Alice Carr's "thankyou" to "Nan" of 5 June 1945, in which she refers to the winding up of Emily's affairs. An added "postscript" concludes the volume. Emily Carr, in a poignant letter to Katherine Cullen Daly in Toronto—written just weeks before her death—reflects nostalgically on aspects of her life and career.

NOTES
1 Carr to Campbell (now Pavelic), 7 Jan. 1942.
2 *H&T*, 11 Dec. 1934.
3 Emily Carr, *Growing Pains* (Toronto: Oxford University Press 1946), 364.
4 [Ruth Humphrey], "Letters from Emily Carr," *University of Toronto Quarterly* 41 (Winter 1972):126, 20 Mar. 1938.
5 Edythe Hembroff-Schleicher, *Emily Carr: The Untold Story* (Saanichton, BC: Hancock House 1978), 175.
6 BCARS, Inglis Collection, Carr to Dilworth, n.d. [12–13 Oct. 1942].
7 [Humphrey] "Letters" 20, 31 Jan. 1938. Although Carr was usually grateful for

editorial assistance, later in 1938 she recorded her strong disapproval of the methods of Burns and Humphrey. "Flora wants too much sentiment and Ruth strips and leaves them cold and inhuman. . . . their way of expressing is not my way." *H&T*, 3 Oct. 1939. See also Carr to Campbell (now Pavelic), 7 Jan. 1942.

8 Carr, *Growing Pains*, 364.

9 Carr to Campbell (now Pavelic), 7 Jan. 1942. See also Dilworth, "Preface," in Carr, *The Heart of a Peacock* (Toronto: Oxford University Press 1953), xi–v, for his discussion of his role in Carr's writing.

10 [Humphrey], "Letters," 103 (postmarked 22 June 1937). A term used by Carr in referring to such words as "forlornity."

11 There are 20 (of 46) Carr letters in Edythe Hembroff-Schleicher, *M.E.: A Portrayal of Emily Carr* (Toronto/Vancouver: Clarke, Irwin 1969), 79–121; and 44 in [Humphrey], "Letters," 93–150. The "Editor's Note" of the latter states: "The possibility of printing the letters without correction of spelling was seriously considered, to be rejected on the ground that it would be unseemly to provoke a little adventitious laughter at the expense of a great-hearted woman who, though humorous, was in no way ridiculous" (pp. 93–4). See also Hembroff-Schleicher, *Emily Carr*, 175. The Hembroff-Schleicher and Humphrey letters are in the BCARS and UBCL, Special Collections Division, respectively.

12 In the "Publisher's Foreword," a passage from Carr's journal is cited, p. x; "If they'd [Flora Burns and Ruth Humphrey] only *punctuate* and let me be and leave them at the best I can do." (The passage cited is taken from a journal entry for 3 Oct. 1939.) The foreword continues: "Taking this as their terms of reference, the publishers have refrained from tidying up the author's sentences, but have sought always to preserve the spontaneous eccentricities of her style." This statement does not always hold up when the original writings are examined.

13 Carr wrote to Campbell (now Pavelic), 7 Jan. 1942, that she had to "work over & over to make the words run with any kind of smoothness." The reference, however, was to her stories, not to her letters. Also, Carr often used identical descriptions in her letters in writing to different persons, a practice she is unlikely to have followed had she thought the letters would become public.

14 *H&T*, 23 Nov. 1930. Harris replied to Carr: "No, I won't let anybody read your letters to me, though I cannot quite agree with your attitude. . . . However your wish is paramount." BCARS, Inglis Collection, 13 Oct. 1930.

15 Myfanwy Pavelic quoted by Andrew Scott in "Emily Carr," *Arts West* 4 (Nov.-Dec. 1979):29; and Mrs. Pavelic in conversation with the editor.

16 *H&T*, 23 Nov. 1930.

ACKNOWLEDGMENTS

IN conducting the research for this volume I have been assisted by many individuals. I would first like to acknowledge my indebtedness to John Inglis, heir of Phylis Dilworth Inglis, for his kind permission to publish the 150 Emily Carr letters printed in this compilation. I am grateful also to the Nan Lawson Cheney estate and to Mrs. Jane Toms, sister-in-law of Humphrey Toms, for permission to include the related Cheney-Toms exchanges, as well as the extant Cheney to Carr and Toms to Carr correspondence.

Access to the papers of Nan Lawson Cheney and Humphrey Toms was provided, respectively, by the Special Collections Division of the Library of the University of British Columbia (UBCL) and by the British Columbia Archives and Records Service (BCARS, Victoria, BC). The 1979 Toms typescripts were made available by Jane Toms, while the Cheney-National Gallery letters were provided by the Archives of the National Gallery of Canada and the Special Collections Division of the UBCL. The three Cheney to Carr letters (now in the Special Collections Division of the UBCL) were initially made available through the courtesy of Mr. and Mrs. J.E.A. Parnall. Carr's letters to Katherine Cullen Daly, one of which is used as a postscript, was kindly provided by Mr. Thomas C. Daly.

I would like further to acknowledge my debt to those who have conducted extensive research into the art and life of Emily Carr, particularly Doris Shadbolt, Maria Tippett, Edythe Hembroff-Schleicher, and Paula Blanchard. Their valuable publications, which are recognized in the Introduction notes, provided an initial and indeed a continuing guide for the Emily Carr research that was required for this volume.

Emily Carr's own books are cited briefly in the annotations to the letters. Permission to cite from *Hundreds and Thousands: The Journals of Emily Carr*, *The Book of Small* and *Growing Pains: The Autobiography of Emily Carr*, and from A.Y. Jackson's *A Painter's Country* was generously granted by Stoddart Publishing Company Limited, 34 Lesmill Road, Don Mills, Ontario. All these books were originally published by Clarke, Irwin & Company Limited. My gratitude also to the *University*

of Toronto Quarterly for details cited from [Ruth Humphrey], "Letters from Emily Carr," 41 (Winter 1972) (the original documents are in the Special Collections Division of the UBCL). Other Carr excerpts in the annotations are drawn from Carr letters in both private and public collections. My thanks to Mrs. Myfanwy Pavelic, Dr. Joyce Zemans, and Mr. Thomas C. Daly for providing me with copies of the ones in their possession; and as well to the BCARS; the Archives of the National Gallery of Canada; the Archives of American Art, Smithsonian Institution; the Canadian Centre for Folk Culture Studies, Canadian Museum of Civilization; the Department of Archives and Special Collections, University of Manitoba; and the Archives of the Vancouver Art Gallery, for access to the Carr letters in their respective holdings. To Mrs. Peggy Knox I am indebted for copies of the Harris to Carr letters (the original documents are in the BCARS, Inglis Collection), and to Mrs. Kathleen Daly Pepper for her Cheney to Pepper correspondence. The specifics of the excerpts cited are recorded, where appropriate, in the annotations.

My sincerest thanks are extended to the librarians and archivists who answered my enquiries and made the files of their institutions available to me during the course of my research. My work was most heavily concentrated on the material at the Special Collections Division of the UBCL and at the BCARS, where I received exceptional co-operation. In connection with the former I would like to thank particularly Anne Yandle, Head; George Brandak, Manuscript Curator; Myfanwy Sinclair; and Marian Wong; and with the BCARS, Frances Gundry, Supervisor, Manuscripts and Maps Unit; Jerry Mossop, Supervisor, and Delphine Castles, Visual Records; Brian Young, Reference Services Supervisor; David Mattison, Librarian; and Brent McBride, Senior Reference Attendant.

In other institutions where I received assistance I want to thank Elaine Phillips, Archivist, National Gallery of Canada; Renée P. Landry, Curator, Documents Collection, Canadian Centre for Folk Culture Studies, Canadian Museum of Civilization; Larry Pfaff, Deputy Librarian, Art Gallery of Ontario Reference Library; Richard E.

Bennett, Head, Department of Archives and Special Collections, University of Manitoba; Bob Foley, Banff Centre Library, Judy Throm, Reference Services, Archives of American Art, Smithsonian Institution; and, closer to home, Carey Pallister, Victoria City Archives; Yvonne Peirce and Eleanor Danks, Greater Victoria Public Library; Christopher G. Petter, Archivist Librarian, Special Collections, McPherson Library, University of Victoria; and in Vancouver, Cheryl Siegel, Librarian, and Ian Thom, Senior Curator, Helle Viirlaid, Registrar, and Ellen Thomas, Publications Coordinator, Vancouver Art Gallery; Melanie Bowden, Northwest History, and Chris Middlemass, Fine Arts and Music, Vancouver Public Library; and finally at UBC, Diana Cooper, Reference Librarian, Jane Shinn, Circulation Supervisor, and Melva Dwyer (former Head), of the Fine Arts Division of the UBCL.

There are a number of other individuals who in various ways assisted me and whom I would like to name. They include Dr. James Caswell, Head, Department of Fine Arts, UBC, for his sound advice and continuing support in connection with this post-retirement undertaking. My thanks as well for professional advice to Dr. Maureen Ryan, also of the Department of Fine Arts, UBC. To Kerri McBeath my warm appreciation for her conscientious assistance with research and for the time-consuming task of word processing the many letters and annotations; and to Patsi McMurchy for her willing help. I am grateful to others for responding to my queries regarding persons or events mentioned in the letters: Betty Bell, Jessie Binning, Kay Cashmore, Denise Fiala, David Hossie, Peggy Knox, Nell Lawson, Dr. James Parnall, Myfanwy Pavelic, Kathleen Daly Pepper, Dorothy Spence, R. Stace-Smith, and William Toms. My thanks also to Carol Birtch and Nancy Antonacci for proposing that I edit the large collection of Carr letters to their aunt. To Dannie McArthur a very special thanks for her exceedingly generous assistance at a time of crisis.

I would like to acknowledge as well the Biomedical Communications Department, UBC, for printing the photographs from the Nan

Cheney Photograph Collection, in the Special Collections Division, UBCL; and the Dean's Office, Faculty of Medicine, UBC, for administration of the Nan Cheney trust fund.

In concluding I would like to express my special gratitude to Doris Shadbolt and Dennis Reid for their diligent reading of the lengthy manuscript and for their most helpful comments. I am deeply appreciative. To Victor Doray my sincere thanks for his unstinting efforts in *all* aspects of the project; he was indeed its mainstay. In addition my thanks to him for his support to me personally. Finally my thanks to the University of British Columbia Press. Dr. Jane Fredeman, former Senior Editor, gave me considerable help and support in the early stages of the project; more recently, Jean Wilson, Acting Director and Managing Editor, has enthusiastically sponsored and ably overseen the copy-editing and production of the volume.

Doreen Walker, Vancouver

ABBREVIATIONS

AAA *Archives of American Art.* **AAM** *Art Association of Montreal.* **AECA** *Annual Exhibition of Canadian Art.* **AGO** *Art Gallery of Ontario.* **AGT** *Art Gallery of Toronto.* **AGB** *Art Gallery Bulletin [Vancouver].* **BCAE** *British Columbia Artists' Exhibition.* **BCSA** *British Columbia Society of Artists.* **BCSFA** *British Columbia Society of Fine Arts.* **BCARS** *British Columbia Archives and Records Service.* **BCCA** *British Columbia College of Art.* **CGP** *Canadian Group of Painters.* **CNR** *Canadian National Railway.* **CPR** *Canadian Pacific Railway.* **FHA** *Friendly Help Association.* **G of 7** *Group of Seven.* **H&T** *Hundreds and Thousands: The Journals of Emily Carr.* **IAACS** *Island Arts and Crafts Society.* **NGC** *National Gallery of Canada.* **NMC** *National Museum of Canada.* **OSA** *Ontario Society of Artists.* **RCA** *Royal Canadian Academy.* **UBC** *University of British Columbia.* **UBCL** *The Library of the University of British Columbia.* **VAG** *Vancouver Art Gallery.* **VSA** *Vancouver Art School.* **VSDAA** *Vancouver School of Decorative and Applied Arts.* **VCA** *Vancouver City Archives.*

PLATE I

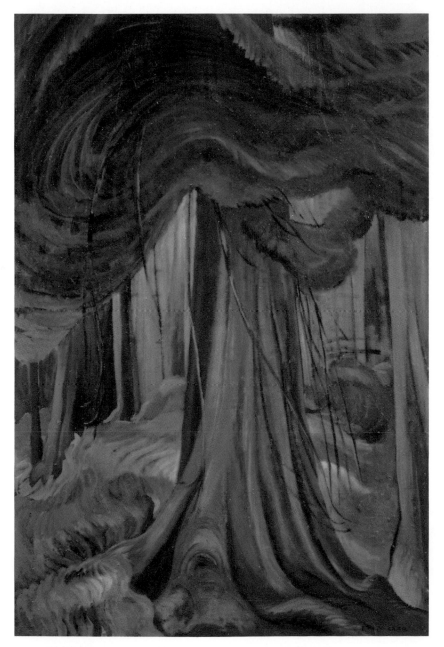

"The Red Cedar" Emily Carr, 1931–3, oil on canvas. *Courtesy Vancouver Art Gallery*

PLATE II

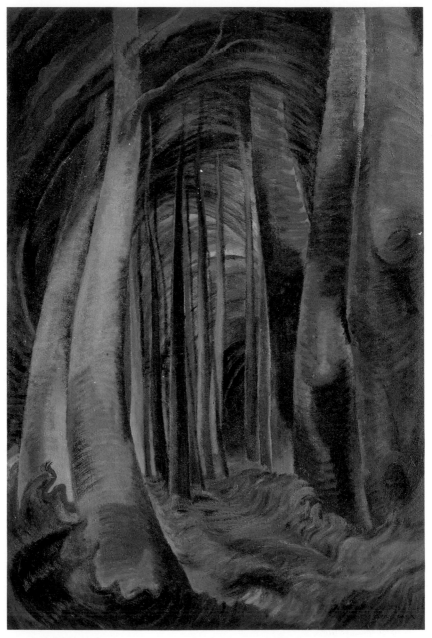

"Wood Interior" Emily Carr, 1932–5, oil on canvas. *Courtesy Vancouver Art Gallery*

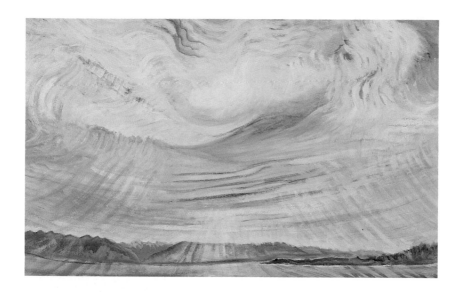

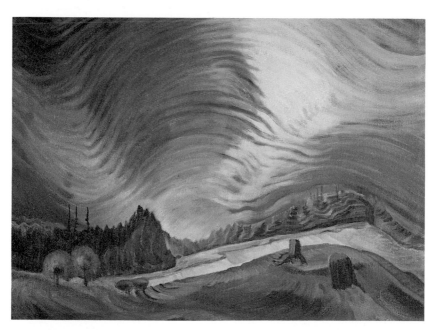

"Sky" Emily Carr, 1935–6, oil on paper. *Courtesy National Gallery of Canada, Ottawa*

"Above the Gravel Pit" Emily Carr, 1937, oil on canvas. *Courtesy Vancouver Art Gallery*

PLATE V

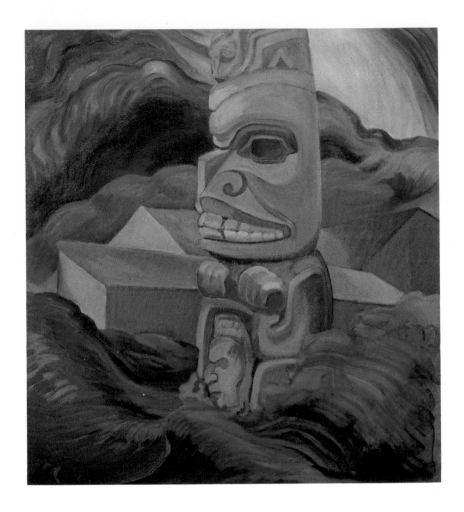

"A Skidegate Beaver Pole" Emily Carr, 1941–2, oil on canvas.
Courtesy Vancouver Art Gallery

CHRONOLOGY

EMILY CARR

1871 Born in Victoria, BC, 13 December 1871. Parents: Emily Saunders Carr and Richard Carr. **1879–89** Attends school and art classes in Victoria. Mother dies 1886, father 1888. Completes first year at Victoria High School 1889. **1890–3** Studies at California School of Design, San Francisco. **1893–5** Teaches children's art classes in "barn studio" on family property. **1899** Visits Nootka Indian mission at Ucluelet on west coast of Vancouver Island in spring. Leaves for England in August and enrols in Westminster School of Art, London, in September. **1901–2** Instruction and sketching sessions away from London in Berkshire, Cornwall, and Hertfordshire. **1903–4** Enters East Anglia Sanatorium, Suffolk, January 1903. Remains there until March 1904. Returns to Hertfordshire and leaves England in June. Back in Victoria in October after 2 weeks in Toronto and 8 weeks in Cariboo. **1905** Publishes a series of political cartoons in *The Week*, a local paper. **1906–10** Moves to Vancouver in January 1906 and rents studio at 570 Granville St. Teaches adults at part-time sessions during 1906, likely at Vancouver Studio Club and School of Art. Continues private classes for children. Teaches a special class at Crofton House School for Girls (then Gordon Neighbourhood School for Girls), likely during 1908–10. **1907** Three-week trip to Alaska with sister Alice. During return trip makes commitment to document Indian poles in their village settings. **1908–9** Travels to Alert Bay and Campbell River, BC, and to mainland villages at Lillooet, Hope, and Yale. Becomes founding member of BC Society of Artists (incorporated 1909). **1910–11** Sails for France with sister Alice in July 1910. In Paris, studies at Académie Colarossi and at private studio. Becomes ill and spends month convalescing in Sweden. Back in France travels to Crécy-en-Brie, St. Efflame, and Concarneau for instruction and sketching. Returns to Victoria in November 1911. **1912** In January rents studio in Vancouver at 1465 W. Broadway. Holds exhibition of her French painting in March. During summer undertakes extensive six-week trip to Alert Bay and nearby villages on east coast of Vancouver Island, to Upper Skeena River area on the mainland, and to Queen Charlotte Islands. **1913** Rents Drummond Hall, Vancouver, in April, and mounts exhibition of nearly 200 Indian paintings, drawings, and

sketches, dating from 1899. Delivers "Lecture on Totems." Returns to Victoria to live on Carr property in her new apartment house at 646 Simcoe St. **1914–26** Operates apartment house, raises dogs, makes pottery and hooked rugs to supplement income. In 1916–17, during eight-month stay in San Francisco, is employed for a time painting decorations for St. Francis Hotel ballroom. In early 1920s has contact with Seattle artists. Limited painting time devoted mainly to landscape. In 1924 and 1925 exhibits in Seattle with Artists of the Pacific Northwest. In 1926 enrols in correspondence course in writing with Palmer Institute of Authorship, Hollywood, California. Visit from Marius Barbeau of National Museum, who makes preliminary selection for forthcoming eastern exhibition, "Canadian West Coast Art: Native and Modern." **1927** September visit from Eric Brown of National Gallery, who makes final selection for "Canadian West Coast Art" exhibition. In November-December Carr travels to Toronto, Ottawa, and Montreal. Meets eastern Canadian artists, including Lawren Harris and other Group of Seven members. Attends opening of exhibition and visits galleries and number of artists' studios. **1928** Correspondence with Harris begins. Extensive summer sketching trip to Indian villages in Alert Bay and Fort Rupert regions, Nass and Skeena River areas, and Queen Charlotte Islands. In September, Mark Tobey gives three-week session of classes in Carr's studio. **1929** In May visits Nootka and Friendly Cove on west coast of Vancouver Island. Publishes "Modern and Indian Art" in June issue of *Supplement to the McGill News*. Visits Port Renfrew in August. **1930** In March gives "An Address" to Women's Canadian Club of Victoria, in conjunction with solo exhibition at Crystal Garden. In spring visits Toronto, Ottawa, and New York. Begins to receive wider recognition in eastern Canada and to be included in shows of contemporary Canadian artists in United States. In August makes final trip to Indian sites in northern Vancouver Island region. **1931–2** Sketching trips in 1930s to sites nearer Victoria. Camps and sketches with Edythe Hembroff at Cordova Bay in May 1931, at Goldstream Park in September 1931, and at Braden Mt. in Metchosin Hills (Sooke Hills) in May 1932. In June camps alone in rented rooms in a farmhouse on Cedar Hill Road near Mt. Douglas woods. In December promotes (unsuccessfully) People's Gallery for Simcoe St. House. **1933** Becomes charter member of

Canadian Group of Painters. In May-June has 1-month sketching trip to BC interior (Brackendale, Lillooet, Seton, Pemberton). In June purchases caravan trailer ("The Elephant") for sketching excursions to surrounding areas. From mid-August to mid-September camps at Goldstream Park. In November visits Chicago and Toronto. Renews contacts with Harris and friends. **1934** During May and June camps at Metchosin (Esquimalt Lagoon and nearby Strathdee farm). In summer enrols in short story course at Provincial Normal School in Victoria, and in autumn in course at Victoria High School. In September camps again on Strathdee farm. **1935** In June and September sketches at Albert Head, Metchosin. In October gives "Talk on Art" at Provincial Normal School. **1936** End of February moves from Simcoe St. to rented house at 316 Beckley Ave. In June and September camps at Spencer's sheep farm, Metchosin, on site overlooking gravel pit. Last trips with van. Sister Lizzie dies in August. **1937** Suffers first heart attack in January. Writing activity increases during recuperation. In February has hospital visit from Eric Newton, English author and art critic, who chooses paintings for exhibition and possible sale in eastern Canada. **1938** In July sketches in rented cottage of "Mr. Godfrey" on Telegraph Bay Road, Cadboro Bay. First solo exhibition at Vancouver Art Gallery in October. **1939** Second heart attack in March. Spends several weeks in hospital. In June camps for three weeks in rented cottage at Millstream Road, Langford. In September camps at one-room shack of "Mrs. Shadforth" on Craigflower Road, Victoria. **1940** In January-February 2 CBC broadcasts of Carr's stories, read by Dr. G.G. Sedgewick (later readings by Ira Dilworth). In February moves to Alice's house at 218 St. Andrew's St. In May camps for two weeks in one-room shack at Metchosin, near gravel pit. Suffers stroke in June. **1941** Foundation of Emily Carr Trust (through efforts of Harris and Dilworth), which establishes permanent collection of paintings as gift to province of British Columbia. In December, University Women's Club of Victoria sponsors large celebration in honour of Carr's 70th birthday and publication of *Klee Wyck*. **1942** Final sketching trip in August. Camps in rented cabin at Mt. Douglas Park for "twelve days of gladness." Suffers stroke after return home. *The Book of Small* published in autumn. Continues with writing (and some painting) despite hospital and nursing home confine-

ments. Wins Governor-General's award for *Klee Wyck*. **1943** Four solo exhibitions: Montreal in January; Toronto in February; Vancouver in June; Seattle, late August to early October. Suffers another stroke. Again in hospital. **1944** Uses wheelchair for trips to park. August visit from Dr. Max Stern of Dominion Gallery, Montreal, who arranges for large exhibition and sale of Carr's work (19 October-4 November 1944). Third stroke in September. *The House of All Sorts* appears in autumn. **1945** In February prepares for proposed April exhibition at VAG. During last week of February enters St. Mary's Priory for rest. Dies there 2 March 1945.

ANNA GERTRUDE LAWSON CHENEY

1897 Born in Windsor, Nova Scotia, 22 June 1897. Parents: Alice Wilson and John William Lawson. **1907–14** Attends Edgehill Boarding School, Windsor, NS. In 1907, family living in Havana, Cuba. **c.1917–18** Studies art at Newcomb College, Tulane University, LA. **1921–3** Enrols in "Art as Applied to Medicine," graduate department program at Johns Hopkins University, Baltimore, MD. **1923–4** Works as medical artist in Montreal with physicians associated with McGill University and Royal Victoria Hospital. **1924** Marries Dr. Hill H. Cheney, physician and radiologist, 23 August 1924. **1925** Resides in Ottawa at 55 Sunset Blvd. Dr. Cheney on staff of Ottawa Civic Hospital. **1926–37** In 1926 begins landscape painting in Ottawa Valley. Member of Ottawa Art Association. **1927** Summer classes at Rockfort, MA. Meets Emily Carr in November. **1930** Summer visit to Victoria, guest of Mary Lawson, an aunt. Meets with Emily Carr a number of times at her Simcoe St. house. Visits Trail, guest of her sister Mary (Mrs. Charles Wright) and family. Paints in vicinity. Holds exhibition of 30 works of Trail Metallurgical Plant and surroundings. Location unknown. Back in Ottawa begins correspondence with Emily Carr. **1928–34** Included in RCA exhibitions of 1928–9, 1931, 1932, 1933, and travelling show of 1934, comprised of works from 1933 exhibition. **1933** Solo exhibition in March at James Wilson and Company's Gallery, Ottawa. Shows BC and Ontario landscapes. **1933–4** Winter 1933/4 attends classes with Edwin Holgate at École

des Beaux-Arts in Montreal. In early 1934 studies portraiture with Lilias Newton at weekly evening classes. **1934–5** Works in Montreal as freelance medical illustrator. **1936** Meets with Emily Carr in Victoria at end of June. Teaches at Banff School of Fine Arts and assists staff at Institute of Technology and Art, Calgary, Alberta, 3-21 August. In autumn spends 3 months in Boston at School of the Museum of Fine Arts studying portraiture. **1937** Moves to Vancouver in March. Dr. Cheney on staff of the Vancouver General Hospital. Paints Carr's portrait in November. In December becomes member of BC Society of Fine Arts. **1938** Solo exhibition of 53 paintings at VAG, 26 March-10 April 1938. Meets Humphrey Toms at Carr's house in May. Promotes and helps organize Carr's first solo exhibition at VAG (12-23 October). **1939–41** Elected representative of VAG. **1940** Moves to new house at Capilano, North Vancouver. **1941** Becomes member of Federation of Canadian Artists. **1942** Solo exhibition of portraits at VAG, 28 April-10 May. **1947** Included in exhibition of Canadian women painters at Riverside Museum, New York City. *Ice Caves* receives special mention. **1949** Dr. Cheney dies. **1951** Begins work as medical artist with Department of Anatomy, Faculty of Medicine, UBC. **1952** Resides at 4634 W. 7th Ave., Vancouver. **1957** "Medical Drawings by Nan Cheney" shown at Fine Arts Gallery, UBC, 26 October-16 November. **1961** "Medical Drawings by Nan Lawson Cheney," shown in Fine Arts Gallery, UBC, 28 November-16 December (Cheney medical drawings of dissections permanently hung at Department of Anatomy, UBC). **1962** Retires from UBC. **1978** Solo exhibition of 1928–48 paintings at Bau-Xi Gallery, 7–19 August 1978. **1985** Death from heart disease, 3 November 1985.

HUMPHREY NICHOLAS WOLFERSTAN TOMS

1913 Born in Victoria, BC, 28 June 1913. Parents: Edith Margaret and Lewis William Toms. Aunts: Jessie and Agnes Gordon, founders of Crofton House School for Girls, Vancouver. **c.1925–30** Attends St. Michael's School, Victoria. **1931–3** Completes 2-year general course at Victoria College. Lives with parents at 2320 Windsor Rd., Victoria. **1933** Visits Emily Carr's studio in

August. **1934** Attends Sprott-Shaw Business Institute, Victoria. **1934–5** Works as clerk at W.M. Hotham Ltd., Victoria. **1936–7** Works as clerk at Windermere Hotel, Victoria. **1938** Meets Nan Cheney at Emily Carr's Beckley Ave. house in May. **1938–9** Works as clerk at Hotel Douglas, Victoria. **1939–40** Attends Provincial Normal School, Victoria. Receives Interim First Class Teacher's Certificate. **1940–1** Teaches at Ashton Creek School, Enderby, BC, from September until end of term in June. **1941–2** Receives First Class Teacher's Certificate. Enlists on 7 July 1941 as Private in Ambulance Branch of Royal Canadian Army Medical Corps. Trains at Debert, NS. **1942–5** Serves in United Kingdom and continental Europe. During leave in England conducts genealogical research in Cornwall and Devon. **1944** Promoted to corporal. **1946** Receives discharge from services on 3 February 1946. Awarded France and Germany Star, Defence Medal, and Canadian Volunteer Service Medal and Clasp. Enters UBC in September to study botany. **1948** Graduates with BSc. Appointed Technical Officer with Agriculture Canada, Vancouver Research Station, Plant Pathology Section. **1973** Retires from Research Station and continues genealogical interests. (Toms' Personal Research Papers are in The Library, UBC, Special Collections Division.) **1983** Dies 9 August 1983 in Vancouver.

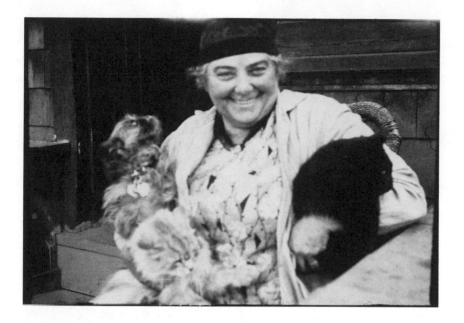

Emily Carr and pets 1930. *Photo by Nan Cheney. Courtesy UBC Library,*
Special Collections Division, Nan Cheney Photograph Collection

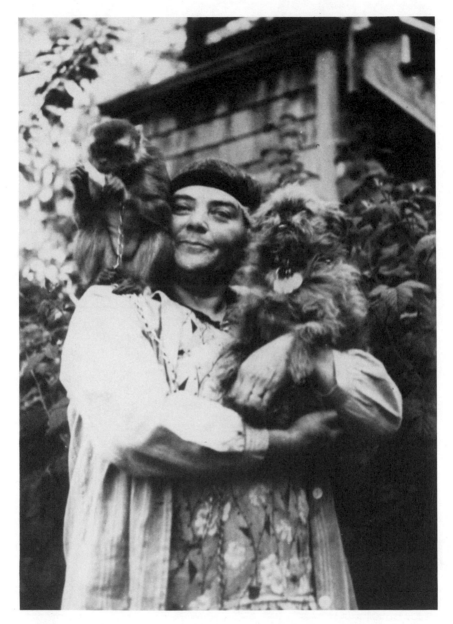

**Emily Carr in the garden, 646 Simcoe Street, Victoria, holding
her long-haired griffon. "Woo" is on her shoulder. August 1930.**
*Photo by Nan Cheney. Courtesy UBC Library, Special Collections Division, Nan Cheney
Photograph Collection*

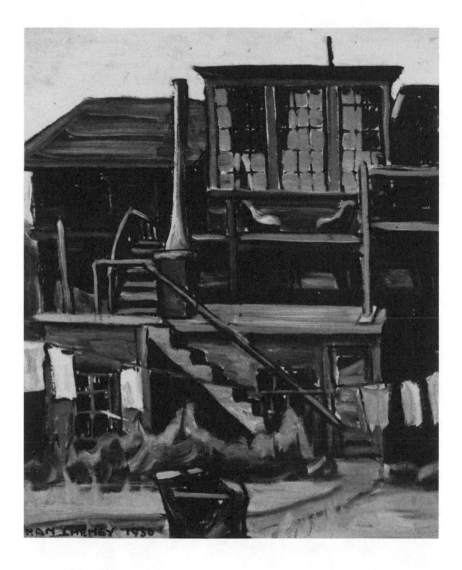

Back of 646 Simcoe Street showing Emily Carr's studio. *Sketch by
Nan Cheney. Photo courtesy UBC Library, Special Collections Division, Nan
Cheney Photograph Collection*

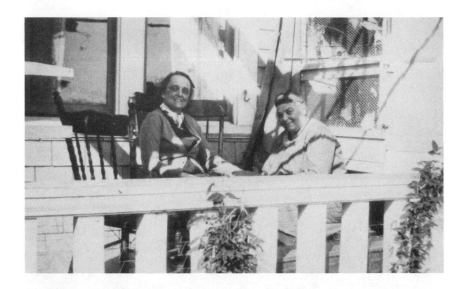

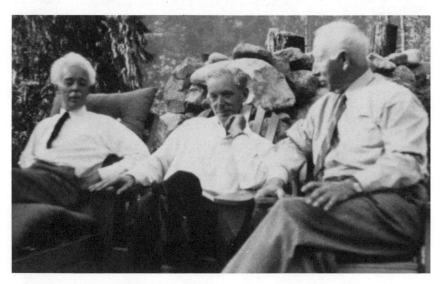

Emily Carr (right) and Nan Cheney on Carr's verandah,
316 Beckley Avenue, Victoria, 1938. Photo by Humphrey Toms.
Courtesy British Columbia Archives and Records Service

Lawren Harris (left), J.W.G. Macdonald (centre), and A.Y.
Jackson (right), Capilano, North Vancouver, September 1944.
Photo by Nan Cheney. Courtesy UBC Library, Special Collections Division,
Nan Cheney Photograph Collection

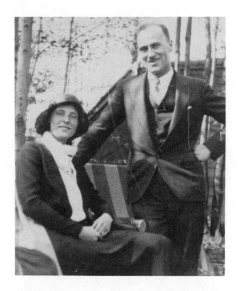

George and Kathleen Daly Pepper, Ontario, ca. 1929–30. *Photo by Nan Cheney. Courtesy UBC Library, Special Collections Division, Nan Cheney Photograph Collection*

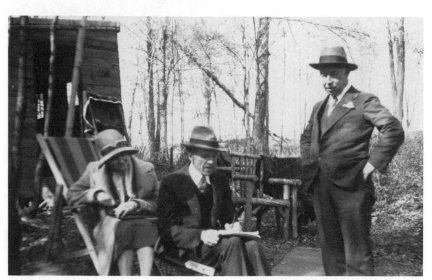

Esther and Arthur Lismer and A.Y. Jackson (right), Ontario, undated. *Photo by Nan Cheney. Courtesy UBC Library, Special Collections Division, Nan Cheney Photograph Collection*

Emily Carr with John Vanderpant in her studio, 646 Simcoe Street, 1933. "Tree" 1931, hangs in upper right. A chair hangs in upper left. Photo by H.U. Knight. Courtesy Victoria City Archives

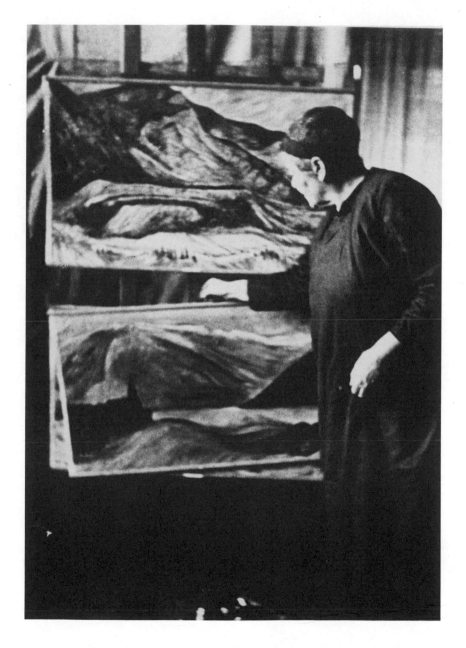

***Emily Carr in her studio, 646 Simcoe Street, with two
sketches from a trip to Pemberton, BC, May-June 1933.***
Photo by H.U. Knight. Courtesy Victoria City Archives

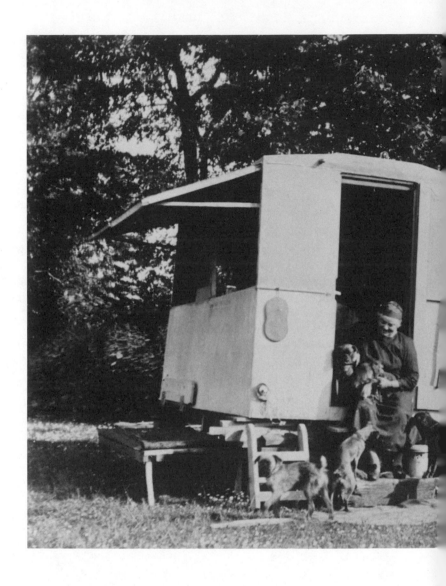

Emily Carr in her caravan "The Elephant" 1934. *Courtesy British Columbia Archives and Records Service*

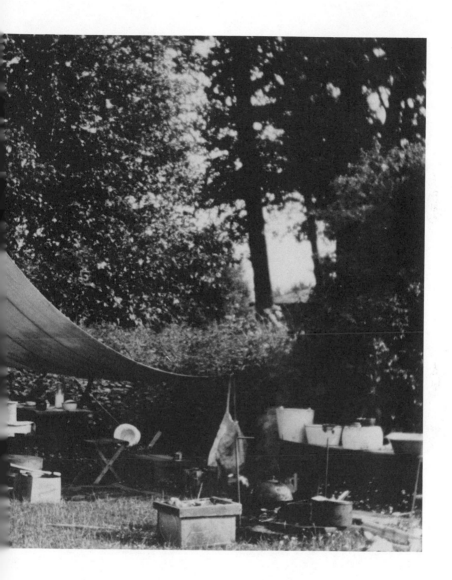

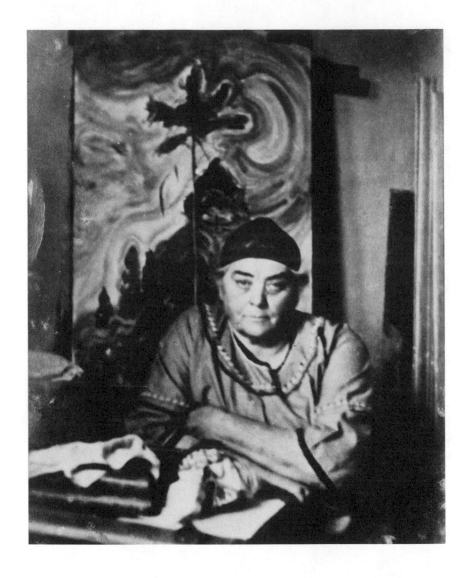

Emily Carr in her studio. In the background "Sunshine and Tumult" 1938–9. *Photo by Harold Mortimer Lamb. Courtesy British Columbia Archives and Records Service*

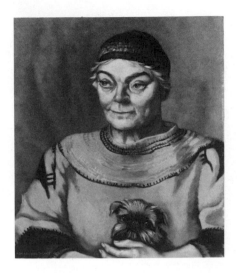

***"Portrait of Emily Carr"* Nan Cheney, 1937.** *Courtesy National Gallery of Canada, Ottawa. Gift of J.F.B. Livesay, Toronto*

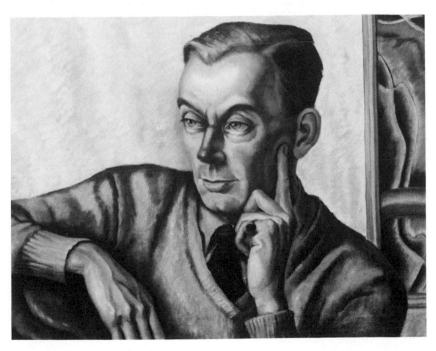

***"Portrait of J.W.G. Macdonald"* Nan Cheney, 1938–9.** *Courtesy British Columbia Archives and Records Service*

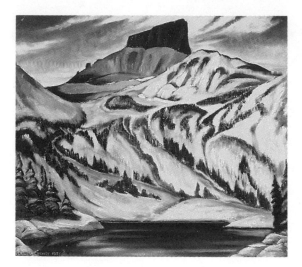

"The Black Tusk" Nan Cheney, 1938. Photo by Biomedical Communications, UBC. Courtesy Victor and Audrey Doray

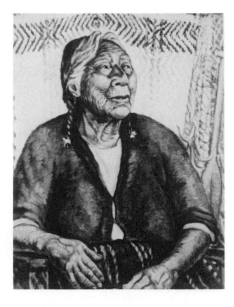

"Portrait of Mary Capilano, aged 97" Nan Cheney, 1938. Photo by Biomedical Communications, UBC, from a BC Artists Series postcard. Location of painting unknown

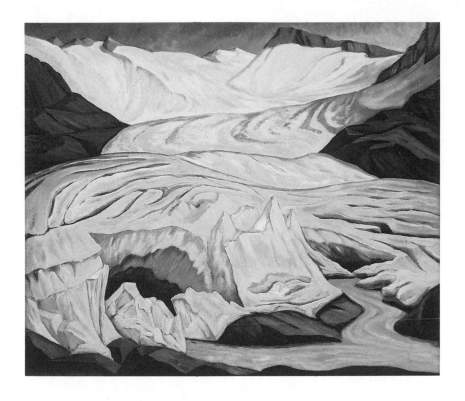

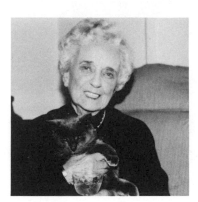

**"Ice Caves at Garibaldi" Nan Cheney,
1939.** *Photo by Biomedical Communications,
UBC. Courtesy Drs. Patrick and Edith McGeer*

**Nan Cheney holding "Uncle Tom"
1981.** *Courtesy Denise Fiala*

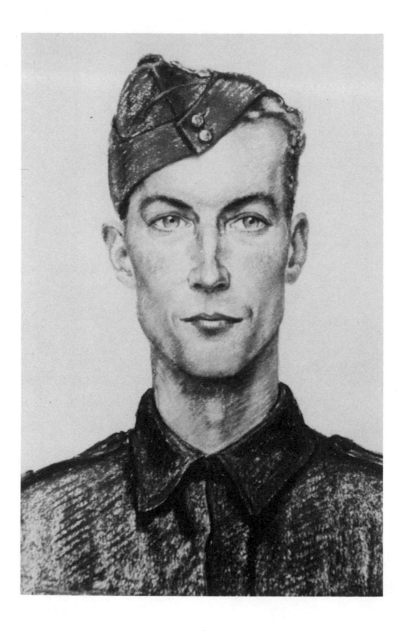

"Portrait of Humphrey Toms, RCAMC" Nan Cheney, 1941.
Courtesy William Toms

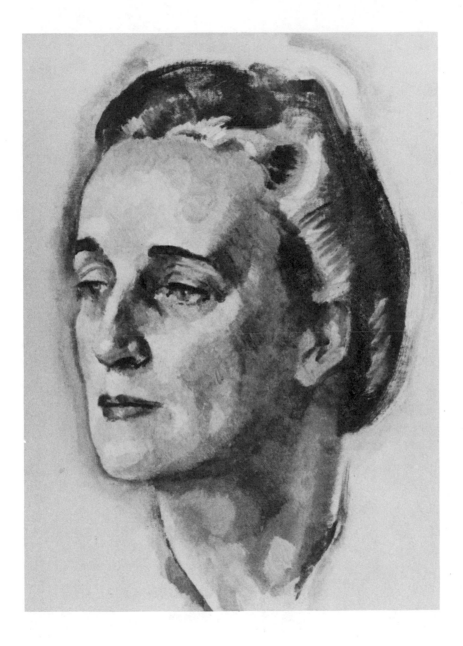

"Portrait of Nan Cheney" Lilias Newton, 1946. *Photo by Biomedical Communications, UBC. Courtesy Carol Birtch*

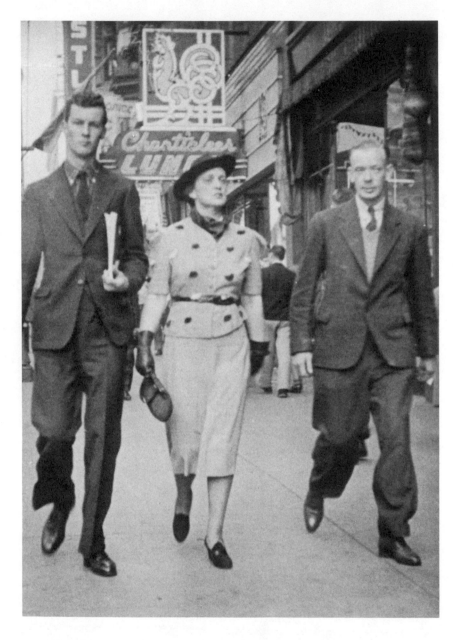

***Humphrey Toms (left), Nan Cheney (centre), and J.W.G. ("Jock")
Macdonald (right), Granville Street, Vancouver, September 1938.***
Photo by Kandid Kamera Snaps

***Emily Carr and Flora Hamilton Burns at Carr's rented cottage,
Langford, Vancouver Island, 1939.*** *Photo by Humphrey Toms. Courtesy
British Columbia Archives and Records Service*

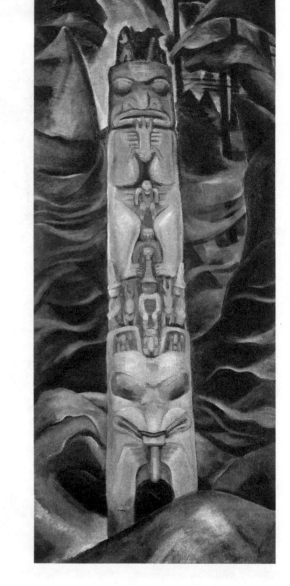

"Totem and Forest" Emily Carr, 1931, oil on canvas.
Courtesy Vancouver Art Gallery

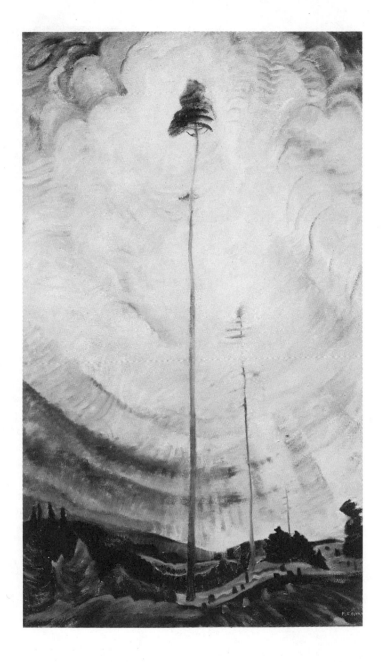

"Scorned as Timber, Beloved of the Sky" Emily Carr, 1935, oil on canvas. Courtesy Vancouver Art Gallery

Dear Nan MERRY MERRY Happy Happy 316 Beckley

[handwritten letter, largely illegible]

DEAR NAN

LETTERS OF

EMILY CARR

NAN CHENEY

AND

HUMPHREY TOMS

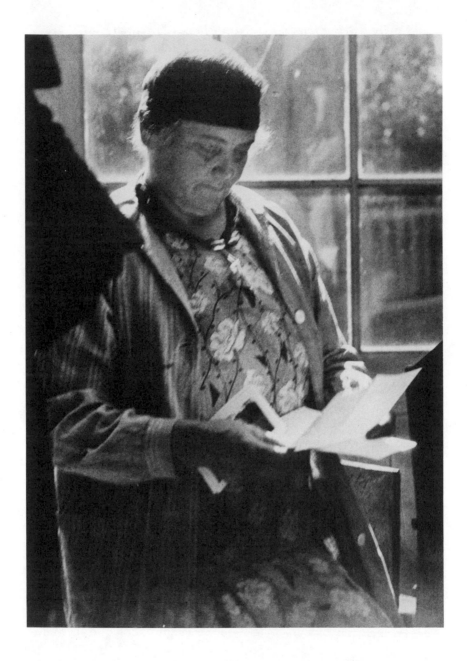

Emily Carr *reading a letter, 1930.* Photo by Nan Cheney. Courtesy UBC
Library, Special Collections Division, Nan Cheney Photograph Collection

1 [*Emily Carr, Victoria, to Nan Cheney, Ottawa*]

[*The 131 Emily Carr to Nan Cheney letters are in The University of British Columbia, The Library [UBCL], Special Collections Division, Cheney Papers, box 1, files 1 33. This is the first of the known Carr to Cheney letters. Carr is replying to a letter that Cheney had written after visiting in Victoria, BC, in the summer of 1930.*]

646 Simcoe Street
Nov 11 [?] [1930]
[postmarked 10 November 1930]

My Dear Nan Cheeney [Cheney]

I was tickled to bits to get your letter. and to think of you in your own home again with your own man.[1] I really felt quite Aunt Maryish.[2] & found. my eyes leaking. well I'm out and out *glad* & may you both have a long and happy life ahead. probably you just had to go through that time to clear things up.

I am so glad your show was successful. & hope the Can. Geographic take the set.[3] You did get some good work in while out West. & I'm shure the old beloved West helped you. Gee! how I love this West of ours. in spite of the terrible Tabby Cats. who spit venom. The Arts & Crafts Ex.[4] has been on. It was just *aweful* [underlined twice], made one *sick* I was for not sending in but one of the old Tabs. persuaded me. & Miss Hembroff[5] would not send unless I did. so I swung in 6 of course they loathed them. 2 oils & 4 water colors. instead of Yowling about them they tried just ignoring them & me. this time. they just did not exhist. nobody made one remark or one mention of them. (The oils were two of my largest) & they were filthily sarcastic the one day I went. saying "oh how gracious of you to deign to come to the show" etc They made me feel just sore & whipped really. I don't think I'll send again. whats the use? somehow I feel they just degrade Art make it mean & little, & I feel it hurts ones work & outlook. it would be

best to stay apart one hates their ideals bemuddied. and really Victorias idea of Art is degrading. Miss Hembroff (you remember she was at my party)[6] she's been studying in Paris. she sent in a pencil sketch of a nude. one of the filthy old men said the most revolting things to her face about it talking of it in the lowest terms of "nakedness" They refused to hang it.

I went over to Seattle 10 days agoe & saw the North West Show[7] it was quite interesting. I had a lovely visit all were so good to me. I've been working like a nigger repainting 4 canvases. I took them. as far as I knew 2 years agoe but felt I wanted to carry them further now. I am to have a show in Seattle[8] 32 canvases. (by invitation) probably going to other Western Cities as well so I wanted it to be as presentable as possible. have several new canvases as well. I have to get the things off by the 16 of the month so am some buisy.

Did you know Kapoor[9] was all burnt to the ground. last Summer. Thank you for your invitation I'd shure love to stay with you but I doubt if I shall get over again for many a Moon. Next year I'll have to stay put last year I was so movable[10] & it costs too much. to do it always. lots of love & good luck to your work & your life.

from yours,

M. Emily Carr.[11]

P.S Photos have not come yet.[12]

NOTES

1 Nan Lawson Cheney and her husband, Dr. Hill Cheney, a radiologist at the Ottawa Civic Hospital, were living at 55 Sunset Blvd., Ottawa, Ontario. Nan Cheney had been in Victoria in the summer of 1930 and had visited Emily Carr a number of times. It is clear from the opening paragraph that Cheney had shared confidences with the older artist.

2 The reference is to Miss Mary Lawson, an aunt of Cheney with whom she had been staying while in Victoria. Mary Lawson was an original member of Victoria's Friendly Help Association [FHA] (founded in 1895 to assist needy families), and was the organization's secretary until her resignation 37 years later. In Jan. 1934 she was named a member of the Order of the British Empire in recognition of her long devotion to community service. Carol Birtch (Mrs. George), Toronto, a niece

of Cheney, has written: "She gave everything to it [FHA] and lived in near poverty herself. When Aunt Nan and I visited her in the '40s, she was living in two small rooms crammed with her memories. Her sense of humour and her keen mind were quite a match for Aunt Nan's." Birtch to Walker, 3 Jan. 1987.

3 Presumably Carr is referring to Cheney's painting done at Trail, BC, during her western trip of 1930. Two of these were reproduced in "The Trail Metallurgical Plant," *Canadian Geographic Journal*, 3 (Sept. 1931): 182–3. See "Catalogue of Pictures," University of British Columbia, The Library [UBCL], Special Collections Division, Cheney Papers, box 5, file 5, which lists 30 Trail works. Handwritten on the printed form is ".1930 Trail B.C." The location of this exhibition has not been found.

4 The Island Arts and Crafts Society [IAACS] annual exhibition was held in Victoria from 28 Oct. to 8 Nov. 1930. Between 1911 and 1937 Carr contributed to a number of their exhibitions despite her frequent criticism of their shows and members. Five Carr oil paintings were included in the 1930 exhibition. Two are identified in the catalogue as "Totem" and one as "Indian study."

5 Edythe Hembroff-Schleicher (b.1906), the Edythe Hembroff and Edythe Brand of the letters that follow, is the author of *M.E.: A Portrayal of Emily Carr* (Toronto: Clarke, Irwin 1969), and *Emily Carr: The Untold Story* (Saanichton, BC: Hancock House 1978). In both works the author records that Carr, in response to a 1930 newspaper account of Hembroff's overseas study experience, contacted the younger artist, and that they subsequently became sketching partners and close friends. Hembroff-Schleicher, in her "Tribute" (*Emily Carr*, 21), states: "It was a privilege to know Emily intimately and to be allowed to work with, and sometimes for, her. I have never met anyone who made such an enduring impression on me." Forty-six Carr to Hembroff letters are in the British Columbia Archive Records Service BCARS, Hembroff-Schleicher Papers, 20 of which are published in Hembroff-Schleicher, *M.E.: A Portrayal*. The artist-author lives in Victoria.

6 Cheney had met Hembroff (along with Max Maynard and Jack Shadbolt) at a garden tea given by Carr in Cheney's honour the previous summer. (Conversation with Cheney c. 1981.)

7 "The Annual Exhibition of Northwest Artists" at the Seattle Art Institute (since 1933 known as the Seattle Art Museum) was held from 1 Oct. to 8 Nov. 1930.

8 Carr's solo exhibition at the Seattle Art Institute was held from 25 Nov. 1930 to 4 Jan. 1931. An account of the exhibition states that the pictures would be shown in San Francisco and Los Angeles following the Seattle show. See "Local Artist's Work on View in Seattle Gallery," *Victoria Daily Colonist*, 4 Dec. 1930, p. 8. There was no catalogue for the exhibition. Carr recorded "there was a great division over my stuff." See *Hundreds and Thousands: The Journals of Emily Carr* [H&T] (Toronto/Vancouver: Clarke, Irwin 1966), 5 Dec. 1930.

9 A railway point in the vicinity of Sidney, Vancouver Island.

10 In April 1930 Carr had visited in eastern Canada and renewed her acquaintance with artists in Ottawa and Toronto. In Ottawa she viewed a small solo exhibition of her work at the CNR offices, and in Toronto saw her six paintings hung at the Group of Seven [G of 7] exhibition at the Art Gallery of Toronto [AGT], since 1966 the Art Gallery of Ontario [AGO]. At the urging of Lawren Harris, Carr had visited New York on this trip and in August she had gone to the north coast of Vancouver Island, which was to be her last trip to remote Indian villages.

11 In answer to a question regarding her name, Carr had written: "It is just plain

Emily but as I have a sister 'Elizabeth Emily,' I have used the M. (initial of my home name [Millie]) to distinguish correspondence, etc. for many years & sign my canvases so." National Gallery of Canada [NGC], Archives 7.1 Carr, E., Carr to H.O. McCurry, Ottawa, 21 Aug. 1932.

12 The Cheney photographs are with the UBCL, Cheney Papers.

2 [*Carr to Cheney*]

Nov 21 [1930]

Dear Nan Cheeney [Cheney]

Thank you ever so much for the Photos they are splendid. I had not seen the *good* one of Woo[1] before & am delighted to have it she looks like a *real* monk. have been awefully buisy getting my show off to Seattle. it left last Teusday. & I have been slacking I was tired, but hope to paint again now soon as I have got a bit of pottery that I hate done up.[2]

Best wishes excuse a scrap letter its only a thank you, this morning.

Yours.

M.E. Carr

NOTES

1 A Javanese monkey acquired by Carr in the early 1920s and with her until 1937 when she was forced, through illness, to send the pet to the Stanley Park Zoo. See Carr, "Woo's Life," *The Heart of a Peacock* (Toronto: Oxford University Press 1953).

2 For a number of years Carr had been producing pottery objects made from local red clay as a means of supplementing her income. In Carr, *Growing Pains: The Autobiography of Emily Carr* (Toronto: Oxford University Press 1946), 310–12, she described the kiln she built and her attitude regarding the Indian designs she employed for ornamentation. See also Maria Tippett, *Emily Carr: A Biography* (Toronto/Oxford/New York: Oxford University Press 1979), 134–6.

3 [*Carr to Cheney*]

646 Simcoe St
Victoria, B.C.
Jan. 11 [1931]

My dear Nan Cheeney [Cheney]

Thank you for the Xmas Card & the photo of yourself. but I don't think it is very good of you not as nice as it should be. still it is interesting & I am glad to have it. Hope your Xmas was nice. we had a nice quiet one. Ate largely & then sat round the fire & snoozed. Most prosaic & elderley.

Life wags on. I am not doing as much painting as I wish I have a freind from Athabasca visiting me & it does put me *off* work I told her if she came she need not expect to see anything much of me from 10–4 (except for lunch) but all the same its a foreign element in the air she does not understand (nor want to) the camera & its like are her 'art' & it's hard to paint. besides my little maid has left & I have to produce three 'squares' per day & wash up well I suppose it wont harm me as I worked hard before the Seattle & Baltimore shows.[1]

We are having a very. mild winter no snow & little rain.

My beast family are well. Woo & Ko-ko full of pep. Dolfie a wonder & Felex & Twinkle the lesser lights quite nice.[2]

I have not seen Miss Lawson she was not down town when I looked in to the rooms. & she could not climb my stair to my pottery exhibit.[3]

Have you been doing much painting?

Is Mr Barbeau[4] in France. I did not hear from him at Xmas & thought he said he would spend Xmas with his family. Have you read his new book[5] I have not seen it but it was to come out last Autumn.

What shows have the National Gallery got on? & are the Browns[6] at home now. They do not seem to spend much time in Ottawa—

always travelling.

I had a lovely book for Xmas. 'The New Art' by Horrace [Horace] Shipp. lots of interest It deals largely with the work of Lawrence Atkinson an Abstract Sculptor.[7] I love it. also got a fine little book out of the library. a new one with a fine chapter on Rhythm.[8] finished a rag rug[9] yesterday. I can rug make easier than paint with a visitor about we read aloud quite a bit but at present have furious colds & our throats refuse to aloudness.

Hope everything is well with you where will you go this summer? or is it to be a 'home summer' Your home by the water there is so pretty.

Best wishes from me and all my 'beastly' family.

M. Emily Carr

NOTES

1 *British Columbia Indian Village* was included in the "First Baltimore Pan-American Exhibition of Contemporary Paintings" held at the Baltimore Museum of Art, 15 Jan.–28 Feb. 1931. It is now in the collection of the Vancouver Art Gallery [VAG].

2 Ko-Ko (generally Koko) and Twinkle were two of Carr's several griffon dogs. (Matilda, Pout, Tilly—sometimes Tillie, Vanathe, and Tantrum are also mentioned in the letters.) Dolphie (Adolphus), Felex, and Kitty John were part of her "cattery."

3 Carr referred to this exhibition in *H&T*, 5 Dec. 1930: "So, that's the devil's job, my pottery exhibition, that annual Christmas horror of mine, is over, and badly over. Scarcely anyone came, though there is usually a throng and good selling. . . . Last show I'll give."

4 Charles Marius Barbeau (1883–1969) was then ethnologist, folklorist, and musicologist with the National Museum of Canada [NMC] (currently the Canadian Museum of Civilization). Barbeau served the museum from its founding in 1911 until his retirement in 1948. Barbeau and Cheney were in the same circle of Ottawa friends who had welcomed Carr so warmly in 1927, and their close friendship continued after Cheney moved to Vancouver in 1937. For Barbeau's reminiscences regarding their association see UBCL, Cheney Papers, Barbeau to Cheney, 16 Apr. 1966, box 5, file 1b. There are disagreements as to when Carr and Barbeau first met (1915?, 1916?, 1926?). For a recent discussion of the question see Paula Blanchard, *The Life of Emily Carr* (Vancouver/Toronto: Douglas & McIntyre 1987), 150–1. Carr stayed with the Barbeaus during her 1930 visit to Ottawa.

5 Likely *Totem Poles of the Gitskan, Upper Skeena River* (Ottawa: NMC, Bulletin #16, 1929).

6 Eric and Maud Brown had visited Carr in her Victoria studio in September 1927. Eric Brown (1887–1939), Director of the NGC from 1910 to 1939 (in 1910

called Curator), arranged for Carr to send examples of her work to "Canadian West Coast Art: Native and Modern," an exhibition being organized by Barbeau and himself, to be opened at the NGC the following December. It was through Brown's instigation that Carr went east for the opening and thus met a number of eastern Canadian artists including Lawren Harris and other members of the G of 7. For Carr's deep gratitude to Brown see NGC, Archives 7.1 Carr, E., Carr to Brown, 19 Oct. 1934. In 1964 F. Maud Brown published *Breaking Barriers: Eric Brown and the National Gallery* (Toronto: Society for Art Publications 1964).

7 *The New Art* (London: Cecil Palmer 1922), now in the BCARS, Parnall Collection, was a gift from Flora Burns. See *H&T*, 31 Dec. 1930 where she recorded that in it she found "lots of things to remember and digest," and resolved that in the coming year she "must work harder, must go deeper." Carr underlined many passages in the book and in an undated note to Ira Dilworth (BCARS, Parnall Collection), she explained that her books were underscored "so as to find quickly the lines that touched deepest." The book was inscribed by Burns: "To my dear friend the artist in loving appreciation of the 'wide horizons' you have opened for me."

8 Likely Mary Cecil Allen, *Painters of the Modern Mind* (New York: W.W. Norton & Co. 1929). See Tippett, *Emily Carr*, 179–82, 184. See also Blanchard, *The Life of Emily Carr*, 229.

9 For a discussion of Carr's early rugmaking activity and her use of Indian crest symbols as motifs for her rugs and pottery, see Tippett, *Emily Carr*, 118–19. See also *H&T*, 4 Apr. 1936: "Humphrey came last night with an armful of breeches, sweaters, bathing suits, etc., which he invited me to trade for some of my old sketches, cast-offs he spied the other night. So we swapped derelict clothes for derelict pictures. His pants and coats will be converted into useful rug mats. I hope he will get something from my old tattered thoughts." See also BCARS, Hembroff-Schleicher Papers, Carr to Edythe Brand (now Hembroff-Schleicher), 16 Oct. 1935. "I am constructing a rug out of Robin Watts 'plus fours'."

4 [*Carr to Cheney*]

646 Simcoe St
Victoria, B.C.
[postmarked 14 Dec 1931]

My dear Nan,

Was very glad to get your letter & enclosed clipping. no I did not ever know McCurrey [McCurry]¹ had been West, it was news to me. I have heard little Eastern news for some while. Mr Barbeau has not written

for ages. has someone else he is interested in Probably. I received word from Vancouver that Mr Brown desired me to send a canvas for the All Canadian[2] & I have not complied. The message was indirect, & I don't feel like bothering nor having the expense of crating & shipping even to Vancouver I sent to the Group[3] and the express was $18.75 *one way* & I've had to lower rents & things are very tight. besides I do feel while McCurray [McCurry] is in power I don't get any show & its so dreadful getting anything home again ever. They've never bothered to buy anything except those two or three old old original watercolors. which they show as samples of my work & make me sick.[4] Lawren Harris[5] tells me the Group show is very good this year. I would like to have seen it. I hope your relatives are sat & will stay put for the winter. and I am so glad that things are easy & comfortable domestically.

Perhaps thats the best way after all. tho you may not have the high ups. You are compensated by not having the way downs. life's queer. and everything has its compensations tho' it may take a good sized telescope to see 'em at times. I hope you paint well this winter. The old pig C.P.R. not to buy some of your things!

I'm grinding away. Edythe Hembroff & I have been painting in my studio her's is small & pokey. we did each other & ourselves in glasses. & Koko.[6] I had not done a head for generations & find it difficult & entertaining. its the model that worries me. I really felt I studded [?] out on my own mug. I could make it as frightful as I chose & no complaints And after all it is flesh & blood & as good as a tree to work from you don't think of it as you.

Yes I gave a tea before my pictures went East as several had asked to see them. I gave no specials just put it in the paper & left it to the public to my surprise the afternoon & evening the studio was full of course some hated but on the whole many expressed *interest* I've been rather downhearted over work lately. but struggle on, take a snivel take a cuss and start again. feel impossible—feel triumphant—and mostly feel a *fool*.

The dear beasts are well. Did you meet 'Kity John' Adolphuses

understudy? of course you did. he's a young devil, & leads me a life while old Dolphie is a pure saint. Madam Woo has a new wardrobe. & is most particular in her tastes adores some of her frocks & scorns others flings them across the room, & refuses to be done up in them. poor darling why shouldnt she have her feminine tastes? as for the Belovedst Koko he's my right eye's apple.

So Mrs Barbeau is off again to France. I expect now she has a taste for it, she'll spend much time there till the girls grow up. he does think those girls fine & will miss them. I havent read much except study [?] books am trying to write some animal stories but find them appallingly difficult. even a cow wouldnt want to read them as they are. Yet I want to do them someday, & dog along at them.

Yesterday I had the big maple tree in the front garden cut down & it made me sick all day. it is horrible, to see a thing that has grown in beauty before your nose for years just hacked down regardless of all those years of patient growing & doing its best it impoversed the garden, spoilt the roof and, stole the old ladies sunshine. but I loved it & spring will be dreary in the kitchen without its glory of blossoms & hubbub of bees, & the robins will be mad they built there every year.

I see Aunt Mary occasionally this is her "hopping high" time getting the helpless, freindlied. theres lots to do this year people want so much. Now it's bye bye time, & I have to use a safety pin to do up my mouth, or go to bed.

So Peggi [Pegi] Nicol is joining McGill?[7] as a student or instructor? Have you read Apples & Madonnas? or the Art Spirit by Robert Henri? its good. two different books.[8]

The cattery doggery Monkery join in wishing you a very fine Xmas and all the best in the New Year write soon. & tell me everything.

Yours ever,

M. Emily Carr

NOTES

1 H.O. McCurry (1887–1964), who had joined the staff of the NGC in 1922, was Assistant Director and Secretary from 1927 to 1939 (and Director from 1939 to 1955).

2 Presumably Carr is referring to the "Seventh Annual Exhibition of Canadian Art" [AECA], held at the NGC from 22 Jan. to 23 Feb. 1932. (A national show, actually called the "All-Canadian Exhibition," was held at the Vancouver Art Gallery [VAG] from May to July 1932. See VAG, Archives.)

3 Carr was one of the invited contributors to the 8th and final exhibition of the G of 7, held 4–24 Dec. 1931 at the AGT (now the AGO). Five of Carr's paintings were included (*Indian Cemetery*, *Thunderbird*, *Trees*, *Red Cedar*, and *Little Pine*).

4 In 1928 the NGC acquired 3 Carr watercolours of Indian subject-matter from the 1912–13 period: *Tanoo*, *Gitwangak*, and *Alert Bay*. Carr would later express her strong feelings to Brown for the gallery's use of "those two miserable old watercolors done more than *twenty* years agoe" as representative of her work. She added: "If the work of an isolated little old woman on the edge of nowhere, is too *modern* for the Canadian National Gallery, it seems it cannot be a very progressive institution." See NGC, Archives 7.1, Carr, E., 19 Oct. 1934.

5 Harris (1885–1970), a leading figure in the G of 7, was an ardent supporter of Carr and a highly influential force in her life. For the impact on Carr of her meeting with the G of 7, particularly Harris, and for her estimation of the value of Harris' letters to her, see *H&T*, 3–19 Nov.-Dec. 1927; and 21, 23 Nov. 1930. See also Carr, "Lawren Harris," in *Growing Pains* (Toronto: Oxford University Press 1946), 340–52, which deals with the importance to Carr of her association with Harris and includes numerous excerpts from his letters to her. In 1942 Carr reread the Harris letters and wrote to Dilworth that they had given her fresh light and inspiration. "I hardly realized what they meant to my work in the transition stage, *how* he helped me." See BCARS, Inglis Collection, n.d. [15 Feb. 1942]. For Harris' career during the period of this volume see Dennis Reid, *Atma Buddhi Manas: The Later Work of Lawren Harris* (Toronto: AGO 1985). For a discussion of the Carr-Harris relationship see Linda Street, "Emily Carr: Lawren Harris and Theosophy, 1927–1933," MA thesis, Institute of Canadian Studies, Carleton University, Ottawa 1979.

6 The two artists worked together every afternoon from early December until the end of February 1932 "doing exclusively portraits, still lifes and animal studies." Hembroff-Schleicher, *Emily Carr*, 34. See also Doris Shadbolt, *The Art of Emily Carr* (Toronto and Vancouver: Clarke, Irwin/Douglas & McIntyre 1979), 180.

7 Pegi Nicol (1904–49) (from 1936 MacLeod), was an Ottawa painter friend of Cheney whom Carr had met in 1927. See *H&T*, 22 Nov. 1927. Nicol spent time in both Ottawa and Montreal in the 1932–3 period. There is no record of her attending McGill, but in February 1932 she wrote to Barbeau that she was attending the Ecole des beaux-arts (Montreal), studying with Edwin Holgate. See *Daffodils in Winter: The Life and Letters of Pegi Nicol MacLeod, 1904–1949*, edited by Joan Murray (Moonbeam, Ont. Penumbra 1984), 17.

8 C.J. Bulliet published *Apples and Madonnas: Emotional Expressions in Modern Art* (New York: Covichi), in 1930. Also in 1930 there appeared a new edition of Robert Henri's *The Art Spirit* (Philadelphia/London: J.B. Lippincott).

5 [*Carr to Cheney*]

646 Simcoe St
Feb. 7 [1932]

My dear Nan,

I thought you might like to have the enclosed. My sister[1] is weeping over Miss Lawson's resignation,[2] and I am certain there are many many who will miss her sorely. I beleive the bulk of the work is to be handed over to the "city relief" and 'cities' have not much sagacity or sympathy. These are difficult times for those in Public office. glad I'm no one important aren't you? Well Honey how goes it with you?

I hope you've had a contentsome winter isnt it joyous to feel spring is on the way—leastways that the winter has probably done its worst for this year it busted my pipes. You can see wonderful things beginning to happen in the garden—the first primroses, snowdrops & aconite. I had a letter from Mr Barbeau he was perplexed about what he heard of my work. said you told him I'd got on & A.Y.J.[3] gave my work the black eye this year[4] called it monotonous uninteresting dull etc he Barbeau, wrote to know who was right? I told him I was shure I did not know A.Y.J. seemed to spread slangs all over the place. but I know he *does* not care about my stuff & frankly I am not thrilled at his so I suppose we take our work from different veiwpoints. he seems to have been high pet of the group. show this year. Lawren Harris feels I am *going deeper* & havent quite hit it yet. & its a case of dig.[5] & I think he's right I imagine some of the work has gone to Ottawa so Barbeau can see for himself. I did not send to the Ottawa show.[6] they sent word from Vancouver that Brown told them to send along one of mine well—I diddent. McCurrey [McCurry] sent me a Xmas card. just one of the Gallery affairs but I reeled with shock. he usually ignores me.

I have been working on heads. for the last couple of months in the

afternoon with Edythe Hembroff. in my studio. thought it would be good for me. & get a little green out of my eye. I have done very little portrait work & found it dull at first but am keen enough now & getting into it more. but done nothing startling. we have any old models we can scrape up both too poor to hire. so do each other half time. or ourselves in mirrors. or an occasional good tempered freind who usually simper or are restless & abhorrent, & I'm longing for spring and the woods for there my heart is. All the beasts are well no puppies alas from that mean Twinkle & Koko getting old.

Have been trying to make some cloe [clothes?] because I was absolutely reduced to my natural skin, & cant get anything to fit my proportions Why do they make ready mades all of a size? they might give the mammoths a show occasionally. I had a patern cut to order & am running up night gown sort of affairs. 4 of them all alike but different colors three are off my chest & then I have one more & throw my thread & thimble away I wish I was a fur bearing specie.

How's Peggi [Pegi] Nicol? remember me to her & tell her to keep going also keep the same advice for yourself what are you doing. did you have some good ones in the Gallery Show?[7] What & how liked? Tell me about them—I thght your Xmas reproduction very nice indeed.

Well I must to bed. just come in from church—sat in front Pew and, two ushers rushed at me with the plates *first man* me. I struggled with my purse to find I had one copper & a dollar bill, I was shamed of one & couldn't afford the other and they *both waited* so I clapped my purse shut & put it in my pocket evidently they thought they haddent given me time for they both looked at me on their return trip & I looked at the ceiling.

Write soon

Yours aff.

M. Emily Carr

NOTES

1 Likely Alice Carr. Originally there were five Carr girls: Edith, Clara (both deceased) and the much younger Elizabeth ("Lizzie"), Alice, and Emily.

2 The resignation of Mary Lawson from the FHA was to be effective 3 Apr. 1932. See #1, note 2.

3 A.Y. Jackson (1882–1974) was a founding member of the G of 7 and a driving force behind the formation of the Canadian Group of Painters [CGP] in 1933. Carr had visited Jackson's studio in Toronto in 1927, and "loved his things."¹ H&T, 14 Nov. 1927. For information on Jackson for the period of these letters see Dennis Reid, *Alberta Rhythm: The Later Work of A.Y Jackson* (Toronto: AGO 1982).

4 Jackson would have seen five of Carr's paintings at the G of 7 exhibition in Toronto in Dec. 1931. It is likely he had been referring to these works. See #4, note 3.

5 In a letter of 20 Dec. 1931 (BCARS, Inglis Collection), Harris wrote to Carr: "Now and for a year or so you enter a new phase, a deeper penetration into the life of nature. It's a thrilling attempt you have begun. . . . You certainly are digging deeper." Carr later reflected, "Every letter he wrote stimulated me to search deeper." Carr, *Growing Pains*, 347.

6 Although Carr did not send to the AECA in 1932, the catalogue records that *Red Cedar* (which had been included in the 1931 G of 7 exhibition) was shown.

7 Cheney showed *Boat House Dwellers, Nelson, BC*, in the AECA in 1932.

6 [*Carr to Cheney*]

646 Simcoe St
March 20 [1932]

My dear Nan.

Was delighted to get your nice letter & the clippings for which thank you. doesnt newspaper stuff make you *sick* [underlined three times]? it does me up purple. its so futile—silly—assinine—maukish.—dirty & altogether unreliable, objectionable & senseless. I think times were better when there was *no newspaper*. every one went round shouting things to one another by word of mouth. what is this Walt Witman [Whitman] says "I swear I begin to see little or nothing in audible words" & then later—'Him who makes dictionaries of words Print cannot touch' I love Walt W[h]itman he takes you right out & up. & hits the spot every time & is so understandable.¹ I've learnt heaps of

him by heart. did it just to spite my memory which pretended it was so poor.

Mr Barbeau did write me a very nice letter & did like my tree in spite of A.Y.J. Mr and Mrs Lismer[2] are due here on March 31st— only be here one day he lectures to the Canadian Club. I'm tickled stiff I wonder how many of the old "Arts & Crafts crew will go. the Canadian Club has a big membership so I'm glad he'll get a big ear, & I hope he'll fill it with stuff that will make them sit up. & listen.

I'm wrestling tooth & nail with spring cleaning and there are no words in no language that can say how I hate it. tomorrow I Kalsomine. today I paint furniture. Yesterday I stand at the window of my top attic & heave. everything burnable hats, boots, pictures, crockery, bottles & bags. out the window down into the bonfire in the lot below. it was quite sport. trying to hit. the old acid drop in the flat below for once kept her pokey head in & her window shute. A rat 'deid on me' upstairs in the bowels of the Attic eaves. & I had an aweful time had to move to the downstairs bedroom. its humiliating to [be?] chased by a mere smell. I crawled in every hole my bulk would permit. with a pocket flash & an agonized nose. I smelled all the cracks & knot holes, but everytime the wind shifted I was off tracked. I got a carpenter & chinaman & my little help & the cat, but they all funked. & found. excuses. so I was forced to leave it. to High Heaven, & the weather being cold it kept so darn well, it took *3 solid months* to disintegrate. I'm moving up again this week.

Pegi Nicol seems to be getting on fine & the Peppers[3] thats fine he has a school.

I'm sory the Harises [Harrises][4] lost in the crash, & couldnt get their fixings its disapointing.

What a time you've had with relatives etc for the winter. it does make it hard to work never mind perhaps you'll work better for it by & bye, when you've all settled down again. better come out & take Aunt Mary back with you thats' the stunt! I have no definite plans for summer. have been offered a shanty in Wrangle [Wrangell] Alaska this Summer. dont know if its possible. I may just take a little shanty

like last year, *if* I can get away from the house.

Edythe Hembroff & I have stopped working on heads I really am not nearly so keen on them tho' I think its good for one. I am wrestling again with my forests. trees are so much more sensible than people. steadier & more enduring. Poor little Edythe did not get married & men are one grade lower than skunks (some of them). Is [?] there a "baby nanny" thats nice. I've got 3 God children & one dead (an Indian the best of them all) but it's hard around. Xmas & keeping in touch with their birth dates.

The creatures are finely well. Twinkle refuses to have pups. Woo's full of antics, & old Dolfie 18 years & going strong Koko & KittyJohn as ever. all send their respects. Write again & *soon* Keep merry.

Yours, ever,

M. Emily Carr

NOTES

1 In Carr's letters and journals there are numerous affirmations of her devotion to Walt Whitman's writing. Three copies of Whitman's *Leaves of Grass* which belonged to Carr are in the BCARS, Parnall Collection. One was the gift of Fred and Bess Housser in 1930; another was from Ira Dilworth in 1941. Flora Burns, a close friend of Carr, has recalled: "She was closely attuned to the poems and ideas of Walt Whitman and always kept his *Leaves of Grass* by her side." Burns, "Emily Carr," in *The Clear Spirit: Twenty Canadian Women and Their Times*, edited by Mary Quayle Innis (Toronto: University of Toronto Press 1966), 235.
2 Arthur and Esther Lismer. Arthur (1885–1969), an original member of the G of 7, was on a lecture tour across western Canada at the invitation of Eric Brown. Carr had met Lismer in Toronto in 1927, and again on this tour during Lismer's short stay in Victoria. See *H&T*, 15 Nov. 1927, and Dennis Reid, *Canadian Jungle: The Later Work of Arthur Lismer* (Toronto: AGO 1985), 14.
3 Kathleen Daly Pepper (b.1898) (known professionally as Kathleen Daly but referred to as "Pepper" in these annotations to avoid confusion with Katherine Cullen Daly, her sister-in-law), and George Pepper (1903–62) were Ottawa painter friends of Cheney and members of the local circle of art enthusiasts Carr had met in 1927. In 1932 George Pepper joined the staff of the Ontario College of Art. Cheney and Kathleen Daly Pepper corresponded following this move to Toronto.
4 Lawren S. Harris and his first wife, Beatrice ("Trixie").

7 [*Carr, Metchosin, to Cheney*]

[*Carr was in Metchosin on her third sketching trip with Edythe Hembroff (now Hembroff-Schleicher).*]

a log cabin in Sooke Hills
Sunday May 15 [1932]

My dear Nan.

How was you?? I wonder if I answered your last? It was nice & newsy & I meant to do it imegiate, but whether it came to a point I can't remember. so will venture another. Edyth[e] Hembroff & I are ruusticating among Ants verdure and wood ticks.[1] Its glorious, exhilarating, soothing, ticklesome & inspiring all at once. Edyth[e] promptly took flue (brought it out from town & fell to it next day.) and was reduced to wormliness for 3 days but is round again. I just love this spot it is completely isolated. & Papa Hembroff[2] looked things when he drove us out under my locating. you can't anywhere approach the door with a car & we had to lug the victuals, & bedding and sketch stuff, very far. He left us at the snake fence & fled. Of course the 3 dogs & the Monk are along & enjoying life fully, & good as gold. Woo is glorying in a new pinafore. I had a scrap of yellow rag & a scrap of blue so I put the two together & made her a lovely particolor garment, yellow to port and blue to starboard, of which she is very proud.[3] I have a new griffon dog, & expectations of a multitude of little griffon dogs shortly. Our cabin is log & very old, 2 rooms, & a passage connecting same with a door each end & cyclones. whipping thro' down the gulley. we are 1000 feet above sea level & everywhere are hills. not too heavily wooded but that you can scramble over them. There is a waterhole among the bullrushes & we have to carry it (water) a long way. in fact everything is primtive & completely inconvenient. There's a junk cook stove which we ignore & cook splendid meals, over a huge open brick fireplace in other the room. a huge,

black iron kettle, & a mammoth steel frypan are our choicest posessions. we sketch all day & sleep all night. I get up at 6 a.m. and go out onto the Hills its glorious. our two weeks will be up Thursday & it's home again. really I've completely forgotten I have a house or tennents⁴ or a garden & relatives.

It is nice seeing Mr Lismer (Mrs is a blight) they spent all their short visit with me. He was very pleased with his reception everywhere.

I have let my living rooms—kitchen, sitting room & two bed rooms for a couple of months still retain the studio & one bedroom so feel pretty free for 2 months. one of my downstairs flats is empty, but as I get a chance of this it keeps things going. & I have no house work. much.

What are you doing with yourself. I shouldnt wonder if you pop up here this Summer. to see your grandchild in Trail.⁵ I suppose Aunt Mary is 'loose' by now bless her heart.

Now my dear I'm going to bathe in a teacup. put all the little dogs into their 'snoring coops' Its a real chorous at night. (Edyth[e] object at first then she got a cold & added her note to the symphony, which tickled me enormously.) then I shall cuddle into my leaky iderdown, kept special for camping & dream deliciously.

Yours ever write soon to

Emily Carr

Edythe send kindest & says its too bad you arent here, too.
M.C.

NOTES

1 Carr and Hembroff were camping together in the Metchosin Hills (Sooke Hills) in an unused house belonging to Mrs. Maude McVicker, an old Victoria friend of Carr. For a detailed description of this trip, see Hembroff-Schleicher, *M.E.*, 39–43. Doris Shadbolt notes that the oil on paper sketch, *Forest Landscape*, was probably done on this trip. See Shadbolt, *The Art of Emily Carr*, 113 and catalogue entry 90.

2 Walter C. and Olive May Hembroff were Edythe Hembroff's parents.
3 The oil "portrait" of Woo in this pinafore is in the BCARS, Newcombe Collection, and was reproduced in *The World of Emily Carr*, an exhibition catalogue for the 1962 shows of the Hudson's Bay Company at the Victoria and Vancouver stores, 13 July–4 Aug. and 8–17 Aug. respectively.
4 Carr's apartment house, built in 1913 on what was her share of the Carr property, contained her own quarters as well as that of her tenants. Carr tells of events and people in her life as a landlady in Carr, *The House of All Sorts* (Toronto/London: Oxford University Press 1944).
5 The reference is presumably to the youngest of Cheney's nieces in Trail. Dr. and Mrs. Charles Wright (the latter Cheney's sister Mary) had four daughters: Carol, Nancy, Charlotte, and Mary.

8 [*Carr, Victoria, to Cheney*]

646 Simcoe St.
Oct. 22–1932

Dear Nan.

No you *don't* deserve this prompt answer but maybbe some little voice out of the daffodil bulbs I was planting when the Post man gave it to me shouted out "That was a nice Nan that used to come to the 'apple dodge parlor' and tramp over the top of us. so best answer quick. Oh the blessed garden I've been digging & planting & trimming & burning busily for the last week, taking advantage of a fine spell. No help whatsoeverkind these days. flats empty—purse empty—tummey *not* empty—nor my happy box either. Well I'm sory about your teeth what a pest the articles are from birth to death. even the cows are in better luck only having uppers, and birds are Toppers with *beaks* & wings. but Lor! who'd want a gizzard? Well Nan I did wonder what was wrong I wrote you when I was up in the Metchosen [Metchosin] hills in May, & never a word since I had thought of writing you to ask if you knew anything of a 'Lysle Courtenay' who started a gift shop 126A Sparks St Ottawa. he wrote me in a violent hurry for some pottery wanted it in time for the Ottawa Convention visitors & asked

as a great obligent if I'd send it right off & take payment in 30 & 60 days. So I did send him to the tune of $30.00 worth and have had no money and no word. no answers to my letters. He told me Mr Barbeau told him of my pots and had helped him to get Canadian craft work so I wrote to Mr B. after a few months but, you say he is away so that probably explains his not answearing. I wish like a dear you'd see if the shop still exhists if so he's a skunk, and you can tell him so politely but firmly.[1] No I did not see Mr B's Sat Eve Post story & I have not heard from him for a long time. Too bad the Pepper[s] have left Ottawa.[2] You will miss them.

Peggi [Pegi] will probably pop up serenely again one gets those oblivions periodicly I think—I have had a *rather* disap[oin]ting Summer's work yet for all that I'm not shure I have not grown a little. The whole summer was aweful till Sept. which was glorious up to then it was wet & cold unsettled & overcast. I got two weeks in May. which I loved, up in Metchosin hills Then in June I went a short way out ('Cedar Hill') carrying with me six dogs. (a new mother with 3 pups 3 days old.) and the Monk. had rooms in an old farm house[3] cooked on a brick hearth, and was as out of date, as Abraham. we had 3 scorching days & then a wet spell in which I dawled round the woods & got a chill and returned home ignominiously to bed so I did not get much from that trip. Then the people left the flats & I had to sit tight at home, however I've done a few canvases, & a lot of thinking. Yes, we do change our veiw point as we go on. I quite understand when you say yours has shifted. it is inevitable if we are to make any progress. The worst of it is that it gives one the perpetual pip to do your best & the week beyond to see how empty that best was. How perfectly scrumptious it must be to have the temperament of the Arts & Craft Tabbies placidly content after 50 anual. exhibitions. of their 'sentiments' or rather 'sediments' confronting them from the walls. I almost envy them sometimes, Its just over (their show) They gave us more modern a room[4] (a small poor one) to ourselves this year that was a step. Yes they are wrangling & squabbling in Vancouver & their gallery seems to give little joy. I have

neither seen it nor exhibit there in fact this year I shall have to lay pretty low express rates are prohibitive & really I hate the showing business. such fuss & feather of crating etc wasting precious time that might be thrown into the wrestle with the real meaning of the thing by going after what you want, & letting the critics & wranglers go zip. The good crits are almost worse than the bad. Most times they credit you with something you never thought of or meant.

Mrs Sallanger[5] [Salinger] is coming this week I beleive to give a Canadian Womens Club lecture. We had Mr Lismer in the Spring funny old duck but she!! Wow! she's a *little minute* [underlined twice] *infinitessimal* [underlined three times] squirt of a human, like a midge. I don't know how he stands her. They spent all the time he wasnt talking—with me. it was lovely to see *them—him* [underlined twice]. Old Victoria was *actually indignant* at the rotton thing Ottawa put on the screene. to represent my work. its one of my old original. watercolors and a rotton one at that. & not the least typical of my work. However that is all they ever favoured me by purchasing. McCurrey [McCurry] wrote me he might be out this way this Autumn & would call if he did but I've seen or heard nothing further. Vancouver always takes care Victoria gets no intimations of any shows or hapenings. in the East if they can help it I beleive when they send selections from the West the No. is limited so I suppose they want the spaces for the Vancouverites. all they can get

I had a scheme that I'd like Beacon Hill Park to take over my house & turn it into a little gallery connected with the park[6] there are four good sized rooms across the front of the house for hanging & the studio to be used for a "talk room" where small 1/2 hour talks on art—music—photography—in fact anything that interested the *people* could be given Sunday afternoons & small exhibitions could be constantly changed. give them all a show. the old Adam & Eve stagess [?] the Modern. the old Tabby who paints cats, & dogs. did you meet her? Mrs Drummond Davis [-Davies],[7] In fact it would be available for all a place *of* the people *for* the people. I feel it could be made a success. & create an interest especilly on the dull winter days

when there is no band in the park, & [if?] it is chilly people could take their little walk & drop in. We have a new Park Superintendent & it the scheme interested him greatly, but, there are no funds. I couldent *give* the house its my only means of support, but I'd give my help & they could have all my old Indian Junk as a standby. that interests people because of its historical side. but as I have neither funds or backing I guess it will all be dumt. but I do think the idea has possibilities don't you? My house is practically in the Park. perhaps they figure that if taxes go on increasing and rentals decreasing it will fall to the city. any how *for* taxes. who knows? then they have it for nothing.

I havent seen Aunt Mary. So the Browns have a house now, thats nice good luck to them in it.

That grand & beloved old cat 'Dolfus' died this summer at age 18 years just slept out had all his faculties to last & was one fine noble beast. Also my little 'Twinkle' you remember the cute little deaf dog. gave birth to dead pups & died of blood poisoning. so my family was diminished & my heart got chipped, but it is so these things must be & it's no good mourning. they led their happy lives gave happiness & I havent any doubts have gone on somewhere. Koko is valliantly coping with the old age problem, & giving up graciously what he finds he has not strength for. & loving the fire side soft chairs & soft food and me more than ever & his heart is still merry. I have a delightful pup a smoother griffon full of the devil & called 'Tantrum' for he's all pepper. he's small & smart. I make him treat 'Grandpa' with all respect, & now that his mother is about tired of him he finds Grandpa very comfortable & Koko really likes him, tho he wont take pup impertinence.

Gee Whyz. what a letter!!!! goodnight. let me know about that rat on Spark St. will you.

yours.

M.E. Carr

NOTES

1 "Courtenay" wasn't in when Cheney went to see him, but she wrote that she had "told his assistant a thing or two." Cheney, to Pepper, 30 Oct. 1932. The Cheney to Pepper letters are in the possession of Kathleen Daly Pepper, Toronto. Mrs. Pepper is an aunt of Katherine Daly Cashmore, Vancouver, younger friend of Nan Cheney.

2 George Pepper had accepted a teaching post at the Ontario College of Art. See *In Memoriam: Capt. G.D. Pepper, 1903–1962* (Ottawa: NGC 1964). See also #218, note 7.

3 The house where Carr camped alone was on Cedar Hill Road near the Mount Douglas woods.

4 The "Modern Room," which was part of the IAACS exhibition of that year (and only that year) showed the work of Max Maynard, Ina Uhthoff, Edythe Hembroff, Ronald Bladen, and Emily Carr. The exhibition was held in Victoria from 11 to 22 October 1932. Four of Carr's paintings were included (*Indian Village British Columbia*, *Tree*, *Red Cedar*, and *Thunderbird*). See Edythe Hembroff-Schleicher, *The Modern Room* (Victoria: BCARS 1981).

5 Jehanne Bietry Salinger, Toronto writer and art critic, had written favourably of Carr's work in connection with the 1930 AECA exhibition in "Comment on Art," *Canadian Forum*, 10 (Mar. 1930):209–11. Harris had urged Carr to read the article and stated that Salinger was the best art critic currently writing in Canada. See BCARS, Phylis Inglis Collection, Harris to Carr, n.d. [1930].

6 Carr envisioned her apartment house becoming a "People's Gallery," with exhibitions and activities of wide appeal. According to Carr's plan, two of her empty suites would be connected through a door, providing six rooms that would be rented to the city "at the lowest possible rental" with Carr herself assuming "a large proportion of the work connected with the hanging of new shows from time to time." See Carr, "Art and the House," in *The House of All Sorts*, 129–33. As part of her promotional campaign Carr delivered a talk at an exhibition and large gathering at her house 14 Dec. 1932. She outlined her plans, stating that she hoped the gallery would be a place for "the spirit of art to grow in," and that it would serve a broader function than the IAACS. See BCARS, Inglis Collection, "People's Gallery Speech," and "People's Gallery Plan Is Under Consideration," *Daily Colonist*, Victoria, 15 Dec. 1932, p. 6, for an account of the evening. It notes that Jack Shadbolt was chairman of the informal proceedings and lists the prominent citizens attending. Carr's proposal, although considered by officials, was eventually abandoned. "She's dead," Carr wrote to Brown (NGC, Archives 7.1 Carr, E., 20 Jan. 1933). Later, in writing of the VAG, Carr expressed a different attitude concerning "people" and a gallery. "I don't know if I think. the messy public masses a great advantage to art. they just go to stuff tea and be entertained," she wrote to Campbell (now Pavelic), 8 Jan. 1943, possession of Pavelic.

7 Nora Drummond-Davies (1862–1945) was a Victoria painter who specialized in animal studies.

9 [*Carr to Cheney*]

646 Simcoe St

Victoria B.C.

Jan 7 1933

Dear Nan

"One card deserves another,
 A letter brings twin brother.

Thank you very much for the cuttings. what a frazzleup! I hope it all comes out in the washing I got one of the antidote petitions & got several names[1] it's pretty rotten and anoying that all those 'objectors' were 'obscurities' no one ever had heard of till their protest & whose work would not possibly be in any N.G. exhibit. Mr Brown wrote me such a nice letter following a wire from him for six canvases.[2] I had not expected to send more than one East this year & that only if I got notice from Vancouver. *in time* which I did not thats the third year Scott[3] has given me one minute notice. so I wrote & told Mr B. why I was unable to send.[4] Mr B. was so nice about my gallery idea. it is not squashed yet & lots of interest being shown. if we can get funds I have had no money from the 'Pot man' & could do with it too these days.

Do write me a *decent* letter clippings are O.K. & I'm obliged but I *need* a letter. or whats the good of correspondence? Yes.

M.E. Carr

NOTES
1 Carr is referring to the heated controversy concerning NGC policy (i.e., Eric Brown's) regarding artists' representation in international exhibitions and National Gallery purchases. Brown was denounced by a number of RCA artists for his bias in favour of the Group of Seven artists in these matters. An anti-gallery petition of December 1932, with one hundred and eighteen signatures, demanded a government investigation and threatened a boycott of NGC exhibitions. See Charles Hill, *Canadian Painting in the Thirties* (Ottawa: NGC 1975), 21–3. This was countered by "anti-dote" actions by Brown supporters. Brown had referred to the actions in a letter to Carr (NGC, Archives 7.1 Carr, E., 21 Dec. 1932).
 He wrote: "You may have heard reverberations of a so-called petition signed by a number of so-called artists, mostly obscure and a good many of them dug up by Mr Radford in Vancouver. It has been done for the purpose of trying to establish

control of the National Gallery by the R.C.A. and other societies and thereby crushing out any freedom of art in Canada. It is not getting very far and does not represent anything that is important and we are not worrying about it. The interesting thing about it is that there are at least three or four hundred artists in Canada who did not sign it and who do appreciate the freedom from autocratic control which the National Gallery stands for."

Harris wrote to Carr: "No, none of us want Browne [sic] deposed—far from it. What the Academy want, though they don't and won't say so, is to run the National gallery lock, stock and cash-barrell [sic]. The only reason we have entered the fray is because we know that and know it for certain!" See BCARS, Inglis Collection, n.d. [1933].

2 Brown's request (21 Dec. 1932) was for six paintings, three or four for the AECA to be held from 7 Feb. to 6 Mar. 1933, and the remainder to be available for other eastern exhibitions. Two Carr works were shown in the AECA (*Zunoqua of the Cat Village* and *Blunden Harbour*).

3 Charles H. Scott (1886–1964), painter, administrator, and teacher, was principal (1926–52) of the Vancouver School of Decorative and Applied Arts [VSDAA] (by 1933–4 called the Vancouver School of Art [VSA], and now The Emily Carr College of Art and Design). Scott was a representative on the first Council of the VAG in 1931–2 and served in this capacity until 1950. In 1933 he became a founding member of the CGP. It is likely that it was through the VAG association that he was requesting Carr paintings for the NGC exhibition. For a recent account of Scott see Ian Thom, *Charles Hepburn Scott* (Vancouver: VAG 1989).

4 Carr explained to Brown that she could not afford the expense of expressage. She stated also that Scott had allowed her only twenty-four hours in which to ship. See NGC, Archives 7.1 Carr, E., Carr to Brown, 15 Dec. [1932].

10 [*Carr to Humphrey Toms, Victoria*]

[*The Carr to Toms letters are in the British Columbia Archives and Records Service, Humphrey Toms Papers, Add. MSS. 2545. The brief note that follows marks the beginning of the Carr-Toms correspondence. It was sent to Toms at his parents' home, 2320 Windsor Road, where he was living, and was in answer to his request to visit the artist's studio.*]

646 Simcoe St.
Aug 2. [1933]

Dear Mr Toms

I am in receipt of your letter asking to come to the studio.[1] I expect to go away before long and am. very buisy. in the day time finishing up

some work for shipping.

If you would like to come on Monday of next week in the evening for a little while about 8:30 You may do so.[2] If you are not able to come at that time please phone me.

I did at one time teach in Miss Gordon's school in Vancouver.[3]

Yours sincerely.

M. Emily Carr

NOTES

1 In late July 1933 Toms had written to Carr requesting the studio visit as he had been much impressed by the Carr paintings he had seen at IAACS exhibitions. See Toms, "Letters from Emily Carr to Humphrey Toms," typescript, 1979, 1 (property of Mrs. Jane Toms, Victoria); and Introduction, note 37, regarding Toms' first viewing of Carr paintings.

2 Mrs. Gwen Cash was also present on the appointed evening, and Toms recalled: "Emily was at first intensely shy but warmed up and showed us a number of her paintings. The evening ended with piping hot cocoa, buttered toast and jam and a friendly good-night." Toms, "Letters from Emily," 1.

3 In his note to Carr, Toms had mentioned that he was a nephew of Miss Jessie Gordon, a founder of Crofton House School. (Toms' mother had also been involved in the beginnings of the school.) Carr taught a special art class for the school, likely during 1908–10.

11 [*Carr to Cheney*]

[Carr to Cheney]

646 Simcoe St
Victoria, B.C.
Dec. 11 [1933]

With all best wishes for Xmas and the New Year—tho you have apparently forgotten my exhistence[1] I am still on earth. and so is Woo. Beloved old Koko is not.

I went to Chicago to see the pictures at the fair but got there too late they closed two weeks before the rest.[2] Also ran up to Toronto and saw them all which was most enjoyable.[3] Bought a caravan trailer[4] this summer too—have to be towed—this summer was very wet for sketching.

Wishing you a very happy 1933 [1934]

Sincerely yours.

M. Emily Carr

NOTES
1 During the winter of 1933–4 Cheney was in Montreal taking classes from Edwin Holgate at the Ecole des beaux-arts. "I am enjoying Mr Holgate's class," Cheney wrote to Kathleen Daly Pepper, and added: "It is wonderful in Montreal—so stimulating after Ottawa, but I do hate leaving Hill just now. Hill is most anxious for me to make the most of my time here so as to have something else at my finger tips in case the worst happens." Cheney to Pepper n.d. [winter 1933]. (Apparently there were problems concerning Dr. Cheney's position at the Ottawa Civic Hospital. See #12, note 3.)
2 The show Carr missed was "Century of Progress: Exhibition of Paintings and Sculpture Lent from American Collections," held at the Chicago Art Institute, 1 June–1 Nov. 1933, during the World's Fair.
3 Carr wrote enthusiastically of "a rounded-out completeness" in regard to her nine-day stay with Bess and Fred Housser and of "long talks with Lawren in his studio." See *H&T*, 17 Nov. 1933. Harris wrote to Carr: "If your visit did you good, it also did us good. Such things are mutual, praise God." See BCARS, Inglis Collection, 4 Dec. 1933. See also BCARS, Hembroff-Schleicher Papers, Carr to Hembroff, 17 Nov. [1933], "I am returning very keen to renew the struggle."
4 "The Elephant," (Carr's name for her trailer) was a converted camper used by her until late 1936 for camping at sketching sites in the environs of Victoria. Carr described van life in some detail in *H&T*, under the date 16 June 1934.

12 [*Carr to Cheney, Montreal.*]
[*Letter addressed to 3610 Lorne Crescent*]
[*Cheney had been mainly in Montreal since the winter of 1933–4. See note 1.*]

646 Simcoe St

Oct 25 [1935]

Dear Nan.

The surprise at hearing from you after three *years* bowled me clean over I thought I was dead to you shure.[1] Never the less I was very pleased. 'Bless old Vanderpant.'[2] He is a nice person isn't he? He comes to see me occasionaly when he is in Victoria. I was most interested in all your 'newses'. but very *very sory* to hear about the 'derty work' and your loosing the position and your lovely home.[3] There are some people in this world that one does not want to insult. the good old swine by likening them to him [crossed out]. Your own job sounds most extraordinary I should loathe drawing livers & Tumors.[4] I *refused* to go and see some remarkable one they cut out of me & still have bottled in the Hospital as a curio. However you must be a very accurate worker to do it. and anything one can do well becomes interesting. Of course there is nothing indecent about kideneys & brains. but I hate to remember I have them. Am sure you would enjoy the portrait work with Lillias [Lilias] Newton.[5] I liked her Do you know Anne Savage?[6] & I wonder what Sara Robinson [Sarah Robertson?][7] Prudence Heward,[8] & Holgate[9] are doing there are lots of Artists there for you to be with. In Victoria they get scarcer & scarcer. at present there is not *one* [underlined twice] real worker My freind Edythe Brand married a professor of Mathematics at University of B.C.[10] so lives in Vancouver. Max Maynard[11] & Jack Shadbolt[12] who were the only others who really worked are also living in Vancouver. So I plod along by lonesome & often wish there were other interested spirits about. for the last 3 years I have been the posessor of a Caravan Trailer (no works) it is a hideous box I got cheap but a great joy. I get hawled out somewhere in May & sit for a month or six weeks. go home again for July & August, & out again in Sept. This year I was at Albert Head 15 or 20 miles out. There were fine skies in June. in September I worked in a jungle of woods.[13] I take all the dogs and the monkey and we have a fine time. & I forget for the time being my

poor old house and the *beastly* tennants. I am trying my best to get rid of the house it is just killing. rents so low & so hard to get tennets at all the place all needs modernizing. & doing up & I have not a bean. Nothing *sells* these days but I am trying to swap it for a hut.[14] I shall loathe giving up the studio & the garden & heaven alone knows *how* I shall live. but this place is running at a loss & the overhead so heavy the city will take it if I do not do something. living is difficult these days for everyone apparently. Winter seems to have fallen from the blue today it is cold enough for snow. & bitter north wind One dreads Winter for fuel & pipes. I got a notice today that there is to be a group show in January.[15] Shant be able to send costs too much transportation I am however having a show of sketches at Womens Art Ass. in Toronto last two weeks in Nov—I beleive.[16] they are on paper & light & inexpensive to transport.[17] The Housser Harris affairs[18] seem in a way to have paralized the art activities in Toronto I suppose things will shake down eventually. Lawren was sort of the centre of art there that is of progressive art & he also had the means. & the Houssers too were very influential in the art set. I suppose things will right themselves by & bye, tho it seems if the Harrisses [Harrises] are going to have a bad time if they want to return to Canada I guess the former Mrs Harris would make it nasty if she could. I'm sory for them all its an unpleasant mess all round. I wonder how 'Evonne [Yvonne][19] will work out as Mrs Housser I fancy her position will be difficult: After all it is only the buisness of the four persons concerned. Mr Lismer was out this year lecturing.

I *never* see Aunt Mary I go out *very* little.

The Blessed old Koko went hence some two years agoe. I have 3 now & one is barrel shaped with expectancy. last year I had a family of pups born in the caravan.

The apple crop was wonderful this year, so was the earwig crop we have had a plague of earwigs. I have got some bantams now they clean them up better than anything.

I gave a *speech* last week.[20] I talk about as eloquently as a tadpole, but I did not seem able to evade it. It was to the Normal School.

Students & teachers. The students gave wrapped attention & verciferous applause. The professors, Ahamed! and. were lukewarm. Said it was quite diffent to the talks they usually got. They were none of them interested in art & particularly not in the creative type. It does one a world of good assembling their ideas, probably far more good than it does the audience.

What of the Browns. we correspond no more, nor do I hear from the Barbeaus. In fact now that Lawren & Bess are gone I seem to be completely cut off from the East. The beloved Hart House quartette. pay an annual visit which is a joy, both the music and the men themselves.[21]

Now I must face the elements to take the dogs out before shutting up. Hope you will write again Remember me to Mrs. Newton when you see her please. Best to yourself.

P.S. Hope you will get out next year

Affectionately yours [?].

M Emily Carr

NOTES

1 Carr apparently had not heard from Cheney since before 7 Jan. 1933. The little that is known of Cheney's activities for these years is primarily from her letters to Kathleen Daly Pepper. (An information file completed for the NGC in 1979 is of no help.) It appears that after her period of study in Montreal during the winter of 1933–4 (see #11, note 1), Cheney remained in Montreal to work as a medical illustrator. She wrote to Pepper (2 Apr. 1934) that she was worn out holding down a job and attending to business in Ottawa; and that her work at the hospital (Royal Victoria), with her studio just off the ward, made her "pretty sick." She acknowledged, however, that she felt lucky to have a job that would keep her for the summer. (As there is no record of Cheney's employment in the Hospital records, it is likely she was working there as a freelance artist.) Except for the summer of 1935 spent camping at Clyde Forks, Cheney apparently remained in Montreal through 1934 and 1935. She may have stayed on at the Hospital in a freelance capacity as she refers to her work, but she provides no specifics. (Victor Doray currently has three medical drawings from Cheney's Montreal period, two of which have notations which state they were executed for Dr. Maude Ibbot, McGill University.) Cheney wrote from Clyde Forks in Aug. 1935 that she hardly felt equal to going back to Montreal in September and "drumming up a job." See Cheney to Pepper, 29 July 1934 and 7 Mar. 1935 regarding Cheney's financial

worries. In a letter of 26 Dec. 1988, Kathleen Daly Pepper stressed that the mid 1930s period was "a most trying time for both Nan & Hill."

2 John Vanderpant (1884–1939), a progressive photographer, had opened Vanderpant Galleries in Vancouver in 1926. He played an active role in the local art scene, serving on the Council of the VAG (1931–4), and holding exhibitions of his photographic work at the VAG in 1932 and again during the 1936–7 season. See *Art Gallery Bulletin* [AGB] [VAG], 4 (June 1937), and Charles C. Hill, *John Vanderpant, Photographs* Ottawa: NGC 1976).

3 In the previous year Dr. Cheney had lost his position at the Ottawa Civic Hospital and there were evidently "awful rows over the whole business." By early 1935 the Ottawa house was sold to the current tenants. See Cheney to Pepper, 2 Apr. 1934; and 5 Feb. 1935.

4 In Cheney's letter to Pepper of 2 Apr. 1934, she referred to her "Tumors of the kidney book," and that she was "well away with it." On 5 July 1934 she wrote again: "I have become awfully interested in my job & altho it is purely commercial art it has a scientific & technical side which holds one's attention. They still use the things I did 12 years ago & flatter me that they have never had anyone who was half as good etc."

5 Lilias Torrance Newton (1896–1980), a leading Montreal figure and portrait painter and a founding member of the CGP, was currently teaching a weekly art class at the Art Association of Montreal [AAM]. Cheney could have told Carr either of this class, or of one she had taken a year earlier ("I certainly enjoyed Mrs. Newton's class," she wrote to Daly, 2 Apr. 1934). For information on Newton, considered "the best Canadian portraitist of her generation," see Dorothy Farr, *Lilias Torrance Newton 1896–1980* (Kingston, Ont.: Agnes Etherington Art Centre 1981). (Carr likely had met Newton during Carr's 1927 visit to Montreal.) Later correspondence between Cheney and Newton is with UBCL, Cheney Papers, box 4, file 14. Newton's portrait of Nan Cheney was painted in 1946.

6 Anne Savage (1896–1971), a Montreal landscape painter, was a founding member of the CGP and was known for her creative art teaching methods in her work at Baron Byng High School in Montreal (1922–48). Carr had met Savage in Montreal during her 1927 eastern trip. See *H&T*, p. 14, and Anne McDougall, *Anne Savage: The Story of a Canadian Painter* (Montreal: Harvest House 1977), 99–100 (their first meeting misdated 1929).

7 Sarah Robertson (1891–1948) was a Montreal painter of landscape and genre, and a founding member of the CGP. Carr had met Robertson in Montreal in 1927. See Blanchard, *The Life of Emily Carr*, 180.

8 Prudence Heward (1896–1947) was a Montreal painter of figures, landscape, and still-life, and a founding member of the CGP. See Natalie Luckyj, *Expressions of Will: The Art of Prudence Heward* (Kingston: Agnes Etherington Art Centre, Queen's University 1986).

9 Edwin Holgate (1892–1977), who became a member of the G of 7 in 1930, was a founding member of the CGP and the unofficial leader of the Montreal figurative painters. He was currently teaching (since the fall of 1934) with Lilias Newton at the AAM school. During Carr's trip to the East in 1927 she recorded in her journal that she had visited Holgate in his studio and had liked him. *H&T*, 14 December 1927. See Dennis Reid, *Edwin Holgate* (Ottawa: NGC 1976).

10 Edythe Hembroff married Frederick J. Brand in 1934. He was a keen supporter of Carr and had introduced her painting to UBC at a group exhibition in the Library in March 1933. See " 'Great Art Hidden in Kitchens' Says Brand," *Ubyssey*, 14

Mar. 1933, p. 1, for a report of his talk relating to the show. Brand, who had met Carr in 1932, referred to her as "one of the greatest artists on the coast." He read her stories to students and subsequently showed them to Dr. Garnett G. Sedgewick of the Department of English, UBC. See Hembroff-Schleicher, *Emily Carr*, 278.

11 Max Maynard (1903–82), a Victoria artist and teacher and an early admirer of Carr's work, was at this date on leave from Lampson Street Elementary School in order to study at UBC. He was active in the VAG as both exhibitor and lecturer (a talk was scheduled for the following month), and became known in both Victoria and Vancouver as an articulate exponent of "advanced" art. (It was Maynard who, as vice-president of the IAACS in 1932, had organized "The Modern Room" as part of the Society's annual exhibition.) See Nicholas Tuele, *Max Maynard: Landscape as Metaphor* (Victoria: Art Gallery of Greater Victoria 1983). See also Tippett, *Emily Carr*, 195–6.

12 Jack Shadbolt (b.1909), an internationally known Canadian artist, was, in 1935, teaching at Kitsilano High School in Vancouver (1931–7) and studying in the night school program of the VAS (1934–7). (He joined the VAS permanent staff in 1938.) Shadbolt, who was from Victoria (where he had attended Victoria College and the Provincial Normal School), had known Carr prior to coming to Vancouver, and with his older friend, Max Maynard, had become an enthusiastic admirer of her painting. See Jack L. Shadbolt, *In Search of Form* (Toronto: McClelland & Stewart 1968), 64. From the time of his move from Victoria to Vancouver in the early 1930s, Shadbolt became both a prominent artist and an influential force in the local art scene. For a chronology of his early years as an artist, see Ian Thom, *Jack Shadbolt: Early Watercolours* (Victoria: Art Gallery of Greater Victoria 1980.). See also Avril Anstie, "Victoria's Jack Shadbolt," in *The Islander*, *Daily Colonist Magazine*, Victoria, 7 Oct. 1973, pp. 2–3. (In 1971 Shadbolt executed *The Hornby Suite: Homage to Emily Carr*, a series of fifteen large charcoal drawings which were exhibited at the Bau-Xi Gallery, Vancouver, and published by the Gallery in a portfolio of fifteen lithographic plates.)

13 Carr describes at some length the joy of the "big woods" and the "blessed camplife" at Albert Head, Metchosin, where she was camping in her van. See *H&T*, 192–200, entries for Sept. 1935. The sketch relating to *A Rushing Sea of Undergrowth* was among the sketches done at Albert Head, where she camped in both June and September. See Shadbolt, *The Art of Emily Carr*, 124–5 and catalogue entry 99.

14 The next year Carr was able to exchange the Simcoe Street house for a smaller one (1266 Osler) for which she would receive rent. In Mar. 1936 she moved into her rented house on Beckley Avenue (misnamed "St." by Carr).

15 A reference to the forthcoming exhibition of the Canadian Group of Painters [CGP], of which Carr was a founding member. The organization was formed in 1933 as a development out of the G of 7. Its members believed that the time was appropriate for the formation of a larger, more widely based organization. Harris was first president of the new 28-member group, which held its first Canadian exhibition in November 1933. Harris had written to Carr of the plans regarding the proposed body, stating that "the time is ripe to enlarge." He told her further: "We are now forming a new Society with the present group as nucleus. When this is rounded into shape there will be no group of seven." BCARS, Inglis Collection, 1 Jan. 1933. (In 1944 Carr was invited to become an honorary life member.)

16 Carr wrote in anticipation of her show at the Lyceum Club and Women's Art Association, Toronto, that it was "a chance to see if my work means anything to

the outside world." See *H&T*, 19 Oct. 1935 and 12 Dec. 1935 for her inclusion of the favourable G. Campbell McInnes review "World of Art," *Saturday Night*, 51 (7 Dec. 1935):27.

17 Carr's unusual medium was oil paint thinned with gasoline. She later explained to Eric Brown that the method allowed "great freedom of thought and action." NGC, Archives, 7.1 Carr, E., Carr to Brown, 4 Mar. 1937. Carr wrote to John Davis Hatch, Jr., "I took those sketches up to loosen myself—the surface is also lovely to work on and the paper light to carry. I felt I learnt a lot by doing them." Smithsonian Institution, Archives of American Art [AAA], Carr to Hatch, 25 Mar. 1937. For a discussion of this technique, see Shadbolt, *The Art of Emily Carr*, 112, 114.

18 Carr had met both the Houssers (Fred and Bess) and the Harrises (Lawren and "Trixie") in Toronto in 1927; and in 1933 she had stayed at the Houssers' home while in Toronto. Fred Housser was a friend of members of the Group of Seven and the author of *A Canadian Art Movement: The Story of the Group of Seven* (Toronto: Macmillan 1926). In the summer of 1934 Fred Housser separated from his wife Bess (later marrying Yvonne McKague) and Harris divorced his wife and married Bess Housser in Reno, Nevada, the couple later moving to Hanover, New Hampshire. Dennis Reid, in *Atma Buddhi Manas*, 23, has commented: "That they all continued on friendly terms was in Toronto the most shocking aspect of the scandal." Nan Cheney had written to Pepper (29 July 1934): "You know of course about Lawren Harris and Bess Housser—quite a jolt all round." Carr recorded that she felt as if her connection with the East was over. *H&T*, 1 Nov. 1934.

19 Yvonne McKague (b.1898), a founding member of the CGP, was a Toronto landscape artist of the generation following the G of 7. See note 18.

20 A typescript of Carr's "Talk on Art," which was given in Victoria at the Provincial Normal School, is dated 22 Oct. 1935 (BCARS, Inglis Collection). Carr wrote in her journal that the topic was "The Something Plus in a Work of Art." See *H&T* for Oct. 1935, and *Fresh Seeing: Two Addresses by Emily Carr*, with a preface by Doris Shadbolt and an introduction to the 1930 speech by Ira Dilworth (Toronto: Clarke, Irwin 1972).

21 The Hart House String Quartet was formed in 1923 in connection with Hart House, a men's centre at the University of Toronto. The original musicians were Geza de Kresz, Boris Hambourg, Harry Adaskin, and Milton Blackstone. The Quartet lasted, with membership changes, until 1946. There are a number of references to the Quartet in Carr's writing. A year earlier, in recording a visit of Harry Adaskin (a particular friend) and Boris Hambourg to her studio, Carr reflected on the inspirational quality of their music. See *H&T*, 26 Nov. 1934 and 28 Nov. 1933 regarding Carr's friendship with Adaskin, who remained a member of the Quartet until 1938.

13 [*Carr, Metchosin, to Toms*]

[*Addressed to Windermere Hotel, Victoria, where Toms was working as a clerk*]

c/o J.W. Spencer
Producers Sand & Gravel
R.R.1 Metchosin V.I.
[postmarked 9 June 1936]

Dear Humphr[e]y.

Thank you for fire permit. One certainly feels very *safe* from *fire* this weather. Dissapointing for work but otherwise rather amusing (sitting dry surrounded by water) I read until sleep & 'dry dogs'

Its a *lovely* spot[1] loads of Ant Hills. (but, not aggressive ants) no humans round. & comfortable camp *when dry*.

I am going to ask you another favour. I enclose $1.00 bill. will you go to Priors hardware & buy me, a 2 lb. can of *Green Seal*. *Zinc White* paint. It is I *think* .40 per lb. & postage would not be more than .20. Thanks awefully.

You'd love this place If the sun was out

Very sincerely

M. Emily Carr

NOTES
1 The J.W. Spencer sheep farm where Carr was camping in her van was some ten miles out of Victoria. Hembroff-Schleicher, *Emily Carr*, 133–5, gives a full account of this trip and notes that the cliff top overlooking the huge gravel pit ("her favorite of all the Metchosin locations") was the site for a series of sea and skyscapes, as well as many of her stump and root paintings. The sketch for *Above the Gravel Pit*, now in the Art Gallery of Greater Victoria, was likely done at this time. Toms bicycled out to see Carr on 22 June. See *H&T*, 22 June 1936.

14 [*Carr, Victoria, to Cheney, Vancouver*]
[*Letter addressed c/o Mrs. F.C. Brand, 4775 W. 4th Avenue, Vancouver*]

[*Although there are no known letters from Carr to Cheney in 1936, the*

friends did see each other in Victoria during Cheney's western trip that summer. Cheney was in Victoria prior to a three-week teaching post at the Banff School of Fine Arts during August. Carr noted in her journal for 4 July: "Nan Cheney came Saturday. We had a long talk." See H&T, 247. In January 1937 Carr had suffered her first heart attack and was forced to spend a month in St. Joseph's Hospital. This letter was sent to Vancouver, where the Cheneys had moved earlier in the month. Dr Cheney had accepted a position at the Vancouver General Hospital.]

316 Beckley St[1]
Mar 17 [1937]

Dear Nan

It was good to get your letter even if only a proxy. You poor dear I am so sory about your shoulder[2] how painful & uncomfortable (right one too) do hope it mends quick & true soon. what a pair of crocks we are?

I progress slowly,[3] have had 10 weeks of bed tho' I do get up a few hours now but am still quite a limp fool. Hearts it seems are very slow to heal. however the pains have gone I just have to be lazy no exertion or strain ad lib, I hope to resume work some day in a doddering manner. Thank goodness one can sit—walking seems to be taboo.

I was delighted to hear both from Mrs Kier [Keir][4] and Eric Brown that you were coming out here to live I'd prefer it to be Victoria. Still Vancouver is better than Montreal There is certainly more art life for you in Van. than in Vic. There are quite a group of interesteds there the few we had in Vic have migrated there. You met Edythe Hembroff, now Mrs. Fred Brand. she is over there her husband is a professor in University. I shall write & tell her you are there. do you care for visitors?

You are here to begin Spring It was such a poor winter for us but nothing to grunt at other parts of world considered.

I am undergoing the agony of finding a housekeeper had a splendid woman the first month out of hospital but she could only stay one month. had a *beast* for 30 hours who decamped at 10 o'clock last night leaving me stranded. It is *so* difficult to get any one efficient they are so *selfish* lazy or unclean, put on such airs. I want a servant the ought-to-be servants are all ladies-in-waiting & *sharers* & I don't want a companion It puts me off work. I've always been so *independent* [underlined twice]. It is horrid to have to pull up unable to wait on yourself, well no good to kick I'm lucky to be able to crawl.

Do come over when you are able. It will be lovely to see you & get news from East Etc. People have been wonderfully good to me.

Affectionately

Emily Carr

NOTES
1 Carr had moved into her rented house on Beckley Avenue by Mar. 1936. See *H&T*, 2 Mar. 1936, and #12, note 14.
2 Dr. Cheney had written to the Peppers from Owen Sound (11 Jan. 1937) that Nan had broken her right shoulder on the day before Christmas. Obviously it continued to give her trouble after the move to Vancouver in Mar. 1937, as Carr wrote to Brown: "I have not seen Mrs Cheeney. She had been in hospital and cannot even write herself." NGC, Archives 7.1 Carr, E., 8 Apr. 1937.
3 By 8 Apr. 1937 Carr could write to Brown: "I am much improved and able to be painting again." See NGC, Archives 7.1 Carr, E.
4 Patricia Keir (Mrs. T.G.), who was then living in Laval, near Montreal (and now in Victoria), was a sister of Flora Hamilton Burns, devoted friend of Emily Carr. They were daughters of long-time neighbours and friends of the Carr family, Mr. and Mrs. Gavin H. Burns.

15 [*Carr to Cheney*]

316 Beckley
April 9 [1937]

Dear Nan

How are you getting on? I had a letter from Edythe Brand and she said she had been to see you I was glad to hear you were home again what a long beastly time you have had with your arm. hope you will soon have use of it. It is so miserable to have to depend on other people to do things for you.

I am lots better (at present have a writched cold.) but my heart has improved a lot. I still have to go slow like an old old tabby, but I am painting again. Get up at 9 a.m. till 3 P.M. go to bed 3–6. up again 6–9 but can't do much walking & no houseworking. so have a girl. Isn't it luck I'm cut off manual labour rather than painting?

Am dreadfully sad today because I have sent my last pup to the hospital. I had two such beautiful little females. one died last week 'gastritis' & this one has same thing & is bad. I had to part with the Monkey. she is in Vancouver Stanley Park Zoo.

Seem to keep busy all the time, one way and another am getting some canvases ready for Vancouver show.[1]

Edythe is so glad you have gone to Vancouver to live. She is a dear thing I am very fond of her and she's so good to me. She was over at Easter. I think you two will be freinds.

Are you able to paint again? I am anxious to see some of your work. Don't know when I shall come to Vancouver Edythe wants me to visit her but one needs to be spry to Visit people.

Mr Brown has written me several quite nice warm notes. Ottawa is buying two large canvases and a sketch from me[2]

Well hurry and improve and I will try to do the same—'sick no fun'.

I wish I had room to ask you to come and stay, but I have no spare anyhow 'Aunt Mary' would eat me up. she will want every crum of you but I do hope you will soon be over. The weather is quite nice. April showers but sunshine too.

Love and Luck

Yours.

Emily Carr

NOTES

1 Carr showed 3 works at the British Columbia Society of Fine Arts [BCSFA] exhibition held from 16 Apr. to 2 May 1937.

2 *Heina, Q.C.I.*, *Blunden Harbour* and *Sky* were the two oils and oil on paper sketches that were acquired by the NGC. Carr had written to Brown that the price for the three would be $750.00. See NGC, Archives 7.1 Carr, E., 4 Mar. 1937.

16 [*Cheney to Eric Brown, Director,*
National Gallery of Canada, Ottawa]

[*Cheney's letters to Eric Brown and H.O. McCurry of the NGC are in the NGC, Archives 7.1 Cheney, N.L. Apparently not wanting to sever her contacts with the National Gallery, Cheney wrote to Eric Brown not long after her arrival in Vancouver.*]

1246 27th Ave W
Vancouver B.C.
April 16 1937

My dear Mr Brown

Just a note to say that I have heard several times from Emily Carr & she is delighted that you have bought some of her canvases. She said you "had written her several quite nice warm notes" and this has bucked her up like everything—I cannot thank you enough for acting so quickly in Jan. and having Mr Newton see her[1]—he made a tremendous hit out here which increased Emily Carr's local prestige as well as meaning so much to her personally. I have not been able to go to Victoria as I am in a plaster cast from my waist to my right wrist with my arm up above my head. They found my right shoulder was badly smashed & dislocated as a result of a skiing accident at Christmas and

so I am writing with my left hand & please excuse the pencil—

I met Mr Grigsby[2] & joined the Gallery. You know that his wife has just died—They had a "Gallery Week" a drive for new members I saw the prints you sent and enjoyed them. The press notices were awful as usual—we are going to like it here I am sure but I can already share the feeling of being cut off from the East. Expect you are all busy with the Coronation exhibition.[3] Remember me [to] Mr McCurry and with kindest regard to Maude [Maud].

Sincerely yours

Nan Cheney

NOTES

1 Eric Newton, English author and art critic, was in Canada on a lecture tour (sponsored by the NGC) in early 1937 and had been asked by Brown to visit Carr's studio and select a number of her paintings for possible eastern sale. In a letter to Edythe Brand from St. Joseph's Hospital, Carr told how Ruth Humphrey had met Eric Newton and had taken him to her studio "where Willie [Newcombe] was in readiness with fires and pictures," and that Humphrey and Newton had later come to the hospital to see her. She added: "I believe he was very enthusiastic." Carr to Brand, n.d. [Feb. 1937], in *M.E.*, 98–9. (Carr also described the Newton visit in *H&T*, 29 Jan. 1937.) Newton, after visiting Carr, returned to her studio and later wrote with lavish praise that he had seen over a hundred of her works. Newton, "Canadian Art through English Eyes," *The Canadian Forum*, 18 (Feb. 1939):345.

2 A.S. Grigsby served at the VAG from 1931 to 1944 as Secretary-treasurer (business manager), and from 1944 to 1947 as Secretary-curator.

3 A reference to the "Royal British Colonial Society of Artists . . . Exhibition of Paintings, Drawings and Sculpture by Artists of the British Empire Overseas," which was held at the Royal Institute Galleries, London, 1 May 1937–3 Apr. 1938.

17 [*Brown to Cheney*]

[*A copy of this letter is found in* NGC, *Archives 7.1 Cheney, N.L. The originals of the 3 other letters to Cheney that are included are from the* UBCL, *Special Collections Division, Cheney Papers, box 5, file 16.*]

National Gallery of Canada . . .

April 27, 1937

Dear Mrs. Cheney,

Thanks very much for your letter of April 16th. You manage to write very well with your left hand, perhaps you can paint with it too.

I am very glad to hear that Miss Carr is well enough to paint again and I hope she will come right along. I heard from A.Y. Jackson of several people who are purchasing her work, so that I hope she will have enough for some time to come and I imagine that you could perhaps help her to arrange a representative show of her work for next winter.[1] I heard that Scotts[2] would be interested.

I hope too that you will soon be out of your difficulties and that your shoulder will take its proper position.

With kindest regards from everyone here, I am,

Yours sincerely,

[Eric Brown]
Director.

Mrs. Nan Lawson Cheney,
1246–27th Avenue W.,
Vancouver, B.C.
B/I.

NOTES
1 Cheney was to follow Brown's suggestion and is credited with the organization of Carr's first solo exhibition at the VAG, which was held 12–23 Oct. 1938.
2 W. Scott & Sons was a commercial gallery in Montreal.

18 [*Carr to Toms*]

[*Addressed to Windermere Hotel, Victoria, where Toms was working as a clerk*]

316 Beckley St.
Sunday
[postmarked 16 May 1937]

Dear Humphry [Humphrey].

I was so sory to see your Father's death in the paper this morning The paper said it was sudden I beleive.

Please accept for yourself and also give to your Mother my deep sympathy. What a blessing for her to have two satalwart sons[1] to lean on and help her at this time I wonder if your brother was home I know he was away when last I saw you. Any way your Mother would have one sympathetic fine boy to lean on. and you have her to comfort you. Your own people are everything at these times.

With sympathy and love

Yours

M. Emily Carr

NOTES
1 Humphrey and Gordon Toms were sons of Lewis and Edith.

19 [*Carr to Cheney*]

316 Beckley St
Victoria
June 13 [1937]

Dear Nan

I could kick myself for an old beast not to have written to you oftener.

Gee! I'm sory about your arm and all you have suffered. Its just too bad indeed. Miss Lawson phoned yesterday. & says you are going into hospital again I am so sory you have to. hope this time the trick will be done. Whats the good of these Doctors? I've had a *hideous* Liver myself and gall bladder & all the Doctor cares about is heart heart heart and how much the old Liver effects it. give me 20 sick hearts rather than half a liver sick. I feel as if I had 20 livers and all were sick. I often hear of you through Edythe isn't she a dear little thing a very true freind. I am so glad you two have become friends. I felt from the first you would.

What have I got to say. lets see. —Shut up here I'm not apt to be a thrilling correspondent. Could count the times I've been out on one hand & a thumb since Xmas. Dr wont let me walk at all when I go it's a taxi, and really I dont feel equal to going much. get tired and short winded. feel lots best at Home up or down as I feel. I really keep quite buisy. writing reading sewing and painting. can't garden but get lots of fun poking in my little bit. the little maid I have a farm girl loves the garden, & helps I only talk about it. I have a hammock at back, too. don't get up till eleven but do 2 or 3 hours writing in bed first.[1] Gets lots of fun out of it never expect to *do* anything, but it helps in lots of ways—painting & thinking to write things down & being able to write lying is great. Get a few hours painting most days too never had so much leisure in my life, to paint. The little girl is fine & mothers me. only she gets terribly homesick for her Mother and a twin sister, first when she does not get a letter and next when she does I dont know how long she will endure I remember how I felt when I went to London Its a bad feel poor child.

Hasn't the weather been wicked since you came West? even now it is up and down and summer should be in full swing Edythe doesn't speak of coming over this summer. Asked me to go over in July, but, I am not visit equal Its better to be home where you can kick & groul in your own den. I am so lucky to have two sit jobs I can do, but I long to get out into the woods sometimes.

My Sister[2] is going into hospital shortly to have an eye fixed. She

had the other one done a couple of months agoe. a last hope & that slim to prevent her going quite blind—not cataract—. She's so plucky. There is only the two of us now My sister Lizzie died last August.[3]

Have not had much Eastern news lately. Hear from Mrs Housser No. 2. & Bess & Lawren sometimes. 'Windy Lismer' I suppose is still in Africa[4] I suppose you cant paint lefthanded? Sometimes I fancy ones left hand does more sensitive things than their right, as long as your mind has what you want clear I wonder how you like Vancouver now you are there. has your Sister[5] been from Trail to see you perhaps she cant leave her babes.

People have been so good coming to see me. all these months I feel a blighter I do. And all the time I get fatter & fatter.

Well my dear enough of this yellow scrawl don't feel its got to be answeared. its so beastly to be hampered—Learn to write with your toes—

If you ever go to the Vancouver Monkey House look up 'Woo' she's the belle of it I hear. No camping in sight this year. far as I can see

Hope you have hundreds of nice books. I have to depend on my maid & her choice is not invigorating. My sister can't read any more it is a great trial for her. Ottawa boght 3 canvasses & Toronto Grange 3.[6] such a help. Ever so much love & good wishes for impruvment.

Yours

Emily Carr

NOTES
1 For many years Carr had turned to writing as a means of expression. "I do think it helps one," she wrote to Brown, "to express themselves more completely to word things as well as paint them." It was following her heart attack of 1937 that her writing activity increased considerably. "It helped hundreds of hours away when I was unable to paint," she explained further to Brown. NGC, Archives 7.1 Carr, E., Carr to Brown, 30 June 1938. See also Introduction regarding Carr's writing.

2 Alice was at this date Carr's only surviving sister. Elizabeth (Lizzie) had died in 1936.

3 See "Goodbye to Lizzie," *H&T*, 31 July-22 Aug. 1936.

4 Lismer taught and lectured in South Africa from June 1936 to May 1937. See Reid, *Canadian Jungle*, 24–5.

5 Mary, wife of Dr. Charles Wright, was a younger sister of Cheney. See #7, note 5.

6 The Grange, formerly a private home, was donated in 1911 to the fledgling Art Museum of Toronto (which became the AGT in 1919). It remains today as part of the AGO complex. The six paintings referred to were part of the group chosen by Newton. Carr was "stunned" when she received word of the Toronto purchase (*Western Forest*, *Movement in the Woods*, and *Kispiox Village*). See *H&T*, 3 Apr. 1937. Regarding the NGC purchases, see #15, note 2.

20 [*Carr to Cheney*]

316 Beckley
Monday
[Late spring or summer 1937]

Dear Nan

While waiting for some unpleasantries to happen I do a write to you. I was so sory to hear your recovery is so slow it is disheartening. Cheer up. Perhaps you've been going on growing inside and will have all sorts of things in your store room when you are in full swing again. you are young it is not like being an old fossil like me with your time limit for work most up. I have always a horror of ending up 'dodder' & weak in work sort of a last trickle buisness—I am glad you are able to paint a little.

Guess there's no sketching in woods for me this year and I am missing the getting off dreadfully. There is no outlook here I could kick the hideous house opposite. for such years I have always got off. I have not even asked because I know I could not. any walking or exertion and I am done as long as I sit or putter—I've always despised crawlers too—I keep very buisy in one way—have been doing up

some writing & not painted last two weeks one can write in bed.

My sister is home from hospital had an operation on her eye. poor dear She suffered so much & is so pateint It is much harder to have to sit doing nothing. I can see to write & paint & sew.

The weather continues funny, but pretty nice compared with some places one never knows tho if they need fur or muslin Wonder if Miss Lawson is with you.

Edythe seems buisy these days all this 'social stuff' in the universities seems such bunk but I suppose it is difficult to avoid friends used to seem much easier managed in old day. Maybe they paid solid visits and more seldom life is so full of little tiddeldy things now. A. fool came to see me the other day because she was the sister of her sister-in-laws brother-in-law who was an artist she knew all about the inner works and workings of Art & Artists. Wow! Was I sick? She brought along another crow who obviously loathed art. They leveled me for one week. D'you know DeMoyne [LeMoine] FitzGerald[1] of Winnipeg? it was his outfit. He gave me the pip when I met him, and he is pippier when rammed down you. She quoted 'DeMoyne' every second as a God. of Art. I'd better end. I seem spiteful, this A.M. Best hope for being better soon

aff yrs.

Me Carr

NOTES
1 LeMoine Fitzgerald (1890–1956), artist and administrator, was principal of the Winnipeg School of Art (1929–47). He had become a member (belatedly) of the G of 7 in 1932, and the following year was a founding member of the CGP. See Patricia E. Bovey and Ann Davis, *Lionel LeMoine Fitzgerald (1890–1956): The Development of an Artist* (Winnipeg: Winnipeg Art gallery 1978).

21 [*Carr to Cheney*]
[*Letter addressed to Cheney, c/o Mrs. F. Brand and forwarded to 1246 W.*

27th Avenue, Vancouver. On back of envelope Carr has written, "lost your address M.C."]

316 Beckley St
Thursday
[postmarked 9 Sept. 1937]

Dear Nan.

Glad to hear from you. Been dumpy & prousty—reason have not answeared sooner.

Too bad your films were spoilt Its disappointing after your bother you ought to make him give you new roll of films.

Life goes on just same in bed-out bed-meals-playing with Joseph & pups & a little paint

Yesterday had a visit from an old dame of 87 rather trying as her eyes & ears are dull, & she is a bit childish. I 'did' her in bed so worked off some rest time on her. The poor old dear does feel it a real *kindness* to visit me too. She arrived appoplectic from walking from car in heat. fortunately a freind of mine came & drove her home.

Several outside visitors this week none interesting.

I am sending a canvas to the show.[1] That is I *hope* Mr Newcombe[2] will be over to pack it for me he's away. Not a much of a one. If I send what *I* consider my best it would rest below in the basement and Mr Band[3] is due beginning of week & is discriminating so I rather keep best home Somehow I have not much use for Van Gallery Seems to me best way is to let the old conservative tripe have its way till it dies and the staleness of its awefulness of exhibitions sickens [?] themselves then they open their eyes to look for somewhat *new*, See! Whats the use of struggling & bickering over it anyhow. I think a gallery should be cut clean in two, academic & original, & let folks choose their own level. but *not mix* the two. Have been very lazy done a little paint & no write.

Went a picnic with my sister in a taxi-cab to the park, lovely to be in among trees & sitting on grass stayed 2 hours & drank tea, just she & I.

Hope you can come over again it's nice to see you, even if I have to sit up on my tail like a begging pup & 'pose'[4] I don't mind a bit tho' seeing its for the good of the cause.

Joseph gets tamer every day & is a pretty joy.

Now my dear I'm dry as a burnt saucepan. (of news not love.) Hope your arm is coming on. You have been so patient under all that pain.

Press of buisness now causes this to close. Much love

M.e.

NOTES
1 The sixth annual British Columbia Artists Exhibition [BCAE] was to be held 17 Sept.-10 Oct. 1937.
2 William A. Newcombe (1870–1955) was the son of Dr. C.F. Newcombe, a distinguished surgeon, psychiatrist, and scientist who settled in Victoria in 1889. Dr. Newcombe became a noted authority on BC Indian culture and an avid collector of native material. "Willie" shared his father's scientific interests and his deep respect for native art and life. He became, from the 1920s on, a devoted friend and tireless helper of Carr. The Indian materials collected by both father and son are preserved in the BCARS, Newcombe Collection. In 1942 Willie was appointed by Carr to the Emily Carr Trust.
3 Charles S. Band (1885–1969), a prominent Toronto businessman, was an early patron of Carr. He was a member of the executive of the AGT from 1926 (serving later as president, 1945–8, and 1965, and as honorary vice-president, 1949–50 and 1953–64).
4 Apparently during a recent stay in Victoria Cheney had approached Carr about painting her portrait. Carr noted a Cheney visit in [Ruth Humphrey], "Letters from Emily Carr," *University of Toronto Quarterly*, 41 (Winter 1972):113, 22 Aug. [1937].

22 [*Carr to Cheney*]

316 Beckley-in-bed
Monday

[postmarked 30 Sept. 1937]

Dear Nan.

Here's my abed correspondence day almost over & not a letter writ-ten—reading writing & sewing. Was so pleased to get your letter & hear about show etc Edythe wrote too & both of you thought entirely different so I guess the show was of mixed quality. Edythe seems rather discouraged over her work lately. I am sory—she gets a lot of interr[u]ption with social duties seems to me Universities all all that scramble after fun & entertaining more than study. professors & wives have to entertain a bit people have to have a good time, everyone is afraid to sit and think. I wonder if Old Lismer speechified really last time I heard him it was rot and he does 'lounge' so and pose.[1] he did not come this way of course. I would like to have seen your portraits[2] Edith [Edythe] said they were good, I wonder who got the medal?

I had a letter from Lawren a few days agoe. Bess was going to visit her people in Toronto they seem settled in U.S. for good—and he is very keen on his 'abstractions'

Thanks for cuttings. I've quit caring I used to be so horribly ashamed, now I can shrug & forget about them next moment I think. they are disgusting—but I'm not agitating myself by protest—send it if you want to. By the way I hear one of my things was reproduced in Studio.[3] I don't know why or what. perhaps one that is mine. no longer.

We had [?] a horrid murder out this way the other night a poor helpless old cripple must have been a maniac. *I even I* went to a show taxi'd & sat out Good Earth. I wanted to see it & was much dissa-p[oi]nted. Thought it very cheap and utterly unoriental, none of the dignity of the book, coarsely americane with hugh foot & hand bouncers. I think the characters were abominbly cast. Did you see it? and the new born babe, three years if it was a day with a bellow like a bull, & the famine stricken youngsters with balloon cheeks, first thing

49

I've seen for weeks, & last I think.

When are you coming over? Nothing exciting has happened. I've been painting & writing.

Hope your arm gets stronger all the time.

Affec. yours

M.e.

NOTES
1 See BCARS, Inglis Collection, "Arthur Lismer crit of some of sketches," undated sheet [1933], for likely source of Carr's change of attitude towards Lismer. Lismer's comments had been forwarded to Carr by Bess Housser (later Harris). See BCARS, Inglis Collection, Housser to Carr, 18 June 1933. The notes state that Lismer had questioned their large size and why the brush had been used in such an accidental way. Obviously Carr resented his comments (although Lismer had said that he admired the sketches for the "big feeling").
2 Cheney had shown two oil "portraits" ("Miss Mary Lawson, MBE" and "Bobsy") at the recent BCAE.
3 Carr's "Heina" [*Heina, Q.C.I.*] was reproduced in *The Studio*, a widely read English art periodical, in 114 (July-Dec. 1937):69. It is in the NGC collection.

23 [*Carr to Cheney*]
[*Letter addressed to 1282 Connaught Drive, Vancouver, to where the Cheneys had recently moved*]

Wednesday
[postmarked 10 Nov. 1937]
[card]

Dear Nan

Will be del[i]ghted to see you Bring canvass for me to me[1] Sitt is my long suit these days
 Hope to see you soon

Emily.

NOTES
1 Cheney was going to Victoria to paint Carr's portrait.

24 [*Carr to Cheney*]

[postmarked 30 Nov. 1937]

Dear Nan

Day in bed no clean paper available so I'll begin on scraps. It's a Heavens day but if I did not sleep till 20 to 10 A.M. was up late 11 o' last night, am aweful these days for sleep. This week I *must* stir & work. Glad to get yours I did enjoy having you so much. I am shure you must be starched with humble pride that the "Snoots" elected you to their society.[1] Had a letter from Edythe she liked the portrait very much.[2]—thought like me background spoiled it a bit A mug is excitement enough without a lively background. I always feel unless background & mug are one, bound by sympathetic lines I think the sharp lines of picture frames cut & separated [separate?] (Shut up old Carr you don't know portrait painting) did you say that or me? Edythe thought you got a good likeness and were sincere in your approach she is still down about her own work. I could kick Fred. I feel he is at the bottom of her oppression these "know it alls" critics make me sick. Day after you left I started my big canvas & then took to bed for Monday & spent a tired grousy week. have 3 canvases on the go always work two or three at a time. as I dry out between each painting, seldom work more than two *consecutive* days on a one. I don't finish a peice at a time I work all over together. I have seen artists that finished parts as they went, every one has their own way, of work. Have not written anything Mind a blank pavement of cement at present

Old. Sedgewick mute.[3] no M.S. no letter. wrote him 10 days agoe.

Have not done much blue light painting. I am going to get a reflector that will fix over the top of the canvas. the reading lamp glistens the paint.

No news my way I look forward to Edythes visit. In two weeks lucky woman me, to have you and Edythe. Ma Hembroff. rather resents my exhistence & I spose the "Little Hussy" (Helen)[4] will be along she always deadens me somehow. nothing fizzes when She's round. She's not a bad youngster Edythe is very fond of her, but I do find her uninteresting.

I will rise about 5 P.M. and trundle out to vote. only have to go to corner of my street, opp the little store & I can walk that far, so no excuse to shirk duty. Reading. Bread & Wine by Ignazio Silone.[5]

Glad 'Inky'[6] ate you. It is jolly to get such a welcome as a pup can give.

Had a visit Thursday from Mr and Mrs Lamont.[7] He met you at 'Doctors Show'[8] (said you were nice). She is an artist studdied in Toronto. has a pair of Twins—1 boy 1 girl 18 months old (boy very ugly) but all there they live out Mount Douglas are very much occupy with the infants he (husband) much older than she. very adoring. She has a whole book full of sketches of the babes quite nice. She knows several of Toronto artists. she is quite young.

Xmas coming along. I plan going to town Teusday to shop before the big shopping rush. Write to me again.

Lots love aff yrs

M.e.

NOTES
1 Cheney was proposed for membership in the BCSFA at a meeting of the Society of 17 Nov. 1937. See Vancouver City Archives [VCA], Records of the British Columbia Society of Artists [BCSA]. (The BCSFA, which was incorporated in 1909, became the BCSA in 1949.) (Until 1960 Cheney participated fairly regularly in the Society's exhibitions, and in 1956 she was awarded a life membership. See UBCL, Cheney Papers, box 5, file 1b, John Koerner to Cheney 31 Oct. 1956.)

2 A reference to Cheney's portrait of Carr. See #23, note 1. Carr wrote to Edythe Brand (now Hembroff-Schleicher): "I agree I dont like my background & told her so. of course Nan had that frightfully exacting work (medical) that would tend to tighten her work." See BCARS, Hembroff-Schleicher Papers, 28 Nov. [1937].

3 Dr. Garnett G. Sedgewick (1882–1949) was Head of the Department of English at UBC, 1920–48 (having served as Acting Head from 1918 to 1920). In the previous June, Carr had sent Dr. Sedgewick twenty of her stories at the instigation of Dr. Ruth Humphrey, Victoria College. Carr names the titles in *H&T*, 24 June 1937.

4 Helen Hembroff (later Hembroff-Ruch), was a younger sister of Edythe and one of the several persons of whom Carr spoke abusively, evidently without cause. See Hembroff-Schleicher, *Emily Carr*, 16.

5 Ignazio Silone, pseud., *Bread and Wine*, trans. from the Italian (New York and London: Harper & Brothers 1937).

6 Cheney's spaniel.

7 Gwen Lamont (d.1979) was a Victoria painter.

8 Possibly a reference to an art exhibition held in conjunction with the annual meeting of the Canadian Medical Association held in Victoria 22–6 June 1936, when Cheney was visiting that city.

25 [*Carr to Cheney*]

316 Beckley
[Christmas Card]
[1937]

MERRY MERRY
Happy happy

Dear Nan

Are you too buisy darning up your socks to write a fellow? Thank you for the book am enjoying it & will get Edythe to bring it back when she goes back after Xmas. It was so nice seeing her. The breif visit gives me a chance to remember all the things I had forgotten to ask her so can collect for Xmas holidays. Fairly good these days finished the house of all-sorts & disgusted with it have put it away for further maturing.[1] all the Xmas kick-up keeps even old hags like me buisy.

done some painting since you left Poor Joseph[2] has to be satisfied with a *green* widdow. There are no single blue ladies & none wishing divorces. marriage will be solemnized next week new residence about ready for occupancy.

Got my stories back from Sedgewick[3] per Edythe. Louise's sister expected today Louise—vague & irresponsible for time being. Hope all goes well with you Edythe says your house is lovely Mrs. Boultby [Boultbee][4] wants us to go over in holidays have doubts. had more pain. so going safe. think probably I'll wait till spring.

This doodad is for your milk jug 'Keep Out' meany fly. or your hot toddy or iced drink by the bed every bede is a good wish when the Xmas stuff is over I'm going to work like a black. whitened over 12 [?] small canvases today in preparation Evonne [Yvonne] wrote me a nice letter about the Toronto group show.[5] she thinks it is losing its Canadian feel there was a reproduction of one of Lawrens abstracts did not appeal to me but was a poor print. He wrote me a splendid long letter in answear to my whys?[6] Be good. if you can & anyhow be happy.

Emily

NOTES

1 *The House of All Sorts* was eventually published in 1944. See #7, note 4.

2 Carr's blue budgerigar.

3 Dr. Sedgewick was favourable in his comments and stressed that they should be published. See *H&T*, 21 Dec. 1937.

4 Una Boultbee (Mrs. Frank W.), a Vancouver resident, was the daughter of Carr's older sister Clara.

5 A reference to the exhibition of the CGP which was held at the AGT, 19 Nov.-19 Dec. 1937. Four paintings of Carr, a founding member, were shown (*Swirl, Lillooet Indian Village, Little Pine,* and *Old and New Forest*). See Hembroff-Schleicher, *Emily Carr*, 359, for Carr's comments concerning the works to be shown.

6 See BCARS, Inglis Collection, Harris to Carr, 15 Apr. 1937. Harris wrote, "you ask about our abstract endeavors" and included in his discussion: "I must say that I become more and more convinced that non-representational painting contains the possibility of expressing everything. It takes the expression away from the specific. . . ."

26 [*Carr to Cheney*]

316 Beckley St
Day after Xmas—bed—
[postmarked 27 Dec. 1937]

Dear Nan

You shall shurely be the first to get a letter out of my swell, writerette
Its gorgeous. I always loose my stamps Can never find my envelopes
& my paper all wrote over with stories. Not a story shall be writ on
my 'Air mail' stationary Thank you a thousand dear, even to the
stamp too. Well its over—we had a lovely one (all except the Dinner
out) that was an orgie. of awefulness. Friends of my sisters Two Miss
Williamses. One gonc blind, thats why she had to be humoured, & my
sister wanted to go. There was round about 20 feet of snow and then
all the slop pails of Heaven overturned & one did not know if they they
were fish or fool, flapping through the slush of it, taxis were at a
premium when we got there my voice couldnt be found never came
back all night. all I could do was mouthe like a goldfish. There were 4
old maids of us. one bouncy batchelor & a giddy young nephew &
neice. The cranberry sauce dish was stick all over the outside silver &
glass affair. (ultra curved) & I got stick all over my fingers & had to
secretly lick them all evening like a cat. Well it got over ultimately.
and A & I taxid through slush to the hubs and a kind young driver
shovelled A. into her door with a flash light & then me into mine. &
thank God. there wont be another such for 12 months. I simply *won't*
go there again for Xmas dinner. Our own A's and mine was fine.
Louise made a good fist of it. Xmas eve, and we had a little tree after
& it was nice & peaceful. people were *tremendously* kind. I was won-
derfully remembered so was A. tired today. Louises Sunday out so
I've kept in bed & been lazy, just been up & fed the pups & come back
to bed with a boul of bread & milk my generel supper when Louise is

out its easy & I like it Hope your Xmas was very nice indeed. glad
to hear you are coming over early in year. Have seen Edythe 2ce. Old
Ma rather resents her coming too much, and then too the 'Little
Hussey' will tag on—never did like Helen gives me pip & E. & I cant
chat so freely & the L.H. is so deadly uninteresting

Did I tell you I had 2 pair of chip monks & Mr Joseph is a dear. I
like that picture of you & inky very much its splendid and funny old
me—think you

Thank you for enquiries about Ex Montreal Such things are a
fearful nuisance, I know. Wonder if you are having this aweful dish of
weather? however thank goodness it is not freezing now. Will finish
when I get out & get your letter among my cards. I got such lots even
from Lady "Tweedtail."[1]

Want to get to work when Xmas is over have been writing &
painting off, & must try & get in. whitened down a lot of old ones
preparatory to having some fun.

Have to post this—snow again—and Louise going out will write
again soon & answear

Yours ever

M.e.

NOTES
1 Lady Tweedsmuir, an admirer of Carr's work, was the wife of John Buchan, 1st
Baron Tweedsmuir, governor-general of Canada (1935–40). The previous August
she had paid a visit to Carr's studio and had purchased a sketch. Carr wrote of the
arrival of "the vice-regal chariot" and the three-quarters of an hour visit. See
H&T, 3 Aug. 1937.

27 [*Carr to Cheney*]

316 Beckley St
Jan 2 [1938]

Dear Nan

Have been writing *all* day (story) so will put it aside now and scribble
to you for a bit Did I write you since Xmas. I've writ[?] & wrote[?]
& wrot[?] I think I 'wret' you on receipt of my "Air Mail". but I do
it all over again with thanks Its *marvelous* not to have to send Louise
all over the estate for a stamp. Yes *I did* write because I sent the first
out of it to you I remember but then came my jolly palette. It was
lovely of Dr Cheney to make & & lovely of you to send it. I set it *red
hot*. & am using it furiously. The other one was. beyond. any *respect-
able* citizen. Well Nan sanity is here again not that I spent a loud mad
Xmas. but you can't feel sane when when everyone is crazy.—can't
wrap your head in sackcloth & eat dirt, & you can't help enjoying
Xmas in between grunts Its so lovely hearing good wishes from
everyone. & getting letters from your hardy anual friends & old beaux
& new friends & everybody. Saw Edythe 3 times. she has gone & sawed
of[f] her plait, to please the craziness of Old Ma[1] & that little Helen
Hussy, and might be any of the fashion plate gang of flappers now. I
thought her long hair so ladylike & distinguished, & said it perhaps *too*
hard It really is not my buisness only I like people to have courage *to
be themselves* & not bulled by the will of sillies the Hembroffs are *no*
class to Edythe.
 "House of All sorts" is now rammed under the birdcage—a
disapointment & forgotten. All. wound up over something else now.
but its saucy and krinkled up like Nigger's hair. spose it will soon go
the way of the others—which is no way at all just sit. Am looking
forward to seeing you in the New Year Goodness 2 days flown
already. I do beleive the days have been a little longer already. bulbs
are sprouting. isn't it glorious to contemplate spring but alas Louise
goes home when spring comes. I try to say "There [are] as good fish
in the sea as ever came out of it" but Louise is a good little fish. I have
just finished 'Kathleen [Katherine] Mansfield'.[2] I was some charmed
and some disapointed. I did not know much about her life before.
rather tragic—rather selfish—poor girl. How difficult home life is to

such always a fight between themselves & themselves. Once I read a story about natives somewhere that impressed me terifficaly (I was quite young) every single soul from the time it could Toddle had a little mud kennel of *its very own* to live in. Men & women each had their own kennels. It struck me as a grand solution all my life I've seen that village of little low mud huts Think of youngsters 3 years old, having an establishment to sleep & sulk & play in none of this uncongenial bicker & slaps & snarls. no one always rushing at you with a hankie and saying 'blow'

Well my dear I'll take a "[illegible]" now. My write is wrote out. So let's get some 'wise' stuff over radio.

Much love. be a good girl. Suppose you are whirling in New Year Parties.

Yrs

M.e.

NOTES
1 Olive May Hembroff, Edythe's mother.
2 Possibly *The Life of Katherine Mansfield*, by John M. Murray and Ruth E. Mantz (London: Constable 1933).

28 [*Carr to Cheney*]

[postmarked 10 Jan 1938]

Dear Nan

Glad to get yours and felt reproached I had not looked up a Griffon photo. will do so right away Bed day today & besides *Starve* day. The 'Old fool' has now (at my own request) decided to try a bit of diet. I've been at him for ages & finally suggested I took nothing but fruit

juice the day I stay in bed which he thought a good plan. I'm sick of this fat round my middle & he agrees something *ought* to be done but will not let me cut down says I *need* what I am getting. he's a fool. Anyhow I'm hungry enough this minute to eat the bed. I feel the same about Edythe lately (her criticizing ability). I cant help but feel Fred has put the Kibosh on E's painting she did better & saw straighter when single at Xmas. I felt her criticisms were vapid. she dabbed at infitessimel things. & liked atrocities. As a rule she & Fred ask to see my things together she was alone this time & it seemed as if she had no support for her own conclusions & flopped, Those Marriedes make me sick. Max Maynard always refers to 'wife' in making his decisions & she knows nothing I feel E's work has gone off ever since she married & I think she knows it, & is worried. There used to be a man called 'Cherry' who sold moulding wholesale in Vancouver when I was there. it is so expensive [?] at the Art Shops. I have no idea where he hung out. I can't quite say why the "House of Allsorts" let me down perhaps I was tired a little after swatting on it so long I read it to Miss Clay.[1] & felt it flat. perhaps after some moons I may feel diffent or see things I can do to it. Am in the middle of the next quite different. another accumulation of little bits of scum. Am very interested but it is a difficult thing to connect up. & unify it wants to straddle too much. still I go on Poor old Sedgewick. too bad.

I have been *more* interested if you had come to Vic—I *wish* you had. well come shure soon you said early in New Year. I expected you previous to Feb. 4.

I am very sad Today. Tant & Vanathe two Griffons I gave to a friend in Van and who were supposed to hold up the glory of the tribe are both dead—distemper the woman is brokenhearted, she adored them. Do go to the Park Zoo & kiss 'Woo' for me. I would love to see her.

Hoping to see you soon

Yours

Emily C

Lawren wrote me an immense letter about abstrats & his work. all about abstract interesting—very—but I dont see it yet.[2]

NOTES

1 Margaret Clay (d.1982) was one of Carr's "listening ladies," a term used in Carr, *Growing Pains*, 363. Clay, who had known Carr since early childhood and had been a pupil in "Miss Alice's" school, was a director of the Victoria Public Library from 1924 to 1952 (having started as a clerk in 1913). She was active in the field of community art and was a keen supporter of Carr's painting and later her writing. Primarily through her efforts, Carr's *Vanquished* was included in the International Federation of Business and Professional Women's exhibition in the Stedelijk Museum, Amsterdam, in Sept. 1933. For information on Clay see G.E. Mortimore, "This Week's Profile," in *The Islander: Daily Colonist Magazine*, 14 Feb. 1954, pp. 1, 12. For Clay's reminiscences of Carr, see Clay, "Emily Carr as I Knew Her," *The Business and Professional Woman*, 26 (Nov.-Dec. 1959):7, 9. Clay wrote: "During the last fifteen years of her life it was my privilege to spend one evening in ten with her. Frequently, we had supper together. . . . We talked about many, many things—painting, writing, poetry, the forests, loyalty, animals, and Indians. . . . She quoted frequently from her favourite poet, Walt Whitman, especially the lines in 'Animals' from his 'Song of Myself.' " See also Elizabeth Forbes, "More About 'Miss Emily' from One Who Knew Her Well," *Victoria Daily Times*, 26 Oct. 1966, p. 9.

2 Carr later wrote to Jock Macdonald: "Lawren Harris is now deep in abstract form and has written me long letters on the subject wanting me to try it out but I have no desire to. . . . what is the good of inventing a new language if there is no one to talk to. Perhaps I may come to see things differently some day." Undated letter of Nov. 1938, possession of Dr. Joyce Zemans.

29 [*Carr to Cheney*]

316 Beckley
Tuesday
[postmarked 25 Jan 1938]

Dear Nan.

My heart suffered relapse when I got yours saying you contemplated backing out of coming down on 5th with Dr. Cheeny [Cheney] *don't you dare funk it*. I was all pepped for your visit, & shall look forward to it, consequences of default *may* be fatal. Oh goodness—buisy as the

Devil. not that I do much but my days are lopped of top & bottom & I'm so slow—a little painting a little writing a little reading a few letters & the day is gone, & I'm making a rug too. You better name my portrait—'Mug of a Lazy Woman'

I agree Edythe makes a mistake working without model. Am sory for her about art. I beleive her love is for, what people call *"The Artistic"* setting not for Art itself she likes Art life, 'studio, para-phanalie' Art jargon, & is willing to work *hard* for that purpose she is the kind that works well *with* a master I suppose she must keep up with Fred's U.B.C. ructions. I[t] seems to me University people waste their strength so on 'doings' they have no vitality left for work & come bump. Fun yes—but they labour to be social & in it. Oh well every one is not a poke like me. & every one is not aged like me I must remember that when I mix with you little frogs.

Mr Vanderpant is a nice man, & I beleve hes nice. I was shure I sent off the griff picture at once & am glad you found it. I thght that better than my photos which were small. Will be pleased to meet Dr Ethelyn Trapp.[1] My dear Nan you are going to be pedistelled on learning. Arts & letters. Greek. I'll have to grovel round your base in wriggling humility. but *do* come over all the same this weekend. I'm very flat. but pretty fair as to health. voice behaving better.

Now I have to get this for post, then I shall retire to kitchen and 'rag mat' there really *is no room* for my frame in Studio. Reading 'Dear Theo', Van Gough's [Gogh's] 'letters to Theo' interesting but I got a bit mad he crawled on Theo's pocket & I don't wonder his people found him trying especially when he adopted a prostitute & two children. (& Theo supporting him) I can understand Theo get-ting riled. before that I read My Father Pau[l] Gauguin[2] I think he was a *beast*. I don't believe even Art can excuse such horridness. Goodby See you Saturday. (or I sulk)

Yours

M.e.

NOTES
1 Dr. Trapp was a distinguished radiologist who became a close friend of Cheney, and through Cheney of Emily Carr. (Dr. Trapp later named her West Vancouver estate "Klee Wyck" in honour of the artist.) During the war years, in addition to conducting her private practice, Dr. Trapp was Acting Director of the BC Cancer Institute. Her niece, Mrs. Nell Lawson of Toronto, became one of Cheney's closest friends in Cheney's later years.
2 Pola Gauguin, *My Father Paul Gauguin*, trans. Arthur B. Chater (London: Cassell 1937).

30 [*Carr to Cheney*]

316 Beckley St
Wed. morn
[postmarked 16 Feb 1938]

Dear Nan.

I ought to be bombed—forgive—'press of bisness'. I got the letter—I got the books. I am one beast. Miss Burns[1] was coming last night to supper & I set myself to have the 'Chins up'' M.S.[2] ready for a pre-pre-view that is I wanted her to say if she thought the thing *could* be done. It is together but not consecutively has millions of revisings to do and *two* more entire typings. one when it is in shape for her to spell & punctuate. & then again the final clean copy: she likes it very much.

Well dear thank you for the letters & three books. I had read most of the Mansfield stories but long agoe.—goodness how Sparkling! makes one feel an earth worm The Garden Party!—what a peach— what a touch she had.—Here a visit from the Doctor says I'm bet-ter—so I asked what about not being quite to careful then, & he said '*more* so'. not to undo the good. He said last year it was doubtful if my heart *was going* to respond but now it is—don't over do & ———— so maybbe I'll be a high kicker yet.

I'm going to have *thousands* of Budgerigars! had. *4 cocks* wished on me—couldnt find a hen at all. but now heard of one—Willie is going

to build me a big cage on the front porch. won't it be lovely they are so pretty. & wont be noisy out there though my two are not a bit noisy in the house. hope others will not pollute their mannas. I *did* [underlined twice] enjoy you & Dr Trapp what a nice person. Yes the books came quite O.K. & I've been *rejoicing* in K.M. not got to 'lust'[3] yet—so buisy—Oh you young things how you frisk from party to party I can see it is impossible to be half in & half out. if you are in with a set. So you met Mortimer[4]—queer old fish. I think I made him sore.—you see, he wanted me to cut both ends of a picture's price. buy for a pittance & pay in dribs: so the [that?] he could make a spludge presentation of the thing to Vancouver gallery. & I refused. I never heard from him since—he's a bit of a bluffer & a duffer too. cries poor & acts rich. a rather silly old man in fact—with a great "blow" like a whale.

I got *4* [underlined 5 times] valentines. That for a sport!!!! but take it from me Nones more comforting that [than?] a black Inkey dog adoring My! what a joy the beasts are—My little brown angels. life would be dank hideous without creatures. G.bye. dont worry over your show It will be *grand* I'm shure of it tip top. You have "entheuse" these gikes are all so 'flat.'—patronizing empty-heads—no stability or stick.

Thanks—love—luck

M.e.

NOTES
1 Flora Hamilton Burns (d.1981) has written that following the death of her mother (1924), who had been Carr's long-time friend, she became close with Emily Carr and for many years was the only person who knew that Emily was writing. "She asked me to be her critic," she wrote, "and read or sent me her manuscripts for criticism, and in the beginning for typing, before she taught herself to type." See Burns, "Emily Carr," 222; and #6, note 1. Among Burns' other writings on Carr is "Emily Carr and the Newcombe Collection," in *The Beaver*, 293 (Summer 1962):27–35, reprinted in *The World of Emily Carr* (1962).
2 "Chins Up" was published posthumously as *Pause: A Sketchbook* (Toronto: Clarke, Irwin 1953) and dealt with Carr's confinement in the East Anglia Sanito-

rium, from Jan. 1903 to Mar. 1904. See Tippett, *Emily Carr*, 56–61
3 A reference to *Lust for Life*, Irving Stone's biography of Vincent Van Gogh (New
York: Doubleday 1937).
4 Harold Mortimer Lamb, who had settled in Vancouver in the early 1920s, was a
mining engineer, a photographer, and, as an art critic, an early champion of the
more 'progressive' in Canadian art. He first saw Carr's painting in 1921 and wrote
to Eric Brown of the "highly meritorious quality of her work." NGC, Archives 7.1
Carr, E., 24 Oct. 1921. See also Lamb, "A British Columbia Painter," *Saturday
Night* (Toronto), 48 (21 Jan. 1933), p. 3.

31 [*Carr to Cheney*]

Monday on an empty *stomach*
[postmarked 1 Mar 1938]

Dear Nan

Just a scratch. I'm so tired—been correcting M.S. trying to get 'chins
up' ready for its last revising slaved on it hard lately want to get it off
my chest before it is really spring.

Expect you are buisy as a hive of bees for your Ex.[1]—luck to it—
Gwen Lamonte [Lamont] has just had an ex in Van Gallery[2] had I
known she was going to I would have asked you to go she was very
pleased with the way they ran things. I hear Parker[3] is to have a show
too. It is quite exciting. so many one manners. My aviary is finished
looks so nice, but now! birds to fill it!! paint still wet.

No painting lately.—finished my white rugs—almost—and sold
them before last is off the frame. Do you know people by the name
Porteous—Montreal girl cripple in wheel chair? terrible blights—
been twice—coming again & I was *never nastier* I swear. they came six
strong & I hated them

When you get over your Ex. you will have to come down &
recoup.—if only Fordham Solley [Solly][4] would operate Aunt M. so
you could be lazy lazy as the devil—with *this* devil

I read 'lust for Life' It is most interesting, but what a man!

genii—but aweful too—I don't beleive all of it (his living for 4 days on coffee etc) & *working* through it & such parts as that. He was *disgustingly* sexy. & extremely dirty in his person & living places but his work glorious but by George how he sucked poor Theo, dry, my sympathies went out to Theo. I must say—poor Vincent was a victim of genius it rode him like a sort of agony. he craved to earn money for his work (for Teo's sake more than his own) that money craving & his various love affairs those revolted me, my goodness how he worked though. I'd love to see an exhibition of his work. This is a slovenly scrap—Louise goes tomorrow have another engaged—time will tell. respects to 'Inky' love to yourself & luck.

M.E.

NOTES

1 Cheney's solo exhibition at the VAG was held 26 Mar.-10 Apr. 1938 and included fifty-three works. See "Clever Portraiture Marks Exhibit at Art Gallery," *Vancouver News Herald*, 28 Mar. 1938, p. 2.

2 Gwen Lamont showed twenty-seven works at the VAG, 22 Feb.-9 Mar. See AGB [VAG], 5, Feb. 1938.

3 J. Delisle Parker's exhibition of landscapes was scheduled for 8-20 Mar. 1938. See *AGB* [VAG], 5 (Mar. 1938). Parker (1884-1964), recently moved to Vancouver from Victoria, became art critic for the *Vancouver Daily Province* in 1940, publishing a weekly column under the by-line "Palette."

4 L.F. Solly was a well-known poultry expert, farming at Westholme (near Duncan). As a small boy in the 1890s he had attended Emily Carr's art classes in the barn studio on the old Carr property. See BCARS, Inglis Collection, Carr to Dilworth, n.d. [Jan.-Apr. 1942].

32 [*Carr to Cheney*]

Monday
[postmarked 15 Mar 1938]

Dear Nan

Per usual I write among the pillows. On the 'moult' last two or more weeks, & spent much time in bed—pain—but getting a bit better slowly. So glad to get yours your & Edythes letters are a great pleasure. Bet your buisy—Bet your show will be fine—You are lucky to have a husband to help you travel cart & help out that is always so wearisome. to me. What did you think of De Lisle Parkers show?— such a name and such a sloppy flop man.—I had such a long cheery letter from Edythe so hope she is feeling more like herself. I hert to think of her down or greiving for she is a sweet little soul naturally— She is so fond of the Art life & atmosphere—has something & not something else—the most vital thing. I shall send you[r] books back soon have enjoyed them so much. This week I had a library beast. unconvincing & sloppy short stories. so I went to Walt Whitman I never tire of him.[1] Song of the rolling Earth. Song of Myself—Open road—etc. Sons of Adam don't appeel so I leave them alone. tho' I think I see why he had to include them and perhaps for the same reason it was necessary for Van Gough [Gogh] to collect sex experiences, perhaps it was really their work made them like that or rather they did it to develop expression in work to develop their whole selves so they could work more wholly & completely with every faculty

Here interuptions. Willie Newcombe came with the log for the Aviary & I *would* get up & help him place it. so scared birds would get out but all went fine. they like to nest in rotten trees & this is a woodpeckers old nest. wont it be fun. The last I got (one hen & the cocks) is a good breeder they say so I hope she'll get buisy am very thrilled. It is such a cold beastly wet day the poor dears are not pleased. well, while I paraded round the porch, dressing gowned in my 'cheeney portrait robe'.[2] a fool man from Lethbridge rings up to know if he & wife can come this morn—so they did (not thrilling) & now I am abed again—a nice fire in my room & cozy. Thought spring was here & theres this [?] bitter slop again. I know McDonald [Macdonald][3] a little never met wife—liked him, & would like to see his work. Gwen Lamonte's [Lamont's] work is slight still she has

entheusiasm & *works* Unfortunately she has a desire to do me since she knows I posed for you. It is so difficult to get models her husband also is 'taking up' portrature. (belongs to Arts & Crafts I am again). I *liked* sitting for you[4] did not mind Edythe[5]—not so struck on the Lamonts but dont see how I can say no. They've been very decent to me, when I feel better maybe My new girl gets on finely. I fin[i]shed that set of white rugs & sold them they looked pretty nice. Whats your date at gallery?? be shure & tell me all about it Edythe said you were having a big private view tea what a chore but still it is probably a good idea. 'Chins up' still has heaps to do I read it to Miss Burns the other night—she liked it very much, & thought I had improved. Its all together and in sequence (the sketches) will still need. 2 more typings. such a pest. that part but it is created. & F. [Flora Burns] thinks holds together well I *dont think* it is dismel tho, it is all about sickness & death, I tried to introduce a note of fun. people getting the best they could out of the flat restricted life. The warp of San rules. across which the folks slipped like shuttles and a stout fabric woven. Love—respects to Ink.—

Yours

M.e.

NOTES

1 See #6, note 1.

2 In the typescript of this letter, Cheney has noted: "the robe I painted her portrait in, made from a blanket." UBCL, Cheney Papers, box 1, file 8.

3 J.W.G. (Jock) Macdonald (1897–1960) was a key figure in the BC art scene as both teacher and painter during his twenty years on the west coast (1926–46). He was currently teaching (Jan. 1938 to June 1939) at Templeton Junior High School, earlier having taught at the VSDAA (1926–33) and at the progressive but short-lived British Columbia College of Art [BCCA] (1933–5). Macdonald, a close friend of Cheney and an ardent admirer of Carr, was a pioneer among Canadian abstractionists with his "modalities." See Joyce Zemans, *Jock Macdonald: The Inner Landscape* (Toronto: AGO 1981), and C.M. Nicholson and R.J. Francis, "J.W.G. Macdonald, the Western Years: 1926–1946," a research project presented to the NGC by the Burnaby Art Gallery, Burnaby, BC, Mar. 1969 (typescript).

4 Carr had recorded the pleasure of both the Cheney visit and the sitting. *H&T*, 17 Nov. 1937. To Cheney it wasn't so easy: "She is so ill and it is difficult to get

her to sit long, but I like what I got & so does she." Cheney to Pepper, 13 Dec. 1937. Carr later expressed different feelings. See #68, note 1; and #231, note 3.
5 One of the portraits of Carr painted by Edythe Brand is shown in Hembroff-Schleicher, *Emily Carr*, frontispiece.

33 [*Carr to Cheney*]

Sunday
[27 March 1938]

Dear Nan

Oh my Oh me!!!!! Shurely a day of the devils own choice. expect you have it too, started fine. and burst upon us of a sudden sleet & wind like the artics. Well how went yesterday? I thought of you all evening & wondered, and hoped & was shure it was a big success. today I bet you are soft as a custard I hope people were desent and appreciative one gets so ⋛⋛ with the beasts. en mass. not the few real ones but the Jabbering jackasses. particularly the ones who ask you to *explain* etc. Poor old De Lisle Parker he is a long haired Jelly fish—childish—*Artistic* [underlined twice] wow! I['d] rather be called villain or sweet. One thing the old boy does *work* I think. I think he'd do any kind to please & any & every kind to sell. his stuff makes me sick. Edythe always stick[s] half up for him. tell me all about the party Did Mrs Boultbee go? poor soul she is dradfully. upset. I doubt if she goes anywhere. her only & beloved son has got a busted heart. 4th in family in 1 1/2 years. other two dead.—her husband, my sister, & Gard[1] & I pretty well crocked he is only a young chap. 3 or 4 months bed. a year from buisnes, & all fun & frolic cut off hard lines. I'm lots better this last week. quite sporty but I *did not go* out to tea parties. I was *invited* & the tea party guest of honor called on me later.

The aviary—oooch! I put 4 birds out, & a great wind came & swiped 2 out of life so I took the rest in. however yesterday I bought

some aviary birds & put them out as they were used to it & today another hurricane I'll be glad when March is gone. where bad Marches go. My new maid is doing nicely her sister got a *hard* place just after & I think she feels. herself luckey. 7 to cook for 2 kids to mind & very limited off time.

That vile housecleaning hangs above us & I *need* it. I am huvering between letting the studio ceiling go this year its *black* or applying to owner for Kalsomine & probably get my rent boosted as well as. all the aweful turn out. life is jam full of decisions & perplexities.

Well some of you should shurely be showing up round Easter I hope 'Auntie' is fired with the desire to see Fordham Solleys [Solly's] little chicks, but if she is not come any how & share yourself with us. I have not done one pill of painting in ages. but am going to soon. Willie say[s] I shall 'loose my touch' poor [?] old dear he is so queer about paint. thinks you churn it out from a grinder like pea nut butter I am ashamed to say, I feel more 'writey' than 'painty' these days, & it make[s] me feel 'bliterish.' I think if once I could make the 'woods' or 'outside' for a spell I['d] sit right side up again. funny once I was always made to feel a waster & blighter. when I dabbed in paint— family would say. can't you do this or that, youre' not *doing anything* meaning that I was only sitting painting or going out sketching. and now that its my recognized job, *I* feel, I *should* be painting not wasting my time. trying to scribble at my age. but writing does not require so much *physical* energy, & perhaps for my 'footle' less mental energy too. & I get dreadfully entheused. Supper in side would be good now so I'll quit. I must answear a nice Edythe letter as well as several others. I told Flora I was rising at dawn today to get through my correspondence. and here its 20 to 7 P.M. and this is my first letter. drafted a *small* story in bed this A.M. went to A's to dinner home 3 P.M. typed for 2 hours & then this letter I get lazier & lazier!! Had an old Artist from Seattle Helen Rhodes[2] teaches in Wash. University. (ought to retire) C.S. and says we don't get old. nor has she a goitre nor has she a broken hip. I gave her a long discourse on graceful retirement & making way for the younger set, which seems I'd do well

to copy it poor old girl she has got vapory it is not fair to let the poor old buzzards keep on & on. & they too are due a little sitting before they go hence—& a little thinking space. Well so long. a successful week. I wonder do you have to sit on your exhibit?

loads of love ink. included

from M.e.

NOTES
1 Gardiner was a son of Una Boultbee.
2 Helen Neilson Rhodes (1875–1938), painter, printmaker, and teacher, was with the Art Department of the University of Washington.

34 [*Carr to Cheney*]

[27(?) March 1938]
[undated]

Dear Nan

Opening up my envelop again. It was so good of you to write instanter. Did not get Edythe yet dont wonder you are done out but rejoice at the obvious success congrats I'm shure it was a delightful show wish I'd been there. Those write up infant fools are impossible straight & simple dont know one thing it really is hard artists have to sit under their vaporish twaddle. but one just has to ignore & forget it.[1] You're the only judge of your own work, judgment is more difficult than painting. I bet its the first *real*. show done decent there's been in the gallery by a private body. Now I suppose its on for a week or so and sold one too by George! If that little fool reporter bought one of Parkers it shows his taste & knowledge no more need be said

Well its Post time & I must re seal & send off by Flora so congratulation & now rest & be easy

M.e.

NOTES
1 Possibly a reference to "Cheney Paintings Gallery Feature," *Vancouver Daily Province*, 26 Mar. 1938, p. 6, which is really a favourable review although the writer does comment that Cheney's work "does not bite very deep."

35 [Cheney to Brown]

1282 Connaught Dr
Vancouver B.C.
March 29 1938

My dear Mr Brown

You asked me to let you know, now & then, how things were in the painting world out here. I am afraid I have not been very responsive as a year has elapsed. We are enjoying Vancouver very much—the beautiful weather & lovely surroundings & hospitable people. I have been to Victoria a number of times & of course have seen Emily Carr. & in Nov. I stayed 10 days & painted a portrait of her.[1] She is better but is not able to paint as much as she would like as she is only allowed up 3 to 4 hours a day. however she makes the most of that time & her last things are better than ever I think—She has been writing short stories which are simply grand & I hope will be published soon. She still has a great deal of *spirit* but is not nearly as *biting* as she used to be. She really has a very warm spot in her heart for you & the Gallery despite the nasty letters she has written you at times. She told me to tell you this & she does appreciate all you have done for her. I find her very good company & her little house is far more attractive than the old

studio. She has 2 dogs—2 chipmonks in a cage) and an aviary built on the veranda. Otherwise she is alone except for a little maid.

J.W.G Macdonald is the next most interesting person out here—he is teaching in a school[2] and has some private pupils, he is doing some lovely imaginative things called "Rain"—"Snow" "Spring" "Autumn"—"Open Sea", etc. but has not exhibited any of them yet. he & Beatrice Lennie the sculptor,[3] have a studio on the top of the Vancouver building. Mr. Macdonald is a charming man & liked by everybody & so is his wife. I have met Mr Scott several times but have not seen any of his work, but I understand he is a very good teacher. Mr Weston[4] had us down one night & showed us all his past & present work—he certainly has a style all his own. There are 3 young men who are doing wood cuts & coloured prints—Goranson, Fisher & Hughes—and they have done murals for one of the churches.[5] They look very promising but find it difficult to sell even their best prints for a few dollars each—I have met Mr Mortimer Lamb who has bought some Canadian paintings & who has a very fine portrait of himself by Varley.[6] Varley's influence is still strongly seen in all the young people's work. I have been roped into an "art study group" of women[7] who take a country at a time & write papers etc—This winter they are doing Greece which is all very well but I discovered that most of them know nothing of Canadian art & had never even heard of Emily Carr so they have asked me to give them a talk on current events in the art world. Could I have the latest National Gallery Catalogue? I get the N.Y. Times regularly & see "The Studio" at the gallery—otherwise there is a decided dirth of news out here. Is there a catalogue of the years important exhibitions & purchases & sort of who's who? Have you any new reproductions of Gallery purchases? I will enclose $1.00 to cover the catalogue & whatever else you can send for that ammount [sic]. I get the "Toronto Sat. night" & have all Mr McInnes reports[8] of shows in Toronto. In the East you certainly do not realize how cut off the west is—Those mountains seem to be the dividing line and it takes weeks to get art books or anything out of the ordinary. You will be pleased to know that the

Gallery here finally bought one of Emily Carr's pictures. It is an old one, 1912, but they consider it *very modern*.[9] Mr Grigsby the Sect. is doing his best to stimulate interest and each year the attendance is increasing—The show of childrens pictures was awfully good and the water colours sent out by you were grand. I will enclose a clipping of a show I have on at the moment—I have been working steadily all winter.

Have you any news of Mrs Newton? and how did the Southam portraits turn out?[10] I don't expect you to answer all this but perhaps Miss Ingol [Ingall][11] *will* and *tell me all the news*—I have another suggestion. Could the Gallery, or the O.S.A. or the R.C.A.[12] sent [sic] out a painter with a group of their own paintings—for instance Edwin Holgate—A.Y. Jackson—the Peppers etc. They could see the country & we *could see them* which would be a fine way I think for the people to really get in touch with what is being done & the people doing the work.

With kindest regards to Mrs Brown & Mr & Mrs McCurry from us both

Sincerely yours

Nan Cheney

NOTES

1 See #32, note 4. Cheney's portrait of Carr is in the collection of the NGC from the estate of J.F.B. Livesay, 1948.

2 Macdonald was teaching at Templeton Junior High School. See #32, note 3.

3 Lennie (1904–87), a Vancouver sculptor, had been a student (VSDAA), and later colleague (BCCA), of Macdonald. At 1938 she was teaching privately and sharing studio space with Macdonald at 736 Granville Street. For information on Lennie see Leita Richardson, *First Class: Four Graduates from the Vancouver School of Decorative and Applied Arts, 1929* (Vancouver: Women in Focus [Gallery] 1987).

4 William P. Weston (1879–1967), a landscape painter, was Art Master at the Provincial Normal School (Vancouver) from 1914 to 1946, and a teacher at twenty of the summer sessions in Victoria between 1917 and 1938. He was a charter member of the CGP and served as President of the BCSFA from 1931 to 1939. See Anthony Rogers, "W.P. Weston, Educator and Artist: The Development of British Ideas in the Art Curriculum of B.C. Public Schools," unpublished PH.D. thesis, UBC, 1987.

5 Paul Goranson (b.1911), Orville Fisher (b.1911) and E.J. Hughes (b.1913), a Vancouver mural group, were commissioned in 1934, through the efforts of the Reverend Andrew Roddan, to execute six panels for the First United Church, Vancouver.

6 F.H. Varley (1881–1969), an original member of the G of 7, was a major force as both painter and teacher during his ten-year stay on the west coast (1926–36). Like Macdonald, he had taught at the VSDAA (1926–33) and at the BCCA (1933–5). Carr had met Varley in Vancouver at the start of her 1927 eastern trip. See *H&T*, 10 Nov. 1927. Also see Christopher Varley, *F.H. Varley: A Centennial Exhibition* (Edmonton: Edmonton Art Gallery 1981). The portrait referred to in the Cheney letter is in the collection of the VAG.

7 It was called the Monday Art Study Group (and on occasion Monday Art Study Club). See #129.

8 C. Graham McInnes, a Toronto journalist and art critic, was currently publishing a column, "The World of Art," for *Saturday Night* (Toronto).

9 The VAG purchased Carr's *Totem Poles, Kitseukla*, 1912, in 1937.

10 Newton painted portraits of several members of the H.S. Southam family. H.S. Southam, publisher of the *Ottawa Citizen*, was chairman of the Board of Trustees of the NGC, 1929–48 (and 1952–3). His portrait by Newton (c.1938) was given by him to the NGC in 1939.

11 Gertrude L. Ingall was secretary to the Director of the NGC, and a friend of Cheney.

12 References to the National Gallery, the Ontario Society of Artists, and the Royal Canadian Academy.

36 [*Brown to Cheney*]

National Gallery of Canada . . .
April 7, 1938

Dear Nan Cheney

Thank you very much for your letter of March 29th with its enclosure[1] and interesting news. I have sent off to you a package of catalogues and other information which you may like to have and will find useful. I am so glad you are finding something going on artistically and it would be a wonderful thing for the Pacific Coast if the various elements could work together to build up an art movement that was not altogether dependent on eastern Canada. Perhaps you are the chosen person to help it.

I am glad Miss Carr is so well and comfortable and able to work. Her stories sound most exciting and I hope we shall see them before very long. Your portrait of Miss Carr from a reproduction looked good and I am glad you are having a show at the Art Gallery.

It is a pity the Pacific Coast is so far away. When passenger flying becomes cheap and possible it won't be so bad. I am glad to hear MacDonald [Macdonald] has a job and is well and working. We should like to see his recent work.

Give my love to Miss Carr when next you meet. She has all our admiration for being one of the most interesting and original artists Canada has ever produced. I only wish I had time to run out and see her. But instead I have to go the European way so often I can't go west. However, I live in hopes of a break in the routine some day.

We don't charge you for information about Canadian art, so I return the dollar and hope you will buy yourself something nice with it, another tube of flake white. Send us a good photograph of your Emily portrait. We would like to have it and would like to see the portrait itself sometime.

With best wishes and regards,

Yours sincerely,

Eric Brown
[signed]
Director.

Mrs. Nan Lawson Cheney,
1282 Connaught Road,
Vancouver, B.C.

NOTES
1 A note on the copy from the NGC states that the clipping "Clever Portraiture Marks Exhibition at Art Gallery" (a review of Cheney's show in the *Vancouver News Herald*, 28 Mar. 1938, p. 2) is enclosed.

37 [*Carr to Cheney*]

[postmarked 13 Apr 1938]
[postcard]

Are you still defunct after show. Aunt M. rang me. My sister ill. Stomach flue. been there every day. will be in bed all this week anyway. before that been housecleaning so being a slow poke had no time for letters am much better tho' & quite proud of doing so much. Love birds nesting furiously. weather nice write when you can.

M.e.

38 [*Carr to Cheney*]

Monday
[postmarked 20 Apr 1938]

Dear Nan

I felt wearines & disgust sticking out of your letter this A.M. cheer up not a bit of it. Your show *was a great success*. the first time anyone has given a desent exhibit & done things nicely. I consider it was a feat, to be proud of. as to selling end. Nobody sells. these days *especilly* in Victoria & west. Mr Band says there is nothing doing in East my stuff came home today[1] have not opened it up yet but Band. told me the three he took back he was *shure he could* sell. & here they are merily home again. don't get discouraged. shove on. You are helping Art along in Van. a lot.

Edyth[e] has been & gone paid me two visits 1st the 'little Hussey' was along & I am never free & easy to talk when she's there.

2nd visit a pestiferous Mother & daughter who Edythe despises came to pay one of their bragging visits & made us ill, (monied and vulgar) so we did not have a great deal of time to ourselves

My sister has been very ill. I sent you a card was up there a lot & *very* tired missed last weeks bed & starve and am having a real one today doing nothing no writing even we had an *aweful* Easter for weather yesterday poured *all* day Fri. & Sat too.

My belov'd Matilda is ill. violent Dihorea Pout also but not so bad. It is such an aweful thing to cope with. & always alarming too How nice of Brown to say that[2] I appreciated [?] it & thank you for telling me. I'd like well to see him. McCurrey [McCurry] I despise.[3] I am thinking many things these days but dont seem to get any forrader don't *want* to work housecleaning seemed exertion enough for next ten & last ten years My flowers are lovely had some such lovlies for Easter, & the Birds look delightfull in their cages. if it was only warm & dry enough to sit out with them, but time I spose, how comic the years rotations are with their seasons. nothing not a single thing standing still.

How nice it will be to see you in Mays middle. By the way. I meant to ask Edythe, this B.C. fine arts is not open to any except members is it?[4] I mean outsiders cannot send in without invitation or can they? I have received no notification & I understand Edythe to say they were not going to invite outsider tho' they or some one had mentioned me. we got on to something & I forgot to ask her I always get Van societes mixed & would hate to butt in by sending & find I was not elligible. when does it open? Was the R.C.A.[5] any good you did not say. Cheer'—hi'-ho'—to you Alice goes to Vancouver tomorrow so I'm 'widdow & orfin'. She is going to Mrs Boultbee.

Much love

Yours Emily.

NOTES

1 In Sept. 1937 Band had ordered three canvases to be sent to Toronto for possible sale. See *H&T*, 9 Sept. 1937.

2 Brown had written that Carr "has all our admiration for being one of the most interesting and original artists Canada has ever produced." See #36. Cheney had obviously passed on to Carr Brown's complementary remarks.

3 Carr's strong feelings against McCurry date back to 1928 when she was annoyed and frustrated over delays in receiving information and funds regarding sales of her pottery, rugs, and paintings. See NGC, Archives 7.1 Carr, E., Carr to McCurry, 9 May [1928]; and McCurry to Carr, 23 May 1928 for his justifiably firm reply.

4 Presumably Carr is referring to the annual exhibition of the BCSFA which was scheduled for 29 Apr.-15 May 1938. Carr's question is puzzling as she had shown in the BCSFA exhibition both in 1936 and 1937, and would be included again in the 1938 show. She had been a founding member of the BCSFA in 1908, but had resigned in 1912 when two of her paintings, out of ten submitted, were refused in the exhibition of that year. In 1929 she was again incensed with the Society. See Tippett, *Emily Carr*, 102, 190. Carr's life membership was confirmed in Dec. 1938. See #110, note 2.

5 The Royal Canadian Academy [RCA] exhibition was on view at the VAG, 13–27 Apr. 1938.

39 [*Carr to Cheney*]

[postmarked 5 May 1938]

Dear Nan

Feel like firing off to someone so will spill over onto you. My new maid is——can't cook or keep in a fire. We were to have an omlet & muffins for supper. *One hour late* she produced a very poor omlet & some *half raw* muffins poor youngster was *very* cockey about her abilities in applying too. Flora was a dandy cook. I told you I think how she "upped & quit" in five days notice. no reason whatever. but did not deny she had taken another place when I put it to her.—she had just got in the way so nicely, & I liked her little beast. They're all the same. There are millions looking for work and take places just to fill in till they can get big pay. & a *smart* place, I spose. One gets weary of them. This one *adores* the beasts thats something. So sory about

Inkey keep him *very quiet* after distemper. I've had them perk up &
want runs etc. & relapse after the excitement & exertion. They say it's
a cross between measels & typhoid. Gee havn't I nursed millions of
pups a vile desease. but they dont die of distemper it's the complica-
tions attack weakest spot lungs, kidneys brain. (convulsions) or
nerves. well I'm glad he's over. thought he'd been inoculated? but I
am sceptical of that. just been getting 4 vile letters off my chest.
McCurray [McCurry] Band Loan Society,[1] & a publisher. trying to
locate pictures & M.S. Lord! Canadians are *bad buisness*. Maybe other
nationals are as bad but the galleries & artists in East are *hopeless*
National Gal. in particular. so sloppy. be hanged if I will loan again.
unless its a straight loan When the[y] shift on from gallery to gallery
its hopeless. no one responsible. Thanks for clipping & catalogue that
would tickle old Weston he's such a conceted cock shure old boy. So
glad you like Edyth's [Edythe's]. Yes I know about Max he takes
one['s] ideas & then blazes them about *as his own*. he took to *buying* for
people. (just a little 5.00 thing) he'd ask for because in years gone by I
let him have one for 5 as he was a poor student (before he married) he
stuck it on his wall & copied it over & over in different ways & came
back for others for *friends* of his, which he'd have them pay for & copy
himself[?] by & bye I got wise, & said. I had no more. the last was he
asked me to *lend* him 6 or 8, for his school children to *see* I knew it
was for Maxey to copy & refused. & he was not pleased. he's a
crumpet—a conceited cribber. dear me my bad supper has had poor
results on my disposition evidently. So you wont be her[e] till 19th
Wow I look forward. It will be grand if you bring your car & perhaps.
you will take me to see the old Van. I am told one window is open &
its been 'Sacked' Where do you *give* your paper how aweful! Oh I
see (Greek ladies)[2] whew!

My sister is better she *refused* to see anyone in Van. felt too mean
but is picking up. I am invited to a garden meeting of the University
Women's Club, next Saturday rather dread it. never been to one of
their things since I was elected a member.[3] but they are coming &
going me. & I'd like to see the garden I really *am better* but these

bitter winds hit my chest. if I go out in them or if I forget & move hurriedly: gee I wish I was not a crock & a crank. The birds are delicious 3 nesting & I've made the lovliest run for the chipmonks they look so jolly on the veranda. if these filthy winds would abate so I could sit among my flocks & herds, more they are great fun. quite woodsey. I've been off everythings. & say every day "I shall paint" and don't Done *some* writing. bad [underlined five times] this girl buisness is *unsettling* & "pippy" I wish I was a chipmonk.

Stay as long as you can. Yes Edythe should have a good summer if Frederick is not *too* selfish. all men etc.

Washed the pups today & they look like Angels.

Thanks for addresses. too disheartened to send no where. I did. write Ryerson Press today have had M.S. 3 months. I hate 'em all.[4] Not worth stampage Of course you'll bring your painting giggs—in May.

Bye Bye Bye. don't throw ashes on your head after reading this. When those uncooked muffins have moved nearer to my boots. I'll likely buck up. Meantime I go to roost. How's Dr Trapp?

Aff. yrs.

Emily

NOTES
1 Likely a reference to the Picture Loan Society, a co-operative venture begun in Toronto in 1936. See #104, note 2. Although Band was not officially associated with the group, it appears he had given permission for some Carr paintings to be sold through the gallery operated by the Society. In 1939 Carr wrote to Brown: "They [Picture Loan Society] have 2 or 3 of my pictures selling on the instalment & I get neither money nor answears to letters. It was never by my consent my pictures went there in the first place. I refused. & then referred them to Mr. Band in whose care the pictures were." See NGC, Archives 7.1 Carr, E., 26 Mar. 1939.
2 A reference to Cheney's talk to the Monday Art Study Group.
3 Carr had been made an honorary member of the Victoria branch of the University Women's Club a year earlier. See *H&T*, 26 Apr. 1937, and "Varsity Women Honour Miss Carr," *Victoria Daily Times*, 17 Apr. 1937, p. 7.
4 For an account of earlier rejections see *H&T*, 1 Oct. and 10 Dec. 1934.

40 [*Carr to Cheney*]

Monday—bed—starve
[postmarked 9 May 1938]

Dear Nan

Thank you for the photos I think they are very good for being taken in
a room. What a nice thing you are. and I am looking forward to seeing
you soon—tremendously to have some one after my own heart to talk
to about work. & if you bring your car perhaps to go peeking into a
wood only I must help 'gas' her please. Given good weather *what fun*.
makes me tickle all over. Drat the Greeks—dont let them hold you up
ten minutes more than they must. I quail at the thought of my 'Talk'
under the scrutiny of the Greeks. Don't remember in the least what I
jawed & spluttered about probably feeble rot. & should probably
blush if faced with the same, & feel quite different about some things.
I don't care 'Emerson' says "we may say something. & say something
quite different a while later." (viz what you prattle in your cradle may
not be your final verdict. shouted just as they screw your coffin up)
((or is it *down*)) So glad Inky is better. so am I. *Went to* a meeting in a
garden by the University Woman's [Women's] Club, and enjoyed
same. (such ugly faced women) but thank the Lord *mild* & left one.
alone. There was a huge bed of clear yellow tulips. And two exquisite
flowring quince A female discourced on the constelations. She
looked so young you expected her to lisp "Twinkle twinkle" but she
was so learned about the Heave[n]ly bodies and so anxious to keep
down to our level that she took for our example a 'currant bun' "not"
she said "a bakers bun but Mother's kind. with a thick spread of
butter in the middle" The currants were stars but I can't remember
what the butter was. I was so exhausted by the stars & hot room that I
sneaked off onto the porch and tead in solitude attended by a nice girl,
and recuperated, away from the mob.

I gave my new girl notice—messy and incompetent but she begged so hard for another weeks, tryout & is improving. My canary hen died on me, but am consoling the widdower today with a successor. the poor thing had her basinette all ready too. We've had the most horrible, bitter, winds. lilacs in full bloom & too delicious, for mere words.

Well heres hoping to see you soon.—no word from Edythe—

Good luck to your speel in greek.

Emily

41 [*Cheney to Brown*]

Victoria, BC
May 18, 1938

My dear Mr Brown

Please forgive my bad manners for not acknowledging your letter and the parcel of books long before this, but I knew that I was coming over to Victoria soon and thought you might like some news of Miss Carr. She is very much better & quite her peppery self again— Yesterday I went out to find her in a very bad temper as she had just heard from Ryerson Press that they had lost her manuscripts in a recent move,[1] by the same mail a card saying a box of pictures, which had been in Vancouver were sent freight, & were on the wharf—so the sparks flew and we managed to get the pictures but the stories look hopeless from this distance—I have the car with me so have been taking her out to the park and to her caravan.[2] and she feels equal to going to the woods for new material. She has read me two stories "Salt water & the woman"[3] and "Chins up"—both are bits of her life

& cleverly written.

The B.C. Society of Fine Arts has just had a show in Vancouver—the best for sometime and Macdonald's four "Modalities" were the most interesting contribution,[4] altho of course not liked or understood by the public. I used the catalogues etc which you sent me to great advantage. thanks so much—Best wishes to Maude [Maud]—expect you are off to England soon. Kindest regards to Mr McCurry

Sincerely

Nan Cheney.

NOTES

1 Carr had sent the manuscripts earlier in the year. (The stories were later found. See #96).

2 A few days later Carr wrote of the visit: "Well I've had a week. Nan Cheney has been over from Van. with a squeaky rattley little car & I've been going places, enjoying it very much, but glad of a 'recoup day.'" See [Humphrey], "Letters from Emily Carr," 130–1 [postmarked 23 May 1938].

3 "Salt Water" was one of the stories included in Carr, *Klee Wyck* (Toronto: Clarke, Irwin 1941).

4 Macdonald's "Modalities" were included in the BCSFA show at the VAG, 29 Apr.-5 May 1938. He later wrote to McCurry: "My enthusiasm grows for expression in the semi-abstract—or my 'modalities'—which I find lifts me out of the earthliness, the material mire, of our civilization. . . ." NGC, Archives 7.1 Macdonald, J.W.G., Macdonald to McCurry, 2 Dec. 1939.

42 [*Carr to Cheney*]

Monday
[postmarked 30 May 1938]

Dear Nan

Bed day & I've been clearing up my writing basket have not touched it. since the night I read you my stories to you which was a disapoint-

ment as they evidently fell *very* flat with you one can always feel
response. when they read. a yarn to anyone that is the sole reason I
read them aloud I do not mean *praise* I mean response. whether or no
anyone gives a kick back. You know how you feel when you show your
pictures to some one dumb who looks over the canvas in to a mirror &
fixes their hat.

I have been real 'rag rug' level this week no inspiration. Made a
print dress made over a garment that shrunk to a necklet in the wash
fin[i]shed my rag rug. and made one sketch unpardonably Poor one. A.
and I went out to see the Mill stream cottage. but it is too ungetable.
too much land and no trees on it. lovely stream but not getatable by
'hearts' I could put in a month there but too difficult & rocky & hilly
for my locomotion & no furnture not even a cook stove & I could not
cart that out, for a month, so thats off. and the 'Badgies' are getting
so noisy in their nests that I'm on tip toes to see them come out.
Shirley & I are betting as to their numbers. Mrs Dove has at last
settled in the box next & so the bottomless stump 'yawns' & does not
excite Flavia at all.

Yours came this A.M. Glad crossing was good & Aunt M better is
it me that upsets her do you think. Shall I dround myself? Probably
she was tired after the trip. No I funked the cockstail. Had pain that
morning & did not feel equal to the *big* function so rang Mrs Spencer[1]
up she was very nice and I am to go & see the work later. Another
thing that put me off was the reporter (Bullock Webster girl)[2] ringing
up & asking me if I would write *her* criticism. No No! dirty job.

Had a fool & fooless yesterday. people from Seattle Man & Mother
rather dredful woman always been big handicap to the young man
Made a fool of him the old girl "poets" too. He does not know much
but smatters in all forms, from soap carving to murals, and every
species of pot boiling.

How aweful about the gallery. what class are the strikers. work
men?[3] I do not envy Grigsby. Van is getting hot better come to Vic.

We have threatened rain two days & I wish it would Cold winds
continue and I find *walking* more impossible than ever then, sets up

pain, in chest. The country was lovely yesterday. up & down country. I rang Mrs Godfrey[4] up to ask when the Telegraph Bay cottage[5] would be empty & she said she find out & let me know but has not. as yet no offers for the Old Van[6]

Shirley in town. and Pout Matilda Joseph & Hitler all on my bed.

Been enjoying K. Mansfield's book very much. 3 P.M. and my appetite working to ravenous not an orange in the house till Shirley returns had better quit before the sharp edge of my appetite cuts this babble short.

I enjoyed having you so much, & you were very good lugging me round I feel better for 'seeing' things again.

love from all of us brute beasts together.

Emily

Edythes Address
330 Panorama Way
Berkeley

Muffins

1 cup bran
1 " corn meal
2 cups flour
salt, fat.
Milk or water soda

NOTES
1 Lilian Spencer was the wife of J.W. (Will) Spencer, son of David Spencer, founder of David Spencer Ltd. (now Eaton's), and mother of Myfanwy. See #44, note 1. "The big function" was a cocktail party given by Mrs. Spencer in connection with an exhibition of her daughter's work. Carr wrote: "Listen! I even! myself! am invited to a cocktail party—put that in your pipe. I expect my sister's ghost to rise at any moment." See [Humphrey] "Letters from Emily Carr," 131 [postmarked 23 May 1938].

2 Barbara H. Bullock-Webster was a reporter for *Daily Colonist*, Victoria.
3 On 20 May 1938, 250 unemployed men occupied the main floor of the VAG in protest. (Between 1200 and 1600 men altogether moved into the VAG, the Post Office, and the Hotel Georgia.) The Gallery was eventually cleared by police (with the aid of tear gas bombs) on 19 June. See "Editorial," *AGB* [VAG], 5 (June 1938).
4 Janet Godfrey was the wife of James T. Godfrey, who operated the Seaview Dairy.
5 Carr was anxious to rent a cottage on the Godfrey farm property in the Telegraph Bay area.
6 Carr's van was sold a short time later. It had not been used since Sept. 1936. See #44.

43 [*Carr to Cheney*]

Monday
[postmarked 6 June 1938]

Dear Nan.

Sory you find my Monday letters dull & depressed because I don't feel that way I rather enjoy them. snoozing reading a little knitting writing and I get up for bath & listen to my radio families while bed cools off. Its *piping hot* today but my cottage is lovely & cool. & talk of cottages I *am* going to my Cadboro Bay. Telegraph Bay place I rang up Mrs Godfrey & asked her to find out how long that man was staying. & she said 3 or 4 months *but* the other. (our friend who gave us direction) was going at end of June so I've taken her for July without seeing but Mrs Godfrey says she thinks it the nicer of the two and that Mr Godfrey will take me to see it one day so I snapped it before anyone else and am thrilled. Shirley[1] wanted to go out & see it yesterday but the busses do not run Sunday so she could not she is thrilled too. I wish my sister would come out for the month but she won't however she says she'll come for a *few days* so I'll take a bed for her and it will be easy if she wants to come odd days to visit its is such a short way from the buss. Whoop! I'm quite excited I'll have to

make bird arrangements but there are several avenues open I think they are much less work in aviaries & the little ones will be on their feet by then they are beginning to peep out the holes such darlings!! Shirley and I are always mounted on stools peeping in. don't know how many yet but are *shure* of 4 blues one green & one yellow. you see they hatch out one after another & the birds laey only every other day so it takes 10 days or so to lay a nest full. its great fun & joy such surprised round eyes. goggling out of the holes, at the enormity of the world, & sinking like jack in boxes when anyone goes near

Yes we knew about poor Una[2] isnt it just too bad poor soul. but you gave us more detail. her sister wrote just upper leg broken I am distressed to hear its hip that is so much worse And she was so looking forward to going to England in August I wonder how long she will be laid up, and Gard[i]ner laid up too. well there you are things happen surprise like and not always pleasant.

Poor Grigsby's being puushed [punished?] O.K. it must be aweful & how terribly uncomfortable for the men you'd think their bones would ache on the floors and what about clean underwear? Some one told me the City were behind the men and feeding them & think the Gov. should fulfill their work promises. Well you cant call this a dull letter is it? Went sketching 5 days last week beautiful & quiet in among a riot of new greenery in the McDonald [Macdonald] park across the corner. Also re-making clothes *turned* a tweed coat for sketching as I had nothing but my one good one & I'm a dirty painter

lots of love

M.e.

NOTES
1 Shirley Duggan (later Bennett) was working for Carr. See Shadbolt, *The Art of Emily Carr*, 218, regarding Carr's portrait studies of Shirley.
2 Una Boultbee. See #25, note 4.

44 [*Carr to Cheney*]

Sunday.
[postmarked 20 June 1938]

Dear Nan.

Won't wait to write on Monday because of your complaints of my Monday writings in bed.

Well yesterday Shirley & I bounced in the worst motor I have ever boarded. out to see the Telegraph Bay cottage. Mr Godfrey was the owner of the vehicle. & you felt indecent staring at all its internals, without one stitch of hide or padding you saw every screw bolt. Spring & snort. peices of the top kept busting & flapping at us. every one just tucked them into the nearest crevace & went on talking we went all round by the sea, a fine ride, snorting & Bellowing up the hills & bits flapping and springs without a pinch of stuffing probing into your vitals. but we got there. & the Godfrey's were most kind & considerate. The cottage is quite different to the other very rural—I wish it was a little further removed from the cow barn but the cows only go in to be milked this weather. The cottage has three rooms. big kitchen-parlor, & two bed rooms is furnished all but pots pans & bedding has a back yard and. private toilet. a water tap of its own & the rooms are bigger windowed it has a meat safe and a huge Maple Tree to shade under. I expected to have to take out furnture but it will be much easier so & Heaven grant the beds are sleepable & the Godfrey's are taking all my belongings in their milk truck & are very kindly. My Sister expects to come out part of the time & maybbe Nan Cheeney [Cheney], might like to come out for a little while? but I will see first how comfortable it is before putting the question, & how the beds are, & if there are cowey smells. There's a bull but he's tied in the barn.

Alice's maid is going to look after the Budgies I expect by then

(1st of July) all the youngsters will be out in the big back yard house. They are so big you can scarcely tell them from Pa's & Ma's they stay in their holes till almost grown & then burst forth into adulthood. They are perfectly facinating I sit wasting time with my nose on the wire. greens & blues in all shades. Yellow, grey & white.

Its miserably *cold* I have a big *coal fire*. threatens all the while but does not rain. & we need it so badly. Have been writing Edyth[e] & can't find her address. send it along. I am so stupid always forgetting to put them in my book

I have sold the van $15.00 sold it to owner of the house I went to Mill stream to see that will pay the rent of the cottage for the month

Una Boultbee has gone home has to be in bed still but getting on O.K. her nurse wrote she cant yet.

Went to see Myfanwy's portraits.[1] She came and got me. was quite impressed with the young girl. & think her work good *very good* considering she has only studied *8* months. & I liked the freshe entheusiasm of the girl. She is fully aware of the advantages she posesses *doting* parents (only child) money & sympathy & she is in earnest I *think* It will probably be harder for her than for one who had more to combat. Takes more self control to man[a]ge herself, with everything thrown at her for the taking. I'm not a portrait critic as you know. but I think the youngster can go far if she will. She originaly wanted music but her wrist went wrong & I think she really wants expression. They are out at their country place. her father has built her a separate studio in the garden out there. & in town she has a studio fitted [?] up in Spencer's store building. small but good light she says. I liked the youngster, & hope to see more of her when she comes back to town.

Have been going to the McD. [Macd.] Park most mornings for an hour & done a few sketches it is quiet & lovely out there. but Summer is now parching things after the long drought. Hope you are not hurling your strikers over onto us. please keep them. How is poor Mr Grigsby bearing up is the gallery still closed? I hear the P.O. reeks & is vile with men rolling round on the floor.

Write soon & tell me the latest

Yrs

Emily

PS This is mixed as to numbering of sheets look for the page numbers.
They are not in sequence.

M.C.

NOTES

1 Myfanwy Spencer, now Pavelic (b.1916), well-known Sydney portraitist, became
a close friend (and correspondent) of Carr in Carr's later years. In a telephone
conversation in Sept. 1988, Mrs. Pavelic stated that in the early 1930s Carr had
arranged an informal exhibition of thirteen of her portraits in a location
(unknown) in downtown Victoria. For details of her friendship with Carr see
Andrew Scott, "Emily Carr," *Arts West*, 4 (Nov.-Dec. 1979), 28–9. See also
Myfanwy Spencer Pavelic RCA: A Selection of Works 1950–1970 (exhibition catalogue)
(Burnaby, BC: Burnaby Art Gallery 1978). Three days after her letter to Cheney,
Carr wrote to Myfanwy's mother: "I think it is amazing the ground she has
covered in the comparatively short time she has been studying. . . . I think she will
go far for she is young yet. I think her work is good—*very good*." Carr to Lilian
Spencer, 23 June 1938, letter with Pavelic.

45 [*Carr to Cheney*]

316 Beckley St.
June 23 [1938]

Dear Nan

I sick of trying to raise Aunt Mary She's either out, or line busy. Of
course my empty noodle has forgotten your birthday date 29th *I think*
but had a spasm yesterday as to wether it was 19th.[1] so I'll write
between dates to wish you all of the best going. May each year be
better & better till you 'ups' aloft. I wonder how you will celebrate.

and look here if you *should* dicide on a picture with any of your "gettings" a fiver comes off the price as *my own* greeting for birthday. but for goodness sake don't feel you *have* to get one it was only what you said made me think perhaps you'd like it that way instedd of a little potty trash. nothing.

Cold wind again tonight hope it is nice for July—fancy that spot will be fairly sheltered—am getting quite 'Theusy' about the event and laying in material bought a camp stool today I wanted a *strong light* [underlined three times] one & could only get a cheap weak one My own old one is too low for my present bulk. & I ran myself up a new sack my old one being beyond words dirty.

The bird babies are all out in the big aviary now & the mothers on a new sit. They wont be any bother now My sisters maid is doing them She lives close. to me we got 10 out of the 3 nests.

Have been sketching an hour in McDonald [Macdonald] park most mornings getting my hand in for I hope some serious work. Two people have *volunteered* visits out there hope I wont have many they tire one. for work & I *do* want to do some. sold a small picture in Ottawa, some time back I think, and another to a man over there. these sales were evidently made some time agoe & casually mentioned by McCurray [McCurry] so I wrote to investigate. really I think the art business over there is carried out shockingly casually. however I am thankful to sell. for my house. (my income rent) has all to be papered & painted, if I want to keep my tennants, & it will be a big expense. always something

I suppose they are *cleaning the gallery* how thankful they must [be] to get those brutes out. we have them here. now. They are like the grass hopper scourge.

Well am tired. so Many Happy returns of whenever it is and goodbye[1]

Love,

Emily.

Have sold the Van.

NOTES
1 Cheney was born on 22 June 1897.

46 [*Cheney to Brown or H.O. McCurry, Assistant Director, National Gallery of Canada, Ottawa*]

1282 Connaught Dr
Vancouver BC
July 10th 1938

Dear Mr Brown or Mr McCurry if Mr Brown is abroad!

You asked me to send you a photograph of Emily Carr's portrait so I had Vanderpant take one & I sent it off several weeks ago. I would like to send the canvas to one of the fall shows in the East but I do not know when or where they are held now as I have not had any notices for several years, also do you think it is worth sending as the expense from here has to be considered. I had a week in Victoria early in June & Emily was much better & keen to go to the woods for new material & we found a cottage at Telegraph Bay which she has taken for July—

Mr Macdonald is doing some very interesting things now which he calls "Modalities". They are most original & miles ahead of anything being done out here—The Gallery is having a hard time to keep going with the lack of funds & being closed for a month, when occupyed [sic] by the unemployed, did not help matters—We are having a beautiful summer—one perfect day after another & not a mosquito. With kindest regards to you all

Sincerely

Nan Cheney

47 [*Carr, Telegraph Bay, to Toms*]

[*Addressed to the Hotel Douglas, Victoria, where Toms was working as a clerk.*]

[Post Card]
Telegraph Bay—
[postmarked 11 July 1938]

Here be I—working, its nice,—last house before the sea. Postal address c/o Godfreys milk farm.[1]

Emily C.

NOTES
1 See #49 for a discussion of this July expedition. See also NGC, Archives 7.1 Carr, E., Carr to Brown, 4 Sept. 1938, in which she describes the cow farm on the outskirts of Victoria: "There were woods a few yards from my cottage door and sea at a distance not exceeding my limited walking powers."

48 [*Carr to Cheney*]

[Telegraph Bay]
[postmarked 11 July 1938]
[postcard]

Love camp have quit letter writing for a spell (receiving only) working—quite hard—weather variable—cottage comfortable—cows soothing—health fair

Emily

49 [*Carr to Cheney*]

[Telegraph Bay]
Saturday
[postmarked 25 July 1938]

Dear Nan

Going to break my resolution of not writing letters out here. for two reasons. 1st yours this A.M. sounded riled, poor dear. I know how things like that can wear & harass. but soon now you will be free & then you will be glad you have been amiable & nice. and after all you *are loved* to *bursting* [underlined twice]—only *old* energy is trying to others of a younger generation—because, the energy has to be so petted & supported by care. its quite a load for the attendant[1]—2nd I'm abed from probably our walking yesterday. I did exceed myself & climb a hill. just *had* to look over the top.—only a rise over the low bottom land. but today I am useless & have pain. went out this A.M. & came home with as clean a sheet of paper as I went out with & tumbled into bed. Anyhow tomorrow is rest day. Out here I take *Sunday* so if fit I can get it over first, today.

I am enjoying the cottage *very much*, it is so airy, very quiet, & restful & the joy of again being in woods is tremendous. the weather has been mixed 1st 3 days some rain then some *overwhelming* heat followed by dense overcast of smoke from forest fires. today *feels* like rain I hope it does those poor roasted trees & people In spite, I've done quite a lot of work slashing away what I shall see *when* I open them out at home I quail to contemplate—They are taken straight from my board to a high shelf & never once looked at. *Can't* open up in front of maid for some reason. Silly I know to feel so at the mercy of their jeers. & really the girl is very good over my work. takes me out brings me back, & sits off waiting till I'm ready, without one peek. but in their unfinished state criticism has a *bad effect* on my work.

breaks up some half formed idea & leaves me stranded. Fred[2] came out twice & wanted to see but I refused. More particularly because old Ma Hembroff was along & its the '*don't* knows' who upset me more than the 'do's'. It may be some hang over from my youth, when family criticism was so scathing. I think I've got some good material, to work from. Mr Brown wrote me, he mentioned he had your portrait of me & liked it. Had a visit from Mr Weston.[3] in fact had quite a number of visitors, but they come afternoons & I work morning & night so they have not interfered with my sketching. It is very ladylike being "done for" in camp & superlative, to be led forth only carying *one* peice instead of laden like a pack mule Shirley is *good* in *these* things & loves camp we giggle & make continual joke. She has some bad blights but I think she is trying to overcome them, & I'm quite fond of the child She is alive & she loves the beasts.

The cows are another joy. I am shure I have far more in common with them than with the ordinary society lady.—flop tailed skulking old hussies at least their jaw-chewing is silent. & unmalicious. My sister comes out quite often & has really seemed to enjoy camp. her bed is made up & she climbs into it whenever she wants to stay. This cottage is much nicer than the other we have that glorious Maple. & a through draft from Front to back.—The other cottage has a babe with a strong yell, & keeps it up. I don't hob nob. but Shirley does—while bathing—the man, is revolting without his clothes. and only barely complies with the law. he catches cod in the evenings & sent me one but I fed it to the dogs. There are mosquitoes and my flesh. is as hilly as the rockies but I suppose one must have something and I love it all. We have one more week here.

Have only been outside the gate twice. went to Telegraph Bay once in in the opposite wood once the charm is to roam in our own enclosure with nothing worse than the Bull to meet. I offered Shirley $50. if she'd lipstick his jaws but she did not rise—she fears cows. Fred was very nice I enjoyed his visits—expect he's home again. E. write[s] cards while she is taking her course too.

Chip, Joseph & dogs superlatively happy Hope 'ink' the same—

cheer up all things end. Weston said your combination show was on.[4] How does it? I'll have to get fixed up for 'October' Gri[g]sby wrote that was when I was to be dated. for extinction[5] Mrs Boultbee is getting on well. still flat but home & weighted by leg.

Write soon.

Yours

M.E.

NOTES
1 Likely Mary Lawson, Cheney's aunt, was visiting with her in Vancouver.
2 Likely Fred Brand. See #12, note 10.
3 W.P. Weston was in Victoria teaching at the Provincial Summer School of Education.
4 Cheney was included in the "Six Local Artists Exhibition" at the VAG, 12–27 July 1938.
5 See VAG, Archives, Grigsby to Carr, 7 July 1938. (The Carr exhibition was to be held at the VAG, 12–23 Oct. 1938.)

50 [*Cheney to Brown*]

1282 Connught Dr
Vancouver BC
July 20th 1938

Dear Mr Brown

Thank you for your letter of the 14th & the addresses[1]—Hill is making a crate for Emily & I will send her off to you in a few days. Macdonald was in yesterday and suggested my lightening the background a little, which I did, & I think it is greatly improved—he is sending "Pilgrimage" & "Drying herring roe" off to the jury for the Tait [Tate] Gallery show[2]—I wonder how you will like them. He is planning to go to Garibaldi in Aug. & wants me to go, & I hope I can

manage it.[3] A party of naturalists & fisherman [sic] go in every year for two weeks & live in tents. Take a good cook etc so it sounds ideal for painting & is only $35.00 for 2 weeks—including transportation both ways, a boat, a train & a pack horse. This country has barely been touched & Macdonald is keen to go north or to the West coast of the island again—for two years—his health is much improved & if he could only get someone to finance him to the extent of $60.00 to $75.00 a month he would be off at once. I am sure he would repay a backer as he has a keen sense of responsibility—he finds teaching an awful grind & only does it in order to live which leaves him Sat. & Sun. only to paint. There should be some sort of fund or scholarship for such people or another Dr McCallum[4] in the background—

I am so glad you have heard from Emily & I hope she is getting some good material. The weather has been wonderful except for the forest fires which are making the skies rather thick. The Gallery here is having a show of hers in October. They want me to go over & pick them out & be the go-between—a very tricky job　however, so far, I have been able to get along with her & it is easier to manage personally than by correspondence. The Gallery is starting something new here for the B.C. show in Sept. They are selling $.25 tickets with numbers & the first 10 winners will have a chance to pick a picture up to $50.00—5 at $35 & 9 at $25.00, so you see that will distribute 24 pictures round the province & give the artists a chance to make a little money—it will also indicate the public taste, which is usually terrible. The Montreal school is certainly lucky to get three such good people[5]—What is Lillias [Lilias] doing now—She never writes—With kindest regards to the McCurry's and Maude [Maud].

Sincerely yours

Nan Cheney

NOTES

1 Cheney wanted to obtain entry forms for eastern exhibitions in the hope that

her portrait of Carr might be shown.

2 "A Century of Canadian Art" was scheduled for the Tate Gallery, London, 15 Oct.-15 Dec. 1938.

3 Cheney went in a group which included (in addition to Macdonald), Jessie Faunt, Sheila Boyd, and a number of people from the Alpine Club who organized the trip. See Nicholson and Francis, "J.W.G. Macdonald," 13. Macdonald wrote to Brown that "the camp was very art conscious and quite as vital as the mountaineer department." He continued: "I am quite sure Mrs. Cheney had an experience which will be stimulating for her for some months to come. She found it fairly strenuous country but she is full of plenty of fight and ventured into 'come what might,' with joy." NGC, Archives 7.1 Macdonald, J.W.G., 7 Sept. 1938.

4 Dr. James MacCallum, a Toronto opthamologist, was a friend and patron of members of the G of 7.

5 Brown had told Cheney that "Mrs Newton, Mr Holgate and Will Ogilvie from Toronto will have the Montreal Art Association School next season." UBCL, Cheney Papers, box 5, file 1b, Brown to Cheney, 14 July 1938.

51 [*Brown to Cheney*]

National Gallery of Canada . . .
August 12, 1938

Dear Mrs. Cheney,

I have been so busy with this Tate Gallery show I have not had time to write and say how very much we have enjoyed seeing your portrait of "Emily".[1] I have had it in my office and looked at it many times. Pegi Nicol (Mrs. McLeod) saw it and was delighted and said she would write to you immediately about it. My wife also saw it and, knowing Emily, thought it was excellent. It certainly marks a great advance in your work and I am sure will be greatly appreciated in any show it goes to. I only wish it could have been included in this Tate Gallery show but unfortunately I cannot alter the list of artists to put it in.

What I would like to do is to recommend it to the Trustees for acquisition after it has been exhibited at some show or other, if it is not too expensive. Perhaps you would send McCurry a note regarding the valuation and as to the show you would like to send it to. If A.Y.J.

saw it he would, I think, invite it to the Group show but you might prefer the R.C.A. in November. If you can do portraits as good as this, why not do others. Vancouver surely needs a portrait painter.

I am leaving next week for London and shall be back in October.[2] I liked MacDonald's [Macdonald's] "Herring Roe" picture and I am glad to hear he is doing other good ones. Remember me to Miss Carr when you see her next. I am glad she is out in the woods again and I hope she will carry on her work from where she left off.

I am,

Yours sincerely,

Eric Brown
[signed]
Director.

Mrs. Nan Lawson Cheney,
1282 Connaught Drive,
Vancouver, B.C.
EB:MW

NOTES

1 Macdonald later wrote to Brown that he was interested to learn from Cheney of Brown's reactions to the portrait, and continued: "I felt that it was quite her strongest portrait and a definite characterisation of her sitter." Macdonald then added: "Mrs. Cheney is probably the only portrait painter who has the particular type of personality necessary to hold the interest of Emily Carr long enough to obtain the necessary number of sittings." NGC, Archives 7.1 Macdonald, J.W.G., Macdonald to Brown, 7 Sept. 1938.

2 Brown was going to London in connection with the exhibition "A Century of Canadian Art." See #50, note 2.

52 [*Carr, Victoria, to Cheney*]

[*Letter addressed to Cheney, c/o G.T. Wallis, Garibaldi, B.C.*]

316 Beckley
Aug 14 [1938]

Dear Nan.

Was just about to send the sheriff to enquire if you were dead, mad, or lazy when along came your letter. Aunt M. does need—oh well not me to judge but: those 'giddy social girls' do give me pip. How lovely going to Garabaldi [Garibaldi]. you'll get some grand stuff I always wanted to see that place. but—I must be content to finish out in mild calm. rather than grandeur. Think anyhow I was born ordinary and little minded. I beleive the 'great grand' is above me. I'm down among roots. and I'm *tired* as the Devil trying to prepare for my show. in October. Miss Aurora [Annora] Brow[n]¹ did *n't* call. Mrs La Mont [Lamont] came to see me & said Miss Brown had been over to see her & enjoyed meeting you—they went to Art school together.

I got out all my Telegraph Bay sketches last Sunday & felt quite thrilled but——when I go to work on them they shrivel away & mediocrite. Wish you could come over after Garibaldi. if we could only do it without Aunt M. knowing so she wouldn't get greived & heurt.

A notice from Mr Brown saying they had selected 4 of my things for the Tate Gallery show. very liberal I call that to me.

one posessed by Vincent Massy [Massey]²
 " " " National Gallery
 " " " Mr Band
Sky, a paper sketch Nat. Gallery
I had forgotten about the Sept show in Van.³ till you mentioned it—will look up the notice. perhaps I *should* send something seeing they are putting me on a show later do you think so? Just fin[i]shing a story am looking forward so to seeing Miss Ruth Humphries [Humphrey].⁴ she will be home in Sept for the colledge. find her very in-spiring re-writing. she criticizes *hard* & well. Edythe is off to Mexico. She has got a lot out of her summer course & seems all bucked up. so glad &

hope she looks in to see Victoria. of course they'll have to house hunt—Fred was so nice when he was up this summer I enjoyed him. going to lunch at the Spencers tomorrow. wish things weren't such an effort—lazy I guess

Hope you have a grand Garabaldi [Garibaldi] trip.

Much love.

Emily.

NOTES

1 Annora Brown (1899–1987) was a painter and teacher (and later author) from Fort Macleod, Alberta. (She moved to Sidney, VI in 1965.) Although it is known she visited on Vancouver Island in the 1930s, her connection with Carr is not known.

2 Massey (1887–1967), an important early collector of Canadian art, was a Trustee of the NGC from 1925 to 1952 (serving as chairman from 1948). At the time of this letter he was Canadian High Commissioner to Great Britain (1935–46). (In 1952 he became Canada's first native-born governor-general.)

3 Carr showed three works at the BCAE held at the VAG from 16 Sept. to 9 Oct. 1938.

4 Dr. Humphrey (1898–1984) was an English professor at Victoria College 1936–45 (and with the Department of English, UBC, 1945–63). Carr and Dr. Humphrey first met in the spring of 1936 when the latter offered to "swamp some crits . . . for a sketch." She subsequently provided Carr with considerable editorial assistance, and as well brought Carr's manuscripts to the attention of Dr. Sedgewick in 1937 and to Ira Dilworth in 1939. See *H&T*, 20 Apr. 1936, 22 May 1937, and Tippett, *Emily Carr*, 251. Carr and Dr. Humphrey corresponded during the latter's extensive travels abroad, and the forty-four letters written by Carr between 1937 and 1944 were published in [Humphrey], "Letters from Emily Carr," 93–150. Humphrey published "Emily Carr: An Appreciation," in *Queen's Quarterly*, 65 (Summer 1958):270–6.

53 [Cheney to McCurry]

1282 Connught Dr.
Vancouver BC
Aug 28th 1938

Dear Mr McCurry,

Mr Brown asked me to send you a note as to the valuation of my portrait of Emily Carr, as he said he would like to recommend it to the Trustees after it has been exhibited this Fall—my price is $500.00, but I do not want to jeopardize its chance of being a[c]quired by the Gallery, so leave it to you to suggest a price, if you think this is too much. I made two trips of 10 days each, to Victoria to paint it & as you know Emily is difficult in many ways & the sittings were short & anything but "posed". however I feel I got *her* & she thought so too. I am awfully pleased that you all like it & only regret that it could not go to the Tate Gallery show. Is the R.C.A. in Montreal or Toronto this fall?[1] I would like to show "Emily" in both places so do whatever with her you think best. I am sorry to be such a bother but it seems so hard to arrange such things at this distance. Mr Brown suggested that I paint others & I hope to get some of my friends & perhaps J.W.G. Macdonald to sit for me—but apparently it is impossible to get a commission out here unless you have "studied abroad" etc. Many thanks for your encouragement,—With kindest regards to your wife—

Sincerely

Nan Cheney

When are you coming West again?

NOTES
1 The RCA exhibition was to be held at the AGT from 18 Nov. to 18 Dec. 1938. (Cheney's portrait was not shown. See #61.)

54 [*Excerpt Toms, Victoria, to Nan Cheney*]
[*The excerpts from the 33 Toms to Cheney letters are from a typescript,*

"Letters to Nan Lawson Cheney from Humphrey Toms," Collection of Jane Toms, Victoria, B.C. Humphrey Toms had met Nan Cheney in the spring of 1938 at Carr's Beckley Avenue house. This is the first of the excerpts preserved from their correspondence.]¹

31 Aug. 1938

I have seen very little of Emily lately though I went to visit her twice at her little shack at Telegraph Bay.² She hasn't honoured me with a showing of her sketches yet, but told me she did over thirty. Her whole outlook and health seems to have improved after the little expedition. It must have meant a lot to her to get out again after two years.

NOTES

1 See Toms, "Letters to Nan Lawson Cheney from Humphrey Toms," typescript, Aug. 1979, 1 (property of Jane Toms, Victoria), in which Toms records the following: "Nan, who always hoarded letters, kept all mine. About 1954 when I casually remarked that I might try to write some sort of a war diary of my own experiences, she handed the whole lot over to me. In due course I lost interest in the project but in Jan. 1956 I made extracts from them for all mentions of Emily and then, with Nan's consent, destroyed them all." He added: "The 1956 version was typed in a hurry, and very badly. In the present copy I have corrected my own few spelling lapses—I was a far better speller than either Emily or Nan!"
2 See #47, and Hembroff-Schleicher, *Emily Carr*, 136–7.

55 [*Carr to Cheney*]

Monday
[postmarked 13 Sept 1938]

Dear Nan

When not too buisy have been too tired to write. Had to get my work off for Vancouver (went today) also had a most strenuous friend in

Victoria from Winnipeg[1] who regularly pulped me—big talker—long sitter—strong voice—accompanied by son 21. and sons girl (violinist) They *were* going every day and are still here I've been in bed all day cross enough to bite, but improving It *quite* decides me tho' I was *just about quite before*. that I'd be foolish & hideously unpleasant if I did go to Vancouver thanks just same for invite. My neices asked me too. don't know how they got wind of it (show). *I did not* tell them. I was showing. I think. Your own shows are *frightfully harrowing* It is *good* for you to see your stuff *hung*. but meeting the onlookers—horrors!! You'll have to tell me about it I am getting on fairly well painting frames & mounting etc Willie is a swine not been near for week & weeks dont know why for. & I won't ask. he can stay away. Humphrey is very pleased at your invite[2] Have heard nothing of Edythe last card was from Mexico & undated. I don't agree with you about Myfanwy's Portraits. considering her age & the time she has studied I think them quite remarkable I know at her age I could not do anything *20 miles* if as good The men in the places where she studied, sent for Mrs Spencer & were entheustic over her as a student said she was exceptional. If she goes. clear sailing on I think she'll go far because I think her work is sincere, and she has ever so long ahead of her, to go on perfecting. & money to do it on too. one could not expect *any one* that young to be a portrait mature painter.

Jack Shadbolt was over to see me he has improved some (in himself) has no work. Of course he is very opinionated & is, swaddled in Art history & Art appreciation I would be interested to see what practice he can put it into. These boys have big talk, & little do so often. he was quite caustic & a little patronizing over my feeble efforts.—maybbe right—

It is awfully good of you to offer to come over & help pack. but I shall get through somehow & I expect Willie *will* help when time comes. am shure he will. I'll do a little each day. Isn't the weather fine? If you'll keep an eye the other end Vancouver for me I'll be so glad. Have they room for me & watercolor show together? People tire me far more than work and my voice quits so I'm best home. Are you

showing Garabaldi [Garibaldi] sketches?[3]

Aff yrs

Emily

NOTES
1 Likely Kate Mather (with son Dick). Mather had known Carr since 1924 when, for three winters, she rented a flat at Carr's Simcoe Street house. They became close friends and later corresponded. See interview with Kate Mather [c. 1957], Imbert-Orchard, CBC Collection, BCARS (tape and typescript). See also Mather to Carr correspondence in BCARS, Parnall Collection.
2 In his typescript, "Letters to Nan," 1, Toms recorded that in September "Nan and Hill" had invited him to Vancouver to be their house guest and to attend "the (then) very formal opening of the 7th Annual BC Artists Exhibition."
3 Cheney exhibited four works, three of which were Garibaldi scenes, at the BCAE held at the VAG from 16 Sept. to 9 Oct. 1938.

56 [*Toms to Cheney*]
[*Excerpt Toms to Cheney. Toms had spent the previous weekend with the Cheneys in Vancouver.*]

20 Sep. 1938

I have not had time to see Emily yet, as yesterday was her rest day but I've written her a note giving an idea of what we did.

57 [*Cheney to Toms*]
[*The 37 Cheney to Toms letters are in the UBCL, Special Collections Division, Cheney Papers, box 5, file 1. This is the first of Cheney's letters to Toms.*]

1282 Connaught Dr
Vancouver BC
Oct 1st 1938

Dear Humphrey

Thanks so much for the Candid Camera snaps. It's awfully funny I think—You look so proper & respectable, which of course you are, & I look as if I was an old fish wife laying down the law to Jock, who is decidely weak in the knees[1]—We had a good laugh at it today as I lunched with Jock & Bea Lennie at the French cafe—on sausages, very good indeed. Jock got his copy too.

Expect you realize by now that you did not draw a picture, but alas! I did, a $25. one & there is nothing in the show at that price that I want except a not bad water colour by Scott, which I was forced to decide on as I could not raise the extra to get one of Emily's—by the way is Emily mad at me? No word for ages & the last rather a tirade. I wrote to her yesterday & the chances are she is worn out getting her show together—Jock & I are going to hang her show but we cannot control the press, so heaven knows what that nit-wit will say—

We are hoping that Alex Jackson will come here before going East—I had a letter from N.W.T. & he is stopping at Lethbridge so I wrote at once—he has been in correspondence with Macdonald for years but they have never met—The Nat. Gal. have written for the "modalities"—but Jock is not sending them yet. Regards to your mother—we did enjoy having you—

Nan

NOTES
1 The photo Cheney is referring to was one of Toms, Macdonald, and herself taken on Granville Street in Vancouver on 17 Sept. 1938 by "Kandid Kamera Snaps." Copy with Jane Toms, Victoria.

58 [*Excerpt Toms to Cheney*]

2 Oct. 1938

I am sending you under separate cover part of the local "Times" with a death mask of Max[1] which I thought might amuse you. Somebody from the National Gallery, I think, had written to Emily to ask her to see this Smith lad[2] and see what he was like as evidently he had heard he had promise. I don't think that she was very impressed by him.[3]

NOTES

1 An article in the *Victoria Daily Times: Magazine Section*, 1 Oct. 1938, p. 1, is headed: "Death Masks for the Living by Local Boy Are Startling New Art," and describes how Charles Smith, a twenty-year-old Victorian, is a master in the technique of making plaster of Paris masks. A photograph of Maynard's mask is included.

2 Charles Smith. See note 1 above.

3 Carr wrote to Brown that Smith had brought some work to show her but she felt it did not seem "*particularly* strong or interesting." His " 'life work' " she judged as "average fairly serious student work," but acknowledged that he had "quite a gift for portraiture." NGC, Archives 7.1 Carr E., 30 June 1938.

59 [*Carr to Cheney*]

Tuesday eve
[postmarked 4 Oct 1938]

Dear Nan

Heaven be praised, the stuff is crated!!! (7 crates) Willie took from 9:30 A.M. to 5:30 P.M. me helping & *so* tired when he left I tumbled into bed had a boul of milk toast & slept like an infant. Thank you for the clipping forget what it was about & have (lost the letter was too tired forgive me.) How nice of you & Mr McDonald [Macdonald] to be going to hang my show.[1] I have tried to send it all in good shape hooks wires & etc. The mounted sketches I dare not put eyes in as they would have ripped & dented each other but they are in a little paper bag tacked to the sketches will you be good enough at end to

see if they are taken out again before packed, as they would do damage in the crate.

I got your other letter just before the last and wonder you *could* ask. *if* I owed you (letter not money.) *You did*. Now the stuff is off (or packed) I can live again it has laid on me like a toppled mountain

It was so nice to see Edythe. I had such a lovely visit from her Saturday thought she looked thin. Ruth is home. I feel as if I'd been travelling myself. a friend from Paris a freind from Mexico & a friend from Africa.[2] All in a couple of weeks. Three cheers you drawing a prize & good for Scott, that you took him.

Humphrey was delighted with his visit—"liked himself & was glad he went"

I wonder will old, Alex Jackson go your way? he'll sit on you if he does I suppose? or rather your door step I mean

Hope you won't be dissap[oin]ted in my show tell me the nasty as well as the any nice things said. You have all been so good with your invites to come over thanks for those too.

Am really too tired to write a letter, head like the bag of a vacuum, full of dust. Tell me what the other show (same time as mine) is like.[3]

ever so much love & don't *hate* me for all the bother I am causing you over show

as ever.

Emily

NOTES
1 Carr's first solo at the VAG was held from 12 to 23 Oct. 1938. See #17, note 1. Hembroff-Schleicher, *Emily Carr*, 310, notes that she worked with Cheney and Macdonald in the hanging of Carr's show, but credits "Nan" as "the one who got the show rolling."
2 Carr is referring to Jack Shadbolt, Edythe Brand, and Ruth Humphrey respectively. See Carr to Edythe, "Saturday, September 1938," cited in Hembroff-Schleicher, *M.E.*, 111.
3 An exhibition of drawings by Margaret Carter (b.1911) and George Goutière (1903–48), two newcomers to Vancouver, was also scheduled for 12–23 Oct. See *AGB* [VAG], 6 (Oct. 1938).

60 [*Carr to Cheney*]

[postmarked 11 Oct 1938]
Teusday—no less,
and me feeling 'Mondayish'—
maybe missing my lay low
because I Thanks gave erect.
having Alice & child to dinner

Dear Nan.

Thank you for your note. Good gracious you seem to think I'm
worried—not in the least. no sir once out of my sight and Mr Grigs-
by's word that they will be sent home express & I'm quite easy & glad
to be rid of them. It is very good of you and McDonald [Macdonald].
How do you yourself feel about the stuff I've sent over. dont you like
my little white frames?

No I guess I won't be over Nan tho thanks a thousand. and I was
going to stay with you if you'd have me and looking forward to doing
so. The show opens tomorrow and will I think be only on for *one week*
end. but Alice says she can't come *that* week end. I guess perhaps its
best as, moneys a bit tight and all just now. My frames etc cost $20.00
I do not expect there will be any sales. this money-root-of-all-evil
buisness isn't it a curse? Unless I make an occasional sale I really have
very little to live on. and my sister's school[1] very small & her expenses
heavy when she quits teaching it will be harder still. she is a bad one
on economy too. is far *too* generous. has a mania for giving, more than
she is able. Poor dear her eyes hurt her a lot these days. she can't
concentrate her sight on anything without suffering.

We had a wet, Thanksgive: today is better lots of fog lately. I am
making new paint aprons—sorely needed. I looked like a dirty
pallette, then I cut them too narrow for my bulk & had to put in bow-
windows so they are none too lovely. but life's like that.

That old swine Dr Pierce[2] did not come to see me as he promised. but for the clipping you sent I would not know he'd been in Vict. so much for that— well, I don't beleive anyhow I shall ever get anything published. have quit even suspecting it. and when I reread I know why. they seem stupid and ignorant, and badly expressed & uninteresting.

Well I hope it won't be *too long* before you come once again. I'd like you before me eye. If it wasn't for the beasts these days. maybe I'd curl up in my comfie coffin got as much pep as a grub. but the birds & beasts are fine and a joy.

Love & lots of thanks

Emily.

NOTES
1 Alice Carr had been operating a kindergarten school in Victoria for most of the years since the early part of the century. See "Victoria's Gentle Schoolmistress, Miss Alice Carr Dies, Aged 84," *Vancouver Province*, 27 Oct. 1953, p. 19.
2 Lorne Pierce was editor of Ryerson Press. Carr had sent "6 stories & 20 Indian sketches" to Dr. Pierce in February. [Humphrey], "Letters from Emily Carr," 120, 6 Feb. 1938. She later wrote that it was "20 Indian sketches & 5 Short stories." Ibid., 131, postmarked 23 May 1938. See also #89.

61 [*Cheney to McCurry*]

1282 Connaught Dr
Vancouver B.C.
Oct 14th 1938

Dear Mr McCurry

Are you sending my "Emily Carr" portrait to the R.C.A.?[1]

I would like very much to show it in Toronto. Will you let me know at once as I have two small portraits I can send if you have other

plans for "Emily Carr."

I am enclosing a programme of Emily's exhibition which is on now & is simply *grand*. The best she has ever done & I think the only time it has been shown together—I wish someone from the East could see it as it should go to Montreal & Toronto as it stands—

The press notice is better than normal but does not half describe the immensity of these canvases. How can we get a catalogue of the Tate Gallery show? I hope there will be something about it in the Sat. night as there is never anything in the papers here—

With best regards to all

Sincerely

Nan Cheney

N O T E
1 The National Gallery shipped the portrait to Toronto for the RCA show, but it was not hung. See #53, note 1.

62 [*Cheney to Carr*]
[*The 3 Cheney to Carr letters are in the UBCL, Special Collections Division, Cheney Papers, box 7, file 14. Courtesy of Mr. and Mrs. J.E.A. Parnall. This letter is the earliest of the three extant Cheney to Carr letters.*]

[1282 Connaught Drive]
[Vancouver, B.C.]
Oct 15th 1938

My dear Emily

Do forgive that skimpy note. I was so, so sleepy after some hectic days. Your show is drawing a great many people despite a show at

Spencers[1] which was opened with great fanfare & the French Consul—They are a collection old dins Spencer bought in Paris & they are a typical old man's choice of quiet lakes & woodland scenes and very young, pink & white, *naked* nudes—really too awful & they built a special gallery for it & thousands have been streaming in. really too awful! however Mr Grigsby told me today that they have had a tremendous number in to see yours & were very pleased—The other shows are nothing to mention—very amateurish stuff except of course the Theatre Art designs which are very interesting if you are keen on such things—They take up the whole of downstairs & the water colour room. about 5 deep. really too exhausting to look at for long. We are having a man take some pictures of your show, he is an amatuer [sic] expert that Edythe knows as I thought you would like to see the way we arranged them I am going to my Art Study Group meeting on Mon. & am giving them a little talk on you[r] show & steer them down to the Gallery. Macdonald says all the teachers in his school have been down & he is going to write to you. he is so thrilled with your show that he could not sleep that night after seeing them. he was quite carried away—I hope you meet him soon as I know you would like him—

I had to send an air letter to McCurry to find out if he was sending my portrait of you, to the R.C.A. as he never answered my letter. he gives me a pain & I much prefere [sic] to deal with Eric Brown. No word from Jackson. I guess he is frozen in, in the far north.

One amusing thing happened about your show—a reporter phoned me & said that no 28—called "Deep forest" was hung upside down!![2] I just hooted at him but apparently the thing that gave him that idea was your signature which was upside down in the rt. hand top corner, but there was also another in the lower left corner—but rather dark. we had a good laugh over that! Well my dear I hope you are having a good rest after such a tremendous effort. If you can come for the weekend let me know & I will meet you with the car etc. & have the bed turned down—

much love

Nan

NOTES
1 An exhibition of "forty-six valuable modern French paintings" was opened at the Vancouver store of David Spencer Ltd. (now Eaton's) on 11 Oct. 1938. The paintings, which had been selected by Chris Spencer at the Paris Salon the previous summer, received enthusiastic praise from the French consul who opened the exhibition. See "Spencer's Art Display Opens," *Daily Province*, Vancouver, 12 Oct. 1938, p. 5.
2 See Alan Morley, "Art Becomes ART When an Expert Can't Decide Which Side Is Up," *Vancouver Sun*, 14 Oct. 1938, p. 2.

63 [*Carr to Cheney*]

Sunday
[postmarked 17 Oct 1938]

Dear Nan.

Thanks for cutting & short note. Between the lines I seem to read something as tho' perhaps you were a bit dissapo[in]ted in the Ex. is that right?[1] You said you'd write me all abot every thing Sayings & doings and after several days. I got this breif scrap. Edythe wrote before the show opened. but not since so had nothing to tell except that they were hung by you two which was good of you. & she thought they looked O.K. but I missed any sponteniaty or entheusiasm in your note which is usually so jolly about you. Maybe you were tired you said you were in fact. Well anyhow—thats that. as far as the perpetrator goes exhibitions are a frost I think—tho' they should be an inspiration that is if you can get first hand what people got when they come in contact with your thoughts. (Critics newspaper stuff we both know amounts to absolutely nothing)—((a pill done up in syrupy wrappings.))

My Sister has never once mentioned or asked anything since the work got off. violent interest eh? I hope McDonald [Macdonald] will write as you say he intended—Yes, I did have one cheery word. an old pupil of mine whose art runs to painting *lamp shades* wrote *before* the Ex. opened her letter was more about the Tate Gallery show, & was very genuine & warmed me. Don't guess she'd like or perhaps understand the show in Van. but at least she had sympathy towards the struggle. Of course my Van. neices & Great neices would not think of attending. Una could not anyhow. but I doubt am *certain* she would not have anyhow. I have 3 neices many greats in Vancouver Aunt Millie's painting has always been rather a hushed theme in the family. something not quite-quite—what *would* they have said had I done loud nudes.

I've been sewing all week. and am going to paint next, queer how we still *go on* luck there is so much rubber in human composition. These times seem so downing never know what next in Europe or Japan or Spain or Jerusalem Yesterday I went to see the film 'Marie Antoinette'. it made me feel really ill all the guillotting in the end was filthy—horrible lookings at for these times. How did you like Gwen Cashe's [Cash's] book?[2] I only know one person who has read it and she said she couldn't. (Miss Clay) but Gwen herself told me it was very successful so somebody must like it.

I was rather annoyed the other day did I tell you I had an answear from McCurrey [McCurry] to a personal letter I wrote Mr Brown. I can't see why he should answear letters even in Mr Brown's absence unless they were on buisness, connected with the gallery. do you?

I still sit carefully with a very sore back where I thudded down on my spine end in my back yard after the rain on slimey[?] planks. Now I must do up some other letters

Thank you so much for the labor you have gone to on my behalf. am shure it was an awful bore. Edythe does not seem well. said she'd been to the Dr. hope it is not serious? I thought her looking very thin but you said she came home looking fine. really sometimes I think strenuous holidays like Mexico are worse for one than staying home

Thank you for invite next week end. not now but maybe later on.

Yours

Emily

NOTES

1 Carr noted in her diary that "Nan" had lacked her usual "entheuse" and added: "Told me nothing about how people took the show ones fizz goes flat." BCARS, Parnall Collection, *Diary 1938*, entry for 15 Oct. 1938. (The diary was written in very occasionally.)

2 Cash, a public relations officer at the CPR's Empress Hotel, had published *I Like British Columbia* (Toronto: Macmillan 1938). As a Carr enthusiast she had written glowingly of Emily Carr in "Famous Women Get Together," *Vancouver Daily Province*, 18 Sept. 1937, p. 4, which described the meeting of Carr with Lady Floud, wife of the British High Commissioner to Canada. Cash occasionally took visiting dignitaries to Carr's studio.

64 [*Carr to Cheney. Included in the same envelope as #63*]

Monday
[postmarked 17 Oct 1938]

Dear Nan.

Mail just in so a scrap to enclose before I post what I wrote last night—no time to tear up & write a new one.

Of course I forgive your scrap. It did chill me, but todays warmed me up. entirely and the next letter I read (from Macdonald) nearly drowned me in tears. It was so genuine & understanding[1] I don't quite know when I shall stop crying I have to keep taking my glasses off. they're so splashed. Also a letter from Mary Coleman [Colman],[2] a little poetess full of genuine feeling & love (I used to know her long agoe) and an old pupil. who was *proud* of me Shurely that all is enough to puff one up. I don't care a hang about Spencers pretty pink

nakeds. and dinky brooklets.[3] I owe you & Edythe great gratitude all say how *beautifuly* you arranged the show—much better than I would. if I'd been there.—I'd have tossed them anyhow I shure.

I'm glad they've said some things to some people (the pictures) and thank you ever so.

Gratefully

Emily.

NOTES

1 Macdonald was obviously deeply moved by Carr's painting. On 15 Oct. 1938 he wrote to her that the exhibition had given him "the deepest pleasure" he had ever experienced in viewing a "one man show." And he added: "in your work I find the first conscious expression of the *rhythm of life* throughout all creation or the unity of life's rhythm—the cycle of infinity. You have so unhesitatingly expressed an inner feeling of life which has never been expressed consciously in paint, and because of this your work is of tremendous significance." BCARS, Parnall Collection. He also wrote a lengthy letter to McCurry praising and analysing her work, and concluding: "In my opinion she is undoubtedly the first artist in the country and a genius without question." NGC, Archives 7.1 Macdonald, J.W.G., 24 Oct. 1938.

2 As a child in the 1890s, Mary Elizabeth Colman had visited at the Carr house. She has related that "it was in the early 1920s that Emily Carr first showed me her writing and that we discussed the possibility of her doing a book about her experiences." Colman, "My Friend Emily Carr," *Vancouver Sun*, 12 Apr. 1952, p. 14. Blanchard, in *The Life of Emily Carr*, 165, comments on those who know of Carr's writing in the 1920s.

3 See #62, note 1.

65 [*Carr to Cheney*]

Wednesday
Oct 19 [1938]

Dear Nan.

What a shilly shally—hobble bones you will think me!! I am coming

up. to Vancouver decided 3 A.M. this morning after a night of rocketing round sleepless. will you meet me? the afternoon boat of Friday? You may have made other arrangements if so don't be put out. Mrs Boultbee has a free house now & I *can* go there (I'd rather go to you if you'll have me) & she would send the car down to meet me. I have told her definitely I am *not coming* up, & I am not going to retell her that I am but will telephone from your house. Please don't tell anyone I am coming up. I am coming *alone* This is what I'd *like to do if you will let me.* go straight to you. have a quiet evening—just ourselves—Saturday morning. go to Gallery alone. no body knows me there. I'll just look a few moments will do me I don't need to see the pictures only to get the effect of them hanging in a strange place. think it would. be a help for future work. I'd like to meet you on way out & be introduced to Grigsby & I'd like to go to see Mrs Boultbee. I'd like to see Edythe & The Macdonalds. Do you think Mr McD [Macd] would bring a couple of his moderitees[1] to your house. for me to see? he lives at the top of something doesn't he? Then I'd like to come home on Sunday morning's boat. What cheek ordering my visit this way just as I want but I'm just shure you'll understand. I don't feel equal to meeting *many people*, they make me so tired. I'm going to take a berth both ways. & one of those filthy push chairs up the long incline, then I'll be just fine I'm shure. So please keep your mouth shut tight I am writing Edythe and asking her the same I mean about meeting odd people. Don't put yourself about if you can get your car or doing somewhat else. we can take a taxi but *do come yourself in person* if you can. & forgive me for being such a fool.

Yours

M.e.

NOTE
1 Undoubtedly a reference to Macdonald's "modalities." See #41, note 4. Macdonald had told Carr in a letter of 15 Oct. 1938 (BCARS, Parnall Collection) that he would like to "try out" his modalities on her: "They are experiments I have been

working on for the past eighteen months," he wrote, "and are expressions of thought in relation to nature. They are not abstractions but again they are not visual representations of nature."

66 [*Cheney to McCurry*]

1282 Connaught Dr
Vancouver B.C.
Oct 23rd 1938

Dear Mr McCurry,

Thank you very much for your letter & the clippings & the R.C.A. form—the latter I have filled in & enclose—We had a surprise visit from Miss Carr—she came on Frid. & left this morning & we had a grand time. She wanted to see her show hanging & at some distance (you know she works in a tiny room—about 8 by 10). It was a beautiful day & everything went off as arranged & she went back full of gratitude to the Gallery here, who paid all the expenses of her show[1] & quite satisfied with everything—her health is better & she had no heart attacks here but it was quite a responsibility—She sold two small canvasses & perhaps another & I arranged about having the show photographed. It is too late to get in touch with Mr Balwin [Baldwin][2] now as they go back tomorrow, however she in [is?] quite in the mood to be approached & perhaps the Montreal Gallery will this winter. Mr Macdonald came up & brought his modalities to show her & she was very interested in them & his developement [sic]. We read the clippings which are the first we have heard of the show & look forward to the catalogue.[3] So glad George Pepper was mentioned & Lillias [Lilias] Newton.

 With kindest regards to all

 Sincerely, Nan Cheney

NOTES
1 Carr's exhibition was by invitation. See UBCL, Cheney Papers, box 1, file 36, Grigsby to Carr (copy to Cheney), 7 July 1938. The general practice at the VAG was for local artists or organizations, upon acceptance of their applications by the Gallery, to pay for their own exhibition space with a fee of between $5.00 and $15.00.
2 Martin Baldwin was Director of the AGT (1932–61). McCurry had suggested to Cheney that she write to Baldwin to inform him how "good" the Carr exhibition was. UBCL, Cheney Papers, McCurry to Cheney, 17 Oct. 1938.
3 A reference to the catalogue for "A Century of Canadian Art," Tate Gallery, London 1938.

67 [*Carr to Cheney*]

Monday
8 A.M.
[postmarked 24 Oct 1938]

My dear Nan

Got home safe & sound. a good trip. Sleept, read. partook of ham sanwitch & coffee. & sat a little on deck watching. Shirley & her Pa met me in their motor. S. under the weather but everything O.K. A. still coldly distant over phone. am afraid I'm still unforgiven. could not ring up much as I had no voice but after a little 'lay low' it came back. And this A.M. I have my usual, for time being.

Well I am very glad I went everyone was so very kind and good. and I enjoyed thoroughly and after my usual bed day will soon rest up. It is pouring wet.

Thank you so much Nan for all your kindness and all you did for the Show & me. You made it all so easy and I love your home & everybody from Inky up.

Have thought a lot about McDonalds [Macdonald's] Modernities.[1] You know I am not so keen on that name. I think it may antagonize certain people who dont take the trouble to hunt up its real meaning,

but only jump on the idea it pertains to 'Modern' few people use a dictionary on their own. They except [accept?] without investigating.

Well the Exhibition is over. —but for your instigation it would never have been but I am glad it was. it has I hope bucked me for fresh effort: but I've got to lay low first. for a few days.

I could not make out yesterday what they'd done about the wharf. There seemed to be no new work going on on the waterfront just a tidy vacancy where the old was, as far as I could make out. Is the present arrangement going to stand as it is? personly I like it, without all those great corridors & waiting rooms etc. but it is not so cityish, I suppose.

Birds & beasts welcomed me with gusto that exceptance of you as one of their necessaries is very comforting.

My face being reduced to one great yawn out of which pours stupidity I'll quit correspondence for the moment closing with vast quantities of love & thank yous

Yours

Emily.

NOTE
1 Macdonald wrote to McCurry that Carr had spent an hour and a half viewing his modalities, and that she "quite sincerely was very interested." NGC, Archives 7.1 Macdonald, J.W.G., 24 Oct. 1938. See also Carr to Macdonald, n.d. [Nov. 1938], possession of Dr. Joyce Zemans, Ottawa. In the latter Carr referred correctly to his "Modalities," and said that they had impressed her very much.

68 [*Carr to Cheney*]

Monday Evening
[postmarked 24 Oct 1938]

Dear Nan

No sooner was my letter *posted* than I got one from you. which I will perceed to answear so you will get it before pictures are packed. Shure you can have first on "above the gravel pit" till Xmas to think on. & You are welcome to keep her till Xmas while you're thinking she'd look well on the wall in place of that little one of mine perhaps by Xmas you'll be sick of her, & think shes not worth her salt. then she can come home. & if you dicide to buy the knock off I promised for your Birthday holds good. had I perhaps better write Grigsby that I am loaning it to you till Xmas. I don't want him to think I have sold it behind his back, but I should think After Xmas it would be O.K. shouldnt you? if you decided you wanted it? He knows how much you helped with my show & can understand my loaning it. to you.

I think Dr Cheney was most awfully nice to me I *knew* you would be but he might have been bored having me there.

Yes I hope National Gallery does buy me for your sake.[1]

Have been in bed all day I *am* tired but will soon be rested I hope & I have lots to think about thank the Lord for My Sister is no better—rather worse indeed. I don't understand it. she feels so *bitter*, but she has never exhibited *any* interest in my ex'es before. Well I spose *Time* will ease her up. I'm sory but do not feel I did *anything mean coming alone*. Perhaps Mrs Boul[t]bee sides with her if you remember she did most all her talking to you & never once mentioned anything family tho' she was very nice to me still when she phoned, she seemed to think it was O.K. for me to have come. but she is awefully fond of Alice. And they had written & phoned. A's eyes are extra bad & she blames the upset. Oh dear!

What luck I had such a fine day in Van it rains here today too. Yes I liked Mcdonads [Macdonald's] things sincerely. & appreciated much his bringing [?] them to me. Tell me has he a car or did Dr Cheney fetch him? I thought about that when I saw Dr Cheney go out the door with him when he left. well you were all so good to me. Bless you all & I'm so glad I went it was all made so easy. Shirley said 'oh I was so *afraid* you might stay another day.' She has a bad cold today.

Love

Emily

read enclosed & if you see fit hand to Mr Grigsby.

NOTE
1 Yet in an undated letter the next month (Nov. 1938), Carr wrote to Edythe Brand that the portrait gave her "the pip," and added, "but *don't tell Nan*." Hembroff-Schleicher, *M.E.*, 45; and Hembroff-Schleicher Papers, Carr to Brand, n.d. [11 Nov. 1938]. to Brown a few months later Carr remarked: "So you like her portrait of me? I don't think anyone knows what they look like. Gives one a shock. I loath[e] the picture but thats not here or there." (Carr then added: "Yes I think Nan is good for Vancouver.") NGC, Archives 7.1 Carr, E., Carr to Brown, 26 Mar. 1939.

69 [*Cheney to Carr*]

Tues—
Oct 25 1938

My dear Emily

Your two letters came this a.m. & I am delighted that you got home safely & found everything in order—& you, yourself not too worn out. I am simply thrilled to have the loan of that picture until Xmas but I do feel it is a tremendous responsibility and I will never feel happy until it is paid for—however I am going to enjoy every moment of it.

I expect by know you have heard from Edythe about the movement a foot to have your show go the University.[1] It is a grand idea I think, if you are not in a rush for any of them as you might sell another. I hear a man named Scott,[2] a commercial artist, bought one & another man, unknown to the gallery, was coming in today to make a final decision. I am so glad they are being appreciated & several more sales are in view. Edythe said that Hunter Lewis[3].was going to "write

you up" in the Province & it all helps—Macdonald has not a car—I went for them & Hill took them back that day. Glad you liked Hill, he liked you too—My dear, excuse this note. have had an awful day of plumbers etc. Pipe burst & sink plugged. Much love & take care of yourself

Nan.

I took the note to Grigsby
Emily said this handkerchief was yours.

NOTES

1 A.S. Grigsby wrote to Carr stating that Professor Hunter Lewis was anxious to have her pictures shown in the Faculty Room, UBC Library, 1–4 Nov., inclusive; and that the paintings would then be returned to the Gallery. See UBCL, Cheney Papers, box 1, file 36. Grigsby to Carr (copy to Cheney), 25 Oct. 1938.

2 A.K. Scott (1888–1984) is listed as a commercial artist in the B.C. Directory (Vancouver), 1938.

3 Professor Lewis was an assistant professor in the Department of English, UBC (1929–62). Jack Shadbolt, in "A Personal Recollection," has written that "it was Hunter Lewis of the Modern English Department who galvanized art life on the campus." *Vancouver: Art and Artists 1931–1983* (Vancouver: VAG 1983), 38.

70 [*Cheney to Carr*]

1282 Connaught Dr
Vancouver BC
Oct 26th 1938

My dear Emily

Under separate cover I am sending your portrait & the reprints of your exhibition. I hear that the Province photographer has been in to take some for the Sunday paper & they are going to give you a whole page write up. Isn't that *grand for you* & I am sure there will be more

sales—I am quite amused at the university people, to hear them talk, you would think they were the only people who had ever heard of you & your painting they are such a little world of themselves ar'nt they? however this is a marvelous gesture, & I am all for anything that they do for you, & with Dr Sedgewick opening the exhibition it is sure to be a success. I am going out of course, & Edythe has asked me to tea—She also asked me to help her hang them. I wish you were coming again—so many people wanted to see you, but I know how exhausting they can be. Scott came in on Mon. for his water colour to send East to the R.C.A., can't think why, it will look like a postage stamp however I lent it to him & he talked about your work—said he would like "above the gravel pit" for the Gallery & suggested we get a number of people to subscribe to it & present it to the Gallery etc[1]— so I told him you had loaned it to me until Xmas & if he can get the people to put up the money it will take sometime to collect—In the meantime I may raise the cash.

Well my dear it is all so thrilling & I am as proud as punch that I know you, & had a little to do with your show—Much love & take care of yourself & you know we will be glad to have you again anytime—

Nan

Mr Grigsby said he was sending clippings & cheque *today*.

NOTE
1 *Above the Gravel Pit* became part of the Emily Carr Trust and was transferred with the Trust paintings to the VAG in 1946.

71 [*Carr to Cheney*]

Friday—one week since I took that
exciting venture in my hands

& went.
[postmarked 29 Oct 1938]

Dear Nan

Its a case of a scrappy note tonight or a longer tomorrow. I have had so many letters to write one way and another. it has taken up all the time. Dr Sedgewick wrote me a beauty also a Miss Betty Streatfield [Streatfeild][1], an old Victoria girl who I have (once only) met years agoe. It was a lovely (*very understanding*) letter not an artist but she seemed to have felt most strongly what the things had to say. I was touched & very pleased.

A Vancouver woman came this A.M. to see me a Mrs Cowan. said she was in Vic and felt that she wanted to look me up to say how much she'd enjoyed the pictures, and so it goes. people have been *very* nice. Dr Sedgewick said he was in the gallery at the same time as three of 'his young people' & I would have been pleased he knew to see the way they took them with their hearts and made them their own posession (the pictures.) wasn't that nice?

Grigsby wrote that he was including the three I had in the other show for the gallery He thought sending the show up to the University was a very good plan. he has certainly been very nice over everything. He wrote me a list of six pictures as sold[2] but I do not think it is really so for instance he put two to Dr Sedgewick who told me he was *considering one* [underlined twice]. —wanted two but knew he could not afford that. And I don't think the Clarkes [Clarks][3] had really decided had they?

My beloved. Matilda is in hospital some stomach trouble & the Vet. thinks pretty badly of her she's a frail little pup. I thought she'd stand the best chance by going there tho' I do hate them going to kennels but the trouble seemed obscure. & I thought he could watche her closer. he's clever. but does not visit. or *very* rarely. Pout is disconsolate. Shirley gave up her half day to take her to the Dr & Back yesterday. but today I bundled them both in a cab as it rained we do

miss her so. Am painting a bit. and the short days fly. had a very tiresome visit-or late afternoon who talked with what appeared to be a succession of millions of hyphenated words. —no pauses—& the same tone note. I only had to say yes & no, but my[?] voice totally went.—thank goodness! for being a nurse she said, 'My! you're tired' and *went* Maybbe the good Lord has a reason giving me a voice with a turn off tap.

Isn't it revolting they've raised my rent. Maybbe I diddent [?] give them some lip!

Alice suddenly forgave me yesterday and is O.K. again. Her mad lasted till yesterday—very thick—& busted with a pop. She went to her eye man. Today. Her worst eye is stationary but her good one much worse he says.

Glad you are going to enjoy 'above gravel pit'

I was a beast. I never thought to ring Aunt Mary up when I got home I *might* have done that. after a few days she phoned me:

The 'Arts & Crafts' show is on here[4] one of them offered to drive me there yesterday but I was expecting the house agent. they tell me theres a new portrait pa[i]nter man called Edwards.[5] By how they *condemned* his work it *may* be interesting. They are an *awful* set of tabbies always on the spit.

Yes I beleive Hunter L. is doing me up. well when I've been so acid to him you'd think he'd make a sour lemonade of me. One thing he knows nothing of my excentricities size of shoe, appetites, vices or digestion, so I hope he'll make it purely work.

Poor Edythe as if she & Fred were not busy enough without shouldering my pictures.

This did not get posted because it was too late to buy stamps now you wont get it till Monday.

Hope your plummers have jobbed their job. there is no viler mechanic living and yet I know the moments I could have hugged them. As when you own an appartment house—blocked drains, and screeching tennants.

Well, I'm bed-ready. So goodnight write soon & keep me

informed of your doings & how your portrait comes on.

Aff.

M.e.

Written with ink by George!

Oh By George! good thing I did not post last night yours came this A.M. & the Photos this aft. They are very good. is not the 'above the gravel pits splendid and thanks ever so for the 'Me' I think Nan that I should help pay for those Van gallery ones wish you'd let me know what, where, how. I do not want you & Edythe to have that expense I did not quite grasp *how* it was being accomplished. these things cost I *know*. Yes Nan it is all too extroardinary to seem true & overwhelms me all they have said and done. so much interest. off [of] course it is all the way you have talked & worked for me. It way [was?] Nan Cheeney [Cheney] in the first place that decided there should be an. ex. and set the thing in motion. I'd never have had energy or spunk to carry through without you at the other end. and now Edythe has taken on the U.B.C show.[6] well you are a pair of peaches and thats so. am glad you are going to help hang you shure made a good job before. Isn't is marvelous how many sold I had a check for $172.00 from Mr Grigsby that is *very* welcome but it [is] not really as big a joy as feeling the pictures had something to say to people that thrills me. The Gravel Pits is yours till Xmas anyhow. so tell Scott to sit on his hat Voiceless again today. My voice has been very aggrevating since I got home takes vacation *every possible* occasion. Been having ripping time today painting. Ex. has pepped me all up. Do come over soon I'll have things to show you I hope. experimenting a bit.

Vet. says Matilda is slightly improved today. The opposite woman who has appalled us so long gave birth to twins. Pa a former Essendale [Essondale][7] patient Ma an emaciated wreck two underfed little boys and now two more for the public works to support. he told me I could have

my pick. when I pick it won't be from an asylum. Oh the poor devils!

Brought the chipmonks into the front studio today rain seems pretty settled.

Must write Edythe.

Barrels of love

Emily

Thanks ever so for the Photos. Humphrey ran in for a minute.

NOTES

1 Betty Streatfeild (now Mrs. Alistair Bell) (b.1902) was living in Vancouver and beginning to work as both a painter and a sculptor. She exhibited with the Atelier Sketch Club and later with the BCSFA. In 1942 an exhibition, "Drawing of the Human Form" by Alistair and Betty Bell, was held at the VAG, 3–15 Feb. See AGB [VAG], 9 (Feb. 1942). The letters of Sedgewick and Streatfeild are in the BCARS, Parnall Collection, and are dated 23 and 24 Oct. respectively.

In Carr's reply to Streatfeild, 28 Oct. 1938, she stated: "Your letter meant a very great deal to me. . . . It rang so true and sincere. and made me feel that the pictures had really spoken to you and you understood. . . . People had been so kind over the exhibition and it does give one courage to go on." See VAG, Archives.

2 See UBCL, Cheney Papers, box 1, file 36, Grigsby to Carr (copy to Cheney), 25 Oct. 1938.

3 Presumably Dr. and Mrs. A.F.B. Clark. See #172, note 2.

4 Carr did not submit works to IAACS exhibitions after 1937 (although in 1940 and 1941 works of hers on loan were included). See Hembroff-Schleicher *Emily Carr*, 358.

5 Allan Edwards (b.1915) appears to have been vacationing on the coast from Detroit in Oct. 1938, and then to have moved briefly to Victoria. By June 1939 he was listed in Vancouver as a "recent arrival from Victoria." See *AGB* [VAG], 6 (Oct. 1938 and June 1939).

6 Although Lewis had initiated the idea of a UBC show, Carr evidently refused to co-operate with him and gave Edythe Brand the authority to take charge. See Hembroff-Schleicher, *Emily Carr*, 312, for a discussion of this exhibition.

7 "Essondale" refers to an institution for the mentally ill in Coquitlam, BC.

72 [*Carr to Cheney*]

[postmarked 4 Nov 1938]

Dear Nan.

Heigh ho! I bloat! with exuberance of appreciation not food thanks
for cutting. How nice of Eric Newton![1] Hope one of these days my
breath will return and my 'astonish'. I do hope you come over soon
you know I have to *bottle* up no one to pour out too. haven't had the
courage to read A. the letters or cuttings. she has never asked if there
were any. If she could only see I could pass them over to her but I
simply *cant* read them out. yet perhaps its mean not to I don't know.
she certainly doesn't *seem* the least interested I'd be so excited if it
were her but her eyes are very mean to her these days enough to make
anyone cranky & she's very patient *this is all entirely between ourselves
please*

Another sale how splendid! Old Man Hood[2] keeps pestering
through one & another, so I've given permission for him to help.

"Woods edge" and "Flung Beyond the waves" till New Year its so
much less trouble to send them home all together. and I don't beleve
he will sell & I beleve his % is .45 so there is little in him except
bother & he doodles round. through Edythe & Humphrey instead of
coming to me direct. Grigsby sent me a check and list. $172.00 with
taggles still to come in. they are to have any comission coming from
the U.B.C show too (the gallery) quite right I think. Shure I am going
to be an outside member, and shall ask Mr Grigsby to keep the $2.00
money for photos as well.

Thanks very much for the portrait photo wonder when you will
hear from Eric Brown regarding it?

On second thoughts seem to me it's *you* should have the help for
photos of show pictures why should you have done that?

Humphrey ran in when I was eating dinner a few days agoe but did
not stay long perhaps the sight was disgusting. he would not join me.

Matilda is home and better I am delighted.

Been terribly tired *and* nervy last few days. but working some
Victoria Papers crawled in behind with a mention of the show yesterday.

Now I must arise, 10:30 and the sun out. Am having a baby

sewing bee on Monday. and my day abed Sunday. 3 neighbours & self making diaps. and nighties[?] for the new borns opposite. four infants. two brand new & no money. & winter coming poor devils. He's a fool but alas the woman!

loads of love

Emily.

NOTES
1 In reviewing "A Century of Canadian Art," Eric Newton had praised Carr's work and had stated that she had "found her own formula" for BC's "engulfing giants." He concluded that she was "completely independent of any tradition, Canadian or European." *Manchester Guardian Weekly*, 39, 14 Oct. 1938, p. 337.
2 Harry Hood (1876–1956), a Vancouver artist and founding member of the BCSFA, was a proprietor of the Art Emporium then located at 1103 Robson Street.

73 [*Cheney to Toms*]

1282 Connaught Dr
Vancouver BC
Nov 7th 1938

Dear Humphrey

Thanks for the catalogues etc. that you have sent & I think I owe you a letter, but I have been so busy & excited about Emily's exhibition that my correspondence has got sadly behind—The show was a tremendous success—she sold 11 pictures & the Gallery is very pleased that I urged them to take a chance—in fact I am patting myself on the back that everything went off so well after my *year* of working Emily up to the idea, & the Gallery up to the point of inviting her—however I understand that Prof. Hunter Lewis is taking all the credit & when the show went out to the University, the speeches to the students were to

the effect that *they* had *just* discovered the genius & no one else had ever heard of her—I was more than amused—however she sold a lot out there & that is the main thing after all & then the write ups from the Tate Gallery came just in time, to give the public the extra punch. Isn't it marvelous that she has been so well received, not that she doesn't deserve it—Mr Macdonald got clippings from all the Scottish papers as well as the English & they were equally glowing. We enjoyed her visit & I think she did too—the weather was fine & I arranged everything as she told me in her letter. She has loaned me "above the gravel pit" until Xmas—I feel quite a responsibility but am thrilled to have it. I hear Miss Cann[1] is coming next weekend & we have been asked to the Macdonalds to meet her again. I expect to go over the weekend of the 25.*th* & will see Daisy[2]—poor thing—I haven't even written. Have you met Allan Edwards. I think he is from Ottawa & I met him before I left—rather clever water colours in a show here.[3] Mary (my sister in Trail)[4] wrote that you sent your brother a killing letter about your weekend here—was it as bad as that? I am going over with Dr Trapp as she is speaking Frid night (25th) at a meeting Regards to your mother—

Sincerely.

Nan Cheney.

Thought you would like this catalogue for your scrap book.

NOTES
1 Jeanette Cann (1880–1956), a teacher of English in Victoria since 1904, was at Victoria College in her retirement year (teaching both English and psychology). She was known for her extensive collection of colour reproductions and lantern slides of famous art works, a number of which were shown at the Cann exhibition at the VAG from 21 Nov. to 3 Dec. 1939. See *AGB* [VAG], 7 (Nov. 1939).
2 Daisy Dodd was a Victoria nurse and friend of both Cheney and Dr. Ethelyn Trapp. The latter had known Dodd since school days at All Hallows School for Girls, Yale, BC.
3 An exhibition of Edwards' watercolours was held at the VAG from 1 to 2 Oct. 1938.

4 Mrs. Charles Wright.

74 [*Cheney to McCurry*]

1282 Connaught Dr
Vancouver B.C.
Nov 10 1938

Dear Mr McCurry,

Thank you so much for attending to my portrait of Emily Carr. I expect you have heard from Macdonald about her show[1]—It was a tremendous success—She sold 11 pictures & a lot more people are interested & the Gallery are so pleased with the chance I *made* them take that they want to make it an annual event. I hung the exhibition and considering the space & the *mustard* coloured walls it really looked awfully well—I am enclosing snaps which give you a fair idea & a catalogue of the sales. No. 25 "Solemn big woods" is a gorgeous one, also No. 10 "above the gravel pit" which Miss Carr loaned me until Christmas. I had these photographs taken thinking she could not get over but she was able to manage a weekend & stayed with us. I would like to buy "above the gravel pit" but can't unless I sell something—We were very disappointed that Mr Jackson could not come out here before going East. I was delighted to see Macdonalds canvas reproduced in the catalogue also the portrait of Mr Southam[2] Thank you very much for sending it, also the clipping from "The Citizen"—With kindest regards to all

Nan Cheney

NOTES
1 See #64, note 1.
2 Macdonald's *Drying Herring Roe* and Lilias Newton's portrait of H.S. Southam

were reproduced in the catalogue of "A Century of Canadian Art." Regarding the Southam portrait, see #35, note 10.

75 [*Cheney to Brown*]

[no date—possibly included
in Nov 10 1938 letter to
McCurry, #74]

Dear Mr Brown,

Was just about to mail this letter when I heard that Mr McCurry had gone to England & you had returned so I will send it to you without rewriting it.

We are thrilled with the news of the Tate Gallery show & the publicity it got—specially the write ups about Emily—they came at a very opportune time & I am sure stimulated her sales out here, where nothing is any good unless it comes from England. I am sure you had a very gratifying trip & hope you are planning to come this way next year.

With kindest regards to Maude [Maud]

Sincerely

Nan Cheney.

76 [*Carr to Cheney*]

[postmarked 14 Nov 1938]
316 Beckley St
Written in bed amid 2 dogs

1 bird 1 chipmunk
Sunday. not ill but unup for day
yet

Dear Nan.

Do you still live? Are you like me drawing long breaths now the Ex. is
past and done? all the while of it I had such a lot of letters to write
you Edythe Grigsby. & all the other fellows who so kindly wrote. I
kept them done right up though. And "last of all the woman died
also." at least she *did not*—meany, She wrote & the last of all my
letters was from Mrs Boultbee—congrats. You rem[em]ber how she
talked of everything *but* the Ex. the day we lunched. When my letters
were all in & the cuttings. I put them in a paper sack and gave them to
my sister to take home and she had a neighbour who often reads to
her, go through the stuff aloud. and she said, "I am very glad" so that
finished up everything and left the slate clean. for new efforts & the
old—a thing of the past.

Am hoping 2 Sundays from today to see you in person & the flesh.
My Sisster went to Vancouver Friday & returns today it will do her good
She's been a bit down, eyes giving a lot of trouble, She loves the sea trip
does not find it tiresome—sits in the observation and enjoys Weather is
pretty putrid, rain and *cold* some real nippy frost. very variable. I am
sorry for my young birds just leaving the nest. I am glad I'm not just
hatched myself I caught one to console it but it gave me a vicious nip
on the lip. The chill of the world had probably riled its temper to be
hatched in spring is best. Matilda is better but not robust.

I am reading memoire of Ellen Terry[1]—very interesting. lots of
side lights on stage life and *I'm* [underlined twice] *going* [underlined
three times] to the Russian Singers (Don. something you know)
tomorrow night Miss Burns has invited me—Arn't I frisky?

Did I tell you I had been absorbed recently in the intricasies of
"Layetting." I invited. 4 ladies of Beckley St to come and drink tea and
sew for the newborn twins opposite who were born unclothed. we had a

great day didies nighties shirts basinettes and bath tubs. (they only had a *cook pot* to wash the creatures in) Poor woman! but what a helpless blithering fool is the man!! all the neighbourhood is disgusted at his blither The other two kids go dirty. & he sits with open mouth grabbing in. however he has 3 stomach ulsers and no memory which *is* [underlined twice] a handicap only *why* go on bringing more stomach ulsers and lack of memories into being? its mean—Its dispicable She's one of these fool English girls who married for a 'home' and drew 'relief in a hovel'. but bless me if she is not *fond* of the creature. The tea party was a great success. We sewed in the kitchen it being big & light. had two sewing machines, & the cutting table. Shirley attended to the tea which we consumed in the 'Parlor' Alice came and brght 4 little shirts she had knitted. & quite enjoyed herself. We all agreed we were very sorry for Mrs 'Whoopla' and that we all despised Mr Whoopla and that we weren't going to be bamboozed by him, and went right on sewing. really these people are good neighbours to each other (when they're not scrapping) and make one ashamed. They have so little to give except their bodily strength and they give that going in to 'help out' when their own hands are alredy full.

I'm at it again—writing—every morning. and painting quite hard too. the ex. stuff is all back in its stalls. People have not paid Grigsby yet wouldn't you think that strangers should 'cash' at public exhibitions? but that seems to be the way, & I guess its O.K.

What have they on now at Gallery? McCurrey [McCurry] sent me a couple of 'Tate' catalogues not looked them over yet.

Here's hoping to see you soon. and Aunt M. not riveting you *too* tight to her flat. would like to see Dr Trappe [Trapp] too very much.

Now for decencies sake (just to set an example to the unemployed) I must arise. & tub. Wow! it's dark & raw. There's a great deal to be said for hibernation.

Affec. yours.

Emily

I *will* [underlined seven times] post that Indian mat this week. Think I might send one to Edythe for her house too do you mind if I send in one bundle? you do see each other quite often & both have cars so nobody'd have to carry it. That is have I two? I have to see before I do send it. so Mum it is while I look see.

Ever

M.E.

NOTE
1 *Ellen Terry's Memoirs* (New York: Putnam's Sons 1932).

77 [*Cheney to Brown*]

1282 Connaught Dr
Vancouver B.C.
Nov 18th 1938

My dear Mr Brown,

I have just received a notice from the R.C.A. that they have turned down my portrait of "Emily Carr"—Do you think it is worth submitting to the O.S.A. in March?[1] I do not want the expense of shipping it back again & I am sure the Peppers would store it in their studio—

I have just completed a portrait of J.W.G. Macdonald, and Mr & Mrs Seminoff,[2] two doukhobors, but I hesitate to send them East. What do you honestly think? I was very much encouraged by your letters last summer. The joke of it is that the R.C.A. is the only show which has any standing out here so for the moment this has killed any chance of a commission which I had in view. Kindest regards to all.

Sincerely

Nan Cheney

NOTES
1 The annual exhibition of the Ontario Society of Artists [OSA] was held at the
AGT 3–29 Mar. 1939. Cheney's portrait of Carr was accepted.
2 Nikolai and Tina Seminoff were known to Cheney through her friend Gaie
Taylor from Nelson, BC.

78 [*Carr to Cheney*]

Sunday
[postmarked 21 Nov 1938]

Dear Nan

And next week me hopes its yourself that will be over here Maybbe
Aunt M. will be so buisy churching it will be a good day for you to get
out. I look forward to your visit very much. If you should be in town
between now & then would you buy me one of those lady finger tins
like you have for a watercolor pallette. I cannot get them here only the
deep kind for cakes, which I dont want

This A.M. I had a visit from Mr Livesey [Livesay],[1] Head of Can.
United Press and his daughter Mrs McNair [Macnair] seems she had
written a speel after seeing the Ex in Van & sent it to Montreal paper.[2]
It so happened someone sent it to a woman I knew and she showed it
to me so I did know about it. However they were very nice people not
snoops & really interested in work, so I enjoyed them and I'd rather
see her after than before her write.

We've had a glorious day cold frost this A.M. though. No newses
but just wrote to say I'm looking forward to you.

By the way I looked up my Indian mats[3] They were in a top

cupboard. & I did not know what I had & was chagrined to find they are not as new & fresh as I thought they used to hang in the old studio at 646 and so—the wrong side is O.K. but I am going to wait to see if you think it's worth having. I like them & have had them on my walls a long time. behind tables & sofas fortun[a]tely I did not mention to Edythe I contemplated sending her one. Glad the Gravel pit picture sits pretty in your room. I may wrack my vengence on you for what you did to me & suggest you sit for me. What would you say? Been working also writing. Went to the Russian Singers & enjoyed it imm[en]seley.

Interuption—goodbye.

See you soon.

love.

Emily

To continue How orful for you to have to spout on me thank the Lord. for the sea between. thank you for the cutting nice of MacD. [Macd.] to send it I wrote him I chuckle at your "bursting into University."⁴ I who can't even spell belong to the University Womens Club!! (completely Honorary. not earned) I am now a Gallery member too I hate 'belonging' to things they sort of trip you up

Emily

NOTES

1 J.F.B. Livesay of Toronto, General Manager of Canadian Press, was on a business trip to the west and had requested a visit with Carr at the suggestion of his Ottawa friend, Alan Plaunt. (Plaunt was interested in purchasing some of Emily Carr's paintings.) See Dorothy Livesay Papers, Department of Archives and Special Collections, University of Manitoba, notes by Dorothy Livesay, 11 Feb. 1979. See also Dorothy Livesay, "Carr & [J.F.B.] Livesay," *Canadian Literature* 84 (Spring 1980):144-7.

2 Dorothy Livesay Macnair (b.1909), distinguished poet, author, and literary critic, became a good friend of both Carr and Cheney. Dorothy Livesay credits her "greatly revived" interest in literature and the arts in the later 1930s ("dormant

since 1930") to a number of Vancouver literary figures (whom she names) and to painters Jack Shadbolt, Nan Cheney, and Molly Bobak. See Dorothy Livesay Papers, Department of Archives and Special Collections, University of Manitoba, notes by Livesay, 11 Feb. 1979. An unidentified clipping (typescript) in UBCL, Cheney Papers, box 2, file 17, is headed "Excerpt from a Montreal Paper," and is a review by "D.K.L. Macnair" of Carr's painting. The source of the item has not been located.

3 See #3, note 9.

4 According to Cheney's notes (UBCL, Cheney Papers, box 7, file 10), her talk on Emily Carr was given to a group of UBC students at the home of Mr. and Mrs. [T.W.] Bingay, Macdonald Street, Vancouver.

79 [*Excerpt Toms to Cheney*]

30 Nov. 1938

I did enjoy having supper at Emily's, and particularly her reading "Sunday",[1] but I was horribly rude, yawning all the time . . .

NOTE
1 "Sunday" appeared as the first story in Carr, *The Book of Small* (Toronto: Clarke, Irwin 1942). There are two parts: "The Book of Small" and "A Little Town and a Little Girl." The stories deal with Carr's early life with her family and the Victoria of her childhood. "Small" was Carr's imaginary name for her childhood self, "Just a phantom child, made up of memories and love." Carr, *The Heart of a Peacock*, xv. Dilworth acknowledged that he was quoting from a Carr letter of 9 Aug. 1943. ("Sunday" was also the title of a short sketch in the "Bobtails" section of *The House of All Sorts*.)

80 [*Cheney to Brown*]

1282 Connaught Dr
Vancouver B.C.
Dec 1st 1938

My dear Mr Brown

You are a lamb to write me such a nice letter[1] as I was feeling rather flat, after such a rebuff from the R.C.A.—however after seeing the catalogue & reading Graham McInnes in the "Saturday night" I feel it was a very good thing as she would have been utterly lost in that awful collection—

I have written to the Toronto Gallery to send the portrait to you if the Peppers have not already taken it, and if they have, I have written to them too, so no doubt it will be along soon. I have just spent a week in Victoria & saw Emily every day—She is in fine form, full of energy & new ideas & her heart is behaving so well that she looks remarkably fit. She has started some portrait sketches & really they are awfully good. One of a little boy is particularly good. She got me to sit for her & in 2 hrs she got a nice one—specially the head, the figure is too shapeless & chunky. You will simply have to come out next summer to see her. Thank you for the suggestion about the Group show[2]. I wrote to Kay Pepper about it as I thought one had to be invited to show with them. I have just about completed a portrait of Macdonald & will send you a photograph of it later. You will be sorry to hear that Mr. Vanderpant looks very ill—he is very thin & a grey yellow colour & has turned most of his work over to his daughter. he does not seem at all worried but we are worried for him. I am enclosing a Christmas card for Maude [Maud] & you—It was made from one of this years sketches at Garibaldi—Hill says it looks like a backdrop in a play. The material up there is unbelieveable—With best wishes to you both.

Sincerely

Nan Cheney

NOTES

1 Brown had counselled her: "Don't be downhearted about the Royal Canadian Academy. You are doing valuable work out there and I hope you will continue it." UBCL, Cheney Papers, box 5, file 1b, Brown to Cheney, 23 Nov. 1938.
2 Ibid. Brown had suggested that Cheney approach A.Y. Jackson about showing the Seminoff portraits at the next CGP exhibition.

81 [*Carr to Cheney*]

[postmarked 9 Dec 1938]

Dear Nan.

Thanks for letters. No word of Mr Henderson[1] yet, nor yet of A.Y. Jackson as to what he wants me to do. re: pictures. for S.F.[2] he is a horrid old boy. always rushes one at last and sends the instructions through Vancouver to me so that I only get one minute notice. I have never hit it off with A.Y.J.[3] always feels he desp[i]sess me for a *woman* artist. and perhaps I have [not?] felt his way as to certain aspects of Art & it has annoyed him. He used to give me fatherly advice which I did not take, & I guess that aggrevated him. I always felt he was commercial-hearted, at bottom.

Thank you I got the catalogue but in it I only see Windsor & Newton, or Shmenkie [Schmincke] colors for *students*, which as a rule means. a cheap & less permanent grade of material & I did not find prices any better (or as good) as sending away curse that it is.

Been mounting busily.[4] It does improve the things greatly. is a lot of work. but means they are permanent have just got 50 new boards. it costs about 100 api[e]ce all told I guess for frame & mount, but is worth it I think.

I too had a lovely letter from Mr Brown with nice messages from Mrs Brown too. Yes on whole I think you are to be congratulated they kicked 'me' What a pity that show is so poor it kicks Canada in the Art eye. is the O.S.A. any better?

We've been having aweful rains & cold & storms today is grand for the moment and I must up & go to town—Xmas shopping.

Hope Ink recovered. Mine fine. me "limpish but still living"

Had an Artist & the Artist daughter who paints the pets. (in portraiture) of Hollywood stars. quite an interesting outfit stayed *2 hours* tho' had to yawn 'em out. very keen on my woodsies

New borns thrive but parents very bad lot. ought to be tarred & feathered.

Fare the well

Emily

NOTES
1 Likely Peter Henderson, MRAIC, Montreal architect and head of the Drafting Department for the new Hotel Vancouver which opened in May 1939. See *Vancouver Daily Province* ("Royal Welcome Edition"), 27 May 1939, p. 3. It seems Henderson was in charge of the art commissions and purchases for the hotel. Macdonald wrote to Nan Cheney on 21 Mar. 1939: "Henderson intends purchasing at least one of your canvases & has in mind some of your water colors." See UBCL, Cheney Papers, box 4, file 13, Macdonald to Cheney. Cheney was on a trip down the west coast of the United States.
2 A reference to the exhibition "Contemporary Art," held in connection with the Golden Gate International Exposition, San Francisco, 1939, and organized by the Exposition's Department of Fine Arts, Division of Painting and Sculpture.
3 Jackson would later comment on Carr: "A fiery spirit, she was not one to accept rebuffs with complacency; as she grew older she sometimes saw slights where none was intended, and this at times led her to be less gracious." And he adds: "I, too, had occasion to feel the weight of her displeasure. . . ." See A.Y. Jackson, *A Painter's Country* (Toronto/Vancouver: Clarke, Irwin 1964), 112.
4 In preparing her sketches for exhibition, Carr at this date was gluing the paper to plywood. See Shadbolt, *The Art of Emily Carr*, 114, for further details.

82 [*Carr to Cheney*]

Teusday
[postmarked 20 Dec 1938]

Dear Nan

I've been a busy woman and now am a tired one. Mrs Hughes my land owner granted me the papering of my ceilings. It was sprung upon [?] me one night at 5:30 the man was to be there 8 next morn well all the ceilings were dirty but some of the walls were exceeding dirty but

only *so much* to be spent they did compromise by doing two walls (kitchen & my bedroom) & leaving the ceilings undone and oh the mess! We are decent again now & lie in a darling bedroom hung [?] with pale grey currants & leafage with my own hand I painted the doors cream they were like cats to paint the hair off all the clothes that had hung over the bum paint of before was sticking to them & I painted right over nothing else to do except singe I spose which needs an expert. The parlor has new ceiling & my new yellow & green curtains 1/2 mast. the kitchen is pure. *hideous*, a form of modernized catterpiller but it appeals to Shirley. In bath room they catered to those lying in the tub only the studio is lots lighter for the ceiling. the walls still gap with cracks. Only one old doddering man so it took a long time of being dripped on. & old scrapings flying. I suppose these things must be but they are painful.

Went to town yesterday got tired & cross Shirley and I gave each other notice on Douglas St. but forgot it when we got home again. Took 8 birds to Mr Cowie[1] with 8 pangs in my heart, but they have to pay their keep.

Expect a sculptress to see me this A.M.[2] they say she's good *and* charming has come here to live the woman introducing her is rather wanting so I don't know.

Mrs Boultbee *might* come over for Xmas if she feels equal but not shure Edythe will be over soon Ruth goes to Vancouver & Duncan[3] and Margaret East Your third rug is just up on finshed only one more little one It will be done early in New Year Have you any special guests coming? I hustle & bustle if you have. Hope you have a glorious Xmas what are you going to do? is your male-in-law still with you? My brain is like a mince pie. did not sleep too good. No word from A.Y.J. I sent him a card to effect I must have a little notice as it was not *always* convenient for Willie to be on hand to crate. A.Y. makes me tired, & I wont take 3rd class notices through Vancouver he must write me direct they've done that too often & I get a 5 minute notices. A.Y. & I never did hit it off. I think he resents my being a *woman* has always sniffed towards me perhaps because I went to sleep

when he was exhibiting his sketches once.

love to all

Emily.

NOTES
1 Mrs. Elaine E. Cowie, wife of Alex G., owned a pet shop on Douglas Street in Victoria.
2 Katharine Emma Maltwood, FRSA (1878–1961), with her husband John Maltwood, had recently arrived in Victoria from England. The Maltwood Collection, acquired by the University of Victoria in 1964, contains two Emily Carr paintings. (The Maltwood Art Museum and Gallery opened at the University of Victoria in Sept. 1978.) See R.A. Brown, *Katharine Emma Maltwood, Artist, 1878–1961* (Victoria: Maltwood Art Museum and Gallery with Sono Nis Press 1981).
3 Duncan is a town on Vancouver Island.

83 [*Carr to Toms*]
[*Toms identifies the Christmas tag as one tied to a small black box with mother of pearl inlay which Carr gave to him.*]

[Christmas, 1938]

To my good friend Humphrey from his Old Girl friend Emily Carr.[1]

NOTE
1 The card is known only through the Toms Transcript. See Toms, "Letters from Emily," 3.

84 [*Carr to Cheney*]

316 Beckley.
The day After
[postmarked 27 Dec 1938]

Dear Nan

As Alice says no need to *look* at the calender, one *feels* it. All very fine for me, doing my bed day in ease for those minding stomachy kids its another matter. Shirley has off for her Xmas dinner at home Yesterday she had off for her dinner at freinds of theirs, & the poor thing has had considerable tongue from me in between lying & naughty she not me. its aweful when they *will lie* don't know where you are & I won't forgive for that. I am viperish, when it comes to 'lie' & pounce *much harder*. Well what *do* you think of *Me* on such stationary? *I'm thrilled with myself*—to feel the pencle glide over the delicious refined surface is a real pleasure Thank you so much I love it & as you know I write much, & mostly in my bed. so it's so handy so thanks again. So you are getting your studio fixed. how nice. it does pay to have a good studio. wish I'd seen it. How will you heat? You said it was cold I *have* to paint warm. Cant you have a stove up there poke a hole in the chimbley. nothing like a stove. You'll be painting the elite. & acruing millions before you know your' you. Good luck to to the Studio & work, for your sake I hope 'I' sell.

Old A.Y.J. sent *no word* to me yet I wrote him that if I was going to send he must let me know in time. & direct too not *thr[ou]gh* half a dozen other people as he generally does. I don't like A.Y. He probably will leave me too late & fill two of his *own* in their place like he did over illustrations in Barbeaus book.[1] he had charge of that end & left mine all out but one & put his own in place, said mine would not reproduce so well. I alwys have felt A.Y. grudged me getting any credid because I'm a woman. I never felt that with the other group men. However I doubt if I am in time for the S.F. show now it opens in Feb. & I shant send unless A.Y. writes me direct. when does McDonald [Macdonald] send his? I wonder if it is Brown or the Group of Can Painters sending? Ottawa or Toronto?[2]

How did Santa do by you? I got such a lot of things I'm ashamed. and millions of cards. Lady Tweedtail included Only seen Edythe once. on Saturday The family have her tight in clutch, but we had a

nice visit She Fred & I Sat. afternoon. Her family (the little Hussy) left everything for Edythe to do after she came shopping and all. I want them for dinner one night and am wondering if I *must* ask the Hussey why should I? she never comes to see me & I detest her & know none of her friends.

Alice came to cold turkey lunch here on Friday. and I went there to hot Turkey Sunday I have a pretty little Xmas tree. in the window. so has she. Shirley is so young a [&] lively about Xmas it is nice having her brightness poor youngster if she'd only be *clean and truthful* of course work has been out a dead stand also mounting but I hope to get buisy right away. now the fuss & feather is over. You should not have gone to so much bother about crates, tell them to send them C.O.D. if they return them I'll pay I got a nice book on Cezanne with reproductions had never read much abt him have several re: Van Gogh.

We had the most *magnificent* day for Xmas today wet again. Did you have to do your own room. or did your landlord bend?

So sorry to hear about Aunt M's pension being cut. too bad!

Mrs Boultbee did *not* come down for Xmas. Still feels her hip badly.

Edythe seemed to be quite perkey says she is much better seemed to like my sketch of you better after a while did not think it good as the others.

Am just starting 4th rug. had to button hole a new canvas same size as the smaller one. may finish them this week. was delayed by the papering kick up. I *am* glad there is only one Xmas per year. Did you hang up Ink's Stocking? Ruth went to Vancouver & Duncan Margaret to Chicago.

Think I'll take a trip to Australia dreamt I did last night and only in a row boat. I was wondering how seasick I was going to be, & where I could sleep, most comfortably.

Gifts poured into the Whoopla's for 3 days prior to Xmas. they must have got tons of stuff. 'Written my write' today. not going *too* well bit off too big a bit to chew perhaps, but I am pegging away.

So sleepy I must sleep Tell me all about the Studio.

love galore.

Bon Soire.

Emilie.

NOTES
1 *The Downfall of Temlaham* (Toronto: Macmillan 1928). One Carr and three Jackson works were reproduced in the volume.
2 According to the official catalogue of the exhibition "Contemporary Art" (see #81, note 2), the Canadian entries were selected by Lawren Harris. See also *Atma Buddhi Manas*, 30. However, Jackson was clearly very involved as well, likely in his capacity as president of the CGP, and was named in the "Acknowledgements" of the catalogue as one who had given of his "time and counsel."

85 [*Excerpt Toms to Cheney*]

28 Dec. 1938

I went to see Emily on her birthday, the 13th, with a present from an old crony of hers, a Mrs. McVicker who owned the Metchosin property on which Emily used to camp, and who now owns a Hobby Shop, —second-hand knick-knacks, in Victoria.[1] Last Tuesday I took her for a very short quiet drive in the afternoon in my brother's car—just long enough for a little air. Emily has sold another sketch, which pleases her very much. On the strength of that, I think, I got some handkerchiefs as a Christmas present! I am formulating a plan for insuring Emily's household effects and paintings for three years. I think the house is too old to stand up well in a possible fire and it will not cost me very much to do each year.[2]

NOTES
1 Mrs. Maude McVicker owned The Hobbies Shop in Victoria. See #7, note 1.
2 Toms in "Letters from Emily Carr," 3, notes that he had arranged for a three-year fire-theft insurance policy on three or four of her largest, named pictures. The cost was $18.00 for three years.

86 [*Carr to Cheney*]

316 Beckley St
Victoria, B.C.
Friday 29 [1938]
[postmarked 30 Dec. 1938]

Dear Nan

Got the rugs off today. Thought you might like them for your parties when you have your Studio warming Sunday & Monday so hurried up hope you will like them. How nice your Studio will be.

I had a letter from A.Y.J. says he had not heard from his S.F. man re: the pictures but asked me to send the little Pine & Old & New Forest right off to Vancouver to be ready with Mr MacDonalds [Mac-donald's] when the word came about shipping so I got them off today too.[1] Three cheers! now I am clean to start the New Year. Am a bit tired. Dr comes tomorrow to give me a check over. perhaps he'll tell me I can now safely fly over the moon.

Excuse scrawl I have a visitor but wanted you to know I'd posted rugs and pictures

Good luck to New Year & Nan.

loads of love

Emily.

NOTE
1 The two paintings (now in the collection of the VAG) were to be included in the exhibition "Contemporary Art" at the Golden Gate International Exposition, 1939.

87 [*Cheney to Toms*]

1282 Connaught Dr
Vancouver B.C.
Dec 30th 1938

Dear Humphrey.

Thank you so much for the book. I have just finished it & liked it very much. I got several new ones, and I bought "Letters of T.E. Lawrence," edited by David Garrett. I have always been a great admirer of his & liked his "Seven Pillars of Wisdom."[1] Had a nice long letter from Emily, very cheerful & she was overcome by all her presents etc. She sent me a pr of grey wool bed socks with pink rosettes. I was amused! I think it is terribly good of you to take out insurance on her place—as its a regular fire trap & she certainly would be in a fix if she burned out—I hope she appreciates it.

I have just had the studio remodelled—the ceiling removed & another window put in. It has made all the difference in space & light. Have started a portrait of Weston[2] & just about finished Macdonald[3]—by the way isn't it grand that Macdonald has the contract to do the big mural for the main dining room in the new hotel.[4] I was instrumental in getting him this & I am awfully pleased. dont [sic] mention it yet as he is only working on the sketches I got "the Studio" for 1939 but would like any 1938 numbers—will you have a look in Victoria—none here on newsstands, art shops or 2nd hand book shops. The Studio for Dec 1938. has Ma[c]donald's "Herring roe drying" Will look up Apollo. Do come over anytime you like. Best for 1939—

Nan.

NOTES

1 See *The Letters of T.E. Lawrence*, edited by David Garnett (London & Toronto: Jonathan Cape 1938), and T.E. Lawrence, *Seven Pillars of Wisdom* (London: Jonathan Cape 1936).
2 The portrait of Weston is in the collection of the BCARS, Victoria, BC.

3 Cheney's portrait of Macdonald is in the collection of the BCARS, Victoria, BC. **4** Macdonald wrote of executing the mural and added: "This mural is easily the best thing I ever did & it came along without too much worry even though it was most exhausting physically." UBCL, Cheney Papers, box 4, file 13, Macdonald to Cheney, 21 Mar. 1939. For photographs and description of the Macdonald mural (which has since disappeared) see Zemans, "Jock Macdonald," 92–4. A photograph of the mural had appeared in the *Vancouver Daily Province*, 20 Apr. 1939, p. 12.

88 [*Carr to Toms*]

316 Beckley St.
Jan 7 1939

Dear Humpty-Dumpty.

The policy came and I *do* appreciate it. Thank you ever so much. I hope you *won't* have to say. 'Told-you-so' but if you do I promise to take it 'sitting-&-smiling.'

Its an aweful lot. and I do hope you won't have to go on releif in consequence if so I'll give you a job as secretary.

I feel frightfully respectable being inshured. proud as a hen with a new leg band. stepping high and beak in the air.

Yours affectionately

Emily Carr

89 [*Carr to Cheney*]

Sunday
[postmarked 15 Jan 1939]

Dear Nan

Its yourself I'm due to write to. Indeed I started this A.M. before breakfast, but was cross and nasty for the moment & tore up the result, when read. Shirley did not get up & I'd been awake all night hence the 'pet.' It is one *glorious* day. Though we have not had bad weather all through some needed rain but mild and no snow. Well what do you spose? My Indian story M.S. turned up Dr Peirce [Pierce] wrote me they fell into a crate he was packing for Queen's Colledge. He said his staff turned every corner of the office over. finally his secretary suggested that crate & he jeered but wrote & they were located. so I shall get them back when he has read them again[1] and he is very releived. they were lost *I think* about a year and a half & cost much evil temper.

I expect you are working in your new studio to beat the band Old Weston was in last week. What a dredfully Self important old chap! I don't know how you can sit & paint him I'd have pip. he does nothing but sit & brag about *his* [underlined twice] tremendous importance in the Art world. He told me everything he belonged to & how it impressed the Vancouver Public & what they said about him. He's thrilled purple at being painted too.

Am so glad McDonald [Macdonald] got the mural. commission. & hope it goes well. Have you seen it? & do you like his design?

Have not been up to much the last week, very tired. Got up late, not before noon, & ready to go to sleep at 2, & to bed early. have had poor nights too. but I spose one gets these spells, & I'll liven up again. Have done nothing exciting nor seen any outstanding individual. just about got my 50 sketches mounted. don't know if I shall do another batch or not it is the only way to preserve them they are going brittle on the cotton backs, & do mount beautifully.[2]

Sister has been ill with a bad cold. on the mend now I hope she now has her Brael typewriter & is delighted. Goodness that stuff is awefull to learn [?] I *never* could if I was blind in 3 eyes. would just die of 'Pip.'

Been reading a book of Humphrie's [Humphrey's] all about prostitutes. there is a dash of salt life in it as well. Finished a couple canvases that have been on the way some while, & done some very poor writing. the thing is a bit obstreberous. & feeble.

Mrs Boultbee has been to the hospital & had her pin out & is more comfortable. Well I have no more to say & 3 or four letters more or less business to write, so will off.

Love, write soon & tell me how your work progresses. sory I'm so stale. next letter may boom and buzzz.

Emily.

NOTES
1 The manuscript was subsequently rejected by Ryerson Press.
2 See #81, note 4, regarding Carr's preparation of sketches prior to exhibiting.

90 [*Cheney to Brown*]

1282 Connaught Dr
Vancouver BC
Jan 23rd 1939

My dear Mr Brown.

It is some time since I last wrote to you & I thought you might like to hear what news there is of the Pacific Coast. We are all very pleased that Macdonald has a contract with the new hotel, to do a large mural for the main dining room—he worked on the sketches during the Christmas holidays & submitted three designs, all very good, I think—They gave him more or less a free hand using a B.C. motif & they are deciding this week which one they will take—

Goranson, Fisher & Hughes have completed 12 murals of B.C. for the San Francisco fair & have put them in place[1]—I have not seen

them so cannnot tell you what they are like—Fisher has the most talent, but Goranson has the push, so between them they are quite a good combination—

The Pioneers Assoc. of B.C. are talking of putting up a statue to the first settlers—Charles Marega[2] seems to have a corner on the sculpture here & the few others think the design should be open to competition all over Canada—or at least open in B.C. & have an outsider to judge them. I had a letter from Mr Gillson[3] asking about a show of Miss Carr's work in Montreal—I advised him to write to her direct as she is able to arrange it herself & is quite hurt if it comes through someone else—I told him about the show we had—the terms etc. & of course I will be glad to do anything I can, on the side—You know how hard Emily is to deal with & one has to be very tactful— She was furious with Mr Jackson because he wrote to me about the pictures he wanted of hers, for the San Francisco show—in fact they almost did'nt get them. I have been thinking lately about Miss Blod-wen Davies.[4] Dont you think it would be a good idea if she could come out & do a book on Emily Carr? She is one of the few people that I think Emily would like & it seems a shame not to get some first hand information. Miss Davies did a fine book on Tom Thompson [Thomson] from other people's views of him, and although Miss Carr's own stories are quite auto-biographical there is something in personal contact with her that no one can get who doesn't know her, and I am sure she would never let a man do it—I was going to write to Miss Davies but thought I would ask you first as you may have some-one else in mind.

Last week I went to the University Women's lecture on "Cana-dian Art". They had asked me about getting this out from the National Gallery & I advised them to do it. The[y] had about 100 women at the Gallery, all college graduates, and they were terribly disappointed in both the lecture & the slides—The comments were that it was not up to date (from Paul Kane to 1925 & the Wembley exhibition) & nothing about Emily Carr & the West—also the slides were poor, not coloured and very indistinct (the last may have been

due to the lantern)—I was rather on the spot & I assured them that there must have been some misunderstanding at the National Gallery etc. but I hope they have another opportunity to hear the latest lecture & see the best slides—

Have you heard of Miss Jessie Faunt?[5] She teaches art in the Point Grey junior high school. She is a sort of Anne Savage of Vancouver,[6] in a small way & against all sort of opposition, but she has made remarkable progress with her pupils & there are a few very promising ones—Peter Sager[7] age 19 & Arthur Erickson,[8] age 14 to mention two.

I have finished Macdonald's portrait & will send it to the O.S.A.[9] I did not write to Mr Jackson about the Doukhabor [sic] portraits as you suggested, as I really didn't know how, but Macdonald mentioned them, or the portrait of Emily & the one of himself for the Group show. Do you think Mr Gillson would like Emily's portrait when her show is on? or isn't that done? I have begun one of Mr Weston but am not making much progress due to interuptions however I have got to know him, & find him a most liberal and fair minded man—he is doing in the normal school what Jessie Faunt is doing at Pt. Grey. he keeps up to date & is unbiased, & all the artists like him which is more than can be said for Chas. Scott—

This is a rather long & quite gossipy letter is'nt it? I hope you are planning to come west this year—lovely weather now, just like spring. With kindest regards to Maude [Maud] & my friends at the Gallery.

Sincerely yours

Nan Cheney.

NOTES

1 The mural panels were for the BC Government Pavilion and dealt with aspects of BC's industrial, commercial, social, and recreational life. See #35, note 5. See also "Three Young Artists Paint Vancouver for the World," *Vancouver Daily Province: Saturday Magazine*, 25 Mar. 1937, p. 2.
2 Marega (1875–1939) was on the staff of the VSA from 1926 to 1939 (at periods part-time), and worked from a studio at 822 Hornby Street. He had served on the 1st Council of the VAG and for several other terms during the 1930s. Among

Marega's many public sculptures were the concrete lions for Lions' Gate Bridge, which were installed January 1939, shortly before his death.

3 In 1939 Dr. A.H.S. Gillson was a member of the council of the AAM, serving on two subcommittees under General Acquisitions: "Paintings (Canadian)," of which he was convener, and "Painting (Modern)." He was as well a member of both the Loan Exhibitions and Hanging Committees. See *Annual Report*, Art Association of Montreal, 1939. Professor Gillson was currently a Professor in the Department of Mathematics (later Dean of Mathematics) at McGill University.

4 Davies, a Toronto writer, had published *Paddle and Palette: The Story of Tom Thomson* (Toronto: Ryerson Press 1930) and the more substantial *A Study of Tom Thomson* (Toronto: Discus Press 1935).

5 Faunt (d.1971), painter and teacher, exhibited locally in the late 1930s. (She was to show three "Improvisations" in the BCSFA exhibition at the VAG, 9–25 June 1939.) As a junior high school teacher she is remembered by Arthur Erickson as "an unusual teacher in love with art," who exposed him "to the world of the impressionists and post-impressionists," adding, "it was as if a light went on. . . ." *The Architecture of Arthur Erickson*, with Text by the Architect (Montreal: Tundra Books 1950), 11.

6 A reference to the painter-school teacher combination. See #12, note 6.

7 Sager (b.1920) had shown his prints and sculptures at a VAG solo exhibition in 1937. See "Youngest One-Man Show in History of Gallery," 1 Dec. 1937, p. 5. An exhibition of his abstract prints was to be shown at the VAG, 26 Mar.-7 Apr. 1940. See *AGB* [VAG] 7 (Mar. 1940). In 1947 Sager went to Paris on a French government scholarship and became an internationally known expatriate artist, residing from 1951 mainly in London.

8 The work of Arthur C. Erickson (b.1924), internationally known architect, was first shown at the VAG when he was fourteen. See *The Architecture of Arthur Erickson*, 11. In 1941 he was included (as was Faunt) in the "Exhibition on Abstract Art" organized by Lawren Harris at the VAG; his "Forest" was awarded an "honourable mention" at the BCAA exhibition the same month. See *AGB* [VAG], 9 (Nov. 1941). Cheney was close to the Erickson family and followed Arthur's career with enormous interest, as evidenced by the Erickson clippings and memorabilia in the UBCL, Cheney Papers, box 6, file 7.

9 Cheney's portrait of Macdonald was shown at the OSA exhibition at the AGT, 2–29 Mar. 1939.

91 [*Carr to Cheney*]

Tuesday
[postmarked 25 Jan 1939]

Dear Nan.

And you had the cheek. to wonder if I *owed* you. I began to think mine had gone straying till you found it later on in your letter. I am shure your studio must be lovely. Edythe says it is. I had a letter from her same mail. I think you are right not to show unfin[i]sheds I never do but I *don't* think you are entirely right re: Edythe she spoke warmly said they had had a nice evening at your house. The studio was lovely & she thought McDonalds [Macdonalds's] a good likeness. I have always found her generous about anothers *work*. More perhaps than about other things like prestige. I used to be so snippy about Max & Jack & the beastly way they treated her, and she was always much more forgiving than I and very generous in her crits. of their work.

How nice for you to have your sister with you (Edith [Edythe] also remarked she liked them so much) how long does she stay? Glad the rugs are satisfactory. Have not started another yet seem to be very busy. & will be up to my eyebrow I guess as another big Ex. is in the air. Yes thank you I wrote acknowledging the check at *once* did it miss? also the gravel pits I can't see why there is a fuss about the mural McDonals [Macdonald's] seems to me the logical person he is a designer & I am shure his will be good. Who is Gail [Gaie] Taylor[1] do I know him or her?

Humphrey lunched with me, today. funny boy!

Well Montreal Art Ass. has asked me if they may put on a "comprehensive" of me in Montreal. and particularily my recentest don't quite know what it means yet. Said Eric Brown & Toronto Gallery had agreed to corroberate or collaberete, or celebrate or something so perhaps they will draw most from the East. will know more later.[2] have accepted & await instructions (for Spring) Have several canvases & a biggish Manuscript under way. Thank Heaven the days lighten somewhat.

Shirley has taken up a stenographers course. Of course it will take some months to get through. & I would not stand in her way they are all alike think Domestic work leads no where tho' she says she is very happy here She's smart enough to get through without much trouble tho the job may be harder to land.

Much love as always

Emily

write soon

NOTES
1 Gaie Taylor was a friend of Cheney from Nelson, BC.
2 Although preparations for the Montreal show were eventualy completed, it did not eventuate because of wartime restrictions. See #122. The AAM held its first Carr exhibition in 1943.

92 [*Excerpts Brown to Cheney*]

[*The 3 excerpts are taken from the Brown to Cheney letters in the UBCL, Special Collections Division, Cheney Papers, box 5, file 1b.*]

National Gallery of Canada . . .
January 30, 1939

Dear Mrs. Cheney,—

. . . . With regard to your portrait of Emily Carr, I should think the Montreal Art Association would be glad to have it hanging with Emily's show there if it comes off and I will see Gillson next month and try to remember to mention it to him. A.Y.J. said he would like to have the portrait for the Group Show, which he said was coming off this winter, but if nothing happens why not enter it either at the O.S.A. or the Montreal Spring Exhibition. If the Trustees consider it, as I am expecting they will, it would be better if it had been shown somewhere first so that the Royal Canadian Academy rejection was wiped out. Please advise me where you prefer to send it and I will have it forwarded.

I am sorry that the Canadian Art lecture is so very out of date. It

is difficult to get reliable people to write them and this has been under orders to be rewritten for a long time but pressure has prevented It. It will not go out again until it is rejuvinated. Satisfactory colour slides are only just becoming possible and available under this Kodacrome process and we are working to make it available in our own slide library.

.... By the way, Dorothy Livesay, I forget her married name,[1] lives in Vancouver now. She writes and is a great admirer of Miss Carr. She would not be so *sentimental* as Blodwen Davies (confidential)[2] and would be on the spot or thereabouts. Why not meet her? The Canadian Press, of which her father is the head, would give you her address. She and her father visited Emily last summer and came back full of her genius and wanting to do all kinds of things for her.

I am glad your portraits continue. Do send us the odd photograph of one or two of them.

Best wishes from everyone here.

Yours sincerely,

Eric Brown
[signed]
Director.

Mrs. Nan Lawson Cheney
1282 Connaught Drive,
Vancouver, B.C.
B/I

NOTES
1 Macnair.
2 "Confidential" added by Brown in his handwriting.

93 [*Excerpt Toms to Cheney*]

9 Feb. 1939

Emily is as pleased as punch with her Montreal exhibition and terribly busy mounting and framing her sketches and now she has nearly 100 on boards. I hope to be able to help her a little, later on when I am free. Have you seen Eric Newton's write-up on her in the February number of the Canadian Forum?[1] He is certainly a good publicity agent for her.

NOTE
1 Newton's article, entitled "Canadian Art Through English Eyes," was a review of "A Century of Canadian Art," 1938, in *Canadian Forum*, 18 (Feb. 1939), 344–5. Newton wrote (p. 345): "If the word 'genius' (a word to be jealously regarded by the critic and used only on very special occasions) can be applied to any Canadian artist it can be applied to her. She belongs to no school. Her inspiration is derived from within herself."

94 [*Cheney to Toms*]

1282 Connaught Dr
Vancouver BC
Feb 11 1939

My dear Humphrey

Your letter gave me rather a jolt—What on earth happened? You sound as if it was sudden. I have just written a note to Emily the first for some time as I have been busy with visitors & my arm is hurting from too much painting I guess—I am doing a large canvas of Gaie Taylor from Willow Point, Nelson B.C. She is awfully good looking & grand to paint, but two weeks, with other things on, means working against time. I have Macdonald ready for the O.S.A. he is in clover just now, as he starts the mural in the main dining room of the new hotel on Wed. & they bought another of his designs outright to be sent to

N.Y. & made in glass. I am so pleased that things are coming his way at last. So Emily is having a show in Montreal. They wrote to me about it first, but *don't mention* this to her as I told them not to tell her they had asked for my help [?] and advice—she is so touchy and would hate anyone else having a hand in it specially when she is able to manage it all herself—in fact she is very annoyed at me at the moment because I critisized Edythe Brand for rooting around my studio & judging unfinished work.[1] One certainly never knows quite how to take her [Emily][2] and I am like you, I don't want a feud started, so I have returned to my Pollyanna letters full of flattery, etc.

I cannot get the feb forum anywhere here but the library will lend it to me I had to give my paper on contemporary art 3 times to small groups such a bore for me but apparently it was a success. The Toronto Gallery have stopped sending me anything since Xmas—thanks for the C.N.E. Catalogue, I used the deffinition [sic] of Surrealism by Herbert Read for my paper. We have asked Ronald Jackson[3] to join the B.C. Soc. of fine arts—he works in a commercial art place here. Scott & his followers are having protest meetings about Macdonald getting the mural & so it goes, the usual rows—the pictures for the hotel are to be weeded out by Scott & go through Hood who gets 30% so some of us won't even have a chance. The feeling is very strong here & the B.C. Society has practicaly broken up over it.[4] Well! Well! do come here & get a job. We need some up & coming young men. I will give Macdonald your message—he & we should like to see you anyway—

Regards to your mother & smooth down Emily. When is her show due in Montreal? Daisy (Dodd)[5] seems to be leading Victoria a dance.

Write again

Nan

NOTES
1 An addition to the letter (presumably written prior to Hembroff-Schleicher

reading the correspondence in connection with her research): "(Edythe don't be upset, I can't remember this.)"

2 The name was inserted in parentheses by Cheney at a later date. Such additions suggest she believed the letters would be made public.

3 Ronald T. Jackson (b.1902), a Vancouver artist, had shown in BCAE annuals in the 1930s, winning an "honourable mention" in 1938. See *AGB* [VAG], 6 (Oct. 1938). He was a Director of Cleland-Kent Engineering Co. Ltd.

4 Little information has been found concerning a sale of paintings by local artists to the Hotel Vancouver. The minutes of the annual meeting of the BCSFA, held in December 1938, contain the following entry (but nothing of the rows): "The question of possible purchase by the new CNR-CPR Hotel next came up for discussion. It was moved by Mr. Hood and seconded by Mr. Macdonald that Mr. Sharp make enquiries in this connection with a view to ascertaining the hotel authorities' intentions. It was the general opinion of the members that every effort should be made to impress upon the hotel architects the desirability of purchasing work by B.C. artists if at all possible. This motion was carried." Vancouver City Archives [VCA], BC Society of Artists, Minute Book 1917–39, Add. Mss. 171, vol 1, file 1. See also #81, note 1. A clue to the fact that an exhibition did take place is found in a letter of Carr to Macdonald, 11 May 1939, possession of Dr. Joyce Zemans. Carr wrote: "I have not heard what happened at the dealers exhibition for hotel stuff did they buy much? Nan did say they had beaten prices. shamefully, too bad." In a letter 3 weeks earlier Carr stated that she hadn't complied with dealers' requests for paintings as she didn't feel equal to doing anything about it. "Mr. Hood," she wrote, "has pestered me for long to send stuff to him but I don't like dealers. their comission is so high & your stuff just gets knocked about, in their shops." Carr to Macdonald, n.d. [postmarked 17 Apr. 1939] possession of Zemans.

5 The name was inserted in parentheses by Cheney at an unknown later date. Daisy Dodd (Mrs. Arthur H.) was a Victoria resident.

95 [*Cheney to Brown*]

1282 Connaught Dr
Vancouver BC
Feb 12 1939

Mr dear Mr Brown

Thank you so much for your nice letter. I am enclosing the sticker for "Emily Carr" for the O.S.A. which you said you would forward—I am sending "Macdonald" direct from here to Toronto & have asked them to send them both back to you. I would like you to see Macdonald &

there is no hurry to send it back here. I am sending the Doukhabour [sic] portraits to the Montreal spring show[1] & I hope to have something for the water colour society—the Peppers offered me frames if I sent them matted, to them. I would like to have Emily's portrait shown in Montreal while her exhibition is on, but it may overlap with the O.S.A. unless it is rejected by them[2]—Emily is busy getting her exhibition ready & Humphrey Toms is helping her. he is a young man who is a great admirer of Emily's work & has taken out a 3 year fire insurance policy for her, on her house & pictures—this was his Christmas present to her as her cottage is of wood with open fires & stoves & other wooden houses very close. he could not cover the actual value but it would give her enough to live on for a time & get started again—of course hoping this will *never* happen. Thank you for the tip about Dorothy Livesay—as she is here, she would certainly be more suitable as it would mean months of work. Macdonald is beginning the mural this week. They are very pleased with his design, & have bought another outright which they are sending to N.Y. & it is to be made in glass. You will be surprised to hear that I have been persuaded to give some short talks on Contemporary Art, to small groups of women. I had a hard time to get the material as there are no books, and even the latest magazines are hard to get, but the articles in the Tor. Sat. night helped me & the Carnegie library have some magazines, but you cant take them out: however I managed to get enough with the Tate Gallery show as the highlight of 1938. You have no idea of the ignorance of the well to do people out here, as regards Canadian Art, or in fact anything later than Holbien [Holbein], and they are keen to know what is going on today. You will be amused at me I am sure, but I managed to interest people who would never go to a real lecture.

With kindest regards to all—

Sincerely

Nan Cheney.

NOTES
1 The Seminoff portraits were shown at the AAM exhibition held from 9 Mar. to 2 Apr. 1939.
2 Cheney's portraits of both Carr and Macdonald were shown at the OSA exhibition held at the AGT from 23 to 29 Mar. 1939.

96 [*Excerpts Toms to Cheney*]

18 Feb. 1939

I was down to see Emily on Thursday and again this morning and during both visits the subject of you and Edythe came up. In your last letter you asked me to 'smooth down Emily'. Well, there is really nothing to smooth down so you had better forget about it altogether. She sometimes confides various little rows and difficulties to me and I heard briefly all sides of the story and she wasn't the least concerned about it. I am not going to get tangled up in any feud. . . .

She is very busy just now and has got, I think, nearly 100 of her sketches mounted and roughly framed with quarter round, preparatory to a selection for the Montreal show. The time of the show is not definite yet as some sort of monthly meeting still has to be held to decide. She is getting quite excited about it and is very busy with Shirley, soaking off old sketches, in the bath-tub, framing them after mounting on plywood and doing quite a bit of writing on the side, so you will be lucky if you get a letter in the next week or two.

Do you remember her Indian stories that went to Toronto and got lost? Well, they turned up at last and she had just got them when I was there on Thursday. They had apparently been thrown by mistake in a packing case going from the publishers to Queen's University and someone in the office suggested they write to Queen's and lo and behold they were still in the case. Emily had of course given them up as lost and was plenty annoyed over the whole matter as she didn't have a copy.

She rang me up on Thursday and in a very severe voice asked that I should come to see her. I went down to Beckley Street in fear and trembling. You will remember that I had one of her big sketches, an Indian rancherie near Seton Lake? She and Shirley had been soaking it off in preparation to mounting it on 3-ply. She had previously rung me up to bring it down to be mounted and framed. It seems that Shirley had ripped it when taking it off and then had not told her, and had thrown the remains in the stove! Hence the command visit on Shirley's day off. As a matter of fact I never batted an eyebrow when Emily told me, and she told me to choose another. Of course I took a more modern one, of the gravel pits out at Metchosin, with a gorgeous sky. I had been to see her when she was camping there[1], so it has a particular interest for me. Shirley and she were really very upset as to how I was going to take it!

She is very well, I think, is working pretty steadily, and is blessing these winter days now that they are growing longer. Sometimes she gets tired and on Thursday, after the strain of 'fessing up'[2] she lost her voice a bit, which worried me, yet she didn't want me to go home, so I stayed for the rest of the afternoon and helped her frame.

She has framed some of the portrait sketches and has mounted all of them so we may be shown privately somewhere! She talks of washing out my face and doing it again which I think is a good thing. She fumbled many tacks and told them 'to go to the devil and sit on their hat' so often that I taught her to say 'bugger' in the Lancashire way!

NOTES
1 See *H&T*, 22 June 1936, for her reference to this visit. Toms later gave the sketch to the Art Gallery of Greater Victoria.
2 This was Carr's expression according to notes in Toms, "Letters to Nan," 3.

97 [*Carr to Cheney*]

316 Beckley St

March 2nd [1939]

Dear Nan.

How is the world the flesh & Devil going with you? Are you still working hard in your new Studio? You sounded very buisy what with visitors & portraits.

Have been very buisy myself. one way and another though I dont seem to have much result. still I have my aim 100 sketches framed & mounted which was a big job. & have been working on canvases as well. and writing. so I have really been buisy only I am slow. about it.

Nothing exciting has happened either vistors nor nothin'

No further news re: Montreal show. except that someone saw. a one man by Emily Me show listed in the Montreal Gallery news so I spose its a fact & will swoop suddenly.

It is beastly cold & horrid today cutting wind ctc no day for sugar girls like me to be out. Its Shirley's day off and I hate looking after myself. as to supper & getting ready for bed I am spoiled.

Next Teusday I am planning inviting 6 gikcs in to tea & view pictures. (nearly all Arts & Crafts Stiffs). I beleive some of same are at dagger points to the others. so the day *may* end in blood shed. Anyhow it will reek with sniffings but there you are. females are feline. it even comes out in Budgerigars. All the hens are fighting tooth & nail. stealing each other nests *and* husbands. its aweful. being J.P. in an aviary. I never realized till now the Parsons *do* earn their Marriage fees.

What is the show in Vancouver of B.C. Art[1] they are scratching up a coop of Island products. and came to me for two sketches. is it the regular B.C. Artists show? or a special conglomerate B.C. affair?

Nothing doing in the Garden yet. Mine is heavy and wet too wet for bulbs.

Well. I covet a hot bottle and my toes on it, and my book. "Out of Africa"[2]

Lots of love

Write Soon

Emily

NOTES
1 Carr was to be included in the "Six Local Artists" exhibition organized by Parker at the VAG, 4–23 July. Six artists were to show five works each. See VAG, Archives, for exhibition list.
2 Ruth Humphrey's travels to Africa seemed to have sparked Carr's interest in reading about it. A year earlier she had written to Humphrey: "Got a grand book—made me feel I was in Africa *with you*." [Humphrey], "Letters from Emily Carr," 118, 14 Jan. [1938]. *Out of Africa* by Isak Dinesen [pseud.] was first published in 1935 (London: Jonathan Cape).

98 [*Excerpt Toms to Cheney*]

17 Mch. 1939

Emily's maid Shirley, is probably going to leave her soon so she will have to get someone new. I think Shirley has been quite helpful and friendly considering that Emily is really a little out of the ordinary and probably sometimes a little crotchety although usually in a nice way. Not every young girl would have stuck with her as long as this one, but she had her drawbacks in other ways which grieved E a lot.

99 [*Excerpt Toms to Cheney*]

21 Mch. 1939[1]

I am afraid Emily is in St Joseph's Hospital again, since a week ago today. She had been having trouble with her maid, Shirley, and was

interviewing girls to get a new one, then had a final row with Shirley which brought on the attack.[2] It was not the first row she had had with her! I was allowed to see her yesterday afternoon for a few minutes and she seemed better, says the heart pains are not so bad, and doesn't have so many drugs. She is thinking about moving to her sister's house at 218 St. Andrews Street, next week. I don't think it's at all serious though it may mean no painting this summer which will make her despondent.

NOTES
1 In Toms' 1956 typescript this letter was mistakenly dated March 1940. Toms, "Letters to Nan," 4.
2 Carr's second heart attack resulted in nearly a month's stay in hospital.

100 [Excerpt Toms to Cheney]

10 Apl. 1939

I have just been to see Emily and found her very cheerful and ready to go *home* to Beckley Street this afternoon. She was to have gone to High Mass in the hospital chapel Easter Sunday morning but as she got into a wheel-chair she felt unwell and didn't go after all. She had evidently seen Edythe and had heard about Eric Brown's death[1] and was rather upset about it. Emily has a sick dog and a newly hatched nest of birds to look at after she gets home so she won't be too lonely, and she thinks she is going to like the new girl.[2]

About a month ago I met a young couple named Webster at Emily's, she an artist, he a newspaper publisher in Port Angeles. I was pleased to see Esther Webster's[3] one-man show in the Fuller Art Museum on Good Friday when I was down in Seattle.

NOTES
1 Brown died 6 Apr. 1939.
2 Toms notes in "Letters to Nan," 4, that the girl's first name was Blanche.

3 Esther Webster (b.1902) was a Pacific Northwest artist who had exhibited at
the Seattle Art Museum in 1939.

101 [*Carr to Cheney*]

Monday
[postmarked 10 Apr 1939]

Dear Nan

I came home today feeling pretty chewed up. Got your this A.M. in
hospital and feel dredfully about Mr Brown Edyth[e] mentioned
casually she had seen it. or *thought* she had in Province. & I refused to
beleive till I heard from some shure source not knowing him she had
not noticed very keenly. Do you know any particulars or when he
died? A few weeks agoe I had a long & most lovely letter hand written
& very long, answearing immediately one I had written him. It gave
me more pleasure than most any letter I ever received.[1] He made some
suggestions to me that I had answeared & I doubt if he got the letter.
before he died, & I suppose that miserible McCurrey [McCurry] will
get the letter. I wonder who will take Eric Brown's place. I hope not
McCurrey [McCurry]. he is a bounder & not an Artist, in feeling. Mr
Brown came of an Artist family Arnsely [Arnesby] Brown[2] a brother if
he was not a working artist he was one in heart & I think he loved that
National Gallery he wrote about it in his last letter. I am glad I got
that letter, he did a lot for me.[3]
 Am so glad you enjoyed your trip I got your letter from S.F.
 Am better have to keep to bed for a while. even now I'm home. so
it rather puts Kibosh on work. not equal to it though so spose it
doesnt matter much have a new girl to break in, which is rather
desolate doing it from your bed. Poor child had to start up in an
empty house she's a mudler. but time may help she is not a bad

youngster, & likes the beasts.

There is all the spring doings, waiting. birds & garden etc.

Won't write more now. tell me about your trip,

Yours

Emily.

NOTES
1 As the letter was handwritten there is no copy in the NGC, Archives, and the original has not been located.
2 Arnesby Brown (1866–1955), English painter, later Sir Arnesby.
3 In a letter to Maud Brown, Carr wrote: "I owe him so much for I was overwhelmed by dispair about my work when he came out West [1927] and pulled me out and made me to start again." See NGC, Archives 7.1 Carr, E., 11 Apr. 1939. See also Carr to Macdonald, 17 Apr. 1939, possession of Joyce Zemans.

102 [*Carr to Cheney*]

Home bed Monday
[postmarked 17 Apr 1939]

Dear Nan

I dont seem able to gather head or tail out of this. Hotel picture buisiness. had a letter from McDonald [Macdonald], one from McPhearson [Macpherson][1] & Hood & now one from Tyler.[2] Whats it all about? Agents of course are all for your sending in & their getting a rake off. Apparently, the others are for your dealing with Hotel C.N.R.[3] direct but can one? I do not see *why* dealers should butt in though it is understandable, that if there was a showing it would be easier for the C.N.R. to see what there was to be had well anyhow I don't feel up to the bother of shipping. & worry. so guess I'm out

I'm still in bed Dr says not to get up till I have had 3 days without

pain went two days but pains again last evening so am back to start. & feeling very slack into bargain. New girl is fair. I like her but she is slovenly & needs some one after her & its not easy from bed & she lives so far that she gets home very late on days off. always something still I hope we will adjust in time, I'm trying to be patient. done quite a bit of read and write, but am very lazy somehow. I'd darn well be glad of some sales new hospital bill & Doctor etc but I'll take chances. Is McPhearson [Macpherson] the man you once wrote was coming to see me? What galleries has he in Vancouver? Old Hood I've never met but he is a pesterer, & too keen on comm[i]ssion. so I've never bothered with him. I do not beleive in the enormous prices many Canadians put on their pictures. I think if picture prices were kept *moderate*, people would buy more & appreciate we are not old masters. Bess says it['s] worse in the states the price is expected to come down to 1/5 [?] of that asked. well. thats silly. ask a *fair* & stick to it say I. Are you sending in to the dealers exhibit?

Been lying on Veranda for a bit today lovely out there. quite hot

Yrs.

Emily.

NOTES
1 Ian Macpherson was owner of the Cluny Galleries, 555 Howe Street, Vancouver.
2 Gerald Tyler (1897–1983) was then an elected representative of the Council of the VAG (1936–45), and Honorary Secretary of the BCSFA. It was probably as an officer in the latter that he was writing to Carr.
3 As the original contract was with the Canadian National Railway [CNR], the hotel was generally referred to at the time as the "C.N.R. Hotel." See #81, note 1, and #94, note 4 re the question of picture sales.

103 [*Cheney to Toms*]

1282 Connaught Dr

Vancouver BC
April 30 1939

Dear Humphrey.

Thank you for the Picture post, & your note of some time ago. I am wondering about Emily & her Montreal show. I wrote to Lillias [Lilias] Newton to inquire about it but no word so far & I dont want to write her until I have some news of some sort. Macdonald & Henderson, the chief designer of the hotel may go over & pick some of her pictures—In fact they may be there now, as I have not heard from MacD. [Macd.] for a week & he now has a car—lent to him for the summer by Mrs Clegg[1]—nice of her wasn't it? Did you see Macdonald reproduced in the ap. Can. homes & Gardens—badly done but will give it wide circulation. Are there any jobs in view? I enclose a clipping which I would like returned—at least I am not at the end in the also ran.

In haste

Nan

NOTE
1 Mrs. E.B. Clegg, a Vancouver resident, was a valued friend, supporter, and patron of Macdonald.

104 [*Carr to Cheney*]

May 8 [1939]

Dear Nan

I was wondering *when* you were going to answer my letter. You leave it

for so long you forget you ever got it.

I have been going to write & thank you for the catalogue but thought every day a letter would probably come from you, but now thank you very much I was *most interested* & very glad to have it. I got a water color off to N.Y. last week & hear I am to be called on for a couple of oils later they are running the N.Y. shows in relays of 6 weeks each,[1] and different groups showing. not a bad plan if they are crowded

The Loan society sent me a Check after I threatened them a lawyer's letter Mr Duncan[2] wrote me a very mad letter, keep clear of that outfit

Mr McDonald [Macdonald] sent me a photo of his mural very interesting & in color must be even better. Sheila Boyd[3] brought it & has asked to come again she had friends waiting.

I had a nice letter from Mrs Brown. Mr Brown was only ill a week & had a very peaceful end. she wrote such a nice unaffected letter about him is going to live on in Ottawa in a house or flat.

Mrs Duncan[4] was quite nice. Don't think I only want visitors with money in their pockets. I am always pleased to see interest*ed* and interest*ing* people.

Am feeling better last few days. up to a week agoe did not seem to gain a bit since hospital, but may be now have started to pick upward.

I see Mable May[5] is having a show in Van Gallery what are her things like. I fancy they are good??

who Are you painting now? your maid seems to be having a long holiday.

Come over when you can, & don't wait till you have *big* things to write about little ones interest me too.

Aff. yours.

Emily.

Had letters from Pepper & A.Y.J. Thanks again for Catalogue.

NOTES
1 H.O. McCurry, Acting Director of the NGC, explained in the foreword of the catalogue for the "Exhibition of Canadian Art," New York World's Fair, 1939, that the decision was made to hold a series of exhibitions arranged through the five chartered art societies of the Dominion, to last six weeks each. Carr showed in the exhibition of the Canadian Society of Painters in Water Colour, 10 June-31 July; and the CGP, 1 Aug.-15 Sept.
2 Douglas Duncan, a Toronto art patron, was an initial member of the Picture Loan Society, which was organized in Toronto in 1936. See #39, note 1. Duncan assisted the Society financially, provided sponsorship and encouragement to numerous artists, and carried on the administration of the co-operative venture virtually single-handedly. See Alan Jarvis, ed., *Douglas Duncan: A Memorial Portrait* (Toronto: University of Toronto Press 1974).
3 Sheila Boyd (b.1925), a Victoria painter, was Supervisor of Crafts for the Victoria Kiwanis Club Association. She was sketching companion of Macdonald and Cheney on the 1938 trip to Garibaldi. See Nicholson and Francis, "J.W.G. Macdonald," 13.
4 "Possibly a woman mentioned in a letter of Edythe Brand to Carr, "The Mrs. Duncan here [Ottawa] who takes Varley under her wing is a friend of hers [Cheney]." BCARS, Parnall Collection, 1 Apr. 1944.
5 May (1884–1971), a Montreal landscape painter and an original member of the CGP, exhibited at the VAG, 2–14 May 1939. See *AGB*, VAG, 6 (May 1939). Mabel May moved from Montreal to Ottawa to run the children's art classes at the NGC, 1938–47, and retired to Vancouver in 1950, where she died.

105 [*Cheney to McCurry*]

1282 Connaught Dr.
Vancouver B.C.
May 13th 1939

Dear Mr McCurry

I expect you have been swamped with correspondence since Mr Brown's death so I hesitate to bother you with my small affairs—I told the O.S.A. to send "Emily Carr" & "Macdonald" to the National Gallery before sending them West again—In the meantime the O.S.A. asked for "Macdonald" for a Hamilton show. If you do not want them

would you send them out in time for the B.C. Society show which opens June 9th[1] Mr Brown spoke of the possibility of showing "Emily Carr" in Montreal when her own show was on, but apparently that has not come off. he also spoke of the possibility of the Gallery buying her[2]—If there is any chance of this or anyone else being interested, I of course dont want either of the portraits back. I have one of Weston nearly finished & one of Miss Gaie Taylor—not commissions of course—with kindest regards to all

Sincerely

Nan Cheney

NOTES
1 Five portraits by Cheney (including those of Carr and Macdonald) were to be included in the BCSFA exhibition at the VAG, 9–25 June 1939.
2 See #51. McCurry answered Cheney's letter stating that "nothing can be done about it here at the moment, but I will keep it on my list of works to be submitted to the Board and may ask for it back later on." UBCL, Cheney Papers, box 5, file 1b, McCurry to Cheney 17 May 1939.

106 [*Carr to Toms*]

[postmarked 17 May 1939]

Dear Humphrey

Enclosed find and thank you very much. indeed. Enjoyed Sunday's drive immensely a [&?] fellt that better of it.[1]

Yours

Emily Carr

NOTE

1 Toms has noted that the amount enclosed was $1.00 and that Carr insisted on paying for gas (35 cents a gallon) when he took her for drives. See Toms, "Letters from Emily," 3.

107 [*Carr to Cheney*]

7:30 Saturday
[3 June 1939]

Dear Nan

Waiting for my breakfast—nice day—am planning an exped[i]tion to house hunt—BORE! but there you are. I do feel I need a little get-off from my 'heavy-house-work' and society ructions. (not had a soul seen a soul, or smelt a soul in months). well, the difficulty is finding. I am getting a U. drive car and *not* me-driving. Humphrey is doing the wheel, & my sister & friend going along, & we are tooting off to hunt I've a notion I'd like inland this year. a lake perhaps & hope Heaven will drop one into my mouth, woods are what I pine for.

I went to the water-front & saw the King & Queen[1]—They made so much to-do about going to be *shortage* of food & rooms that people got cold feet & did not come so many as were expected. & grand stands & room renters had all their work for nothing serves their greed right they skied prices. even the hotels I believe were not full.

I got a ream of invitations for the B.C. fine arts. I did not know till then they were having a show maybbe I'd have sent too late now is it one of these pay-a-dollar & be juried shows?

Yes I wish you you were coming over to help me house hunt. Last years houses are both full I'm mad with those people too. I wrote asking the *mob* of kids to get me moss for the chipmonks said I'd pay .50 per two sacks it is thick round there & they deliver milk round here so it would not have cost anything for delivery to them. took

them a *month* to deliver & then a nothing but *mud* no moss. & then I had to write & phone *twice* each. really these people are too sloppy to exhist. the youngsters can't stir a finger for pocket money. I'd like to have seen me offered .25 for a bag of moss that would take 5 minutes to collect.

Humphrey is gardening & very happy!

You will have a buisy summer with visitors. I am getting away now because. Alice has a guest from New York. & won't be alone. & after her school closes she is doing some alteration to her house and may need help. (in advice not manual. besides in July & August the places get so beastly full & noisy & *dear*. Have painted a bit last 2 weeks. also writ. hard trying to put something over before summer is through, & quite a mouthfull.

I am glad you are on the Gallery Board.[2] Maiden among the Jacks. Hope Edythe will come over sometime don't seem to have anyone to cheer me these days Flora has sick brother, Ruth away, Margaret rushing round to conferences, all over earth Humphrey working. My sister entertaining her friend who is also a sick girl so I've beached quite high & dry. feel like a boat being scraped. Will Aunt Mary be able to give you a corner in her smaller flat when you come over now? I have the studio couch but it is not very roomy one must be slim.

Affect Yours

Emily.

NOTE
1 King George VI and Queen Elizabeth were in Victoria 30–1 May 1939.
2 Cheney was an elected representative of the Council of the VAG (1939–42).

108 [*Cheney to McCurry*]

1282 Connaught Dr.

Vancouver BC
June 3rd 1939

My dear Mr McCurry

The portrait of Macdonald arrived about a week ago & I just took it
for granted that they had let you know—Apparently they entirely
forgot about sending it to you so when it was finished with the
Hamilton trip it was sent out direct—I am so sorry you have had so
much bother about it—I was beginning to wonder about "Emily" but
I am sure it will be here on time—by the way I heard through Prof. Ira
Dillworth [Dilworth][1] that Mr Allan [Alan] Plaunt[2] was interested in
the portrait of Emily—& he told Prof. Dillworth [Dilworth] that he
would consider buying it if the National Gallery did'nt—Have you
heard any rumours of this sort?[3] Thank you for sending her prepaid—
Kindest regards to all.

Sincerely

Nan Cheney

Thought you might be interested in the Art Gallery Bulletin

NOTES
1 Ira Dilworth (1885–1962), at the time, was on leave as an associate professor in
the Department of English, UBC, in order to serve as Regional Representative for
the CBC. (In September 1939 he resigned from UBC to continue with his radio
work.) From 1939 on, Dilworth and Carr were friends, and their correspondence,
now in the BCARS, Inglis and Parnall Collections, reveals the closeness of their
relationship. In 1940 Dilworth became Carr's editor, in 1941 a Trustee of the
Emily Carr Trust, and later, literary executor of Carr's writings. See #216, note 2.
2 Alan Plaunt, a wealthy Ottawa citizen, was involved in various concerns pro-
moting Canadian nationalism. He was currently a member of the original board of
governors of the CBC (1936–40). See also #201, note 1.
3 In McCurry's reply to Cheney, he stated that he had no recollection of Plaunt
expressing a desire to purchase the portrait. See UBCL, Cheney Papers, box 5, file
1b, 7 June 1939. Plaunt, nonetheless, did buy the portrait.

109 [*Excerpt Toms to Cheney*]

8 Jun. 1939

I took Mother and Emily for a drive in a U-drive two weeks ago after which she was very tired and glad to get home. The following week I dropped in without warning and was greeted at the door by an Emily with a frown on her face and brushes between every finger, so she has started painting again. Then, a week ago she phoned and asked if I would hire a car and take her out house-hunting in the country as she wanted to do a little sketching. So on Saturday she and Sister Alice and I drove out to Langford[1] in a drizzle and drove around for a couple of hours. We discovered one clean, empty shack with a 'For Rent' sign up and walked in through the unlocked back door. It's on level ground and lonely, so she can walk for nearly half a mile without bumping into her neighbours. I heard today that she got off safely, but it was a horrid wet afternoon, so she wouldn't like that. She plans to be there a couple of weeks and a little longer if everything works out all right. She has a new little maid called Blanche—brainless but obliging so far as I can gather, so she is in good hands.

NOTE
1 Langford is on the western outskirts of Victoria.

110 [*Carr, Langford, to Cheney*]

[Langford]
Monday
[June 1939]

Dear Nan.

Yes I'm in camp and so happy to be camping. again.[1] My old house is very comfortable. it had an old cupboard and two tables all the rest I had to bring but it all got into a small van and is very cosy. there are six rooms we only use 3 a kitchen Blanches bedroom & a big dining room (my room) wooden wanscott to hang [?] things on big window almost due north. lots of air. and looking out across rough field swamp were [where?] frogs sing at night, and pine trees with broom showing through. we are completely private wide space all round. sheep bells tinkling & ewes & lams blaaing to each other, real rural and yet, only 10 minutes walk for Blanch[e] (not me) to P.O. & general store. we have a large wide veranda both front & back eat & sit there when not in bed and a camp stove (built under my directing) plum in front of steps, which cooks beautifully, & B. doing well on the job. I have spent most time in bed, but today sketched somewhat from the veranda I took my Monday on Sunday can't walk any distance at all without pain but hope with rest it will ease up. the ground all round (as far as I shall walk anyhow) is level, and for all this I pay $7.50 for the month of June though I did not come out till 8th I have to be home beginning of July. 2 exhibitions to ship to. I was sory not to send to B.C. show but did not get notice in time at least I have no recollection of any notice, coming before. Tell me *when* did I *become a life member?*[2] and did I know? it was quite a shock unto me all I know about was being an anual member (out of town) of gallery. 2.00 per year If I was ever made one I'm shure I never acknowledged it. We get up early or (at least B. does) & gives me breakfast round 6:30 & so far we have used neither lamp nor candle. today is first day I have really got up, have been in & out of bed & cot on veranda in gown. Edith [Edythe] & Fred came out to see me & I have invited them to supper on Wednesday. They have their toy car with them. I had a letter from Ira Dillworth [Dilworth], said he'd met you & liked your portraits. I hear there is yet no successor to Mr Brown. have had a couple of letters from her she is going to live in Ottawa still. The dogs & Joseph love camp

You have a buisy Summer ahead. looks as if I shall not see you till

Aunt M. next goes Sollying unless you bunk on my studio couch, and I dont know that that would be comfortable enough. Springey but narrow You need something more comfortable with that shoulder.

How nervy one is first day out sketching for a year there seems so *much* of everything. & too much light. last year I had been out in McDonald [Macdonald] Park working before I went to Telegraph but not this year & I cant walk as much as I did then havnt caught up from Hospital yet.

Humphrey drove me out to hunt house I got a U. drive car & Miss Sister & her guest & H. & I had a picnic. he drove very well. Brought billions of books out but all poor seemingly. We are very hungry out here alas for waistlines.

It is now time I applied myself to beauty-sleep.

Bon Soir.

Emily.

P.S. Teusday Had an aweful night of Stomache thought I'd have to go home little better today but in bed again its a pest to be so wormy and I grudge not being able to work. Edythe ran out to see me today. Blanch[e] has one of her multi-lovers out visiting today—a curse—her lovers are. such mongrels too. I have not seen this one. being barricaded into my bedroom he is Steward on a boat mostly she runs to Butcher & fish market delivrees.

I observe something in a palee blue silk effect, which I spose is B's jimmy crossing the field. she's making him lug & chop. An ultra shiny car *with radio* embellishes my front. B. herself is encased in sky blue *slacks* and a morie silk bolero of royal blue, with various sweaters, shirts & Brief bathing suits below. and dowdy old me lies in grey coarse blankets on a rusty spring cot. well they're young & still gloat in cuddling. Oh Lor!

Well I will finally close. I feel like a cat with her tail singed.

Aff yrs

Emily.

NOTES
1 Because of Carr's illness earlier in the year, this was her first sketching expedition of 1939.
2 The proposal for Carr's life membership in the BCSFA was confirmed at the annual meeting of 7 Dec. 1938. VCA, BCSA, Minute Book 1917–39. See also #38, note 4.

111 [*Carr, Langford, to Toms*]

Monday
[postmarked 19 June 1939]

Dear Humphrey

Lovely out here & the habitation completely successful, weather less so—Mondayed on Sunday to fool the rain. In bed most of 1st week done quite a bit of work nothing breathtaking some scribbling also. Air excellent and appetites unfortunately (for waist line) large.

Complete privacy—frog music at night—I am peppered with bites few mosquitoes but those wee no-see-ums and the whole Royall family of Ants—who have all cut their teeth.

One of your lady freinds called this A.M. Dist. nurse I beleive, I was out labouring, & did not see her.

Come out Sat or Sun whichever suits you best.[1] its our last week end.

We don't leak except chimneys. a family of young rats live in the field under my window pretty ones who live on the hay. I have the big dining room for bed-studio better studio than at home.

Hope to see you week end

Yrs.

Emily Carr

NOTE
1 Toms and Flora Burns both went out to Carr's camping site on the Saturday: Burns by bus and Toms by bicycle. Toms had taken his Brownie box camera and recorded the event. See Toms, "Letters from Emily," 4.

112 [*Carr, Victoria, to Cheney*]

[Beckley "St."]
Saturday
[late June 1939]

Dear Nan

Expect you are 'hecticing' with Summer guests, and down to the bone exhausted. which are the most exhausting the young or the old? I came in from Camp yesterday the man truck-devil kept us 1 1/2 hours waiting packed, which rendered one of my poor temper very grousy as well as tired. & today I'm a rag. woke at 5:30 but had an hours nap and am a bit smoothed out. I enjoyed the 3 weeks mightily poor weather & any other poornesses included. I beleive I wrote you from Camp? I did not write many letters. devoting myself to painting when fine & correcting M.S. when wet, & got a lot of work done.[1] It was deliciously quiet & peaceful, the cottage so bare & refreshing after my choked up abode not a picture in sight. I had 3 empty rooms to scuttle sketches into as perpetrated. when fine sometimes even when it rained. the girl broght our dinner *hot* to the woods. so I did not have to walk twice at the back was a logged off clearing at the front a wood with great yellow green moss rocks. never saw a soul. it was mine I rented the 15 acres for 7.50 the 3 weeks wasent it lucious?

Beckley feels stuffy and the kids faces dirtier than ever, & I miss the camp smoke taste in food. My garden is full of bloom though, & all the new baby birds are entrancing all so wild and unacqua[n]ted with humans. only saw a girl for 3 minutes at 7:30 each morning. I don't even know who belongs to who as all came out of holes after I left.

Just heard from Ira Dillworth [Dilworth] Dr Sedgewick has consented to be reader of my Indian stories. over air,[2] date as yet unknown. says Dr S. agreed *entheustically* to do so. wont it be funny to hear ones thoughts spouted out of no where? thinking aloud like. will let you know date, if I know it. fancy it's not till Autumn. Thought you were one of this 6 group showing in the gallery why aren't you?[3] got a card with names of showers today & was very surprised well. perhaps you have a private show up your sleve?

Don't guess you'll have much time for Paint this summer. I am shure my trip [h]as done me good. I look like a cocoanut & need a few days rest to find how fit I am underneath, though I Might have Smallpox I'm so mosquito bitten, & scratch like a dog. I think July & August in that spot would be pretty nippy. there was a small lake or rather reedy pond. Can't you come over when your guests go? I think the studio couch will be pretty comfortable will tell you after Ruth Humphries [Humphrey] has tried it out she has her flat rented for summer & is coming a few days in 2 weeks time for dentist work

Edith [Edythe] looked into camp 3 times (found me in bed each time) It was nice to see her she is doing more study this summer. hope she won't over do.

What do they charge for renting that gallery?[4] (one I had before.) I *might* put on a show later.

Look forward to working on my sketches—some nippy ideas. write soon.

aff yrs.

M.e.

NOTES
1 For examples of work executed on this trip see Shadbolt, *The Art of Emily Carr*, 160, catalogue entry 142 (*Forest Landscape I*); and 167, catalogue entry 154 (*Langford, B.C.*).
2 Carr's stories were broadcast on 29 Jan. and 5 Feb. 1940. See *H&T*, 315, 8 Feb. 1940. In two later broadcasts of 1940 and others of 1941 and 1942, Dilworth was the narrator. On 29 Feb. 1940, Dilworth wrote to Carr (BCARS, Parnall Collection): "I do think your sketches should be published. We had a great many interesting comments on them. A great many more, I should say, than we have had on any other talks or readings."
3 Cheney had exhibited in the "Six Local Artists" exhibition at the VAG, 12–27 July 1938, not in 1939.
4 See #66, note 1, regarding exhibition fees.

113 [Excerpt Toms to Cheney]

7 Jul. 1939

Just a line to enclose some snaps of Emily which you may keep. The shack is the one Emily rented. There were three young rats there which disported themselves outside her window and delighted her, hence the name Rat Hall,[1] also named because the next property, permanently inhabited and kept tidily, goes by the grandiose name of 'Lark Hall.' The lady on the steps beside Emily is Miss Flora Rhodes [Burns][2] who works in the B. of Montreal. Emily had spoken of her often, and she seems to be an old friend. Emily seems very pleased at what little work she was able to do. I have only seen one sketch.

NOTES
1 Named by Toms. See Toms, "Letters to Nan," 5. See also Hembroff-Schleicher, *Emily Carr*, 138. Toms is quoted regarding his bicycle visit to Carr's camp at Langford: "She told me with glee that she had well behaved rats as co-tenants so I promptly christened the shack 'Rat Hall.' " Toms took a photo of the cottage, which is reproduced on p. 56 in Hembroff-Schleicher's book.
2 Ibid., 1. Toms wrote: "Forty years later I don't know why I referred to Flora Burns as Flora Rhodes, but it was only too easy at the time to confuse the names of Emily's maids as they were changing continually and some I barely saw." Toms, "Letters to Nan," 1.

114 [*Cheney to Toms*]

1282 Connaught Dr
Vancouver B.C.
July 10th 1939

Dear Humphrey.

What is this about you buying a Picasso for $4.50?[1] Edythe Brand told
me but she was very vague about the details. I am delighted that you
were the one to get it, but I cant imagin[e] how it ever happened to be
in Victoria. Thanks for your letter with the snaps. Very good of Emily
& she writes that she got good work [done][2] despite the weather & has
come home full of "nippy" ideas. She wants me to pay her a visit &
sleep on her studio couch, but I would hate to risk our friendship as I
am sure such close quarters would be too much for us both—however
when Aunt M. goes to the Solley's [Sollys'] in Sept. I can stay in her
flat—I hear Daisy is there now until Aug. I met your aunt with Miss
Sanderson at the opening of the B.C. Soc. show. The "six local
artists" show is dull except for Emilys five sketches, altho I did like a
portrait by Alexander[3] called "Deckhand" which I had seen before—
Edythe had a well painted still life but not thrilling. The books of
tickets are out for the Sept. drawing, and we hope to sell twice as
many I am on the purchase & Acceptance Committee—also the
prize drawing—Macdonald & Weston are on the exhibition Commit-
tee but its pretty hard sledding against the old idea(s) specially as they
hold the money bags. Macdonald & family have gone to Calif. in a
little car loaned to them for the summer by Mrs Clegg. Weston is
building a house on 52nd with the whole top floor a studio. How are
you liking the insurance business? It sounds awful to me & the ones I
know are hard boiled & rich—apparently you cant be a success unless
you are h.B. I am giving some portrait lessons to Jessie Faunt &
another school teacher—I go over to Jessie's studio in Capilano Can-

yon 3 times a week & really enjoy it. They pay me too, strange as it seems. The Jones' were here for tea & supper yesterday & are in Victoria for a few days—expect you will see them. Mrs Goodland— Llewelyn's sister—very nice. I have two nieces—age 9 & 11—with me,[4] & we have been doing the town. They are thrilled with everything so its quite a treat to take them around. They go to Crescent beach on Frid & Aunt M. returns until Aug 1st needless to say I have not done any painting. You see I belong to the soft boiled class & will certainly never be rich. Marius Barbeau has been here & as funny as ever—had a *pink* home spun (Canadian) suit on, & blue rayon tie & his hair long—he has gone north for 3 months—Emily told me that Dr Sedgewick is going to read her stories on the air—Mr Dilworth arranged it. I missed doing a portrait of Dr Klinck[5] as he wouldn't have a woman Paint him—ha!

Nan

NOTES
1 Toms had come across a Picasso print in a second-hand sale and recognized its value. Late in life the work was sent to a friend in England. Information from William Toms, Vancouver, nephew of Humphrey.
2 Inserted in square brackets by Cheney at a later date.
3 Robert S. Alexander (1916–74), a Vancouver artist, had exhibited in BCSFA exhibitions since 1936. He was employed at the David Hall Sign Co.
4 Carol and Nancy Wright (now Birtch and Antonacci) were visiting from Trail, BC.
5 Leonard S. Klinck was President of UBC from 1919 to 1944.

115 [*Carr to Cheney*]

Monday-in-Bed
[July 1939]

Dear Nan

I was thinking I had answeared your last, but you are right. I've been rather wriggled. had to rest up after camp—for I worked pretty hard out there, making most of opportu[ni]ty (when weather permitted). then some friends came from Vancouver a week agoe Sunday and I was persuaded to spend a long day at Patricia Bay & that just exhausted me. 11 A.M. to 1/4 to 10 P.M. the long drive. a lot of cackling I was wordless. for 2 days after then my maid left (by request). after camp she was *impossible* a new lover one & *two* letters from him *every day* to be answeared. & so filling her head she could think of *nothing* else *forgot* vegetables for dinner forgot toast for breakfast (I don't have anything else.) forgot tea for tea & the house like a piggery. I then found all the girls were off, berrypicking. My add brought only half a doz impossibles till a Pa and Ma brght a child of 14 & begged me to give her a try & teach her. she is doing splendidly so far more competent in many ways than my two last girls, but of course she is only a child and I cant put too much on her, but she is nicely brght up bright & very capable. They asked me to "Mother" her, so its Ma, I am now. & I like the youngster She cooks quite nicely & keeps her kitchen nice too the last was *so* slummicky. Edith [Edythe] said your little girls were so nice, and am so glad you enjoy them Suppose Aunt M. is with you again by now. Yes you can have the pictures shure. I sent over 8, 2 small canvases & 6 sketches but I beleive Grigsby only hung[?] 6.[1] one is sold. so as not to overcrowd[?] space I thght the small ones would hang double & break the monotony of even size.

Have told Mr Grigsby I'd like the gallery in Nov. that is if Comittie permit.

Ruth was down & told me the bed was most comfortable it is in my front sitting room, & I'd love to have you in it, any time.

So old. Marius did not honor me. Guess I'm a past number. Sory. Old McCurrey [McCurry] is liable to step into Mr Brown's place, I suppose Old Weston in teaching in Vancouver Summer School this year he is usually over here, & gives me the pip by a visit.[2] Am getting canvases primed & ready (job I hate) Shall be buisy getting ready for Nov. now. Fog now! I hear the horn looks as if next winter will be

here before this Summer or perhaps the world has taken a twirl, and we are now antipodees. How many pupils have you? Do you enjoy them? I keep having the odd, strange visitor none exciting so far.

Much love

Yours

Emily

NOTES
1 A reference to the "Six Local Artists" exhibition (4–23 July) in which *five* Carr paintings were hung.
2 It was Weston's practice during the 1930s when he was teaching at the Summer School of Education (Victoria) to take his students to Carr's studio to view the paintings and have tea. See Anthony Rogers, "W.P. Weston, Educator and Artist," unpublished PH.D thesis, UBC, 1987.

116 [*Excerpt Toms to Cheney*]

1 Aug. 1939

Went to see Emily this afternoon and was given tea. Very chirpy and had just had some new canvasses mounted, ready to 'spoil' she said, and she had been fixing up some of this summer's work. Also said she was considering going out painting again this year.

117 [*Cheney to Toms*]

1282 Connaught Dr
Vancouver BC
Aug 6th 1939

Dear Humphrey.

Enclosed are your 4 tickets—two count up to 13 & two count up to 7, so you should have some luck. I will do my best by you although you cant expect much after getting that Picasso bargain. I met Dr Sedgewick last week & I was telling him about it & he was terribly impressed. Thanks for the snap of it & your last letter with the details—in fact I owe you two letters. I am just recovering from 6 weeks of visitors and have not had a moment to myself—however I hope its over for this year—The exhibition at the University[1] was a flop, due to that stupid old Riddington [Ridington].[2] It was not advertised, even round the University & of the 700 pupils only 20 turned up for Westons lecture. It was an awful lot of work—actual physical labour—& Riddington [Ridington] was too superior for words—considered he was doing us the greatest favour etc etc—I haven't been so mad for years or ever had to deal with such a rude, ignorant old man—never again—they can whistle for the next show. dont tell Emily as it might upset her & I can explain what is necessary when I see her—If & when—I hear Scott has been edgeing [sic] in on Weston['s] job in Victoria.[3] he is gradually cutting his own throat & his school has gone down to practically nothing. I was much amused by your going to the far East & being independent at 45—better marry a rich girl—there must be dozens even in Victoria. By the way have you thought of writing something about Emily—I think you could very well—from what you have heard & what you know of her— someone will be doing it soon & we are afraid someone like Gwen Cash will *cash* in on her—Even if you made notes after each visit I am sure they would be valuable for a biography Think it over as I feel you are just the one to do it.

I saw the Margaret Manuel etchings[4] quite good of their sort. We have just had a show of flower pictures which *everyone* liked[5]—in fact, wrote to the papers that the Gallery should purchase them etc—They were photographic & belong to the seed catalogue variety—botanicly [sic] correct etc—but not "ART." however they went over with a bang

& she sold several, one for $50.00—Emily sold one of her sketches in the 6 local artists show, it was bought by a Russian girl, a pupil of Macdonald's. I hear Miss Cann is having a show in the Gallery in the fall,[6] & Emily is having one in Nov. no news from the East but everyone hopes McCurry will get the Nat. Gallery. Kindest regards to your mother.

Sincerely

Nan

I hope you seriously consider doing "Emily" I will give you all the letters she has written me & my portrait of her & anything else to help.

NOTES

1 This has been referred to as a "lost" exhibition as no other reference to it has been found. See Hembroff-Schleicher, *Emily Carr*, 313.

2 John Ridington, UBC's first librarian, was Head Librarian from 1915 to 1940.

3 Weston's final term at the Summer School of Education (Victoria) was 1938. It seems there was a certain rivalry between the two teachers. On 20 July 1939 Macdonald had written to Cheney that Weston was giving lectures at the University "on Scott's ground," and continued: "Scott gives his annual instruction to the normal school university students every winter I believe and he will not relish Weston introducing himself there." See UBCL, Cheney Papers, box 4, file 13.

4 "Margaret A. Manuel, Boston Mass," is shown as an exhibitor at the VAG during the 1930–40 season. See *AGB* [VAG], 7 (June 1940). A list headed "Etchings and Drypoints by Margaret Manuel," undated, is in the VAG, Archives.

5 Emily Sartain (b.1903) exhibited thirty-two flower paintings at the VAG, 18 July-13 Aug. 1939. In 1939 Sartain was described as "an English flower painter of marked talent." See *AGB* [VAG], 7 (May 1940).

6 Cann's exhibition of a selection of her colour reproductions was to take place at the VAG, 21 Nov.-3 Dec. 1939. See *AGB* [VAG] 7 (Nov. 1939).

118 [*Carr to Cheney*]

Sunday
5:30 P.M.

[August 1939]

P.S. Been entertaining Missionaries from India. had 'em to tea, & think of asking them to supper. they were *interesting* & had interesting photos. one was a[n] Anglo-Indian & the other pure Ceylonese, a sweet girl all done up in Indian draperies, yards of it.

Dear Nan

just about thought you'd forgotten there was a ole' me. but I do understand how buisy you have been this summer. for me it has been rather a dull old Summer. Alice has been very buisy with her alterations besides having Joan Hennel[1][1] staying with her since Easter so she had not been down very much. all my friends [?] seem to go away. & I have been out *very* little since I came in from Camp. *May?* go off again for a short while in Sept. but don't know yet am going next week to look at a one room shack. I have had offered to see how accessible it is for me. I would like a little more outing before summer goes have done no sketching but that at camp. having 3 canvases under way. but they progress slowly. any little extra I do seems to call for a 3 or 4 days rest after so I get on slowly.

The youngster is doing all right. but after all she is quite a child. not companionable. not that the others were very still they were adult you did not have to double down to their comprehension in ordinary matters tho one was a fool and a fraud. always something. perhaps the babe is best. she keeps the house better. I just have to allow a margin for gumption.

Joan Hennel[1] & I gave a garden party for my sister in her own garden lovely day & went off very well. just around 16 or 18 old friends of hers Joan did all the manual work. the function took place last Wednesday, & I'm still rather derelict, but it went off well & my sister was pleased. poor dear. I think just now is perhaps her very hardest time she can see so little & is so independent it heurts her frightfully to give up & she *wont* have help. I am anxious to go (if I do

go out for a few days) before Joan leaves. Not that I can do anything to help she won't let me. still I'm here. She won't admit she can't do things & people gyp her like fury the old carpenter did, but she would not listen when we told her he did. she got mad. I feel so very sory for her its aweful to be bungling round in the dim. She is trying to rent the rest of the house but it is old and dowdy. what decreped old lumpty dumpties we are. This is the time out great-grand-children ought to be on hand to minister

Glad your portrait pupils were successful. Yes the sketches are home have been a week but I can't uncrate them too hard getting out the nails. oh for brutish strength like a bull.

It has been awefully hot but last few days filthy winds. you fry & freeze pant & sneeze.

I have no newses. Had two very nice letter[s] from Mrs Brown. I sent her the sketch that was to have been her. husbands and she was very appreciative. from what I hear (not from her) Old McCurray [McCurry] is *it*. worse luck

Have not heard from Edythe in ages. I suppose she's a *corpse* after Summer School. I do *not* beleive in these summer crams. breaks people down—that part of year was made for rest & recupe. Well I look forward to a visit from you hook or crook, but let me know for fear I might be flit. if I go where I said. it is only a little way out and only a one room. I'd have to share even the plate & cup with the maid, but I have yet to see if there are any prospects for sketching round in that part that is *why* I want to go. Have not heard definitely if the fogies (you are one I think) have given their sanction for me to one man in Nov. What B.C. show is this in Sept. 15?[2] is it the same as that show a while back where they drew prizes. I can't keep track of your Van Societies?

I am enclosing a note in yours please will you re-direct. it is to that artist colorman. I'm not shure of name Frazer[3] *I think* or address & lost the Catalogue you had him send me. I have enclosed 1.00 & asked him to send[?] me permanent green (pre tested) and am anxious to get it soon, so if you address & post I'd say thank you kindly. Edith

[Edythe] got me a tube at. Hoods. but I dont like Hood. for unknown reasons he's so round-the-bush. (asking your friends to ask you) Flora Burns was up in Van. Was dissapointed in the Hotel. painting by McDonald [Macdonald]. said they were to mixed up, she thought Mrs Boultbee is about to or has arriaved home. not heard from her yet expect shes dead beat seems like us is a world of "weary willies" goodbye write soon

aff.

Emily

(Colorman on Granville St I think)

NOTES
1 Joan, who was visiting from New York, was a daughter of the Alexander Hennells for whom Alice had once worked as a governess. See Tippett, *Emily Carr*, 122–3.
2 The BCAE was held at the VAG from 15 Sept. to 8 Oct. 1939.
3 Artists' supplies were sold at J.G. Fraser Ltd., 62 Pender Street, Vancouver.

119 [*Carr to Cheney*]

Thursday
[postmarked 31 Aug 1939]

Dear Nan.

Yes thanks I got my paint & Cat. No, Dr Chase did not come. No I dont think you a crab long drawn visits from folk who demand constant entertaining are extremely tiring.

I do not think I shall send to B.C. fall show because I have so many exhibitions on hand & will be one 'manning' in Nov in Gallery. (Vancouver)[1] I have heard at long last from Montreal air-mail-mad-

rush want their Ex in *3rd week Sept* after dallying a *year* rush me into short notice. fools!! I am waiting to hear from them again. they asked me 10000 questions I had to air-back. My work is ready but I have some mounting & framing & of course the crating. in *October* comes the Can Group Show.[2] as the New York stuff is to travel I'll have to send fresh stuff for that, in November my show in Vancouver and, in Toronto they are putting on a series of 1 month exhibitions 4 Artists at a time for six months I come in March (things shipped middle Feb) and am grouped with Lawren Harris, Comfort[,] Brantner [Brandtner] & me.[3] so it is going to keep me on hop fairly.

I hoped to get off into woods, for a week or so have my hut picked & all ready if the weather comes fine again its been rain on & off. & after I got Montreal packed & off The hut is up Gorge this side Craigflour [Craigflower] Bridge so not far out. if you do come in Sept. you go along Craigflour Road and, turn in on right next to a sign, "Cameron's Wrecking" (where they bust up derelict motors) its all among bushes & trees quite nice, but I'm not there yet. and yesterday my maid chopped her fingers badly, & is semi-laid up, so I have to be hands & she legs, so we are only one-man-power instead of two, fortunately Dr Bailey [Baillie][4] was in the house at moment (came to pick up a guest.) a Miss Watts from Toronto (said she'd met you) and he dressed it. the youngster is very brave but it's nasty & will need care.

I saw little dabs of Edythe her fool family hang onto her tail every minute, but we did have a lovely a peaceful tea in the Japenese Garden's—very nice. her sister from East was in Vic with a husband and two revolting infants who should be in reformatories incarcerated. they are devils & the parents Arch Devils to allow such behavior Edythe is the only peach on the Hembroff family tree. Why Judge floats?[5] (I mean you)

Had some interesting French people 1 man 2 women, from Paris.[6] He an ardent surrealist—she a poetess. It was very refreshing. I saw them 4 or 5 times he bought a sketch & was most interested in Indians also my latest work I was surprised as he is so modern. from here went to Seattle & then Mexico, & back to New York where he is giving a

one man show. hes just given one in London.

My Sister is all settled in her new flat. now. but the other unrented as yet.

Isn't the war news unsettling & beastly makes one so jittery if War comes it knocks bottom out of *everything* unthinkable! I hate to go from Radio & News. well I'm not gone yet & war has not come, only one feels as if they [have] been thrown onto an ant-hill and cant sit steady. Do you know if Aunt M. goes to the Solley's [Sollys']? & when?

Well I must up & prepare the lunch vegetables. fortunately the house was in good order things well ahead and two attacks of jam successfully over. My plums have been lovely just over now.

Did you cloud over too? it has helped forest fires thank goodness. The days are drawing in so fast & cold night & morn.

Yrs affec.

write soon.

Emily.

P.S. Humphrey is going back to Normal[7] poor thing this out of work is so bad for boys.

NOTES
1 Carr's second solo show at the VAG was to be held 7–19 Nov. 1939.
2 The CGP was scheduled for the AGT, 20 Oct.-13 Nov. 1939.
3 Carr exhibited with Harris, Charles Comfort, and Fritz Brandtner at the AGT, 1–31 Mar. 1940.
4 Dr. David Baillie was Carr's doctor, to whom she dedicated *Pause: A Sketchbook*.
5 Cheney had likely been asked to be a judge in connection with the floats for the Pacific National Exhibition parade.
6 Carr wrote that Wolfstang [Wolfgang] Paalen, a surrealist, his wife, and a friend were in Victoria for several weeks and that she saw them a number of times. "I can't get the surrealist point of view," Carr wrote, "most of their subjects revolt me. . . . To my surprise Mr. Paalen was very enthusiastic about my work. I felt like a hayseed but he found something in it." See AAA, Hatch Papers, Carr to Hatch, n.d. [Sept. 1939].

7 Toms in "Letters from Emily," 4, recorded: "After many ups and downs of employment in the Dirty Thirties I enrolled at the Provincial Normal School after the outbreak of War." (Toms attended from September 1939 to the end of June 1940.)

120 [*Excerpt Toms to Cheney*]

2 Sep. 1939

Today I went to see Emily for the first time in nearly a month,[1] and found her very well. Her little maid, just a girl of 14 or 15 had chopped her finger nearly off the other day so Emily had had to help out a bit with the cooking and housework, but she didn't seem to grudge doing that a bit. She had had two sets of visitors; one, a Frenchman, had bought one of her Indian period pictures (how she hates to be divided into periods—I often talk about them just to get her goat) and she had dinner at the Empress with him, and apparently thoroughly enjoyed herself which is unlike her! She was quite crowing about her three shows in the offing, one in late Sept in Montreal (rather short notice after all this delay), one in Vancouver and in March a quarter of a show with Lawren Harris, Chas Comfort and somebody else at the Grange Gallery in Toronto. She is also talking of a few days of sketching before the weather gets too cold, somewhere close in to Victoria. She is well and chirpy, no grumbles about the new girl and proud as punch of her newly grown-up fledgeling budgerigars. She showed me some of her this summer's work but said she didn't like to show me pictures as I never said anything! I said I hated using art jargon. She said why not say in a natural way what you think about pictures, there is no need to be hypocritical about it. I said about one; I like that tree. She said, I don't. I couldn't quite get the effect I wanted to, but it did teach me something. I said I didn't like that parallel effect of cloud and sky movement forming a sort of colour edging around the top of that clump of woods. She said: Oh! but that

was put there for a purpose. Then Silence. I said, Oh well, I like them all anyway and I do see something new and different in them, thanks for bringing them out! I left with a full bag of unripe Bartlett pears to put in the shed at home to ripen and was told to notice the now rapidly growing Monterey Cypresses growing in tubs on the verandah rail.

NOTE
1 Toms, "Letters to Nan," 6, notes: "As I had been out of school for several years I found the return to studying difficult. During the period I seldom visited Emily."

121 [*Cheney to Toms*]

1282 Connaught Dr
Vancouver BC
Sept 3rd 1939

My dear Humphrey

Your P.C. from Seattle came some days ago & with this awful news today I cant help thinking about you & what it is going to mean to one of your temperament. It just seems unbelieveable that war could be declared again—do let me know what you are going to do—The teaching profession really sounds more suitable than any others you have considered & it is too bad to have to give it up—

There is nothing more I can write today—everything seems at a standstill—and yet events are rushing forward & with the radio, the war is in every household.

Nan

122 [*Carr to Cheney*]

Monday [4 September]
[postmarked 11 Sept 1939]
[card]

Dear Nan

off to my shack today.[1] if you should come to Vic. address card to
Craigflour P.O. it is at end of Gorge Bus line & I could send the girl
to meet you there & direct you. it shack [insert] is on Craigflour road,
next to the "Cameron Car Wrecking place but the shack is back in
the woods, & cannot be seen from road. It looks fine & I hope keeps
so yesterday was stormy & over-cast. one does not feel inclined to do
much. jaunting in this mess. but I think it is the only thing to go
straight ahead with our ordinary untill such time as the *extraordinary* is
required. exhibitions are off presumably no word from those rude
Easterners[2] I think they might have courtesy to write though. don't
you? I had everything ready. wonder if Aunt M. goes to Solleys [Sol-
lys']? No one seems to know where they are. oh my! why must we
humans be so ugly. & mess things up so, instead of living and let live.
we are worse than any beasts. there is a jungley bit of woods & I am
shure I'll find some material we have only *one* room and I am taking
very crude necessities only plenty of bedding night & mornings are
cold we have a stove. in hut [?]. days are short now but middles love-
ly. plan to stay 10 days or 2 weeks if weather possible.

Yrs aff

Emily.

NOTES

1 Carr was going to a cabin on Craigflower Road where she would camp until 25
Sept. According to #122, Carr's "today" must have been 4 Sept. 1939. Florence
(plus dog and bird) was to be with her. See *H&T*, 14–25 Sept., for a record of the
trip and her stay in "Mrs. [Evelyn] Shadforth's little one-room-shack." Carr wrote
from there: "Camp is camp even in rain & I love being out. The sketching is
undergrowth & tall firs, just a spot up the Gorge waters that has been overlooked

by civilization & left untamed deliciously quiet completely private." AAA, Hatch Papers, Carr to Hatch, n.d. [Sept. 1939].
2 Presumably a reference to the officials of the AAM who had arranged to hold a Carr exhibition. Carr wrote to Edythe Brand n.d. [late September?]: "Well Montreal is off door slammed to[o] for good after wires of yes and wires of no, & air mail communications, and letting poor old Willie do all the crating, a *final* to say 'War and expense forbade'." See BCARS, Hembroff-Schleicher Papers. See also #125.

123 [*Excerpt Toms to Cheney*]

8 Sep. 1939

This evening I rang up Willie Newcombe, Emily's good friend who packs her pictures for her, to enquire after the Montreal show but no news has come through yet. . . . Emily, however, has gone off to her one-room shack on the Gorge (about 4 miles from town) not expecting that the show will come off because of Eric Brown's death,[1] but she has left her pictures sorted out in case she has to send word to Willie. He says that the place where she is is quite paintable and that she has already done several sketches. I don't know whether she has her school-girl maid, Florence with her or not. Emily seems quite pleased with her, just a quiet country girl of about 14.

NOTES
1 It's strange that Carr refers to Brown's death (6 Apr. 1939) rather than to the outbreak of war.

124 [*Cheney to Toms*]

1282 Connaught Dr
Vancouver BC
Sept 14[?] 1939

My dear Humphrey

Thank you so much for you[r] long interesting letter & it was such a relief to hear that you are not rushing in to this awful war. There will be time enough & for one of your temprament you will have to approach it slowly in order to adjust yourself to the *mental* horrors of such a life, let alone the physical discomforts. I am glad you had such a good holiday in Seattle nothing like a chance to give one a new perspective I wonder if Emily will have her show in Montreal—I have written to Mr Gillson to find out if they want my portrait of her with her show. Will you find out from her when her show opens? I know its no good writing to her as she may not answer for weeks & it takes time to get things East. Eric Brown suggested my showing Emily with her show & was going to arrange it in Montreal but he died before it was settled & I have not had word from McCurry. In view of the war it may be all called off but let me know the date anyway as soon as you can. Hope I can get over for a day or two later—When does N.S. begin?

Nan

125 [*Cheney to Toms*]

Tues Sept 19 1939

Dear Humphrey

Just had an air mail from Prof. Gillson of McGill,[1] who is Chairman of the Montreal exhibition committee—he wants my portrait of Emily to be hung with her show & wrote to her by the same mail saying the pictures had to be there for Oct 1st I expect she is furious with such notice & would not realize that he could not let her know sooner,

because of the war they had a special meeting & decided to go ahead with her show anyway—he seems to think we live next door & wants me to help her pack the pictures—well knowing her that is out of the question even if I did live next door he also wants some of her early stuff—I dont want her to know he has written me at all as she hates people having a hand in her affairs so I wondered if you could casually go round to see her & perhaps give her a hand. Prof. Gillson is very keen to make this an outstanding show but he has no idea what Emily is like to deal with & she will just send what she likes. She sent me a P.C. last week complaining about those rude Easterners not letting her know & now I suppose she will have to come in from the Country. How are you enjoying school again? My portrait of Mary Capilano is quite the best in the show[2] but as Mr Barbeau says that is not a compliment as its the worst show he ever saw.

Nan

P.S. Can you find out Emily's birthday—month & date. Its about 1870.[3]

NOTES
1 See UBCL, Cheney Papers, box 1, file 34, Gillson to Cheney, 15 Sept. 1939.
2 The portrait of Mary Capilano, widow of the late chief of the Capilano Indians, was shown at the BCAE held at the VAG, 15 Sept.-8 Oct. 1939.
3 Carr was born 13 Dec. 1871.

126 [Cheney, Trail, BC, to Toms]

306 Ritchie Ave
Trail BC
Oct 21st 1939

Dear Humphrey

Have been here for two weeks—drove up with the Turnbulls and it is the only time of year to see this country—I spent last weekend with Gaie Taylor at Nelson—They live up the lake on a place half way up the mountain with waterfalls on each side of the house & a beautiful view. Mr & Mrs Seminoff, the doukhobors I painted in 1936 work for the Taylors & live in a little house at the gate. They welcomed me most entheuiasticly [sic] & on Sunday morning brought me up a large pot of *borsh*, their national dish—It is a thick soup made of vegetables entirely, as they do not eat meat or chicken—It was awfully good—Gaie & I walked up to the 2nd water fall behind the house—there are 4 in a series & very different, but one has to be a good mountain climber to see them all & I am not. Last night my sister had a supper party & she wanted to have your brother as his friends the Ransome's [Ransoms][1] were here—I am sorry to have missed him too—Young Mrs Fowler[2] plays the violin awfully well so we had some good music & I enjoyed the simple easy going way they have a party up here. I have not done any painting needless to say as the hospitality of the people has taken all my time and energy. I plan to go down on Thurs. by the Great Northern if I cannot get a ride—I wonder how Emily is these days, it wont be long before her show is on in Vancouver—How are you liking normal school? With kindest regards to your mother from my sister & myself

Sincerely

Nan

NOTES
1 Fred and Erica Ransom.
2 Likely Mrs. Pat Fowler. Information from Jane Toms, Victoria.

127 [*Carr to Cheney, Vancouver*]

Thursday Oct 24th [1939]

Dear Nan

Don't know if my doing interest you any more as you no longer answear letters I wrote you two months agoe giving you directions where to find me at camp should you come over as you had planned to do in Sept. No answear—presume you did not come. & as you know I do *not* keep up one way correspondence. I proved that years agoe in the East. However I am letting you know. though I wrote some time back that I *was* having a one man in Van Gallery, in Nov. 7-19 have to get my stuff over by 4th had not thght it would be so soon. by 4 or 5 days and am very buisy.

Yours

Emily.

128 [*Carr to Cheney*]

Monday
[postmarked 30 Oct 1939]

Am not going to expense of printed Catalogues am I foolish?

Dear Nan.

Yours receved this A.M. Am glad you have had a trip to Trail and hope you will feel pepped sory you found sads on return, dead freinds & mums. And too bad about your picture it is dissapointing and the express is so high it is hard on Westerners to be turned down what did you send?[1]

I am all in—dead tired—have been at it strenuously these 'one man's' do mean a lot of work that must be done by you & no one else.

Willie packed a crate Sunday, & expects tomorrow night to finish I hope to duce he does. I want to see the last of them & then retire to bed. first Grigsby hopped me short, & then Willie could only help days ahead. Grigsby has to have things on 4th means shipping not later than 3rd (Friday) I cut out the finish of one or two pictures. A number of our crates are away just now which is a plague we had to reconstruct some new.—Hope war wont freeze the show and flop it. I had no idea Grigsby was asking you to help. I asked if it were necessary for me to come over or if the gallery hung shows, & he replied "he hung 95 percent of all shows & would willing do so" I don't think he need to have cursed you with the job. I am a little worried at not being able to put hooks & wires on. it does interfere so in the packing, & they always return without so perhaps they keep stock. if not, tell Mr Grigsby to charge it up to me will you. I plan to come over possibly on 11th unless Edith [Edythe] should be going away for the Armistice holiday that date, then I'll come later in the week I am better much than last year (as long as I don't hurry or walk much.) and shall enjoy meeting a few people this time. I plan to take a couple of days in bed when things get off so as to feel sporty. Florence can manage very well, I think while I am gone, & is not nervous at being left alone she is only 14.

Am looking forward to seeing you thanks very much for helping at gallery. will let you know definitely when I am coming when I know myself. Cheer up paint more pictures and plant more 'mums'

Yours aff

M. Emily.

NOTE
1 Likely a reference to the current CGP exhibition at the AGT (20 Oct.-13 Nov.). George Pepper wrote to Carr, 6 Nov. 1939: "I am sorry that Nan Cheney's picture was tossed out by the hanging committee. I would like to see her a member of the Group [CGP] but she will not be eligible now until our next exhibition. . . . When Nan does come up for membership I think she will be elected. Her work has certainly made a great advance since she went out West—whether because of the

environment, that air or your influence, I do not know." See BCARS, Parnall
Collection, Pepper to Carr, 6 Nov. 1939. Cheney did not become a member of the
CGP.

129 [*Carr to Cheney*]

Friday
[November 1939]

Dear Nan

Thanks for yours that is good news about Mrs Brock at least I mean
about a picture for the memorial.[1] Thank you for your leadership &
interest in project.

I plan to come on Teusday day boat, hope it is not foggy & cold.

Thank you for helping in hanging. Grigsby says you made a good
job I wonder how you like this show & how it compares with last &
will it flop?

I am fairly rested up now been making tomato Catchup today.

Wont write much now shall be seeing you so soon it will be nice.
in meantime

Florence goes to the post before it's too late & tomorrow is a
holiday & Sunday is Sunday, and I wasted a whole sheet.

So long

Emily—

Looking forward to seeing all your latest

N O T E
1 Two Emily Carr oil on paper sketches (*Grey and Gold* and *Early Fall*), were
presented to UBC by the Monday Art Study Group (according to the attached
labels) in memory of Mildred Britten Brock, a former member. They were to be

hung in the Women Students' Lounge (to be known as the Mildred Brock Room) within the Brock Memorial Building, which was then being completed. Dean Brock was formerly Dean of Applied Science and was killed with Mrs. Brock in a plane crash in the summer of 1935. The building, dedicated to the memory of the Brocks, was officially opened 31 Jan. 1940.

130 [*Carr to Cheney*]

Sunday.
[November 1939]

Dear Nan

Can't help wondering how the McDonald[1]–Sedgewick picture. settled itself perhaps. two black eyes a torn picture & sulks?? & nobody buying nothing

 I enjoyed my visit so much you were all so good to me. Show ends today hope you had a fine day like we have—glorious—came down with a filthy cold yesterday but otherwise O.K. found everything all right & let Florence have today and Yesterday off. by the way I felt sory I did not say Hello etc to your Emily. She was not in the dining room when we went in I thought it would embarras her during dinner and after I forgot. which was horrid of me. she was so kindly over my first visit. & must have thought me horrid.

 Alice seemed very glad to see me home & I was glad I did not dissapoint her by staying longer. & I was tired & think two days of going & the travel was enough, for old me. but *how much* better I am than last year. My Sister came to supper last night and I gave her a *long read* she is coming up one evening a week and I go there every Sunday to dinner—besides odd visits. She enjoys being read to now. at first she hated it. She can read 'Moon' and is getting on with 'Brael' but it is awful that 'Brael' I don't see how anyone Can learn it—endless pinpricks I'll have to go blank, when I'm blind. Could as soon knit with

my toes & crochet with my ears. She's so patient.

I guess poor Mr Grigsby will be walking head down & feet waving for next two weeks Miss Cann,[2] is as bad as sedletz powder, & gives me pip. Hope her show is a success, but glad I don't have to hang it, arn't you? The old Carr woman's were at least all sizable: I would like to have seen her show though.

Now I am going to take my sniffles to roost. Remember the parlor-couch is yours for ringing the door-bell. love to have you. love to Ink.

Ever

Emily.

NOTES
1 Likely a reference to Dr. W.L. MacDonald of the English Department, UBC, who was an admirer of Carr's painting.
2 Jeanette Cann. See #73, note 1, and #117, note 6.

131 *[Alice Carr, Victoria, to Cheney]*
[*The 2 Alice Carr to Cheney letters are in the UBCL, Special Collections Division, Cheney Papers, box 1, file 34.*]

[end of November/beginning of December 1939]

Dear Nan

I am writing for my sister as she is ill in bed, has an "infected sinus" and says be sure & let her know before you come down. Miss Lawson phoned her yesterday to ask if she knew when you were coming, having told you to come anytime, she thought it better for you to know, she is ill, & could not have you just at the moment. She has been pretty ill and suffered a lot, the pain is easier today but she has less than no voice.

Millie sends her love.

Sincerely

Alice M. Carr.

I did not make this [ink spot] it was there

A.M.C.

132 [*Cheney, Vancouver, to Toms*]

1282 Connaught Dr
Vancouver B.C.
Dec 2nd 1939

Dear Humphrey

Have just been speaking to Mary at Trail & she said your mother was there & your brother. I have been wondering how you are getting along as Emily said very little about you. The show was a tremendous success despite the bad times—I hung it early one morning & Ross Lort,[1] the architect was so impressed, he thought the Gallery should buy the whole show & keep it as it stood, for a permanent collection of Emily Carr's work—not so the founders, & Mr Stone[2] in particular, who raved & ranted & said they were a disgrace etc. Remind me to tell you about one of the meetings as its too long to write. Poor old Weston got a bad panning in the last "Sat. night"—Ayre[3] wrote "It was hard to shake off the nausea of W.P. Weston's trees." I just saw by the paper that Harry McCurry has been made director of the Nat. Gallery altho Emily said Lismer was to have it. however I expect pressure was brought down on that as the R.C.A. Group have political

friends & McCurry will be easier to manage. I hear Emily is quite ill. She was in great form over here but we were shocked at her size—She must have gained 50 lbs since last year. I have not done a bit of work all fall but hope to do some serious painting in 1940. How would you like to run the business side of a summer sketch class next Aug— down on the water front—I am playing with the idea so don't mention it yet. I only saw Miss Cann once. I think she had some difficulty about her selling arrangements. Dont know when I will get over as I haven't a place to stay now—altho Emily has offered me a cot in her front studio. Aunt M. is coming for New Years & a little stay. Have seen very little of Macdonald—he has moved his studio to the 10th floor[4] as he had no privacy & he is not well. looks miserable & has got very "mystic"—Poor man he had a hard summer driving his family all over California—only made one sketch & came back a wreck. How are you enjoying school again?

Affectionately

Nan

NOTES
1 Lort, an architect, was a member of the Royal Architectural Institute of Canada, and locally a member of the BCSFA, exhibiting in their shows. He served on the VAG Council from 1935 to 1946, and was the architect for the extensive VAG rebuilding program, which was completed in 1951.
2 Henry A. Stone (1861–1943) was Chairman, Founder's Committee of the VAG, and first president of the Council (1931–2). As a watercolour painter he had frequently shown his vacation landscapes at gallery exhibitions. (A recent group, "Travel Sketches by Mr. H.A. Stone," had been exhibited at the VAG, 4–23 Apr. 1939. See VAG, Archives for list of works.)
3 Robert Ayre was a public relations officer with the CNR, and a part-time journalist and art critic. From 1938 to 1941 Ayre wrote for the *Montreal Standard*. (In 1944 he became co-editor, with Donald Buchanan, of *Canadian Art*.)
4 Macdonald's studio was in the Vancouver Block. He had been sharing studio space with Vancouver artist and teacher Beatrice Lennie.

133 [*Excerpt Toms to Cheney*]

4 Dec. 1939

I have just been phoning Emily's sister Alice and she says that Emily has just developed a cold after nearly recovering from flu. She evidentally *has* been *quite* ill, and appears to have lost her voice and hearing for a few days, however, sister said that she was supposed to get up today and that she was much better except for her hearing. At her age, she will be 68 next Wednesday, I suppose she might be in danger of suffering from increased deafness. Her heart is behaving all right. I was glad to hear that she did so well in the Vancouver show.

134 [*Carr to Cheney*]

Dec 6 [1939]

Dear Nan

Was so sory to hury that note off to tell you *not to come.* Aunt M. rang up to know which day you were coming & I had *told* you you need do nothing but ring bell bed was ready but if you'd landed into *bad* flue, I'd have felt aweful. & I ashure you you'd have been in an uncomfortable place. am still in bed & pretty wretched. (3rd week) Dr wanted hospital but I got a trained nurse 2 weeks. flue & badly infected sinus in middle of head behind nose.—rotten. keeps coming back again. Florence got a bad cold too. Did you particularly want to come before Xmas? I'll shurely be O.K. *about* Xmas time. It is so disgusting I was so tickled with how much I did & how well I got on in Van. & then to be sat down with such a spank, my crates from Van. are still not opened. can wait. Till domesday for all I care. How did Miss Cann's show come off? did she do well?

Love to you all. Emily

135 [*Carr to Cheney*]

[Christmas Gift Card]
[undated]
[likely 1939]

Nan with Emily's love

I did not fashion lovely gift,
I lay upon my bed and 'snift'
Twas misery kept me there
 not thrift.

136 [*Carr, Victoria, to Toms*]
[*The following greetings and verse accompanied the 1940 diary which Carr
had given Toms for Christmas. See Toms, "Letters from Emily," 4.*]

[Christmas Card 1939]

Humphrey,

With love and best wishes Emily

[on the reverse]
 The pedigog requireth book when
 o'er the class he's swanking
 To note the date when last he gave
 each seperate child a spanking

If he belabor more than oft, some
Mother's special darling
He'd get the sack and off he'd pack
to tune of mammas snarling.

137 [*Carr to Cheney*]

[postmarked Jan 1940]

Dear Nan

Happy New Year. here is Xmas 7 days gone & I have not 'written pretty' yet. though I *have* thought of you plenty. thank you for that lovely bottle *and* cover. you did make that beautifully I show it to everyone & they admire the workmanship enormously If Government house or some of the *real snobs* ask me to stay, I shall flaunt it on their noses—have my bottle broght to me in their drawingrooms & I'll bet none can reach within 2000 yards of 'my satin polka dot' however I shall not postpone using it on the chance of such invites. I run through hot bottles with great velocity as I use them night & day. thank you again. I love it.

Spose you are Aunt Marying for the moment. don't you want to *personaly* conduct her home when the moment is ripe? I am all Clean & clear & the Couch waiting. Made a good recovery—not *much* deafer than before, but that darn old pain (chest-heart) is annoyingly handy and pops up at slightest excuse. doesent like the cold if I am idle and warm it lays low.

We had a nice Xmas & I hope you did just A. & I. ate hot Turk. on me Sunday & Cold Turk. on her Monday. had a small Xmas tree each, and lots of remembrances. How nice the Christmas letters are that once a year of waking up of old freindships. I seemed particularly to enjoy mine this year perhaps the beastly war draws all the corners

of the earth closer together, also this appaling earthquake in Turkey, so fearful one can scarcely realize it, with the aweful cold on top. When I read this morning that the wounded on the Russian battle feilds mostly froze in 15 minutes of lying there it almost seemed a mercy rather than an agonizing dragging round and Heavens knows if they cant feed & clothe their poor soldiers how they nurse or Doctor them that below Zero must make the suffering for the soldiers fearful. Well this is not cheerful Stuff for a New Year greeting

Edith [Edythe] is over, & I am afraid not having a restful holiday Fred went into Hospital & had tonsils out and Mr Hembroff is recovering from a rather serious broken & infected thum & her mother not particularly well & Edith [Edythe] with a bad cold. & *of course* the 'little Hussey' (Edythes Sister Hellen [Helen]) off in the East. that brat wants kicking.

I have got through *"Woo's life"*. started long before I was in Vancouver. that is it is finished up to its last typing Writing seem[s] about all that I can do these days.

Humphry [Humphrey] was in other day. He was for the moment fed up with teaching but don't suppose, it was serious. I fancy he intends to stick it out. Probably was effect of 3 old Aunts that came to Xmas with them.

The Lord saw not fit to feed Aunts into our family tree thanks be! (I wonder if my neices say that of us).

Write soon. I have 1000000 *pretty* letters to write so must get on with job.

May. you and Hill and Inkey enjoy health and good bones to pick in 1940.

Love to you all from

Emily

138 [*Carr to Cheney*]

Friday
[postmarked 26 Jan 1940]

Dear Nan

Has Edythe told you that I have to move? My landlady wants to sell. she gave me first option, but nothing doing tho' she gave me a very low figure I. soon got over my stunn & set to work arranging, am going to live in the other half of my sister's. we will each have our own flat. The school room is wrong light (South.) otherwise it is a good big room (there is no north wall in the place) but I shall manage I have no doubt, and I am altering the rest so I think it will be cosy, and nice for both of us to be in easy reach of each other in our dotage. I am very buisy doing preparatory turn outs & burnings the contractor is held up by those fool "boards" must be passed by 3 one's away one's sick so the odd man must await death or return. These bylaws are a curse they have made building & altering as difficult as possible fools! they should be glad to have people make homes & improvem[en]tes I have to go slow. unless it should sell & the new owner want *immediate* possesion (which he would not get.) it will probably be a matter of 6 weeks, that is if not held up by weather conditions, for building. I am making a new bath room & altering quite a bit, round kitchen part. the pictures will be aweful to move. I shall probably prolong into spring as long as I can so as to take some of my garden but will have very little garden space there. anywhere Done no work since Nov. and now halt! for reconstruction boost from rut may be good. Hope you are well. & rest after Aunt M.

Lots of Love.

Emily.

139 [*Carr to Cheney*]

Teusday
[postmarked 6 Feb 1940]

Dear Nan.

So glad the pictures look decent and that you liked the Broadcast. last night's was quite different I wonder if people liked it better or worse? I think Dr Sedgewick has arranged them & reads beautifully. he had to shorten somewhat to get in in the time & did it so you never noticed the gaps. & yet used my very own words. It is rather fun listening. & hearing your own thoughts with your ears instead of inside. I did not think I was excited the first time I shut myself in all alone & had to get my heart pills out from aggitation and when I went to wash my face for bed it was very white & I could not sleep. but I havent been sleeping well lately last night I felt quite different and quite O.K. except that I got little sleep. how assenine one is. inside.

I suppose I'm too tired & rather stirred up. My work day is from noon to six, then I go to bed. done for. but today I should be gay I had all Sunday lazy & all Monday (mostly) in bed.

The house is at last getting buisy.[1] It is going to be quite nice. Lor! no if you put a sky light the roof would fall in I'm fix light somehow have a big new window. the only where it could go. I hope to move round first of month. it is all quite exciting, & very tiring the *old* pictures have had 4 years grime wiped off their mugs & look surprised. I expect to take *all* pictures up first & get my racks in place then the vulgar things of the flesh can receive attention the birds & a dog yard are the most important of all I insist on their safety and comfort first. no matter if chimney & underpinings fall down. then there is my pet garden roots I shant have much up there & want to confine to my flowering shrubs & a 4 x 4 foot lawn havnt [?] desided whether it's bouls or tennis yet. anyhow it will be big enough for a

chair & me on the chair.

I think that write up was *filthy*[2] never again! I loathe those reporters like revolutions. I said you may write about the pictures & I'm willing to tell you anything about them but personalities I *will not* have & she said of course I understand and having *forced* herself into my house 'snooped,' following me rudely from room to room. Most *impertinently* they tell me the Times head is all the same type, heaps of people refuse to read the stuff of that dirty chit of a girl. I am so sorry they turned down your portrait in East. well go right on. A.Y.J. wrote me the other day. I never feel, in sympathy with him, & I think he feels same with me. I have always felt he resented me as a woman artist, getting recognition & that *money* was first consideration in [?] his work. perhaps I misjudge him Lawren, Comfort, & I are on this month in the Grange Gallery. rather like my broadcast I dont know what is being used. I am anxious to be painting again after a long quit, both sketch work & typing have been piling up. Writing goes right on (in bed) 'Woo's life' is ready for its final type.[3] Hope you are feeling better. Love to you and Hill and Ink.

Yours.

Emily

NOTES
1 Renovations were being made to Alice Carr's house at 218 St. Andrew's Street to accommodate Carr.
2 Elizabeth Ruggles, a reporter, had published, "Emily Carr and Her Art" in *Victoria Daily Times: Magazine Section*, 13 Jan. 1940, p. 1. In the lengthy article she quotes Carr directly a number of times. ("What does it matter if I keep monkeys, or am fat or thin, or stand on my head. What's that to do with art?")
3 "Woo's Life" formed the second half of Carr's *The Heart of a Peacock*. See #2, note 1.

140 [*Excerpt Toms to Cheney*]

3 Mch. 1940

I had to miss Emily's first story because I went to see Ruth Draper that night, but the other three I enjoyed very much. Just phoned Emily this minute to see if she had any news as I haven't seen her since the week before Christmas. I suppose you heard that she had had notice that her house was up for sale? She moved a week ago into her sister's house which was being turned into a duplex for her. She says she is quite tired still after it all.

141 [*Carr to Cheney*]

[218 St Andrews St., Victoria]
Thursday
[postmarked 7 Mar 1940]

Dear Nan

Yours just come I wondered why you & Edyth[e] did not drop a line or two to cheer me in the awefulness of moving.[1] E. wrote a card saying she was *waiting for* a letter from me but who, even healthy persons *can* write & move? It was very strenuous—I am a rag & simply lived on heart pills for the pain am pretty well settled now. only very very tired. I shall love to see you Sunday & can put you on the studio couch, if you will take things very simply. Florence I am giving the week end off she has worked well & we would be cosy. of course I understand Aunt M. would want you as much as possible in daytime but I can sup you. after a fashion beds O.K.

I love my new flat.

Post time so

goodbye

Emily.

NOTE
1 See *H&T*, 23 & 25 Feb. 1940, for Carr's move from Beckley Avenue and her settling in at St. Andrew's Street. Of Beckley Avenue Carr wrote (23 Feb.): "I have had four of the calmest and best working years of my life there. I have had more distinguished visitors, sold more work, had more recognition and been more independently myself that ever before."

142 [*Carr to Cheney*]

Saturday night *in bed*
[postmarked 25 Mar 1940]

Dear Nan.

I'm so tired excuse any foolish stupidity that may ooze from this letter. I too enjoyed seeing you very much. Wish I had a comfortable spare chamber to invite you to, but the corner of the studio would be quieter than that beastly October Mansions. I too am glad you told me about your building plans[1] I am really *very* interested and have seen it build & & visited with you alredy in my minds eye. You will have a hectic summer but there is lots of fun 'planning,' too, as well as worry & women do love fixing their nests all except the budgies who lay eggs right on the bare floor & refuse all ornamentation or cosiness
Alice & I went out to cemetery today (by train) and I feel like a soup bone a boiled one. after that people from Guelph Ont. Came & *stayed* had a revolting boy child of 12 who gave me pip.
Glad you like my new quarters I do too. light worries me a little it is unrestful but when I get down to work I shall contrive somewhat & it is really not bad for showing things I sold a big Indian picture to the States[2] Some man who is getting up a collection of representative

canvases one from Each State of America & one from each province in Canada I am now wrestling with the framers. Had a nice letter from A.Y. Jackson last week says Lawren Comfort Brantner [Brandtner] & Me was a great success, best of three little groups they have had yet.

I spose you and Aunt M. have been giving in marriage this week. Have been writing and typing but so far not painting, the fire is still in my marrow & somebody contrives to fix it so it is impossible for me to *lie* on Monday. I'll just have to change the day I think my picture sale went through at the cost of two Mondays Simply *had* to get up & see the men who were putting it through. Also it is the only day I can get the garden chinaman they are all buisy now for spring, & I *have* to suprentind. Hope Easter is fine. tell me *all about* the new place I think it will be grand among those trees etc. You never took your ash tray lots of love.

Yrs affec.

Emily.

NOTES
1 The Cheneys were planning to build a home on a wooded lot in Capilano, North Vancouver.
2 The sale of Carr's *Village of Yan* was to the IBM Corporation. See Hembroff-Schleicher, *Emily Carr*, 390, for an account of the role of W. Kaye Lamb, then Provincial Librarian and Archivist, in the promotion of this sale.

143 [*Carr to Cheney*]

218 St Andrews
Thursday
[postmarked 5 Apr 1940]

Dear Nan

Thank you a thousand for the Pickle It is good of you & I am thrilled, they *are* good.

I have been on point of sending a book of yours I have back also the ash tray *now I shall* I'll pack her in the same wrappings.

How's house plans? I wish it was ready right this Summer I'd be upon you. (regular Aunt M.)

Am working this week (some of last years sketches want to get 1/2 doz mounted. anyway only did a few before Van Ex. & none since with move & flue.

Don't know what I shall do this Summer Weather is perfect but frost I beleive Early Yet. I'm pretty good but too much pain to suit me, unless I'm sitting like a graven Immage.

Little birds hatching in all quarters—most exciting & some lengthy divorce suits hanging fire.

My pollyanthesus are grand I'm specializing they come while My Maple still permits sun to trickle through its buds. soon the old boy will be in full glory & he is a grand one too.

Am very comfortable like it More & more wish all the world was as luckey. Am getting in a lot of reading to my sister she enjoys it. what do you think Old Mortimer Lamb did? Jewed me down $5.00 on a picture & *re sold* it for its original price the folks who bought it told me he had sold it to them & what they paid.[1] old. swine. no more cuts or reductions for him you bet. It was that little green thing I was fond of & was in the minds not to part with.

I stand bare and *must* sew if only I *could* squeeze my bulk into stock size & buy ready-made. I do not need *many* ball & reception but *lots* of smocks & undies would like to be a common cat (Tabby for preference) Persians coats mat.

Got a cold coming that dratted hand maiden of mine fetched it from her Aunts I could choke her & Aunt too draw me rough sketch of your plans.

Had a letter from Evonne [Yvonne] today. the usual "not very well" letter *why* is every soul on earth "Ailing"? seems so, too bad. Why cant we be healthy like cows? or would we sit hoof in mouth &

complain of 'foot in mouth' disease. Oh Goodness!!!

Pickel thanks again

Emily.

NOTE
1 In a lengthy letter of 1 Aug. 1941, Mortimer Lamb wrote to Carr of his longstanding admiration for her work and that she was misinformed concerning the circumstances of the sale. He insisted that the price was the same as that which he had paid, and that he had only given it up reluctantly. On the envelope Carr has written: "Twaddle from old Mortimer Lamb." See BCARS, Parnall Collection. See also #30, note 4.

144 [*Carr to Cheney*]

218 St Andrews
[postmarked 1 May 1940]

Dear Nan.

I have been keeping my nose *deep* in a manuscript which I finished at noon today I mean finished so it can be read, consecutively I wanted to be able to read it to someone before they go East next week to have their opinion.[1] there is still all the typing of the final copy. I put one out to be done the other day. they charged $7.25 and did it *badly*. Why the deuce write? But I cant stop it's like drinking, not that I have experenced *that* [underlined twice] *yet* [underlined 6 times].

Was gld to hear from you and much interested in plans of house looks nice hurry hurry!! I want to come and sketch & visit you. So McDonald [Macdonald] will be a neighbour too well you should get some work done providing you don't spend all your time running into town when you move out of it.

I am hoping to have two pictures (not very. big) for the B.C.

Artists in May.[2] Yesterday a freind took me out to some property of theirs near Cordova Bay. The woods were *delicious* I did enjoy it so much & did some sketching hope she takes me again. It made me squirm to go out into the woods for a spell I may try for the latter part of May don't know yet I hate to think of the effort only just having settled in. but its spring I like to get out best of all & feel I ought to try, to do so. if I can. Well, I'll see what offers I can find of up-to-date *modern* equipped?? shacks. oh for the dear late Van, but I am glad I have not the care of her just now & me plus Florence in that van, would be squashy. Well, why worry the rest of the earth is too cram jam full of worry to fret over trifels isn't it horrible?

I love my new abode & feel quite settled now done some painting and mounted. 15 of last years sketches after doing odd bits to them

Have let all my letters go. owe everyone. too tired when through my other writing.

Have Wednesday as bed day now. feel glad of its being due tomorrow the day in woods tired me. had a letter from A.Y. Jackson yesterday Old Lismer is to be out lecturing Van on 6 & 7. Vic I believe on 9th wonder if he will favour me. & pray that pippin of a wife won't be along. she's a bad smell. in my nose. No news from Edythe. for ages don't know if I owe her. or not. Long letter from Lawren H. yesterday.

I bet we have a long bad spell of wet its been fine for so long & so lovely. Are you tied up for gas? here's where shankses come in. only car people all crowd into the trams & oust out the natural 'shankers' who patiently leg it. Year in & year out.

Sold a picture. (sketch) at the Harris, Comfort, Carr show in Toronto.

Birds not behaving. lost many infants in arms among canaries. & Budgies eggs on strike—The devil walks the earth—only my patient dove sits & rears, & those dirty old canary hens rip out the young doves feathers to line their nests.

It *pours*. I'm off to bed to sulk. Goodbye. really *will* post your trifles one of these days. just made a dressing gown a. smock & a bed

jacket. in odd moments, by the Radio, listening to news

Yours Ever

Emily

NOTES
1 Ira Dilworth had brought Carr's stories to the attention of William H. Clarke, president of Clarke, Irwin & Company Limited, and manager of Oxford University Press (Canadian Branch). The reference is likely to Carr's manuscript being readied to send to the latter.
2 The BCSFA annual was scheduled at the VAG for 17 May-2 June 1940.

145 [*Excerpt Toms to Cheney*]

4 May 1940

I saw Emily for an hour, one afternoon during my week's Easter holidays. She had been quite seedy as a result of the rigours of her move, but was very well when I saw her, and almost settled in her sister's house. I phoned again within the past two weeks and she was quite all right again. Her sister's house is much brighter and larger and more comfortable than 316, but the studio, although a very attractive room, has no north light.

146 [*Carr, Metchosin, to Cheney*]

At Camp
[postmarked 25 May 1940]

Dear Nan. (Had a nice long visit from Lismer left his lady on the beach thanks be!) Mosquitoes Aweful!

Have just been answearing a letter of MacDonald's [Macdonald's] He seems very delighted with his little house. I wonder how your own proceeds? I seee Miss Lawson has just returned from a visit to Fordham Solley's [Solly's]

I came out to camp a week or more agoe. found a one room and woodshed in Mechosen [Metchosin]¹ It is very comfortable in a park like private property & I'm doing good work. I nearly balked at the start seemed as if I could not go away, with things so aweful. there is no radio but I have a daily paper. It is no good Yapping war all day long but I do think it is comforting to get the news *with someone* else isnt it appaling, and I do not think we should push it right away as if we had no share in humanity, because we are lucky to be on the rim. I think Canada is little better than the States, in greed and the *we're safe* attitude off [of?] far off indifference. we'd expect the Old World to help us if our turn was on. Where are all the fliers they were going to train? and which are so urgently needed.

I shall probably stick out one more week, now all my stuff is out here Florence is behaving better since I talked to Pa. it is not so very far from her home. she is off today. I made the sketches this A.M. but am giving the afternoon over to letters I *can't* lug my pack brings on pain she has to take it out & bring it home however she is quite good & puts up the easel, & fills the gas bottles & does the chores. we have our beds in cabin but are quite private, & she is nice about making herself scarce. We have had some very hot weather but cool winds in afternoon the cabin is hot for waking I light the oil stove for breakfast.

write soon & tell me how things go—

Emily

NOTES
1 See #49 for an account of this final sketching trip to Metchosin (and her only camping trip of 1940 and 1941). See also Shadbolt, *The Art of Emily Carr*, 166 and catalogue entry 152 (untitled), for an example and a discussion of a work from this trip. Carr later referred to the sketches from this venture: "They are very full of

spring joy, high in key, with lots of light and tenderness of spring. How did I do these joyous things when I was so torn up over the war? They were done in Dunkirk days. . . ." *H&T*, n.d. [1940].

147 [*Cheney to Toms*]

1282 Connaught Dr
Vancouver B.C.
June 3rd 1940

My dear Humphrey

It is a month since your letter came and I expect by now you are through school & no doubt have a teaching job lined up for the winter. I am sure you are glad you sold your house & you sound very comfortably settled—altho I expect you will miss your garden. We are going to move in Sept. if all goes well—In fact they started the house today—we find this too big & expensive so have got a bit of woods on the Capilano river & we are going to build a shack of some sort. It is next to Jessie Faunt & only 10 mins. from town & this time of year really lovely but I expect it will drip pretty badly in the winter—however there was nothing else we could do & have borrowed right & left to finance the building etc. Emily is to be our first visitor and now that the first sod has been turned I am actually glad to be leaving the city. Since we got our place, Macdonald has bought a little house on the other side of Jessie so with Ralph Cox, the cello player across the road we will be quite a little colony of congenial souls. Macdonald & his family look so much better since they moved after those years in that Barclay St. attic which was condemned by the Fire dept. & they had 2 weeks to get out. Jessie has a badmington [sic] court with lights on it so we play until 10 pm on Sat—then hear the cello until midnight—It is all very simple but most attractive and such a relief from the radio, the newspapers, & the horrors & slaughter of this

awful war. On Thurs. night I am going up to Savary Island for ten days with the Van. Art School[1] (don't faint) but I thought it a chance for a cheap holiday—$17.50 for everything including fare there & back. The Royal Savary Hotel do this every year for the Art School & about 25 go up. I am not very keen on Mr Scott & Co. but with a room to myself & many books I can take to my bed & read if they get too awful. I am very anxious to see the Island with its white sandy beaches etc. & only wish I had someone really congenial with me, however they may surprise me & not be too *too* infantile. I cant quite see myself singing round the bonfire & being matey—but one never knows. Shadbolt, no doubt will caricature us all in most repulsive poses which will adorn the Gallery next fall—he has a show on now which possitively [sic] smells.[2] We are trying to have a really good B.C. show for Aug. for the tourists but there is the usual row about it & I expect it will be a hodge podge with one or two good in it. I have done several portraits of Chinamen, the park Gardener, etc. in Emily's medium[3]—Can do them in an hr. & they are really awfully good. Charging $7.50 only for them & sold one to Mrs Wallace Wilson[4]—in fact it was an order & I did her Chinese Cook. I did a self portrait which *I* think is grand but no one else does. I hope Emily got in from camping with out mishap. Selling that big canvas this spring must have bucked her up. What are your plans for the summer?

Nan

NOTES

1 The "Preliminary Notice" from Scott stated that the "Summer School Sketch Camp" would be held at Savary Island from 6 to 16 June 1940. See UBCL, Cheney Papers, box 7, file 9.

2 The Shadbolt exhibition which was held at the VAG, 1–9 June 1940, featured mural panels and caricatures. See *AGB* [VAG], 7 (June 1940). Cheney's critical comment relating to Shadbolt seems strange for one seemingly an advocate of 'advanced' art. Several instances in her letters, as here, reveal prejudices similar to those of Carr.

3 In the early 1930s Carr had developed a sketching technique which involved oil paint thinned with gasoline for use on manila paper. See #12, note 17.

4 Ethel Wilson (Mrs. Wallace Wilson), well-known BC author and poet, was a close friend of Cheney. See Wilson to Cheney correspondence in UBCL, Cheney Papers, box 4, files 20–4.

148 [*Excerpt Toms to Cheney*]

7 Jun. 1940

I took Emily and her sister out in a U-drive car to look for a place in the middle of May and settled her in a shack near her beloved gravel pits at Metchosin. I was practice-teaching in the neighbourhood and got off the teachers' bus the last Friday afternoon I was out there, and went in and had tea. She was purring like a kitten, had done two sketches a day in the first two days and toddled me around the estate. The country out there is all quite flat, so is very suitable for her, and she has her girl Florence, who is blossoming out into quite an attractive kid, and her dogs to (literally) dance attendance on her. She intended to stay as long as she could, so she may yet be there. I haven't had time to phone her lately. Emily must find gouache and builder's paper[1] a great help for spontaneous work with her portrait sketches. I want some day to acquire her self-portrait, rather severe, but very like Emily [is when][2] disturbed, in her painting smock, glaring at an intruder through her specs.[3] I would like her to have a shot at me sometime, she tried, but my appearances for sittings were erratic and to my disappointment she stopped.

NOTES
1 Toms, "Letters to Nan," 7, acknowledges that he was wrong on both counts. See #147, note 3.
2 Toms' addition. See "Letters to Nan," 7.
3 This oil on paper portrait was reproduced in Shadbolt, *The Art of Emily Carr*, 190, and on the cover of Doris Shadbolt, *Emily Carr: A Centennial Exhibition* (exhibition catalogue) (Vancouver: Vancouver Art Gallery 1971). Shadbolt notes that the portrait is in a private collection.

149 [*Excerpt Toms to Cheney*]

9 Jun. 1940

Emily is *very* ill in hospital again. She had been back from camp about ten days and had to be taken to St. Joseph's on Thursday night.[1] Her sister sounds quite alarmed over the phone and says Emily is the worst she has ever been.

NOTES
1 Toms, "Letters to Nan," 6–7, comments that he believes 6 June (a Thursday), not 5 June, as reported in Hembroff-Schleicher, *Emily Carr*, 140, is more likely the date of Carr's stroke, as it was "stated nearer the time." At the time of his letter to Cheney on 7 June 1940, Toms was unaware that Carr had suffered a stroke the day before. He adds that Nan was alarmed when she heard and phoned from Savary Island, where she was sketching.

150 [*Excerpt Toms to Cheney*]

16 Jun. 1940

Emily is much better and is to be able to go home but to stay in bed, late this week. Sister Alice sounds cheerful so everything must be all right again.

151 [*Excerpt Toms to Cheney*]

19 Jun. 1940

Just phoned sister Alice. Emily is about the same; not strong, and has to stay very much in bed but, as the hospital and its food frets her, she is coming home tomorrow to rest quietly in bed.

152 [*Cheney to Toms*]

1282 Connaught Dr
Vancouver, BC
June 20th 1940

Dear Humphrey.

Thank you so much for your letter & post cards re. Emily. Too bad she wont stay in hospital as she will be difficult to manage at home—however they might as well let her have her own way at this stage of the game. Edythe sent me a P.C. too. The Savary island trip was really lovely. I made some good water colours—perfect material for such—with huge skies of great variety—We had wind & clouds but no rain—in fact hot sun all the time. The sandy beaches were beautiful & such shells & purple star fish—Shadbolt ran everything & he gave two good lectures. he only made grotesque drawings of a very fat girl, no landscape work at all, so all the pupils copied him & they spent their days in a huddle drawing each other—such a waste with the material at hand for out side work. Mrs. Bell[1] and I went off together & really did the only outside work—Shadbolt is clever, but limited, & so far shows no individuality—his things are baby Cezanne's—Van Gogh's etc. but he has terrific self confidence & nerve & is saving the Van. Art School which is on its last legs. Scott is so colourless & tight lipped— he did *not* improve on acquaintance & is not liked by the pupils,— while Shadbolt is very appealing to the young—Binning[2] & Amess[3] are not bad—fat & easy going—Amess was courting one of the pupils so was very much preoccupied. Mr Lamb (Mortimer) puttered round with his paint but mostly took photographs—he hired a fishing boat one day & took us all to Ragged Island. The swimming was wonderful & as we were on D.L.S. time we had long days —

They had a play called "the Can[n]ibal King," which was a scream—I had no idea I could be so entheuastic [sic] but it was so care free & seemingly out of the world—we did not listen to the radio and the papers only come twice a week so it was a tremendous change from all the horrors of the moment. Aunt Mary came as soon as I got

back so I am gadding about with her and hating tea parties etc more than ever. Our house has the foundation in—They had to move a glacier deposit of some million years ago, so it took 10 days to dig the hole. The rocks were small but wedged ın & cemented together by the pressure I suppose. Last night we went to a frightful binge at the Gallery—for the Red X. & put on by McGill & the B.C. Reg. I introduced myself to Graham McInnes & wife. (going to Vic. tonight for short visit) & was just having a nice talk when I was rudely pushed aside by Malkin & wife (W.H. the Pres.)⁴ I was furious and I did not see them again. I like McInnes' reviews in the Tor. Sat. night, better than any Art Crit. in Can.

Gaie Taylor's book was returned from the Atlantic Prize Contest—which was rather surprising as they kept it so long. She is not discouraged & I am sure will find a publisher & be a success. She is coming down next winter to stay with me if they are not swamped with refugee children. She does all the housekeeping & cooking etc— her mother being one of these "sporting" English women who cant make a cup of tea. Do let me know what luck you have in the selection of a school—So Peter Sagar [Sager] called on you—he had possibilities at 17 but like so many Jews thinks he is a great deal smarter than he is. As for that Creature he goes round with—who has long hair & a short upper lip—he is really too awful—I think he has got in with the wrong people as he was a nice boy with decided talent. Jessie Faunt is an art teacher in the Pt. Grey Junior high school & one of the most progressive teachers in the city.⁵ She is middle age—& has lived on Capilano road for 20 years—she is doing some nice painting—musical interpretations. You must come & see us when we are all settled in—Will write to E. in a day or two—It is so difficult to know what to say—I want to buy one of her canvases when we move if there is any money left over from the building etc. Mr Lamb has asked Jackson out for the summer but no sign of him yet.

Nan

NOTES

1 Dorothy Bell (1893–1954) (Mrs. F.C. Bell), a Vancouver painter, had exhibited at BCAE annuals at the VAG in the late 1930s.

2 B.C. Binning (1909–76), prominent Canadian artist, teacher, and administrator, was an instructor at the VSA from 1934 until he joined the Faculty at UBC in 1949 (appointed Head, Department of Fine Arts at the time of its founding in 1955). In the early 1940s, B.C. Binning exhibited regularly in BCAE annuals and his drawing entry, *Young Man at a Table*, was singled out as "distinguished work," and the "most worthy" of all the graphics. *AGB* [VAG], 9 (Nov. 1941). For an account of the artist's early career, see Ian M. Thom, "Introduction," *B.C. Binning: Drawings* (Victoria: Art Gallery of Greater Victoria 1979). See also *B.C. Binning: A Retrospective Exhibition* (Vancouver: Fine Arts Gallery, UBC 1973), and Nicholas Tuele, *B.C. Binning: A Classical Spirit* (Victoria: Art Gallery of Greater Victoria 1986).

3 Fred Amess (1909–70), Vancouver painter, became a full-time instructor at the VSA in 1934 (having been part-time since 1929). Amess exhibited with the BCSFA and in BCAE annuals, winning a bronze medal in the 1939 BCA show. See *AGB* [VAG], 12 (Nov. 1944). (In 1952, following Scott's retirement, Amess became the Principal, serving until 1970.)

4 W.H. Malkin, a prominent local businessman, and former mayor of Vancouver (1929–30), was a founder of the VAG and served as President of its Council from 1936 to 1948.

5 See #90, note 5.

153 [*Carr, Victoria, to Cheney*]

218 St Andrews
June 26 [1940]

Dear Nan

So interested in hearing of Savory [Savary] Island it does sound like a beautiful place glad you enjoyed it. I've been very ill. (stroke) collapsed 3 weeks agoe & was scooped off to hospital in ambulance Dr let me home a few days agoe because the hospital was so *rotton* he said they were doing nothing to help me. I have a nurse every day & am still in bed. & allowed no physical exertion at all they say I'll probably get all right but say it will take a *long* time the feeling is coming back to my face & the difficulty with speech is clearing but I can't stand leave alone walk one leg wont take my weight & flops me down—Well

enough! heads been so bad. I just *lay* No reading no writing begin to feel a little better but only want dark & quiet have had no visitors Edith [Edythe] came twice, at first for a minute[?], but has been buisy with exams, since last time I could not see her.

Ira Dilworth was over on Sunday & I *had* to see him there is a new 'Emily' Series CBR. beginning on July 1st. 6:30 evening

Glad house is getting on

Can't write more

love

Emily

154 [*Excerpt Toms to Cheney*]

4 Jul. 1940

Emily is improving slowly. Florence (the maid) says she is better. I know she has had visitors but I am waiting till I am told I may go to see her.

155 [*Excerpt Toms to Cheney*]

12 Jul. 1940

This morning when I phoned sister Alice, she told me that Emily would like to see me now, so I made an appointment for this afternoon. After Florence had announced me I went into her bedroom, on the east side of the house. The room was very dark, all the curtains and blinds drawn, but the windows were open, and with a screen

arranged to stop any light that could come through the gap at the bottom of the blinds. The only noise was that of heavy rain on the big maple outside the window, and the squawks of Joseph the budgerigar.

She lay there very quietly with her knees drawn up, and opened her eyes when I went to the bedside. I took a limp hand in mine. How are you? A long sigh, then a mumbled murmur——"Oh, I think I'm a little better." Then followed platitudes about my recent trip to Vancouver, passing my exams from Normal School, about you and Aunt Mary, etc. "I think I should have been allowed to go when I was in hospital, but I suppose I'm a little better. I *want* to go. I don't feel I'm good for much, but the doctor told me I should have seen myself five weeks ago; he didn't think I'd come through, and didn't think they'd ever be able to get me to hospital in time . . . I told him I didn't think it was worth patching old people up, they were old, and got in the way. I think the old should make way for the young to take their place. I am too old, no use for anything now." "Bunk and nonsense," I said, "you have work to do and work to finish."

"I can't do any work, haven't any more capabilities. There's no use in old people living; and this war, why doesn't *Canada do* something? It's the first time I have been ashamed of my own country. . . ." Up till now she had been lying very still, her feet thrashing in impatience sometimes, and always her eyes were closed. She spoke with difficulty, stammering slightly over some words, propaganda for one. She seemed very drowsy and tired and her voice was a murmur until she started to talk about the war and sentimental English twaddle (to rhyme with paddle) about the Englishwoman who was playing patience when an incendiary bomb fell into the house. She got up and put it out then went on playing patience till the police came. . . ." The silly old fool, she was just showing off! would you have gone on playing patience? (Heavens, no!) The old fool was just doing it for effect. When I was small the dentist always told us to yell and let the pain out——there's something in it; these English are absured with their restraint," etc. etc.

Her voice was faster and louder and clearer as she became excited

but her eyes were still closed, and her chin was sunk in a roll of her neck folds. She told me that she was losing Florence on Monday and would have to break in a new girl. Her good friend Flora Burns had been writing business letters for her, and when I offered my assistance she said no, she'd get along somehow. I was most depressed during the whole time I was there. She never smiled or chuckled once. I didn't feel I was contributing at all to the conversation, and just let her labour on, slowly and painfully and regretfully. However, a manuscript lay on the bed so she must be doing a little quiet work from time to time, rereading and correcting her stories. For once she paid no attention to the scufflings and snufflings from the 'pup-chicks'[1] in their boxes in the corner of the bedroom, nor to Joseph's squakings. I am afraid that we may hear that she has gone, one night in her sleep.

NOTE
1 Carr's term of endearment for her griffons.

156 [*Cheney to Toms*]

1282 Connaught Dr
Vancouver, B.C.
July 18th 1940

My dear Humphrey

Your letter came some days ago about Emily & another letter some weeks ago & I have just not been able to answer as I am still flat in bed (3 weeks now)—as dizzy as ever & now very weak. Macdonald came in today for a moment & I gave him your letter, & he is planning to go to Victoria on Sat. to see Emily—This was my suggestion as I thought she would like to see him as it is impossible for me to go for some-time—if all summer—he knows Mrs Boyd (Shelia's Mother) but no

one else except you so perhaps you would meet him (day boat Sat.) & if Mrs B. cant put him up you could suggest a cheap hotel or something & then take him out to see Emily—you may be all booked for the weekend but in any case I know he would appreciate your meeting him etc & so would I. Jock may be able to do something for your Russian friend as I have not been able to look him up or even tell Jock about him. I *am* worried about Emily & feel she needs a good practical nurse who could cook as well as look after her. She could afford it too as she is better off than she wants people to believe—and her niece Mrs Boultbee pays all the hospital & extra bills and she told me that both Alice & Emily had investments which brought them in a monthly income. E. is so hard to manage but with the right person she should live for years as she needs *diet* & the proper food to keep her blood pressure down—She has a tremendous appetite judging from the week I was with her & the times she has been here & she eats the craziest things—Poor Emily, what a life, & I know how she hates being tied to her bed. You were a lamb to write so sympatheticly [sic] about her and you are really one of the best friends she has in Victoria—Edythe was in last weekend but did not seem greatly concerned about Emily—said she was so cranky she must be better—but Edythe may be upset about her own affairs—her husband has been let out of U.B.C.—dont mention this as she is very sensative [sic] about it —

I hope you are able to see Jock & do keep me in touch with E's progress—I am sure she would like to see you oftener than she lets on. What are your own plans?

Affectionately

Nan.

157 [*Excerpt Toms to Cheney*]

22 Jul. 1940

I met the boat on Sat. but did not see Jock and went up to Emily's afterwards for 50 minutes or so. She was a changed woman, said she was enjoying the second day of 'clear-head' and was really enjoying life again. *She* did all the talking and told me all about the stroke, what happened before and during and after, and seemed to enjoy herself immensely in the telling! After an unsatisfactory temporary woman (to take Florence's place) she got a Japanese girl called Ruby, who is quiet, capable and quite satisfactory to Emily. She is to last until school goes back in Sept as she hasn't finished High School. Emily's leg, I don't know which one, is still partially paralyzed, but she sits on an apple box with casters on the corners, and pushes herself around with the other foot, but she has to have help going over door thresholds. After her face had loosened up she had had violent neuralgia and one very sore eye which must have been the feeling coming back to the semi-paralyzed face. Her food needs are very simple, and she has a V.O.N. nurse come in every morning around 8 to wash her and make her bed, after which she sleeps again. So, everything is all right again. She really did look dreadful last time I saw her. She told me that since my last visit she had cried the whole of one day, which she thinks did her the world of good. Anyway her eye trouble and giddiness has passed, and with it her main source of discomfort.

158 [*Cheney to Toms*]

1282 Connaught Dr
Vancouver, BC
July 28 1940

My dear Humphrey

Expect you have heard from Emily that Jock went to Vic. the following Tues. because there was a one day excursion & he spent 2 hrs with her. She was in bed but *very* lively and altho' she told him her leg was paralyzed he said she moved them both very freely. I was so sorry I could not let you know but I did not know myself & he only had time to see Sheila Boyd, now married to a sailor—he said Emily for all her disability was a real inspiration just to talk to & he enjoyed his visit very much—I was so glad to get your letter too about her, as you gave me more details than Jock, and are able to size things up better as you know her so well & her way of living—Dr Trapp has gone over this weekend on business & will go & see her if she has time otherwise will phone her Dr. I have written several short notes but she has not answered them—She does not like her freinds to be ill when she is—I dont like it either—however I am better & hope to get up this week— "nerves" are the devil & I am not cabbagey enough. I have read dozens of books—mostly travel & History—at the moment I am deep in "Bali & Angkor" by Geoffrey Gorer,[1] and it is the best book of *any* sort that I have read for ages—not the usual travelogue, but gives you the essence of the country—I have not listened to the radio or read the paper for weeks. Cant you possibly stay out of this awful war. dont be embarrassed by a lot of puppets in uniform as we will sorely need *your* sort to remake the world. however I appreciate how difficult it is for you. Do send me some "wretched jingles & brawdy verse"— nothing I would like better in my low state of mind —

Affectionately

Nan

NOTES

1 Geoffrey Gorer, *Bali and Angkor; or Looking at Life and Death* (Boston: Little & Brown 1936).

159 [*Carr to Cheney*]

Sunday
[postmarked 29 July 1940]

Dear Nan.

Do hope you are feeling better am so sory you are so rotton, it gets so monotonous and it must be doubly hard just when you want to be poking round the New House both Mr McDonald [Macdonald] & Dr. Trapp say it is going to be lovely. It is *nice* to have your own finger in your own pie I know but its no good going about it before you feel fit. it is only liable to throw you back & upset the apple cart I will just quote that tiresome "patience" they are always rubbing in to me. I have now got to reckoning by weeks or months not days am well on in my 8th week in bed. & am now beginning to see improvement. It was such a *pleasure* & *surprise* to see Dr Trapp. I enjoyed her visit greatly & hearing about you from an eyewitness

A friend has been altering my front veranda making the entrance at end insted of side. It would make it much easier *if* & *when* I ever go abroad. in a motor (or easier for the undertaker to lug me out) besides it gives me what I always wanted here a trellice to climb roses on and to hide my winter supply of wood behind. It is so much cheaper & more satisfactory to buy in summer he has put my tub-trees up on the Veranda so that I am sheilded from being a curio to the dame next door the weather has had a break but if she 'hets' up again I can go to the veranda on my scoot-box and lie on the porch, & watch the birds.

My little jap maid is very nice. she is quite untrained except helping her Mother & a high school girl has little time for home help these days so it is difficult at times shewing her things especially as we have a *brute* of a cook stove here however she has infin[i]tely more *sense* than a white girl of same age & is quick & uses her eyes & memory alas only one more month before school begins & she will be

away back. & I'll be training again I feel like a circus manager training dull beasts who die on them soon as proficient. Dr Trapp said Hill was enjoying the new house's building I am so glad. & I can tell you you are lucky to have some one to keep an eye & keep you informed I built when I was in Vancouver house in Victoria. & had to trust the fool architect who was a hydraheadded brute & cheated & antagonized all his men. What a time I did have. My poor little garden has been very potty for lack of an oversee, or worse these last days I can look out of door or window, & see the 'need-doings'. & cant get out to do them. the scoot-box is impossible on the pebble walk. Alice's garden has been lovely she says, but I have not seen that either, but she has brought me in beauties. Have you still your nurse? Mine comes evey morning V.O.N. & gives me far better attention than I got in Hospital, & my room is so shady. under the tree I just crave dark & quite when I am ill like a sick Cat does. Have done no reading or writing have a radio by my bed but dont use it much prefer the singing canaries & bouncing pups.

You made me blush reputing me with backbone & spirit. sometimes I get so down & dont carish one whole day I balled because I thought the time had come to get rid of all my creatures. I *wont* kept [keep?] pets if they are neglected & the fool I had was, a hard cold devil, with no feeling for flowers or animals. but the Jappie, tho' not specially fond of creatures is fond enough of me to try & make them happy, for me. I can see them from the window & will enjoy them from the porch deliciously. I get up only for wee spells once per day, to cool the bed. head wont stand too much up yet. without making me feel sick but I do feel now I am getting on & *may some day* attack work again will forgive anything if my head is clear & I can work legs are not very important but I can take a few wobbling steps now. I enjoyed McDonald's [Macdonald's] visit so much but am so mad that I forgot the sketch for his school[1] he could so easily have taken it with him. I *hope* now I shall be able to have my annual. in Van Gallery in November[2] I have quite a lot of last years that was mounted after the last show & I have this May's waiting to be mounted. how much I do

between now & then remains to be seen I shall not attempt too soon
It would be better for the work to wait. Ever so much love do hope
you are feeling better. If I had more efficient help I would ask you
over for a few days change presently I made my tiny lumber room
into a servants bedroom so the girl is there & the bigger room can be
used by either Alice's flat or mine & is at present lumber [?] & odds &
ends. but beyond a few trunks & things could be used. but if you came
Aunt M. would wear you out rushing you back & forth. my girl *can't*
cook. Alice does me one meal per day. The rest is scratchy & uninter-
esting & nothing to invite an invalid to, I have to semi-starve any-
how—but you will need feeding.

Yours ever

Emily.

NOTES
1 Macdonald was obtaining the Carr oil painting (*Cabin in Woods*) for the 1940
graduating class of Templeton Junior High School (now Templeton High School),
for their presentation to the school. Macdonald, who had taught at Templeton in
1938, was currently teaching at the Vancouver Technical School. The painting is
presently on extended loan to the VAG.
2 Carr's third solo exhibition at the VAG was to be held 5–17 Nov. 1940.

160 [*Excerpt Toms to Cheney*]

1 Aug. 1940

I went to see Emily again on Tuesday and found her out on her back
verandah, her hair in pigtails, shouting at Ruby who was clearing the
yard ready for a load of wood. I followed her into the house—she
went ahead on her 'scooter,' hopping along and then was helped into
bed by Ruby. She was full of beans. She tells me that Ira Dilworth is
reading some more of her stories every Monday at 8 p.m. right across

Canada, subject to cancellation without warning. She had had a burst water pipe one day last week and had not allowed me to go and see her then as she had been too tired. Her voice was at first husky (as it always goes when she is tired) but it cleared up, and I stayed nearly two hours. Although she didn't discuss him she had quite evidently enjoyed Jock Macdonald's visit. Her legs both move around restlessly. Apparently the one can't be controlled when carrying weight; also she gets dizzy and doesn't want to stand up properly yet. She has re-arranged her yard so as to accommodate her wood and has made a little lattice fence across so that it is more private. Also she has had new steps put at the end of the verandah so that she can get into a car easier when the time comes for drives.

161 [Excerpt Toms to Cheney]

10 Aug. 1940

I went to see Emily on Wed afternoon and stayed an hour. She seems to be herself again except for being bed-ridden. Her voice is normal which is a tremendous change. As usual I let her do all the talking. She didn't seem to notice that I said nothing, but went on with grumbles about her exceptionally poor treatment in hospital. . . . amongst other things she had had to wait four days before anyone touched her hair. Her diet does not allow her much choice—even then her weight does not go down. She has to have a salt substitute which annoys her as she says the little she is allowed to eat has to go saltless. She can't read much, but craves short stories, and does a little writing and correcting and has just had her typewriter overhauled. So everything is alright again.

162 [Carr to Cheney]

218 St Andrews
Sunday
[postmarked 12 Aug 1940]

Dear Nan.

I am *so sory* your miseries are so prolongered it is so disheartening
when one *can't* hurry despite the best intentions of oneself & the most
violent efforts. I know all about it & can truly sympathize but can now
see that *forcing* is *no* good keeping as happy as one can, & occupying
your thghts with other things helps. in demonstration of this, I had a
bout of *crying* lasting 12 hours & *let myself enjoy it to the full* & have
been better ever since. washed away lots of sediment we Britishers
have *forced* for so long ourselves to be strong and put on a surface of
heroics & smash under all feeling, that we've over-bottled ourselves, &
it's hard to let go.

What a lot you have to look forward to in the new house It has
been beastly hard not to boss operations I know but you will have the
fun of bossing the settling in, & finding the new places for putting, all
your *particular* things which is I found most amusing they seem actu-
ally to shout 'me here' The nooks just seemed made to fit them, that
is, provided you discard. enough. before you move. not to be over-
stocked

Glad you liked the broadcast I agree with you Mr. Dilworth does
read them *well* I told him—"you read them as if you were in the
places & loved them" he said "I was & I did" He is East for two
weeks came to see me last Sunday. I dont know about the series when
he returns but I do know the *East* does *not* think much good *can* come
from the West & grudge them the time which anyway is now over-
taxed with war & with trashy, crooners, & bum pianists. Yes I know
how visitors tire, visits of over 15 minutes should be forbidden by law
sick visiting is an art *few* have acquired.

I crawl into my garden. (dog yard) from the studio and sit on my
veranda when not too hot. it has no lid, but most [of] my time is still

spent in bed. Poor Dr Trapp what a consignment![1] It is hard on people. I do think evacues should be allowed to bring *some* contributing sustinence. for my part I think I'd s[t]ay among the boms. maybe when one fell on my hat, I'd up & scoot. Am glad Edythe feel[s] better I never do know with her she seems so fin[i]shed, & next thing she is as completely recovered, as anything. Her letters are misleading. she always stops mid-air. & half tells things in letters I have not read at all yet—eyes bother a great deal, & nose red as a beet. Most ugly!

Poor Humphrey he is an old hen, I think perhaps a session of Army training & drill would make a man of him he lacks something nice boy though he is.

Garden got cold so—I moved to veranda there is a sharp little wind. Willie altered my veranda is is very nice & private now. I still have my little jap (only until school starts). I like her very much of course she has limitations never been out before & foreign. doesnt know white ways but she has nice handy little fingers & is willing she can't cook. (even for herself she makes only Japanese messes). My sister does my dinner & we botch up the rest my diet is vile anyway no sugar *no salt* no puddings only a few vegetables no bread. no *anything nice* and yet I *put on* weight! Dr doesent know what to make of it. I would not mind the hatefulness if it thinned me but it doesent.

Well cheer up. and I hope you feel really better soon.

much love

Emily

NOTES
1 Dr. Trapp knew and respected a Dr. Bannerman in Edinburgh and agreed to look after his wife and three young sons as evacuees during the war. Information from Mrs. Nell Lawson, Toronto, Dr. Trapp's niece.

163 [*Carr to Cheney*]

[*Letter forwarded to Capilano, B.C.*]

218 St Andrews
[postmarked 11 Sept 1940]

Dear Nan

I expect you are moved or in the act. we are thundering and deluging at the moment

Hope the new house is all you dreamed, and that the mountain did you good.[1] I always wanted to see that place, but I was scared too of a hill & precipice road is it?

Humphrey came and *kissed* me bye bye. he was in good spirits. Hope he likes the job.[2] poor boy, he is so child like at times.

I began this week beginning to commence, preparing for my Nov. Ex. Have done no painting since illness but am mounting what I did just before I collapsed.[3] The mill was *very* slow with my material and I am anxious to not have to rush can't do much at a time. Am again without a maid. My delicious treasure of a jappie went back to high school this month. I got a girl who I was satisfied with & she seemed happy I struggled one week—felt she was fairly started and last night a swine of a Mother came and yanked her off. a horrid woman. I had allowed the girl an *extra* time off to go home she was to be back at 8 & arrived at 9 1/2 with Ma in tow who said she missed the girl & wanted her back & toted her off—very upsetting & the girl felt bad & cried she said I'm happy here & I dont *want* to go but Ma. took her so it is all to go through again They are *so* scarce and *so* uppish. the Dr gets into a fuss over each maid. says I should *not* have that worry & tho I am better he says I am not making the improvement I should he wanted me to go into a nursing home for *2 months* but I think I got him out of the notion, and he has now gone off soldier-camping, & I hope will forget it. It really is so comfortable & convenient in my flat I have just had the gas put in. Now if only *I could*, tap in some efficient help I'd

be O.K. I prefer the youngsters, they are so much more biddable, & quick-footed, but Oh the mothers—bring them up so shocking ignorant of work. & with such fool notions. the little oriental was so much more efficient & methodical & kindly. I toddle round a little but can't do much except look-see over. Wonder *if* I shall ever be a guest in your new house? I *had* looked forward to it. Well who knows? I shant kick if I can just go on quietly seeing & feeling. The Dr says I must not expect to take up where I left off for I wont. well never mind there's lots left & anyhow we have no boms, blood, and underground shelters. Edythe is over with her Mother & seems happy & proud about Fred he is enjoying his work E's Mother is better

Building the house is only half the show there is the fixing it & the garden you'll be buisy & I do hope feeling well enough to enjoy it

love

Emily

Send new address

NOTES
1 Cheney's second trip to Garibaldi was likely in a sketching party with Macdonald, who was there that summer as well. See Nicholson and Francis, "J.W.G. Macdonald," 28.
2 Toms had accepted a teaching post in a one-room rural school at Ashton Creek, near Enderby, B.C.
3 See *H&T*, n.d. 1940, [Sept. ?] and #146, note 1. Carr's stroke had occurred in June.

164 [*Cheney, North Vancouver, to Toms, Enderby, BC*]
[*The Cheneys had moved to Capilano Road in North Vancouver earlier in the month. Toms was teaching at Ashton Creek School.*]

[3065 Capilano Road]

Capilano B.C.
Sept 17th, 1940

My dear Humphrey

Was simply delighted to get your letter yesterday with the details of
your school your "home life" & the countryside. It really sounds very
interesting & such a change from smug Victoria—The only draw back
is not having your own kind to talk to now & then, however its not as
bad as some places where you could not get away for the holidays—I
had a letter from Emily last week & she said, to quote "Humphrey
came & *kissed* me bye bye, he was in good spirits, hope he likes the
job, poor boy." She is having trouble getting a maid again & the Dr.
says she shouldn't have that worry & should have a housekeeper as she
must not expect to take up where she left off. She is planning her
Nov. show over here & will come too & stay with us if she is able—
There are rumours that Lawren Harris Sr. & wife may come here to
live from New Mexico[1] as he cannot get his income over the border
(Massey-Harris Farm Impliments [Massey-Harris Company])—and it
is doubtful if he can go back to Toronto just yet as wife no 1. still lives
there & as they have not a Canadian divorce she could make it rather
uncomfortable for all concerned. Wife no. 2 has a sister in New
Westminster & she is trying to urge them to come here, even has a
furnished house in Caulfields [Caulfeild] in view for them—It would
be wonderful for we few struggling artists to have a man of his
character & ability in these parts—his painting is now entirely
abstract but I am sure he would be interested in Jock & in Jessie Faunt
who is doing lovely things in the abstract field using music as a
motive. I will enclose a clipping about "The Capilano Colony" you
will be amused—please return it— The B.C. show[2] opens this week
and apparently they have had more entries than ever (400) & poor
Jock has to help select & sort—I put in two water colours done at
Savary—We have been here just 2 weeks & really I feel as if I never
want to see the city again—The move was pretty awful—luckily the

weather was perfect but the painters plumbers, tinsmiths[?], and carpenters were still here & haven't finished yet—The best workmen have all joined the army or are working on Gov. building so the rest are very independent & come when they damn well please—however we are settled in & Hill is on holidays so is puttering round the garden etc—one of our neighbours Sydney Smith, has made us a lovely rock garden & Jessie & the Macdonalds have given us plants etc. We have nearly an acre fenced in & no houses in sight and yet we are only 8 mins. by car from Birks corner—The trees are very tall and straight and the river is very still & green just in front of the terrace-to-be & 100 ft. down—There is an Emily Carr canvas from every window & door and several from the two upper decks. You simply must spare us a few hours on your way through at Xmas. The Macdonalds have had a good summer & all look 100% better—I am terribly pleased as I was personally able to make it possible for them to buy this little house. I had a tiny nest egg of $500.00 which I loaned them (Hill does not know this & I don't know why I am telling you except that you would do the same thing I am sure). I felt it would be of more value to the future of Canada than put into war bonds—dont you agree? and Jock has paid some of it back already—dont ever let on that I told you this & I really shouldn't have but I can't rewrite this letter now. I like your description of the Armstrong fair & the & the "funny little maiden thing" at the Art Exhibit—You may be surprised & find she is the town floosie. I expect the school teacher is quite the catch so dont follow your predecessor—altho it was the other way round. I can understand your life in that a community as we lived in such a one at Clyde Forks Ont.[3] when H. hadn't a job—only we had a log cabin & no inside plumbing etc & were kept awake by the porcupines crying at the door & gnawing the corners off the house—I had a lantern rigged up above my bed so I could read. So glad you like your landlady—our neighbours were the dour Scotch—poor & very suspicious of a kindness or any generosity—so very hard to deal with I found & very dull—they were mean even with words—Do write to me again & I will try to keep you in touch with news of the Art world—Would you

like my "Art digests" or any other magazines I can find. I am much better but taking it easy & slowly unpacking my books & pictures —

Affectionately—

Nan.

Do I address you as Mr. H.T. or H.T. Esq? in such a place? We get mail once a day & have to go 1/2 mile for it.

NOTES

1 The Harrises had moved to Santa Fe, New Mexico, from New Hampshire in 1938.
2 The BCAE was held at the VAG from 20 Sept. to 13 Oct. 1940.
3 After leaving Ottawa in August 1934, Dr. Cheney lived for the most part at a cottage on farm property at Clyde Forks, Ontario. Nan Cheney wrote to Pepper from there on 19 Aug. 1935: "[I've] never put in such a trying summer. You know how I hate this place anyway & with the heat & mosquitoes and now deer flies & no place to bathe within 2 miles—it has been dreadful. I hardly feel equal to going back to Montreal and drumming up a job."

165 [Carr to Toms, Enderby, BC]

218 St. Andrews St.
Sept 20 1940

Dear Humphrey

Glad to hear from you and super-glad you are so pleased & happy with yourself & job. It all sounds very nice and wholesome and peaceful fill yourself with its niceness. I would like to see that country[1] was interested in the trees & beasts about made my spirit dance to be off woodsing . . . Have been mounting & framing my June sketches preparing for Nov. Show in Van. gallery Have a month yet but dare not hurry so am getting into shape am well enough now probably

about as well as I will be. The Dr. said not to expect to take up where I left off have not been out yet. I mean no drive or anything, nor dressed yet as I am in and out of bed so much its not worth while. it has been a cheap summer on. clothes.

Letter from Nan in the new house she says it is nicer than she expected and she seems happy Hill is in 7th with holidays & puttering around doing things. It must be quite nice over there I wish I could visit without the bother of getting there or being nice when got. and Nan is strenuous & emotional or depressed? I am very selfish. I am tired of me.

I have no help at all last two weeks it is just impossible, so I have quit trying. Alice is boarding me. Rubie comes 2 hours Saturday mornings with a pick & shovel & uncovers me from debris. and another jap woman on Wednesday afternoon & dusts me off. for the rest I crawl in & out of cobwebs. and enjoy peace. They are not worth their pepper leave alone salt so why fuss with them. I throw Old Maid pernicketyness to the wind and accumulate.

I have had gas put in & it makes things so much easier with hot & cold in my bed-room & no food to prepare a maid is superfluity. The house is *very* nice without. & I think It is really good for Alice. she has no school enjoys cooking & feeling she has something to do in life she is more cheerful than for a long time past I have not many visitors people are all to busy with their own doings & charities, Red X, etc., so I have time in plenty to think & enjoy the very lovely autumn days.

why dont you take *more* radio in place of newspaper[2] one never need be cut off now-a-days. I know the coyotes youl. I heard a man say they were ventriloquists—I dont know. I played with one once in the Cariboo I wanted a close veiw & he did not scent me I had to Yahoo! to make him look up or he would have butted into me. & we would each walk off a little way & look back & sit & study the other. They said I should not have startled him at close quarters like that but I'm still here.

Edythe Brand came today Fred is in an air training camp he has a position as instructor has done very well. E. is here with Ma who is ill.

Selfish old devil wont be left alone one minute of day is in hospital & besides all Jub[i]lee staff has two specials two daughters one husband. *all* holding her both hands *all* day & night—her heart is bumm. I don't wonder!

How can you suppose I have anything to write about any more than those two gold fish in my garden boul my eyes are bad still so I can't read, & what with only 1 3/4 legs I'm pretty much sediment.

Affectionately as ever

Emily

NOTES
1 A reference to the area around Ashton Creek, BC, where Toms was teaching.
2 Toms, "Letters from Emily," 5, notes: "I must have grumbled about getting my hometown paper once a week with the mail. The batteries in the farmhouse where I boarded were always running down, leaving us with no news of the war."

166 [*Carr to Cheney*]

218 St Andrews St
Sept. 1940
[postmarked 20 Sept. 1940]

Dear Nan.

So your dream house is now reality I am so glad it is '*nicer* than you thought it could be' I am shure it is lovely. someday I hope to see it someday—someday. Glad you are feeling better and hope the new environment will boost your complete. I bet Ink. does love it. I spose I am a pig but I like my property *fenced*: it never seems personal till it is. I love the privacy that a border gives. I hate these promiscuous gardens ebbing out the boulevard with everyones cats dogs & kids floating in & out like wreckage & drift. If I never inherited any other trait from

Father I did that one *very* strong—an ordered, seclusion *with gates* open them to who you like but be able to shut them too. if we were not meant to be *people* with *personals'* why weren't we made liquid?

Such a grand autumn day! but getting real nippy in early morning. Hope your new woman is a success. I've *quit* my last two have been so *quite impossible* I now rejoice in *none*. plus·two, that is 1 1/2, that is, a japenes woman 4 hours once a week and my Japenese school child 3 hours once a week that keeps me passibly clean. And Alice feeds me, and I think it is doing her good she has no school kids this term and feel[s] she is some use again. she can manage seems to find little difficulty *if she* cooks in her *own* flat & is not fussed & my meals are so spare and *simple* no fancey stuff most days a chop & vegetables. I get my own breakfast (one slice melba one cup tea)

I had gas put in last month & it makes it possible without a girl I *could not* have tackled that *frightful old stove*. Everyone says there is *no* help to be got no matter *what* you pay. I have runing hot & cold in my bed-room also, and my flat is convenient. My Eyes are perhaps slightly better but cant read much yet (not read a book since June)

I have been getting underway for my Nov. Ex. pulling out my June sketches (not painting). I doubt anything comes of the Harris rumor. Dont think Lawren cares about west. Both wrote me not long agoe mentioned the possibility of a return to Canada, but not West. I doubt he would go so far from his mother who is ill. that is my own feeling. also Besses [Bess'] Pa is *very ill* if not dead already by now they might as well be East as. in Vancouver far as I was concerned. & I do not think her sister's 'set' is very congenial to Bess Though she is very fond of 'Dorit' His present work would find no sympathy out West— little enough in East too bad when he was so happy in the group he found in Mexico.[1] but everyone is stirred up everywhere. & may be new commotions are good for us all. I am afraid he would find no sympathy to speak of in Vancouver but his own natural charm might create it.

I had a nice letter from Humphrey very happy & content I am so glad he is.

Ruth is home again bringing with her a refugee Nurse & baby.[2] an exhausting child of 1 3/4 years. an *hour* of it this week nearly finished me Ruth is charmed, & I felt mean at being so tormented. The fool nurse was to come for the kid in 10 minites & took *one hour*, & I was nearly crazed. I simply can't stand the Goo! & Boo! age. when they get to 4 they begin to have sense & before 6 months, no one expects it, but between they are a blight, and heavy going especially when their adult is goofy on them. I am *not nice I know* & the meanest part is that the brats *like me* (because I don't fuss & 'goo' at them)

Dont see much of Edythe Ma keeps her to heel pretty tight. Ma always resented Edythe coming to or being fond of me. & now of course had a good excuse & is one of those invalids who will not be left alone *one minute* someone has to hold her hand while she sleeps.[3] Oh Lor! Now it is 9:30 time I bathed then I putter in studio for a little bit. back to bed 12–3, & then another little putter.

Ira Dilworth has been East again I dont know about Broadcasts. but I wish they could keep the paper's right on them people get mad. Glad Hill enjoys the new place so much fixing up to do. I am only just fixed in my tiny corner after all these months but I have had a set back or two, & of course once fixed you have to keep on fixing to *keep* straight. I have been making all my sofa pillows button on & off, for easy changing—the pups do make pillows dirty & I let them up on the sofa. they must have some comfort & really are *so good* considering they are never out, beyond their tiny yard, & have so fool a Ma. Pout is looking old, he is getting on. My Sisters old dog is a wreck poor chap.

Much love to yourself. (some for Hill too)

Yours

Emily

P.S. Edythe came today I gave her your message. Ma still poorly in hospital 2 daughters. 2 *Spec[i]al* nurses 1 husband *all* holding her hand

all day. the sister I call "Hussie" is here been married one week[4] in East She is Tripe!

NOTES

1 Following his arrival in Santa Fe, New Mexico, in March 1938, Harris became involved with the newly formed Transcendental Painting Group. The Harrises stayed for 3 months but didn't settle there until October. See Reid, *Atma Buddhi Manas*, 27–9.

2 A nanny and "Gillian," a young child of English friends of Ruth Humphrey, spent most of the war years with Dr. Humphrey before returning to England in 1945. [Humphrey], "Letters from Emily Carr," 150, note 44.

3 Hembroff-Schleicher, *Emily Carr*, 16, is highly critical of Carr for such remarks, explaining that her mother was desperately and terminally ill.

4 Helen Hembroff married Dr. T.C. Ruch.

167 [*Excerpt Toms to Cheney*]

[Enderby, BC]
Sept. 28 1940

. . . I had a long letter from Emily in the same mail [as yours], full of personal things, and she ends up 'doing so little, how could I expect her to find anything to write about.' I let her talk . . . she simply had to blow off steam to someone about her grumbles. I hope she has a chance to have some of her stories published. She told me in August that Ira Dilworth had sent her a publisher who was interested,[1] and who wanted to publish a mixed bag *soon*, not just 'after the war is over.' The idea of the mixed bag displeased her as she wanted the 'Indian stories' and the 'Reminiscences of the old Carr House' kept separate. Perhaps a taste will gather a public who will ask for more. Thanks for the catalogue of the B.C. show. Philip Hennell Amsden, who had three pictures in it, is an old friend of Emily's.[2] He used to board with Emily on Simcoe St. and has several of her older sketches. Later, in the hard times when he was working in a tie or cordwood camp on the Malahat, the Provincial Police rang up to tell him his

application had been accepted. Emily begged them to hold the job open, laying it on thick, and moved heaven and earth to get someone to go up on the mountainside (some 15 miles from Victoria) to ferret him out. He is now in the force at Nelson. His Hennell cousins[3] were in Victoria from New York last summer and one of them was out at the Langford cottage when I was there one day. . . . next summer I must get Emily to take my unfinished portrait sketch out of the cupboard and finish it. She and I were both dissatisfied with it as it was when she left it in the autumn of 1938. . . . [4] Emily tells me in her letter that sister Alice is doing her cooking for her 'which gives her something to do and an object in life.' Emily seems to be keenly looking forward to her Vancouver show in November.

NOTES
1 Oxford University Press (Toronto). See #144, note 1.
2. Amsden published ''Memories of Emily Carr,'' in *The Canadian Forum*, 26 (Dec. 1947), 206–7. See also #190.
3 Joan and her brother, Val. See #118, note 1.
4 The portrait was likely destroyed at the time of Carr's move to St. Andrew's Street. See *H&T*, 7 Feb. 1940, regarding moving preparations.

168 [*Carr to Cheney*]

218 St Andrews St
Oct 13 [postmarked 1940]

Dear Nan

I've sworn a swear to get some letters off Today how one does put off. but I really am quite buisy doing odd jobs in my ups & downs. its a nusance being in bed so much. have to as after a few jobs or two am tired. am still maidless. Edythe has just been telling me they got one & she up and offed without a moments notice after 2 days. really they are impossible. an eight hours day & $25.00 per month. I am far

better off with none. The house is so peaceful. & with a jap half a day twice a week its pretty clean. with no cooking going on. Alice is man[a]ging fine & I do not think is any the worse—rather better and certainly more cheerful. I am able now to read to her that takes up lots of time. I think she missed that when I was voiceless though she never said so. I give her several sessions per day it is less tiring. Have just been signing some sketches am pretty well in hand for November's show, but don't count much on seeing *me*. At one time I thought perhaps I might make it, but judging by how exhausted & flat-out I was after a drive just to Oak Bay, I can see I'd only be a nuisance. Edythe took me into the park last Sunday I begged her just to toodle among the trees in the Park & not go the Marine drive. (I hate that glare of light) & we sat still in the motor for two little spells & I really enjoyed it. This other woman asked me a few days later & I said I love a little drive, not more than half an hour at most. & she dragged me round after promising I should come home when I liked, consequence I was quite voiceless & knocked out & will never go with her again. She did me that trick last year taking me out to their country place, & sticking me there (having promised I should be home in time for tea). we got home 10:30 P.M. & I was ill for a week after. You are so helpless & at their mercy when you can't get out and walk. just because one is fat & not dead white they take it you're a horse. I shall stay in my own place. I can go to the door & breathe every now & again & sit when not too cold. Dr told me those bouts of exaustion took back weeks of improvement, & I see it is so. I did want to see your house it must be delightful thank you for photos. it is such fun planning & fixing out of new ground, when you can do as you like being your own. I wish you could have come down when Aunt M. was up country, & we could have had a visit without duty butting in.

Well Lawren & wife expect to be in Victoria round 22–24 of this month for 2 days. his Mother is now at Empress Hotel. their plans are not quite settled. several things *may* happen—he wrote me day before yesterday.

Have seen very little of Edythe Her mother is *aweful*, keep[s]

them constantly on the hop, is home now. was *ambulanced*. though she's been walking about for weeks. has a night nurse as well as That fool Helen is a nurse you know (Edythe's sister). so with the two girls home Pa a night nurse & a maid they should get by. She won't be left alone *one minute*. I said "but what can you all find to do for her, especially a nurse at night?" Edythe said "She is a *very* difficult pat[i]ent & finds something for us to do for her every minute"—I call it downright selfishness. And poor old Pa is not so well off. but that the hospital all that time & 2 specials as well & all her other nonsense. must have pretty well emptied him well none of my buisiness. but she shure does seem to be a selfish flab. Edyth[e] is tired & looks disgusted & admits Mother is spoiled.

Don't be too wounded over the crabs. I'm not supposed to eat much of those goodies you know. am still on diet not *quite* so severe but even if I have not lost much I do not want to *gain*, nor do I want to be ill Doctors are too busy to be bothered with elderly crocks now.

I have very few visitors every one is too buisy & I quite understand. I am all cosed down for the winter. stoves in shape yard full of wood, heavy curtains over big windows. fires are cosy already.

I'll send the photos on. I answered Humphrey's letter some time agoe yes he seems very happy & I hope will. strengthen [?] up a bit probably good for him to be absent from Mother

Am just finishing a set of 3 rugs. for red cross. sale place.—blue & gray—have been trying for weeks to get some refugee sewing from the rooms but they appear to have *shocking* organization I got so disgusted I boght material & made women's night gowns told them I'd make 12 *more, if I could get* the material. heaps has been donated. but I cant get any from them so am thinking of applying to Vancouver. 'Clem Davies Ministry'[1] has work rooms & they are alive. I can do quite a bit of sewing, if it is simple & does not have to be worried over. when I am listening to radio & lying in bed I make big-woman's-size-nighties like I wear only flanletter. All the flappers & young women wear pajams, but it is hard to get big well-made gowns for old women. poor souls what misery ahead for winter! I wish you could see

my studio & rooms they're nice, not fancy but comfortable. There is *something* in the rumour you heard (stories) but nothing definite yet. so I do not say anything. I still get letter re: broadcasts one from near Ottawa this week from people who were mentioned (Old timer freinds of My Mothers) they were delighted. tea time so goodbye. tell Mr McDonald [Macdonald] I am ashamed about his school picture I looked[?] it out but have been neglegent about sending it off. Need a few pins stuck into my person. Write soon, & look for me next spring *shure*.

Yours as ever

Emily

NOTES
1 There are a number of entries in Carr's Journals of her attending the Sunday services of Dr. Clem Davies in the old Empire Theatre, and later of her listening to his radio broadcasts. See *H&T*, 28 Apr. 1935 and 3 Sept. 1939, as examples.

169 [*Carr to Toms*]

218 St Andrews St
Oct 13 1940

Dear Humphrey

Nan asked me to send these snaps on to you The house looks very jolly & she seems pleased with it.

Things waggle on. no maid much more peaceful without & getting on all right jappies 1/2 day twice a week & my sister meals me & is much better & br[i]ghter for having it to do apparently.

It is very late autumning but lovely with heavy rain at Times. Am preparing my stuff for the Nov. ('one man of me in Van in early Nov.)

I wont be able to go up as Nan hopes quiet & home is my role now. A fool took me for a drive promising to bring me home when tired & did not & I got laid flat & voiceless. it was not an hour so if that flattened me, I dont know what Nan's would do.

Hope your pupils are good & getting on. & you are happy.

Yours affect.

Emily.

170 [*Carr to Cheney*]

218 St. Andrews
Nov 7 [1940]

Dear Nan

Was glad to get your letter I get few these days My freinds all seem to have evaperated, bodily & correspondently. You are about the only left. Edythe used to be very faithful. but for months now of course she is neither visitor or correspondent & I miss her. even though I quite understand in her case. her time was fully occupied with her Mother. She & her sister came to see me on Teusday. by invitation. poor girls they feel badly about their Mother & [are] very buisy trying to console their father & get the house into shape before leaving. Edythe expects to join Fred not shure where exactly but soon, & the "little hussey" (sister) to join her newly acquired husband. he seems to have improved her somewhat. I never could stomach that girl, but found her nicer (a little) on Teusday. she is such a spoiled selfish [?] common little beast.

I wonder if you got to my show yesterday & what you thought of it. Grigsby thought he'd hung it. O.K. but made no remark as to its

quality. only said some who had seen it considered well hung. I am sory Lawren was not in Vancouver while it will hang. he was very entheustic over my work & raked a great deal out. & wants to come back and. drag out *everything* I thought perhaps he'd find it very lacking after his abstractions but he said not (he is so ardently abstract) they were both very nice, and stayed a long while. I fancied they were a little taken aback to see me different. both were so cons[i]derate of my every move. and very gentle & kind. I had told them I had had a stroke Lawren wrote a nice letter at once. followed in a couple of days by one from Bess in which she made no illusion to my illness but wrote a rapsody on her petunias. & hoped I was 'quite well'. & I think it staggered her to see me crawling round so slow. not even dressed yet, but in gown & bedroom slippers I don't think Bess ever gets much further than herself & her ailments of which she always keeps herself well stocked. She is a bit of a 'poser'. Lawren is genuinely fond of me I know. a faithful correspondent and although we have not the same outlook now that he has gone abstract. we are thoroughly interested in each others work, and lives, and our freindship is a deep one. I did not find him nervy nor her more so than usual. in fact their visit was a long and restful one & I thoroughly enjoyed it.

I am glad they have at last located the base of your miseries.[1] it has been a long, unsatisfactory time with nothing to get at. and very trying for you I sincerely hope they will make a start on recovering you—make a splendid salvage.—I hate to think of your being depressed and miserable on top of sick. try not to worry over the long enforced idleness. I know so well what it is to go through but you may be shure you are growing and gaining in some way by it. bye & bye things will pop up in your life and you'll say wherever did I learn *that*, giddiness & headaches are some of the worst things to endure I think, I can forgive everything if my mind is clear to think & mine is not always since I was ill. this time I forget & forget. Since I made up my mind just to gather up what was left of me & make the best of it I am happy & thankful there is as much desbris to pick from. Mr. Grigsby

seemed surprised I could not come over seemed to have expected I would be there. I expect [he] thought I'd be able to help, set the show up or help. It was absolutely out of the question. 'at home' that is my place now & I am lucky to have such a pleasant one. where I can potter among the birds & my tiny garden—just been putting it to bed for winter or bossing a chinaman to do it. I don't even think of struggling beyond the gate the only time was so disasterous. just seeing Lawren & Bess robbed me of every vestage of voice it shut right off. it looks so stupid. any emotion or excitement does it. Dr says its heart not working right. sometimes its hours sometimes days before it returns.

I am sory I forgot to enclose Mr. Mcdonalds [Macdonald's] picture it was such a job getting them crated and off. Willie is as slow and doddery as treakle. Glad your mid-age-maid is satisfactory

I still have only a jap. 1/2 day twice per week but manage and the house is very peaceful without the bother of looking after them the cleaning that is done in their hours lasts till the next time They bring in wood enough. the dogs are good as gold only shove them out the studio door into the garden everything is very convenent Alice loves them, which is luck.—What a storm we had yesterday even hail! Have 3 canvases under way. they progress slowly. the light is aggrevating these days, blare & gloom. one is always shifting curtains over the south window how do you find your studio light? it is nice for you being with others the same, Jessie Faunt & McDonald [Macdonald] and a bit removed from "society." How dull is the average being!!!!!!! Alice had two women to tea yesterday what deadly cackle!!!! They roll & revel in war being so empty otherwise. war claps round their insides like rattles while their knitting needles. click & their tongues lap of the juice of horror, & they *feel* they're keeping up with the times. they dote on all the sentimental side queues, partly bommed babies, and those aweful cockney sob-stories. I think they are simply fine those Britishers but they are sentimental in a clumsey posing sort of way that irritates me. poor dears. it must be just awefull never having pure unmolested rest but I wish they would not drag 'im and 'er to the

microphone to bray of 'ow they're doin' it! that is filthy of me—
perhaps its these old dames on this street purring over horrors that
gets my goat.

Sold a picture (Indian) in the East² which will help the pot to boil.
Am working for a rcfugee & red cross society in Vancouver. flanelette
nighties *very large*.

Isn't everyone buisy. Men & women on the rip every buisness place
disorganized for short-handeness. How they contrive to *keep going*. in
England with traffic dislocations, black outs & casualties, is to me one
of the marvels. I dont beleive it *can* run as smoothly as they make out
do you?

Are you painting? far as I can make out there is no work much
being done in the East. I had a bid to join a new 'loan' society in
Ottawa, no thanks loan societies are rot. Anyhow for Artists the other
side of the earth you can't lay hold on your things when wanted and
they have no organization. They tell me in the States they are well run
and a success like libraries all very well for books which can be
renewed but hard on pictures which get battered round in the hands
of fools who dont know how to pack handle or protect in any way. I
am about fed up with having my stuff. handed round & never able to
recal it. & nobody seemingly responsible.

Will leave space for P.S. if anything occurs before posting It is
difficult for me to get postings & shippings done now I have no girl I
cannot ask my sister. her eyes make her hate being bothered She has
enough to do & put up with. I try to be as inconspicuous as I can on
her horizon, and we get along very comfortable I read aloud all
evening. (go to bed at 9)

P.S. These snaps came this morn Humphrey sent envelope long agoe
and said he'd sent snaps to Ma & would she send on to me & would I
send to you.

[no signature]

NOTES

1 In a 1941 letter Cheney wrote that she had had a nervous breakdown in the summer of 1940. See Marius Barbeau Collection, Canadian Centre for Folk Culture Studies, Canadian Museum of Civilization, Hull, Canada, Cheney to Barbeau, 1 Feb. 1941.
2 A reference to the sale of *Village of Yan* to IBM. See #142, note 2, and #173, note 3.

171 [*Carr to Cheney*]

218 St Andrews
Wednesday Aft
[postmarked 13 Nov 1940]

Dear Nan

While my habitation is in chaos and all the jobs I can job are jobbed and the Jappie ploughs thrgh the rest I will write to you. What a glorious day! cold but sunny I wish I could take a swift walk & pull in great breaths of it insted of hiding my head in hot air like ole' ostriches well I can't so there you are. & I'm darn lucky to be able to do what I can, so old Emily don't kick but make the best of whats left!

Was so gld you and Dr Trap[p] like the show it was my first intimation of what it looked like. poor Grigsby wrote only of the *hanging* which he seemed to think I might not feel so good because *he did it alone* & he said several, had told him it was allright today however he dropped me a line that there were *many visitors* on Armistice day & people thought it my best yet in Vancouver, which was encouraging to a crock. I wanted it to be something light & br[i]ght & happy, these dreary days. no sales yet says Grigsby. So sory you have to change help again it is so trying, especily in bad weather. I had everything ready for the cold snap, birds extra sheltered, wood all in, garden put to bed for winter, and was able to meet the elements with a grin. by keeping the two stoves going I can be *very comfortable.* have

good heavy curtains at the big windows. Twice per week the girls fill up with wood in kitchen & studio & by picking up a stick as I come in from doing the birds the fuel for the present is solved. You will find when you shake into your walls that you will find short cuts at warming. this door shut & that one open etc & furn[a]ces & stoves *have* to find themselves I am sory you find it not *too* hot, but hope it will solve the problem of Aunt M. not wearing you out with Society ructions. personaly I think the Treeish place sounds delicious. and Ink a better, wholesomer, companion than gasping females on the rush. I am very buisy what with painting sewing writing, house pottering & reading aloud which I do all evening every evening.

Have just written (nearly ready for final typing), a small thing about nothing. It was difficult to probe into but very interesting to do. a pure exercise in digging Nothing that I would ever show to anyone though I *may* get Ruth to criticize, also I am putting the final on three good size pictures. (ready for *next* year's show) I do hope I can get into the woods next summer there are so many things I want to dig into I have got plenty of sketches to work from but I do *love fresh* meat. I did not realize that Miss Jessie Faunt painted till you mentioned it in speaking of Lawren

Sory I clean forgot McDonalds [Macdonald's] picture though I dont beleve there was a crack to hold it. Willie made a box to exactly fit my smaller sketches. My dear I *want* you to have a picture for your new house we'll have to fix it somehow blow Fin! It is not so Almighty there are other things.

That was a nice write up I did appreciate it that they left *me* out. (my size shoe & stomack & clothes and animals.) like those filthy reporters fill up the vacuum of your work with

Are you really settled? I meant, all the little etcs? I do hope you are feeling better & the Drs have found something to get over that wretched giddiness. Make up your mind to *take easy* till spring just drift & then bust out like a daffodil

Had a ring up from Myfanwy Spencer today had not heard of her for ages & ages. she has a very attractive new house wanted to take me

to see it I had to refuse. as I had to refuse lunch at the Empress with
an old Vancouver pupil on Sunday (Mrs Gilmour)[1] (writes poetry) have
you run across her? Home is the place for this girl if she wants to keep
going. I get very few visitors now. everyone it too buisy. there is so
much to be done in the world.this minute.

Well so long! I am nearly cleaned & must make my "*staff*" a cup
of tea. when the daughter is not working herself she comes along with
Ma & they do things up together. Alice has a young man visitor staying
for a few days. A melancholy youth with toothache and a brother just
off with air force.

lots of love

Emily.

NOTES
1 Formerly Hazel Scott. See Carr to Edythe Brand, 15 Mar. 1937, published in
Hembroff-Schleicher, *M.E.*, 102.

172 [*Cheney to Toms*]

Capilano B.C.
Nov 17th 1940

My dear Humphrey.

Your long letter with all the questions is nearly a month unanswered
and I feel very badly as you must depend on your outside friends quite
a lot and letters mean so much when one is in an isolated spot. Emily
sent the snaps early in the week with a long & cheerful letter—but no
comment about your surroundings—The farm house is certainly in a
nice spot & those big trees are beautiful—also the farm buildings
from the back porch—You got an awfully good composition in that

spot. The school house is unbelievably small but the pupils look attractive I suppose you have a stove to keep going & a bucket of water at the door with the usual tin mugs. It is awfully hard to imagin[e] *you* in these surroundings but it will give you something that you could not get any other way. Do you want the snaps back? I am afraid I cannot answer any of your questions about the B.C. show—I only saw it once very hurri[e]dly but the row over the medals is still reverberating— The committee gave the top prize to Fred Amies [Amess'] water colour & Mr. Stone raised objection as he said, "The Beatrice Stone Medal[1] was meant for an oil." however nothing to that effect was in the original notes about it—but he held out & so did the jury—so they had to create a new medal which tops them all regardless of medium & given by W.H. Malkin. Poor old Stone took to his bed & has been there ever since—Mr Grigsby spent a long weekend with us—& worked like a navie—made a path etc. he was very nice to have in the house & is quite lonely with his daughter now in Berk[e]ley, Calf. Last week the CBC asked me to speak with Prof. Clarke [Clark][2] & Scott for 1/2 an hr. but of course I couldn't & wouldn't with that combination so I suggested Jessie Faunt and she was delighted but had a difficult time—Scott just hogged the whole show & at the rehearsals he ruled out every good idea she had. Scott thought it grand to be on with Clarke [Clark] of U.B.C. but very much infradig to be on with an art teacher in the public schools—however Jessie downed him & the C.B.C. saw the situation at once. You will be interested to hear that Lawren Harris Sr. & wife are coming here to live They came through 2 weeks ago from New Mexico—he has to come back as he cannot get his money (Massey-Harris farm impliments) [Massey-Harris Company] out of the country—They called on Jock & we all saw them—I had met them before. They are going to take a furnished house on Marine drive & I hope they will impress the rich of that nieghbourhood that *all* artists are not poor. Nothing else will—It is going to be a shock (Lawren is *very* abstract now) but money will soften any blow. Jock has done no painting since last spring—he strained his heart playing badmington [sic] & does not look very well. Being in debt all

the time is an awful worry to him & yet he is generous to a fault & hands out to every beggar—You ask about Kathleen Sha[c]kleton[3]— her stuff is pretty bad—but she has the nerve of a brass band & uses her explorer brother (dead sometime) as a handle to edge her way into people's purses. She talks incessantly & has made heaps of money in Canada but is always on the verge of starvation—she just flings it round when she gets it. She has been in love with Sir Ed. Beattie[4] for years so she tells everyone (I take it not returned) but she pesters him to death & he has now given her a job to keep her quiet for 6 months—(he was out here not long ago & she nailed him) the clipping will explain—I expect it is out of Sir Ed's own pocket as surely in war time they are not considering portraits of brake men & 'porters' draw your own conclusions—I am really being gossipy. Emily's show is on now & simply *glows* from those dingy old Gallery walls. This is the 1st one I have not been able to hang but they look very well. Only 5 canvases & all Indian so doubt if she sells them—in fact no sales so far—but it is going to U.B.C. for a week[5] It needs someone there (all shows do) to talk them up a bit—I sold 3 for her last year. She says she has 3 canvases nearly finished for next year & is making *very large* flannel nightgowns for the refugees—she says there must be a lot *her* size who are cold & homeless. You ask about Ronald Jackson—he had a big canvas in the B.C. show—quite striking—very blue sky—those rolling hills—water etc—but spoiled by a slickly painted car in the foreground—I am dying to buy an "Emily" this year but alas! no cash—Have had 3 maids—damn them & now one "Islay" from the Prairies who seems possible. a few days in hosp. for tests & am better in spots—You asked about the "decks"—they are just upstairs balconys [sic]—one out of the spareroom & one out of the studio—You *must* stay over a day at Xmas & come out here Sat afternoon & eve. would be the best as Ralph Cox plays his cello & Jock & Jessie are home—You need not have returned the snaps but I knew Emily would only burn them so told her to send them to you. Edythe Brand's mother apparently died altho Emily mentioned it so casually—just said Edythe & her sister were leaving Fred is in Trenton teaching

something to the air force This is all the news—a most inadequate answer to your letter—Dr Trapp has asked me to do 3 portrait sketches (Emily's technique) of her nephews & neice ($7.50 each) hardly worth doing—however I would do a lot for her—if I dont asphyxeate [sic] myself or blow up the house—Expect you are having cold weather—I will get some magazines off this week.

Affectionately

Nan

P.S. You asked me about Emily Sartain's work[6]—She is an honest person who does not pretend to be an artist in our sense of the word—but only a photographic scientific reproducer of flowers (she worked for one of the botanical Soc. in England) she had done very well here—sold over $200.00 worth this spring at the Gallery.

NOTES

1 The medal was donated by H.A. Stone in 1933 in memory of his wife, who had died in August that year. It was to be given in connection with the annual BCAE. See *AGB* [VAG], 1 (Oct. 1933).

2 Professor A.F.B. Clark was with the Department of French, UBC, from 1918 until his retirement in 1949. He was an active participant in VAG affairs and lectured on a variety of art-related topics. See *AGB* [VAG], 4 (Feb. 1937) and 2 (Oct. 1934).

3 Shackleton (1884–1961), a figure and portrait painter, had exhibited at the VAG in "Canadian Mosaic," 30 May-4 June 1939; and in a one-person show, "Portraits of Persons and Places," 15–27 Aug. 1939.

4 Sir Edward Beattie was president of the Canadian Pacific Railway from 1918 until 1943, the year of his death.

5 The exhibition at UBC, held in late November following Carr's VAG show, was organized by Professor Hunter Lewis. See #69, note 3.

6 Sartain's "Flower Paintings" from the "gardens and florists shops of Vancouver" were shown in her second VAG exhibition, 21 May-2 June 1940. *AGB* [VAG], 7 (May 1940).

173 **[*Carr to Cheney*]**

Sunday
[postmarked 18 Nov 1940]

My dear Nan.

Thank you ever so for the crabs. They look *de*licious have not sampled
yet. but am shure we shall enjoy them. It was good of Dr Trap[p] to
tote them, and I am glad she had the excuse or she might not have
found time to give me the delightful visit which I did so enjoy. I know
she has many freinds & plenty to do when she comes over she is a dear
soul. I wish the report of your progress was quicker but she says you
are getting on so take heart. I do know how discouraging slowness is. I
had 3 years of it once—18 months in sanitorium[1] & 18 more crocked
& wretched cut out of doing everything I wanted to do. so I can
realize how trying it is and I was at an age when I should have been an
up & kicking. bunch of energy. well there you are all part of the game.
& not the joke part. only something to be wriggled through. Well
here's a real pouring rain to wash my exhibition off the slate for
1940—no not quite—it goes to U.B.C. for a spell first. that *fool*
[underlined five times] Hunter Lewis wrote me a speel he is absolutely
undependable. full of excuses etc. & I detest the man.[2] suffered
extreme meanness at his hands however as there are other men in the
faculty I spose they might keep him up on the ex. No Fred & Edythe
this time No Nan in Vancouv no nobody no nothing not even an old me
to poke my nose round the corner. Well I am glad some folks have
enjoy[ed] the pictures & found them a br[i]ght spot. no sales up to
date I got a medal last week[3] (big as a meat plate) for my contribu-
tion to art of the world it says. Came via the big Indian thing I sold to
States last year. Think it would make good munitions size of a bom! I
have a new supply of red cross sewing on hand, refugee's of queer
shape must be they are all cut out, & puzzle me there is no map or
dictionary or explanation & I'm lost rather. but a nice old woman
wrote & said "I done" grand on my last batch so I take heart hoping I
shant make 3 legged pejams & infants pants with no seats, that's what
they do look like

I am having my bed-day shirked it last week & it doesn't pay. Lovely & mild out. Christmas soon!!! Dr Trapp took Mr McDonald's [Macdonald's] picture it was good of her & such a help these odd canvass[es] are such a nuisance to post. too small to crate but must be protected or express refuses exccptance. well thanks for the pickles I'll eat to your helth in them. Hope you are feeling better.

lots of love

Emily

P.S. So awkward having *no one* I can ask to do anything. post a letter do a shopping etc. My sister *can* but hates it does her own but mine seems the last straw so I do without, everyone is too buisy to bother with crocks & my jap even forget[s] its 2 weeks before she returns with the goods & has then forgotten.

NOTES
1 See #30, note 2.
2 An evidently undeserved diatribe. Hembroff-Schleicher, *Emily Carr*, 316, argues that Lewis was "an extremely polite man and deferential to Emily in his dealings with her."
3 Indeed, each artist who exhibited in "Contemporary Art of Canada and New-foundland," the IBM-sponsored show at the Canadian National Exhibition (Toronto, 23 Aug.-7 Sept. 1939), received a specially designed medal to commemorate his or her participation. Works from the IBM Canadian Collection included Carr's *Village of Yan*. See #142, note 2.

174 [*Carr to Cheney*]

218 St Andrews St
Dec 2 1940

Dear Nan.

I don't owe you a letter and you know it is against my *principals* to keep up onesided correspondents I like *receiving* letters too and one way & another I have a great many to write. Though I have cut down lately, & may make further cuts in favor of more sewing. & really news is very scarce my way. but I do not think news counts much in letters that rolls mechanically. in potted formula from the radio. wonderful how it swamps in so soon after happenings but sometimes I think we were better off with less & without riling the sky with planes. and certainly without scraping the ocean bed. and yet one goes faithfully to the radio if it is being done for us we've got to open the dial & let it roar forth How bad overseas reception has been.

Dull days are here with a vengence & much rain but mild & one feels the winter is getting well underway & spring that much nearer. & in the meantime all the dripping trees are refreshing themselves & doing much drinking to put them through next Summer. I get such a kick out of the lovely cedars along this boulevard straight up sober, evergreen, trees, minding their own buisness only *perhaps* a little nosey about drains.

How are you feeling?? Have you seen Dr Trapp since she was in Victoria??? I wonder if she has selected her picture she took two home from here that she liked particularly as I told her they could return in the crates from gallery in place of what she bought if she like[s] the one there better. The U.B.C. meant 2 more sales, says Grigsby, but the things are not home yet—awaitin Dr Trapp's decision which I hope she makes soon. Did I tell you I got a medal as big as a soup plate for "contributing to the Art of the world"?

The bears are *wise* to hibernate. these long dark mornings & yawny after noons round four P.M. one sees their wisdom their stomachs too grow delightfully flat. I wonder if they dream?

9:30 A M The crates have just come home!! and been shoved into the maids room to wait till Willie we have time to uncrate. everyone is so buisy these days he has lots of jobs ahead always & I am much further from where he lives now & have to wait his convenience. I wish I'd been born with a seraphic waiting disposition, nobody *could* accuse me of it.

I have just stretched & primed 11 canvases & feel very *nice*. I found I was on my very last & I hate to be without a clean one. So that was my main job last week. I did not get new stretchers but stretched over all my *old* frames. They made a good job but I am not too satisfied over my quality of canvas. still they will come in & I must get some new stretchers made at the mill and some good quality tent canvas & get some of the bigger size ones ready. I always like my canvases primed & left to harden for some time before using. I did not feel up to painting most days last week. it is not so much *working* but *preparing* to work which seems so much effort though all my things are there handy—pouring out liquid, & setting pallet seem the last straw sometimes, & the light goes so quickly.

Have seen Edythe only 2ce since Ma's death she was out with Evelyn Maynard[1] this week. looked very gay & bright, & is entertaining a French visitor this week the hussy sister has gone back to her new husband Edythe's different somehow. she has been so near yet completely out of touch with me for so long. They have an excellent maid, & she has her own car, so I feel Ma may not have been all responsible for preventing her visits. this war knocks everything even ones friends. everyone is too buisy to be bothered & I can quite see it, & do not even *expect* visitors now. thank the Lord for dogs & birds.

Do you read much? I read every evening aloud. it is hard to get hold of really worthwhile books we are on 'Archangel House'[2] grandly blurbed but it seems silly a piffle of maukish love so far. Alice can't see to make a pick and we have to depend on the selection of those empty headed girls I guess [?] anyway it is impossible to pick books for other people trash to one is grand for another same as on radio one just wonders *how* ears can bear some of the tripe & I spose the tripe ears feel the same about the other stuff. I suppose the Harrises will be returning soon. I am inter[e]sted to hear what he says of the East. I hear little now but no body seems to be doing anything *much* or is it I dont hear of it? war must inevitably[?] pause. those sort of things, perhaps in the end for their good, to wake up fresh vigor after. I often wonder about the Artists in the Old world how they must be having a

lean disheartening time of it. it is all very puzzling, but not the time to puzzle only to go on in faith that things are working out, and that under the ground nature is preparing Spring, as absolutely shure as ever she was: in spite of the muddle on top of the soil.

Now its time to get out to the birds A & I do it together doesent take long we must look two funny old jays with umbrella & rubber boots & dressing gown. carry pots & kettles but I love seeing to their few wants, & get a breath of air its only just outside the door. There is a baby dove he must think he's hatched into dripping dullness, but all the seven others Coo to him all night. I love their mournful 'Coos' well Cheerio, remember no letters no answears. there's always something to say about *you* if no external news.

 lots of love

 Emily.

NOTES
1 Evelyn, an accomplished pianist, was married to Max Maynard.
2 Esther Morgan McCullough, *Archangel House* (New York: Gotham House 1939).

175 [*Cheney to Toms*]

Capilano B.C.
Dec 2nd 1940

My dear Humphrey.

Your letter just came & I hasten to return the snaps in case you want to send them to someone for Xmas—You poor thing, struggling with plays & carols—nothing more boring for a real adult. You sound as if you were not going back after Xmas. Can you leave in the middle of the year? or get another school? don't bother to answer until you come

down. Plan to have dinner & spend Sat eve. with us & we will put you on the Vic. boat—stay over night if you can—or the weekend—we are only 8 mins from the C.P.R. I loathe Xmas & all the mock joy etc. It is nothing but a tradesmen's racket—I will ask anyone you would like for dinner & we will go down to Jessie Faunts after & Ralph will play his cello—The Macdonalds are usually there & the odd interesting person—We do this every Sat. night. I have not been in to town yet—Emily's show is over—she sold 5 pictures which is wonderful considering they were on during the Federated Charity (another racket) week. She thought she should have sold more & wrote Grigsby & me an awful bleat about it but you know what she is like—always biting the hand that feeds her—Grigsby was quite hurt but I smoothed him down with an explanation of her moods. She has recently sold another in the East so is doing well considering the times.

Mild here—48—fog today—am reading "For Whom the Bells toll."[1] by Hemingway—he has to repeat & repeat as he is dealing with peasants & I find it rather tiresome—I sent you the New Yorkers as a relief from country life. Do hope we see you but quite understand your mother wanting you all together—Let me know & Hill can meet you etc. Can't imagin[e] Country dances not starting until 11 p.m.

Affectionately

Nan

NOTES
1 The correct title for Ernest Hemingway's novel is *For Whom The Bell Tolls* (New York: Charles Scribner's & Sons 1940).

176 [*Carr to Toms*]

218 St Andrews St

Dec 4 [1940]

Dear Humphrey.

How are things going? have not heard of you for a long time. have been very buisy myself. one way & another exhibition in Vancouver & then on to University, Refugee sewing, many letters to see to etc etc. And winter well under way. Today is fine & yesterday glorious I went for a little drive just round the Park. The first for six weeks. nobody has thought of it. people with cars never do and especially people with *2 cars don't*. The old white bear looked in excellent form, you could hardly have put your foot down without stamping on a duck, & the chipmonk cage was alive. my kind driver gave me every opportunity to see all these except I did not put foot on ducks, I could of *sat* but that would have squ[a]shed. 20 or more at one sit, so I did not get out of car.

The exhibition was successful people more enthustic than usual I had nice letters & sold 5. More that I expected specially as it was during the Community Chest drive. I felt this time particuraly anxious it should be a br[i]ght happy springish show these war days as a little boister to spirits, & it seemed to work.

Nan liked it went several times, does not drive her car or go anywhere alone still they say she is really much better Dr Trapp spent a long afternoon with me 10 days agoe & told me all about her & now she has a good girl at last, I had a letter yesterday — quite cheery.

I suppose you will be having Xmas holidays before so long & Xmas entertainments etc.

The war goes on as diabolical as ever I am glad they are not 'trucing' over Xmas it would be just like Germ. to put in some dirty work. I am sory for the men not to have the relax but this is a time for *being men*. They can still keep Xmas in their hearts. I sometimes think we overdo the weak & *sentimental* side as a nation, thinking far more of the national traditions than the spiritual meaning.

I sent the photos on long agoe soon as I got them from your Mother. They were very good, interesting, must be nice country. There are lots of places I'd like to see still I have seen a lot more than some. & my days of travel are about over. Beacon Hill is quite a jaunt for me & I am still capable of finding great pleasure in such an excursion it is much further afield than the dove house & the wood pile. The doves have a baby and all the 7 adults coo all night why I can't think the nights are not too balmy & spring like I stretched & primed 11 canvases I do not work with velocity so it took me a week The studio is very cosy these winter days stove working O.K. & light not too bad

No help beyond my bi-weekly japs, but we manage, & the dogs keep well. Old Chim ended a fortnight agoe poor old chap he was in a sad state at the last. My sister misses him he was a faithful old dog. I miss his sad eyes. always watching. he took to lying on the boulevard under the cedars just out of my bedroom window.

Where do you Xmas? Where hang your sock? expect Xmas will be quiet this year, it should be, there is enough rattle of bomb for fire work.

The cedars on St. Andrews boulevard get more lovely all the time I do so enjoy them after the crude work a day Beckley St. but St. Andrew is dead as a door nail, no yelley kids & sloppy women in Tin Curl pins & felt slippers hustling to the store for loaves & milk bottles. There are no youngsters on this street. even dogs & cats are old & the women middle-class, prim. wouldnt dream of crossing the street without gloves & umbrellas—well they mind their own buisness anyhow but they are not alive just *very respectably* [underlined twice] *dead*.

I read to A all evening and at present the book is "Archangel House" (very blurbed on cover & sloppy sentimentality & nonsense within) we're disgusted with it, & skip every 4th page so perhaps we land in the slop & miss the stable-bits *if* there are any, but the blurb is a lie. You just can't trust any judgement of anything these days. one wishes sometimes, the world had not learned to write. it has led to such. smart-Allec superficiality every journalist trying to out-journal,

advertizing, advertizing, exploiting! even plain decency has to be decorated with falsity—to push it down peoples throats but they will gulp any indecency or dirt. everything seems wrong. I spose that is why we must go thrgh these great upheavals. to stir the sediment settling at the bottom.

As ever

Emily Carr

P.S. Received a medal big as a soup plate for 'Contributing to art of the world' (states) Lawren Harris & wife coming West to live.[1]

NOTES
1 The Harrises arrived in Vancouver in late December 1940.

177 [*Carr to Cheney*]

218 St Andrews St
Dec 13 1940

Dear Nan.

Wow! its cold frost white as snow all over the shop. No likee! too much stoke fire. Your letter & mine crossed such a bother when we do that, as you generally write round Sunday I must try to get mine in toward end of week.

I spose McDonald [Macdonald] *got* my sketch he did *not* acknowledge it. he had just written me a long letter re: ex. so I suppose did not think it worth while, again so soon. I am fed up with letter writing that is about all I am doing this Xmas & there is so particularly little of interest to write of.

Thornton Sharp[1] called on me yesterday he has tried about 6 times & I never could see him one way or another he lives at Crofton V.I. & comes down quite often. I think him a stupid horrible dull old ass. I was not a *bit* nice I know so have no doubt he thinks me even worse he phoned & I thoght said he would like to *see some work*. I had a visitor when he came, but she went & I got out some stuff. but he never turned an eye on it. just sat explaining *his feelings* (very feeble feelings too) on his watercolors v.s. oils, as if it matter what the medium if one has anything to say after a long time he got up & began pulling my things from racks. I said "please don't. I did not think you were interested or I would have got out some more." he had not opened his ugly mouth nor glanced at anything. "Oh I'm interest he said but I don't know what to say". Well, say what you *think*" I said "you need not say *nice* things or the old things that everyone says. but for goodness sake say *something*, nothing makes a body feel so *flat* as *dead silence*" All the rest of the visit he spent apologizing Oh a *tiresome* brute "I did not come to see *pictures* he said but *you* & I've learnt more from you than your pictures." Well he must have accumulated a most unpleasant eye & ear full—a dredfully self-conscious donkey-person—kept saying "I'll bring my daughter to see you" she is apparently pert and smart allec. I never said 'oh do': I sat stony. Thank goodness an old girl came to call & chased him off. the studio felt just choked with stagnation, and it was my 69th birthday too. no *today* is, but I had just got two lovely canary hens for a birthday present & I wanted to be looking at the sweet things not admiring 'sharp' Yes I'm *pretty old*. I told my jap women. and she said "My you heap *up!*" I never thought of oldness that way before. life always seemed like a long drawn line horizontal, not *virtical*.

Edythe got off. at least she rung up & said she was going that night. (Monday I think) she did not find time to come to say goodbye. I've seen *less* of her since Ma died than before, so perhaps Ma was *not* the excuse, she was very nice but I do feel. with a *good* maid and her *own* car she could have come *if* she had *wanted* to the last some weeks now & she was a bit *insincere*. she only came once after Ma's death

beside the time I *invited* Hellen [Helen] & her to tea she is off to Fred & probably goes on to Helen.

No news of Harrises yet. I doubt if they come over till after Xmas. His mother's memory is quite gone. she has no idea of time thinks she saw them the day before. so as long as she is O.K. & has her companion. there is not much use I suppose. & they will be buisy settling Bess always makes a great fuss I wonder how she will take in Vancouver, probably O.K. she is a bit of a poser probably even more so as Mrs Harris than as Mrs Housser.

Let me know if you read anything good in way of books. Alice has got dreadful piffle from Spencer's library[2] lately, she can't see & the girl gives her awful slush, we are reading a Pearl Buck at present but not as good as the others of here's [hers] we've read

Have not heard a word from Dillworth [Dilworth] publication plans probably fallen through I beleive they generally do probably they are not publishing any trash these days only war jargon.

Alice has invited "two very dulls" for tea, & I must get up & re-adjust the dust in my studio. by flipping a rag around. Hope your maid continues satisfactory

Love to Hill & Ink & don't forget yourself.

Yours ever

Emily

P.S. Has Miss Fant [Faunt] one of those out-door fire places? Humphr[e]y is coming down for Xmas early Xmas week he says.

NOTES
1 G.L. Thornton Sharp (1880–1974), a founding member of Sharp and Thompson (now Thompson Berwick Pratt & Partners), and briefly the principal (inaugural) of the VSDAA prior to Scott, was the architect of the original VAG building, and had been a representative on its Council from its inception in 1931 to April 1940. Sharp was described as a "watercolourist of charm and distinction" in connection with his third VAG show, 15–27 Oct. 1940. *AGB* [VAG], 8 (Oct. 1940).
2 The library connected with the department store of David Spencer Ltd.

178 [*Carr to Cheney*]

218 St Andrews St
[postmarked 22 Dec 1940]

Dear Nan.

Glad of yours two day[s] back. It must have been rather enticing, in the trees in the fog. I'd have loved it. How nice to have a bulb bed in rocks they'll love it. I think Hill's Xmas presents to you are both *very choise* if I had a husband I'd rub his nose on them & say "do likewise" but as I have not, I'll enjoy my two stoves & two dogs & bring in an extra canary from the aviary. I thought he was a she so I caught her yesterday to prove himself. in a cage & he's singing, so she's a he.

Wonder if your dinner party came off last night Humphrey wrote he was. coming down for Xmas. I expect Mommee [?] wanted her little boy & stood it. I think she ideas him as suffering in primitive starvation for Arts and, soft victuals. I think it is what he needs. women have always petted him too much he has a kind soft way with old dames.

Somehow I don't place Lawren & Bess in the west I wonder how they will fit? they are Eastern. I dont know if they are still ardent Theosophists—I immagain so, but I never mention or discuss it with them any more I used to Fred[1] & Lawren were both strong upholders and I was *interested* & discussed it a great deal with both of them & also Bess. I agree that they are intollerant people (especially Bess) though they *claim* to be just the oposite. there is such a lot of vague, queer man-made rigmarole about the 'wheel of destiny' etc. I got all churned by the whizz of it. I admired Lawren's work so much. (I do not know his latter work) I wanted to see if I could get a slant, that would help me on my own. so I listened & I thought & discussed with them Fred was a very fine man and a good expounder & very patient.

Bess had all the jargon but I could never feel her very deep or sincere in that or art she could criticize & discuss, & Lawren being in love with her trod on me hard when I accused her of incincerty once, to him. well. by & bye the whole thing soured on me. mainly the supercillious attitude towards the bible & their denial of the *devinity* of Christ, & the atonement. christ was *only a good man* to them. Bess sent me a Madam Blavatsky book[2] which infuriated me I flung it across the room when partly read & then I burnt it & told Bess & Lawren I did not like Theosophy.[3] I liked & beleived in plain bible, & I burnt Madam B. & they sighed and we've never mentioned the matter since. in our letters. Macdonald will get quite a lot from Lawren to help him I think, and I fancy he is rather weak isn't he? Lawren is rather too, I'm fond of him but I feel that, & I don't follow along the abstract line he used to write me a lot about it but to me it is too mechanical. They say his coloring is lovely & people have told me it stirred them in some *vague* way but "remote" is the term (very favourite of Bess by the way) that they seem to use. So many things & people they were keen on riled me, & I used to say so and I wonder they tolerate me at all. There was a man in New York (used to be in Toronto) who Lawren gave me an introduction to. he was a lecturer & high cockelorum in Theosophy & I detested him.[4] He *sneered* at some sacred things & I told L. what I thght of him also of some books, & I really wonder Lawren did not drop me as an intolerant hussy but he is always *very lovely* to me, as though I was a venerable, old dame, due respect. instead of needing a good stepping on.[5]

I had a card from Edythe very happy in having Fred. said "he looked so *handsome* [underlined twice] in his uniform" and the camp was *very* primitive

I read the "Yearling"[6] some time agoe & enjoyed it. Margite [Margaret] Clay thought it *very sentimental* but I think these young women like more sex & less nature

Dr Trap[p] sent me such a nice greeting card wasnt it nice?—says she is enjoying her picture I am so glad. I have *very* little respect for Lismers criticisms & find his art very ———— I think he is a "poser"—

always have—it is rotten cheek of *me* to criticize these men. I have just come to the conclusion there is *nothing in criticism* its only one man's argument against anothers there has been so much. cheap journalism of ignorant art critics it seem[s] to me to have become an empty clack of jargon. I think Walt W[h]itman was right that after a certain stage your own inside *honesty* is the only critic you can trust. I have some canvases under way this week has been a little broken even if you give Xmas the glass eye, it twinkles somewhere behind. if we only remembered it *was Christmas* & not Santa Clause day. like they teach kids now and make it just a greedy thing.

I have had a long glorious day in bed & *enjoyed it* Alice engaged elsewhere have felt in need of it for several days snoozed, written and sewed refugee. I have about 50 yards to make up (my own) as well as 3 pajams 2 slips & 2 panties of their material I want to do a lot Xmas week because so many women with families will be laid off, & that won't make refugee bodies any warmer. and one never knows what may have sunk.

Sometime Nan I'm sending you as long intended a Sketch for your house I keep putting off. I told Lawren once "any fool can *paint* a picture but not every genius can *'crate'* " but I will get to it one day It is not a Xmas gift. it has been in my mind since your cellar was dug & I did not mean the cellar to be furnished with rare wine & choice whiskies before I got buisy which is now probably the case.

Give Hill my Christmas love. and dont forget yourself & Ink. My jap asked if Matilda was "going to make pups." I don't wonder she is like a little barrel.

Hope you are lots better Dr Trap[p] said on the card you looked much improved.

Alice has a young man staying over Xmas a boy she practically rose from cradle She is enjoying him & it will do her good, as your Islaylet will probably cheer you Xmas day. if children would only be themselves & children they are nice, it is only these blazee "dead before they live" young uns that are so boresome.

You better bite a section of this off per day or you'll hate me like taxes.

Your Ever

Emily

P.S. Merry Xmas ⎱ to all
 Happy 1941 ⎰

P.S.S. I see Mrs Cheif Joe Capilano is dead[7] her heirs will be buying her portrait off you & you will will rise to affluence

NOTES
1 Fred Housser (c.1889–1936). See #12, note 18. Housser, like his friend Harris, had been a keen theosophist as well as an admirer of Carr.
2 Helene Petrova Blavatsky, a founder of the Theosophical Society in 1875, was author of several publications dealing with theosophical thought and principles, including *The Secret Doctrine* (1888) and *The Key to Theosophy* (1889). Harris had once offered to send the latter to Carr, referring to it as a "clear exposition in the form of question and answer. . . . very honest, direct stuff—and worthwhile." BCARS, Inglis Collection, Harris to Carr, n.d. [1931?]
3 Carr was first introduced to theosophy during talks with Harris in Toronto in 1927, and during the next several years she both accepted and questioned the theosophical ideas to which she was exposed. By late 1933, however, she wrote to Harris that she "couldn't swallow some of the theosophy ideas," and shortly after recorded that she had been unable "to see a way through theosophy." In May 1934, four months after "snapping of this theosophy bond," she wrote: "Somehow theosophy makes me shudder now. It was reading H. Blavatsky that did it." *H&T*, 14 Dec. 1927, 12 Dec. 1933, 29 Jan., 7 Feb., and 22 May 1934. See also Street, "Emily Carr: Lawren Harris and Theosophy."
4 Dennis Reid suggests that the reference is almost certainly to Roy Mitchell. Mitchell was the first director of the Hart House Theatre in Toronto, and is credited with introducing Harris to Eastern thought and philosophy. See Russell Harper, "The Development," in *Lawren Harris 1963* (Ottawa: NGC 1963), 20.
5 Harris, ever supportive of Carr, wrote following her decision to return to "plain bible": "I am deeply glad that you have found what gives you the fullest inner life." BCARS, Inglis Collection, Harris to Carr, 10 Feb. 1934. Bess Housser, too, wrote with understanding regarding Carr's decision, enquiring only "How does Whitman fit in?" BCARS, Inglis Collection, 20 Feb. 1934.
6 Marjorie Kinnan Rawlings, *The Yearling* (New York: Charles Scribner's & Sons 1938).
7 Mary Capilano died 16 Dec. 1940. The whereabouts of the Capilano portrait is unknown (and was unknown to Cheney in her later years.) A reproduction of the

Cheney portrait is found in one of the "British Columbia Artists Series" post-cards. See UBCL, Cheney Papers, box 5, file 4.

179 [Excerpt Toms to Cheney]

[Toms was home in Victoria for the holidays.]

[Victoria, B.C.]
31 Dec. 1940

Today I went to see Emily all afternoon. She was very bright and cheery, and showed me some of her past summer's work, which, being numbered, must have been the small pictures in her November show.[1] I'd like to have several

NOTES

1 Toms noted: "I didn't see others of her smaller paintings until Flora Burns' exhibition in the Hudson's Bay Company in Vancouver in August 1962." Toms, "Letters to Nan," 10.

180 [Carr to Cheney]

218 St. Andrews St
Jan 9, 1941

Dear Nan.

This woman deserves a kick. I *have thought* about your sketch but it still is not off. It is, the packing it up. but I am determined to now to try a new scheme. I got the province for Xmas so have newspaper to spare now was always short before and will really work out a padding to protect the face let me know how it arriaves jeggers will there be parcel delivery to West Van? will CPR Express will tell me I spose. I

was so glad to get your nice newsy letter. Am always so interested in the bits about the settling of house & garden. I spose I'm just naturally a domestic woman I love houses & gardens & home things. *And* [underlined twice] I am housekeeping myself now. Alice has a boy there come over from States to join air a selfish youth who gives her lots of work so I just had to independ. she was mad at first but all the time I felt she was glad underneath. she could manage O.K. with only *me* & it was good for her but *he* is enough for anyone in small quarters & her age so I advertized and have a girl (Jessie Pollock the Scotch dancer and bag pipest) from 8 A.M. to 12, and I cook myself (not my own flesh) but prepare meals. They are so simple & sparse & with the gas it is quite easy & I really was very tired of eating. Alice & I are the exact opposites. She's a vegetarian and a monotonous feeder. if its is something she likes (and she only *likes* very few things) she keeps right on the same thing 365 days in the year. *Good* food but *so* tiresome. I'm like a squirrel. like constant change, and all kinds of little odds & ends. of variety she wont touch never were two sisters more different. last night my supper was a boiled egg & some cottage chese & some of *your* crabs. they go very well together, & that brittle sweedish bread. the crabs are very nice & tasty. Isn't meat a price? and going higher. Alice bought me .65 ct a lb. loin chops. I think that is preposterous and I got something cheaper. rib[s] are .38 & just as nice. She never prices anything just phones 'send along' and of course they *do her* she has *always* been like that & always taken advantage of by the trades men who soon know. and she never considers whether things are in *season* or not & pays fancy when one eats same all year there is no enjoyment of *season* and one pays through the nose.

McDonald [Macdonald] never acknowledged the sketch I wonder did it not please him?

Your Xmas sounded nice. I did not know there was such a thing as a 35 lb turkey are you shure it wasnt a quarter of beef?

I had a visit from the Harrises a long one & enjoyable, but I do feel Bess has weakened Lawren. They or *his* crits (hers I don't give a fig for. they are all Art & Theosophy jargon) were poor & petty not

that he did not entheuse over my stuff he did but they were not constructive (on the whole thing) they were petty & stuck upon some high light or wrong twisted twig. I used to get so much from his crits. I expect Bess has absorbed a good deal from him but her work is most *talk* I always feel. She is always just *going* to settle down to work but so seldom does, but of course I have seen nothing of hers for years. what I did see long agoe were *very* weak copies of Lawren's with no back-bone. They spoke very easily of their being plenty of good domestic help in Vancouver, but may get a jolt. They say they are pretty far out in country as yourself He said he'd see me again in about a month & she doubted if she'd come that time. I hope not I could talk more freely of work without her.

Humphrey came he looks very well. I did not see much change in him he was very buisy rushing about & his time was short though he had one good visit here & looked in twice.

Oh what a vast amount of good some military training would do the young me[n] of this country. This youth Alice has 21. is about to take his month & I enjoy thinking of his bed-making having to be up to time & form when I go into her sitting room at 5:30 P.M. & see his *unmade* bed, & smell his unaired room opening right into her sitting room. I teased him at first thinking to give him the hint but he did not take it he sits feet up on another chair smoking & reading trash while she washes dishes & feeds him at *all* hours never comes to meal when she has hers & that makes me furious in a guest of course she *should* not stand for it but there you are—none of my buisness but its like gas under a pot to me.—that family (used to live in Vic) always overrode her, those beastly type English who think Canadians only fit to wipe their boots on, you know the type coming out without money or ability & slanging the colonies & taking, taking, all they can get. we used to get millions of them particularly in B.C. because they considered it the *most* English place to come to they were Canada's worst Trial.

Now my dear, let me stop spitting—all we hear of England's people these days is *too marvelous* but they *are* brave & facing up & will

learn a lot in this war, poor souls, & I guess we have same stiff lessons to learn too. The world just seems that its gone selfish & grabby. Must get up. lots of love & I really *will* endeavur to post that thing today or any how tomorrow

Yours

Emily

181 [*Cheney to Toms, Enderby,* B.C.]

Capilano B.C.
Jan 14th 1941

Dear Humphrey

Just a note to say that I am sending off 3 bundles of Toronto Sat. night—They are oldish ones & I will keep you up to date from now on if you want them. They have news of the artists—even recipes for your landlady & finally they make very good shelf paper for the pantry Yesterday I got a real surprise—Emily sent me one of her $50 sketches "for the new house"—She has spoken of it often but I never really expected to get it. It is this shape ☐ and is a seascape with a nice sky & a lovely tree on rt. hand side which saves it from so much blue—I was really scared to open it as some of hers I do not like at all—specially the heavy blue skies—This has a lemony sky with a grey cloud on the left & a bit of distant landcape & is really lovely in design & balance—Hill says the sea is going up hill but it really isn't—I am thrilled needless to say but I think Emily is fond of me & she appreciates my getting her started on having her yearly show over here— but I still want to buy one & as soon as MacD. [sic] pays me back I hope to be able to do what I want with the cash—I am afraid it is

going to be a long pull—he has no business ability & she's worse however that was my risk—I have renewed the note twice & in April some other arrangement will have to be made—Last Sat. we went to the Harris' for the evening & were simply stunned by his abstracts— They are really beautiful in a cold impersonal way & yet they fascinated you & the colour is gorgeous—he is going to show them at the Gallery but I dont know when—Jessie & Sydney & the Macdonalds went too—they were most hospitable—Mrs. H. was dressed in a long white crepe—form fitting—dress with flowing sleeves & she sat on the floor in graceful poses on white angora goat hair mats which they brought from New Mexico—I told Emily this & I can hear her snort as she thinks Bess very much a poser—We spent most of the evening in the dark listening to the gramaphone—music box, they call it, & the last word in recording.[1] They have *all* the symphonies & thousands of records. It was very nice but too loud for my tender ears—We had drinks & sandwiches & conversation afterwards. Jock seemed very immature beside Mr Harris in his statements & outlook—of course he is very much influenced by Barbara.[2] I have been reading one of their books on "Problems of personal life" by Keyserling.[3] Havn't found anything in it I didn't already know—he is one of those wordy Germans—very tiresome to read & Barbara says he writes that way in order to make people think?? ————— just rubbish!

We have a piano—loaned to us by Lillias [Lilias] Farley—the wood sculptoress[4]—they had it in storage.

This note has got to be a letter. The sun is creeping out & Inky dog is urging me to go out for a walk—Sydney is burning a huge brush pile over the fence so I must go & inspect the process. We had egg nog well braced with Rye on New Years day on the veranda about noon. It was Grand! Ralph is going to play here on Sat. night also Denise Mara[5] from Victoria—Sydney is going to read "Maisie" from the last New Yorker—it is priceless & he reads aloud very well. Mr Crawley—the blind man & his wife[6] are coming so I want things for his entertainment—Hope you are settled in—the winter has really turned the corner with the days longer.

Affectionately

Nan

NOTES
1 These musical evenings became a regular event, being held every second Satur-
day evening. As a youth, Arthur Erickson attended and has described the occa-
sions: "The Harrises were the centre of Vancouver's modest artistic life at that
time, opening their home to anyone who wished to come to hear music in the dark
through a then unheard of 'high fidelity' sound system. With the accumulation of
refugees from Europe, conductors like Sir John Barbirolli might be there, or
composers like Arthur Benjamin, besides dancers, poets and painters." *The Archi-
tecture of Arthur Erickson*, p. 12. (Erickson included Carr among those attending,
but Dennis Reid has pointed out that it was probably at the Harris home in
September 1941 and/or May 1942, when Carr was the guest of the Dilworths, that
Erickson met her.)
2 Barbara Macdonald was married to J.W.G. "Jock" Macdonald.
3 Herman Alexander Keyserling, *Problems of Personal Life* (trans., London: Jona-
thon Cape 1934).
4 Lilias Farley (1907–89), a Vancouver artist, was currently employed at Neon
Products of Western Canada Ltd., doing precision war work. In 1939 she had
completed two large mural panels for the new Hotel Vancouver. She was known
particularly for her figurative sculpture work, examples of which had been shown
at BCSFA exhibitions in the 1930s and 1940. For information on Farley's career see
Richardson, *First Class*, 5–27 and 35–8.
5 Denise Mara was currently living in North Vancouver and studying piano with
Jan Cherniavsky, well-known Vancouver musician.
6 Alan and Jean Crawley lived in Caulfeild, West Vancouver. The former, who
became blind at 46, was a critic and confidant of poets, and from 1941 to 1952 was
editor of *Contemporary Verse*, an influential west coast periodical published in
Victoria. See Joan McCullagh, *Alan Crawley and Contemporary Verse* (Vancouver:
University of British Columbia Press 1976). A letter of reminiscences from Alan
Crawley to Cheney, 18 Jan. 1973, indicates the warm relationship that existed
between Cheney and the Crawleys. See UBCL, Cheney Papers, box 5, file 1b.

182 [*Carr to Cheney*]

218 St Andrews St
Saturday
[postmarked 25 Jan 1941]

Dear Nan.

Am glad you liked your sketch as for a name. it has no particular—
names are for catalogues—still I sent it to you because it is of
Telegraph Bay where you took me to hunt a cottage.

I have had a poor time last 10 days Alice has been in hospital.
was suffering greatly with her eye & had to have it operated on. I have
been unable to go to hospital to see her. I had to write a letter get an
ambasador & have them take & read it to her & come back with
messages. well I had a nice girl. but if she did not have to come down
with measels. & retire home to quarantine. I got a new one yesterday
(not her equal) but the creature is trying & here I am teaching again
Alice was to have come home yesterday but has to wait till Monday
now as I have to get the girl in shape to take on for her as well as me:
and to warm & clean up her flat before she comes home. She has got
on splendidly much better than the Dr dared hope how much she will
be able to see we don't know yet but the Dr *hopes* she will take on
much where she left off. she has wonderful recuperative powers,
always. has suffered fearfully for a few days but they tell me [she]
looks rested and is cheerful: we will share my girl for the present. A.
is so difficult to do for waits on a maid & wont *let* her go ahead, even
if she *wants* to be helpful so I don't know. but I guess it will *have* to
come out *somehow*. Eye suffering is *so* dreadful. they gave her heaps of
dope. she has every confidence in her Dr. & he thinks the world of her
& is very good to her he is the only one she will obey orders for.
thank goodness there is someone. for she is very stubborn. I have
been doing my own cooking (what little it is) for some time as that
wretched youth squatted himself on A. with an enormous appetite &
coming at *all hours* for meals. her fault she should have insisted he
come at stated & *her* hours. she spoils & pampers him he's 21 & *very*
selfish. he is at training camp this month, & I am terrified will sit
down on her & wait & wait to get into flying core after. I *can't* cook &
wait on the brute, my fear is she will let him mess about. I wrote to
his sister (family in N. York) the English type who think the world was
made to wipe their boots on. A. has always been devoted to the Tribe.
the boy has been good going to see her in hospital & it has been a

great pleasure to her which is fine, but he is the baby at home spoilt & thinking the earth revolves round him. Time will, tell, it is too bad about Jessie (my girl who came from 8–12 Alice like[d] her (measely one) & she was quiet. I hope she will come back eventualy. I had sent her to hospital & got A. used to her.

I have never told you about the Hossies[1] They were a Godsend. came day before A went to hospital. She phoned & asked if she could come & see pictures was a friend of yours, also did I mind if she broght 3 young children—*I minded*—so she left them in the Park with the policeman. She stayed from 3:30 to 7 P.M. Mr Hossie met her her[e?] at 5. I was rolling round in a jelly of exhaustion & thought they were only "lookers" anyhow. She could not make a decision, said he'd promised her a picture for Xmas. He is a *very nice* man. well in end he got one of my *big* old Indian ones & a sketch and maybe it is a magnificent help. just at this time of hospital.

Letter from MacDonald [Macdonald] *at last* acknowledging the school sketch, a long blither dither of excuses, but I do think he could have dropped a line of *acknowledgement* even if he could not tidy up the arrange[men]ts at school. He wearies me with all his fancy talk about life and philesephy his letters are full of those 'theopsophy phrases' I bet. Bess falls all over him he's her type

I guess he is a nice creature enough but weak, & maukish in the hands of his woman.

Jack Shadbolts show seems to disgust rather[2] though he has got a lot of fluff & blaa in the paper. did he sell much? I suppose he has a Clique. Those who like "show-off" or don't recognize it, or mistake it for genius. (even to Lismer)

Now I must rise & be at the scuffle. and tomorrow it is my bed-day fruit-juice-&-sleep-behind-locked-doors. the girl only lights fires & hands me out a cup of tea, & is off again.

Hope you are on the up, Spring won't be long now.

lots of love

Emily.

NOTES

1 David N. and Mary G. Hossie were Vancouver residents.

2 Not according to the published accounts. One reviewer praised Shadbolt for his originality and stressed that "an exhibition of his paintings may therefore be regarded as an artistic event." See *AGB* [VAG], 8 (Jan. 1941) regarding the VAG exhibition held 14–26 Jan. 1941. Both Carr and Cheney are overly critical of, and yet at the same time intensely interested in, Shadbolt's work and the public's response to it. It is hard not to believe that Shadbolt's growing prominence is at the base of their criticisms and concerns.

183 [*Carr to Cheney*]

218 St Andrews

Feb 2 [postmarked 1941]

Dear Nan

What a nice long letter you wrote me You poor soul you have my sincerest tooth sympathy. I had 16 out at one bang & the fools let me come round so that my 4 fronts (2 eyes) were yanked out with nothing they were afraid to give me more gas I suffered fr[i]ghtfully from shock, and they were all ulcered & broke so I feel very sincerely for you there is only one consolation they dont *grow* again, and *in time* you get *used* to the false though you need not expect ever to feel they are *blood* brothers they aint. don't bother about the looks. I got real bold of my naked gums. Alice would rather be seen *undressed* than without her teeth Poor Alice I don't think I've written you since she went to hospital and had a *most painful* eye operation (they cut the white of her eye bald [ball], & sewed it up 3 stitches.) She was away nearly 2 weeks, & in the middle the girl I had just trained & was quite nice got measels so it was to do all over on a lump of girl-flesh that was as dull as & tough as tripe! and then the beastly measel one's sister had a baby, & measel decided she had to stay home & mind it. I dont spose having a baby is fun but the fool women these days make such a fuss over looking after them you'd think she was a super-human & the job,

needed a whole staff to raise the creature. So Alices coming home was postponed 3 days which was to the good gave her a longer rest from the blight of a soldier boy who squats on her all his off time from camp (& believe me its plenty) of course she's a goat to do it but she adores him like a pet-lamb. She has got on very well much better than the Dr expected. he rather expected to take the eye out & found it not so bad as he feared (dont say anything about this I don't think she knows, the Dr told me and believe me I was pretty sick) She does not see as well as before but can get about & do her little jobs which is a blessing for she just loathes to have anyone else about. her flat. Of course she can't sew, or read or even knit it may strengthen by & bye (a little) it must be devilish she studies her brael. The Dr says it is good for her to potter round as long as she can do things & keep her mind free from fretting I read aloud a lot, she like[s] that.

I am *very* tired this week reaction I expect my "lump" is taking hold fairly well. *Wants* to stay & learn that is something I'll always help them if they really want to try

Weather is really lovely in spots some rain which is to the good & some hard sun. I was so interested in what you said of Mr Crawley he must be fine. I felt so pleased the stories had given him pleasure I don't think you had an easy job describing a picture I hope to meet him some day I read that part of your letter to Alice & it interested her. I hope she won't shut herself up too much. she always was very secretive over herself.

McDonald [Macdonald] did write at last a lot of stuff very maukish. more to the point if he'd just acknowledge & done it considerably sooner I guess his excuses were genuine. but I do like people to be busness like. I gave a good ear-full to a youth in the East this week I did him *well* (a reduction, terms, & a rush shipping) as he wanted his picture before he left for his holidays 19 of Dec. he is a school teacher, & after tearing the hide off me he never acknowledge[d] (though he got it before he left Toronto) for well over a month. I was mad & wrote after 5 or 6 weeks asking if it arrived if not it must be traced & the rubbishy goo that fool wrote would make one billious.

Sheets of comparisons one artist & another & me. The most fearful blaa. of ignorance & sop, culled from cheap art journalism & poor critics Art jargon of lowest type then he ended "tell me how you find *my* reactions?" I replied "The stuff you wrote made me sick none of it was *yours* or *genuine* I don't know what *you* thought. That was all. borrowed Art prattle. & meant nothing" etc. That boy will feel flat if he is *compressible at all* which I doubt. These brats of school boys that are all critics & write & lecture on art are just *too awful*. & Lismer is a lot to blame for the tommy-rot he vomits into the schools.[1] Art Appreciation!

Blaaaaaaaaa-aaa!!

I am glad you have a piano do you play? it will be company an instrument can be. if one is fond of it. I used to think I *loved* music now I think *not*. perhaps it is my poor hearing but *most* music is just noise to me now. The good symphony's on the radio even seem long & boring & Canned and amature music seems irritating and vocal just screeching. so it must be me that is wrong I think. Bird singing gives me great joy & so does my old doves cooing but the other edges my nerves up

Yes I'd love to read your Roger Fry[2] thank you: who is the Sydney you mention? Jessie Faunt's freind or relation?[3] you mention them together. I am shure it is much better to live out of town and not in the razzle-dazzle of folks you don't want to see twice.

Sometimes *I don't beleive I am an artist at all*. and I am shure I am not a *nice person*. I'm so intollerant. Did little painting these last two weeks too wrought up. but queer to say I *did* write. I find when I need *calming* I get it that way best. some times if I am too worried to sleep I do a little and take myself off into the woods & places that way sometimes I find it so hard to be patient, not over my own afflictions, but Alice's. she is *so* difficult sometimes & if I'm impatient I feel so mean afterwards people all think she is so saintly but she can be pepper & obstin[a]te as a mule I'd be a thousand times worse I know, & I am getting into a habit of just giving in its not good for her or me, but there you are she takes offence at everything & feels so ill used if

you don't & madder if you do. I hope your mouth is better & lack of teeth will help things generally

luve,

Emily

Mrs Boultby [Boultbee] is wintering in Kamloops she is a poor misery, her asthma is bad. she is savage at *me* again. wrote me a cruel letter when I was in hospital so I've left her alone ever since. I had to write her about Alice who she adores as much as she despises me. I guess we never did hit it off too near of an age for Aunt & neice. she has never approved of me,—self,—works,—character—or body. Poor thing she has too much money to be comfortable, and too many fancied deseases to enjoy a *real* one. I guess asthma is a mean show anyhow they say it wracks the nerves.

E. C.

NOTES
1 Lismer, an authority in the field of children's art education, was currently Educational Supervisor at the AAM. See Reid, *Canadian Jungle*, for Lismer's career as an educator.
2 Roger Fry was an influential English author and critic whose *Vision and Design* (1920) was widely read. The reference, however, is likely to Virginia Woolf's *Roger Fry: A Biography*, published in 1940 (London: Hogarth Press). It includes the photographs referred to in #187.
3 Sydney Smith and Jessie Faunt lived together.

184 [*Carr to Cheney*]

Thursday
[postmarked 13 Feb 1941]

Dear Nan

Been very buisy finshing up a M.S.[1] and am dissapointed in it thought it was going to be better, worked hard. one never can tell.[2] Do hope you are through teething I know there is all the misery of the new fellows, beastly job. never mind think of the glistening smiles you will bestow & of being able to take them *out* to clean one thing I would *not* have is a glass eye. Alice feels the same its *no good* teeth *do* smash the food. even if they never do bite like real and (dont expect it) they *don't*

I spose if They were made sharper we'd cut out tongues off in my instance an advantage. it is unruly at times

Well what weather! *grand*. no real winter this morn quite a little frost. I am getting 2 new rose bushes to cover the back fence a pinkish white & a Paul's scarlet and am thrilled. My japonica (Pink broght up from Beckley St) is just lovely about its 3rd year a lovely rosy color & in full bloom & my big outdoor fuscia is all a little leaf buds. it is a sweet thing I did its roots up in sacks & I think now it will get through winter O.K. it is a little apt to winter kill.

Wonder how Jack S[h]adbolts show will take in Toronto.[3] The creature is good-looking & women usually *swallow* him. I *always feel* he is after *show* above anything I do *loathe* low nudes. Did you ever like, Holgates? they were not vulgar but they were just plain nakeds *not* nudes. mind I am not preducided against nude—real nudes are lovely, but I loath vulgar or suggestive nakedness. Seems it ought to be nearly time for Lawren to be over in Vic again. I have not heard from them dont even know their address I think Bess is fin[i]shed on me. well I dont care. I don't trust her any more I think she is a poser & I think she has weakened Lawren, he relys on her opinions too much but I'd like to see his new work hope she has not influenced him there because Besses [Bess'] own work is not (or was not when I saw it) much. too 'slush' & too 'theosophy'. She will have a circle round her soon you'll see, rather a mushy circle & she will pose to the eyebrows in black & soft greys & graceful poses well I'm a cat, & I used to be intimate & fond of Bess once but after I felt she was a hypocrite it put me off. I hope I get over in Spring I do want to see your place. & I am beginning to get the tickle of spring wanting to see the woods again

don't know what I can do this year in sketching line. there is Alice to be considered as well as me. if I get out it will be very close in so I can keep an eye here as well. Alice would never consider going into country with me she loathes it and would be miserable so I'm like the woman with the fox & the goose but things will doubtless settle themselves War looks pretty rampant and beastly doesent it?

Well I must do some correction work & then get up. my girl is not a.I but might be worse she is not tidy comes from a slatterly home I should think. Cant *see* when things are not ship-shape. Alice is pretty spry, doesnt see much but brighter has her soldier boy back as long as he does not lounge & leave her everything to do for him, it keeps her happy but she lets people wipe their boots on her (all except me. with me its 'boots off')

How's the patch gown getting on? Sounds loud.—well write soon Hope you are feeling lots better, remember me to Dr Trap[p]. Love to yourself Hill & Ink.

How did Hood's reception for the Harrises come off. I'm rather dissapointed in McDonald [Macdonald].

Aff.

Emily.

NOTES

1 Carr recorded in *H&T*, 21 Feb. 1941: "I finished 'Wild Flowers' and gave it to my sentimental critic." This unpublished manuscript is in BCARS, Inglis Collection. The critic referred to was likely Flora Burns who Carr believed wanted "too much sentiment." *H&T*, 3 Oct. 1939. Carr sent the manuscript to Dilworth who replied that he found the "Wild Flowers" sketches of BC plants and flowers "delightful." BCARS, Parnall Collection, 20 Feb. 1941.

2 Carr, in an undated letter to Lawren Harris [Summer 1941?], described the "dissapointed ache" she experienced upon finishing a canvas or manuscript. UBCL, Cheney Papers, box 1, file 36.

3 Shadbolt was included in a four-person show to be held at the AGT, 2 Feb.-2 Mar. 1941.

185 [*Carr to Toms*]

218 St Andrews St
Feb 16 [1941]

Dear Humphrey

2 months have slipped away since you went back to school. soon you
will be having Easter break. What sort of a winter have you had? Ours
has been marvelous—no snow. The last few days br[i]ght *sunshine* &
cold nights spring flowers out. I have a lovely pink japonica in full
bloom one I brought from Beckley St. it is lovely against the grey
house. I put in 2 nice new climbing roses this week. New Dawn &
Pauls Scarlet to climb over my back fence What fun spring is! Had
Alice in hospital for 10 days very painful eye operation. Dr thought
she was going to loose [lose] one eye but he saved it, & she is much
better (no sight) but still able to get about. I read 2 hours every day to
her so am quite buisy with sewing painting, writing. I do my own
cooking too have a rather slovenly girl from 8–12 daily. had quite a
nice one (Jessie Pollock the Scotch dancer played bag-pipes) & while
Alice was in hospital she got measles & I had to take this as a make
shift. however, Jessies sister had a baby & Jessie quit to go to her
sister. (these fool Mothers these days can't even manage their own
brats) so I went on with the secondary lump one thing she likes me &
wants to stay though her ambition is a Laundry & she has her name on
a waiting list. That miserable Florence is out of a job every 2nd month
and sends pe[o]ple to me for a reference she gets none. I told her I
could not reccomend her with such a lying etc reputation. I'm afraid
she is an out-and-outer now. even her parents seemed to have given up
trying to do anything with her, little beast.

 This is bed day I have been doing a lot of radio-listening. war
looks bad. what a mess! every one seems affected in some way or
another although Canada is still hybernating. guess by the time she

wakes there will be nothing but the dust left.

I begin to tickle to get out into the woods, too early just yet—& don't know what I can be managed this year, on Alice's account as well as my own! She hates camping so it is no good taking her & I can't leave her so there you are, besides it will probably have to be very close in. well I suppose it will settle itself. it always does I wish you were here to chaufer me for a hunt. I found a delightful place in my dreams the other night a tiny village of white-washed huts on a river bank very low lying (I should say rather swampy) thick forest behind and tall lush grass before. I made arrange[men]ts with a woman to board me $30. per month & then another told me it was too much she had a good room to let me at $25, & I did not know how to get out of the other. I even enquired about drinking water which I heard was *excellent* and was obtained from a green flat place (in buckets) known as the "green." The bother is I have *no clue* as to where this spot is located, except that it was obviously B.C.

I have just finished a fair sized manuscript no one has seen it yet. Send it to Ira Dilworth yesterday[2] he is always very kind and helpful in his criticisms & I believe quite honest as well, & knows & points faults out not just quibble for the sake of quibbling as so many do I find, people who *want* to be critics! Oh what a lot I do get of that one way & another. A young man school-teacher in Toronto bought from me a picture begged me to *rush* it off so he could have it for Xmas, I did, & it got there on time but I heard nothing from the young man for 6 weeks not even acknowledgement of shipment, so I wrote telling him to let me know at once so I could trace if lost. back came sheets & sheets of Bla-a-a-a oh the conceit of the creature. He liked the picture but the fool tommy rot! comparisons, expositions, flattery the biggest show off of Art jargon *I ever heard*, ending up with, "I would be interested to know what you think of *my* reactions" _____ He got an ear-full. I told him "I knew nothing of *his* reactions the dreadful rot he had written was merely stuff culled from books— Arty words he did not know the meaning of"

Lismer is responsible for a lot of that rot, teaching *Art appreciation*

to children so every brat swanks as a critic & makes you sick. let them give an honest talk of how a thing effects *them* but all this mush this Art history from Adam this fancy Talk & big wording is so ignorant & exasperating worse that [than?] when I was a child when the usual criticisms rude but honest was "What is that *supposed to be*. That was what I always got as a child from my own people oh well. such is Art. I do not wonder I have such a hatred of "showing" to people I dont know which is really worst a stupid wordless oxlike stare or a volume of stuff neither you nor they know the meaning of I think the silence *hurts* most the other makes you *mad*. That is the unpleasant side of doing *anything* (the public) The effort of making and trying to get a little beyond is so very entertaining once you have put *all you know* into a thing (not all that *could* be put into it) it is finished & you turn the page I rarely want to look at one of my canvases. guess most artists are the same let others enjoy them if they want to, your enjoyment stops when your limit of knowledge is reached. You put that phase out of your mind (it just goes unrequested) and are away on something else. I expect *most* artists feel like this. I have seen some who could go on gloating & entheusing but I think in that case their growing has finished.

Miss Cann sent me absolutely demented she had a notion before I was ill (stroke) she wanted a sketch she exhausted me an entire afternoon going over & over, havering & fussing and after reducing me to a jelly went off saying "of course I could not decide in such a hurry." Oh lor! she'd been 3 hours & made me haul out thing after thing All the 3 months I was *very ill* she kept demanding audiences some man she wanted to *see* before she decided. she was told I could see no one but she went on pestering so I said Florence could get the sketches out & she could go over them with her man. but I *could* not be there (was in bed). No, she said she wished *me to be present*. Well, in January she came (6 months after her first visit) with Ruth who did the lifting and oh I did *hate* the woman & her hesitating & havering (Ruth adores Cann) & thinks I am preduceded [prejudiced?]. When she had pulped me she went off with two, & now she is grumbling says

one his [has] a scratch or something I said "well none of us saw it in studio if it is marred & I cant do anything you will have to change it (there were 5 she liked equally well) or you can have your check back" gee! I'd sooner go hungry than sell to an old hag like that. she has gone to Vancouver one of these days I spose it is all to go through again when she *changes*.—she does not know a thing about *art* her foolish jargon tells that—she is only history I *de*test that woman— always did. I think I'll try sleep now, having boiled enough.

Hope everything goes well.

Yours

Emily Carr

P.S. Nan writs more cheerfully.

NOTES
1 There was no sketching trip for Carr during 1941. In the spring she was busy with visitors, including her publisher, W.H. Clarke; in the summer she became ill once again; and in the early fall she was preparing for her "annual" exhibition at the VAG.
2 See #184, note 1.

186 [*Cheney to Toms*]

Capilano B.C.
Feb 21st 1941

My dear Humphrey.

Was delighted to get your letter and your news up to date. You sound much more settled in & happier than you did before Xmas. Glad you like the Sat.night—I hesitated about sending more but I will get some off at once. "Life" keeps you pretty well informed & the "Chris. Sc.

Mon." is always good. How grand to get some money unexpectedly & I am much amused at you owning a pregnant cow—They have a real cash value these days so I am sure you won't loose out on your deal. I am afraid I will not be so fortunate—It is a year nearly now & no sign of even the interest—& to make it worse Barbara is fed up with the place & hankering for town again. She is getting crazier every day and nearly knifed me when I returned a book she had loaned me of Keyserlings called "problems of personal life." She said it was a philosophy of life & I said I did not find anything in it I did not already know She was furious & just lit into me with her eyes blazing & her face white. I was scared to death as I am not equal to dealing with that sort of thing & I tried to calm her but she got worse so I fled, & reached Jessie's in a trembling condt. Sydney was home & we sat in the sun until I was able to get this far—I was a wreck for 2 days—I think she is on the verge of insanity & she needs a good physciatrist [sic]. They had dinner at the Harris' one night & they thought she was crazy too—They have read *all* the books she quotes from & they say she has got off on the wrong foot entirely. We have seen quite a lot of the Harris' [Harrises'] & like them more all the time—Bess is really a fine woman & he is so *gentle & tolerant* & they are so happy together— This is the effect one should get from the reading B. is doing but she is so unbalanced & *in*tolerant that she does not get it properly—Jock is terribly influenced by her & he is getting *very* superior towards us all over here—Needless to say Jessie & Sydney see through it & so do the Harris [Harrises]. Until they came Jock was cock of the walk in abstract painting here (he has never given Jessie credit for developing anything herself) so we hope Mr H. in his gentle way will have more influence with him than his wife. You should have been with us for dinner at the Harris' as you do appreciate things nicely done. Everything was perfect—the dinner, which was beautifully served by a silent maid—the silver—china—glass—in perfect taste—We sat by the fire & talked & enjoyed it all tremendously—Jessie & Sydney went on Frid. night & everything was just as nice & the Harris' [Harrises] are terribly taken with them both—They recognise worth & sincerity

at once—I have not read "Education of Hyman Kaplin" [sic] It must be good if the New Yorker printed it—I am deep in "Out of the Night", by Jan Valtin[1]—your "Life" has an account of it this week. We have had 11 days of pure sunshine & I have done a bit in the garden & Sydney & I have tea on the front steps—In the eve. he & Jessie usually come up for an hr. We have a piano now and they play for me. Aunt M. will be 80 March 11th so I have arranged a small tea party for her at the Empress. I can't possibly go over but the manager said they would do it up in style birthday cake & all.

Emily writes quite often—Alice had an eye operation (cataracts) & is better—Emily rants as usual about everybody etc but she is planning to come over this spring & I think she can get some painting just in the woods round here. It is all on the level—I went to my first council meeting at the Gallery on Frid & Mr Harris is to have the big *north* gallery for a show in May[2]—no one has ever had this before & the words "north gallery" got passed the founders without a blink—I expect they were all busy thinking about their war projects. Groceries, sugar electric light & newspapers who head the board—It was a nervous moment for us—I have not done a bit of painting but I am beginning to feel a little like it. I actually sold a sketch for $15.00 which will just cover the aged Aunt's Tea party. Hope you have a good Easter Holiday & do plan to see us on your way down in June—This is rather a ratty letter but my encounter with near insanity this week has left me quite flattened out.

I quite agree with you about the Art patter—& I know how Emily loves to have one rave—even if you say the same thing over & over again. dont ever do it—

Affectionately

Nan

NOTES
1 Jan Valtin, pseud., *Out of the Night* (New York: Alliance Book Corp [1941]).

2 The Harris exhibition of abstract paintings was scheduled for the VAG, 29 Apr.-
14 May 1941.

187 [*Carr to Cheney*]

Sunday
[postmarked 26 Feb 1941]

Dear Nan

I had a great pleasure today—a visit from Dr Trapp. her account of
you was good. I am so pleased you are better keep gooing [going].
Well hows things? thank you so for Roger Fry I am reading him and
enjoying it I dont get so very much time for reading to myself as I do
2 hours per day aloud & A only likes certain books. with enough story
element to amuse It must be so dull to know you can't pick up this
and that & read for yourself. That Roger Fry's mug on the book cover
& in his 'young man picture' I hate (as a little boy he has a dear little
face) up after his mouth always hangs open. I want to shut it up I
don't like gapping mugs, and his head so flat on top. Well you are all
fixed now in beauty again (teeth). glad they are not too aweful in
agony I dont see how people bear them so soon my were out 3
months I mean I was tooth-naked. & my gums so lacerated I dont
think I could have *stood* a plate. Dr Trapp says they look very nice too.
We've snowed today only a few dozen flakes but its been cold as a
refrigerator if we go back into winter I shall blub (maybe I'll drownd
myself) I love Sundays in bed now I know so many buisy beople who
ought to have a day in bed I feel greedy Alice still has her soldier so
she is not lonesome & I can enjoy 4 walls two dogs one radio and one
jug of orange juice. Tho' old stomach growes and gaunts a bit, but I
have the vindictive delight in paying (he she or it?) back for converting
every food I eat into fat.

Good land I *hope if* [underlined seven times] I ever succeeded in having an 80th birthday a tea festival at the Empress, wont be my idea of a *treat*. I am narrow but I *won't* contemplate a bundle of my contemporarees, slurping tea & gossip, with me as the Queen Slurper of the occasion, at a public, waiter infested, band-drowned, hotel! Well—I'm an old crow with no spunk Aunt M. is young enough to be my grand-daughter & I spose she sat at that desk souping out charity to crawling misery for so many years she had no time for ructions & do's herself.

The post man's neglect is scandalous these days. doesnt even look my way You are the only corespondent I have left, along with the gas & telephone Co's bills.

Alice is pretty *lively* her health seems very good & though her sight pretty *poor*, still she gets round. Oh, by the way Mr Hossie came yesterday & asked me *point blank* if I told you he got the pictures so I had to say 'yess', so its no good shamming when he shows them to you. I wonder if you will ever see that aweful Miss Cann in Vancouver she is over there indefin[i]tely. if you do, tramp on her worst corn & ram her with a hat-pin, & with a *sweet* smile [?] say 'Millies' love' Ugh! that tiresome tiresome old hag.[1] I hope I never, never, never, have her in my studio again. she inflames my *very roots*.

I dont like pajamas they sent me a whole bolt of rag and a pattern like a jig-saw puzzle. no peice fits any other it had 10000000000 peices, you reckened them like war debts by the multi-billion & nothing matched any other peice. Anyhow I'd rather make *any other garment in the world* I think they are immoral & immod[e]st. A woman in pajams makes me ill everything shows off at its worst. they are plain *ugly*. I got so worried over the patern and two pair of failures that I wrote saying I could *bear* no more & they could take back all the nice things they'd said about my work & they sent me a decent stra[i]ght forward pattern. (pajams still alas) but perhaps I dont feel *quite* so ashamed as if I'd been *entirely routed* by the pajam, & I have 7 pair under construction, & thousand[s] of yards to cut pajamwise still well, perhaps pajams must be my particular cross. perhaps I shall be so

reconciled I shall "effect" them "—Heaven Forbid!" I hope to die in a good roomy 'gown' Your patch gown sound unique & quite interesting Yes there is fun moving round a garden that is quit[e] private enough to go into *naked if you wanted to*. I used to love that in camps, & the cold wet grass tickling your bare feet, only unfortu[na]tely the ants bit them too. the dogs & Woo & I used to go to get water for breakfast most sketchily draped in nature so you see my loathing of pajam is not *modesty* they are so utterly unbecoming to the female form particularly when fat.

I fought a cold all last week & was very low it wasnt all pajam but the cold never quite caught up with me only a sprinkle of sneeze & foggy head. The maid had one & Alices soldeir, & I'd finished a manuscript & was waiting to hear about my sewing, & my 3 canvases were pretty poor but I hope to be uppier this week. I have not your letter by me so write again soon then I will have something to answear Glad you find the Harriss [Harrises] nice—they are—

Best of everything.

Emily.

NOTES
1 In marked contrast to the tirades of #185 and #187, Carr some years earlier had briefly acknowledged the *kindness* of Miss Cann. See Carr to Hembroff-Brand, 8 Dec. 1936, in Hembroff-Schleicher, *M.E.*, 94.

188 [*Carr to Cheney*]

Wednesday
[postmarked 13 Mar 1941]

Dear Nan

So glad to get your letter yesterday sory you have been feeling poorly It must be lovely to roam right from your door into the woods no fuss & bother to get there these Brilliant days & no leavs on the trees try my eyes very much. I am always devising new curtains somewhere. I *hate* strong blare my bedroom is frightfully morning—sunny & in the aft. the studio gets it, wish it were reversed. And when I growl at sunshine I feel a low-down, it *is* grand, only one wants Tin eyes to bear it. I seem to have been buisy not much result to show but always some thing yawning to be done. I get up at 11, & get to bed at 8 tired out, and read aloud then for 1 1/2 hours voice gives out then but I know A. does enjoy it tho she is always ungracious over it as if doing me a favor by listening. She has stored up so little of entertaining thought to fill in time with, has not observed or taken pleasure out of things much, so it leaves her resource-less & empty, & I feel so mean I *can't* discuss my work (paint or write) but she has always despised & repelled it. & now there is no connection between it *her* & me Our interest were *always totally different* every single taste & habit. (dyed in the wool) & there is nothing to be done about it. her soldier is gone & she misses him she *can* go out seemingly without difficulty, but she does not much, she studies her brael a lot, & there is the radio she has never cultivated her neighbours She adores her house but she broods & takes offence at every little thing She is bright enough when visitors come in, but curses them before & after as pests for coming.

I was interested in what you said of Mr Burnst [Brunst].[1] never heard of him, before, I saw the name in Gallery notices. I also saw in Province. Lawren was having a one man Gallery by invitation, that will be interesting I wonder how Van. will take it? I have expected to hear from the Harrises He said *before* Xmas they or he would be down in about 5 weeks, again. I have not heard a word from them don't care about Besses [Bess'] letters—splurgy & insincere, but I have alwys valued Lawren as a correspondent. Edythe wrote yesterday. She has been in New Haven Conn. for some months & hopes to stay there a couple more she seems sore that no one from West writes her. personaly I lost contact when she was here & never came to see me,

after her mother was dead thgh she had a good maid & *her own* car so I felt she *could* have had she wanted. Gee! The world is insincere, or rather *people* are

Mrs McNair [Macnair] did write me, & I refused[2] I know she is nice & she once wrote a very nice 'do', about my work for province.[3] I do not feel elligible for a biography In first place I'm *not DEAD* & I don't think these things *should* be wrote till one is. (if ever) ((written not dead)) I have written one (of a sort)[4] Eric Brown wanted me to, but he died before I got a chance to send it for his crit. in fact before it was finished. it needs revising & rewriting. Maybe some day I'll get to it it maybe not what checked it was really that I read the first part to Alice & she was so white-hot-furious she did not speak for weeks, & has never mentioned it since. I would only write the thing if I *could* be honest & show bits of our home life as *it was after our parents died*, (pretty hellish). My two sisters next above me never went through what I did they were meek & goody & swallowed but I sputtered. Alice would have had me make pretty & smoothe over all that, but had it not happened the trend of my work might have been very different. An *Auto*biog. is the only Biog. that can truthfully be done, I think & Alice would not tollerate it & I'd feel a FOOL if I wasnt dead.

Old Boultbee too is on her ear unless the Aunts (other than me) are saintified and smothered in goo. She only knew them outside they never *dared* to *spank* the neices only spoiled & cossited them so ———— She Mrs B. even objected to 'Sunday'[5] said *She* loved, her Aunts, O.K. but she did not know them as I did I *loved them* too but I *knew* them I am not very devoted to any of my neices & they shure don't think much of me, Where the duce I ever came from, goodness knows! Indeed I've heard my own Mother wonder that same thing except for my father's bad temper, I inherited nothing famil all *un-Carrlike* traits. I was the only *fat* thing in the family too.

The Hart House Quartette, were in Vic. last week no matter how rushed they are they always find time for a good long visit with me—nice men. What's-his-name Scott? calls upon me tomorrow (Duncan Campbell Scott) Poet, his wife[6] (any thing but attractive if

the Province photographer is truthful) is with him,—very tired—
finish tomorrow.

———— And tomorrow (Thursday) Done my bit of Refugee
(after breakfast first thing). I am now *promoted* to dresses for little
girls nice to do. The pajam bolt is finished. The last two were regular
spankers I could almost have worn them me self!! another blaring day,
sun roaring, a regular bellow. must say its the grey day for me & quiet
woods, rather than shimmering sea.—always.—but I am not con-
sulted by those who command. weather conditions

Yess I always feel married women leak news. to husbands. Edythe
always tells Fred says he is as interested in my letters as she & always
reads them. up to marriage I always felt she was pretty reliable of
course I knew old Fred pretty well before he married her still one
mentions some things to their own sex! I never fell onto men's bosoms
with confidences. So Aunt M.—I told Alice. "Good for Aunt M.",
she said. She always is for opposition to me. She and my other sisters
always went without half of life during Lent etc. Poor old Mortimer.
he has at last hooked. some Art relic. he is always trying to get
Jackson (A.Y.) for a visit, or me or Shadbolt & now he has landed a
'next of kin'. I am not very keen on Roger Fry. it is interesting as a
man but I don't get much enlightenment about Art. Am about 3/4ths
through & will then post back

Well I would like to be strolling in your woods though what a
sparrow beside the richly varigated Mandariness!!

Am glad Macdonald is having a go in Toronto.[7] Do you know what
impression Jack Shadbolt made there? Well I must get up the Poet &
Poetess (she writes too) tea on me, & I must provision against their
appetites. in print she looks greedy, & greasy complectioned with
bobbed, *old* hair. I'd most rather see Oldish women *bald* and *naked*
than languishing in 'bobs' and knees skirts. Their legs are *so* ugly. (all
wrong bulges. & bandy.)

Aren't the States picking the plums & war-glory guzzling, them
down with great draughts of "*We* [underlined twice] *done it*" thank
goodness they *are* with us, but they do remind me of Woo & the dogs.

Woo would gaze at the sky & would & let the dogs settle to their dinner pans, & get one good sniff, then she'd pounce & pick out all the tid-bits with complete satisfaction, & "I'm me!"

I seem rather acid this A.M. so will quit. How's teeth? Are they good chewers?

Yrs.

Emily

NOTES

1 S.E. Brunst (1894–1962), recently from Saskatchewan, was noted particularly for his watercolours. See *AGB* [VAG], 8 (Jan. 1941), which refers to a forthcoming exhibition of his paintings.

2 Dorothy Livesay Macnair had been enquiring about the possibility of writing Carr's biography (BCARS, Parnall Collection, Livesay to Carr, 4 Mar. 1941). In her reply Carr thanked her for her interest, but added "let me die first." Dorothy Livesay Papers, Department of Archives and Special Collections, University of Manitoba. See BCARS, Parnall Collection, Livesay to Carr, 4 Mar. 1941, and Carr to Livesay, n.d. [Mar. 1941].

3 See Livesay, "Rhythm of Nature Expressed by Emily Carr," *Vancouver Daily Province: Saturday Magazine*, 6 Jan. 1940, p. 2, in which she asks: "Have you ever seen the spirit of British Columbia better expressed?"

4 During 1938–9 Carr had worked on an autobiography which remains unpublished (BCARS, Inglis Collection). *Growing Pains*, the "autobiography" which Carr developed in the 1940s, was published posthumously (Toronto: Oxford University Press 1946). As early as 1933 Harris had urged Carr to write her story. "I fancy," he wrote, "if you were to write your story, fully, with situations—somewhat as you write your letters it would be very much worth doing. . . . you would have a very great deal that would be of real value. The thing would be very frank, direct and natural and that should be easy for you. A book of nearly three hundred pages whenever you feel like it. It might take a few years that doesn't matter. . . . I am dead certain it would be worth while doing. Would it interest you?" BCARS, Inglis Collection, Harris to Carr, n.d. [1933].

5 See #79, note 1. Carr's older sisters did not appear in a favourable light in this account.

6 Scott and his wife Elise were at the west coast for the winter of 1940–1. Burns, "Emily Carr," 234 states: "As her paintings became known in Canada and abroad she made many new friends and her studio became a gathering place for visiting artists, writers, and musicians." Burns noted that Dr. Duncan Campbell Scott was one. In the BCARS, Inglis Collection, is a typed poem bearing the handwritten inscription, "To my friend Emily Carr, [signed] Duncan Campbell Scott, Beaver Hill Park, Spring '41."

7 Macdonald was scheduled to be included in a four-person show in the *AGT* in April.

189 [*Carr to Cheney*]

Tuesday
March 24 [postmarked 1941]

Dear Nan

Glad to hear from you today. I have had a very buisy last 10 days or so. Much visitor. 1st the Hart House men, then Camble Duncan [Duncan Campbell] Scott & Mrs, then Mr and Mrs Clark[e][1] (publisher) then Dr and Mrs Martin[2] from Montreal do you know them? he is on the Art Gallery board or comitte or something, also Fred Brand. He was so nice thinner quieter, & more interesting. He came twice for long visits and Sunday he & Pa Hembroff took me to a little house Pa has in Saanich for a drive, & I *enjoyed* it the country looks so delicious & 'early year'. Edythe is still in New York or New Haven or somewhere.

Well, it is *really going* through, the Oxford Universit[y] Press is bringing out a book of me.[3] about Xmas if we are not bommed off the earth first. He came to see me (he & she) nice people spent two long afternoons & one morning Mr Dilworth brought them over & introduced he is dear old Ira. so kind. its all his doing. he is an old friend of Mr Clark[e]'s. The Clark[e]s are very entheustic over the material. I had no idea publication was such a performance so many things to consider I hawled out pictures & M.S. & information till I was purple as a pansey, and just as I'd sat down to sigh for rest Mrs Maltwood[4] phoned to see if she & Mr Maltwood could bring Dr & Mrs Martin & Mrs [illegible], and all the hawling out was to do over. Mr Martin wants something for the Gallery (Montreal). he had in mind a sketch but got enamoured over canvases & felt I should have a more dignified representation in the gallery than a sketch, so it has ended in Willie crating two canvases & 2 sketches to be sent over to face the committie who he says are difficult & have *no* funds. Dr Scott bought a sketch he was very nice and Mrs head & shoulders above expections by her

news paper picture. she writes & is realy a very nice person lots younger than he. The picture he bought was an anniversary gift for their 10 wedding, & they went off hand in hand. smiling at each other.

Lawren wrote me he had made very swift visits & asked if he might drop in in the morning for a few moments next time.

I'm sory you have not good light in your studio thought you'd be shure to fix for that when building My great south window is very bombastic & keeps me hopping when people are inspecting I have curtains & more curtains & just as I get it fixed the sund dashes round the corner & attacks the West window. still on the whole, by perpetual slithering, the light is not too bad. I run all the Curtains on easy rings so they can be instantly adjusted, and of course on dull days all that light is valuable.

Have 19 garments about ready to ship this week, there is a lot of fixing to dresses as much as pajams but of a higher order (more refined). personaly I am naked, as a refugee whats the good of *buying* clothes & living in a smock, but shoes I *must* have and soon even the uppers have holes. they are absolutely forlorne. I must try & make town & I loathe even the anticipation, & put it off. I expect now I'll have a long lull from visitors. I wish I could get over to see Lawren's show I *might* in a month's time. Its not *only* me its leaving Alice, she's so darn stiff-necked about having anyone in & I dont think I like to leave her now. I would not be easy in my mind She is very well but her sight gets worse. I think she really enjoys the visitors but the only way she consents to appear is if she can bring in the tea. I hate for her to have the bother but the Dr says she must have interests, otherwise she mopes, so as long as she can do things she must, & she can't go tracing those brael lumps *all* day. It is fearfully difficult I never never could master it not if I had *10* blind eyes I would not have the memory.

Why don't you make an outdoor aviary? Hill could build it They are such fun. I'll give you a pair of doves to start they are such delicious cooers, & would sound nice out among the trees, close to your house. Soon the garden will be rushing to weed. I too will have to

get to my kneebones my big maple tree is as prodigal of sprouting seedlings as Hitler is of soldiers, not one seed misses fire. Its time I reposed myself. That is the same old ash dish I gave you thousands of years back Dont mention what I told you about my having written of the Biog. it may never be finished. never in my time will it be *public* I'll keep my insides *in* till my breath is *out* thank you!

Yours aff.

Emily

NOTES
1 W.H. and Irene Clarke of Clarke, Irwin & Co. Ltd. W.H. Clarke was president of the company and also manager of Oxford University Press (Canadian Branch).
2 Dr. C.F. Martin, a former Dean of the Faculty of Medicine, McGill University, was president of the AAM from 1937 to 1947.
3 Carr's *Klee Wyck* (Toronto: Oxford University Press 1941) came out in the fall (and received the Governor-General's award for non-fiction in 1942).
4 See #82, note 2.

190 [*Carr to Toms*]

218 St. Andrews St.
April 5 [1941]

Dear Humphrey

Glad to get yours in February.—getting on for Easter now—weather lovely & the Earth looking A.I. flowering shrubs & all sorts of good things, in bloom. today is one of those remnant sales of weather every door slams on you, & every window slithers on it[s] rod, one minute you are withered with sun & the next drenched with rain you could dress & undress all day & never hit comfort. Glad life is settling more comfortably in the primitive, spells of that (life) are wholesomely

good The trend of falseness grows so exhasperating & unsatisfactory

The 'Coyote' howls are wracking at first but once used to them I like the sound. saw them up in Carboo [Cariboo]. the old men there claimed they had ventriloquistic powers & could throw their v[o]ices in different directions to fool man—maybbe—I played with a young 'Coyote' once in a remote feild he & I met his nose to the ground & the wind the other way he did not spy me. we stopped short about 3 yards apart I yelled or I think he would have butted into my skirt. we would each go a little way & then sit down & stare at one an[o]ther. Bring me a flying squirrel? The chipmonks are 5 years old don't think they are good for much more than that Is the country full of Chips? The little striped chaps? Don't be stupid—nothing pointed about that Toronto fool's Art jargon *when if* [underlined three times] you ever write me *10 pages* of that stuff I *will* write back *with points* [underlined twice]. I think you were feeling pretty acid the day you wrote your letter Feb 27th?

Have had so many big pot visitors last few weeks eastern & others. Oh! *and publishers* I am being published I dont come out till Autumn, & not then if we are bounced of[off?] Earth previously. I'm quite thrilled too to think they *sought* me not me them.

Nan seems much better. Lawren Harris is having a show in Van Gallery (one man) this month. I've bust my lowers and *may* have to have my last 6 roots extracted & get new plates.

Re. portrait[1]—no can do—I rid myself of all unnecessaryies & failures at time of move if one thing is most reproachful & painful it [is?] a failure portrait.

Have done a good many canvases against my next show but last two weeks have been too buisy with Artists, poets, musicians, & *Publishers* so show off antics have exhausted me beyond paint.

Hope you will have very nice Easter holidays.

As ever

Emily

NOTES

1 Toms, "Letters from Emily," 11, noted that Carr had previously done a portrait sketch of him and that he probably at this time had asked if he might purchase it. Hembroff-Schleicher, *Emily Carr*, 179–80, stated that portraits of friends "were tossed on Emily's super bonfire when she was weeding out four years' accumulation in the cottage before moving to Alice's house." See also #167.

191 [*Carr to Cheney*]

Good Friday
[postmarked 14 April 1941]

Dear Nan.

My doctor came today. I contemplate having 6 teeth (my last) out & the Dentist, refused without the Drs advice & now I have gone & got a beast of a cold & have to wait, for that date, & have them squeezed out one at a time.

Well my plates are all busted up & I need new ones & the 6 are beyond repair & it seems as I am in pretty good repair at present the wise but unpleasant course. If my darn nose hadn't gone & colded, and stopped the pulling & started up aching, & made me sit pretty & snif!

While he was here (Doctor) I spoke to the Doctor about making the trip to Vancouver but he said best *not*. He thought I *might* be able to wrangle a *very easy* near in trip round here if I could motor door to door but does not favour boat etc. & I feel he is right last time when I went to Edithe's [Edythe's] & she *missed* meeting me I had *such a bad time*. There are those long beastly ramps & one never knows what the boat will dump you at 1—10th floor it would only wory you I'd best stay put Theres this jaw buisnes now too. Sounds like I am a feeble molly-Cod but I know inside me, The way to *keep going* is to go *very* slow & easy. I had not seen the doctor for months & he thinks *I'm wonderful* to do all I do. said he never expected it. I told him that *his* telling me long agoe "*not to expect to take up where I left off because I*

could not gave me the best boost to say to myself, "Then I have got to make the best whats left." before that I always was sort of waiting to be back just where I had been. I'd so much rather they were *honest* with me, that is why I like Dr Lucas,[1] he is not a blue-bag but he doesent lie to you. there is always the problem of leaving Alice too. She will never cooperate. she is getting very blind, yet she went to some ones house for first time this week & gave me most minute details of the house & garden & furnture, so she must see somewhat.

Mrs McNair [Macnair] is coming to see me tomorrow over for week end I beleive. Its been a glorious day for Good Friday. I am shure your woods are lovely I *would* like to see them I see them in my mind quite clearly. expect I've got it all wrong. You owe me two letters *now* this & the other, you know my principals—but, I thought you might be wanting to ask someone else at Lawrens Show time.

lots of love,

Emily.

Later Mrs McNair [Macnair] called & we had a nice talk I had to hold my teeth up with my hand mouth inflamed & they wont stay in. I have to retreive them from odd corners whenever I sneeze cough or yawn—awkward.

NOTES
1 Dr. Oscar C. Lucas was a Victoria physician.

192 [*Carr to Jessie Faunt, Capilano, BC*]

[*The Carr to Faunt letter is in the UBCL, Special Collections Division, Cheney Papers, box 1, file 27.*]

218 St Andrews St

Victoria
Thursday
[postmarked 17 April 1941]

Dear Miss Faunt,

Thank you so very much for your letter I had been wondering I had not heard from Nan, poor girl. I am so very distressed she is ill again. She has had such a long miserable spell of sickness—I am so glad she has you for a neighbour she gets so much pleasure from your nearness and companionship.

I wrote last week telling Nan I could not come over at the time of Lawren Harrises [Harris'] show as she wanted me to. Of course now she would not want me anyway. The Dr advises against trips that mean the bother of boat or train changes, & I know he is right I *would* like to see Your two places (Your[s] & Nan's) & the woods must be delightful. I thirst for woods this time of the year.

On Sunday I have to have some teeth out, *at home* the Dr won't let me go to the Dentists office They are both coming here. Well it will be nice to get it over & teethe again I am only uppered at present moment.

I am going to write to Nan now Thank you very much. I know from experience what a goodness it is when you want to write & can't, to have some one do it for you.

Very Sincerely Yours

Emily Carr

193 [*Carr to Cheney*]

218 St Andrews St

Thursday
[postmarked 17 April 1941]

Dear Nan.

I am so sory, havn't you had your share of sickness don't be greedy!
and in such lucious weather too when it must be so nice among your
trees. Spring does seem to be trying its best to make up for some
other shortcomings in the world just now. even my tiny garden is gay,
though my big maple umbrella's it, entirely, but she is so beautiful
herself she can do what she likes up to falling on the roof & smashing
me in bed. that would be messy. I would like so much to show you my
house & to see yours with my eye well anyway we can 'magain.

Don't think me a copy-cat I am being 'untoothed' too Dr &
dentist coming Sunday morn. to hawl. So as to make it *thoroghly
comfortable & enjoyable*, I am to be done in my bed I'd far rather yell
the old dentists office down, & have his iron foot rest to kick, & the
hat rack behind to butt, but my wishes are not consulted nor can I gas.
There *are* those who say lower-fronts *don't hurt*, but I notice they
never whine for a chance to have a repeat. You will *have* to be up for
Lawren's show we can't both miss it & nobody have nobody to tell the
other body about it. I am dissapointed about that I mean not seeing it.
he was here the other day. Glad Bess has a new dog. I am snooping
round after a Spaniel for Alice. she does not know, and I dare not
approach the thing thrgh her or she'd down the idea. she doesnt want
a big dog & she hates small ones. A real cuddely, stay-by dog is what
she needs & I thought a spaniel is that. she is at home a lot now does
not care to go out much since her old dog died. & a dog would be an
incentive to go out she can still see to get around without *too* much
difficulty. Once established I am shure she'd love it she went to see a
blind woman the other day who had one (spaniel). & was charmed
with it.

Mr Dilworth was over yesterday & we had a session with M.S.es
It is lovely going over them with him wish I had studied English under

him in my Youth.[1] I'd be doing better work now.

The publishers are going ahead I had a letter this A.M. & a photo taken from one of my sketches for Jacket. I have got to think of a name for the brute now.[2] it is to be just Indian things (the first book) a book of childhood things is suppose[d] to follow it fairly soon. (unless first is flop I presume.) quite exciting but when & *if* I see it looking at me printed I bet I'll want to crawl under a piano.

The birds are vipers! won't sit—only sitter on the premises is *me* I've lured & coaxed. but they stand up on their legs & gauk, & either play ball or make omelets of their eggs. I think its the air so full of war & insurrection. they jolly well need a pinch of Hitler's regimentation to teach them what domestic security & family life is in a decent land and a decent aviary under a dove-like (?) owner (me), can be.

Hope you have a nice one to look after you. something neither vixen or the "dearie" sentimental kind.

Very much love not forgetting Hill & Ink. I was missing your letters and am so much obliged to Miss Faunt for writing. Be good girl & take your medicine docilely.

Yours

Emily

NOTES
1 Ira Dilworth had taught English and French at Victoria High School from 1915 to 1926 prior to his becoming the school's principal (1926–34).
2 Carr's original suggestion for *Klee Wyck* was to call the book "Cedar Bark Stories," based on the idea that cedar was perhaps the commonest element in the life of the Indians. See BCARS, Parnall Collection, Dilworth to W.H. Clarke, 5 May 1941.

194 [*Carr to Cheney*]

Monday night

[postmarked 22 April 1941]

Dear Nan,

I shall be glad to see your fist again weilding the pen. hope you are upping I am like a clicking bud on a twig tonight, not a tooth in my head they made a *fine* job. The Dr & Dentist came at 9 A.M. Yesterday at my bed & did it. The Dr gave me a big hypo & the dentist was an expert, then the Dr insisted on a nurse to watch me sleep all day, & I did and all the night to follow. and tonight feel much better & devoutly thankful that we don't grow *3rd blood & flesh teeth*. I want to be about because I have a lot to do. preparing M.S.es. Mr Dilworth was over last week & expects to come this I'm afraid I shall be talking to him empty mouthed & I am practicing to speak clearly. The girl says I don't look half so bad as *some she's seen* I spose Lawren's show opens one week tomorrow hope you will be able to go while it is on. On Saturday Margaret Clay brght a small Englishman with a large portfolio of his sketches (water color) Ensor I *think* his name was. seems he's had shows in Gallery octagonal room downstairs,[1] some of things were quite nice not thrilling but quite charming. I did not fall in love with *him*. he said he did not know you he did not *think* Ira Dilworth says the Harrises [Harris'] house is *delightful* he was there to dinner I am shure it would be. both of them had lovely homes in delightful restful good taste. when I knew them other-married. I must tell Lawren a joke which he'll enjoy. His is the only picture on my bedroom wall at present & my fool nurse (who knew no more what art is than a turnip) was acting up big yesterday pretending she knew art from A-Z & she entheused over Lawren's picture taking for granted it was *mine*. I lay & took all his bouquets, too *low* body, soul, spirit, *and* gums to retort. She was an ox-woman & fat. I loath fat women *particularly* nurses. I like being surro[un]ded by leaness, when I'm sick & she had an unpleasant voice, & over-talked. however as I slept the day round it did not matter I advocate not *deaf* but *dumb* [underlined twice] *mutes* for the nurse profession. She left her phone hoping I'd

call her again if I needed one. I took it *carefully* so as I'd know who *NOT* to call. I expect all are buisy so they have to resort to outsize & leavings for short orders like that.

As I'm not too gorgeous yet I wont write more. This is just a hullo! dribblingly lisped.

and luck

Emily

Teusday morn.

P.S. Just got a your letter and am so glad you are improving be good & do as told & dont fuss & fret if its slow.

Emily

NOTES
1 John Ensor (b.1905), English landscape artist, had exhibited at the VAG in both 1939 and 1940. See *AGB* [VAG], 7 (Dec. 1939) and 8 (Nov. 1940).

195 [*Carr to Cheney*]

218 St Andrews St
Fryday
[postmarked 25 April 1941]

Dear Nan

I am so glad you are feeling upper hope you keep it up "sick no good." now I've lost your last! what I thought was yours is from an antedeluvian Jake from somewhere around Montreal desiring me to tea with her at Empress—means I'll have to tea her here instead. I

wish visitors were not so sticky-seated. some *yes*, some *no*!

I'm hopping round again, (in a sloppy creep.) mouth healing nicely—conceit *all gone* I *read aloud* to Mr Dilworth all last evening without a tooth in my head he said he did not mind & could understand me. I can read them quicker & he correct & there is so much to get through They want the M.S. soon as possible, and when his time over here is limited I just have to go ahead & let teeth go to the Devil. it is really awfully good of him to do it, & just a labor of love. on his part. He is kind to the marrow.

Birds is devils! & give me much sorrow they are so 'Nazi.' If I was German today I spose I'd be in jail (& I *could* not eat black bread crusts) Yesterday a man came when I was bathing, & after greasing me with compliants on my birds he stuck a picture under my nose (Churchill & the King & Queen grouped) "No!" I said "I'm too busy for the Royal family today." (I *did not* tell the creature I was wet & soapy under my gown, so I spose he thought I was traitorish he looked very shocked & went) I simply *can't* be nice to these door-pests and then am ashamed, when I see their dejected heels turn the corner. I *do have* the greatest respect for Churchill & the Royal family but I don't want them in my bath. Wouldn't it be aweful to think one couldnt spit out like that, sudden against your nation's rulers without Gestapo Torture. we have so much to be thankful for nationaly.

I got such a cute (spaniel pup) for Alice, but she would not have it it had the most mournful eyes—well if she won't she won't! I shan't try again I think she'd have got lots of comfort out of it.

Mr Dilworth said Lawren told him to tell me he'd be over in about a couple of weeks time (After his show I expect) they seem to hit it off, well. (Lawren & D) He L thinks D. a man that will leave his mark on the West.

Have your teeth settled quite comfortably?? I have just about given up hope of going out this Spring. Teeth, the book, busness and general circumstances seem against it. well really my tiny garden is lovely so are the Street Cedars & off course I'm off on another writing spasm (appart from the cleaning buisness of the other (old) M.S.) I

want to keep well not flop in the middle & leave things messy.

Now I must off to the kitchen and lap something pappy. Write when you can,

aff yrs

Emily.

P.S. Here's a good one. A small god-son I have in Toronto was told to name 10 celebrities of the present time. He stuck in *"Mom. Emily Carr"* (his mother has always called me Mom.)[1] the teacher was a bit perplexed. & made enquiries she gave the youngster full marks though she said it wasnt. just the answear she expected and told him the M. I used to use in front of 'Emily', (when my two E. sisters were alive) did not stand for Mom. bless his heart I nearly died laughing.

P.SS,er Nice letter from Edythe joined a paint class. well & happy seemingly—in New Haven Con had been up to New York seeing things.

NOTES
1 Carol Pearson (later Williams), as a young girl in Victoria, had established a warm relationship with Carr. She later moved to Ontario and, in 1954, published *Emily Carr as I Knew Her* (Toronto: Clarke, Irwin). See #229, note 2. See also Tippett, *Emily Carr*, 136–8.

196 [*Carr to Cheney*]

Monday
[postmarked 12 May 1941]

Dear Nan

Mr Dilworth is 'Airing' me at 3:30 Wednesday afternoon next May 14

(CBR) [CBC][1] foolish time of day but they are going over National network & they want them good hour for East, (7:30 Toronto.)

How are you?

Had two splendid visits from the Harrisses [Harrises] last week Gee! I'd like to have seen that show.[2]

Tyler wrote asking for something for show (BC)[3] today he's been ill. I'll rattle round & see what I have

Montreal pictures came back. Those Montrealars are dirty-rotters. I'll *never* have anymore to do with any of them This is the second time they've served me dirt.[4] and I had thought Dr Martin a *real nice* gentleman, too.

No time for a letter I'm buisy & tired today.

love,

Emily

NOTES
1 The Canadian Broadcasting Corporation [CBC] was established in 1936. Carr was likely thinking of the earlier Canadian Radio Broadcasting Corporation [CRB].
2 Likely a referene to the Harris exhibition held at the VAG, 29 Apr.-14 May 1941.
3 Tyler, Secretary of the BCSFA, was likely requesting paintings for the Society's forthcoming exhibition at the VAG, 16 May-1 June. Four of Carr's paintings were shown.
4 See #22, note 2.

197 [*Cheney to Toms*]

Capilano B.C.
May 19th 1941

My dear Humphrey.

Your letter came this a.m. & I am ashamed to say that I owe you two as

I usually keep my letters answered & up to date—Fact is I was *very* ill in April—acute infection of some sort—temp. 105° for 4 days—two nurses for 2 weeks etc. etc. even Hill got quite a fright—however I am alright now & feeling better than I have for ages, so I expect I have got rid of germs which have been lurking in me for a long time—Emily was coming over for Lawren Harris' exhibition but had her last few teeth out & apparently is toothless until they entirely heal—which will be months yet—anyway the Dr. said she couldn't come over again so she is quite resigned to the idea. Lawren has been over a lot of times & has been to see her often, & Mr Dillworth [Dilworth] is getting her first book out in Aug. another to follow about Xmas. Lawren's show was tremendous we had it in the north gallery—(the first time it has been allowed for a living artist) & his 27 canvases really filled it with good spacing Of course the public did not like it much but you would be surprised how many people really enjoyed them. Sydney Smith has written a corking good article about them which he has sent to Sat. night[1]—of course no one on the local papers could write anything decent about them & you could see quotations from Scott & Shadbolt in the bit Brownie [Browni] Wingate[2] wrote— They went to U.B.C. after the Gallery and Dr Clarke [Clark] wanted to buy one There were no prices, names or numbers on them so Mr Grigsby had to insure them at so much a square inch. I put Mr Harris up for the Council & we got rid of Willie Dalton[3] who was terribly sore & said we artists "fixed" the vote—as if we could—so to soothe him down the founders made him a vice pres. I felt it would have been an insult to Mr Harris if we had not got him in. so I am very pleased—Jock has a show on now[4]—his first here—& he put in everything he has painted in B.C. The last abstract is pretty awful. he is really a landscape painter & should stick to that. I see very little of Barbara no outward sign of hard feeling on my part—but she just bores me—Jock came several times when I was ill but she has never been near the place. We meet at Jessie's & talk about cooking & such trivial things We (the Harris' [Harrises] & I) are trying to get Jock off to the artists conference in Kingston.[5] The Carnagie [Carnegie]

are supplying money for 4 traveling scholarships to each province so we are determined to get Jock one. Bess & Lawren are perfect dears & are so generous with their time & thoughts & money. They are an asset to Van. They seem to like us & Jessie & Sydney & we have had some nice evenings together. By the way my loan has been repaid—minus $30 interest but I feel relieved to have got it back at all—don't mention this of course—I have not done the portraits of Dr Trapps nephews yet but hope to this summer—My studio is useless—too low no light except right in to the woods so I will have to do them out of doors when the weather is good. I would like to try you again with Emily's technique & will certainly expect you for an afternoon the end of June. We were interested in your finding so much Pipsissewa our few are rather sad—The country must be lovely up there now. It is grand here except for the last 10 days rain. Our garden is really wonderful for the first year—Daisy is in town—staying at the Trapps. looks about the same & is going back to Revelstoke this week. She told me you phoned her on your way from Calgary. I saw a lovely Picasso book from the U.B.C. library & it had a reproduction of your etching. Hill was almost dragged into the Army—They are so short of Drs.—he is 56 & managed to get a younger man for them—it was a bad moment. Expect to see you soon—

Affectionately

Nan

NOTES

1 "The Recent Abstract Work of Lawren Harris" was eventually published in *Maritime Art*, 2 (Feb.-Mar. 1942):79–81.

2 Browni Wingate, a specialist in commercial art, wrote a weekly column, "Speaking of Pictures," for the *Vancouver News-Herald*. On 3 May 1941, p. 17, her discussion was devoted to Harris' abstract paintings which were on view at the VAG. "Few of the public will find them a valid excuse for the expert work that has obviously been entailed," she wrote. And she concluded: "It lacks the power of emotional expression on the part of the artist."

3 Dalton, a founding representative of the VAG, had served in various capacities on the VAG Council since its inception in 1931–2.

4 Macdonald's solo exhibition at the VAG was held from 6 to 18 May 1941.

5 Macdonald, as newly elected president of the BCSFA, was a western delegate (as were Scott and Shadbolt) to the Conference of Canadian Artists ("Kingston Conference"), held at Queen's University, 26–8 June 1941, and in Ottawa 29 June. Some 150 painters, sculptors, and museum directors assembled from all parts of Canada to discuss the art situation in Canada. A program of the meeting, with the signatures of many of Cheney's friends ("W.P. Weston, Alex Jackson, Arthur Lismer, Lilias Newton, Thomas Benton," etc.), was likely brought to her by Macdonald. See UBCL, Cheney Papers, box 4, file 1.

198 [*Carr to Cheney*]

Wednesday
[postmarked 30 May 1941]

Dear Nan

While I am waiting for the re-Broadcast to come on I'l *do* you. Did you know they gave re-broadcasts of my readings at 10:30. they took records. Did you hear Canoe?[1] That is my favourite of all the Indian ones Mr Dilworth did it last week and *beautifully* I never thought to enjoy one of my own that much. took me right back to the spot. todays were 'people' more than 'places.' I think I go deeper in places than in people. I am so delighted that you are feeling so much better. hope it keeps up, & you will soon be skipping like a doe.

Have had a *very* buisy day felt productive first. writing 2nd typing 3. sewing 4 painting & all *ardently*, so spose I have the right to be tired. glad you like the pictures I sent. I *am so glad* Lawren is on Gallery,[2] he is such an inspirational person. Expect him over tomorrow. It has done me no end of good talking to him over work. Given me a fresh spurt.

I have just been preparing 12 new clean canvases. a job I hate but there is nothing more thrilling than to see a stack of new clean canvasses waiting for inspirations they seem to contain such possibilities and probably 12 dissapo[i]ntments. Going over the Indian

sketches has stirred up a homesickness for Indian.[3] Mr D. has been fearfully buisy & not able to get over I expect him tomorrow. part of the gallery print has come—quite exciting but after hearing them read on radio flat print seems so tame & I have spasms of 'flop' terrors these are such aweful days to produce in. I think there is a great stimulous to create I find it so, tho' so many write that "it kills creative work, & they're dead" It seems to whip me up. I have rebelled. at making 'Bommed drawers.' I made a change for pretty well every woman in London, Coventry & Liverpool & the pattern *most* intricate I cut out & couldnt put together. & got all het up but I fin[i]shed my bolt of material & then 'sez' I *"no* more *draws"* & my ladies were dreadfully distressed that I'd taken them so to heart & put me on a change I have 18 peices wanting to pack up tomorrow none of our cases have been lost so far It is all so gastly.

I have still no teeth peices working out of jaw & will have to wait till they work in or out or up or down & then for two jaws full. there wont be room for a one sillabel word in my mouth. I forget I have none now unless I look in the glass & I dont do that much.

How's Dr Trapp. give her my love please. Not one one baby bird and all my gold fish dead life is very temporal.

Have had no time to read lately What have you read? Have you picked up your fat yet? wish I could drop some

What a *filthy* Idea that making pictures by recipty[4] at the gallery was—smelt of Shadbolt. it lowers pictures to the level of making pudding or "Bommed underwear." I call it revolting—as if *anyone* [underlined twice] could show *anyone* how pictures *are made*.

Old Mortimer Lamb rang me up the other day but I said I could not see him & I don't intend to he's ear-wig level.

There is nothing newsy round, that you don't know yourself from Radio & paper I have no freinds they have gone or died, even my enemies have died on me. (as well as my gold fish)

Alice is pretty good. & brighter these days.

Love to Hill, Ink, & yourself & dont be lazy about writing now that you are again robust.

Ever yours

Emily.

P.S. How's the garden? Have you a nut crop yet?

Am dredful hankery for the Woods. A Year since I came a cropper.

E.

NOTES
1 'Canoe" was published in *Klee Wyck* (1941).
2 Harris was elected to the VAG Council at the tenth annual meeting, May 1941, and served on this body until 1957.
3 For a discussion of Carr's return to Indian themes in her painting, see Shadbolt, *The Art of Emily Carr*, 180, 183–5, catalogue entries 169–72, and *Emily Carr* (1990), 143–4.
4 "Living Art Week" was a five-evening event held at the VAG, 19–23 May 1941, under the direction of Jack Shadbolt, originator of the concept. The idea (hardly "pictures by recipty") was to enable the public to see the approach, and watch the progress, of a number of artists working from the living model, in order to encourage an appreciation of the fact that "each artist has his personalized and individual point of view, and thus evolves a method best suited to his expression." Shadbolt later was praised for his leadership, and the event was counted as one of the "most successful efforts to popularize the Gallery." *AGB* [VAG], 8 (May and June 1941).

199 [*Carr to Cheney*]

Sunday-in-bed
[postmarked 16 June 1941]

My dear Nan

I am being nicer to you than you deserve had made up my mind to let you write a decent letter before I efforted however I must thank for the Pickles & *do* My jaw is at last healing so I live in hopes of teething soon. & shall enjoy the relish I am used to lapping tho' I

must confess to being tired of it. Was so sory not to see you I rang up Aunt M. she sounded sour on phone. You had never told me you *had* a visitor except that Bess said you'd been over *with your visitor* I would not have known & had no idea who Gail [Gaie] Taylor was, so thats how long since (other than the P.C. saying you were coming Thursday) you had written am so glad you are so much better. don't tear round to functions in the heat take things mild & easy. & give yourself time wonder if you have a maid yours had just given notice last you wrote (the one you'd had ever since you moved) You were interviewing but I never heard you got.

Have been very very buisy—& *very*, *very* [underlined twice] *very* [underlined three times] tired. Ira D. has been in the East hope I shall know more about things (book) on his return Lawren is coming over tomorrow. (if Bess is out of danger), she had a corn operation & makes a big fuss over herself, I guess. She never mentions help question I wonder if she got a good one.

Jack Shadbolt came to see me he is a goof-nit-wit. I think that Art 'Congestion' in Toronto[1] is rot. if they *worked* more & talked less better. I'm disgusted with Canadian Painters. they are slops, & they are little & mean. Lawren is not, he's fine, & most generous.

Too bad you are dissap[oin]ted in your studio but most any place *can* be worked in if there is light at all I have green trees all round my windows here the light in this on[e] I have is *all* wrong but by experimenting & curtains etc you get around these things land! the old barn studio (dearest studio I ever had) you could only stand upright in the middle & a little dormer, & leaky roof & busted walls & the cow munching below & the hens cackling & the stinks of the wash house & tool shed & woodshed. Got to busin[e]s & made the best of what you do have & *forgot* what you have not. so many artists have gone pot because they thought they *had* to have perfect environment & every thing A.I. for work its the make-shifts & make-dos & the struggle they create that sharpens ones desires & energy. & wantings. I don't mean to preach but this giving up because all is not *just as you want for your painting, is twaddle*. Straddle the difficulties & play horse.

329

& do[n't?] be always putting Art in the terms of making money out of it. it throws the Art idea all squejee.

Don't call me energetic. I'm flabbed to death with tiredness half the time. have been painting rather heavily & *so tired* I can only roll into bed, around 7 P.M. *if* I have the luck to go to sleep soon I often wake around midnight & do a little work then but I don't *force* myself to remember to wake, was sewing at 7 A.M. this morn—too tired yesterday to prepare my work over night & was behind with this weeks bundle Don't think me inhuman I've been all through it—was knocked [?] *flat* for 3 years as a young woman & I know the desparing feel but you'll make up later. Thanks greatly for pickle & lots of love

Emily

NOTES
1 Undoubtedly a reference to the Conference held in Kingston and Ottawa (not Toronto), which Shadbolt had attended. See #197, note 5.

200 [Carr to Cheney]

218 St Andrews St
June 22 [postmarked 1941]

Dear Nan

Many *Many* happy returns of the day. also to Miss Jessie Faunt. Mr Dillworth [Dilworth] told me he was invited to the party with the Harrises I hope it was lovely the day here was a little clouded not *not* cold well may this be a more Bucksome year than last for you my dear. "a swell epoc!!" are you fattening again? oh that 'fat war' It has been difficult with no teeth to wrestle with fibre. I must begin to consider to reflect upon a new mouthful. I thought I could last week but seemed to get very groggy in the underpinning & very tired (not that

my legs need to be impressioned for teeth) but getting into town, etc.

All the book (Indian) is off to the printer, & we are about to be away on the second.[1] I had no idea Publishers had so much to wrestle with. as for Authors if they had no upholder as I have had I can see the poor things raked into heaps like withered leaves, but *all* writers are not new & ignorant I spose. & stand up. alone.

Lawren & Bess were over last Monday & we had a long delicious visit. How good it is to have them out West.

Did the fire place finish? in time for party?

Lawren told me that Edith [Edythe] Hembroff was coming west. do you know? I understood the "little hussy sister" was to come out in June. perhaps Edith [Edythe] is coming with her I have heard nothing from her (I owe her) for around a month I'd think. Then she did not know her plans possibly she has decided to Summer with Pa. or with freinds in Vancouver. Well thank goodness the victory loan over-topped I'd have been so shamed if it had not all that silly torch expense, might so much better have gone into the pot.

Have several new canvases on the way[2] my show in Vancouver comes last week of October this year I think.[3] Have quite a number of new canvases ready no sketches as yet, though.

I'm sending you a small offering of smelly & a large bundle of love. take life easy & keep serene Have you still your nice little visitor, *and* have you a good maid? Love to Hill, Ink, & yourself. Dr Trap[p] does seem a buisy woman. All Doctors these days seem driven, will the world ever have time to sit again. One wonders. some quarters find ample time to "*lie*" Ah me!

Affectionately

Emily

NOTES
1 *The Book of Small* was published in 1942, the year after *Klee Wyck*. See #79, note 1.
2 See #198, note 3. See also [Humphrey], "Letters from Emily Carr," 137, 6 July

[1941]. Carr wrote to Humphrey: "five new Indian ones nearly finished."
3 Carr's fourth solo exhibition at the VAG was held from 21 Oct. to 2 Nov. 1941.

201 [*Excerpt Toms to Cheney*]

[*Toms was in Victoria to attend the Provincial Summer School of Education.*]

[Victoria, B.C.]
26 Jul. 1941

Was in to see Emily during the very hot weather[1] but as Flora Burns, who I don't know well, was there we didn't talk much. I was there again on Tuesday for an hour and a half, and only left when her voice started to get husky which is always a sign of her being over-tired. She told me about your having sold your portrait of her to Alan Plaunt[2] and also said something about the 'Trust'[3] about which I feigned ignorance. She is thrilled about her book coming out, and more grateful than ever to Ira Dilworth for his help. . . . Thank goodness Emily has given up the idea of camping out by the 'Gorge.' Being so near the Colwood Army Camp she would have been visited all the time by drunken boys of an evening!

NOTES
1 A huge forest fire at Campbell River during July had caused the temperatures on southern Vancouver Island and the lower mainland to soar.
2 Plaunt purchased the portrait in the summer of 1941 with the plan that the work would be held by either himself or his friend, J.F.B. Livesay, and eventually given to the NGC. After Plaunt's death Livesay became the "temporary custodian" of what he considered a "very remarkable portrait that perpetuates for Canadian generations this unique artist." Livesay, "Alan Plaunt: An Appreciation," *Ottawa Journal*, 15 Sept. 1941, p. 8. With Livesay's death in 1944 the portrait was deposited in the NGC as a Livesay bequest, according to the original arrangements made by Plaunt. See NGC, Archives 7.1 Cheney, N.L., "Memorandum for Mr. H.S. Southam," 23 Sept. 1941; and NGC, Curatorial file no. 4947, E.M. Henry, Chartered Trust and Executor Company, Toronto, to H.O. McCurry, Ottawa, 25 Oct. 1944.
3 The Emily Carr Trust was founded in 1941 with Harris and Dilworth as trustees. The purpose was to establish a permanent collection of Carr paintings which would be given to the Province of British Columbia. Initially it was decided

that forty-five paintings would be set aside, but in 1942 this number was increased by thirty-five. The additional works were intended, through sale, to provide funds to maintain the original group. For a full discussion of the Trust, see Hembroff-Schleicher, *Emily Carr*, 145–67 and Blanchard, *The Life of Emily Carr*, Appendix 4. For Carr's explanation, see #227.

202 [*Cheney to Toms*]

Capilano. B.C.
Aug. 4th 1941

Dear Humphrey

Your letter of July 26th was rather a shock—I never thought you would really do it—however I think by now you are quite wise & have chosen the least uninteresting of the army jobs.[1] Thanks for the clipping re—Emily—I got $250.00 for her (portrait). Alan Plaunt made an offer & Lawren thought it wise to accept—alas! The money just paid the taxes! I did not tell Emily the price so don't broadcast it. The frame just has not been cut. I am sorry as you should have [seen][2] it [in] is [sic] proper condt. before leaving—been so busy & now hav'nt a maid which snows me under in one day—The studio is nearly ready & is 15 x 20, & really just what I want. I have several Commissions for portrait sketches in view—Ira D. said Emily was coming over on or about the 15th to stay with him & perhaps me—I am planning to go to Vic on the 17th with Carol, my niece,—for 2 days if I can find a place to stay—E. may come back with us—What day do you actually get here? Excuse this awful note but I am half way between dish washing & bedmaking.

Nan

NOTES

1 Toms was with the ambulance branch of the Royal Canadian Army Medical

Corps [RCAMC]. He had enlisted in Victoria on 7 July 1941.
2 A later insert by Cheney.

203 [*Carr to Cheney*]

Tuesday
[postmarked 5 Aug 1941]

Dear Nan

Thanks for letter. Thinking about writing you since your last but as
far as I have got teeth *are* occupying me at present. They will be over
(my six app[oin]tments) middle of the month. then I *may* come to
Vancouver to go thrgh Manuscripts with Ira He has asked me to stay
with them. and it would simplify matters, especially now you are not
steadily settled with a girl & so far out. He says he will take me out to
see you. I am not able to go about much, and working quietly in his
home will be best. I dont just know when, the work & the Dilworths
will be ready for me. I look forward to a little change, very much. I
certainly shall *not* fly.

I am so glad you have your studio. am shure you will enjoy it.

My exhibition is working up. I laid off work entirely for 2 weeks,
had just got back when I had a nasty upset.—boys in the aviary & a lot
of damage.—am just getting back again to work My Sister has
visitors at present. I'll let you know when there is anything to know. I
am shure you will see. it would be best for me to be handy to work
on. M.S. Ira has been so good coming over and he is such a buisy
man.

I have not been out at all this Summer. had my first drive. of the
year Saturday just round the park. Lawren and Bess are having a good
time.[1] I had a card last week. So thankful that heat is over arn't you
hope you are lots better, expect I shall be here on 17th.

Have not time for more & am tired from 1 1/4 hours in dentist chair.

Ever

Emily

NOTE
1 Reid, *Atma Buddhi Manas*, 106, notes that Lawren and Bess Harris spent six weeks in the mountains, at least three of which were with Jock and Barbara Macdonald at Lake O'Hara Lodge, Hector, BC.

204 [*Excerpt Toms to Cheney*]

8 Aug. 1941

Went to say good-bye to Emily on Monday and dropped in late this afternoon again. During the weekend some brazen small boys from the neighborhood opened all her bird cages (while she was in the house) and let them *all* out. The same kids had been taking fruit from sister's garden, next door, and Emily knew who they were. . . . Today she was all blown up with the thought of the new book *and* her new teeth! Lack of a title is holding the book back, down East. She is *very* well and cheery.

205 [*Carr to Cheney*]

Sat. morn a-bed.
[postmarked 30 Aug 1941]

Dear Nan

Well it was nice to see you last week and see you looking fit. The weather looks pretty dowdy, I am not further in arrangements for Vancouver. Ira's people still away Ira *very* buisy & me sitting pretty. Any way over the holiday and Fair week the boats are jam-pack, couldn't attempt any passage tell the 1st is over. What did you find about the landing of ancient dames?

Hope you are not suffering as per the lambkin re. your picture— wishing you haddnt. or wanting to *exchange* (or to turn over at profit)

My teeth *hurt* It certainly is not for taking pains. That dentist couldnt have tried harder for his own mother, grandma or aunt. He says the trouble is more to do with my 'general condition' darn my 'general' they lay everything down to that organ (or corporation is it?) That['s] what they say of my eyes, gizzard & temper and all the evil spots in me I say the glory & reverance of old age falls short its crackings up, & is a common *blight*, & I dont wonder the aged (all but Aunt Mary!) take to their beds and sulk, darn! I never paid for my darning-wool which reminds me! I won't send a *check* will reimburse and [on?] sight. or you can pick the darns out of my stockings if I default. Been getting the frame situation ordered, & some painting & writing, done.

Nice little girl (Carol).[1] Hope new domestic is desirable & amenable. I am still. maidless & sick of the situation, but sicker when I contemplate cutting another down to fit my humble requirements.

Hoping to see you soon or maybe not for 6 months. or *never* or maybe next week or tomorrow, & mean-time good luck.

Yours

Emily.

NOTES
1 Carol Wright (now Birtch), was staying with her aunt and uncle, the Cheneys.

206 [*Carr, Vancouver, to Cheney*]

[*Carr was staying with the Dilworths in Vancouver*]

218 St
Van. [Victoria crossed out]
[postmarked 20 Sept 1941]

Friday

Dear Nan.

Tomorrow I go home. would like to have seen you again but that cannot be fixed Phyllis [Phylis]¹ has been in Victoria this week and even when she was here. you see it meant her going down town & getting the car. & taking it back again. I feel wonderfully better for the holiday and sleep sleep sleep. was probably tireder than I knew Ira has not let me work too awefully hard. thought I needed rest. The weather had ought to be ashamed that day with you was the only day fit for the woods. so no sketching I *was* dissapointed. but there you are, and the year's summer gone, without fruit. Lawren took me out there yesterday & I went thrgh all his abstracts again a *real* joy & treat I love them. I am going by tomorrow's day boat. feel I should. go back to Alice now and to work I shall miss all the care & spoiling it was wonderful to be looked after however I really do think Alice is going to be *glad* to have me home again though she has got on very well. Lawren & Bess go East on Saturday a visit to see his soldier son.²

The book name is Klee Wyck and the jacket, an Indian village,³ & the preface written (by Ira) so she *may* get finished but at least she sits on the far horizon anyhow instead of floating in space. pelt! pelt! did you ever see such dripping? one feels like a drain. There were two rain bows day before yesterday, otherwise one might forget the flood was not giving an encore.

I am stupid over your manner of phone, alwys, forget which is ear

& which mouth. put your talk in my mouth & my hear in your ear. it seemed more coherent to write. you goodbye. so—Maybbe in Spring my legs will be more gracious[?]. they have picked up their kick a lot. I must now get my Ex. into order. I hope Lawren will be back for it. said he would hang it for me if so. lots of love.

Yours Ever

Emily.

NOTES
1 Phylis Dilworth (Mrs. W.W. Inglis) was Ira Dilworth's niece and adopted daughter.
2 Lawren P. Harris (b.1910) was a lieutenant in the army, later serving as an official war artist.
3 *Indian Village, Alert Bay*, 1912, was reproduced on the jacket. It is in the collection of the Beaverbrook Art Gallery, Fredericton, New Brunswick.

207 [*Carr, Victoria, to Cheney*]

Tuesday
[postmarked 26 Sept 1941]

Dear Nan

Thanks for letter. Ira says he phoned you he had delivered me on my doorstep safe and sound. I was taken good care of Lawren taking me up Ira bringing me down. dear men both so *truly*. *kind* & considerate I love those two—from the bottom of my heart, and have cause to.

My visit was so very happy, & I feel so much better for it—steadier on my pins. alas my old Ticker, is acting up a little the house is so *filthy* & I can only do such dibs of jobs and the Jap woman I get occasionaly is nursing a sick husband All I can do is sit on top of the dirt & wait—heart pains & weariness, if I do more. I shall get a girl

but want to get the Jap first for a houseclean I don't like a new girl to come into a dirty house.

Everyone was *so* good to me (6 dinner parties no less.) I hope your innards have recouped. It is a pest to be delicate I know still after a year or two you will probably be yourself again you are young yet. The weather is *glorious* why couldn't Van. have behaved?

I am sory Grigsby is leaving[1] wish he was to be there for my show. Maxie! Oh Lor Heaven forbid the Gallery will go to pot if he ever gets in or Jack S.! Old Judge will lead us gently back to the Art of Eve in Eden (with Eve draped) & well peticoted.

I am hunting Spaniels. Ira is delighted. I am going to get a pup, house train & have it spayed, for the old lady. it will be so companionable for her I am sure it will be great company. for her. So the Harrises did not get off. I am sory because now they will probably go & L. was going to hang my ex if he was in Van. Max. says *women cant paint* if he is it we are damned. May as well give our brushes away & take to cookery. or drink.

Oh what have I done with your letter! ! ! I have begun reading Kabluna [Kabloona][2] to Alice.

No I did not see as much of you as I wanted but you are far out & of course It meant Phylis going down to get the car and taking it back to Ira at night. Mercey he is a buisy person & so is Phylis with her music

Ira & I did quite a lot of work at first he would not let me do much said I was too tired & I spose I was we worked on the boat coming down. Goodness its wonderful to be taken care of & thought for instead of skragling round—dodging evils for yourself & usually getting in the path of the knocks & dust.

I loved Lawren's abstracts 100% mor'n ever 2nd time they are exquisite he shewed me the whole gim-bang again & is so patient, telling & shewing.

I don't like cleaning house at all guess I got spoilt, living clean and lazy. I simply must buckle too [to?] a finishing [?] up for Ex.

Oh sure change the squat (picture) for the lofty if you want to. price is same—clean exchange.—but I dont want you to remove Mary

Capalaino [Capilano] from that place she looks so well there. I think it is the best thing you ever did, and she looks well there. I wonder what will happen to *me* now my buyer is dead[3] hope I did not hasten his end poor man.

Well—goodbye for now—my peepers ask sleep. they don't do so good at the job as in Vancouver, but better than before I went. lots

Love

Emily

P.S. Have got a darling *small* spaniel for Mrs Dilworth 7 week old sire a champion ma just beat 3 Seattle dogs. in show she is lemon & white, very dainty & full of beans. The woman knows cockers through & through. says most do have the tip curl like Ink but they trim it out for showing.

love

Emily

Friday afternoon

NOTES
1 A.S. Grigsby, secretary-treasurer of the VAG, was going to a wartime position with the Department of Public Information in Ottawa.
2 *Kabloona*, by Gontran de Poncins (in collaboration with Lewis Galantière), was published in 1941, and based on the northern diaries of de Poncins.
3 Presumably a reference to Cheney's portrait of Carr, which had been purchased by Alan Plaunt. See #201, note 2.

208 [*Carr to Cheney*]

Sunday

[postmarked 12 Oct 1941]

Dear Nan,

Yes I have heard of Maxes app[oi]ntment[1] & wonder what good you & Lawren are on the committee. I cant think why the directors did not look into his rotton record before making the app[oi]ntment. with Jack Max & Lamb running the Gallery what can be expected. I send my show of[f?] this week wondering. would never have had one this year had I known how things were going.

I told Max about your exchange & the picture you were to have. I told him to put your present one in the show at $75.00. has it a name, if not catalogue it as B.C. Landscape or some such

My puppy is a darling Lady Jane by name is broken to leash & collar & can be chained when she becomes obstreprous. She is very well mannered & very lovely & very intelligent shaddows my every step. the old lady will love her.

Willie is crating today they have stood finished & waiting for a week they have to be in Van. next friday

Alice has been ill all week—Tummy upset.

I have no help other than a jap woman two half days per week but am managing & doing some writing. too. also making trips in to see eye Dr—one eye gone back on me.

Wails from the Pup—I made her a lovely box & she is very good sleeps 7–7 without a squeak a [&?] periodically spends spells in it during the day. How did Humphrey turn out? he phoned he was coming to see me today

Hope you are able to get to my show wish Lawren would be back in time. Glad your studio so satisfactory. winter is really *almost* now. well so-be-it.

Amen and love

Emily

NOTES
1 Max Maynard was appointed Interim Director at the VAG during Grigsby's absence.

209 [*Carr to Cheney*]

Sunday
[postmarked 27 Oct 1941]

Dear Nan

How lovely of you to give me that phone call. was I excited? I did not expect to sell any. & was very grateful to have your $25.00 tucked away for gallery & expressage. Do tell me just where "Jack" sat me & did he lower me with an *aweful spank* onto an awful hard seat?[1] Ira did not go.—perhaps no one did—so nobody saw Emilys. location. Well the book is a real. *object* at last even though only in her underwear. Ira brought her over to see me he took her back with him. dear Ira he is so delighted, mor'n me I think, well it never would have got there but for him. You are to have a copy (Automobiled by the Author) of course do don't bother to buy Robert Simpson Co. in Toronto have asked to use one of the original canvases. to centre a window. Mr Clarke wrote me & is pleased. The library (Marionette[2]) has also asked the lend of a picture for their window.. I beleve they expect to sell Klee Wyck, & there is a studio (English) article by Mr Buchanan[3] using a couple of the plates so Klee Wyck had better put on her corsets and Jacket & face the world. pretending to be brave even if she doesn't feel it.

Glad your friends have come to Victoria to winter wonder *if you will* come over or only *threaten* you know I always have a spare bed & can give some sort of meals and a muddle, to anyone I *know* & don't have to put up fancy No I have no maid simply have not had the courage to hunt & train A Jap comes in once a week I have not been

using the studio just bed-room & kitchen *and puppy* room. she is a love of a thing Lawren was over this week & thought her "swell!!" she is growing—manners not all that *could* be desired yet, but learning, & very pretty. pale biscuity brown & white *lovely ears* rebellious & self-willed, & *very* puddlesome. do come over & see her she knows collar & leash, & provided she is leashed *to me* loves it. I keep a spank-stick on every ledge, because she will *yap* for me she has a nice safe little yard. beside the doves, but her voice is not a "coo" she wants *me* in the yard. & I do & sit with her sometimes Ira pretty near needed 'waders' to leave the studio in yesterday she excelled herself never so puddeldy before poor Ira! he offered to mop up but I said "No you'll have enough of that later!" But she *must* be dryer before going to the old lady.

They say the ex. is beautifully hung. and, (so they say) shows no signs of decay and senility thats a releif, to me.

I hope the 'tree or two' "sits pretty"

You seem to be doing lots of work, these days I am so glad the studio is such a cosy success I really think both yours & Lawren's studios are "swell" I'll have to get buisy & paint soon have a peice of writing in hand to wrestle with & now the old Ex is over I must settle down to Bom-sew again. The last autumn days are glorious. one feels hot & lazy in the noons nippy morn & night. I should think poor Maxie must feel the ooze of antagonism Ira says he has not heard of one person glad of his appointment.

Exhibitions and '1st publications' are rather disorganizing to the system thanks for the cutting. Is 'Pallett[e]' Delisle?[4] I think Delisle an *aweful fool* big poser & poor worker poor Mrs Parker lost her son (air force) the other day She's a *brave* woman. her husband Delisle's brother is an *ultra*-idiot deaf, blind, nerve wracked & idiotic don't know how she stands him to be husbanded by such a thing would blight life entirely.

Now Lady Jane (the Spaniel) is demanding that she receive a share of me, and being peaceful about it she should be humored I won't obey her whims when she *yells* for things. every one who sets foot on

the place is crazy over her garbage-man, to fine lady. Alice is very entertained[?] I often wonder if she wishes she had kept the one I got her but she would never let on if she did.

Another Sunday nearly gone, and a whole week before another I *love* Sunday I'm a bed-bug always did surmise there was some anti-elegance about my composition Jane's ears tie under her chin and & then some, they're lovely.

Love and Luck.

Yours ever

Emily.

NOTES
1 The enquiry is with reference to Shadbolt's talk, "Emily Carr: Her place in Canadian Art," given at the VAG, 24 Oct. 1941. See *AGB* [VAG], 9 (Oct. 1941). Notes taken by Cheney at the Shadbolt lecture (incorrectly marked by Cheney as 1939) are in the UBCL, Cheney Papers, box 7, file 10.
2 A library in Victoria.
3 Dennis Reid has noted that the reference must be to Donald Buchanan's "article," "Emily Carr: Canadian Painter," that appeared in *London Studio* in Aug. 1943 (vol. 26, p. 60). About 1935 Buchanan had helped found the National Film Society, a volunteer organization that became the Canadian Film Institute in the early 1950s. He worked for the CBC from 1937 to 1940, and in 1941 joined the National Film Board. Buchanan was hired by the NGC in 1947 to head their new Industrial Design Department and served as Associate Director from 1955 to 1960. He was also editor of *Canadian Art* from 1944 to 1959. See Gloria Lesser, "Biography and Bibliography of the Writings of Donald William Buchanan (1908–1966)," *The Journal of Canadian Art History*, 5 (1981): 129–37.
4 Delisle Parker's column "In the Realm of Art," *Vancouver Daily Province*, appeared under the by-line "Palette." See #31, note 3.

210 [*Carr to Cheney*]

Wednesday
[postmarked 5 Nov 1941]

Dear Nanny. (he! he! I see your rear)!

Thanks for yours. I'm so perplexed. at being a 'legend,' sort of a half-lie, I take it. Oh these 'Jacksies' and these 'Maxies!!' I'm tickled you *did left* before he finished his boresome speel.[1] Did you hear Dr Sedgewick on Klee Wyck last night at 9? He was *very generous* to me. Lawren & Bess came & listened in too. and Ira was over yesterday so I had a plummy day! Bess thinks Jane lovely. & partic[u]larly admired her sturdiness of course Jane performed the drama of the 'Great Lakes' (her favourite role) but I don't even need to blush while mopping They've 'reared' (them Harrises)

Today is *Heavenly* Alice is going to a party for the blind at Government House today, got a new dress too.

Look here *do come over* any time, doesent matter if your friends are or aren't housed. I have a spare and between us we can knock up a mess of some sort. My house keeping is simplified to vertebra & ribs. the house is a little dirty, by Sunday & then I hide in bed from it, & the Jap comes Monday & digs out. Alice puts my fire on in morn, so I'm man[a]ging very well and "maids isnt" perhaps by & bye we shall acheive the heighth of snail simplification, houses that we carry on our backs and ooze in & out of, not a particle of room for superfluties letter writing a streak of slime on the grass—no cooking utensils to wash—nor clothes—no darn pocket-hankies drat! where is mine?

I've had a wretched cold, in bed most last week—better this.

I will post Kabloona soon as I can do it up. one of my diffic[u]lties now I have no maid is getting things posted Alice can only go in clear good light, & I never *ask* her. only if she is going for her own to the box I think if she is asked & the little extra of *having* to do wether she wants to or not is enough to distract the dim glimmer of seeing she has when she suggests & does things of her *own will* she squeezes by. poor soul she gets depressed & I dont wonder. I read 'Kabloona' to her & we both enjoyed it very much. but she has now taken a dislike to being read to for which I am very sory because one can't find talk material for ever (especially a cooped up being.) and she will not tolerate my radio. so we can't listen to programs together if mine is going she leaves immediately [?] she only listens to her own & my ears

can't hear hers so there you are! she has so many lonely hours while I am working. I spose there is not much fun going out if you can't *see* things when you *are* out

I started in to paint again this week time I got to solids again. book publishing and Exhibitions arnt healthy for *steady* diet. (too fattening tend to lazy one)

Letter from Edythe *expects* to come West shortly holiday only I think. now in Rivers with Fred.

Hope your indigest. is better what a pest innards are. You'd think inside perfectly good skins they could do better.

Poor Aunt M. I guess its going to be a pinchy winter for half the world. I wish old Hitler got more pinch—the creature!

Now I'm most asleep & I just believe I'll wink for 40. Alice is out & the others sleeping.

love

Emily.

NOTES

1 According to the press, the Shadbolt talk on Carr was hardly "boresome." See "Art Lecturer Challenged," *Vancouver Sun*, 25 Oct. 1941, p. 6, which reports that the lecture was "nearly broken up" by the protests of a member of the audience. The person in question was known to Shadbolt and had on previous occasions acted in a highly disturbed manner.

211 *[Excerpt Toms, Quebec, to Cheney]*

[Military Camp, Valcartier, Quebec]
16 Nov. 1941

Ordered Klee Wick [Wyck] from a bookstore in Quebec City. The manager had heard Christopher Ellis[1] speak for 10 minutes about it last Friday night on the radio from Toronto.

[This is the last of the excerpts that were transcribed from the Toms to Cheney correspondence. Seemingly the letters that followed this one contained no references to Carr. see #54, note 1.]

NOTES
1 Christopher Ellis, a British-born news commentator, was living in Montreal and was heard frequently on radio programs.

212 [*Cheney to Toms*]

Capilano B.C.
Nov 24th 1941

Dear Humphrey.

Your two letters came today with the enclosed. I wish all my models were as prompt as you are. I am going to rephotograph your portrait[1] with my own camera & see the result before sending that print to your mother as I know she did not like it much—chiefly due to the printing. I have just finished an awfully good one of Mr Crawley—the blind man—perhaps I have not mentioned him before. They live at Caulfields [Caulfeild] & he looks a little like Lord Willingdon. I got an awfully good 3/4 view of him. Emily sent me one of her books autographed—I hear they are selling very well they have certainly had enough publicity, with two big shops in Toronto giving them full windows & all the papers praising it to the sky, however she had to get mad at something & wrote Maynard one of her stinkers about the way her canvases were returned etc & the money held up. Max was pretty upset & told me all about it & asked what to do, so I told him she had written letters of that sort to the Nat. Gallery & lots to other people & just to ignore it etc etc—but not Max—he said he didn't believe in people getting away with things no matter how important they were so he disregarded my advise & wrote her a snorted [snorter?] which of

course has not improved things—her money $450.00 was a few days late because Miss Melvin[2]—that Scotch lassie at the Art School with heaps of money (private income), held up her cheque. They are always the people who are difficult to dig the cash out of. Max has pretty well got himself in wrong all round & it is just as well Mr G. will be back on Jan 1st[3] apparently the Ottawa job was not so good. Too much boot licking & back slapping I expect. I have the largest abstract which Jessie painted in our living room on the long wall by the door— It is very good—in spots—but was painted in too much of a hurry— The design is lovely but it is a bad colour & the frame is awful— however despite all this it makes everything else look like cheese—the Harris' [Harrises] have rented another house across the st. & move in this week while they install his mother with Companion & maid in the present house—We have not seen much of them lately as the new house having the usual dark brown Vancouver interior had to be entirely redecorated—I wonder how you will like N.S. It is so old & different from this part of the world & the people more standoffish— Terrible old wooden houses, but nice things inside. John Symons has his wings but is still in Ottawa—his aunt is Miss Florence Symons & she lives with her brother-in-law—Mr Harry McLatchy—a lawyer— at 92 Willow St. Truro, N.S. I will write to her by this mail—She is an old maid of 60-ish & she may be terribly dull to you—however I am sure she is good for a meal. If you do go to Hfx. I have a sister living there. She is Mrs Hugh Bell.[4] 53 Oakland Rd. her husband is a prof. at Dalhousie & the oldest daughter has just been married to a Dr. in the navy called Woolhouse[5] from Saskatoon—I will write to Marjorie by this mail too. Eastern hospitality is not like the west where they take you in without a question—They are apt to be—apparently cold & indifferent—really they are not. There are some old interesting things to see in Hfx. like St. Pauls church etc. it is full of history but not much to look at—the climate is awful but certainly not as cold as Quebec—I am enclosing a "Mary Capilano" reproduction which I had made for Xmas cards.[6] 2c each. I don't suppose you will see any N.S. Indians—There are lots of negroes in Truro. We had 3 days of

below freezing & it was awful however it rained last night & it is like early Sept. today. Went to a cocktail party for Air Commodore Collishaw last Wed. He is Dr Trapp's brother-in-law.

Affectionately

Nan

P.S. later—hav'nt the Hfx letter written yet.

NOTES
1 Cheney's portrait of Humphrey Toms is with William Toms, a nephew, in Vancouver.
2 Grace Melvin (1890–1977), a painter and designer and sister-in-law of Charles H. Scott, had joined the teaching staff of the VSA (then the VSDAA) in 1927. (She remained with the school until her retirement in 1952.)
3 A reference to A.S. Grigsby's temporary position with the Department of Public Information, Ottawa.
4 Marjorie Bell (Mrs. Hugh) was a half-sister of Nan Cheney.
5 Peggy Bell was married to Surgeon-Lt. Tony Woolhouse.
6 A copy of the card is in UBCL, Cheney Papers, box 5, file 4.

213 [*Carr to Cheney*]

Sunday
[postmarked 22 Dec 1941]

Dear Nan

Happy Xmas to you, and all the best for 1942. Have been *very* buisy & forced to retire early & often to my bed. Crated 3 pictures yesterday with help of my girl who is very good also we mad[e] a crate for Lady Jane who becomes a Vancouver citizen this week I wish I could have fin[i]shed her behavior off better it still lacks you cant complet the job till after 6 months & I want Mrs Dilworth to have her for Xmas she is beautiful.

I had a visit from Mrs & your friend (forget name)[1] they are at James Bay Hotel. Been too tired to do anything I did not *have* to, but *had* to do a good bit. My party was *tremendous* and I loved it[2] it was made easy & people were so kind. I had a huge cake with candles & flowers & letters galore

Ira was over, & now I'm a Septenagarian which sounded like a ceptic tank when that beastly 'Province' writer stuck it in her article along with a lot of false statements meant to be smart.[3] Mr Clarke sent me the cutting

Hope you will have a very nice Xmas you ought to out there in those nice quiet woods with the lovely little studio.

I have a nice girl but she went home sick today. hope she is on deck tomorrow she is very satisfactory can hammer a nail & loves the creatures.

Xmas love to Hill & Ink, & don't forget yourself.

Always

Emily.

NOTES
1 Gaie Taylor was the name of Cheney's friend.
2 Carr has described in some detail the large affair which was hosted by the University Women's Club, and held in her honour to celebrate her seventieth birthday and the publication of *Klee Wyck*. See Carr, *Growing Pains*, 68–73. See also "Victoria Artist Honored at Reception Today," *Victoria Daily Times*, 13 Dec. 1941, p. 6: "More than 100 members of representative societies, clubs, provincial departments and native organizations paid tribute today. . . ." The affair was held at the home of Mrs. H.E. Young, a member of the University Women's Club, which sponsored the event.
3 See "T.C.," "Emily Carr Among Indians with Facile Pen and Brush," *Vancouver Daily Province: Saturday Magazine*, 29 Nov. 1941, p. 6.

214 [*Pte. H. Toms, Ottawa, to Carr*]

[*The 2 Toms to Carr letters are in the* BCARS, *Parnall Collection, Add.* MSS. *2763. Toms was in Ottawa on leave from Camp Debert, Nova Scotia.*]

Christmas Day, 1941
Ottawa

Just a note to wish you a very Happy New Year, and continued
success. Everywhere I have been in the East "Klee Wyck" is well
displayed in bookstores and book departments and the eastern papers
have been full of it, though I have only been able to see the Toronto
Saturday Night.

During the last eight days I have been hitch-hiking my way around
Eastern Canada, and have at last arrived at Ottawa, tired but glad to
rest up for a few days.

In Montreal I spent an hour in the Art Association Galleries and
tomorrow I hope to see the Canadian Section of the National Gallery.

I am afraid the Fire Insurance will not be renewed. It is due on
January 3rd, 1942. I had written Lawren Harris just to see what the
views of the "trust" were, but of course his answer was non commi-
tal. I had hoped to do it again, but army pay is a little different to that
I have been getting.

Mother writes that your birthday has been celebrated for you in
some style. You'll soon have that old maple stump worn down.

I read "Klee Wyck" after writing the enclosed note, so I didn't
say how much I enjoyed it. I hope the second volume comes out before
I leave Canada.

Take care of yourself, and don't have too many callers on New
Year's Day.

With my love

Humphrey

215 [*Carr to Cheney*]

Monday
[postmarked 29 Dec 1941]

Dear Nan,

Thank you for the lovely pillow. I use those small ones such a lot & the two pretty covers are wonderful! I always sit on a pillow in bed it hoists one. I have a box behind the pillow too. I have spent much time in bed since my party and Xmas. seem to get on best there & do quite a bit of work. I can direct the girl in the kitchen from my bed when I am up it is constant puttering up & down to A's flat and from one end of house to the other, always something—what a *glorious* day Sunny & clear Christmas was all right but I'm glad its past.

I could not get the puppy off.—Mrs. D. was ill & Jane keeps having diohrea & that is too difficult to cope with & the change of food would likely have upset her so I'll keep her a bit longer I had a lovely picture of her & me so the old lady knows what she looks like now. I sent no cards—made no candy—this year 'Klee Wyck' went out before Xmas so got ahead of my presents Hope you had a nice time I took Alice for a drive day after Xmas The woods were lovely I love winter woods. dripping and quiet.

You should see the *fearful* pictures of me in our papers I look like a half-wit fish-wife—oh hideous! I expect they are leveling off any conceit bumps I might have rose to.

Am trying to get some letters tidyied up. loosing my glasses for a week before Xmas sort of behinded me.

Love and thank you again for pillow

Affectionately,

Emily.

216 [*Carr to Toms, Camp Debert, NS*]

[*Addressed to K82039, Pte H. Toms, 12th Can. Fld. Ambulance* RCAMC-A.F. *Camp Debert,* N.S.]

[postmarked 2 January 1942]

Dear Humphrey.

Thank you for letter & now I have an address thank you for birthday greeting. You are seeing something of the world. fine. I posted your Mother's book¹ right off, so she would get it in time for Xmas our mail is aweful, no *morning* delivery till *3 P.M.* well the Birthday Party was a huge affair, but very enjoyable not a bit stuck up & formal, huge *cake* toasts speeches. readings from Klee Wyck Coffins full of flowers all the spoilings of me that you can think of in fact the news papers have had to *level me strenuously* by the most appaling pictures in which I look like a drunken fish-wife with only one eye. no body *could* have a shred of conceit left (hardly self respect even) don't know when next book appears Publisher is clamoring for the Material but "My Editor"² is fearfully buisy (C.B.C. & war) so I don't know.

Xmas was got over somehow. I loathe what we have made of it & now we are launched into 1942 and goodness knows *what* new troubles.

Lawren spoke to me about inshurance I thought it had expired a year or more agoe. we both agreed it was rather an impossible arrangement, apparently only specified pictures would be collectable on & they'd be shure to be the ones not burned, pictures in a studio are always changing Sending a definite collection to a definite show is a different matter. Thank you for what you *did* do it was good of you, but as far as I can see a quite impossible affair to inshure any way under a policy of that type.

Hope you had a nice Xmas. Now its 2 P.M. and me not up yet I've had much bed since Dec 13. these dark days & with a rhumatic back its the most comfortable place.

Love and all

Emily

NOTES

1 Toms, on leave from Camp Debert, had purchased a copy of *Klee Wyck* in Quebec City, and then sent it to Carr to autograph and forward to his mother. Carr had signed it and then added: "Autographed at the request of your tiny son Humphrey, Xmas 1941." Toms, "Letters from Emily," 12.

2 A reference to Ira Dilworth, to whom Carr was devoted at this date. Carr, in referring to the preparation of her *Klee Wyck* stories, acknowledged the relief she had experienced when Dilworth had offered to act as her editor. See Carr, *Growing Pains*, 364–5. See also Dilworth, "Preface," in Carr, *The Heart of a Peacock*, xi-xv, for a discussion on his role in the editing of her work.

217 [*Cheney to Toms*]

Capilano B.C.
Jan. 14th 1942

My dear Humphrey.

We are in the midst of one of The Thickest fogs I have ever seen in Van. It is so bad here I can not even see the studio from the front steps. It is deadly quiet too & gives one quite an eerie feeling— however it makes a beautiful light in the house & I have just taken a snap of Emily's canvas hanging over the desk. Thanks ever so much for your offer of the "Gravel Pit" I would love to have it & I suppose it is as safe here as anywhere when Hill has to go overseas & then I may have to rent the house. We hear they are getting a B.C. hosp. unit together to go to Debert in Feb. & Col. Kenning[1] phoned Hill from Vic. 10 days ago but he has heard nothing since so perhaps they have secured a younger man. Your Col. Baldwin was home for New Years— I did not see him but I am doing a pastel of his boy Jack in the O.T.C.[2] age 19. big & handsome & looks 10 years older in his officers cap &

uniform—I did Capt. Coy's boy[3] before Xmas not in uniform, & he has since left for the air force. Mrs Coy got me the Baldwin boy— Lawren & Bess were here for lunch one Sun. before Xmas & they liked your portrait the best from all stand points. I have not tried to use it for a poster or anything yet as Mr Grigsby says that Dept. in O. is in a hell of a mess & being very badly managed—he was disgusted with the whole set up—as it is against his principles to draw a salary & have nothing to do so he resigned—but he said lots were doing it. he got a Carnagie [Carnegie] grant for his return trip & visited all the big galleries in the States—We also hear the Nat. Gallery is to be closed & used for offices & the Tor. Gal. for lack of funds however we are still going strong altho we had to cancel the Van Gogh show this month. Insurance & risk too great.

Your letter came several days ago. Glad you spent your leave so profitably but wish I had known as I could have given you some good introductions—Hope you have had a meal by this time at Willow St—Florrie[4] is a good scout & so is Mr MacL. I wrote to my sister in Hfx. about you so if you go again you might want to look them up— They have some Ernest Lawson pictures[5]—also look up Leroy Zwicker—he is the Sect. Tres. of Maritime Art"[6] which by the way is getting better all the time. I have had some correspondence with him & apparently he knows a good deal about the pictures in Hfx. There are quite a lot of really old ones—his address is 69 Vernon St. Hfx. The Bank of N.S. has a portrait of one of my ancestors William Lawson which is particularly good. Yes! I think Leroy Zwicker would be a good man for you to know—I dont know what age he is. What is your cousins name in Montreal & the married daughter. I suppose they live at the Linton apts. from your description—

Emily['s] birthday party was a huge success—the Mayor & Lt Gov. & all the nabobs turned up. She was thrilled and really enjoyed all the fuss being made over her—her book has entirely sold out 2500 copies & another edition is on the way. Mr Dilworth had a letter from Sir Humphrey Milford—Ed. of the Ox. press. in Eng. wanting 300 copies, but will have to wait for the new ed. Emily suggested sending

copies to the Service Clubs for Canadian boys in Eng. so Dilworth is arranging it. You may see them when you get overseas. She has also sold another big canvas "The Cedar," to Mrs Fell[7] in Van—for $300—also she has a very good maid now so is being looked after decently—"Pout" has died & "Lady Jane" is still with her as Mrs D. could not have her just yet. Emily must get 25c a copy at least for her book so that is a nice little income. Think this is all the news for the moment. Jessie is sending a big abstract to the Group show in Toronto[8] & is all in a flutter. We are going to the Harris' [Harrises'] new house for dinner Sat. night They have moved across the St. & his mother is in the old house—I hope to go to Vic. by March anyway & can stay at the James Bay with my friends the Taylors. however I will see your mother—Gaie Taylor has gone into the Army & is at Esquimalt in an office doing typing.

Aunt Mary spent Xmas at the Solley's [Sollys'] in Duncan—We had 2 weeks of very cold weather. Grand for the skaters & the fuel dealers. It was really lovely with the sun every day but most Van. houses were freezing & Xmas dinners were eaten in fur coats & sweaters on top of eve clothes. I will send off some New Yorkers in a day or two.

Best Wishes for 1942

Affectionately

Nan

NOTES

1 Likely Dr. Stuart Kenning, a Victoria physician.

2 Lt.-Col. Sidney George Baldwin was with the Royal Canadian Army Medical Corps. His son, Lt. John Baldwin, was with the UBC Contingent, Canadian Officers Training Corps (Militia) and later on active service with the Royal Canadian Ordnance Corps and the Royal Canadian Electrical and Mechanical Engineers.

3 Lt.-Col. Filmer Engers Coy served with the Royal Canadian Army Medical Corps. His son was Filmer Rupert Coy.

4 Florrie Symons.

5 Lawson, a Halifax-born relative of Cheney, was part of the New York art scene in the early 1900s, executing Impressionist-inspired landscapes and exhibiting

with "The Eight" (the "Ash Can School") in their New York exhibitions.
6 *Maritime Art* was published from Oct./Nov. 1940 to July/Aug. 1943. *Canadian Art*, its successor and a more expansive periodical, appeared in Oct. 1943.
7 Ella May Fell (Mrs. James P.) was a Vancouver art patron, and a friend of the Harrises. (In 1943 she was instrumental in the formation of the Women's Auxiliary to the VAG and became its first chairperson.)
8 The CGP exhibition was held in Toronto from 6 Feb. to 1 Mar. 1942.

218 [*Cheney to Toms*]

Capilano B.C.
Frid. Feb 20th
[and Feb 21st] 1942

My Dear Humphrey.

Your letter came last week & today a p.c. re. Morris Longstreth & Zwicker. Morris is an old friend of ours & his book on N.S.[1] is by far the best one written we think—My grandmother—a sister of Florrie Symons'—mother was a Rudolf from Lunenburg & decendant [sic] of the first settlers of the town. This ancestor of mine was one Leonard Christopher Rudolf who came out to Halifax under the protection of Lord Halifax, from Germany, in 1751 and as he was an educated man he was asked by the Governor, Edward Cornwallis to oversee a party of foreigners In 1753 he settled a colony of 300 families in Lunenburg. They were Swiss—German—& Montpeillards—Zwicker belonged to one of these families. They had a militia regiment formed & a Col Lawrence in charge—& Rudolf kept a diary of which I have a copy—I do not think there is one family by that name left in Lunenburg—So you see we have our roots very deep in Canadian soil. Not long ago I had a row with Jock who was grumbling, as usual about Canada. I wish such people would go back to Scotland—they come out here & earn a good living & spend their time running the country down—I finally silenced him by saying we people who had been here

for 200 years felt differently—enough of that!

So glad you saw my sister & family—You told me more about them than I had heard for ages but I was amused when you said "She evidently *used* [underlined twice] to admire you quite a lot." We have drifted apart as I have not seen her since 1924 & she is definitely more domestic than I am—I was interested in what you said about Zwicker & his wife, and their pictures etc.—I am going to a council meeting today & will take a look at Shadbolt's latest efforts which plaster the walls of 2 galleries upstairs[2]—Molly Lamb has a show too.[3] I am hoping to go to Vic. about Mar 7th & stay 6 days. Aunt M's 81st is on the 11th—I may stay a day or two with your mother if she can have me but will probably stay at the James Bay with the Taylors. I have planned to have my show Ap. 28 to May 10th—I have 8 pastell's [sic] ready & several on the way. I think it will be all men. about 12—in the small room downstairs off the sculpture court![4] I dont want many, & each one to be good. I will have to get some local celebrity as a drawing card. perhaps old Malkin if I can stand his smugness & inanity for 2 sittings. Also he is a champion paw knee chief, of the tribe of garter snappers!! ugh!!

Sat. Feb 21st Well I saw the old boy at the meeting & asked him to sit & he is coming late in March. The Shadbolt show was awful—The colour particularly It was sinister & made one feel quite sick. Molly Lamb is a poor imitation except that a sense of humour ran through the lot—but the drawing was crude & the colour positively revolting It may be a reflection of the times & will eventually have its place—I wonder!

He went to a small cocktail party at Mr Grigsby's after the meeting. The Harris' [Harrises] were there—They are enjoying life in Van. very much & every other Sat. night have a musical eve. for young people, college students & the upper crust & they are really doing something for the cultural life of the city Lawren is trying to find a fire proof vault for the 40 canvases of Emily's which they have picked for a future permanent exhibition. He wants to get them out of that

house & thinks the Empress Hotel basement may have a suitable place—or bring them over here to the Van. hotel basement.[5] We are told we are being bombed in April if not sooner. Am enclosing a snap of your portrait—more to follow—Have just read "The tale of a casualty clearing station" by Col Frank Symons,[6] Florrie's brother, who was killed in the last war—It is really awfully good & think you would enjoy it—We are having beautiful weather—frost at night but hot sunny days—Jessie has peas & beans planted & things are started in the greenhouse. By the way if you go to Toronto be sure & look up the Peppers first thing—They live in the big studio building at 25 Severn St.[7] which is not far from the center of the city. I will write & tell them to be on the lookout for you. They have a phone I am sure— A.Y. Jackson lives in the studio above—Expect you will be glad to leave us. Florrie wrote that they enjoyed having you drop in etc.

Affectionately

Nan

NOTES

1 Thomas Morris Longstreth, *To Nova Scotia: The Sunrise Province of Canada* (New York/London: D. Appleton-Century Co. 1935).

2 Shadbolt's show was at the VAG, 17 Feb.-1 Mar. 1942.

3 Molly Lamb (b.1922) (later Bobak), Vancouver painter and daughter of Mortimer Lamb, had her first one-person show at the VAG, 17 Feb.-1 Mar. 1942. (Lamb joined the CWAC in 1943 and was appointed a war artist in 1945.) The Bobaks (Molly and Bruno) moved to Fredericton, NB, in 1960.

4 Seventeen pastel portraits, mainly men in uniform, were exhibited at the VAG, 28 Apr-10 May 1942. See "Three Exhibits on View," *Vancouver Sun*, 30 Apr. 1942, p. 5.

5 In April, sixty-one of Carr's canvases and nineteen oil-on-paper sketches were sent to the AGT for safe keeping. Lawren Harris had made the arrangements through correspondence with Martin Baldwin, the Director. See AGO, Archives, Harris to Baldwin, 20 Mar. 1942.

6 *The Tale of a Casualty Clearing Station by a Royal Field Leech* (Edinburgh/London: W. Blackwood & Sons 1917).

7 The Studio Building (Toronto), constructed in 1913, was financed by Lawren Harris and Dr. James MacCallum and conceived as a centre for those doing "distinctly Canadian work." From 1914 it was occupied by Tom Thomson (for a short period) and by several of the artists who later formed the Group of Seven. The Peppers moved into the building in 1932 and lived there for seventeen years.

219 [*Carr to Cheney*]

Friday
⌊postmarked 22 Feb 1942⌋

Dear Nan

Havnt heard of you for a long time have no idea who ows who but have been very buisy, and had a great many letters that had to be ans-weared. have been coping with the help problem today have had an excellent help for 2 1/2 months & the fool left last Sunday to marry I think the womans upkeep (wife allowance) is disgusting the girls rush to throw up work and live on their separation the next thing is divorces & more divorces[?] she was 20 boy 21. known each other 3 months—baaa!

We are having glorious weather but *very* cold hard frost. I have not seen your freinds the Taylors more than once they were at James Bay Hotel but I have been too buisy to have people in it means a whole days work wasted. had an M.P. & wife in today (by their *own* invite). & just grudged the time am a wreck tonight, maids applying, doing my own work & these nosers to show to. besides which my new pup a little Australian Terrier had a dreadful attack of diorhea & has kept me hopping all day I came to bed at 6 a wreck. Lady Jane has gone to Dillworths [Dilworths] some 3 weeks or more they love her she is a lovely dog not as mannerly as *I'd like* she is so full of life & after all only 6 months. my new pup is only 2 1/2 very small very affecti[on]ate very rare. Pout died before Xmas so I only had old Matilda who also is getting on in years.

Letter from Humphrey last week seems very gay. I expect the Harrises over the end of the month.

Nice to think Winter is neary over eh? You will enjoy the spring in your woods

We are keeping fair, hope you are 3 fearsome creatures called

upon me yesterday one said she knew you one *old* (you could have shoveled the rouge off her cheeks with the fire shovel) two half old half young I don't rem[em]ber any of their names Sir of Christian broght a Klee Wyck for autographing, of Mr Hossie's.

Hope you are getting in work with your quiet out there & a lovely studio you shure should this year

Love,

Emily

220 [*Carr to Cheney*]

Sunday a-bed
10:30 A.M.
[postmarked 29 March 1942]

Dear Nan

white paper all out Glad to hear you were all right again.[1] You must just keep quietly happy at home for a few years, & not rush round. There are spells in our lives when that is the only thing to do. I've had 'em.

It is glorious today real spring I was up at 7:30 Sara had her 4th month birthday & has come to the point where she must be *seriously* trained. now the weather is not so hard on my chest for in and out puttings she is a good little tyke. has had her operation & is very well, and a happy bit of comfort so gentle & loving—I am very glad I got her. I had the offer of a second. but turned it down while Tillie lives they keep each other company, & get on very well except or an occasional dispute Tilly has most weight. Sara most pep. I leave them to fix it for themselves unless it is *too* enormous a ruction then both

get the spank-stick. Macdonald wrote for 6 pictures for B.C. Artists in May.[2] I'll see probably have something am settling after the great upheaval in the studio. it looks very bare.[3]

No help yet Nothing whatever to be got even chars at a premium & very hoity-toity.

Lawren's Mother is very low. very sad for them all. thank goodness she does not suffer they say.

The proofs of "Book of Small have not come yet presses don't hurry. but I am astonished they do *anything* at all these days.

I think spring is just here really now it got that old snow off its chest. We had such bitter wind. all March. I am so dead sleepy I can't think sense so goodbye for the present My love to Dr Trapp. arent the Doctors Conventions or Societies needing her in Victoria soon? seems a long time since she came Did she decide on that Capilano property?

Abundance of love. Ink & Hill included

Affec[tio]nately

Emily.

NOTES

1 Cheney had just returned to Vancouver from a five-day trip to Victoria, at which time (as she described) she became "terribly exhausted and nervous" due to rushing around with her Aunt and listening to Carr's "grumbles." See Dorothy Livesay Papers, Department of Archives and Special Collections, University of Manitoba, Cheney to Livesay, 31 Mar. 1942, and #221.
2 Macdonald, then president of the BCSFA, would be requesting paintings for the society's exhibition to be held at the VAG, 15 May-1 June 1942. Seven Carr paintings were shown.
3 A reference to the removal of Carr's paintings for safe-keeping. See #218, note 5.

221 [*Cheney to Toms*]

Capilano B.C.
April 16th 1942

Dear Humphrey

It seems I have two letters of yours unanswered Mar 18 & Ap 4th—my
trip to Vic. pretty well knocked me out—what with the noise & the
wind & the dust and finally the energetic old ladies—in fact I had to
fly back and was unable to bring your picture—I had it all wrapped up
& actually there would have been room in the plane as we were only 3
passengers but they told me to take as little as possible as we had great
difficulty getting off the water—the wind so high—If I had been a
250 pounder they would not have taken me as every extra lb.
counted—however once off we were home in 1/2 hr—& what a relief
to settle down again in these quiet woods. I am getting to be a really
old lady myself—I suppose that is why they irritate me so—I was most
anxious to stay with your mother but did not like to write again after
not getting an answer to my Xmas letter with two pictures in it of the
(your) portrait & a Mary Capilano card mounted on a red folder—I am
really quite shy as I told her then I would be over in March—well it
turns out—she never got the letter at all and was naturally wondering
why I had not sent the pictures as promised etc. Apparently it was
stolen in the mail as it looked fat & promising & at Xmas they have so
many outside people on the routes however we had a very nice evening
with your mother.—I think she is most attractive looking & I found
her giggle very disarming,—as she rather awes me—I am sure we
would have hit it off—next time, if & when! I will certainly avail
myself of her kind hospitality—The James Bay wasn't bad—very good
meals & less like a cheap hotel than any I have encountered—It was
filled with the Jolly old Empire type of person which I find rather
trying en masse—I saw Emily several times and she grumbled inces-
santly—about maids mostly—You know she cant keep one more than
2 weeks. She was well & really has less than ever to grouch about—
her 2nd book is in the press & Lawren & Ira doing everything for

her—All her pictures have been safely stored for the duration[1] & she has a new pup—an Australian something—still she complained about *everything*—I was terribly fed up with her this time specially as she attacked all the people who have done so much for her in the past.

I was interested in what you said about the Robert Harris collection.[2] Aunt M. has a portrait of her little sister which he did—one of his first—simply awful! but she loves it.

Imagin[e] you meeting Dot Holmes—she was terribly plain as a girl & must be a sight to see now—she was N.S. tennis & golf champ etc. & there was always some thing mysterious about her family—or so we thought at school—she wasn't one of my particular pals but I always liked her. I hope you see the May flowers at their best. I always long for them this time of year—the perfume is exquisite & no Nova Scotian ever forgets them. I think I will write to Florie to send me some air mail.

My show is due to hang Ap. 28th & I will certainly send Mrs Huntington[3] a card. I will leave this open to enclose some snaps—you might return them after you show them at Willow St. You can keep the one of yourself if you like—

I loved the jingle from "Time"[?]—I know some good stories but they are not writeable. Geo & Kay Pepper are going to teach at Banff summer school & we are trying to get them to come here first. There is an R.C.A. show on at the moment which is simply awful—the same old stuff

I hope you see a Sugar Camp in operation—the real stuff poured out on the snow to cool—They should do a big business this year with cane sugar rationed. I was interested in your trip to P.E.I. & the Bartletts. I went to school with 2 Bartlett girls but I think they were Newfoundlanders—relatives of the famous Capt. Bob Bartlett who goes to the Arctic every summer.[4] however they are all more or less related in the Maritimes. I am also enclosing a copy of Sydney's article on Lawren Harris' show last year it was in the Feb-Mar-issue of Maritime art—

We had 10 days of wonderful weather over Easter & the gardens

are well advanced. Our peas—carrots—beets, etc are well up & the tomatoes are 6 in. high in the greenhouse. Daffs are over & tulips coming along. Vic. beats us by two weeks. Thanks for the clippings— have reread your letter in bits which accounts for this disjointed answer. Have decided to resign from the Gallery council—simply cant stand the atmosphere any longer. latest is old Stone wants each founder to be allowed to appoint a successor & they to appoint one & so on forever—Can you imagin anything worse? Lawren asked a lot of questions & objected to the idea on very sane grounds & they were furious—F. Bird [Burd][5] was very rude & made remarks about people who have their money left to them etc. & do not make it etc. It is to come up at the annual meeting & we are going to do our best to vote it out—Lawren's mother just died so they are in the East & we hope he will be back for the meeting. The A.Y. Jackson film[6] is to be shown while the ballots are counted—are your incoming letters censored I hav'nt noticed any censored this way. Hill is making beer—has about 12 doz. in the process. Sorry you are so bored with the camp, but dont blame you at all.

Affectionately

Nan

Do you want anymore "New Yorkers"

NOTES
1 See #218, note 5.
2 The Harris Collection, under the care of the Robert Harris Memorial Trust, was then housed in the Robert Harris Memorial Gallery, on the site of the present Confederation Art Gallery and Museum, which took over responsibility for the collection in 1965.
3 Mrs. Lionel Huntington, formerly Elizabeth (Beth) Roberts.
4 Captain Robert A. Bartlett (1875–1946).
5 F.J. Burd, publisher of the *Vancouver Daily Province*, was a Founders' Representative on the VAG Council.
6 The film was entitled *Canadian Landscape Painting*, with the narration by C. Graham McInnes.

222 [*Cheney to Toms*]

Capilano B.C.
Ap. 30th 1942

My dear Humphrey

Just a note to thank you for the maple sugar It is simply delicious & I am being very tight with it—not offering it to just anybody—in fact Hill & I are eating it all ourselves. Would you like a bag of Welch's & what particular kind? I am enclosing the write up of my show[1] Delisle Parker wrote me a note apologizing for the shortness of it etc. but as the Emily donation was the big news he had to give it the space. however next week he is writing more & putting in a reproduction of Young Baldwin, as it came out so well in black & white. I was very annoyed at him calling my pastels "coloured drawings." He said in his note that "pastels covered such a multitude of soft sloppy things without honest to goodness drawing." Well for that very reason I wanted to show that they did not have to be that way—I will send you next week's clipping too. I suppose you get the Bulletin. so will see the statement Dilworth made about Emily's donation.[2] Actually Lawren is behind it all—I am going to stand again for the council & if I am voted in I am going to retire at once & appoint someone to fill out my term. This may keep some undesireable off the council as *they* are putting up a lot of rich yes men citizens in order to get the artists off—however I may not be elected & I won't mind as I have done my bit getting Lawren on the council & also Dr Clark of U.B.C I had a note from Zwicker saying how much he enjoyed your visit—I hope you see Lunenburg in good weather—also the valley & some of the small fishing villages like Peggy's Cove & Herring Cove.

Affectionately

Nan

Are your letters censored?

NOTES
1 In "In the World of Art," by Palette, the main item is headed "Emily Carr Donates Canvases for Permanent Display Here." A very brief account under "Portraits Exhibited" deals with Cheney's work. See *Vancouver Daily Province*, 29 Apr. 1942, p. 31.
2 See "Emily Carr Trust," *AGB* [VAG], 9 (May 1942).

223 [*Carr to Cheney*]

May 10th 1942

Dear Nan

How did your ex. come off? I expect you are a rag after it but hope not too bad & that it was successful in every way.

I got 7 sketches off to B.C. Artists[1] McDonald [Macdonald] wrote again afraid they were going to be short of material & asking I do what I could to help I spose its all an 'honorary' *can* do. So out of my studio and all my crates gone left me only sketches with [without?] any thing that would crate them but none have been shown before. I am buisy on 3 big canvases[2] & have my reservation made for my usual autumn show guess I'll scrape up enough I had thought of sending some of my *big* ones never shown in Van. but they are all off to the trust for keeps I bet Maxie and Jacksie wish I'd die & be done with it. too bad I hang on so long & *work*.—often think that way myself. when I *don't want* to paint any more I *wont*. Lawren & Ira have promised to tell me if my work gets weak & maudling & should quit. and I trust them hope Ira gets on the Gallery. he is honest. he & Lawren (who I do *hope* they won't ooust) are a good team.

Spring is lovely this year I have been out into *real* woods twice—

taken & *left* no one within miles.—³ the Spring coloring is so fleeting. changes every day I had hoped to go out oftener but one expedition takes a day or two's recuperation from.

You *may* see me in Van. before *many* moons date uncertain. Lawren & Bess will be back now. My darn maid has "fell ill." She has taken another job on top of mine & the two is too much.

Sara is a darling, cute quietly merry, very affectionate. ⎯ Having dreadful ructions with teeth miserable ulsers in mouth very painful have to have a new lower set made—my fault not the dentists—eating is mean, I do it in the kitchen alone.

Hope you are all right. also Hill & Ink.

lots of love

Emily

NOTES
1 B.C. Society of Fine Arts. See #220, note 2.
2 *Clearing*, *Cedar*, and *Quiet* are three oil paintings executed in 1942. See Shadbolt, *The Art of Emily Carr*, 186–8, and catalogue entries 173–5. See also Shadbolt, *Emily Carr* (1990), 211–12.
3 These were day outings prior to the Mount Douglas camping trip of Aug. 1942. On 3 May 1942, Carr had written to Dilworth: "Tomorrow if it is fair I plan to go into the woods—taxi & be dumped!" BCARS, Inglis Collection.

224 [*Cheney to Toms*]

Capilano B.C.
May 13th 1942

My dear Humphrey.

Your long letter is still unanswered but I wanted to let you know about the Annual meeting—We had 8 new candidates & much to my relief I

was not elected—however all the others got in & Ira Dilworth was elected in my place. I am very glad as Lawren got in again & Dr Clark—both originally nominated by me, and the other "rich & influencial [sic] citizens" they were trying to get in to overthrow the artist element, were all defeated. I was only a vote or two behind Dilworth so apparently I am worth some thing however that is that & they have no women on the council at all—altho Mr D. is so nearly one—I am sure he wears lace on his B.V.D.'s. The Jackson film was magnificent & the autumn colour brought back the flavour of the East also the snow pictures taken in Quebec—Then they had a maple sugar picture & it was grand—the whole process in backwoods Quebec with colourful old types doing the boiling etc. I wonder if you have seen a sugaring off. You did not mention it.

The B.C. Society show opens this Frid. Emily is putting in 7 sketches—she is working on 3 large canvases for her autumn show & has been going out to the woods again—getting some one to take her & leaving her alone & calling back at night—I think it rather risky but apparently she doesn't & has been O.K. She is coming over soon to visit Ira—Well my show was a fair success. I sold "Capilano fisherman" to my dentist for $20.00—who is a keen fisherman & I think it is going to adorn his office. Mrs Huntington phoned me & was full of praise etc. & asked me to tea etc.—I could not go & said Hill & I would call on her some eve. Thanks for the low down on her—I take it she is a sister of the Roberts who married the old lady of 85, last year—for her money, I hope! he runs Sylvia Court—Ethel Wilson[1] knows Mrs H. & likes her & I do intend to go & see her when I feel equal to it—The May flowers!! They arrived on Mon. & were simply magnificent—the perfume when I opened the box almost bowled me over—There is nothing quite like it to a Nova Scotian—You paid for too much postage but I can't tell you how much I appreciated them— Just a week later Leroy Zwicker sent me a few in a little box—I was quite touched. Your description of Dot is priceless—She was always a bit skittish. Did you see the church in Lunenburg built by one the early Rudolf's—I dont suppose you saw or heard the name as I think

they have all died out. Lunenburg is the home of the famous "Blue-nose" of the Gloucester fishing boat race which was a big event in the East before the war. Tom Coventry is a Sub Lt. in the Navy now & expects to go to Royal roads any day now. They are renting their little house—Sydney is a very well informed person with a better background than you would think & he keeps it well hidden. You ask about Max. M. he is substituting at the Pt. Grey—Jr. high & teaching Art app. at the summer school he hopes for a perm. job at Pt. Grey next year. Jessie says he is a *very* good teacher Bess & Lawren are back for good we hope, & so do they, as they have really fallen for Vancouver. Lilias Newton R.C.A. has painted a typical Can. soldier which is being printed on P.C.'s & placed free in the canteens[2]—This is one of a series so look out for them—She is the best portrait painter in Can. The Peppers can't come to B.C. before the school opens in Banff. We are *so* disappointed. We are having a cold wet late spring—my tulips are just in bud—

Affectionately

Nan

Letter from my sister in Hfx. saying they enjoyed seeing you very much

NOTES
1 See #147, note 4.
2 Toms mailed Cheney a "Lilias card" dated 21 June 1942, and one dated 15 July. See UBCL, Cheney Papers, box 4, file 15. The portrait of Private Alexander ("Canadian Soldier") is presently in the Canadian War Museum, Ottawa.

225 [*Carr, Vancouver, to Cheney, North Vancouver*]

Me in bed, Nanton St.

9 A.M.
Friday
[postmarked 5 June 1942]

Dear Nan.

Too bad, too bad, the bridge and a half dozen other things intervene between thee & me.[1] why did you have to go & sick it when I came up? well. so it is & can't be helped. we'll make the best of it by letter for over phone I am *most* as deaf as Mrs Blaiklock some times can & sometimes can't hear. Old ages shortcomings are many & stupid, but one can't run away from them so may as well face about & show teeth in a grin even if sour.

I am into my 3rd week here & *better for the rest*. was tired have been working hard & hope to go home and work harder—

Vancouver has looked so *lovely* this time woods & shrubs in full glory, the Park & the University unspeakably glorious.

Ira says you talked of possibly coming to see me Saturday well my dear I do not want you to make an effort you are unfit for—I understand,—shurely I ought to being so flabby myself.—gas & distances—flesh, blood & indispositions all link hands & the centre of all is war. *filthy* [underlined twice] *war* and the world was never more lovely than this year seems she's doing her darned best (our side of it anyhow) to make up to us. for the rotton spots.

We had a glorious day at Dr Traps [Trapp's]. 'Crescent Beach' is beautiful.

Jane is beautiful! bursting with beans.

Alice is well & I think enjoying a bit of herself—Change good for us both. The party at the Harrises was lovely wish you could have been there better luck next time be good to yourself and meek for a spell & get what fun you can out of what's close. when you are stronger you can stretch further now's your time to sit tight, in your garden & studio. heaps of work to be done (nice work too) in both spots. We'll see each other later. if not this trip, next with lots of

love & hoping you are better

as ever

Emily

NOTES

1 Carr was staying at the home of Ira Dilworth on Nanton Avenue in Vancouver. This was her second stay there. See #206.

226 [*Carr, Victoria, to Cheney*]

218 St Andrews St
June 11 [postmarked 1942]
[card]

Dear Nan

Hope you are feeling better was so sory we were unable to meet in Van. This buisnes of being 'crocked' is a bother but there you are! the only way is to easy ourselves & sit I enjoyed my visit very much & am better for it. people were most kind. I am afraid several precious allotments of gas were dwindled because of me, but I did enjoy the Park & the University grounds the flowers & trees were just grand. The C.P.R. were disgusting, pulled out, 1/2 hour ahead of skedual leaving my foot in air & the gang plank just beyond reach. (nearly) so we came Nanaimo & had a very lovely trip. on bus. it is so pretty (not bus or its smell) but the country.

We rain,—and are cold. The studio is nearly blacked out with foliage.

Alice was O.K. dogs fine. Crescent beach is lovely. so glad Dr Trap[p] has taken the Capilano place.[1] she says you walked over Sunday so it cant be so very far

loads of love & best of *healthy* wishes.

Go easy—love—

Emily

NOTES

1 Dr. Trapp's property was off Keith Road on the Capilano River. She later deeded the estate to the Municipality of West Vancouver with the proviso that she would continue to live there during her lifetime. On 5 June 1943 Dr. Trapp wrote to Carr asking if she might name her Capilano home "Klee Wyck." "It seems to me entirely appropriate for such a happy place," she wrote. BCARS, Parnall Collection. "Klee Wyck," as it is still known, is presently the centre for the West Vancouver Community Arts Council.

227 [*Carr to Toms*]

218 St Andrews
June 15/42

Dear Humphrey.

I am a no good swine (not even a good fat porker). time has hopped along & I've delayed writing. Well pile no maids, & bad maids, work, celebrations, painting & writing and a visit to Vancouver, into a heap beyond my ability to crawl over and tender your heart meward—Hope you are getting on fine, *fat*, healthy & happy.

I have just returned from 3 weeks in Vancouver visiting Mr Dilworth. Was given a reception at Lawren Harrises some dinner parties & some lovely drive[s] in spite of gas shortage. Vancouver was looking beautiful its gardens are very fine now & the University grounds & Stanley park magnificent, beds & beds of Iris the lovliest I've ever seen.

It has been a cold late wet spring & the foliage is terrifically dense and lush in consequence.

Am working hard at present. 6 canvases under way have a one man in Vancouver in autumn. The 'Book of Small' is not out yet but Klee Wyck is in her second edition also she is just out in America. And England is bringing "Small out" in England this autumn. Things move slow. War strides over them, kicking them out of the way Hurry up & win the war so the world can get normal, its so beastly.

C.P.R. did a dirty trick on us when I came down from Van.—shot their old boat out 1/2 hour ahead with no notice & one of my feet on the gang plank. Ira was bringing me home—we came by Nanaimo— Mad! but the woods looked lovely. All fresh not dusty & dried up yet.

Did you know I presented 80 canvases to the Nation, that is to British Columbia, They are in trust Lawren Harris & Ira Dilworth are the trustees. 45 will be kept for a permanent collection, housed in Vancouver. The rest sold as opportunity offers for upkeep & support of the rest. They are now housed in the Toronto Art Gallery[1] till the Japs are sat down, then they will be returned to West. It was quite a turn out of the Studio but there is quite a lot left, & I'm not quit[e] through yet (painting)

It is called the Emily Carr Trust and *should* have come to Victoria only Victoria is too hopeless. she could never have bothered to arrange or house, all her top men are ossified.

I did not see Nan in Vancouver she was ill again & she is impossible of access now, what with the bridge & no gas, & she is so emotional & fussing. always dissatisfied. too bad. I'm sorry for her and sory for Hill too. Dr Trapp has bought a place across the river 5 minutes walk from her. I beleive it is lovely.

Alice is well, but pretty well blind. Ruth is in East for the holidays

No particular newses. No births, deaths or marriages even in the aviaries just the Japs & Hitlers dirty doings, & shortage of this & rationing of that & the rain ruining the strawberry crop.

Well be a good boy let me hear some time how you do I don't know where you are but will apply to your Mother for information.

Everyone is as buisy as anything no one has time to do nothing but talk and groan.

Much love & best of wishes

Yours

Emily Carr

P.S. = write.

NOTES
1 See #218, note 5, regarding the Trust paintings.

228 [*Cheney to Toms*]

Capilano B.C.
June 22nd
[and June 27th] 1942

My dear Humphrey

It is more than a month since I received you[r] last letter—and although it is nearly the end of June, it might be the end of March it is so cold & wet here. We had the furnace going until a week ago & now have a roaring fire in the grate and not a bloom in the garden. Actually it has rained for weeks with an occasional fine day—I hope Nova Scotia is treating you better than that—

The B.C. Society Show was very good this year. Emily sent 6 sketches & sold 4 & got her money on the dot. Mr Grigsby is the white haired boy—She then came over to stay 2 weeks with Ira Dilworth— at the same time Aunt M. was visiting the Symons, & I was between the devil & the deep blue sea—knowing Emily hates Aunt M. (no reason of course) & I did not want them to clash out here—however just then I took to my bed with a temperature & that took me out of

the picture as far as entertaining either of them—in fact I did not see Emily at all & Aunt M. only 4 days. Emily stayed nearly 3 weeks and I heard lots about her. Bess gave a dinner party for her & afterwards when no one happened to be talking to her she threw a "heart attack." I dont want to be mean but from the description she apparently was *not* the centre of attraction for the moment. however she soon regained that possition [sic] as they all fluttered round—Ira "gently" took her shoes off (cant you see him?) some one dashed for a hot water bottle & someone else for a cup of tea & the evening was wrecked as far as anyone else was concerned. Emily recovered & was on the go the whole time she was there. Apparently there were some tiffs in the Dilworth household & they found her *very* difficult in spots.[1]—

June 27th I heard from Mrs Taylor that you had gone overseas so I sent a p.c. to your mother for your address & all she said was it was the same as usual so I take it you are still in N.S. I got your p.c. from Louisbourg—You have seen far more of N.S. than I have.—I am very interested that you liked Lunenburg—I met Bailey[2] the artist in Ottawa about 10 years ago. I read your letter to the Symons as they were much interested in your description of N.S. & the food at Willow St. Glad you like scallops & bacon & lobster—Have you tried salt cod & pork scraps? or fish chowder? Well done, they are marvelous. I am afraid my letters will be a disappointment to any future biographer. What do you do with them? send them to your mother? She must be highly entertained!

I have a coloured p.c. of Lilias Newton's "Canadian Soldier." It is awfully good except for the foreshortening of the knee in the foreground. Hill is on holidays & the maid has left for a job at $60.00 a month, so I must tackle the dinner. Sorry this letter is so scrapy [sic]. I went to a federation[3] meeting last night—will enclose their folder. The Gallery has been cleared out of practicly [sic] all the "Valuable" pictures & the window has gone,[4] praise be. I have been asked to loan "Mary Capilano" for the summer & I may put you in too. Jessie has been asked to have a show in Toronto with a Group of 4 abstract

painters[5] She is thrilled. I am going to do a lot of oil paint & gasoline portraits on dark paper this summer—that is war & the budget permitting We will have about 10c a month to live on.

Affectionately

Nan

NOTES
1 Ada McGeer, a friend of both Carr and the Dilworths, recalled such times, and her attempts "to pour oil on the turbulent water, rescuing either Emily or the Dilworths, whichever way you looked at it." See McGeer, "The Emily Carr I Knew," in *"Oh Call Back Yesterday, Bid Time Return"* (Vancouver: Versatile Publishing Co. Ltd. 1981), 50–1. The Carr to McGeer correspondence is with the Patrick McGeer family, Vancouver.
2 Likely Evern Earle Bailly (1903–77), a Nova Scotia polio victim, who painted holding a brush in his mouth.
3 The Federation of Canadian Artists, which was made up of local branches across Canada, was formed as a result of the 1941 "Kingston Conference." See #197, note 5.
4 A stained glass window, "Harmony" (from a painting by Sir Frank Dicksee), had been presented to the VAG in 1932 by H.A. and Beatrice Stone in memory of their only son, Lt. Horace Gordon Stone, who died in service in 1918. During the war the window was put in storage and later returned to the Stone family. On 11 Nov. 1950 it was presented to the West Vancouver Memorial Library by Mrs. Alan Gentles, Lt. Stone's sister.
5 The four-person show had been held at the AGT, 8–20 May 1942.

229 [*Carr to Toms*]

218 St Andrews St[1]
[Mayfair Nursing Home]
[postmarked 26 September 1942]

Dear Humphrey

It is a long time since I got your interesting letter, but things have happened. I went to Vancouver then I had a friend with me for a

month from the East.[2] Then I went 10 days to a cabin sketching.[3] Came home very ill (overdid I spose) had thrombosis (clot of blood in artery of the heart) and nearly died (considered remarkable with my other heart trouble too that I squeaked thrgh. That is 6 weeks agoe I am still in bed was in hospital 2 weeks Specials and all that stuff treid home (could get no help had 2 nurses) so came in here for a month or more (Mayfair Nursing home) after that what???? Domestic help impossible! Glad you are having a good time seeing so much of the country.

Life gets more & more difficult we may do this & may not do that mostly may *not* do.

It's been an extraordin[ar]y summer & is Indian summer now fog in the morns thick enough to chew & day middles that broil you. no sense or decency to anything.

Klee Wyck is in her 3rd edition Book of Small listed among this years books but not out yet all presses commandeered by Gov.

My usual autumn Ex. in Vancouver was indefin[i]tely postponed. I had engaged the gallery for Sept-October Hope to finish up [?] sketches I did & maybbe have one in Spring. Hope to return to a *meek* normal, but will have to go easy no physical exertion use my type writer a little in bed.

No news. I only travel by ambulance Most violent excitement is when a spider walks over the ceiling which is my veiw—a mottled paper.

So long no news

Yours affectionately

Emily Carr

This P.S. is mistake thought I was adding it to Edythe Brand's letter

[*The following was deleted*] P.S. Don't know a soul in Ottawa now except Maud Brown Eric Brown's relect and Marius Barbeau & wife

who used not to pull together well, have lost contact entirely with them & Ottawa.

NOTES
1 Carr was in the Mayfair Nursing Home (not at St. Andrew's St.) and spent some six months there.
2 Carol Pearson Williams had come from Ontario to stay with Carr. See #195, note 1.
3 The August stay at Mt. Douglas Park was to be Carr's last sketching expedition. During her stay there she had corresponded with Dilworth, and wrote: "The cabin is bliss—tar paper and ship lap." Near the end of her life Carr reflected: "Do you know when I'd like to have died? At the Mt. Douglas time. I've got bitterer since then." BCARS, Inglis Collection, Carr to Dilworth, 2 Aug. 1942, and n.d. [Feb. 1945].

230 [*Carr to Cheney*]

Mayfair Nursing Home
1037 Richardson St.
Monday
[postmarked 29 Sept 1942]

Dear Nan.

Thank you for the dear little pillow kind of you to think of it. I am a pillowy person these days.

Am improving but it is a slow buisness help is impossible to get so I am in a nursing home goodness knows for how long am still in bed 7 weeks now. however it seems to be surprising I am here (on earth) at all.

Hope you are O.K. exp[ec]t. Dr Trapp has moved now & is a neighbour give her my love.

I am allowed to do a *little* writing in bed now, that helps the time along. so far the only visitors I've been perm[i]tted are Mr Lawson[1] (our lawyer & an old friend) & Ira. Women stay too long & talk too much.

I have old Joseph my blue budge here with me. one live note, & I had lovely flowers.

Good luck

affectionately

Emily.

NOTES
1 Henry Graham Lawson, Carr's lawyer, was the son of James Hill Lawson, Carr's guardian following her father's death in 1888.

231 [*Cheney to Toms, Sussex, England*]

Capilano B.C.
Oct 18th 1942

My dear Humphrey.

Have only had word from your mother that you were in England but yesterday the Eric Kennington book[1] arrived—I am simply delighted with it & can't say how much I appreciate your sending it. I had just cut a coloured reproduction of Air Chief Marshall Sir Chas. Portal out of a new world magazine which makes a good comparison with the black & white. The others in colour in the book are grand—I made one of Norrie McLeod, a sailor son of our local grocer—very like the squadron Leader Malan one, and no one liked it so I didn't show it— now I have taken new courage & to hell with these nobodies who tear your stuff to pieces without a moments hesitation or any knowledge.

These portraits of Kenningtons just show what can be done with pastel—the strength of statement & such good modeling—he is a superb draftsman. I love the Canadian airman on the cover, & hope you get a chance to meet him Kennington, I mean—

The Peppers were here in Sept. for 3 days. George was teaching at the Banff school & they came out after just to see us. We had a marvelous time—mostly talking & catching up on 5 years—They were very taken with my work & wanted to buy your portrait not knowing who you were then when I told them George let out a whoop & said, so that's the fellow who bought my canvas. They were tremendously interested & very pleased with their judgement of the portrait—Kay had some work here. Quite wonderful quick drawings done with a lithograph lead on a special paper. She has a great deal of talent & has developed her own style & personality—George is a more careful worker & an awfully good teacher. They were very much liked at Banff and may come back next year—They went to the gallery with Mr Weston & saw your pictures—the whole place looks so much better with most of the monstrosities in storage and that saccharine window removed—The first gallery has about 20 "old masters" (?) and the north gallery the modern ones & the few Canadian "because they could be replaced." It is all very amusing but Lawren Harris is gradually getting more & more authority & the old boys are listening to him—alas! not because of his knowledge but because of his money. however it is lucky for us that he has the combination of both as we have suffered too long from money spent the wrong way.

Mr Grigsby got married this summer to a dame of 40 odd, named Miriam Mordham. English, well educated, tall raw boned & red hair. I have not been able to entertain them yet so have only met her here & there. The gossips say he proposed to every eligible woman in Town & he caught this one on the rebound of a husband who has taken to Easondale [Essondale]—permanently—I expect you have heard from your mother about Emily being so ill. She insisted on going to the country for 10 days—and did 17 sketches—2 or 3 small canvases and 2 manuscripts—with the result that she collapsed & was rushed to hospital & was unconcious for 3 days. She had a coronary blood clot and only has about 25% heart action. however that was nearly 2 months ago & from hospital they took her to Mrs Clarks Nursing Home on Richardson St. No one but Ira Dilworth & her publisher are

allowed to see her. I have just phoned Ira & he said she was able to get up a little & use her typewriter. Luckily she is happy in the nursing home as the Dr. wants her to stay 6 months—She is really remarkable but I am afraid her prognosis is not very good. "The house of Small," [sic]² is not out yet but I expect they are holding it for the Xmas trade. Her exhibition is not to be held in Toronto until Feb. & she refuses to have my portrait of her included³—I am not surprised, knowing Emily, & eventually I expect it will be hung with her collection. when it is permanently housed out here.

I met Gordon [your brother] this summer when he brought my sister down for 10 days visit.⁴ I am afraid your mother & aunts were rather shocked as they spent the night on the Seattle boat in the car, not a stateroom to be had, let alone two—and going back they stayed at a hotel. however it was my sisters only chance to come & she has to do odd things these days in order to travel anywhere. Carol is spending the winter with us & going to North Van. High School—taking music from Max Pirani, an Englishman who came out here a few years ago. Dr Trapp moved into her house in Sept. after being here for 6 weeks. You know it is just down the river below Jock's—on the other side & luckily the Keith road bridge is open so we can walk over often. She has quite an estate—with a caretakers house at the gate and a drive-way curving round to the house. Several ponds fed from a mountain stream & 5 wild ducks who seem to have come to stay. I redesigned the house for her & if I do say it, the result is well planned & spacious—Daisy is coming down after Xmas to board in West Van. for a few months. She has been working in the Revelstoke hosp. & finds the altitude gets her after a time. I have not sent you a thing for Xmas—I wrote to your mother for some ideas but she hasn't answered yet. Hill is gradually cutting the trees, at least one a week for fire wood & let in more light—I am not painting at all as I am out of material & too busy with other things—the studio is gradually being filled up with screens & garden chairs etc. Greetings & best wishes—

affectionately—

Nan

NOTES
1 *Drawing the R.A.F.: A Book of Portraits* (London: Oxford University Press 1942).
2 Inserted in square brackets by Cheney at a later date. The title should read *The Book of Small*.
3 In an undated letter of 1942, Carr wrote to Dilworth concerning the exhibition scheduled at the AGT, 5–28 Feb. 1943, and expressed strong feelings about the Cheney portrait: "Did I tell you he [Harris] is for having that *filthy* Emily Carr (portrait) of Nan's hung in the Trust shows. I kicked like a steer and he has given way, but without approving." See BCARS, Inglis Collection, and #32, note 4. See also AGO, Archives, Martin Baldwin to J.F.B. Livesay, 19 Oct. 1942. Carr's position would have been difficult for Cheney to accept considering the latter's ambitions regarding the portrait.
4 Gordon Toms was living in Trail at the time. The bracketed addition is by Cheney at a later date.

232 *[Carr to Cheney]*

Mayfair Nursing Home
1037 Richardson St
October 25 [postmarked 1942]
[card]

Dear Nan

How are you? I hear you have your neice with you[1] that will be nice. also having Dr Trapp for a neighbour will be nice too are you painting?

I am still in a nursing home it seems the only way no help & the problem of fires to be kept up. Am still in bed 3 months now. sit in a chair occasionally to do a little typing as it doubles me less than trying to type in bed. Everyone is very good to me nurses are as scarce as sparrow's teeth. They have great difficulty in getting them to stick all

the young are war-mad. glorious weather. I have had a steady supply of lovely flowers, & I have Joseph with me. so am not lonely My sister comes every 2nd day it is getting hard for her to get about alone but she is thankful to have me here safe. It is a bother being such a helpless plague when all the world is so buLsy lovely to see Dr Trapp in Victoria. Don't read very much. write quite a bit, rest quite a 'bitter'

Don't like the roasting glare of October Middle days they wilt me & the cold night & morn hurt chest.

love

Emily

NOTES
1 Carol Wright, who was then fourteen years old.

233 [*Toms, No. 12 Cdn. Lt. Fd. Amb.,* R.C.A.M.C., *Canadian Army, England, to Carr*]

2-XII-42

My dear Emily

Thanks so much for your September letter which followed me here from Debert. I sent you a birthday greeting a while ago, but you probably won't get this until the New Year.

I'm terribly sorry that you have been so ill again—but if you will go out sketching and camping what can you expect? I know that your life has been damnably restricted during the past few years and that must chafe a lot. But do try to take care of yourself.

Now that you are being published you have so much more to give,

and without the physical effort. For heaven's sake:—all of us younger people want to see more Books of Small, and more Governor's medals. You deserve more publicity and fanfare after all these years of quiet, hard work. People may never stream to your door to such an extent that they will wear down the old maple stump, but they'll certainly come. Your friends are all trying to give you a helping hand. Ira Dilworth and Lawren Harris are rather earthly guardian angels, but your work which we want to see more of is in very good hands.

My short sojourn in this country has been most interesting in every way. My leaves are spent mostly in travelling and visiting numerous cousins who have all turned out to be quite nice, Thank God!

We are billeted in a proper camp disguised in a farm amid rather pleasant surroundings of vast houses and acres of cabbages and leeks. I discovered that I had some rather nice neighbours among the London refugees who live in the district. One is Douglas Goldring, an author of rather scholarly travel books and reminiscences;[1] a friend of D. H. Lawrence and James Elroy Flecker (a ship, an isle, & a sickle moon).[2] He introduced me to Tommy Earp who was art critic in the New Statesman and Nation, and now writes for the Daily Telegraph. He lived in Paris for a number of years and knew everyone; Modigliani, Braque, Picasso, Marie Laurencin, in fact all the people who have since become famous. He is brother-in-law of Frank Dobson the sculptor, a junior to Epstein, but a person who has caused just as much furore as Jacob.[3]

They all have me to their houses and are very kind to me. When I went to London on leave last month they put me on to Nina Hamnett,[4] a particular friend of Tommy Earps, a most unusual woman who sits most of the day in the Saloon Bar of the "Swiss" in Soho. She is writing her third volume of reminiscences—the first was quite a success—"Laughing Torso," and I remember reading it at home about seven years ago. I have since bought a copy to learn more about her. Like Tommy Earp she has lived in Paris for a number of years and enjoys a certain fame as regard to her pictures. She is going to do a portrait sketch for me next time I go to town. Poor thing, she drinks

so much that she has fallen to doing things cheaply. But she is still and extraordinarily vital personality. I am most lucky to have met these people.

The "Mayfair" smacks of babies! I'd like to be in Victoria to tease you about it. Anyway if you are frisky enough, you will be able to give birth to Book No. III.

If you can someday, will you write something about Mrs. Mac-Vicker[5] and Metchosin not so much about Mrs. Mac. but your summers there, and about the Gravel pit, and ants, and the heat at Telegraph Bay.

The country is very lovely here in the South but I dislike many things; class distinctions, slowness of travel in wartime and the black-out. God grant that I see this country lighted at night.

I don't know when we will be going abroad—perhaps never. The real second front is going exceedingly well and the Germans are getting their pants dusted both in Africa and in Russia. People here seem to think there is a possibility of collapse within a year. Maybe.

Bombers roar everhead at Supper time on their way to Turin and Genoa, and wake me up when they come back at 1.30 AM. May the carnage hasten the end and bring back peace at any price.

Do take care of yourself. I want to see you when I get back. My best to your sister.

Affectionately

Humphrey

NOTES
1 Douglas Goldring (1887–1960) was a novelist and critic as well as a travel writer.
2 The title of a poem by English poet James Elroy Flecker (1884–1915).
3 Jacob Epstein (1880–1959), an American-born sculptor, lived in England from 1905.
4 Nina Hamnett (1890–1956), an English artist, wrote *The Laughing Torso* (New York: Long 1932).
5 Maude E. McVicker. See #7, note 1, and #185, note 1.

234 *[Carr to Cheney]*

Mayfair Nursing Home
1037 Richardson St
Dec 23 [postmarked 1942]
[card]

Dear Nan,

I hope you & Hill and the neice have as comfortable a Xmas and as happy a New Year as possible after all this old world is just as lovely, its only bad in beestly people and they are temporal

I just had the most exquisite plant I have ever seen brght to me a pure *pure* white cyclamen (26 blooms out & buds) I can't take my eyes off it. Am still in nursing home expect to winter here very comfortable, shamefully so for these days, when nearly everyone is *un*comfortable am still in bed (5 months now) bed is a good bit more comfortable than *some sorts* of legs.

Love,

Emily

235 *[Carr to Cheney]*

Mayfair Nursing Home
1037 Richardson St
Dec 28 [postmarked 1942]
[card]

Dear Nan

I can't for the life of me remember did I write you yesterday? You were on my list and the power (light) went off & rattled me & the nurse collected my letters for post before I'd made my list anyhow 2 thanks will be better than *none* & excuse. The flowers. pink white & yellow chrysanthemums grown naturul were lovely thank you and Hill. for thinking of me I *lay* this year & *took*— no give—but, I thought. hope you had a good Xmas It was a lovely day I enjoyed the peace & quiet here. & had a happy day. 5 months of bed *now*, and will be here for Winter that is long enough to look ahead. Hope this will be a very happy year for you and Hill give him my love and keep lots for yourself

Affectionately

Emily

236 [*Carr to Toms*]

Mayfair Nursing Home
1037 Richardson St
Victoria B.C.
Jan 28/43

Dear Humphrey

Thank you for Xmas and Birthday greetings good of you to rem[em]ber me am glad to hear you are enjoying your work and seeing and learning a lot, meeting interesting people etc.

We have had an awful freeze up. worst in years. fuel shortage and a lot of discomfort It seems to have been all over the land we have not been too badly off here hot air which would not heat against the cold winds & of course having to go easy on fuel still I being in bed did not

suffer much except to get flue. on top of all the rest. thank goodness snow has gone. *won't* people be glad to see Spring but what it must be like in Russia etc this cold weather. I shudder to think.

Keep buisy in spite of being alwys in bed (in 6th month of bed now) Do some writing. 'Book of Small' has had *good* success. 2nd. edition. called for in 2 months. 1st edition 4000 copies. She has been very well reviewed.

Alice is well has been tied up 12 days by bad weather I won't let her come when its slippery & dangerous

Old Tilly the little Griffon died last month so that is the last of the Griffs. I had to part with all my birds but Joseph when I was ill but Joseph is in hospital with me. We undergoe the 'stink' of being house cleaned. Wagh! They paint everything & *such* smelly paint.

Naturaly I collect little news, a third book is on the way & in fact a *fourth* one per year.

Well good luck the big conference looks as though they were going to put something big on[1] Oh for a soon settlement but *not* as you said at *any price* I hope the war wont end softly like last time & have to be done all over again.

Love and luck

Yours

Emily

NOTES
1 Likely a reference to the Casablanca Strategy Conference held in Casablanca, 14–23 Jan. 1943.

237 [*Cheney to Toms*]

Capilano B.C.

Feb 24th 1943

My dear Humphrey.

Since I last wrote a week or two ago—I have received some more books. Making 9 in all—They are, "Artists [Artist] Quarter"—Chas. Douglas[;] "Eng Sculptor [Sculpture]" by Eric Underwood[;] "Mod. Eng. Art" by Christopher Blake[;] 4 booklets of war pictures—the Sea, the Blitz, the Army, & the R.A.F.—also Mod. German Art in a Penguin book & Primitive Art in a Pelican book—the only one you have mentioned which has not come is the Kennington Royal Tank corps. brochure[1] They have all come direct to our little post office except "Artist Quarter" which I had to get from the customs but there was no duty. I think the reason it went there was because it came direct from Foyle's[2] & they know they are book dealers—I have just finished reading it and enjoyed every word but wish there had been more photographs & reproductions of paintings. Do find out who Chas. Douglas really is as you said Goldring did the ghost writing—find out too who the English Poetess is who lived with Modigliani—apparently she is still alive as Douglas is careful not to describe her very well & said he hoped she would write her memories. What an extraordinary man "Modi" was & it was interesting to read about the effect of dope—alcohol etc. on his work. The Crawleys were here for dinner last night & I read them your last 2 letters (Dec 2–42) & (Jan 28–43).—they were very much intrigued by your interest in the galleries etc & said you were certainly getting the most out of your leave—they knew all the places you spoke of as they have been abroad so much & have always been interested in pictures & have remarkably good taste. I loaned them "Artist Quarter" and then the Harris[es] want to read it—I am sure you dont mind as they are both people who look after books & Hill made a good cover of celophane [sic]. I also read your letters to Et[hyln Trapp]—yes it is nice to have her so near. She has 2 Emily sketches in her big living room with a water colour of mine & they look quite stunning & my water c. holds it[s] own very

well—By the way E. has a new book coming out called "Creatures."[3] She has promised Ira to stay another month in the nursing home but what then? Thank Goodness it is Ira's worry. By the way you know he is her literary executor & nothing of hers can be printed without his permission. You can imagine the biography he will write having only known her the last 3 years. You could do much better with all the letters you have & could collect as I have no intention of giving Ira mine however until she dies & he dies there isnt much chance, & if her disposition is any indication of a genius, she is a super one.

I wonder if you got the Xmas box I sent—no doubt it went to the bottom—It was'nt anything very grand—just cigarettes—a lighter—a case & a *real* silk handkerchief to flourish on your nights out. Have you sent the drawing by Nina Hamnett to your mother. I would certainly like to see it. Lord! how I envy you having the chance to see some original stuff.

I may send your portrait & Mr Crawleys to Toronto to a show. It is rather a risk as they handle things so badly & no insurance can really cover it.

I just phoned Mr Grigsby to ask if you had been getting the Bulletins & he said he would send them from now on. Lawren has been writing some wonderful articles on galleries in general & in the ap. no. is going to rip the Van. edifice from stem to stern. Lawren is certainly a tremendous asset to Van & I think it is eventually going to be a bigger art center than Toronto or Montreal. I have only read bits of the Sculptor book & the chapter on Dobson. It is very tame after "Artist Quarter" I hope you have a chance to meet some of the really young painters who [are][4] coming along—They may be in the army but not in the murdering section as I think the Gov. at last has the good sense to realize their value. Even our friend Shadbolt is in uniform but continuing his *"art."*[5] I suppose to preserve a few good ones they have to protect them all—

We have had a week of solid sunshine & spring is in the air—at last—I may go to Victoria for Aunt M's birthday (Mar 11th age 83) & hope to see your mother & bring back your picture. I hope you get a

chance to see Lt. Lawren Harris—his father says he may come out here to live after the war—

Best wishes from us all—

Affectionately

Nan

NOTES
1 See Charles Douglas, *Artist Quarter* (London: Faber & Faber 1941); Eric Underwood, *English Sculpture* (London: Faber & Faber 1933); Christopher Blake, *Modern English Art* (London: G. Allen & Unwin Ltd. 1937); Peter Theone (pseud.), *Modern German Art* (trans. by Charles Fullman) (Harmondsworth, Middlesex: Penguin Books 1938); and Adam Leonhard, *Primitive Art* (Harmondsworth, Middlesex: Penguin Books 1940). Eric Kennington's *Tanks and Tank-Folk* was published by permission of the War Office and Ministry of Information. The booklet in UBCL, Cheney Papers, box 7, file 3, is inscribed: "Nan Lawson Cheney from H.T. 1943."
2 W. & J. Foyle Ltd., London.
3 The sheep dog stories which formed part of Carr's "Creatures" manuscript were published as the second section of *The House of All Sorts* under the title: "Bobtails." See Tippett, *Emily Carr*, 265–6.
4 Inserted in square brackets by Cheney at a later date.
5 Shadbolt had enlisted in the Canadian Army in 1942 and was assigned at first to the Camouflage Training Centre, demonstration staff, Vancouver. In 1944 he became Acting Administration Officer of the Army War Artists at Canadian Military Headquarters in London.

238 [*Cheney to Toms*]

Capilano BC
July 5th 1943

My dear Humphrey.

Your last letter was written Ap. 21st & I am very ashamed that I have not answered it before now. Thanks for the snaps. The moustache

adds to your age but is quite becoming. I have finally got your picture over after all this time—I telephoned your mother as I had'nt time to let her know by letter & she seemed a little surprised however she got it down to the Empress, & they left it with Ira Dilworth at CBC & Hill picked it up. It is an awfully nice one & I have it in the living room over the book case. Hill is having difficulty getting glass that size—as it is very scarce—however we will get it framed as soon as possible & take care of it for you.

Emily had a small show in the watercolour room downstairs[1] & made $250.00 It wasn't half as good as in former years[2] but remarkable that she was able to do anything last year—She came home from hospital in May but has been back several times with heart attacks. She is so bad she has to have oxygen but pulls out of it & is as good as ever again—She is doing several books & her biography of course. Last week Mr Stone died much to the relief of the gallery altho he hasn't had much to do with it lately—apparently last year he tried to get Weston & Macdonald off the exhibition committee without success & was so mad he said he was changing his will & would not leave the Gallery a cent to buy those awful modern pictures—I hav'nt heard the details yet! Our spring show[3] was the best ever with all the rooms downstairs cleared out. The abstract painters had one wall & aside from them there was a lot of new & interesting stuff. I had a still life of shells, glass floats, fish net & a big bottle with the beach at Savary in the background—It is really quite nice & I called it "Relics of the Sea"[4]—Jessie had nothing—she has stopped painting as she is still worry[ing] about the income tax and can talk of nothing else—we find her very boring.

I got the Goldring book you sent & liked it, in spots, very much—he has a large chip on his shoulder & yet I am sure all he says about Critics, etc is perfectly true. The parts about France etc were charming. I sent it on to your mother. I wonder if you bought the Rouault etching & what do you do with such things in camp? Where is the sketch you had Nina Hamnett do? I reread her "Laughing Torso" with interest—It came too—from your mother, but no comment on what

she thought of it.—I am afraid she thinks you are going to the devil. I saw a picture of Edwin Holgate—Chas. Comfort—& Goranson—in the last Maritime Art. Taken in Eng—I wonder if you have seen any of them yet.

I was interested to hear about the concerts you have been hearing but strang[e] about the negro Conductor getting such a poor reception. I read your letter to the Crawleys & Ericksons[5] & last night to Et Trapp. They were all very interested & think you write awfully well. We are having a cold wettish summer with no strawberries & the few for sale are 30¢ a box needless to say no jam is being made by us. however the huckleberries are numerous & I have made a lot of jelly & flavoured some with geranium. It is marvelous with hot biscuits for tea—will save you some! Aunt Mary has been here & is now up at Pender Harbour on an Island with the Jermains[?][6]—she is due back on Wed for another week. She is as energetic as ever despite her 82 years. Dr Trapps place is simply lovely now & they have 24 wild ducklings on their ponds. They feed them of course & they are so tame they follow you about. We are expecting Daisy over later in the summer. She has an apt. in Vic. & is looking for a part time job.

George Pepper is in the army now & Kay is ill so I am sure they are not interested in buying your picture at present—anyway I want to keep it as a showpiece. I am going to try this by Air Mail & see if you get it any more quickly—I do enjoy your letters & do forgive my slowness in answering. I expect things will be happening with you soon—best of luck

affectionately—

Nan

NOTES

1 The show at the VAG of twenty-seven Carr works, was held 11–24 June 1943 and included paintings from her final sketching trip of Aug. 1942 when she camped at Mount Douglas Park. In May, prior to the June show, Carr had written to McGeer: "I plainly see it as the 'Goodbye Emily' show (may send an odd sketch or picture

to mixed exhibitions) but will never undertake one on my own again. What the Trust do with their 'M.E.'s' is now none of my worry. So go and say goodbye to me in June and let me know what you think of the show. I'm afraid it may be a little sombre (most are deep woods, but I assure you they were happy places.) It was 12 days of gladness. I hardly expect to get off like that (in a cabin by myself again)." Undated letter cited in McGeer, "*Oh Call Back Yesterday*," 51. See also BCARS, Inglis Collection, Carr to Dilworth, 13 Mar 1943. Carr wrote, " 'one man's' are almost too much for this old woman now."

2 The Cheney view of the Carr exhibition differs from other opinions. See Hembroff-Schleicher, *Emily Carr*, 319–20, and Mildred Valley Thornton, "New Emily Carr Show at Gallery," *The Vancouver Sun*, 16 June 1943, p. 12. Doris Shadbolt, however, has noted (*The Art of Emily Carr*, 182) that the Mount Douglas Park sketches "often reflect a diminished élan, usually a marked characteristic in her sketches, without compensating qualities."

3 The BCSFA exhibition was held at the VAG, 15 May-6 June 1943.

4 In the UBC collection.

5 Oscar and Myrtle Erickson were parents of Arthur.

6 Likely Mr. and Mrs. Robert L. Jermain.

239 [*Cheney to Toms*]

Capilano B.C.
Aug 23rd 1943

My dear Humphrey

Your last was dated June 17th and I am just getting round to starting a note—I have had a busy summer with visitors & no maid and canning fruit etc against a very lean winter.

Daisy Dodd is with us now. She came for a visit but I think will stay on a bit. She is a great friend of the Trapps & has friends in town & is company for me. needless to say I have not painted a stroke except to put some faces on rag dolls for English children—They are sending 500 from here the end of Aug. for Xmas. Jock went up to Garibaldi & the Harris[es] went to the Rockies which is the only thing to do in the summer in order to get any work done. My "Relics of the sea" is still in the gallery & has been greatly admired. Lilias Farley's brother is just back from Nigeria & has brought the most marvelous

collection of masks & carved figures some are solid ebony & polished—the others painted with boot black and have aluminum teeth & eyes. Some look very north coast Indian. also a mahogany tea table with a carved elephant for a pedistal [sic] very simply done—quite modern—Its a grand show. The B.C. Show is to be nonjury this year— 2 entries allowed but I expect the walls will be plastered Have you seen the portrait of Beurling[1] done by Edwin Holgate? It has been reproduced in a lot of Can. papers & in Maritime Art. Shadbolt is still doing camo[u]flage work at one of the barracks here—also decorating a new club for soldiers which is being built by the Rotary club on Burrard near Dunsmuir[2]—Jessie is not doing a thing but cook & fuss over Sydney—he has been working since Nov. & is a source of income—She retires in 1945 & we dont know what will happen then as she wont be able to keep this big property—I am terrified she will sell it for an auto camp or something equally awful.

We have a good garden this year considering the poor soil & lack of sun—we have several new things like Rhubarb chard. It is like very good beet tops—we also have a huge zucchini squash & celtus [sic] & celeriac & oak leaf letteuce [sic], which is simply delicious down to the last leaf.

We have strawberries—the everlasting variety & raspberries— luckily as they have been 35¢ a box.—peaches are 10¢ each—

I have not heard directly from Emily for over a year but Lawren tells me that she is in bed all the time now & is writing but of course no more painting—her last show here was very feeble however she sold quite a few, and Lawren has arranged a show for her in Seattle[3] which is on now I think. Ira's mother died so Emily now has his undivided attention.

I wonder if you are getting the Bulletins from the Gallery—Mr G. said he would send them regularly—Hope you like your new job and do tell us something about it—I think Geo. Pepper is in Eng. now with the official artist Group. Daisy sends her best

affectionately

Nan

NOTES
1 George ("Buzz") Beurling was a Canadian fighter pilot ace during WW II. The portrait is in the Canadian War Records Collection, War Museum.
2 United Services Club.
3 The exhibition was held at the Seattle Art Museum, 25 Aug.-23 Oct. 1943. There was no catalogue for the show.

240 [*Cheney to Toms*]

Capilano B.C.
Dec 2nd 1943

My dear Humphrey

This is terribly late I know but I hope you had a nice Xmas etc— despite the fact you were in barracks. I had a marvelous week end with your Mother. I wanted to see Aunt Mary & I asked your Mother if she could put me up for a few days. I expect you have heard from her as I know she writes regularly One of your letters came while I was there and so I got in on your latest news. I must say I was a bit nervous about staying with your mother as Daisy put me off with stories of her wonderful housekeeping etc. however we got along famously and your mother has a grand sense of humour. I did not smash any dishes and I am full of admiration for your beautiful belongings. Your Mother & Gordon expect to be in town over the holidays so I hope I can get them out here for dinner—

I saw Emily on Sat. afternoon[1]—after phoning & making an appointment through her housekeeper—one Mrs Shanks, I was ushered into the Studio which was so clean & tidy I hardly knew it except that miserable chipmonk [sic] is still racing around on its wheel—Emily's door was shut, but she was up and cursing Mrs S. for one thing and another—finally she came out—I should say lurched

out gasping for breath & looking too awful for words. She has lost weight & her face & neck looked "all fallen away" so to speak—She got to a chair with my help & began a tirade, between panting, about the Art Gallery & the social affairs to bring in new members etc. She lashed out at Bess & everyone of her old friends except Ira & Lawren—She ranted about the posters being made by the Can. artists for the canteens etc in England & thinks artists are crazy to have anything to do with the war—well, I just sat & looked & listened & felt as if I never wanted to see her again—I know she is ill but she has far more energy than a normal person to waste on cursing & grumbling. I saw Alice for a moment while E. was writing a letter and she said they just lived from day to day hoping the housekeeper would'nt leave—but she said "Millie's temper is enough to drive anyone away"—so after an hr. I left and I have a horrible memory of her[2]—She has written her Autobiography which she gave to Ira & he let Bess & Lawren read it—They say it is really good in spots. It must be *very* egotistical & of course is not to be published until after her death. Aunt Mary & I had dinner with your Mother after that depressing afternoon and we made up for it with one story after another & we all laughed until we were weak—Your mother has some rare ones & even Aunt M. produced a few which were decidely [sic] naughty—we had a lovely dinner & an entertaining evening—I came home on Mon—by boat—I had flown over—but the fog was too thick to return—I had left Daisy in charge here and found her in a very black mood—she left last week quite suddenly while I was out one day—She is getting very queer and just hated it out here—was afraid of the dark & the *neighbours* etc so I am really glad she has gone to town and the bright lights. I am all alone for the first time in 20 years as of course there are no maids to be had—however I am really enjoying it and aside from breaking the dishes cutting & burning myself I am getting on very well—in fact I am a remarkably *good* cook—

I expect you saw in the Art Gallery bulletin that I got an hon. ment. for my "B.C. River"[3]—reproduced on the enclosed card. It is a big canvas & really not too bad but *very* conservative—I am full of

ideas for something quite different—all the awards were dull and stupid—Myfanwy Spencer getting the medal for a wishy washy portrait.[4] They had Dr Clark, Dr Dolman[5] of U.B.C. & Delisle Parker as judges so what could you expect. I hear Geo. Pepper is in Eng. I wonder if you have seen any of the painters—Your mother showed me the clipping about your hunting up the family tree etc.[6] You and Gordon will have to get busy and put some more branches on it—

We see a good deal of Dr Trapp—her place is a real estate now—she has a man & his wife living in the cottage at the gate & he is an experienced gardener then she has a pensioner living in another little house & he does all the chores so it is being well looked after. The house is lovely—my design—and Et is very pleased with the whole thing. Jessie & Sydney are just the same except that Sydney is working & is far more independent—J has one more year after this & then we all wonder if they will get married. Daisy did not approve of this situation at all which is so mid-victorian of her—but of course she did not like any of our friends—even the highly respectable ones My sister in Halifax wrote for your address—She is now a grandmother so more than busy as they are living with them while the father—Surg. Lt. Tony Woolhouse is stationed in Newfoundland I suppose you have heard that John Symons is missing, since Sept 29th he was in a bomber—Florrie is very upset as she was so fond of John & seemed to understand him better than his father & mother. I am glad she sent you some maple sugar—she is 70 now but does not seem that old. The last letter I had from you was June 18th—Hope you will find the enclosed useful—you told your mother you would rather have money, anyway there is nothing to send, of interest from here—

Good luck for 1944—Hill sends his regards.

Affectionately

Nan

P.S. The Bank of Nova Scotia in London will send you a cheque for £1.

I found this the easiest way to get it to you—buy yourself a show or a meal—

NOTES

1 On the same day Carr had written to Dilworth: "Nan Cheeney just phoned. She's coming over today. Mrs. McGeer wrote me yesterday—a first since June. I thought all the Vancouver people had gone back on me." See BCARS, Inglis Collection, n.d. [Oct.-Dec. 1943]. The contacts between Cheney and Carr had lessened (partly due, undoubtedly, to Carr's stand regarding the Cheney portrait). See #244, note 2.

2 Late in life, Cheney was more sympathetic about Carr's situation. "Yes, Emily was a genius to cope with her heart condition, her weight, her house & her correspondence—not to mention her writing and painting." Dorothy Livesay Papers, Department of Archives and Special Collections, University of Manitoba, Cheney to Livesay, 25 Mar. 1979. At the time of the Cheney letter to Toms, Dr. Trapp expressed warmer feelings when she wrote to Carr to thank her for a painting and stated that it was an inspiration to her as "a medical woman to see how far the spirit can dominate the flesh." BCARS, Parnall Collection, 22 Oct. 1943.

3 The recognition was in connection with the BCAE, 25 Sept.-20 Oct. at the VAG. See *AGB* [VAG], 11 (Nov. 1943).

4 The oil portrait of Judith Robinson, Canadian writer, was reproduced on the cover of the *AGB* [VAG], 11 (Nov. 1943), and described as a work "of a high order of merit." Myfanwy Campbell (now Pavelic) was awarded the Beatrice Stone Silver Medal for this work. She also received the BC Artists' Association Bronze Medal in the graphic arts class for her portrait of Jan Cherniavsky. The *Bulletin* notes that this was the first occasion on which one artist had received two medals in a single exhibition.

5 Dr. Claude Ernest Dolman was Head of the Department of Bacteriology and Preventative Medicine at UBC (1936-51). (He was later Head of the Department of Bacteriology and Immunology, 1952-65.)

6 Toms' research into his family genealogy seems to have begun during his service in England. It centred on the towns of Stratton and Bude in Cornwall, then extended out to North Cornwall and Devon. He conducted his research through both correspondence and personal visits to libraries and record offices. He continued his research in the postwar years, and the extensive correspondence and papers derived from this pursuit are held at UBCL, Special Collections Division, Humphrey Toms Research Papers.

241 [*Carr to Cheney*]

[218 St Andrews St]
Dec 17/ [19]43

[card]

Dear Nan

Merry Xmas. (as much as you want to be.) are you going to be at home? I've been 'over-birthdaying' it & feel like a 'mud pie' so have been pretty laid out since.

Been wrestling with the wood problem today[1] then when one gets the wood there is the problem of getting a man to stack or chop it. You either have to get a baby-boy with curls & a teething ring or a rhumatic old cronie who you feel you should go out & sit on the the woodpile with for fear he collapse. I have a sweet little youth who gives one an occasional hour after school. but I wont let him cut *frightful* knots & in the kitchen I have the biggest woman-fool on earth she gets worse. been here 10 months & not threatened to go once but how I have *longed* to kick her.

Well here is to a kindly Xmas to you Hill. a good dinner & a comfortable year.

Affectionately

Emily.

NOTES
1 Although Carr was home from hospital at this date she was forced to return again early in 1944. See #243.

242 [*Carr to Cheney*]

218 St Andrews
Dec. 30/43
[card]

Dear Nan & Hill

Oh how perfectly glorious! I dont think there could be anything much lovlier than a pure white Cyclamun my flower table is just beautiful I've been just punk! but I manage to crawl out & sit by it every day even the days I not up they dont seem to mind my dressing gown I did not write one card or letter for Xmas. I've just laid *flat*. & not even thought much. I'm pretty much of a worm when I can't work. Happy New 1944 I hope she'll improve on 1443 [1943] she seemed all snags get January over & Feb. will begin to think spring things anyhow its very nice to be home and not in the old ''sick-house'' & by dinning & worry I've got some nice wood thank you again she's *lovely*.

love

Emily

243 [*Carr to Toms*]
[*Cpl H.N.N. Toms, 5 Can A/T.K. Regt Canadian Army Overseas*]

Jubilee Hospital
Mar 12 19/44

Dear Humphrey

Your welcome letter came a few days agoe. glad to hear of your doings. You will see from heading what I am up to! 7th time in 6 years I've been hustled off in that hateful white glass hearse & then ''the cat comes back'' everyone's given up being astonished, even me. I'm rather rebellious for each return finds me a bit more groggy.—I never quite catch up its a cruel game, & I've had 8 years of it. Now to answer your letter I have not done anything last 9 weeks but lie not

even think. The hospital is ROTTON. The most uncouth staff (a last pick) every decent nurse is overseas I think civilians have been horribly treated in this war They peeled us of Drs Nurses food If they'd forbid thes[e] unfair last minute[?] marriages & the girl wives toting round after their husband[s] it would ease the whole housing shortage, traffic congestion and there'd be *homes* for the men to come back to, instead of chaos & congestion

Yes 'Small' came out in England (the *only Canadian* book printed in War time London) her first edition was sold out in 2 or 3 month[s] & she has gone into a second of course its wartime paper & suplementary[?] but quite nice to have under the circumstances. The Oxford U Press did not print Klee Wyck in England but they boght from their Canadian Firm quite a lot. I've had several letters from people! Oh the War! well I'm glad to hear of one soul who has felt benefit from it. It will take a *long* perspective of looking back to see it as a whole. our noses are too close on it, right now.

I immagain the comradship of barrack life, must be very amusing very broadening You met all classes all nationalities I have no doubt it has been fine for your corners the fact you know it has shows it has. You have been wise in seeing all you could of the country too as a young girl *I said to myself* I am going to see all the places I can now so that when I am old & cant get about I shall have something to *think* about. (I did not know then that I was to have 8 years & I don't know how much more of invalidism.) A moustache by George! well don't extend it to a beard or its never again will you kiss me. I agree school days are *not* the happiest ones: Bosh! neither wasn't mine

If you ever read my Biog: you will see I think that I did love *country* England It was London & the english worship of traditions that riled me. My publisher, Editor, & Lawren Harris the only three I have allowed to read my biog: say she beats Klee Wyck Small & the rest & should be my best thing to be published personaly I think it very bad taste to publish a autobiog till you're dead. I hope it wont be too long before you come home. Thank you for wanting me to be here, that is not in our hands I have come round some very ugly

corners in last few years the Doctor tells me which have astonished him but I know this, each, turn tells—I never quite catch up a wheel chair has always seemed to me to be almost the next to lowest rung of the ladder but I am going to effect one so that I can get up into the Park & sit around & see things, but everything seems so unpredictable. I gave my last one man show in Vancouver Art Gallery a year agoe (I had the sense to stop at flood tide they say it was some of my best work) it landed me in hospital still it went over. My trustees have told me honestly they will pick me up if they see floppiness in my writing I do not think there will be much more. Why my dear Humphrey what could you have found to write of in Me?[1] except I love the earth & earthy things—The grim picture[2] is I beleive among those unchosen by the Trust in the Studio.

Good bye lots of love from

Your old friend

Emily

NOTES
1 As early as Aug. 1939 Cheney had suggested to Toms that he write a biography of Carr. See #117.
2 Likely a reference to the oil-on-paper self-portrait of Carr. See #148, note 2.

244 [*Carr to Toms*]
[*This is the last of the known Carr to Toms letters.*]

Jubilee Hospital
April 3/44

Dear Humphrey

So glad to get your long newsy letter I often think of you but most
my thinks are done in hospital beds. I'm in Jubilee at present. been
here 3 months (guess the size of the bill) & that is the 3rd visit here
within the last year & before that 6 months at Mrs Clarks Nursing
[home] to die would be much cheaper but you dont get the choice
My heart has accumulated to itself all the stupidity it can immagain
and on top at present it has mounted flu & Bronchitis. I am going to
effect a wheel chair think of that! so I will be able to go up into the
park and see the spring flowers little ducks & signets etc. Shanks[1] can
push. I have on my table a lovely bunch of wild lillies & am joy crazed
with them They smelled so sweet all night. They are so choicely
delicious not one pinch of grossness or vulgarity about them. Yes
"Small" is loose in England (the only *Canadian* book to be published
in War London to date so the publishers say & people took to her so
well that they had to put out a second edition in from first 2 months. I
believe the "Creatures Book" Comes out in autumn whether England
is publishing or just Canada I don't know.

Oh this dreadful dreadful war. when will it end? and even so leave
a trail of horrors behind. Scars that will *never heal* possibly better
things will come in their place who knows, one scarcely dare think
these days go at life day by day with steady cruel pounding I am glad
you feel grown by it. I think it would inevitabley *grow* one I think
mixing with men—all sorts—would expand you & the seeing of
another side of life and new places. *if you keep* your eyes open and are
ready to be taught.

Since last midsummer I have done practicaly no writing—too
ill—I asked Doctor "shall I *force* or rest." he said "he was afraid for
me to force or the whole works might go smash!" I wont even now I
dont seem [illegible] physical or mental strength to nail down to it.
My painting was finished. with the one man show last spring. I'd like
to do a little more writing but _____ well who knows

That fierce sketch of me?!! I spose its still in the racks it is so long
since I went through them. And now I see on your envelope (which
contains *2* letters other not from you "answeared" so if I've dupli-

cated forgive I just write an occasional letter & dont keep good track
Thank you for wanting me to be here when you come home sometimes
I want to go on sometimes not, & its lucky I do not make up my own
mind. I never hear from Nan nor write.[2] Nan's like that. letters thick
& fast or none at all & I wont write one sided correspondence.

Much love.

As always your old friend

Emily

NOTES
1 Mrs. Shanks was Carr's current maid.
2 The Carr-Cheney association at this date seems indeed strained. Cheney did go
to see Carr late in 1944 but the latter was not too receptive to Cheney's gesture.
BCARS, Inglis Collection, Carr to Ira Dilworth, n.d. [November 1944]. Undoubt-
edly part of the problem was the very close friendship that had developed between
Carr and Dilworth. BCARS, Inglis Collection, Carr to Dilworth, ''Testament,'' n.d.

245 [*Carr to Cheney*]

218 St Andrews St
June 4 [postmarked 1944]

Dear Nan

Thank you a million for the beautiful box of flowers received yester-
day a joy to the nose and eye.

I have heard rumours of an impending visit from you for a long
whiles—I expect you were in Victoria & could not find time I've just
popped up after two weeks down my life is very see-saw. I have a
wheel chair & on good days get into the Park a little it has looked
unusually lovely this year I was in hospital (Jubilee) 3 months & came

out just in time to see the flowers. Hospitals are fierce these days so short handed as for food. I told suprentendent I would not sit a pig if I had one down to it.—and *she* agreed with me.

I hope you are better & also Aunt Mary and that you have more than a half-wit to help you, Goodness I'd love to see these miserable creatures that rushed off to don uniforms come crawling to our doors begging *good cook* jobs again They say they give no end of trouble in the camps. & that comes from a *head* (woman in womens works)

Well thank you again and love to both you and Hill.

Yours affectionately

Emily

246 [*Cheney to Toms*]

Capilano B.C.
Aug 27th
[and Nov 12th] 1944

My dear Humphrey

I was indeed surprised and very pleased to have a letter from you from Normandy—I dont deserve to hear from anyone as I have practicly given up writing letters, and I feel very guilty about the few people I know overseas as I have neglected them so terribly—however I am getting on to being a charwoman and now have a little more leisure but I am bored stiff and lead a very dull life. My sister was down in April and we went about quite a lot then—had a lovely dinner party and evening at the Harris' which she considered the high light of her trip.

Lawren has been made the Dominion pres. of the Federation of Can. artists[1] and he has great plans for the post war cultural life of Canada—I only hope he can pull it off—however despite all the

history of the past the Government thinks of nothing but vote-getting and pandering to the illiterate hordes of a certain province in the East, who breed like rabbits. You can guess what it will be like in another 25 years. The Gallery here is booming never had so many members & the shows are getting better—more drastic weeding & the decent ones are hung for 6 weeks at least.

Nov 12th You see what happens to my correspondence. I send [sent] you Christmas Greetings & 1£. through the Bank—which I am sure you can make use of. I was in Vic. last week and saw Emily, who has taken a new lease of life—but her dispossition [sic] is as bad as ever— She has sold 38 pictures in Montreal—through a private Gallery run by a Jew who is a super salesman[2]—also her latest book, "The house of all sorts" will be out before Xmas.

I heard your mother was in hosp. but could not get any details—I expect you have heard from your Aunts about her—

I suppose you know that Capt Geo. Pepper was missing for 10 days behind enemy lines & was given up—however he got back to his unit & apparently is alright I was in Trail in Oct. but did not see Gordon—he was away—The country round about was beautiful all yellow & gold with a few red maples but I did not paint as I had no transportation—I found the people little changed mentally but very prosperous with houses full of *new* antiques and crown derby china which I found very depressing. Your Picasso is still in the B & W. room & is much admired—I hear he is having a show in Paris & expect it will eventually come to N.Y. but never out here I fear Our gallery had the usual *jury* show this fall[3] & hung 200 out of 400 & the papers were swamped with letters of complaint—The usual thing of course & aftermath of a nonjury show last year where all the Cranks got in. Seattle had 700 entries & hung only 150—I did a big canvas of those Ice Caves at Garibaldi & got 1st hon—ment.[4] which might have pleased me 20 years ago but is just ridiculous at my age. Sydney is still working & Jessie is in her last year of school. She is not painting & doubt if she ever does again. Our neighbours are all getting Crazier than ever—I would move if we could—Well Humphrey I do hope you

are alright and the best from us all for Christmas—If you want any specific thing do write & ask for it—how about Welch's candy? Hill sends his best

Affectionately

Nan

NOTES
1 Harris was elected President of the Federation of Canadian Artists in Mar. 1944. See Dr. John D. Robins, "Lawren Harris, National President Federation of Canadian Artists," *Canadian Review of Music and Art*, 3 (Apr.-May 1944): 13–4, 18. Reid, *Atma Buddih Manas*, 46, notes: "A charismatic figure, he had always been a popular leader, and his return to the national stage was greeted with enthusiasm." Harris commented regarding the Federation: "It could be a grand thing for the country but whether the artists amateur & professional (?) will pull together—unite over & above their differences, I dunno." See BCARS, Parnall Collection. Harris to Carr, n.d. [April? 1944].
2 Dr. Max Stern of the Dominion Gallery, Montreal, had visited Carr's studio in early 1944 and arranged at that time to exhibit her work in Montreal. The large comprehensive show was held from 19 Oct. to 4 Nov. 1944.
3 The BCAE was held at the VAG from 23 Sept. to 22 Oct. 1944.
4 See UBCL, Cheney Papers, box 5, file 1b, Grigsby to Cheney, 7 Oct. 1944. This painting is owned by the Patrick McGeer family.

247 [Carr to Cheney]

[*This is the last of the known Carr to Cheney correspondence. It is doubtful that there were any further letters.*]

[postmarked 21 Dec. 1944]
[card]

Merry Xmas and fine New Year haven't got around to Xmas business this year think it good to skip a year and let War get over

best wishes

Emilly

248 [*Cheney to Toms*]

Capilano B.C.
March 20th
[and April 20th] 1945

My dear Humphrey

Your letter of Feb. 8th came last week with my airgraph. It repro-
duced very well—I also got The Art booklet by Barker Fairley[1] some
time ago—very interesting.—By now I expect you have heard from
your mother of Emily's death on Mar. 2nd[2] She had gone into the old
James Bay hotel[3] for a change—It is now run by R.C. nuns for the aged
& I am surprised they accepted her as they do not take people who
need medical attention—she just hated it of course & was only there a
few days when she had a very bad attack one morning—They got the
Dr. who gave her morphia & she died at 3 p.m. She was conscious
right until the end—We heard about it first on the radio at 8:45 p.m.
apparently they had tried to get Ira D. but could not locate him until
late that Evening—he went over next morning & the funeral was set
for Tues. but for some unknown reason they changed it to Mon.
Lawren was there & I hear it was rather a grim affair in a 2nd rate
parlour (she had had a fight with the best undertakers) anyway it was
all done in a hurry & from the account in our paper you would think
she had no relations at all—Ira was named as the chief mourner—
Poor Jock went over on the Mon. night boat & of course it was over.
Grigsby did not know a thing & would like to have gone—needless to
say I did not go but I would like to have been on the side lines to have
written you an unbiased account. Emily was much better off than she
ever let on & Alice will be very comfortable. I expect your mother has
kept all the clippings etc for you. A great to do is being made over her
now in Vic. & the Gov. wants to buy some pictures—apparently the
Hon. Mark Kearley has everyone steamed up[4]—I had a letter by the

same mail as yours, from Geo. Pepper. he was going to look you up if ever in your vicinity—but he expected to go back to Eng. soon to work up his material.

We seem to be having a long wet spring & no flowers in our garden but everything is late here on account of the trees—They have grown tremendously since we came 5 years ago, specially to the South of us and Jessie is getting more stubborn every day—We dare not cut a twig as we would have a law suit on our hands in 1 min. flat. In fact we are seriously thinking of selling the place if we could find something else—I really cannot stand this cave like existence another winter.[5] Grigsby has bought a wonderful place on the corner of Keith Rd & Taylor Way—4 1/2 acres—Southern exposure—view of harbour & bridge & a small house—very low taxes as it is in West Van— we only wish we had seen it first. I have not done a stroke of work for months—This being a cook charwoman is no joke—U.B.C. are going to buy some pictures & have asked me to submit some & I havn't a thing—

We were interested in your description of the preserved cantharelle—I expect you run into some odd things used for food.

The news is very good and surely the European war cant last much longer—

April 20th Humphrey, you will think I am the world's worst correspondent, not to have finished this & got it off but I am getting to be more of a procrastinator every day—so much has happened in your world since I began this & it may be all over by the time this reaches you. U.B.C. bought my canvas "Relics of the sea" which came home from a tour of the west (gone 6 mos. & I almost forgot it)—The Gov. have bought 6 of Emily's canvases and from the papers you would think no one had ever heard of Emily until Ira D. "discovered" her 3 years ago. Apparently the women in the legislator [sic] did the propaganda—the C.C.F.ers chiefly as they are the only so called educated ones. Mrs Steeves[6] etc—Well I must get this off & hope it catches you before you are on your way home. Jock is going to teach at Banff this summer & is very pleased. Collishaw[7] has come home but we have not

seen the great man yet—we merely being neighbours & of no political military or social importance. Et's house is bulging but she has made a beautiful place of it—Kay Pepper is going to have a show here in late May—She is still at Canmore Alberta & it will be on with our annual B.C. Soc. show[8] nearly forgot Grigsby is having a baby—that is his wife—in Aug—she being 45 at least & he seems none too happy about it as he is already a grandfather. The gallery is booming and bursting its seams in more ways than one & they will be needing an assistant just about when you get home so keep it in mind—This is unofficial of course but they are planning a new wing at the back & a special gallery for Emily's work.[9] Hill sends his best—

ever affectionately

Nan

NOTES

1 Fairley (1887–1986) was a professor of German literature at the University of Toronto and sometime painter and art critic. His "Art—Canadians, for the Use Of," *Canadian Affairs*, I, 2 (1944), was one of a series published for the armed forces overseas by the Wartime Information board. Cheney's copy of the twenty-two-page booklet is in UBCL, Cheney Papers, box 3, file 7.

2 See "Emily Carr, Famous Victoria Born Author and Painter, Dies," *Daily Colonist*, Victoria, 3 Mar. 1945, p. 6.

3 St. Mary's Priory. On 19 Feb. 1945 Carr had written to Katherine Cullen Daly regarding the difficulty of getting into a nursing home. She was anxious to enter one "for the rest of winter to further help cure by rest." Letter with Thomas C. Daly, Montreal. Carr entered The Priory 26 Feb. 1945. See Tippett, *Emily Carr*, 276.

4 Kearley, a painter and architect from Metchosin, VI, was appointed Chairman of the Vancouver Island Region of the Federation of Canadian Artists in the summer of 1944. Kearley, in a letter to the editor, *Victoria Daily Times*, 15 Mar. 1945, p. 4, wrote about the "complete indifference" that had been shown to Emily Carr in her native city and urged the citizens to take action in order that "some of Emily Carr's best work" might be retained in Victoria. In 1946 Kearley published a booklet entitled "A Few Hints and Suggestions about Emily Carr and Her Work," which was based on a talk given to the students at Brentwood College, VI [n.d.].

5 Things clearly had not worked out as Cheney had hoped. See #47: "We will be quite a little colony of congenial souls."

6 Dorothy Steeves was a member of the BC Legislature (1934–45). J.K. Nesbitt, "Day in the House," *Vancouver News-Herald*, 7 Mar. 1945, p. 2, reported from Victoria: "It fell to Dutch born Dorothy Gretchen Steeves, now a good Canadian,

to pay a moving tribute to Emily Carr, one of Canada's noted daughters.''

7 Air Vice-Marshal Raymond Collishaw was a brother-in-law of Dr. Trapp.

8 The BCSFA exhibition was held at the VAG, 18 May-10 June 1945. Five works by "the late Emily M. Carr" were included. They were listed in the catalogue as owned by Dr. G.G. Sedgewick (3), Cpl. Humphrey Toms (1), and Mrs. Hill Cheney (1).

9 Official announcements came the following year. The formal presentation of the Carr Collection to the City of Vancouver was made at the opening of the travelling memorial exhibition, "Emily Carr: Her Paintings and Sketches," at the VAG, 1–16 May 1946. Two weeks later, at the annual meeting of the VAG (14 May 1946), Alderman John Bennett, representing the City of Vancouver, announced that "funds would be provided by the City Council for the purchase of a site adjacent to the Art Gallery Building for the construction of an addition to the Gallery premises to be utilized for housing the Emily Carr Collection." *AGB* [VAG], 13 (June 1946). The expanded and renovated VAG was officially opened on 20 Sept. 1951.

249 [*Alice Carr to Cheney*]

220 St. Andrews St.
[postmarked 5 June 1945]

Dear Nan

Thanks ever so much for the beautiful flowers. Ira was here and put them in water for me, they are lovely. I think it was sweet of you to send them. Bess says you still have no servant and are working too hard. I am sorry for that. I suppose things take a long time to straighten out, still they have made a start so we can hope for better things before so very long. The trustees seem to be settling things pretty well, it has been such hard work for them both but the end of that seems to be in sight too. With my love and again thanks

Yours affectionately

Alice M. Carr

NOTES
1 Alice Carr lived until 1953. See "Epilogue," Maria Tippett, *Emily Carr* (Toronto/Oxford/New York: Oxford University Press 1979).

[*In 1979, Humphrey Toms concluded his typescript, "Letters from Emily," 18, with the following: "When Emily died I was in Germany. A few days after her death (2 Mar 1945) I was astonished to see a 3-line report in the Army newspaper the Maple Leaf: an artist's death displacing hockey news from home? And when I returned home early in 1946 it was to find Emily's name was famous."*]

POSTSCRIPT

EMILY Carr continued to write a few letters during the closing months of her life. Mainly they were to Ira Dilworth, who received some seventeen during January and February 1945 (apart from the messages among her papers that were left for him). They show, as did many of her earlier letters, the extent of her admiration for him, and her seemingly obsessive need to keep in constant contact.

Perhaps not uncharacteristically, Carr acquired a new correspondent during these same late months. A brief but meaningful friendship developed between herself and Katherine Cullen Daly, a Toronto woman, who at Christmas time in 1944 sent Carr "a lovely letter of praise" (24 December 1944, BCARS, Inglis Collection, Carr to Dilworth). In her letter, Mrs. Daly told Emily Carr that she had seen her paintings, had read her books, and had wanted to write to her for some time. According to Katherine Cashmore, Mrs Daly's daughter, it was the only "fan" letter her mother had ever written. Carr was exceedingly grateful for the letter and for the others that followed. ("I am so tired tonight," she later wrote to Daly, "but not too tired to love you for your kind thought of me" [16 February 1945].) Alice Carr, in a letter after Emily's death, thanked Katherine Daly for her "great kindness" and for the letters that had cheered her sister so immensely (4? March 1945). Mrs Daly kept in contact with Alice Carr and it was through her generosity that the bridge was erected in Beacon Hill Park in memory of Emily.

The Emily Carr to Katherine Daly letter that follows is included because it seems to sum up, at a time when Emily Carr's letters to Nan Cheney and Humphrey Toms had ceased, a number of the artist's thoughts on her life and work. It is printed with the permission of John Inglis, who holds the copyright, and with the consent of Mrs. Daly's son, Thomas C. Daly, Montreal. Five Emily Carr to Katherine Daly letters, and two from Alice Carr, are in the possession of Thomas C. Daly.

250 *[Carr to Katherine Cullen Daly, Toronto]*

218 St Andrews St Victoria, B.C.
Jan 17/45

Dear Mrs Daley [Daly],

It is with deep humiliation in my heart and pours of tears that at last I settle to answear your kind kind letter. I left it till the last so as to give it time & thght for it touched me deepley. I am so much less nice than you immagain I am. I have written & painted to be shure that was because I could not help it. those things were my life and because it has been a long life (though not so long as old women's lives go now-a-days.) and because not loving them my mind was not much distracted with things that did not belong to my work. I am tired *very* tired and 8 years of invalidism. have in some ways I am afraid soured me a little. I am not corageous as you think, I have such lots of weeps and am impatient very often with things. Mr. Dilworth should have told you that in his lecture[1] but this is enough about me. I am so glad you like first my painting then her twin writing. I have been luckey indeed to have words come to me when I had to give up the woods & sketching & prepare for long inactivity. Small was never a patient child! I am glad you liked my "Bobbies" In that miserable Tormenting House of All Sorts they were what kept me up They were too good to keep to myself. I think I spent more love on that M.S. than almost any other. I tried to meet the Bobbies halfway not expect them to come to my human level but to go to theirs. I did not give them human traits but their own natural loveliness [?] of character to some they they will only be only *dogs* to others they will be more
Klee Wyck was written for pure joy of reliving and traveling among the places & people I loved. She was written in *hospital* (not on my trip as is often stated) I was too buisy painting from dawn to dark to do more than write home. but I intended to use those letters later perhaps—It was a blow when I got home to find the Sister I had written them to had burnt them as received. so I had to rely on memory but having sketched intensely helped & the places came to

me with great vividness.

Sometimes I wish I was beginning all over again. look over old work & you find so many mistakes. but there you are when the time comes to stop you've *got* to stop. I did not expect to have any more shows and here I am preparing for a 'one man', in April,[2] in Vancouver followed by one in Montreal, "Dominion Galleries"[3] Dr said "Well go ahead when your painting stops you stop!" some days I can do nothing this show is feild sketches I did out in my caravan some years back when I was struggling to find a way to approach. B.C. for one or another reason they were put aside. as long as I had caught the main idea I found it easy to pick up the thread & cary it further in a way I was unable to do then. This *will* be the final. My good friends have *promised* (& I trust them) to tell me when for the sake. of other people & Art I should stop

Mr & Mrs Clarke[4] I am very fond of they are so good to me as are Lawren Harris & Mr Dilworth I owe such help & encourage[m]ent, as few have the luck to receive, & to friends like yourself helpful cheery letters that help one along amazingly thank you for writing folks so often *mean* to and *don't*

Very Sincerely Yours

Emily Carr

NOTES

1 Carr wrote to Dilworth (BCARS, Inglis Collection, 23 Dec. 1944), that Mrs. Daly had referred to his talk "before the Canadian women in Toronto." There is no record of Dilworth's talk in the files of the Women's Canadian Club of Toronto.

2 The April exhibition was not held, but a large memorial show, "Emily Carr: Her Paintings and Sketches," was shown at the AGT from 19 Oct. to 19 Nov. 1945, at the NGC from 8 Dec. 1945 to 8 Jan. 1946, at the AAM from 24 Jan. to 10 Feb. 1946, and at the VAG from 1 to 26 May 1946.

3 The Dominion Gallery, Montreal, held a memorial exhibition from 10 to 28 Nov. 1945.

4 Mrs. Daly was a friend of W.H. and Irene Clarke, Emily Carr's Toronto publishers.

TRANSCRIPTION OF THE CARR LETTERS

THE MISSPELLING in Emily Carr letters, as noted previously, is a major problem. Some of the errors occur fairly consistently (a few only once). Carr generally put *e* before *i* (freind, beleive, neice) and often wrote *sh* for *s* (shurely, inshure, inshurance) or added an *e* where none was required (fancey, aweful, agoe). She also frequently used a double consonant where a single one is required (stunn, widdower, untill), and a single for a double (sory, colapsed, personaly). In individual words the usage is sometimes reversed (appal, dissapoint, ocassional). And Carr often practised a phonetic manner of spelling (crum, alreddy, dicide).

In some cases a word is incorrectly spelled only according to its context (principals for principles: symphony's for symphonies; correspondents for correspondence). The same is true of proper names (Edith for Edythe; MacDonald for Macdonald; Evonne for Yvonne), and for grammatical errors (kept for keep, got for get, object for objected, etc.). Some national terms are found both misspelled and in lower case (sweedish, japenes, americane), while elsewhere incorrect mid-sentence capitalization occurs. Often it is difficult to distinguish between upper and lower case letters, although, clearly, some sentences begin with the latter. The letter *t* with its variations in size and form most persistently presented a problem as there was no consistency in its use.

There are unusual punctuation patterns throughout. Carr's use (or lack of use) of periods, commas, colons, and apostrophes is erratic and unorthodox. Again, many irregularities are likely products of either haste or indifference. Periods often appear randomly in mid-sentence (a peculiarity in her style of writing), commas are used in place of periods and semicolons, and colons are employed unconventionally. Apostrophes for possessives and contractions are sometimes misused or omitted while terminal punctuation for a sentence, quotation or bracketed phrase is often ignored. Punctuation is transcribed throughout as closely as possible to the original. Where there is no punctuation, but where a break is indicated by Carr's handwriting, extra letter space has been added in the transcription.

Emily Carr's handwriting is often exceedingly difficult to decipher. Letters are often run together (the en in appointm-nt, the oin in disappointed, etc.), and mid-word vowels are repeatedly ill-defined (apprec--ted, cons-derate, etc.). Generally, in these cases, letters are supplied for readability, but, as their delineation is conjecture, they are placed within square brackets. At times the letter at the end of a word is hardly indicated. This is frequently the case with the *e* in *have*, while the ing at the end of a word is reduced in most instances to little more than a diagonal stroke. Such practices are recognized as characteristic of Carr's personal writing style and are not considered errors. In certain instances, contractions seem clearly intended (gld for glad, alwys for always, thgh or thogh for though, etc.). These are not expanded and are simply further confirmation of a hasty, informal manner of writing.

Some words remain a puzzle. Where there is a likely or possible solution, it is provided in square brackets with a question mark. For those few words that defied all conjecture, the term "illegible," again in square brackets, is substituted.

ABOMINABLY (*abominbly*)

about (*abot*)

abstracts (*abstrats*)

achieve (*acheive*)

affectionately (*affectionaly*)

aggravated (*aggrevated*)

aggravating (*aggrevating*)

agitation (*aggitation*)

ago (*agoe*)

already (*alredy*)

alright (*allright*)

always (*alwys*)

amateur (*amature*)

ambassador (*ambasador*)

American (*americane*)

amount (*ammount*)

annoying (*anoying*)

annual (*anual*)

answer (*answear*)

antediluvian (*antedeluvian*)

antipodes (*antipodees*)

apart (*appart*)

apartment (*appartment*)

apiece (*apice*)

apoplectic (*appoplectic*)

appalling (*appaling*)

appeal (*appeel*)

aren't (*arent*)

arrangements (*arrangets*)

arrive (*arriave*)

asinine (*asseninee*)

. (*assinine*)

assure (*ashure*)

awful (*aweful*)

. (*awefull*)

. (*orful*)

BACHELOR (*batchelor*)

ball (*buld*)

bassinet (*basinette*)

bead (*bede*)

beastly (*beestly*)

beautifully (*beautifuly*)

beginning (*beging*)

believe (*beleive*)

. (*beleve*)

beloved (*belovedst*)

biggish (*bygish*)

bilious (*billious*)

blasé (*blazee*)

bombed (*bommed*)

bomb (*bom*)

bought (*boght*)

. (*bogt*)

bouncy (*bouncey*)

bowls (*bouls*)

braille (*brael*)

brief (*breif*)

brought (*brght*)

. (*broght*)

budgies (*badgies*)

bus (*buss*)

business (*bisness*)

. (*buisness*)

. (*busines*)

. (*busness*)

busy (*buisy*)

but (*butt*)

CAN'T (*cannt*)

. (*cant*)

carry (*cary*)

carrying (*carying*)

caterpillar (*catterpiller*)

cemetery (*cemetry*)

cheese (*chese*)

chief (*cheif*)

chipmunk (*chipmonk*)

choice (*choise*)

chorus (*chorous*)

clothes (*cloe*)

clumsy (*clumsey*)

cocky (*cockey*)

collaborate (*collaborete*)

collapsed (*colapsed*)

college (*colledge*)

commission (*comission*)

committee (*comitee*)

. (*commite*)

. (*committie*)

complete (*complet*)

comradeship (*comradship*)

conceited (*conceted*)

constellations (*constelations*)

contemporaries (*contemporarees*)

convenient (*convenent*)

correspondent (*corespondent*)

cosseted (*cossited*)

credit (*credid*)

crevice (*crevase*)

cripple (*criple*)

crony (*cronie*)

crumb (*crum*)

cuddley (*cuddely*)

cygnets (*signets*)

cyclamen (*cyclamun*)

DEBRIS (*desbris*)

decent (*desent*)

decide (*dicide*)

decided (*desided*)

decision (*decesion*)

decrepit (*decreped*)

deeply (*deepley*)

delightful (*delightfull*)

deliverees (*delivrees*)

dirty (*derty*)

describing (*discribing*)

despairing (*desparing*)

despicable (*dispicable*)

despises (*despisess*)

deuce (*duce*)

diarrhoea (*dihorea*)

. (*diohrea*)

didn't (*diddent*)

died (*deid*)

different (*diffent*)

dirty (*derty*)

disappoint (*dissapoint*)

discoursed (*discourced*)

diseases (*deseases*)

dismal (*dismel*)

divinity (*devinity*)

doesn't (*doesent*)

doomsday (*domesday*)

dreadful (*dredful*)

dreadfully (*dradfully*)

. (*dredfully*)

drippy (*drippey*)

drowned (*dround*)

. (*drownd*)

dumped (*dumt*)

EARFUL (*earfull*)

eccentricities (*excentricities*)

eiderdown (*iderdown*)

elderly (*elderley*)

eligible (*elligible*)

embarrass (*embarras*)

enthuse (*entheuse*)

enthusiastic (*enthustic*)

envelope (*envelop*)

epoch (*epoc*)

especially (*especilly*)

evacuees (*evacues*)

evaporated (*evaperated*)

exasperating (*exhasperating*)

exertion (*excertion*)

exhaustion (*exaustion*)

exist (*exhist*)

existence (*exhistence*)

expectations (*expections*)

experienced (*experenced*)

expired (*expered*)

explaining (*explaning*)

extraordinary (*extroardinary*)

FANCY (*fancey*)

fascinating (*facinating*)

felt (*fellt*)

fields (*feilds*)

fierce (*feirce*)

finished (*finshed*)

flowering (*flouring*)

. (*flowring*)

flu (*flue*)

forlorn (*forlorne*)

fortunately (*fortutely*)

fresh , . (*froshe*)

Friday (*Fryday*)

friend (*freind*)

friendlied (*freindlied*)

furnaces (*furnces*)

furniture (*furnture*)

GAWK (*gauk*)

general (*generel*)

ghastly (*gastly*)

going (*gooing*)

goodness (*goddness*)

grieved (*greived*)

growl (*groul*)

grows (*growes*)

grousey (*grousy*)

guillotining (*guillotting*)

HADN'T (*haddent*)

. (*haddnt*)

happenings (*hapenings*)

haul (*hawl*)

haven't (*havnt*)

. (*havn't*)

health (*helth*)

heavenly (*heavely*)

hello (*hullo*)

hovering (*huvering*)

hurry (*hury*)

hurt (*hert*)

hurts (*heurts*)

hussy (*hussey*)

. (*hussie*)

hydraheaded (hydraheadded)
IMAGE (immage)
imagine (immagain)
immediate (imegiate)
immensely (immenseley)
impoverished (impoversed)
improvement (impruvment)
indefinitely (indefintely)
inevitably (inevitabley)
infinitesimal (infitessimel)
insincerity (incincerty)
instead (insted)
. (instedd)
insure (inshure)
insurance (inshurance)
interruptions (interuptions)
intolerant (intollerant)
intricacies (intricasies)
invalid (invalide)
JAPANESE (Japenes)
. (jappie)
KIDNEYS (kideneys)
LAMBS (lams)
lay (laey)
leaves (leavs)
letters (leters)
lilies (lillies)
loathe (loath)
lose (loose)
losing (loosing)
lucky (luckey)
luscious (lucious)
'MAGINE ('magain)
manage (mange)

manners (mannas)
marrieds (marriedes)
maudlin (maudling)
mawkish (maukish)
maybe (maybbe)
measles (measels)
measley (measely)
memoir (memoire)
mercy (mercey)
merrily (merily)
minutes (minites)
miserable (miserible)
modernities (moderitees)
moire (morie)
mournful (mournfull)
mouthful (mouthfull)
muddler (mudler)
NATIONALLY (nationaly)
naturally (naturaly)
natural (naturul)
negligent (neglegent)
news (newes)
nicely (nicley)
niece (neice)
nuisance (nusance)
OBSTREPEROUS (obstreberous)
. (obstreprous)
occasionally (occasionaly)
omelette (omlet)
opposite (oposite)
originally (originaly)
orphan (orfin)
oust (ooust)
owes (ows)

PAINTER (*panter*)

pale (*palee*)

palette (*pallet*)

. (*pallett*)

. (*pallette*)

pansy (*pansey*)

paralyzed (*paralized*)

parlour (*parlor*)

patient (*pateint*)

pattern (*patern*)

pedestalled (*pedistelled*)

pencil (*pencle*)

perky (*perkey*)

periodically (*periodicly*)

personally (*personaly*)

persuaded (*preduaded*)

petticoated (*peticoted*)

philosophy (*philesophy*)

pickle (*pickel*)

piece (*peice*)

plumbers (*plummers*)

polyanthuses (*pollyanthesus*)

possessed (*posessed*)

practically (*practicly*)

prejudiced (*preducided*)

primitive (*primtive*)

principles (*principals*)

proceed (*perceed*)

puddledy (*puddeldy*)

pyjamas (*pejams*)

. (*pajamas*)

QUARANTINE (*quarentine*)

quite (*quit*)

REALLY (*rally*)

. (*realy*)

recall (*recal*)

received (*receved*)

recipe (*recipty*)

reckoned (*reckened*)

recommend (*reccomend*)

relief (*releif*)

relies (*relys*)

relieved (*releived*)

retrieve (*retreive*)

reverence (*reverance*)

rhapsody (*rapsody*)

rheumatic (*rhumatic*)

rhythm (*rhythmn*)

royal (*royall*)

running (*runing*)

rusticating (*ruusticating*)

SANDWICH (*sanwitch*)

schedule (*skedual*)

scraggling (*skragling*)

screen (*screene*)

see (*see*)

septic-tank (*ceptic-tank*)

shadows (*shaddows*)

shielded (*sheilded*)

short-handedness (*short-handeness*)

shut (*shute*)

sickens (*seckens*)

sister (*sisster*)

sit (*sitt*)

slamming (*slaming*)

sleeve (*sleve*)

slept (*sleept*)

sniff (*snif*)

societies (*societes*)
soldier (*soldeir*)
sorry (*sory*)
spasms (*spasams*)
speaking (*speeking*)
special (*specal*)
spontaneity (*sponteniaty*)
springy (*springey*)
squeejee (*squejee*)
stages (*stagess*)
stalwart (*satalwart*)
started (*startded*)
stomach (*stomache*)
. (*stomack*)
strenuously (*strenuosly*)
studied (*studdied*)
stuff (*stiff*)
stun (*stunn*)
success (*sucess*)
sun (*sund*)
superfluities (*superflutees*)
superintend (*suprentind*)
superintendent . . . (*suprentendent*)
sure (*shure*)
surely (*shurely*)
sustenance (*sustinense*)
Swedish (*sweedish*)
syllable (*sillabel*)
sympathetically . . . (*sympathetcaly*)
symphonies (*symphony's*)
TEMPERAMENT (*temprament*)
tenants (*tennants*)
. (*tennents*)
. (*tennets*)

terrifically (*terrificaly*)
thought (*thght*)
. (*thogt*)
through (*thrgh*)
thumb (*thum*)
tidied (*tidyied*)
tolerate (*tollerate*)
too (*to*)
trashy (*treshy*)
trellis (*trellice*)
tried (*treid*)
trifles (*trifels*)
Tuesday (*Teusday*)
tumbled (*tumpled*)
tummy (*tummey*)
ULCERS (*ulsers*)
unacquainted (*unacquaited*)
undergo (*undergoe*)
until (*untill*)
upon (*upone*)
VALIANTLY (*valliantly*)
variegated (*varigated*)
view (*veiw*)
vengeance (*vengance*)
. (*vengence*)
vertical (*virtical*)
vestige (*vestage*)
viewpoint (*veiwpoint*)
vociferous (*vercifirous*)
WAINSCOTT (*wanscott*)
wasn't (*wasent*)
watch (*watche*)
week's (*weeks*)
whether (*wether*)

widower (*widdower*)
wielding (*weilding*)
worry (*wory*)

wrote (*wrot*)
. (*writ*)
YES (*yess*)

INDEX

ABOVE THE GRAVEL PIT, xx, 121, 122, 124, 126, 127, 131, 132, 138, 156, 164 (sketch), 354 (sketch)

Above the Trees, xx

Adolphus, 7, 10–11, 17, 23

Alexander Robert S., 185

"All-Canadian Exhibition," 10

Amess, Fred, 229, 265

Amsden, Phillip Hennell, 253

Antonacci, Nancy, xxix, 186

Annual Exhibition of Canadian Art, 10, 13

Annual Exhibition of Northwest Artists, 4

Apples & Madonnas: Emotional Expression in Modern Art, 11

Archangel House, 271, 275

Archives: British Columbia Archives and Records Service, xxxvii, xxxviii; Canadian Museum of Civilization, Canadian Centre for Folk Culture Studies, xxxviii; National Gallery of Canada, xxxvii, xxxviii; Smithsonian Institution, Archives of American Art, xxxviii; University of British Columbia, The Library, Special Collections Division, xxxvii; University of Manitoba, Archives and Special Collections, xxxviii; Vancouver Art Gallery, xxxviii

Art Association of Montreal, 97, 118, 156, 157, 310, 351. *See also* Carr, Montreal

Art Gallery Bulletin [Vancouver], 177, 366, 391, 396, 398

Art Gallery of Toronto (now Art Gallery of Ontario), 140, 156, 160, 295, 355, 374, 376, 382

Art Spirit, The, 11

Artist Quarter, 390, 391

Arts and Crafts Society. *See* Island Arts and Crafts Society

Atkinson, Lawrence, 8

Aunt Mary. *See* Mary Lawson

Ayre, Robert, 208

B.C. RIVER, 398

Baillie, Dr. David, 194

Bailly, Evern Earle, 376

Baldwin, Jack, 354, 355, 366

Baldwin, Lt.-Colonel Sidney George, 354

Baldwin, Martin, 118

Bali and Angkor, 237

Band, Charles S., 47, 76, 79, 100

Banff School of Fine Arts, 36, 364, 381, 411

Barbeau, Charles Marius; 7, 9, 13, 16, 21, 31, 145, 186, 187, 201, 378; correspondence with Emily Carr, 13, 16, 31

Barbeau, Mrs. Charles Marius (Marie), 11, 378

Bartlett, Captain Bob, 364

Beacon Hill Park, 22, 415

Beattie, Sir Edward, 266

Bell, Betty, xxix, 125

Bell, Dorothy, 229

Bell, Marjorie, 348, 355, 358, 382

Beurling, George ("Buzz"), 396

Binning, B.C., 229

Birtch, Carol, xxix, 333, 336, 382, 383

Blake, Christopher, 390

Blavatsky, Madame, 280

Blunden Harbour, xix

Bobak, Molly, 358

Book of Small, The, 324, 331, 362, 374, 378, 382, 385, 389, 403, 405

Boultbee, Gardiner, 68, 87

Boultbee, Una, 54, 68, 77, 87, 89, 96, 114, 117, 121, 134, 143, 146, 152, 193, 235, 294, 307

Boyd, Sheila, 172, 234, 237

Brand, Edythe. *See* Edythe Hembroff-Schleicher

Brand, Frederick J., 29, 36, 51, 59, 61, 80, 95, 101, 126, 146, 179, 213, 235, 245, 249, 258, 266–7, 268, 278, 280, 308, 310, 346

Brandtner, Fritz, 194, 219

Braque, Georges, 385

Bread and Wine, 52

British Columbia Artists' Exhibition, 47, 100, 226, 246, 265, 396, 408

British Columbia Society of Fine Arts, 38, 51, 77, 83, 160, 174, 175, 179, 185, 221–2, 362, 367, 369, 375, 393, 412

Brock, Mildren Britten, 205

Brown, Annora, 100

Brown, Arnesby, 168

Brown, Eric, xi, xxii, 7, 10, 13, 23, 25, 31, 36, 38, 71, 77, 95, 100, 102, 112, 114, 129, 141, 145, 156, 179, 200, 307; death of, 167, 168, 172, 173, 199; letters to Nan Cheney, 40–1, 74–5, 98–9, 157–8

Brown, F. Maud, 7, 23, 31, 40, 73, 83, 97, 98, 133, 140, 141, 154, 172, 192, 378

Brunst, S.E., 306

Buchanan, Donald, 342

Buck, Pearl, 278

Bullock-Webster, barbara II., 84

Burd, F.J., 365

Burns, Flora Hamilton, 62, 67, 134, 176, 184, 193, 234, 332; as editor, xxxi, xxxii, 62, 67

CANADIAN CLUB, 16, 22, 417

Canadian Forum, The, 159, 160

Canadian Geographic Journal, 3

Canadian Group of Painters, 30, 54, 140, 145, 154, 157, 194, 356, 362

Canadian Homes and Gardens, 171

Canadian Landscape Painting ("A.Y. Jackson film"), 365, 369

Canadian Soldier, 370, 376

"Canadian West Coast Art: Native and Modern," xii

Cann, Jeannette, 131, 190, 207, 209, 210, 299–300, 304

Cannibal King, The, 229

"Canoe," 326

Capilano Fisherman, 369

Capilano, Mary, 201, 282. *See* Cheney, portraits

"Caravan trailer" ("The Elephant"), 28, 29, 79, 82, 85, 89, 91, 222, 417

Carnegie Library, 162

Carr, Alice, xviii, 13, 86, 88, 95, 109, 114, 121, 126, 129, 134, 145, 175, 176, 178, 180, 190, 191, 195, 206, 210, 212, 214, 217, 218, 228, 232, 235, 239, 240, 243, 249, 251, 254, 255, 264, 269, 275, 278, 281, 284, 285, 291, 292, 294, 295, 296, 303, 304, 306, 307, 308, 311, 315, 317, 321, 327, 334, 337, 339, 341, 344, 345, 346, 352, 371, 372, 384, 398, 410; correspondence with Katherine Daly, 415; health, 43–4, 46, 77, 79, 109, 121, 126, 151, 206, 289–90, 291–2, 297, 302, 389; letters to Nan Cheney, 207–8, 413

Carr, Elizabeth (Lizzie), 44

Carr, Emily
– animals, 7, 10, 11, 17, 18, 23, 56, 58, 63, 79, 80, 95, 120, 175, 215, 239,

360, 416. *See also* Adolphus, Felex, Hitler, KittyJohn, Koko, Lady Jane, Matilda, Pout, Sara, Tantrum, Tillie, Vanathe, Woo
– on art criticism, 3–4, 13, 22, 46, 49, 51, 70, 94–5, 104, 113, 126, 196, 263, 280, 281, 284–5, 292–3, 298–9, 300, 313
– on art galleries, 21–2, 47, 79. *See also* VAG, NGC, AAM
– automobile trips, 88, 147, 174, 175, 178, 255, 274, 352
– birds, 54, 62–3, 66, 68–9, 80, 84, 87, 88–9, 91, 110, 143, 165, 215, 218, 220, 222, 272, 275, 277, 279, 293, 311, 318, 321, 334, 335
– broadcasts, 183, 215, 217, 232, 240, 242, 252, 257, 322–3, 326, 345
– on Chicago trip, 28
– Cordova Bay sketching, 221
– chronology, xli-xliv
– death of, 410
– exhibitions
 (1930), (Victoria) IAACS, 3; Seattle Art Institute, Northwest Artists, 4; (solo), 4, 7
 (1931), AGT (G of 7), 10; Baltimore Museum of Art, 7
 (1932), NGC (AECA), 13
 (1933), NGC (AECA), 25
 (1935), Lyceum Club and Women's Art Institute (solo), 30
 (1936), AGT (CGP), 30
 (1937), VAG (BCSFA), 38; VAG (BCAE), 47; "Coronation Exhibition" (London), 40; AGT (CGP), 54
 (1938), VAG (BCAE), 100; VAG (solo), 41, 96, 97, 100, 104, 106–9 *passim*, 111–25 *passim*, 127, 130, 132, 134, 135, 137; UBC (solo), 122, 123, 124, 125, 126, 130–1; Tate Gallery (London), 100, 129, 131, 133; IAACS (Victoria), 126
 (1939), AGT (CGP), 194; Golden Gate International Exposition, 141, 145, 148, 153; New York World's Fair, 172, 194; VAG (solo), 187, 193, 194, 196, 202, 203, 204, 205, 206, 208, 210, 220; VAG ("Six Local Artists"), 165, 185, 187

(1940), (The Grange; four-person
show), 194, 196, 219, 222; VAG
(BCSFA), 221–2; UBC (solo), 266,
268, 274; VAG (solo), 239, 248, 251,
254, 255, 257, 260, 262, 266, 273
(1941), VAG (solo), 331, 334, 338,
339, 341, 343
(1942), VAG (BCSFA), 362, 367, 369,
375
(1943), AGT (solo), 382; Seattle Art
Museum (solo), 396; VAG (solo),
393, 396, 404, 405
(1944), Dominion Gallery (Mont-
real), 408, 417
– friendship, ix-x, 417; with Cheney,
xi-xv; with Toms, xv
– health, 36, 38, 43, 45–6, 62, 80,
84–5, 93, 114, 118, 168, 180, 207,
209, 210, 217, 220, 228, 229, 231–7
passim, 240–1, 245, 255, 259–60,
268, 291, 305, 313, 314–15, 316,
317, 327, 330, 336, 338, 368, 376,
378, 396, 397–8, 401–6, 408
– hospitalization, 166, 167, 231, 378,
379, 381, 383, 403, 405–7, 410
– housekeepers: Blanche, 178, 179,
180, 187; Flora, 69, 71, 78; Florence,
199, 204, 205, 206, 210, 217, 222,
224, 227, 232, 234, 297, 299; Louise,
54, 55, 56, 57, 65; Ruby, 236, 238,
239, 243, 244, 249; search for, 37,
167, 246, 254, 285; Mrs. Shanks,
397–8, 405; Shirley Duggan, 84, 85,
86, 88, 94, 95, 119, 121, 125, 135,
143, 151, 156, 164, 165, 166–7; un-
identified, 7, 43, 67, 69, 78, 82, 168,
169–70, 187, 191, 194, 196, 244,
291, 296, 297, 350, 356, 360, 401
– Indians, references to, 23, 151, 183,
194, 196, 218, 253, 266, 268, 290,
318, 326–7, 331, 337
– letters to Humphrey Toms, 26–7,
34–5, 41–2, 93, 144, 150, 174,
181–2, 211–12, 248–50, 257–8,
273–6, 297–300, 312–13, 352–4,
373–5, 377–9, 388–9, 402–6
– letters to Katherine Daly, 416–17
– letters to Nan Cheney, 3–26, 27–34,
35–9, 42–71, 76–82, 83–91, 93–6,
99–101, 103–5, 107–10, 113–17,

119–22, 125–30, 134–6, 41–7, 148,
151–2, 155–7, 165–6, 168–70,
171–3, 175–6, 178–81, 182–3, 186–8,
190–5, 198–9, 202–8, 210–11,
212–16, 217–22, 223–4, 231–2,
238–40, 241–5, 250–3, 254–7,
258–64, 267–71, 270–3, 276–82,
279–80, 283–6, 288–96, 303–11,
314–15, 316–23, 326–31, 334–5,
337–46, 349–50, 351–2, 360–2,
367–8, 383–4, 387–8, 400–2, 406–7,
409–10
– Macdonald Park expeditions, 87, 89,
91, 180
– on proposed exhibition in Montreal,
56, 153, 154, 156, 157, 159, 160,
162, 163, 165, 171, 194, 196, 198,
200, 201
– on men, 95, 135, 143, 308, 338
– moves, 30, 36, 214, 215, 217, 223
– on music, 293, 302
– on neighbours, 134–5
– painting and sketching, 3, 4, 10,
13–14, 17, 30, 35, 43, 51, 61, 79, 87,
89, 91, 94, 95, 114, 126, 127, 135,
141, 151, 163–4, 169 70, 176, 178,
180, 182, 183, 192, 196, 218, 220,
222, 227, 261, 263, 266, 270, 271,
275, 281, 286, 305, 326, 330, 331,
343, 346, 356, 367, 374, 378, 381,
405, 416, 417; *Above the Gravel Pit*,
xx, 121, 122, 124, 126, 127, 131,
132, 137, 156, 164 (sketch), 354
(sketch); *The Cedar*, 356; *Deep Forest*,
112; *Flung Beyond the Waves*, 129;
Indian Village, Alert Bay, 337; *Little
Pine*, 148; *Old and New Forest*, 148;
Solemn Big Woods, 132; *Totem Poles,
Kitseukla*, 73; *Village of Yan*, 118,
218–19, 260, 261, 268; *Wood's Edge*,
129
– portraits: Nan Cheney, 138, 140; self-
portrait, 10, 13–14, 227, 404, 405;
Humphrey Toms, 254, 313
– unidentified portraits, 140
– on pottery, 6, 7, 20–1
– on reading, 8, 11, 52, 57, 61, 72, 64,
85, 165, 271, 275, 278, 280, 292,
303, 306, 327, 339, 345
– on rug-making, 8, 61, 64, 67, 84,

137–8, 146, 148, 256
- sales, 10, 22, 39, 41, 44, 73, 76, 91, 109, 118, 122, 125, 127, 129, 130, 132, 133, 135, 147, 170, 196, 218, 219, 220, 222, 261, 266, 268, 273, 274, 290, 342, 356, 375, 408, 410, 411
- on sewing, 14, 49, 84, 87, 91, 134–5, 220, 256, 261, 266, 268, 274, 281, 304, 308, 311, 327, 330, 343
- sketching trips
 (1932), Metchosin, BC, 18, 19, 20, 21, 386
 (1935), Metchosin, BC, 29
 (1936), Metchosin, BC, 35
 (1938), Telegraph Bay Road, Cadboro Bay, BC, 86, 88, 92, 93, 94, 95, 103
 (1939), Langford, BC, 178, 179, 180, 181, 182, 183, 187
 (1939), Craigflower Road, Victoria, BC, 194, 198
 (1940), Metchosin, BC, 223, 224, 227
 (1942), Mt. Douglas Park, BC, 378, 381
- speeches, 30–1, 81
- on Toronto visit, 28
- visitors: unidentified, 7, 44, 47, 103–4, 141, 194; unwelcome, 46, 64, 77, 84, 126, 218, 260, 284, 285, 289, 292, 319–20, 360
- visits to Vancouver, 116–17, 118, 119, 225, 245, 334, 337, 338, 339, 371–3, 374, 375, 376, 377
- on woods, 17, 29, 45, 69, 80, 87, 89, 91, 94, 182, 194, 198, 219, 222, 248, 263, 295, 298, 302, 316, 328, 337, 352, 367–8, 369, 371, 374
- writing, 43, 46, 49, 56, 69, 71, 80, 82, 83, 84, 88, 100, 110, 135, 138, 145, 183, 216, 219, 221, 222, 232, 234, 241, 263, 281, 295, 298, 305, 307, 312, 313, 316, 317–18, 321, 326, 331, 334, 393, 398, 403, 404, 405, 46; "Autobiography," 307, 312, 393, 398, 403; *The Book of Small*, 253, 317, 324, 331, 362, 374, 378, 382, 385, 389, 403, 405; "Canoe," 326; "Chins Up," 62, 67, 82; "Creatures," 391, 405; *THe House of All Sorts*, 53, 57, 59, 408, 416; *Hundreds and Thousands: The Journals of Emily Carr*, xxiii; *Klee Wyck*, x–xi, 253, 318, 331, 335, 337, 342, 345, 346, 347, 351, 352, 353, 355–6, 361, 374, 378, 403, 416; "Salt Water," 82; "Sunday," 139, 307; "Wild Flowers," 295; "Woo's Life," 213, 216
- *See also* Note on the Text and Transcription of the Carr Letters re Carr's handwriting, punctuation, and spelling (in this volume)

Carter, Margaret, 108
Cash, Gwen, xv, 27, 114, 189
Cashmore, Katherin (Kay), 415
Cedar, The, 356
Cézanne, Paul, 146, 229
Cheney, Dr. Hill, xiv, 36, 57, 60, 96, 121, 123, 140, 213, 216, 247, 249, 252, 273, 278, 279, 281, 286, 296, 311, 318, 323, 324, 325, 327, 331, 354, 362, 365, 368, 369, 374, 376, 382, 387, 388, 390, 393, 399, 401, 407, 412
Cheney, Nan (Anna Gertrude) Lawson
- art talks, 72, 162
- Capilano Rd. house, 221, 238, 242, 244, 249, 250, 257
- chronology, xliv–xlv
- exhibitions
 (1932), NGC (AECA), 14
 (1937), VAG, (BCAE), 49
 (1938), VAG (solo), 64, 70, 76; VAG (BCAE), 104–5; VAG (Six Local Artists), 96
 (1939), AGT (OSA), 136, 154, 157; AAM, 162; VAG (BCSFA), 174; VAG (BCAE), 201
 (1942), VAG (solo), 358, 364, 366, 369
 (1943), VAG (BCAE), 398
 (1944), VAG (BCAE), 409
- friendship with Emily Carr, xi–xv
- friendship with Humphrey Toms, xi–xiii, xvi
- health, 20, 38, 39, 234, 242, 259, 295, 303, 316, 324, 371, 374
- interruption in correspondence with Emily Carr, xiii
- letters to Emily Carr, 111–13, 122–4
- letters to Eric Brown, 39–40, 71–3, 92, 96–7, 133, 139–40, 152–4, 161–2

– letters to H.O. McCurry, 101–2, 110–11, 118, 132, 173–4, 176–7
– letters to Humphrey Toms, 105–6, 130–1, 149, 159–60, 170–1, 185–6, 188–90, 197, 200–2, 208–9, 225–6, 228–30, 234–5, 236–7, 245–8, 264–7, 272–3, 286–8, 300–2, 323–5, 333 4, 347–9, 354–9, 362–7, 368–9, 375–7, 380–2, 389–400, 407–9, 410–12
– as medical artist, xiii, xxii, 29, 31
– as member of Ottawa art community, xii-xiii
– move to Vancouver, 36
– paintings: *B.C. River*, 398; *Boat House Dwellers, Nelson, B.C.*, 15; *Capilano Fisherman*, 369; *Ice Caves at Garibaldi*, 408; *Relics of the Sea*, 393, 395, 411
– portraits: Jack Baldwin, 354, 355, 366; "Bobsy," 49; Mary Capilano, 201, 339–40, 348, 363, 376; Emily Carr, xiv, xxii, 50, 51, 67, 71, 75, 92, 95, 96, 98, 102, 110, 112, 121, 123, 127, 132, 136, 140, 145, 154, 157, 161, 162, 173, 174, 177, 200, 333, 382; Filmer Coy, 355; Alan Crawley, 347, 391; Mary Lawson, 49; J.W.G. Macdonald, 102, 136, 140, 149, 154, 156, 159, 161, 173, 177; Norrie McLeod, 380; self-portrait, 226; Nikolai and Tina Seminoff, 136, 140, 154, 162; Gaie Taylor, 159, 174; Humphrey Toms, 227, 341, 347, 359, 363, 381, 391; William P. Weston, 149, 151, 154, 174; unidentified portraits, 226
– on reading, 149, 237, 273, 287, 290, 301, 302, 357, 380, 390, 393
– sketching trips: Garibaldi Park, 96–7, 100, 101, 104–5, 140; Savary Island, 226, 229, 231, 246
– studio, 149, 156, 311, 325, 334
– Vancouver Art Gallery Council, 176, 302, 324, 341, 365, 366, 367, 368–9
– visits to Emily Carr, 60, 77, 79, 81, 82, 85, 88, 92, 140, 180, 203, 371, 397–8
Cheney Photograph Collection, xiii
"Chins Up," 62, 67, 82
Christian Science Monitor, 300–1

Clark, Dr. A.F.B., 125, 265, 324, 366, 369, 399
Clarke, W.H., 310, 342, 350, 353, 381, 403, 417
Clarke, Mrs. W.H. (Irene), 310, 417
Clay, Margaret, 59, 146, 176, 280, 319
Clegg, Mrs. E.B., 171, 185
Collishaw, Raymond, 349, 411
Colman, Mary, 115
Comfort, Charles, 194, 196, 216, 219, 222, 394
Conference of Canadian Artists ("Kingston Conference"), 324, 329
Cornwallis, Edward, 357
"Coronation Exhibition," 40
Courtenay, Lysle, 20–1, 23, 25
Coventry, Sub-Lt. Tom, 370
Cowie, Alex G., 143
Cox, Ralph, 225, 266, 273
Coy, Filmer Rupert, 355
Crawley, Alan, 287, 292, 347, 390, 391, 394
Crawley, Mrs. Alan (Jean), 287, 390, 391, 394
"Creatures," 391, 405
DALTON, WILLIE, 324
Daly, Katherine Cullen, xxxi, 415–17
Daly, Thomas C., xxxvii, 415
Davies, Blodwen, 153, 158
Davies, Clem, 256
Dear Theo, 61
Deep Forest, 112
Dilworth, Ira, 177, 179, 183, 186, 232, 319, 321, 330, 333, 336, 338, 355, 367, 368, 369, 374, 375, 376, 379, 381, 382, 385, 391, 393, 396, 398, 410, 411, 415, 416, 417; as editor, xxxv, xxxvi, 253, 278, 298, 310, 317, 319, 324, 329, 332, 334, 337, 339, 353, 355–6, 403, 416; Emily Carr Trust, 366; friendship with Emily Carr, xiv-xv, xviii, 338, 363–4, 385, 417; as story reader, 240, 242, 252, 322, 326; as Vancouver Art Gallery Council member, 369
Dilworth, Phylis. *See* Phylis Dilworth Inglis
Dobson, Frank, 385, 391
Dodd, Daisy, 131, 160, 185, 325, 382, 394, 395, 396, 397, 398, 399
Dolman, Dr. Claude Ernest, 399

Dominion Gallery, 408, 417
Douglas, Charles, 390
Draper, Ruth, 217
Drummond-Davies, Nora, 22
Drying Herring Roe, 96, 99, 132, 149
Duggan, Shirley. *See* Carr, housekeepers
Duncan, Douglas, 17?
EARP, TOMMY, 385
Edge of the Forest, xx
Education of Hyman Kaplan, The, 302
Edwards, Allan, 126, 131
Ellis, Christopher, 346
Emerson, Ralph Waldo, 81
Emily Carr Trust, 124, 332, 351, 358–9,
 364, 366, 367, 374
Empress Hotel, 196, 255, 264, 302, 302,
 304, 320, 359, 393
English Sculpture, 390
Ensor, John, 319
Epstein, Jacob, 385
Erickson, Arthur, 154
Erickson, Myrtle, 394
Erickson, Oscar, 394
FAIRLEY, BARKER, 410
Farley, Lilias, 287, 395
Faunt, Jessie, 154, 185, 225, 230, 247,
 260, 263, 265, 273, 278, 287, 293, 301,
 302, 318, 324, 330, 348, 356, 359, 370,
 376, 393, 396, 399, 408, 411
Federation of Canadian Artists, 376, 407
Felex, 7
Fell, Ella May, 356
"First Baltimore Exhibition of Contempo-
 rary Paintings," 7
Fisher, Orville, 72, 152, 153
FitzGerald, LeMoine, 46
Flavia, 84
Flecker, James Elroy, 385
Flung Beyond the Waves, 129
For Whom the Bell Tolls, 273
Fowler, Pat, 202
Fraser, J.G., 192
Fry, Roger, 293, 303, 308
"GARDEN PARTY, THE," 62
Garibaldi Park, 96–7, 100, 101, 105, 140,
 395
Garrett, David, 149
Gauguin, Paul, 61
Gillson, Dr. A.H.S., 153, 154, 157, 200,
 201

Gilmour, Hazel, 264
Godfrey, James T., 86, 88
Godfrey, Janet, 85, 86, 88
Golden Gate International Exposition,
 141, 152
Goldring, Douglas, 385, 390, 393
Good Earth, The, 49
Goranson, Paul, 72, 12, 153, 394
Goutière, George, 108
Grange, The (Art Gallery of Ontario),
 44, 196, 216
Grigsby, A.S., 40, 73, 84, 87, 89, 96,
 109, 112, 117, 121, 125, 127, 129, 134,
 135, 187, 204, 205, 207, 259–60, 262,
 265, 270, 273, 324, 339, 348, 355, 358,
 375, 381, 391, 396, 410, 411, 412
Group of Seven, xii, 10, 33–4
HAMNETT, NINA, 385, 391, 393
Harris, Beatrice, 16, 30
Harris, Bess, 30, 31, 44, 49, 170, 246,
 251, 255, 259, 260, 265, 271, 276, 278,
 279, 280, 284, 286, 287, 295, 296, 301,
 305, 306, 319, 322, 324, 325, 328, 329,
 330, 331, 334, 337, 339, 344, 348, 354,
 356, 358, 360, 368, 369, 370, 371, 373,
 376, 390, 395, 398, 407
Harris, Lawren P., 337, 392
Harris, Lawren S., 10, 16, 194, 196, 216,
 219, 222, 246, 251, 259, 260, 263, 271,
 278, 279, 284, 295, 296, 301, 306, 311,
 319, 329, 330, 333, 334, 338, 341, 342,
 343, 345, 348, 353, 355, 356, 358, 360,
 362, 363, 364, 365, 370, 371, 373, 390,
 396, 398, 403, 410; abstracts, 49, 54,
 259, 265, 286, 337, 339; Emily Carr
 Trust, 351, 366, 374; Federation of
 Canadian Artists, 407; friendship with
 Carr, 259, 280, 326, 338, 363–4, 367,
 385, 417; Rockies trip, 334, 395; VAG
 (solo), 311, 313, 315–17, 321, 322, 323,
 324, 364; VAG Council member, 324,
 326, 365, 366, 368, 381, 391
Harris, Robert, 364
Hart House String Quartet, 31, 307, 310
Hembroff, Olive May (mother of Edythe
 and Helen), 52, 56, 57, 95, 213, 245,
 249–50, 252, 253, 255–6, 258, 266,
 271, 277
Hembroff, Walter C., 18, 213, 256, 258,
 310, 331

Hembroff-Ruch, Helen (sister of Edythe), 52, 56, 57, 76, 146, 213, 253, 256, 271, 278, 331

Hembroff-Schleicher, Edythe, xxxv, 3, 10, 14, 17, 19, 29, 36, 38, 49, 51, 52, 54, 59, 61, 66, 67, 69, 70, 77, 79, 89, 104, 113, 114, 116, 117, 122, 124, 126, 128, 129, 134, 136, 138, 143, 156, 160, 163, 167, 168, 176, 185, 187, 192, 204, 214, 217, 222, 235, 243, 254, 255, 256, 266, 268, 277–8, 280, 306, 308, 310, 314, 322, 331, 346; as artist, 3, 10, 17, 61, 100–1, 185; as critic of Carr's art, 59; friendship with Emily Carr, 38; friendship with Nan Cheney, 43; marriage, 29, 36; at Metchosin, 18; social activities, 46, 49, 51; visits to Emily Carr, 52, 53, 56, 57, 76, 108, 145–6, 179, 180, 183, 194, 213, 232, 235, 249, 252, 258, 271, 277, 306–7, 331

Hemingway, Ernest, 273

Henderson, Peter, 141, 171

Hennell, Joan, 191

Henri, Robert, 11

Heward, Prudence, 29

Hitler (cat?), 84

Holbein, Hans, 162

Holgate, Edwin, 29, 73, 295, 394, 396

Holmes, Dorothy, 364, 369

Hood, Harry, 129, 160, 169, 170, 193, 296

Hossie, David N., xxxix, 290, 304, 361

Hossie, Mary G., 290

Hotel Vancouver, 149, 152, 160, 169, 171, 193, 359

House of All Sorts, The, 53, 57, 59, 408, 416

Housekeepers (Carr's). *See* Carr, housekeepers

Housser, Bess. *See* Bess Harris

Housser, Fred, 30, 279

Housser, Yvonne McKague, 30, 44, 54, 220

Hughes, E.J., 72, 152

Humphrey, Ruth, xxxii, xxxvi, 100, 108, 143, 146, 176, 183, 187, 252, 263, 299, 374

Hundreds and Thousands: The Journals of Emily Carr, xxxii

Huntington, Mrs. Lionel, 364, 369

INDIAN VILLAGE, ALERT BAY, 337

Indians. *See* Carr, Indian references

Ingall, Gertrude L., 73

Inglis Collection, British Columbia Archives and Records Service, xxiii

Inglis, John, xxxviii, 415

Inglis, Phylis Dilworth, xxxvii, 337, 339

Inky, 52, 56, 63, 65, 79, 95, 141, 146, 263, 296, 340

Island Arts and Crafts Society, xv, 3, 16, 21, 22, 126, 165

JACKSON, A.Y., 13, 16, 41, 73, 98, 106, 108, 112, 132, 141, 143, 145, 148, 153, 154, 157, 173, 216, 219, 222, 230, 308, 359, 365, 369

Jackson, Ronald, 160, 266

James Bay Hotel, 350, 356, 360, 363

Jermain, Robert L., 394

Joseph, 47, 48, 54, 56, 85, 95, 179, 232, 234, 380, 384, 389

Jubilee. *See* Royal Jubilee Hospital

KABLOONA, 339, 345

Kearley, Mark, 410

Keir, Patricia, 36

Kenning, Colonel Stuart, 354

Kennington, Eric, 380, 390

Keyserling, Herman Alexander, 287, 301

"Kingston Conference." *See* Conference of Canadian Artists

KittyJohn, 10, 17

Klee Wyck, x-xi, 253, 268, 317, 324, 330, 335, 337, 342, 345, 346, 347, 351, 352, 353, 355–6, 361, 374, 378, 403, 416

Klinck, Dr. Leonard S., 186

Koko, 7, 10, 11, 14, 17, 23, 27, 30

LADY JANE, 341, 343–4, 349, 352, 356, 360, 371

Lamb, Harold Mortimer, 63, 72, 220, 229, 230, 308, 327, 341

Lamb, Molly. *See* Molly Bobak

Lamont, Gwen, 52, 64, 66–7, 100

Laughing Torso, 385, 393

Laurencin, Marie, 385

Lawrence, D.H., 385

Lawson, Ernest, 355

Lawson, Henry Graham, 379

Lawson, Mary, 3, 7, 11, 13, 16, 23, 30, 38, 43, 46, 64, 69, 76, 84, 90, 98, 100, 126, 135, 136, 137, 146, 176, 180, 185, 186, 187, 195, 198, 207, 209, 210, 212,

214, 217, 219, 220, 223, 224, 229, 230,
240, 262, 263, 302, 304, 308, 329, 336,
345, 346, 356, 358, 364, 375, 376, 391,
394, 397, 398, 407
Lawson, William, 355
Lennie, Beatrice, 72, 106
Letters of T.E. Lawrence, 149
Lewis, Hunter, 122, 126, 130, 268
Life, 300
Lismer, Arthur, 16, 19, 22, 30, 44, 49,
208, 222, 223, 280, 293, 298–9
Lismer, Esther, 16, 19, 22, 222, 223
Little Pine, The, 148
Livesay, Dorothy (Macnair), 137, 158,
162, 307, 315
Livesay, J.F.B., 137
Longstreth, Morris, 357
Lort, Ross, 208
Lucas, Dr. Oscar C., 315
Lyceum Club and Women's Art Associa-
tion, 30
Lust for Life, 64
MACCALLUM, DR. JAMES, 97
McCullough, Esther Morgan, 272
McCurry, H.O., xi, 9, 10, 13, 22, 40, 73,
77, 79, 91, 97, 98, 112, 114, 133, 135,
168, 187, 192, 200, 209
Macdonald Park, 87, 89, 91, 180
Macdonald, Barbara, 72, 247, 273, 287,
301, 324
Macdonald, J.W.G. ("Jock"), 66, 72, 75,
96, 99, 102, 106, 107, 109, 112, 114,
115, 117, 121, 123, 131, 132, 138, 139,
145, 148, 160, 169, 171, 185, 209, 221,
224, 225, 234, 236–7, 238, 241, 246,
257, 260, 263, 265, 266, 273, 276, 284,
286, 287, 290, 292, 296, 301, 308, 324,
357, 362, 367, 382, 393, 395, 411; exhi-
bitions: (1941), VAG (solo), 324; (1938),
VAG (BCSFA), 83; financial problems, 97,
247, 286–7, 325; "Modalities," 83, 92,
106, 117, 118, 119, 121; mural (Hotel
Vancouver), 149, 151, 152, 156, 159,
160, 162, 171, 172, 193; Templeton
High School sketch, 239, 257, 263, 269,
284. *See also* Cheney, portraits
MacDonald, Dr. W.L., 206
McInnes, C. Graham, 72, 140, 230
McKague, Yvonne. *See* Yvonne McKague
Housser

McLatchy, Harry, 348, 355
McLeod, Norrie, 380
Macleod, Pegi Nicol. *See* Pegi Nicol
Macnair, Dorothy Livesay. *See* Dorothy
Macnair Livesay
Macpherson, Ian, 169, 170
McVicker, Maude F., 147, 386
Malkin, W.H., 230, 265, 358
Maltwood, John, 310
Maltwood, Katharine Emma, 143, 144
Mansfield, Katherine, 57, 62, 63, 85
Manuel, Margaret, 189
Mara, Denise, 287
Marega, Charles, 153
Marionette Library, 342
Maritime Art, 355, 364, 394, 396
Martin, Dr. C.F., 310, 323
Massey, Vincent, 100
Massey-Harris Company, 246, 265
Mather, Kate, 104
Matilda, 77, 85, 125, 127, 129, 134, 281,
360, 389
May, Mable, 172
Mayfair Nursing Home, 378, 379, 381,
383, 386, 387–8, 405
Maynard, Evelyn, 271
Maynard, Max, 29, 59, 79, 107, 156, 339,
341, 343, 345, 347–8, 367, 370
Melvin, Grace, 348
Milford, Sir Humphrey, 355
Modern English Art, 390
Modern German Art, 390
Modigliani, Amedeo, 385, 390
Monday Art Study Group, 72, 112
Mordham, Miriam, 381
My Father, Paul Gauguin, 61
NAN LAWSON CHENEY PAPERS.
University of British Columbia, The
Library, Special Collections Division,
xiii, xxiii
National Gallery of Canada, xi, xii, xxi,
7, 9, 10, 25, 38, 39, 44, 71, 72, 73, 79,
91, 100, 101, 102, 106, 121, 153, 154,
168, 173, 174, 177, 208, 347, 351, 355
New Art, The, 8
New York World's Fair, 172
Newcombe, William A., 47, 62, 66, 104,
107, 143, 199, 204, 243, 270, 310, 341
Newton, Eric, 39, 129, 159
Newton, Lilias Torrance, 29, 31, 73, 97,

118, 171, 370, 376

Nicol, Pegi, 11, 14, 16, 21, 98

North West Show. *See* Annual Exhibition of North West Artists

OSA. *See* Ontario Society of Artists

Old and New Forests, 148

Old Chim, 252, 275

Ontario Society of Artists, 73, 136, 141, 154, 157, 159, 161, 162, 173

Out of Africa, 165

Out of the Night, 302

Oxford University Press, 310, 403

PAALEN, WOLFGANG, 195

Parker, J. Delisle, 64, 66, 68, 70, 343, 366, 399

Parnall Collection, British Columbia Archives and Records Service, xxiii

Pavelic, Myfanwy, xxxii-xxxiii, xxxviii, xxxix, 89, 101, 104, 263, 399

Pearson, Carol. *See* Carol Williams

"People's Gallery," 22, 25

Pepper, George, xiii, 16, 21, 73, 118, 136, 162, 173, 359, 364, 370, 381, 394, 396, 399, 408, 411

Pepper, Kathleen Daly, xiii, xxxvii, xxxviii, 16, 21, 73, 136, 140, 162, 359, 364, 370, 381, 394, 412

Picasso, Pablo, 185, 325, 385, 408

Picture Loan Society, 79, 172

Pierce, Dr. Lorne, 110, 151

Pilgrimage, 96

Pirani, Max, 382

Plaunt, Alan, 177, 332, 333, 340

Pollock, Jessie, 284, 297

Portal, Sir Charles, 380

Portraits: Carr by Carr, 10, 13-14, 227, 404, 405; Carr by Cheney, xiv, xxii, 50, 51, 67, 71, 75, 92, 95, 96, 98, 102, 110, 112, 121, 123, 127, 132, 136, 140, 145, 154, 157, 161, 162, 173, 174, 177, 333, 382; Carr by Edythe Hembroff-Schleicher, 10, 67; Carr by Gwen Lamont, 67; Cheney by Carr, 138, 140; Cheney by Cheney, 226; Gaie Taylor by Cheney, 159, 174; J.W.G. Macdonald by Cheney, 102, 136, 140, 149, 154, 156, 159, 161, 173, 177; Mary Capilano by Cheney, 201, 339-40, 348, 363, 376; Nikolai and Tina Seminoff by Cheney, 136, 140, 154, 162; Toms by Carr, 254,

313; Toms by Cheney, 227, 341, 347, 359, 363, 381, 391; William P. Weston by Cheney, 149, 151, 154, 174. *See also* Cheney, portraits

Pout, 77, 85, 125, 252, 350, 360

Problems of Personal Life, 287

RCA. *See* Royal Canadian Academy

Ransom, Fred and Erica, 202

Relics of the Sea, 393, 395, 411

Rhodes, Helen Neilson, 69

Ridington, John, 189

Robertson, Sarah, 29

Rotary Club of Vancouver, 396

Rouault, Georges, 393

Royal Canadian Academy, 73, 77, 99, 102, 110, 112, 118, 124, 136, 140, 157, 208

Royal Jubilee Hospital, 402-3, 405, 407

Rudolf, Leonard Christopher, 357

Ryerson Press, 80, 82, 151, 163

SAGER, PETER, 154, 230

Salinger, Jehane Bietry, 22

"Salt Water," 82

San Francisco World's Fair (Golden Gate International Exposition), 152

Sara, 361, 368

Sartain, Emily, 190, 267

Saturday Night, 72, 111, 140, 162, 208, 230, 286, 300, 324, 351

Savage, Anne, 29, 154

Scott, A.K., 122

Scott, Charles H., 25, 72, 106, 108, 124, 127, 154, 160, 189, 226, 229, 265, 324

Scott, Duncan Campbell and Elise, 307-8, 310-11

Sedgewick, Dr. Garnett G., 51, 54, 59, 124, 125, 183, 186, 189, 206, 215, 345

Seminoff, Nikolai and Tina, 136, 202. *See also* Cheney, portraits

Seven Pillars of Wisdom, 149

Shackleton, Kathleen, 266

Shadbolt, Jack, xx, 29, 104, 156, 226, 229, 290, 295, 308, 324, 327, 329, 339, 341, 342, 345, 358, 367, 391, 396

Shanks, Mrs. *See* Carr, housekeepers

Sharp, G.L. Thornton, 277

Shipp, Horace, 8

Silone, Ignazio, 52

Smith, Charles, 107

Smith, Sydney, 247, 287, 293, 301, 302, 324, 364, 370, 396, 399, 408

Solemn Big Woods, 132
Solly, L. Fordham, 64, 69, 180, 185, 195, 198, 224, 356
Southam, H.S., 73, 132
"Spencer's" (David Spencer Ltd.), 112, 115, 278
Spencer, J.W., 35
Spencer, Lilian, 84, 101, 104
Spencer, Myfanwy. *See* Myfanwy Pavelic
St. Joseph's Hospital, 35, 166, 227, 231
St. Mary's Priory, 410
Steeves, Dorothy, 411
Stern, Max, 408
Stone, Beatrice: medal, 265
Stone, Henry A., 208, 265, 365, 393
Streatfeild, Betty. *See* Betty Bell
Studio, The, 10, 49, 72, 149, 342
"Sunday," 139, 307
Sylvia Court, 369
Symons, Florence, 348, 355, 357, 359, 364, 375, 399
Symons, Frank, 359
Symons, John, 348, 399
TANKS AND TANK-FOLK, 390
Tantrum, 23, 59
Tate Gallery (London), 96, 98, 100, 102, 111, 114, 131, 133, 135, 162
Taylor, Gaie, 137, 156, 159, 174, 202, 230, 329, 356, 358, 360, 376
Terry, Ellen, 134
Theosophy, 279–80, 284, 295
Tillie (Tilly), 361, 389
Toms, Edith, 42, 208, 261, 376, 382, 391, 393, 397, 399, 408
Toms, Gordon, 42, 208, 382, 391, 397, 399, 408
Toms, Humphrey Nicholas Wolferstan, 104, 108, 129, 152, 162, 175, 176, 180, 243, 251, 264–5, 278, 360; as amateur historian, xii; chronology, xlv-xlvi; death of father, 42; friendship with Emily Carr, xv; friendship with Nan Cheney, xvi; as genealogist, xxii, 399; letters to Emily Carr, 350–1, 384–6; letters to Nan Cheney, 103, 105, 139, 147, 159, 163–4, 166, 166–7, 178, 184, 188, 196–7, 199, 217–18, 223, 227–8, 232–4, 236, 240–1, 253–4, 283, 332, 335, 346; military service, xv, 197, 243, 333, 385–6; papers of, xxxvii; visits to

Emily Carr, 26–7, 103, 139, 156, 188, 196–7, 213, 223, 227, 232–4, 236, 240–1, 246, 283, 285, 332, 341. *See also* Carr, potraits; Cheney, portraits
Toms, Lewis, 42
Totem and Forest, xix
Trapp, Dr. Ethelyn, 61, 63, 80, 131, 135, 237, 238, 243, 262, 267, 268, 269, 270, 274, 280, 296, 303, 325, 327, 331, 349, 362, 371, 372, 374, 379, 382, 383, 384, 390, 394, 395, 399, 412
Trust. *See* Emily Carr Trust
Tweedsmuir, Lady, 56, 145
Twinkle, 7, 14, 17, 23
Tyler, Gerald, 169, 323
UNDERWOOD, ERIC, 390
University of British Columbia, 29, 36, 61, 122, 124, 125, 127, 129, 130, 189, 235, 265, 266, 268, 270, 324, 366, 371, 372
University Women's Club, Victoria, 79, 81, 138, 153
VALTIN, JAN, 302
Van Gogh, Vincent, 61, 64–5, 66, 146, 229, 355
Vanathe, 59
Vancouver Art Gallery, 21–2, 40, 47, 63, 64, 72–3, 75, 84, 89, 91, 92, 97, 112, 117, 118, 124, 125, 127, 130, 132, 135, 138, 172, 176, 183, 185, 189, 190, 192, 204, 208, 226, 266, 267, 302, 306, 313, 319, 324, 326, 327, 339, 341, 342, 365, 366, 367, 368–9, 376, 381, 391, 393, 396, 398, 404, 408, 409, 412; Carr as member, 138; occupation of, 84, 87, 89, 91, 92
Vancouver Art School (now Emily Carr College of Art and Design), 226, 229
Vanderpant, John, 29, 61, 92, 140
Varley, F.H., 72
Village of Yan, 218, 261, 268
W. SCOTT AND SONS, 41
Webster, Esther, 167
Weston, William P., 72, 79, 95, 96, 149, 151, 154, 185, 187, 189, 208, 381, 393
Whitman, Walt, 15, 66, 281
"Wild Flowers," 295
Williams, Carol Pearson, 320, 378
Wilson, Ethel, 226, 369
Wingate, Browni, 324

Women's Art Association. *See* Lyceum
 Club and Women's Art Association
Women's Canadian Club of Toronto, 417
Women's Canadian Club of Victoria, 22
Woo, 6, 7, 11, 17, 18, 21, 27, 38, 44, 59
"Woo's Life," 213, 216
Wood Interior, xx
Wood's Edge, 129
Woolhouse, Peggy, 348

Woolhouse, Tony, 348, 399
World War II, 146, 195, 197, 212, 213,
 224, 233, 237, 260, 271, 274, 308, 371,
 374, 403, 405, 409, 411
Wright, Mary, 44, 131, 208, 382, 407
YEARLING, THE, 280
Young Pines and Sky, xx
ZWICKER, LEROY, 355, 357, 358, 366,
 369